WORLD ART
— IN —
AMERICAN MUSEUMS

WORLD ART
IN
AMERICAN
MUSEUMS
A PERSONAL GUIDE

By Richard McLanathan

Illustrated with photographs and maps

Foreword by J. Carter Brown, Director, National Gallery of Art

Anchor Press
Doubleday & Company, Inc.
Garden City, New York
1983

For everyone who works in and for museums,
both in Canada and the United States

Library of Congress Cataloging in Publication Data

McLanathan, Richard B. K.
 World art in American museums.

 1. Art—United States—Guide-books. 2. Art museums—
United States—Guide-books. 3. Museums—United States—
Guide-books. 4. Art—Canada—Guide-books. 5. Art—museums
Canada—Guide-books. 6. Museums—Canada—Guide-books.
I. Title.
N510.M34 1983 708.13
ISBN 0–385–18515–4

Library of Congress Catalog Card Number 81–43541
Copyright © 1983 by Richard McLanathan
All Rights Reserved
Printed in the United States of America
Design by Jeanette Portelli
Endpaper photograph: *Le Repos du Sculpteur et la Sculpture Surréaliste*
by Pablo Picasso. Courtesy of the National Gallery of Art, Washington,
D.C., Rosenwald Collection.

Contents

Foreword

More people go to museums than attend all the sports contests in any given year combined. They are making a discovery. It is the recognition that the arts are not an escape from life; instead, they bring us closer to the basic realities of human experience, to the best of thoughts, hopes, and ideals as creatively expressed, with infinite variety, over centuries of time.

World Art in American Museums is for all of us who have made, or hope to make, that important discovery. It is for families and for individuals, for all ages and interests—in short, for all of us who come to our national galleries and all the other museums across the continent, both in Canada and in the United States. In the seven hundred or so museums listed, ranging from Samoa to Newfoundland and from Alaska to Puerto Rico, the guide tells where to find the work of any major artist, school, or period of art, extending in time from the prehistoric beginnings in the ancient Near East to yesterday, and in category from American and European painting and sculpture to the arts of cultures as distant as Central Asia or the islands of the South Pacific. It is all there for your pleasure, and this guide is the key to finding it.

I can think of no one who brings to the task of writing and compiling it a happier combination of expertise, experience, and enthusiasm than Richard McLanathan, former director of the American Association of Museums, who has spent a lifetime with the arts. It gives me great pleasure to introduce him to you, and to join him in inviting you to enter the exciting world of art.

J. Carter Brown, Director
National Gallery of Art
Washington, D.C.

Acknowledgments

I am grateful for the assistance and advice of too many friends and colleagues to permit my mentioning them all, but for specific professional help I must, and am delighted to, acknowledge my indebtedness to the following: J. Carter Brown, Director of the National Gallery, Washington, D.C., for writing the Foreword, and to Katherine Warwick, Ira Bartfield, and Barbara Bernard, also of the National Gallery; Dr. Michael Ames, Director of the Museum of Anthropology, Vancouver; Dr. James E. Cruise, Director of the Royal Ontario Museum; Robin Inglis, former Director of the Canadian Museums Association and currently Director of the Vancouver Museum; John R. Kinnard, Director of the Anacostia Neighborhood Museum, Smithsonian Institution, Washington, D.C.; Dr. Thomas Lawton, Director of the Freer Gallery, Smithsonian Institution, Washington, D.C.; Professor Neda Leipen, Curator of the Greek and Roman Department, Royal Ontario Museum; Abram Lerner, Director of the Hirschhorn Museum and Sculpture Garden, Smithsonian Institution, Washington, D.C.; Paul Perrot, Associate Director of the Smithsonian Institution for Museum Affairs; Edmund P. Pillsbury, Director of the Kimbell Art Museum, Fort Worth; Warren M. Robbins, Director, and Bryna Freyer of the African Museum, Smithsonian Institution, Washington, D.C.; Dr. William E. Taylor, Director of the National Museum of Man, Ottawa.

Roxlyn Yanok and Susan Ransom, both of Bowdoin College, provided valuable assistance in research, while Julie Bortola, Dinah Buechner, Elizabeth Dujmich, Margaret McCormick, and Andrea Swanson, also of Bowdoin, took time from their studies to compile essential data. Lorraine Bisson helped in the typing of the manuscript. My editors at Nelson Doubleday Books, Barbara Greenman, David Bearinger, and Henry Krawitz, have been unfailingly helpful, while Marjorie Goldstein's encouragement has meant much.

Among the many publications consulted, The American Association of Museums' annual, *The Official Museum Directory*, was essential for the latest factual information. Such recent museum guides as *Art Museums of America* by Lila Sherman, the regionally arranged *Curators' Choice* by Babette Fromme, the *American Heritage Guides to Historic Houses* and to *Historic Places*, the admirably comprehensive Reader's Digest *Treasures of America*, and the AAA state guides proved most helpful. S. Lane Faison's highly informative *The Art Museums of New England* has recently been updated and published in three volumes. G. E. Kidder Smith's invaluable three-volume guide, *The Architecture of the United States*, is in a class by itself, while Eloise Spaeth's *American Art Museums* remains a constant delight.

Finally, for standing helpfully and encouragingly by during the pachydermatous gestation period of the project, I am grateful to my wife, Jane, and for his constant attendance during its realization, to our cat, Phip.

Richard McLanathan

Author's Note

This is a personal guide in several senses. Its purpose is to encourage the indulgence, and enlargement through experience, of individual taste and curiosity. When one discovers some of the seemingly unlikely places where artistic treasures are located, one cannot but recognize the traditional American individualism that caused them to be there. To keep the whole within practical bounds, many difficult choices had to be made as to what was to be included here and what, regretfully, left out. Though I have consulted dozens of knowledgeable friends, in selection and general approach this guide reflects the experience and opinion of a single person, myself. This emphasis on individualism is appropriate to the subject at hand, because the enjoyment of art, like a love affair, is a strictly one-to-one matter, a dialogue and a sharing between the observer and the artist through the medium of the work of art.

Because of recent decades of experiment, discovery, and rediscovery in the arts, our definition of them must, of necessity, be at some variance from that of previous generations, who emphasized the fine arts rather than art in general, and for whom anything outside the Western tradition, except possibly the Far East, was totally alien. And many still take it for granted that when one speaks of "art" one has only painting in mind. Where, then, are music and dance, literature, theater, architecture, and sculpture? We now know, when we bother to think about it, that all that is creative in life is indeed art, that art is, in essence, a function of life. Though the present guide concerns itself with the visual arts rather than the others, its approach is in terms of the broader definition. You will therefore find listed along with the art museums other cultural institutions in the immediate area, with such practical information as to enable you to decide whether they are also worth a visit.

xiii

The history of the arts in America is as full of variety as the national, regional, and religious traditions brought to the New World by migrants and adventurers, pilgrims, seekers, and refugees. Looking back from the vantage point of today, one cannot but be impressed by the strangeness and power of the native American cultures, so long misunderstood, as well as the complex of legacies of Baroque Europe, of Catholic Spain, Catholic and Huguenot France, Protestant Britain, of the still-medieval traditions of Pietist Germans and Puritan English, and of Black Africa—a heterogeneous mix to which other ingredients were being constantly added. All of these, plus a myriad of other cultural strains, are evident in the collections of American museums, in which the artistic expression of almost every historical and cultural epoch is represented. It is the purpose of this guide to provide information about where these treasures may be found.

Art may be a passion, as it has always been for collectors, but its appreciation also demands action, a vicarious participation in the creative process through the work or art, whatever its category or medium. An understanding of some of the technicalities of the artistic process—the artist's means—is therefore necessary, as are some notion of the artist's purpose and an idea of the world in which he or she lived. The short introductions to the various sections of this book endeavor to note these factors. If all this is old hat to you, please skip it and start using the guide. Blank pages have been left in the back of the book for your notes and comments, and the author will welcome any suggestions of additions or corrections you may be kind enough to make. Whatever continent, archipelago, or atoll of the world of art may be your destination, welcome aboard!

How to Use the Guide

In planning a trip, the guide should enable you to find out if there are museums that you might like to see along the way. It gives names, addresses, and telephone numbers, the latest available information on the times the museum is open, and whether there is an admission fee. It briefly characterizes the museum's collections, noting their scope and high points, in many cases, even including references to individual works of art of particular interest. It also lists such other attractions as nearby historical sites, monuments, and buildings, so that if you can't see them all, at least you can make a choice and know what you are missing.

The Contents is the key to the guide. Everything is arranged alphabetically under the various headings, the list of museums in Part I being arranged geographically as well and containing the greatest amount of general information. The entries under the other headings are limited to what pertains to those subject categories. Therefore, if you are consulting Part II, and wish to know what else may be found in a given museum, or need specific information or museum addresses, phone numbers, hours, and fees, check Part I. Almost all museums appearing in any other section are also listed there. Under particular categories certain collections are listed which, because of their specialized nature, do not appear in Part I. In such cases the address and other practical information are included in that entry. Collections mentioned by name only are fully described in Part I.

If you are particularly interested in a specific artist, school, or period of art, check the lists under the appropriate headings to find the museums that have examples, be it Rembrandt's paintings or Pre-Columbian artifacts, prints or clocks, goldsmithery or paintings of Colonial ancestors. To make things easier, Primitive Arts, Decorative Arts (furniture, furnishings, etc.), and Prints and Drawings have been listed separately. Since almost all art museums have some objects in these

categories, only those that have strong representation in the given field are noted. Under Special Collections you will find a delightful miscellany, including national and ethnic collections and museums devoted to such matters as the circus, horses, the theater, photography, and the China Trade.

Since it is all but impossible to talk about the arts without using some technical terms, a glossary of those most frequently encountered is included at the back of the book.

When individual museums are mentioned in the text, I have followed the traditional style of referring to them by the city in which they are located or by their name, in shortened form, according to popular usage. Their full names appear in Part I, and a key list follows the introduction to Part III on Artists.

All museums are required by law to make their facilities available to the handicapped. Since there are as yet no precise guidelines, and since institutions differ tremendously in physical layout—from historic buildings and nineteenth-century palaces of the arts to the most up-to-date structures—and, finally, because they are notoriously understaffed due to financial stringencies, it would be wise to telephone or write ahead if special arrangements are necessary. The museums will be grateful for this thoughtfulness on your part, which will enable them to make your visit more memorable.

A hand (☞) has been used to denote collections and individual objects of particular artistic importance. A star (★) marks my own favorite works of art, and I have usually included a word or two to explain why. Obviously you will have yours, but compiling this guide has given me the opportunity to introduce you to works that have become, to me, old and valued friends. I am delighted to have the chance to share them with you.

As a further help in planning your visit, I have laid out several regional tours. You will find them in Part I, arranged geographically, with maps and approximate mileages.

Richard McLanathan

WORLD ART
— IN —
AMERICAN
MUSEUMS

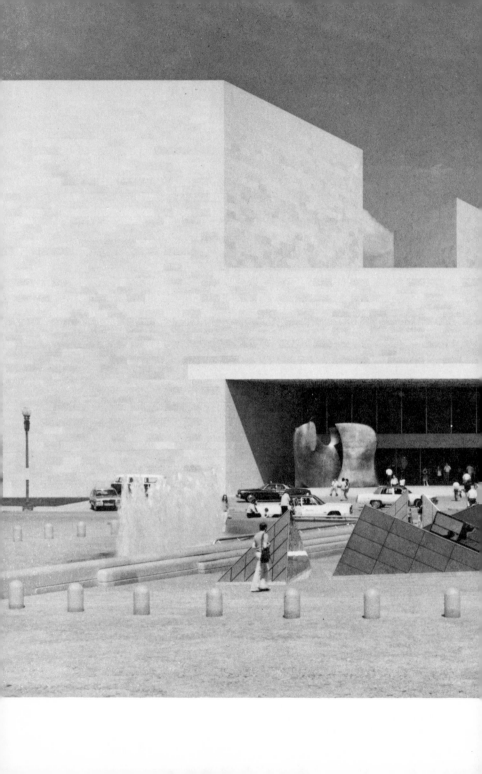

I. MUSEUMS

East Building, National Gallery of Art, Washington, D.C. COURTESY OF THE
NATIONAL GALLERY OF ART

I. MUSEUMS

The story of art museums in America is a story of individuals and of ideals. All such institutions—from the earliest, founded before the start of the nineteenth century, to the latest, which are even now springing up across the country in astonishing numbers—are the result of the initiative of those fired by an enthusiasm for the arts and by a belief in their value to the community. Private philanthropy and, more recently, federal, state, county, and municipal funds are a part of the story, along with independent and corporate foundations, but from the beginning the operational force has been supplied by dedicated individuals.

There were a number of generous patrons of American artists before the Civil War whose acquisitions often became the nuclei of important museum collections. They shared with their contemporary artists and writers an interest in landscape and the American scene, as well as a preoccupation with change and the sense of the inexorable passage of time and the brevity of life. These themes, typical of the Romanticism of the period, led to an increased interest in the past, expressed in architectural revivalism, romantic literature, and evolving archaeology. The prevailing Neoclassicism of the earlier decades of the nineteenth century and the enticing vistas into the Middle Ages opened up by the Gothic novel, Sir Walter Scott's romances, and Thomas Cole's paintings were reflected in the architectural styles of the museums and other public buildings of the period. The earlier Classical style can be seen, for example, in Alexander Parris' Pilgrim Hall (1824) in Plymouth, America's first public museum building. On the other hand, Hartford's distinguished Wadsworth Atheneum (1842), sponsored by Daniel Wadsworth, is built in the medieval manner, as is the original Smithsonian Institution (1855) on the Mall in Washington, D.C., the work of the exuberant James Renwick, Jr.

2

Luman Reed, a prominent New York merchant, was a leading patron in the 1830s and '40s. When his collection of contemporary American pictures outgrew even his spacious house, the New York Gallery of Fine Arts was established to enable a larger public to see it. After his death in 1858, it became a major part of the outstanding collections of The New-York Historical Society. Reed's son-in-law, Jonathan Sturgis, carried on the tradition, assisting many an ambitious young American along the path of the arts. Robert Gilmore of Baltimore collected Old Masters with an eye far more knowing than most of his contemporaries; he also admired the works of Thomas Cole and the Hudson River landscapists, with which he surrounded himself in the Gothic Revival mansion "Glenellen," designed by his friend Alexander Jackson Davis in 1832. Nicholas Longworth of Cincinnati not only produced what his European friends considered a very acceptable wine from the local Catawba grapes but also financed the immensely successful career of Hiram Powers, a leading sculptor of the period, both at home and abroad. In addition, Longworth launched Robert Duncanson, the black portrait and landscape painter, with a commission for decorative murals for his handsome Greek Revival house, today the Taft Museum.

James Jackson Jarves, financed by a fortune made in Sandwich glass, was a pioneer in acquiring works of the late Middle Ages and early Renaissance in Italy. His collection became the glory of the art gallery at Yale, even though the college reluctantly accepted it in repayment for a bad debt. Jarves' second assemblage became the foundation of the superb collection of the Cleveland Museum. W. T. Walters of Baltimore and William W. Corcoran of Washington, D.C., were contemporaries of Jarves; their collections became the Walters Art Gallery and the Corcoran Gallery, respectively. In the seventies the acumen and enthusiasm of T. B. Walker of Minnesota and E. B. Crocker of California led to the

3

creation of the prestigious Walker Art Center in Minneapolis and the Crocker Art Museum of Sacramento. The "Proud Possessors" of the next few generations followed the lead of these earlier collectors. They included Morgan, Marquand, Altman, Mellon, Hanna, Rockefeller, and Garvin, leading on to Kress, Karolik, Hirschhorn, the younger Mellons, and the many others whose personal pursuit of the arts has led to their being shared by an ever-increasing audience.

The museums of Europe were founded as royal or aristocratic collections, such things being a part of the appanage of exalted social position, but those in America were established by private citizens for the general public.* American architects borrowed the palace form for many nineteenth- and early twentieth-century museum buildings, but, like our railroad stations, theaters, and even our Mississippi and Hudson River steamboats, museums were built as palaces for people in general, not for the favored few. Furthermore, they were established with a definite educational purpose, because their founders shared the contemporary belief not only in the moral and spiritual value of the arts but also in their ability to provide a generally accessible means of enlightenment and understanding. One has but to read the founding documents of New York City's Metropolitan Museum of Art, its American Museum of Natural History, and Boston's Museum of Fine Arts—all of which were established around 1870—to find their educational aim explicitly stated. In terms of exhibitions, installations, publications, and other aspects of their programs, today's museums increasingly endeavor to carry out an educational function, thus adding a dynamic dimension to their basic responsibilities of collection and conservation. If the dramatic rise in attendance figures for America's museums is any criterion, they are providing the ingredient of enjoyment as well.

* Foundation dates are included in the following list.

4

ALABAMA

Birmingham Museum of Art
1951
2000 Eighth Ave. N, 35203
(205 254-2565)
Tues.–Wed., Sat. 10–5; Thurs.
10–9; Sun. 2–6; closed New
Year's, Christmas. No charge

General: Kress Collection of Italian Renaissance and Northern European; Dutch and Flemish 17th C. painting; English 18th C. painting; Western America, incl. 12 Remington bronzes; native American artifacts from Northwest Coast, Plains, and Mounds; Peruvian gold; Oriental and modern ceramics; English and American silver, incl. Hester Bateman, Paul de Lamarie; Beeson Collection of 1,500 Wedgwood pieces before 1830; Reeves Collection of Palestinian artifacts; Paleolithic to Byzantine ceramics. ☛ Canaletto's *View of the Grand Canal, Venice;* ★ Anon. Flemish painter's *Battle of Pavia* (c. 1525), naive, fascinating detail; Rubens' *Ceres and Pomona,* beautifully painted, probably mostly by assistants.

Mobile: The Fine Arts Museum of the South at Mobile 1964
Museum Dr., Langan Park, 36608
(205 342-4642)
Tues.–Wed., Sat. 10–5; Thurs.,
10–9; Sun. 12–5; closed Mon.,
holidays. No charge

General: African, folk, and contemporary art; special emphasis on the decorative arts of the South in a growing collection; graphics; Pre-Columbian arts; Oriental art; 19th–20th C. American and European painting, sculpture, and decorative arts.

• Historic districts and buildings, incl. Oakleigh, 1833–38 Greek Revival, raised-T house, museum, and garden; open daily early Jan.– late Dec.; fee.
• USS *Alabama* Battleship Memorial with USS *Drum,* 1941 submarine, 2 1/2 m. E via US 90, Bankhead Tunnel; daily 8–sunset; no charge; 205 433-2703.
• Historic Pensacola, FL, 60 m. E on US 10; historic buildings; 904 434-1042.

Montgomery Museum of Fine Arts 1930
440 S. McDonough St., 36104
(205 834-3490)
Tues.–Wed., Fri.–Sat. 10–5;
Thurs. 10–10; closed Mon.,
holidays. No charge

General: 19th–20th C. American painting, graphics; French Impressionists; sculpture, decorative arts.

• Historic district and buildings, incl. First White House of the Confederacy, 644 Washington St.; Mon.–Fri. 8–5; Sat., Sun. 8– 11:30, 12:30–5; closed holidays; contribution; 205 832-5269.
• Tumbling Waters Museum of Flags, 131 S. Perry St.; everything about flags; daily 10–5; no charge; 205 262-5335.

ALASKA

Anchorage Historical and Fine Arts Museum 1968
121 W. Seventh Ave., 99501
(907 264-4326)
June-Aug.: Mon., Wed., Fri.-Sat. 9-6; Tues., Thurs. 9-9; Sun. 1-5; Sept.-May: Tues.-Sat. 9-6; Sun. 1-5; closed Mon., holidays. No charge

Cook Inlet Historical Society collections of Alaskan objects from Russian period (1741-1867) to present; Eskimo, Aleut, Athabascan, and Tlinget-Haida objects; 19th-20th C. Alaskan painting.

Sitka: Sheldon Jackson Museum 1888
Box 479, 99835 (907 747-5228)
May 15-Sept. 15: daily 8-5; Sept. 16-May 14: Tues.-Fri., Sun. 1-4; closed Sat., Mon., and holidays. Adults $1, children no charge

Anthropological museum of Sheldon Jackson College, with objects from all native Alaskan cultures; Russian Orthodox and Finnish Lutheran religious objects.
• Sitka National Historical Park, PO Box 738. Site of Battle of Alaska between Russians and Tlingets, 1804; historical collections; mid-May-mid-Sept., daily 8-8; mid-Sept.-mid-May, Mon.-Sat. 8-5 (closed Sun.); no charge; 907 747-6281.

ARIZONA

Phoenix Art Museum 1949
1625 N. Central Ave., 85004
(602 257-1222)
Tues., Thurs.-Sat. 10-5; Wed. 10-9; Sun. 1-5; closed Mon., holidays. No charge

General: Medieval, Renaissance, Baroque, 18th-19th C. European arts; Oriental art; contemporary American painting, sculpture; Central and South American arts; Mexican and Western art; Peruvian silver; costumes.
• The Heard Museum, 22 E. Monte Vista Rd.; one of the great anthropology museums with superb American Indian collections, esp. Southwest, early to modern; Mon.-Sat. 10-5; Sun. 1-5; closed holidays; fee; 602 252-8848.
• Pioneer Arizona, I-17 and Pioneer Rd.; living history museum, more than 26 buildings incl. a saloon and an 1860 ranch with live animals; Tues.-Sun. 9-5; closed Mon.; fee; 602 993-0210.
• Taliesin West, Shea Blvd. and 108th St., Scottsdale (a suburb, a half hour's drive from downtown Phoenix); spectacular winter headquarters designed by Frank Lloyd Wright for his architectural school, continued by the Wright Foundation; Wright's last important commission, the Grady Gammage Auditorium, is on the Arizona State University campus in nearby Tempe.

• Scottsdale Center for the Arts, 7383 Scottsdale Mall, has changing exhibits and the beginning of a collection; cultural programs.

and La Casa Cordova, a museum of Mexican art and life. Tours in English and Spanish; bilingual labels and publications.

Tempe: Arizona State University Art Collections 1950
Matthews Center, Arizona State University, 85281
(602 965-2874)
Mon.–Fri. 8–5; Sun. 1–5; closed Sat. and holidays. No charge

Outstanding collection of American painting, 18th–20th C.; fine Americana and decorative arts, esp. pottery; fine print collection, incl. Dürer, Rembrandt, Whistler; European painting and sculpture; crafts; Latin American arts. ☛ Homer, Ryder, Prendergast, The Eight, and ★ Audubon's vivid *Otter, Osprey and Salmon.*

Tucson Museum of Art 1924
140 Main Ave., 85705
(602 624-2333)
Tues.–Sat. 10–5; Sun. 1–5; closed Mon. and holidays. No charge

Strong in Pre-Columbian, Spanish Colonial, and Western art; 19th–20th C. American and European painting, sculpture, graphic art; contemporary arts and crafts of the Southwest; Latin American art housed in a new building designed by William Wilde in a historic district, with 19th C. adobe houses adapted to museum functions such as the art school,

University of Arizona Museum of Art 1955
Olive Rd. and Speedway, 85721
(602 626-2173)
Mon.–Sat. 9–5; Sun. 12–5; closed holidays. No charge

Primarily a European and American collection of painting and sculpture; note esp. the paintings of the New York School, sculptures of Moore, Maillol, and Archipenko; Kress Collection of Renaissance art is dominated by a colossal retable from the cathedral of Ciudad Rodrigo, Spain; attributed to Fernando Gallego, a minor and mannered painter, it shows the strong Flemish influence then prevalent in Spain; a collection of Jacques Lipchitz maquettes.
• Arizona State Museum of Anthropology, also on campus, has artifacts of the Southwest; Mon.–Sat. 9–5; Sun. 2–5; closed holidays; no charge; 602 626-1180.
• Arizona-Sonora Desert Museum, Rt. 9, 14 m. W in Tucson Mt. Park; everything about animal life in the desert; Labor Day–May 31: daily 8:30–sundown; June 1–Labor Day: 7–sundown; fee; 602 883-1380.
• ★ Mission San Xavier del Bac, Rt. 11, 9 m. SW on Mission Rd.;

a strikingly handsome example of a Spanish mission dating from 1794–97; daily 9–6; no charge (contribution to mission optional); 602 294-2624.

ARKANSAS

Little Rock: Arkansas Arts Center 1960
MacArthur Park, 72203
(501 372-4000)
Mon.–Sat. 10–5; Sun. and holidays 12–5; closed Christmas. No charge (donation accepted)

Varied collection; strongest in prints, watercolors, and drawings; contemporary works from the Delta area; music collection is strong in American jazz. ☛ Odilon Redon's poetic *Andromeda* about to be rescued from a fantastic monster by the hero Perseus.
• Little Rock has several historic districts, esp. the Arkansas Territorial Restoration, with 13 period buildings on their original sites in a beautiful setting to show pre–Civil War Arkansas life; fee; 501 371-2348.
• The Old State House Square Historic District contains the distinctive Greek Revival Capitol designed by Gideon Shyrock in 1840; no charge; 501 371-1749.
Pine Bluff: Southeast Arkansas Arts and Science Center 1968
Civic Center, 71601
(501 536-3375) (40 m. S of Little Rock on Rt. 65)
Mon.–Fri. 10–5; Sat. 10–4; closed Sun. and holidays. No charge

19th C. European paintings; 20th C. American paintings and prints; changing exhibitions, cultural programs.
• Metrocenter Mall has an important Henry Moore sculpture.

CALIFORNIA

Berkeley: University Art Museum 1965
2626 Bancroft Way, 94720
(415 642-1207)
Wed.–Sun. 11–5; closed Mon., Tues., holidays. No charge

General collections, with special emphasis on the contemporary; modern painting and sculpture, esp. New York School, 45 paintings by Hans Hofmann donated by the artist, with personal archive; Far Eastern painting; Pacific Film Archive.
• The Bade Institute of Biblical Archeology, 1798 Scenic Ave.; objects from Tell al-Nasbeh, probably ancient Mizpah; artifacts from Egypt, Syria, Cyprus, Greece, and Rome; Mon.–Fri. 9–5; Sat., Sun. by appointment; no charge; 415 848-0529.
• Judah L. Magnes Memorial Museum, 2911 Russell St.; Jewish ceremonial arts, mss., artifacts, archive, esp. from India and North Africa; Holocaust collection; Sun.–Fri. 10–4; closed for Jewish holidays; no charge; 415 849-2710.
• Robert H. Lowie Museum of Anthropology, 103 Kroeber Hall, University of California campus;

good primitive arts collections from the Americas, Oceania, Africa, Asia; Mon.–Fri. 10–4; Sat.–Sun. 12–4; closed holidays and University administrative holidays; fee; 415 642-3681.

La Jolla Museum of Contemporary Art 1941
700 Prospect St., 92037
(714 454-3541) (next door to San Diego)
Tues.–Fri. 10–5; Sat., Sun. 12:30–5; closed major holidays. Contribution

Primarily 20th C. collections of painting, prints, drawings, sculpture, photography; Oceanic, Pre-Columbian, and African art. ☛ 70 oils and watercolors by John Marin and Marsden Hartley, Kirchner's *Self-Portrait with Model.*

Los Angeles: The Frederick S. Wight Art Gallery of the University of California at Los Angeles 1952
405 Hilgard Ave., 90024
(213 825-1461)
Tues.–Fri. 11–5; Sat.–Sun. 1–5; closed Mon., holidays, month of Aug.. No charge

Located in an extensive sculpture garden displaying outstanding modern examples by Smith, Calder, Moore, Lipchitz, Noguchi, Maillol, Rodin, Arp, Archipenko, etc.; Welcome Collection of African art; Kennedy Collection of Oceanic art; Wood Collection of Pre-Columbian art; Japanese prints and an extensive graph-ics collection in the Grunwald Center for the Graphic Arts; German Expressionist collection. ☛ Matisse reliefs ("The Backs"), Duchamp-Villon's *The Horse.*

Los Angeles County Museum of Art 1911
5905 Wilshire Blvd., 90036
(213 937-4250)
Tues.–Fri. 10–5; Sat.–Sun. 10–6; closed Mon., holidays. Fee

Housed in three pavilions designed by William L. Pereira, surrounded by a sculpture garden with works from Rodin to present; a great general collection ranging from early Near and Middle Eastern antiquities, Greece, Rome, and Western art to modern, with fine Far Eastern collections as well; Heeramaneck collection of Indian arts, arts of Nepal and Tibet; outstanding decorative arts dating from the Gothic and beyond; textiles; costumes; prints and drawings; Hispano-Moresque pottery; Greek, Etruscan, Hellenistic, and Roman sculpture; Pre-Columbian, African, Oceanic arts; 19th–20th C. American and European painting. ☛ Assyrian reliefs, works of Giovanni Bellini, Masolino, Holbein, Cézanne, Degas, and the Americans Copley, Stuart, Homer, Eakins, Inness.
• El Pueblo de Los Angeles State Historic Park, 845 N. Alameda St. historic buildings; guided tours, no charge; 213 628-1274.
• Hebrew Union College Skirball Museum, 3077 University Mall;

Kirschstein Collection of Jewish ceremonial art; Glueck Memorial Collection of archaeological artifacts from the Near East; Hamburger numismatic collection; Solomon Collection of engravings and photographs; mss., textiles, decorative arts; Tues.-Fri. 11-4; Sun. 10-5; closed national and Jewish holidays; no charge; 213 749-3424.

• Southwest Museum, 234 Museum Dr.; anthropological and art collection of Indian cultures of the Americas, prehistoric to modern; Hispanic cultural artifacts; Tues.-Sun. 1-5; closed holidays; no charge; 213 221-2163.

• University Galleries, University of Southern California, 823 Exposition Blvd., Hammer and Fisher collections of 15th-20th C. paintings; European and American painting, sculpture, and graphic arts; photographs; no charge; 213 741-2799.

Malibu: J. Paul Getty Museum
1953
17985 Pacific Coast Hwy., 90265
(213 459-2306)
June-Sept.: Mon.-Fri. 10-5;
closed weekends; Oct.-May:
Tues.-Sat. 10-5; closed Sun.;
closed holidays. No charge

Housed in a re-creation of the 1st C. B.C. Villa dei Papyri at Herculaneum, complete with gardens; the museum probably has the largest endowment of any in the world, with extraordinary Classical collections and French decorative arts. ☛ ★ Life-sized bronze hero, attributed to Lysippos, found in the sea off the Italian coast, Lansdowne Herakles from Hadrian's villa at Tivoli, Mazarin Venus, Cottingham relief of Greek youth with a mettlesome horse, Orpheus mosaic from France; fine Renaissance and Baroque painting; Classic French furniture and furnishings. (*Note:* Phone ahead! The museum's immense popularity has led to its being overrun and its generous parking facilities filled at peak times of the year.)

Oakland Museum 1969
1000 Oak St., 94607
(415 273-3402)
Tues.-Sat. 10-5; Sun. 12-7; closed
Mon., holidays. No charge

Devoted to the arts, natural science, and cultural history, the museum is housed in a building of tiered terraces and galleries designed by Kevin Roche/John Dinkaloo & Associates; Kahn Collection of 19th C. painting of California by Californians; California arts and crafts and contemporary arts. ☛ Bierstadt paintings; contemporary works by Diebenkorn and Wayne Thibaud.

Pasadena: Norton Simon
Museum 1924
Colorado and Orange Grove
Blvds., 91105
(213 449-6840)
Thurs.-Sun. 12-6; closed Mon.-
Wed.. Fee

The former Pasadena Museum of Modern Art has been transformed by the dedicated collector Norton

Simon into a showplace for his own remarkable and compendious collections—which are constantly growing—primarily of European art from the Renaissance to recent times. Includes Old Masters of the highest quality (esp. a famous Raphael *Madonna,* Rembrandts, and Rubenses) up to the present, plus an extraordinary collection of 19th–20th C. sculpture; Matisse, Picasso, Klee, Kandinsky, and German Expressionists; Impressionists and Post-Impressionists; a background collection of objects from Classical antiquity through the Middle Ages, with primitive arts, Indian art, and art of the Far East shown on a rotating basis.
• Pacific Asia Museum, 46 N. Los Robles Ave.; housed in a Chinese-style building containing a collection of Chinese and Japanese scrolls, screens, ceramics, textiles, toys. Wed.–Sun. 12–5; closed Mon., Tues., holidays; fee; 213 449-2742.
• Kidspace, A Participatory Museum, 390 S. El Molino, 91101; children's museum with art of West Coast artists. Oct.–June 15: Tues.–Thurs. 9:30–12:30; Sat. 10–4; June 15–July 31: Tues.–Thurs. 9–12:30; Sat. 9–3; closed Sun., Mon., Fri., holidays, Aug. 1–Sept. 30; no charge; 213 449-9143.

Sacramento: Crocker Art Museum 1885
216 O St., 95814
(916 446-4677)
Tues. 2–10; Wed.–Sun. 10–5; closed Mon., holidays. Fee

Early Renaissance to 20th C.; 15th–20th C. master drawings, incl. Rembrandt, Dürer, Fragonard; antiquities, incl. Babylonian clay tablets, Greek vases, Roman glass; Pre-Columbian ceramics; Far Eastern art, incl. Korean pottery.
• California State Indian Museum, 2618 K St.; located near historic Sutter's Fort; California Indian arts; daily 10–5; closed major holidays; no charge; 916 445-4209.
• Old Sacramento Historic District, located at the junction of US Rts. 40, 50, 49 and State Rts. 16 and 24; the largest group of 1849 Gold Rush buildings on the Coast; contact Sacramento Museum and History Commission, 1931 K St., 95814, on this and other historic buildings and districts; 916 447-2958.

San Diego Museum of Art 1925
Balboa Park, 92101
(714 232-7931)
Tues.–Sun. 10–5; closed Mon., holidays. Fee

Occupying a Spanish-style building inspired by the California/ Panama International Exposition of 1915–17, the museum contains a collection of European and American painting and decorative arts; outstanding Spanish painting, incl. Zurbarán, Goya; Italian, incl. Tiepolo, Bellini; examples of major European schools; Far Eastern collections, Indian and Persian art; 19th–20th C. Ameri-

(Continued on p. 14)

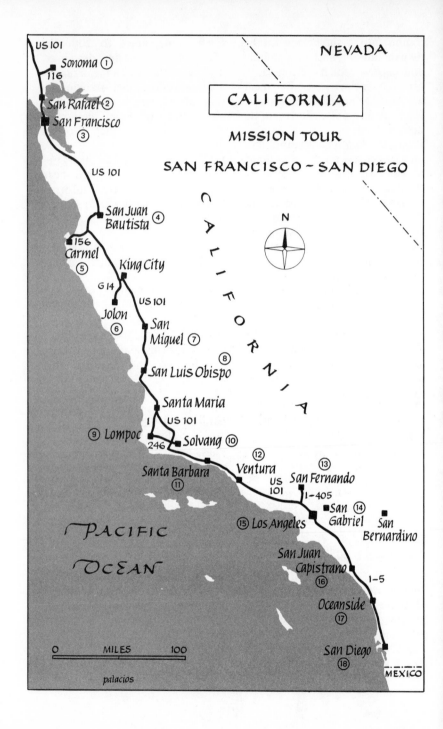

CALIFORNIA

Mission Tour

The California missions were founded by Franciscans, starting with the redoubtable Fray Junípero Serra, between 1769 and 1823, twenty to thirty miles apart — about a day's journey — along an old Spanish trail that became known as El Camino Real, the King's Highway. US 101 roughly follows the course of El Camino Real for much of its length.

There are two interesting missions north of San Francisco:

1. *Sonoma:* San Francisco de Solano (1823), the farthest N of the Franciscan foundations, part of the historic Sonoma Plaza ensemble; 40 m. N of San Francisco, via US 101 to Petaluma, E on 116 to Sonoma.

2. *San Rafael:* San Rafael Arcangel (1817), a reconstruction on the original site; 5th Ave. and A St.; 15 m. N of San Francisco via US 101.

The following are the most interesting of the remaining missions between San Francisco and San Diego.

3. *San Francisco:* San Francisco de Asis, also called Mission Dolores (1776); Dolores St. near 16th.

4. *San Juan Bautista, (1797),* State Historic Park 3 m. E of US 101; the church is part of a picturesque historic group of adobe buildings on the famous Old Plaza.

5. *Carmel (Monterey):* San Carlos Borromeo (1793), Church St. between Camino El Estero and Figueroa St. off State 1 (from San Juan Bautista take US 101 S to 156 SW to State 1; 35 m.); beautifully restored in the 1930s; the heroic Fray Junípero Serra is buried here.

6. *Jolon:* San Antonio de Padua (1771), 20 m. SW on G 14 from US 101 at King City; in the picturesque Valley of the Oaks.

7. *San Miguel:* San Miguel Arcangel (1797), E off US 101 on Mission St.; with interesting murals done in 1821 by Esteban Munras, a Catalan artist, and Indian assistants.

8. *San Luis Obispo:* San Luis Obispo de Tolosa (1772), just off US 101 on Chorro and Monterey Sts.; built by Chumash Indians.

9. *Lompoc:* La Purisima (1787), 3 m. NE on St. 1 and 246, the Lompoc-Casmalia road (bear right on St. 1 off US 101 just S of Santa Maria; mission is 15 m. S of Orcutt); carefully reconstructed in the 1930s.

10. *Solvang:* Santa Ynez (1804), 6 m. E of US 101 on 246 (25 m. E of Lompoc on 246); well restored; note 18th C. carved and painted Mexican figure of St. Agnes over the altar.

11. *Santa Barbara* (1786), 2201 Laguna St. (NE off US 101 at Mission St. has fine facade, interior, and a beautiful cloister.

12. *Ventura:* San Buenaventura (1782), Main and Figueroa St.; a restoration of the ninth and last mission founded by Serra.

13. *San Fernando:* San Fernando Rey de Espana (1797), 15151 San Fernando Rd. (10 m. N off 101 on I-405 to Mission Hills); the garden fountain, based on the design of one in Córdoba, Spain, dates from 1812.

14. *San Gabriel:* San Gabriel Arcangel (1771), 314 Mission Dr. at Junípero Serra Dr. (W off US 101 onto San Bernardino Freeway — I-10 — N on Gabriel Boulevard, W on Main Street, S to Mission); semi-fortified and impressive. *(Note:* The Asistencia Mission in San Bernardino, Alabama Street, a couple of miles S of I-10, 60 m. E of San Gabriel, has also been restored; in 1851 it was purchased by Mormons, who laid out a new city around it on the plan of Salt Lake City but abandoned the project six years later, though elements of their plan remains.)

15. *Los Angeles:* Nuestra Señora la Reina de los Angeles (1814), El Pueblo de Los Angeles State Historic Park, 100 Calle de la Plaza, along with other restored historic buildings.

16. *San Juan Capistrano* (1776), 3 blocks W of I-5 on CA 74 and Ortega Hwy.; ruined by an earthquake in 1812, but still a picturesque ruin, famous for its swallows and Serra Chapel.

17. *Oceanside:* San Luis Rey de Francia (1811), 4 m. E of I-5 on Mission Road — CA 76; reconstructed and rededicated in the 1890s as a seminary and parish church.

18. *San Diego:* San Diego de Alcala (1769), 10818 San Diego Mission Rd. (E from downtown on I-8 to I-15, N on Mission Rd.); the first of the California missions and California's earliest church; carefully restored in the 1930s.

can painting; surrounded by sculpture garden displaying American and European modern works by Moore, Miró, Smith, and Marini.
• Timken Art Gallery, 1500 El Prado, Balboa Park, adjacent to the San Diego Museum of Art; a very fine small collection of Old Masters, incl. Giotto, Bosch, Christus, Ribera, Cuyp; note esp. ★ Pieter Brueghel the Elder's *Parable of the Sower* (1557), with its superb Alpine landscape, and ★ Corot's *View of Volterra*, with its clear Italian light; 19th C. American painting; 17th–18th C. Gobelin tapestries; Russian icons. Tues.–Sat. 10–4:30; Sun. 1:30–4:30; closed Mon., holidays; no charge; 714 239-5548.

• Historical Shrine Foundation of San Diego County, 2482 San Diego Ave.; historic houses, incl. the Derby-Pendleton House shipped from Maine in 1851; Wed.–Sun. 10–4:30; closed holidays; small fees; 714 298-2482.
• San Diego Maritime Museum, 1306 N. Harbor Dr.; consisting of three vessels, incl. *The Star of India* (1863); daily 9–8; fee; 714 234-9153.
• Mission San Diego de Alcala, 10818 San Diego Mission Rd.; the heroic Fray Junípero Serra's 1769 mission, rectory, and residence; daily 9–5; closed Christmas; small fee; 714 281-8449.
• Old Town San Diego State Historic Park, 2725 Congress St.;

group of historic Hispanic houses and buildings; small fee for the two museum collections; winter: daily 10–5; summer: daily 10–6; closed holidays; 714 737-6766.
• San Diego Historical Society, 2727 Presidio Dr.; Serra Museum near site of his historic first mission and presidio in Alta California founded by Fray Junípero Serra and Governor-Captain Gaspar de Portolá, in 1769; small fee; Mon.–Sat. 9–4:45; Sun. 12–4:45; closed holidays; 714 297-3258.
• There is also an Aero-Space Museum in Balboa Park; daily 10–4:30; closed holidays; fee; 714 234-8291.
• San Diego has one of the world's greatest zoos with a wild animal park; fee; 714 231-1515.

San Francisco: The Fine Arts Museums of San Francisco:
M.H. de Young Museum, Golden Gate Park, 94118 1895
(415 558-2887)
California Palace of the Legion of Honor, Lincoln Park, 94121 1924
(415 558-2881)
Daily 10–5. Fee

(*Note:* Though the two museums have combined administrations, they are located some distance apart; the Asian Art Museum, Avery Brundage Collection, also has a separate administration, though it is virtually a part of the de Young Museum.)
M. H. de Young Museum: Kress Collection of Renaissance and Baroque art, incl. Titian, Fra

Angelico, El Greco, Rembrandt, Rubens; Hearst Collection of Flemish Gothic tapestries; German, English, Spanish, and French period rooms, decorative arts; American painting, Colonial period to Abstract Expressionism, incl. William Harnett's famous trompe l'oeil *After the Hunt,* as well as works by Church, Copley, Stuart, and the Hudson River School; Hassam, Twachtman, The Eight; fine primitive Pre-Columbian, Northwest Coast Indian, African, and Oceanic arts collections; objects from Egypt, Greece, and Rome.
California Palace of the Legion of Honor: It is esp. strong in 18th C. French furniture, decorative arts; Louis XVI salon from the Hôtel d'Humières, Paris; French painting 17th–20th C., incl. Fragonard's *Self-Portrait,* Boucher, Le Nain, Corot, Manet, Monet, Renoir; Medieval and Renaissance art and decorative arts, incl. a series of *Apocalypse* tapestries (1375–80) woven for the Duke of Anjou, the oldest such series extant; Rodin sculptures, incl. *The Burghers of Calais, St. John the Baptist;* the Achenbach Foundation for Graphic Arts has an extraordinary collection of prints and drawings of all periods. (*Note:* The building is a copy of the Palace of the Legion of Honor, formerly the Hôtel de Salm, Paris, and the site is spectacular.)
Asian Art Museum, Avery Brundage Collection: Housed in a wing of the de Young, an outstanding

assemblage of Far Eastern art, incl. Chinese paintings, bronzes, jades, ceramics, stones dating from the earliest times; a parallel collection of Japanese art, incl. fine screens and scrolls, Haniwa figures; lacquer and decorative arts; Indian sculpture, bronzes, and other objects from India, Korea, and Southeast Asia; collections are rotated for display.

• San Francisco Art Institute Galleries, 800 Chestnut St.; 19th–20th C. European and American art, incl. contemporary West Coast painting, sculpture, and prints. Daily 10–4; closed holidays; no charge; 415 771-7020.

• San Francisco Museum of Modern Art, McAllister St. and Van Ness Ave.; located on two upper floors of the War Memorial Building in the Civic Center, the collections are almost entirely 20th C. European and American, incl. Picasso, Matisse, Braque; German Expressionists; West Coast contemporary artists; Americans, from Marin, Davis, Hartley, and O'Keeffe to Abstract Abstractionists, the latest experiments, and media; Tues.-Wed., Fri. 10–6; Thurs. 10–10; Sat.-Sun. 10–5; fee; 415 863-8800.

• Chinese Culture Center Gallery, 750 Kearny St.; collections pertaining to China and the Chinese in California; Tues.-Sat. 10–5; closed Sun., Mon., holidays; no charge; 415 986-1822.

• Museum of Russian Culture, 2450 Sutter St.; primarily archives and numismatic collection. Wed. and Sat. 1–3; closed other days and holidays; 415 921-4082.

• San Francisco African American Historical and Cultural Society, 680 McAllister St.; collections and material on Black culture in West Coast, the Americas, the Caribbean, Africa. Tues.-Sat. 10–6; closed Sun., Mon., holidays, Martin Luther King's birthday; no charge; 415 864-1010.

• National Maritime Museum, Golden Gate National Recreation Area; large collection of models, logs, archival material, maritime history (primarily of the West Coast); paintings, artifacts, carvings; historic ships, incl. full-rigged ship *Baclutha,* for which there is a fee; daily 10–5; summer daily 10–6; *Baclutha* 10–10; no charge for other vessels and buildings; 415 556-8177.

• Wells Fargo Bank History Room, 420 Montgomery St.; Concord stagecoach; guns, photographs, records of the Pony Express, Gold Rush, early West Coast banking. Mon–Fri. 10–3; closed Sat., Sun., holidays; no charge; 415 396-2619.

• The Exploratorium, 3601 Lyon St.; housed in the Palace of Fine Arts, a pioneering participatory museum, with exhibits and experiences to reveal the nature of the physical world and our perceptions of it; Wed. 1–5 and 7–9:30; Thurs.-Fri. 1–5; Sat.-Sun. 12–5; closed Thanksgiving, Christmas; fee; 415 563-7337.

16

San José: Rosicrucian Egyptian Museum and Art Gallery 1929
Rosicrucian Park, 95191
(408 287-9171)
Tues.–Fri. 9–4:45; Sat.–Mon. 12–4:45; closed major holidays, August 2. No charge

Assyrian, Babylonian, and Egyptian arts and artifacts; reproduction of an Egyptian tomb; mummies; sculpture, textiles, jewelry, scarabs—all housed in a reproduction of an Egyptian mortuary temple complete with pylons and twin statues of Horus, the falcon god of the sky.

• Winchester Mystery House, 525 S. Winchester St.; a house containing 160 rooms, endless passages, stairways, and doors going nowhere, constructed during a 38-year period by carpenters working daily for the entire time at the direction of the heiress to the Winchester rifle fortune, who sought in this way to placate the spirits of those killed by Winchester weapons; work was abandoned at Mrs. Winchester's death in 1922; open daily except Christmas; fee.

San Marino: Huntington Library, Art Gallery, and Botanical Garden 1919
1151 Oxford Rd., 91108
(213 681-6601)
Tues.–Sun. 1–4:30; closed holidays. No charge

Extraordinary collections in an idyllic garden setting, complete with Japanese garden and a 16th C. samurai's house. Outstanding 18th C. British paintings, esp. portraits, incl. Gainsborough's famous *Blue Boy,* in Van Dyck costume; Lawrence's *Pinkie* (Sarah Barrett Moulton), painted when the artist was 25; Reynold's *Mrs. Siddons as the Tragic Muse,* plus 10 other top-notch portraits by him; ★ *View on the Stour* by Constable, along with several others; Hogarth, Turner; French tapestries designed by Boucher, Savonnerie carpets; Renaissance bronzes; 18th C. marbles, incl. Clodion, Houdon; the library is one of the greatest English collections extant, incl. the Ellesmere Chaucer, early editions of Shakespeare; illustrated English classics; prints and drawings.

Santa Barbara Museum of Art 1941
1130 State St., 93101
(805 963-4364)
Tues.–Sat. 11–5; Sun. 12–5; closed Mon., holidays. No charge

Greek and Roman antiquities from the 6th C. B.C. to the 2nd C. A.D.; Far Eastern painting, sculpture, ceramics, bronzes; musical instruments; American painting from Colonial times to the present, incl. Copley, West, the Hudson River School, The Eight; Indian arts; European drawings and watercolors; Old Master paintings; contemporary West Coast work.

• University Art Museum, Santa Barbara, University of California; Sedgwick Collection of Italian, Flemish, Dutch, and German paintings; Morgenroth Collection of Renaissance medals and plaquettes; Dreyfus Collection of Luristan bronzes, Near Eastern ceramics, Pre-Columbian arts; American painting; sculpture, prints, and drawings, incl. architectural drawings. Tues.-Sat. 10-4; Sun., holidays 1-5; closed Mon., major holidays, between exhibitions; no charge; 805 961-2951.

Santa Clara: de Saisset Museum
1955
University of Santa Clara, 95053
(408 984-4528)
Sept.-June: Tues.-Fri. 10-5; Sat.-Sun. 1-5; closed July-Aug., Mon., holidays. No charge

A collection strong in decorative arts, with 18th C. French Boulle furniture and ivories; 17th C. tapestries; Sèvre, Meissen, Capo di Monte and other European porcelain; Kolb Collection of 17th-18th C. prints and drawings; African art; Oriental art; Spanish Mission historical collection; 19th-20th C. sculpture, painting, photographs.

Stanford University Museum and Art Gallery 1891
Lomita Dr. and Museum Way, 94305 (415 497-4177)
Tues.-Fri. 10-5; Sat.-Sun. 1-5; closed Mon., month of Sept., major holidays. No charge

General collection, with Egyptian arts from Pre-Dynastic to Saitic; Classical antiquities, incl. Cypriot objects; Far Eastern art, with Chinese and Japanese paintings from the 14th-20th C., ceramics; Japanese lacquer; Chinese jade; Old Master paintings; 18th-20th C. drawings, prints, and watercolors; Cantor Collection of Rodins, incl. 88 bronzes, among them ★ *Walking Man*, a landmark in modern sculpture; historical and photographic archive on California history, esp. the Central Pacific Railroad, which Leland Stanford founded.

Stockton: Haggin Museum 1928
1201 N. Pershing Ave., 95203
(209 462-4116)
Tues.-Sun. 1:30-5; closed Mon., major holidays. No charge

19th C. French and American paintings; American, European, and Far Eastern decorative arts; California and American Indian historical collections.

COLORADO

• Alamosa: Adams State College Museums, ES Building, college campus; American Indian collections, incl. Paleo-Indian folsom points; Pueblo pottery and other artifacts; Navajo weaving; santos and other objects of Hispanic culture and cultural influence. Mon.-Thurs. 1-5 and by appoint-

ment; closed holidays; no charge; 303 589-7011.

• Boulder: Leanin' Tree Museum of Western Art, 6055 Longbow Dr.; Cowboy and Western Indian art, incl. mostly modern paintings, and sculptures; Jan.–Sept.: Mon.–Fri. 8–1:30; closed Sat.–Sun.; Oct.–Dec.: Mon.–Fri. 8–1:30; Sat. 9–12; no charge; 303 530-1442.

Colorado Springs Fine Arts Center 1936
30 W. Dale St., 80903
(303 634-5581)
Tues.–Sat. 10–5; Sun. 1:30–5; closed Mon., major holidays.
No charge

A collection strong in Southwestern Hispanic and Native American art, incl. the Taylor Collection of Navaho, Hopi, and Southwestern arts, Northwest Coast Indian arts, with outstanding bultos and santos, paintings, carved panels—some, such as those by the Penetentes, combining Christian subjects with hair-raising pagan bloodthirstiness; American arts, esp. 20th C.

• Museum of the American Numismatic Association, 818 N. Cascade; a compendious collection of coins, medals, currency, and tokens. Mon.–Fri. 8:30–4:30; and by appointment; closed holidays; no charge; 303 473-9142.

The Denver Art Museum 1894
100 W. 14th Ave. Pkwy., 80204
(303 575-2793)

Tues., Thurs.–Sat. 9–5; Wed. 9–9; Sun. 1–5; closed Mon., holidays. No charge

Housed in a distinguished modern building designed by Gio Ponti of Milan, Italy, and James Sudler of Denver, the collection is particularly strong in primitive arts from Africa, Oceania, the Americas, with Native American and Northwest Coast Indian examples; Hispanic arts from Peru; Colonial to 20th C. American arts, incl. West, Copley, C. W. Peale, Hudson River School painters, Homer, Ryder; arts of China, Japan, Korea, Tibet, India, Southeast Asia, Middle and Near East; Kress Collection of European Renaissance and Baroque painting; period rooms, incl. a French Gothic room and an English Tudor room; Impressionist, Post-Impressionist, and modern paintings, incl. Monet, Renoir, Pissarro, Picasso, Braque; prints, drawings, and photographs; Neusteter Institute of Fashion, Costume, and Textiles. ☛ ★ Veronese's *Portrait of the Architect Vignola,* c. 1560.

• Denver has several historic districts and buildings; consult Denver Hospitality Center, 225 W. Colfax; Colorado Heritage Center, 1300 Broadway (303 839-3681); Colorado Historical Society, same address, (303 839-2136); Historic Denver, Inc., 770 Pennsylvania St. (303 837-1858).

• The Denver Public Library, in the Civic Center, has a notable

19

collection of paintings of the American West.

CONNECTICUT

• Bridgeport: Museum of Art, Science, and Industry, 4450 Park Ave.; circus collection; antiques; historic Capt. John Brooks House (1788); Tues.–Sun. 2–5; closed Mon., holidays; fee; 203 372-3521.

• P.T.Barnum Museum, 820 Main St.; historical and circus collection; Barnum memorabilia; Tom Thumb and Jenny Lind memorabilia; model five-ring circus. Tues.–Sat. 12–5; Sun. 2–5; closed Mon., holidays; fee; 203 576-7320.

• Bristol: American Clock and Watch Museum, 100 Maple St.; horological collections. April 1–Oct. 31: daily 11–5; fee; 203 583-6070.

Farmington: Hill-Stead Museum
1946
671 Farmington Ave., 06032
(203 677-9064)
Wed., Thurs., Sat., Sun. 2–5; closed Mon., Tues., Fri., Thanksgiving, Christmas. Fee

The personal collection of Alfred Atmore Pope, Cleveland industrialist, preserved in the 1900 house designed by Stanford White and Pope's daughter Theodate, who left the house as a museum; fine French Impressionist paintings,

esp. Manet, Monet, Degas, Cassatt; Whistler; Japanese prints; prints by Whistler, Dürer, Meryon, Piranesi; Oriental ceramics; decorative arts. ☞ Monet's early *Boats Leaving the Harbor;* Degas' superb pastel *The Tub* (1885); Manet's wash drawing for his famous oil *The Absinthe Drinker,* and his ★ *Woman with Guitar,* deliciously painted.

Hartford: Wadsworth Atheneum
1842
600 Main St., 06103
(203 278-2670)
Tues.–Wed., Fri. 11–3; Thurs. 11–8; Sat.–Sun. 11–5; closed Mon., major holidays. Fee

The original building, designed in Romantic Medieval style by A. J. Davis, the distinguished Gothic Revival architect, has been much added to, resulting in a major museum with outstanding collections in the major fields of world art, ranging from the Classical past to the contemporary; J.P. Morgan Collection of Greek, Roman, Early Christian, and Renaissance bronzes, as well as outstanding Meissen porcelains; European and American painting from the 15th C. to present; Old Masters; American painting from Colonial times to modern period, incl. Copley, West, an important group of Cole's works; European furniture and decorative arts; Wallace Nutting Collection of Early American furniture; modern painting

and sculpture; silver; costumes and textiles; Lifar Collection of ballet design and costumes; Colt Collection of firearms; primitive arts; prints and drawings. ☛ Caravaggio's *Ecstasy of St. Francis,* an extraordinary early work; Rembrandt's late, masterful *Portrait of a Young Man;* ★ Poussin's impressive nocturnal *Crucifixion;* Panini's *Roman Picture Gallery;* Tiepolo's grand *Building of the Trojan Horse;* and Goya's delightful tapestry cartoon *Gossiping Women,* anticipating Manet; Ralph Earl's *Chief Justice Oliver Ellsworth and Abegail Wolcott Ellsworth;* Francavilla's immense *Venus Attended by Nymph and Satyr,* a masterpiece of Mannerism.

• Hartford has historic buildings and districts; check Antiquarian and Landmarks Society of Connecticut, 394 Main St., 203 247-8996; the Connecticut Historical Society, 1 Elizabeth St., 203 236-5621, has outstanding collections of early Connecticut furniture, incl. Wethersfield chests, as well as portraits by Samuel F. B. Morse.

• Museum of Connecticut History, Connecticut State Library, 231 Capitol Ave., 203 566-3056, has the Colt Collection of firearms, the Newcomb Clock Collection, and the Mitchelson Coin Collection; Mon.-Fri. 9-5; Sat. 9-1; closed Sun., holidays; no charge.

• Middletown: Davison Art Center, Wesleyan University, 301 High St.; extensive collection of prints, from 15th C. to present, housed in handsome Alsop House, c. 1940. Tues.-Fri. 12-4; Sat.-Sun. 2-5; closed Mon., holidays, June-Aug.; no charge; 203 347-9411.

• Mystic Seaport Museum, Greenmanville Ave.; maritime museum on the site of a 19th C. shipyard, with sail and rigging lofts, tavern, countinghouse as well as other buildings, and historic vessels, incl. the ship *Joseph Conrad* and the last wooden whaler, built in New Bedford in 1841, the *Charles W. Morgan;* ship paintings and models, scrimshaw, instruments, tools; figureheads, esp. the monumental kilted Scot from the *Donald McKay,* the second largest American clipper, named after the inventor of the clipper ship. Daily 9-5; closed New Year's, Christmas; fees vary with season; 203 536-2631.

The New Britain Museum of American Art 1903
56 Lexington St., 06052
(203 229-0257)
Tues.-Sun. 1-5; closed Mon., holidays, day before Labor Day. No charge

An outstanding collection of American painting from Colonial times to the present, incl. Smibert, Copley, West, Stuart, Hudson River School painters, The Eight; Low Memorial Collection of American illustration contains classics by N. C. Wyeth; Thomas

Benton's murals, *The Arts of Life in America*, painted for the Whitney Museum in 1932. ☛ ★ Inness' early *View of St. Peter's* (1857), five Homers, plus Eakins, Burchfield, Ryder, Whistler, Eastman Johnson, Prendergast.

New Haven: Yale Center for British Art 1977
Chapel St. at High, Box 2120, Yale Station, 06520 (203 432-4594)
Tues.-Sat. 10-5; Sun. 2-5; closed Mon., holidays. No charge

A collection of British paintings, watercolors, drawings, prints, and books considered the largest of its kind outside the United Kingdom; outstanding paintings by Blake, Hogarth, Turner, Constable; housed in a distinguished building designed by Louis Kahn to resemble a medieval or Renaissance palace, with shops lining the ground-floor level on the street, while the life and activity of the institution, with its research and teaching programs, exhibitions, archives, and library, centering on a handsome interior court; the Center was the idea and gift of Paul Mellon, the major benefactor of the National Gallery and a lifelong collector of British art.

New Haven: Yale University Art Gallery 1831
1111 Chapel St., 06520
(203 436-0574)

Tues.-Sat. 10-5; Sun. 2-5; Sept.-June: Tues.-Wed. and Fri.-Sat. 10-5; Thurs. 10-5 and 6-9; Sun. 2-5; closed Mon., holidays. No charge

An outstanding collection representing major areas of world art; Jarves Collection of early Italian paintings is the first such American collection, to which the Griggs Collection made significant additions; Garvan Collection of American silver, painting, decorative arts; Hobart and Edward Small Moore Collection of Near and Far Eastern art and textiles; the Société Anonyme Collection of modern art; Linton Collection of African sculpture; Stoddard Collection of Greek and Roman vases; Clark Collection of modern art; medieval sculpture and painting; fresco sections and other objects excavated at Dura-Europos; prints and drawings; American painting from Colonial times to the present; primitive arts; antiquities; mss. ☛ ★ Smibert's *The Bermuda Group: Bishop George Berkeley and His Family* (1729), with the artist himself seated at left, recording a failed project to found a university in Bermuda for the Christian education of Indians.

• Yale University Collection of Musical Instruments, 15 Hillhouse Ave.; an outstanding collection, primarily of keyboard instruments from the 16th-18th C., strings from the 17th-20th C.; an exten-

sive collection of bells. Tues., Thurs. 2–4; Sun. 2–5; closed Mon., Wed., Fri., Sat.; also closed Sun. in June–July; closed holidays, month of Aug., and all University recesses; no charge; 203 436-4935.

• Peabody Museum of Natural History, 170 Whitney Ave.; anthropological collections of Pre-Columbian and Native American cultural objects. Mon.–Sat. 9–4:45; Sun. 1–4:45; small fee (no charge Tues.); closed major holidays; 203 432-4044.

• Beinecke Rare Book and Manuscript Library, Wall and High Sts.; housed in a very distinguished building designed by Gordon Bunshaft of Skidmore, Owings & Merrill, which utilizes translucent stone slabs to create a softly filtered light inside; the handsome courtyard is distinguished by an impressive Noguchi sculpture; there is a schedule of exhibitions of various aspects of the library's extraordinary collections. (*Note:* New Haven has several outstanding historic buildings, the three churches on the Green being especially noteworthy: Center Church, 260 Temple St., was designed by the distinguished New Haven architect Ithiel Towne after a London model; the British allowed the framing timbers to be floated past their blockade during the War of 1812, enabling the construction to be completed in 1814 [note the Tiffany window commemorating the colony's founding]. Trinity Church, designed in Gothic Revival style by the same architect, was completed the following year; its Tiffany windows are more at home in the handsome Gothic interior. United Church, located at Temple and Elm Sts., was designed by David Hoadley. It was also built in the same year in the Federal style, reflecting the influence of Charles Bulfinch, whose designs were published by Asher Benjamin; the latter's useful books became bibles for carpenters and builders across the country. For hours and information, consult the New Haven Information Bureau, 157 Church St.; cassette tapes are available for self-guided walking tours of the Green and nearby area.)

New London: Lyman Allyn Museum 1930
625 Williams St., 06320
(203 443-2545)
Tues.–Sat. 1–5; Sun. 2–5; closed Mon., holidays. No charge

Varied collections; strong in Connecticut painting, furniture, and decorative arts of the 18th–19th C., incl. portraits by Ralph and James Earl and William Jennys; Thomas Cole's *Mt. Etna from Taormina,* good examples of Kensett and Church; drawings include Ingres' study for the *Portrait of Mme. Moitessier* in the National Gallery, Tintoretto, Tiepolo; ★ *Portrait of James Francis Smith* (1837), age six, just returned from

a whaling voyage on his father's ship; Isaac Sheffield, a local artist, painted a life-sized portrait of the boy in his penguin-skin coat, with his father's ship, the *Chelsea,* in the background; a collection of modern art contains a Renoir bronze entitled *Maternity,* paintings by Degas, Matisse, Braque; Far Eastern ceramics; Mediterranean antiquities; decorative arts; costumes.

• The Tale of the Whale Museum, 3 Whale Oil Row; whaling museum housed in restored 1834 Greek Revival building; whaleboat; archive; tools; scrimshaw. Tues.–Sun. 1–5; closed Mon., major holidays; small fee; 203 442-8189.

• U. S. Coast Guard Museum, U. S. Coast Guard Academy; models of ships and airplanes; paintings and artifacts relating to the Coast Guard and its predecessors, the Revenue-Cutter Service, Lighthouse Service, and Life-Saving Service; historical material from Revolutionary times to the present. Mon.–Fri. 8–4; closed weekends, holidays; no charge; 203 444-8511.

Ridgefield: The Aldrich Museum of Contemporary Art 1964
258 Main St., 06877
(203 438-4519)
Wed., Sat., Sun. 1–5; and by appointment; closed major holidays. Fee

Housed in a 1783 building where the architect Cass Gilbert once lived, Larry Aldrich shows his growing contemporary collection, both inside and in the surrounding sculpture garden, in changing exhibitions.

DELAWARE

Wilmington: Delaware Art Museum 1912
2301 Kentmere Pkwy., 19806
(302 571-9590)
Mon.–Sat. 10–5; Sun. 1–5; closed holidays. Fee

American paintings, incl. West, Rembrandt Peale, Hudson River School painters, Eakins, Inness, The Eight, Burchfield, Hopper; works of the Brandywine School, the famous illustrators Howard Pyle, N. C. Wyeth, and others, incl. Andrew Wyeth; an archive of American artists and illustrators; the Bancroft Collection of English pre-Raphaelites is the most complete outside Britain, except for that at the Fogg at Harvard, and has extensive background material; contemporary arts; research library on American arts, with emphasis on illustration; prints and drawings. (*Note:* The Brandywine River Museum, Chadds Ford, PA, is only a few m. up the Brandywine and has the largest collection of works by members of the Wyeth family. Take Rt. 202 N to Rt. 1; W on Rt. 1 to Chadds Ford. Phone 215 388-7601.)

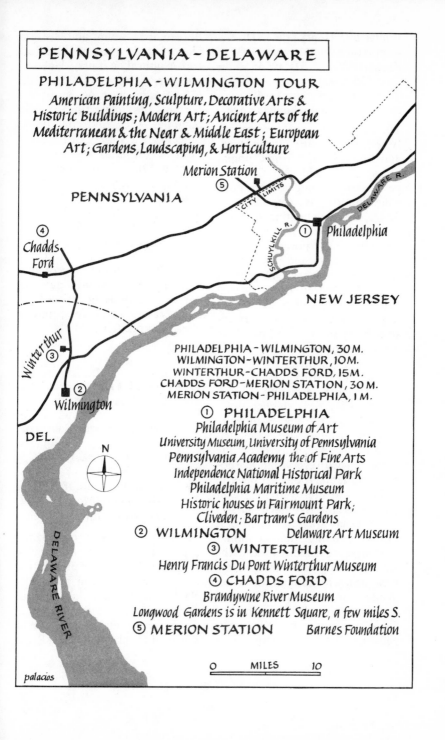

PENNSYLVANIA – DELAWARE

PHILADELPHIA – WILMINGTON TOUR

American Painting, Sculpture, Decorative Arts &
Historic Buildings; Modern Art; Ancient Arts of the
Mediterranean & the Near & Middle East; European
Art; Gardens, Landscaping, & Horticulture

Merion Station
⑤

PENNSYLVANIA

CITY LIMITS

DELAWARE R.

SCHUYLKILL R.

④
Chadds
Ford

① Philadelphia

NEW JERSEY

Winterthur
③

PHILADELPHIA – WILMINGTON, 30 M.
WILMINGTON – WINTERTHUR, 10 M.
WINTERTHUR – CHADDS FORD, 15 M.
CHADDS FORD – MERION STATION, 30 M.
MERION STATION – PHILADELPHIA, 1 M.

②
Wilmington

DEL.

N

① PHILADELPHIA
Philadelphia Museum of Art
University Museum, University of Pennsylvania
Pennsylvania Academy the of Fine Arts
Independence National Historical Park
Philadelphia Maritime Museum
Historic houses in Fairmount Park;
Cliveden; Bartram's Gardens
② WILMINGTON Delaware Art Museum
③ WINTERTHUR
Henry Francis Du Pont Winterthur Museum
④ CHADDS FORD
Brandywine River Museum
Longwood Gardens is in Kennett Square, a few miles S.
⑤ MERION STATION Barnes Foundation

DELAWARE RIVER

O MILES 10

palacios

Winterthur: Henry Francis Du Pont Winterthur Museum 1930 Kennett Pike (Rt. 52), 19735 (302 656-8591) Tues.-Sat. 10-4; Sun. 12-4; closed Mon., major holidays. Fee

The outstanding collection of American furniture, furnishings, and decorative arts from Colonial times to the mid-19th C., with period rooms and compendious collections of glass, ceramics, furniture, textiles, lighting fixtures, carpets, interior architecture, Chinese export porcelain, 17th–19th C. English and Continental fabrics; major research center on American decorative art, material culture, conservation of art objects, period horticulture; extensive library and archives. Nowhere are the distinctive regional characteristics of American style in furniture and furnishings demonstrated more effectively, with richer variety, or at a higher standard of quality; the beautifully planted grounds are a model. Because of the nature of the museum—with everything at a domestic scale and rooms arranged in series—visits are by appointment only, with expertly guided tours. (*Note:* Delaware is rich in history, historic buildings, and communities. Because distances within the state are not great, one can see a great deal with comparative ease. Winterthur operates four historic properties in the delightful town of Odessa; consult the Winterthur Museum. The state, through its Bureau of Museums and Historic Sites of the Division of Historical and Cultural Affairs, Hall of Records, Dover, 19901, 302 678-5314, manages dozens of important and interesting historic buildings, sites, and collections, reflecting the variety of architectural styles, arts, and artifacts from the 17th C. into the early 19th C., and the contributions of the Dutch, French, and Swedes as well as the English. The Historical Society of Delaware, 505 Market St., Wilmington, 19801, 302 655-7161, has collections of Delaware silver, costumes, decorative arts, and historic buildings and gardens. Various hours and, in some cases, small fees; phone ahead for specifics.)

DISTRICT OF COLUMBIA

Washington: Corcoran Gallery of Art 1869 17th St. and New York Ave. NW, 20006 (202 638-3211) Tues.-Wed., Fri.-Sun. 10-4:30; Thurs. 10-9; closed Mon., Christmas. No charge

Though there are European paintings, sculpture, and decorative arts in the collection, it is primarily a museum of American arts, with classic examples of painting, from John Smibert's *Peter Faneuil,* Copley, Feke, and other Colonial artists, through the Hudson River

School, Homer, Eakins, and members of The Eight, to the avantgarde, which is the main area of the gallery's activities. ☛ Samuel F. B. Morse's *Old House of Representatives,* an evening, candlelit session with 86 portraits; ★ Thomas Cole's *The Departure* and *The Return,* examples of American Romanticism and the Gothic Revival; Hiram Powers' *The Greek Slave,* certified by five Cincinnati clergymen as not nude but "clothed in her own virtue," and the hit of London's great Crystal Palace Exposition of 1851 (compare it with Gaston Lachaise's bronze *Torso*).

Washington: Dumbarton Oaks Research Library and Collection 1940
1703 32nd St. NW, 20007
(202 342-3200)
Tues.-Sun. 2-5; closed Mon., holidays. No charge

Founded by a gift of Mr. and Mrs. Robert Woods Bliss to Harvard, the museum occupies a landmark Georgetown house with famous gardens; original house, since added to, built in Georgian style in 1801 by William H. Dorsey, an Orphan's Court judge; the site, in 1944, of the international conference that led to the foundation of the United Nations; library and archive for Early Christian and Byzantine research, Pre-Columbian studies, and gardening and landscape design. ☛ Outstanding Byzantine collection: ivories, enamels, textiles, jewels, mss., 4th–15th C.; fine Pre-Columbian collection installed in an elegant ★ Setting designed by architect Philip Johnson.

Washington: Freer Gallery of Art 1906
12th St. and Jefferson Dr. SW, 20036 (202 357-2104)
Daily 10-5:30; closed Christmas; library open Mon.-Fri. 10-4:30. No charge

One of the world's great collections of Oriental art, from the Far to the Near East, in all media; a definitive collection of the works of James Abbott McNeill Whistler, admired friend of Charles Lang Freer, who formed the collection and gave it to the nation. ☛ Collection of Japanese screens, Chinese paintings, early Chinese bronzes (note the superb dragon, ★ The benign little horned and hoofed creature), early Chinese jades, Sung porcelains.

Washington: Hirshhorn Museum and Sculpture Garden 1966
Independence Ave. at 8th St. SW, 20560 (202 357-3091)
Daily 10-5:30; extended spring and summer hours (vary yearly); closed Christmas. No charge

An outstanding comprehensive collection of modern art, with important examples of sculpture extending from ancient times to the

present; the emphasis of the painting collection is 20th C., but the museum's holdings are so vast that there are many surprises—and contemporary artists are often represented by dozens of works; though the building is far from small, only a fraction of the collections can be shown at any one time; the building is externally formidable, a colossal doughnut shape on piers designed by Gordon Bunshaft of Skidmore, Owings, & Merrill; monumental sculpture is displayed in the circular court and extends into the partly sunken garden. ☛ Rodin's *Burghers of Calais* and *Balzac,* two of the greatest examples of modern sculptures; Matisse's *Four Backs,* a demonstration of the process of abstraction; rare sculptures by Medardo Rosso, a pioneer of Italian modernism, Brancusi, Maillol; Manzù's brooding *Cardinal.*

• Anacostia Neighborhood Museum, 2405 Martin Luther King, Jr., Ave. SE; a black cultural center with lively exhibits; Mon.-Fri. 10-6; Sat.-Sun., holidays 1-6; closed Christmas; no charge; 202 287-3369.

• Diplomatic Reception Rooms, Department of State, 2201 C St. NW; superb American paintings, furniture, decorative arts; by reservation; no charge. Write: Tours, Department of State, 20520; 202 632-3241.

• Museum of African Art, 316-318 A St. SE, incl. house of Frederick Douglass, famous black abolitionist; Mon.-Fri. 11-5; Sat.-Sun. 12-5; closed holidays; no charge; 202 287-3490.

• Museum of Modern Art of Latin America, 201 18th St. NW; Tues.-Sat. 10-5; closed Sun.-Mon., holidays; no charge; 202 789-3490.

Washington: National Gallery of Art 1937
Constitution Ave. and 4th St. NW, 20565 (202 737-4215)
Winter: Mon.-Sat. 10-5; Sun. 12-9; summer: Mon.-Sat. 10-9; Sun. 12-9; closed New Year's, Christmas. No charge

One of the great museums, with extraordinarily rich collections of painting and sculpture of all schools of Western art, from the later Middle Ages to modern times; all the classic masters are represented; there are also American collections, important drawings and prints; decorative arts. The museum was the creation of the late Andrew Mellon, whose children have continued his benefaction with unparalleled generosity, including the new East Building, which contains special exhibition galleries, the Center for Advanced Studies in the Visual Arts, a library, and offices in a handsome environment created by the architect I. M. Pei. ☛ Old Masters and 19th C. masterpieces, esp. ★ Leonardo da Vinci's incomparable *Ginevra de' Benci,* the only painting by him in the Western Hemisphere.

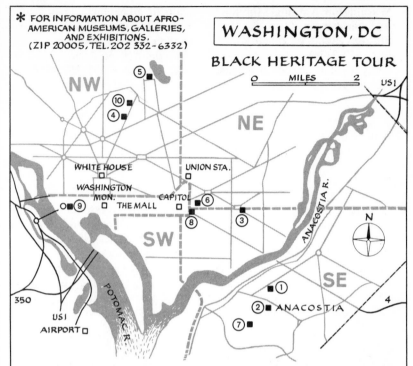

* FOR INFORMATION ABOUT AFRO-AMERICAN MUSEUMS, GALLERIES, AND EXHIBITIONS. (ZIP 20005, TEL. 202 332-6332)

WASHINGTON, DC

BLACK HERITAGE TOUR

0 MILES 2 US1

NW

NE

WHITE HOUSE

UNION STA.

WASHINGTON MON.

CAPITOL

THE MALL

SW

SE

N

POTOMAC R.

ANACOSTIA R.

350

US1

AIRPORT

ANACOSTIA

① Anacostia Neighborhood Museum, 2405 Martin Luther King Jr. Avenue SE: Afro-American history, culture, experience, and achievement. ② Frederick Douglass Home and Visitor's Center, W and 17th Streets SE (National Park Service): the house in which the great abolitionist lived and worked for many years. ③ Mary McLeod Bethune Memorial, Lincoln Park, East Capitol Street SE between 11th and 13th Streets: a moving portrait statue and memorial to an extraordinary woman. ④ Bethune Archive and Library, largely devoted to black women's history and contribution, is on Vermont Avenue NW. ⑤ Howard University Gallery of Art, and Howard University Museum and Moorland Springarn Research Center, 500 Howard Place NW: a museum and archive of black history. ⑥ Museum of African Art, 316-318 A Street NE (the Smithsonian Institution): outstanding collection of African and Afro-American arts. ⑦ Frederick Douglass' first home in Washington. ⑧ Afro-American Collections, Library of Congress, 10 First Street SE: a historial, literary, and cultural archive and collection. ⑨ Lincoln Memorial, at the end of the Mall, opposite Arlington Memorial Bridge, with Daniel Chester French's monumental, brooding figure of the Great Emancipator in Henry Bacon's classic temple. ⑩ Afro-American Museum Association, 1318 Vermont Avenue NW. *

Washington: National Museum of American Art
8th and G Sts. NW, 20560
(202 357-3176)
Daily 10–5:30; closed Christmas. No charge

A comprehensive collection of American arts from Colonial times to the present, including archival collections, memorabilia, decorative arts; the Renwick Gallery (Pennsylvania Ave. and 17th St. NW; [202 357-2531]) is a branch that exhibits the Smithsonian Institution's decorative arts collections in a distinguished Romantic building designed by James Renwick, Jr., architect of the Smithsonian on the Mall, the National Collection is itself housed in the historic Greek Revival Old Patent Office.

• National Museum of American History, Constitution Ave. and 14th St. NW; comprehensive collections of decorative arts, cultural artifacts, and historic objects of great interest; note esp. the seated marble *Washington* by Horatio Greenough, the first piece of monumental sculpture by an American, the dignity of whose concept transcends the awkward Neoclassical vocabulary in which it is expressed; daily 10–5:30; extended summer and spring hours vary yearly; closed Christmas; no charge; 202 357-2700.

• National Portrait Gallery, 8th and F Sts. NW; a collection of portraits, in all media, of people who have made a notable contribution to their country; changing exhibitions daily 10–5:30; closed Christmas; no charge; 202 357-2866.

Washington: The Phillips Collection 1918
1600–1612 21st St. NW, 20009
(202 387-2151)
Tues.–Sat. 10–5; Sun. 2–7; closed Monday, holidays. No charge

A delightfully personal collection formed by Duncan and Marjorie Phillips and housed in their former home, showing the roots of modern art as well as many of its masterpieces in an inviting and sympathetic environment. ☛ ★ Ryder's *The Dead Bird,* with its moving echoes of the "feather'd guests from Alabama" in Whitman's "Out of the Cradle Endlessly Rocking"; Daumier's *The Uprising;* ★ Renoir's joyous *Luncheon of the Boating Party;* the sunstruck Bonnards; the elegant, painterly Braques.

• Renwick Gallery of the National Museum of American Art, Smithsonian Institution; see National Museum of American Art.

• Smithsonian Institution, 1000 Jefferson Dr. SW; the picturesque headquarters of the parent institution of the various national collections in Washington and elsewhere, and of various research centers throughout the globe; ★ the building, designed by James

Renwick, Jr., and begun in the late 1840s, has been sympathetically restored to include an orientation exhibit of Washington containing a historic dimension, plus offices, archives, and a lounge and restaurant for Smithsonian associates; note the tomb of James Smithson, illegitimate scion of the Duke of Northumberland; James left his considerable estate to a new nation, which in life he had never visited, for "the increase and diffusion of knowledge among men"; daily 10–5:30; some buildings open evenings in summer; closed Christmas; no charge; 202 357-1300.

• The Textile Museum, 2320 S St. NW; a major collection and textile study center; Tues.–Sat. 10–5; closed Sun., Mon., holidays; donation accepted; 202 667-0441.

• Truxtun–Decatur Naval Museum, 1610 H St. NW; housed in the handsome carriage house of historic Decatur House, designed by B. H. Latrobe in 1818 for the naval hero Commodore Stephen Decatur; now owned by the National Trust for Historic Preservation; daily 10–4; closed holidays; no charge.

• The District of Columbia has many historic buildings, from the Capitol and the White House to the recently restored Ford's Theater, where Lincoln was assassinated. In addition, the various colleges and universities in Washington have their own galleries and art centers.

Information is available in various local guides.

FLORIDA

Coral Gables: Lowe Art Museum
1950
University of Miami, 1301
Stanford Dr., 33146
(305 284-3535)
Tues.–Fri. 12–5; Sat. 10–5; Sun.
2–5; closed Mon., holidays.
No charge

Varied holdings, incl. Kress Collection of painting and sculpture of the Renaissance, Baroque, and Rococo; the Barton Collection of Indian weavings and pottery from the Southwest; Guatemalan textiles and Pre-Columbian objects in the Lothrop Collection; artifacts from the Northwest Coast and Africa; Oriental collections, mainly Chinese; Spanish-American religious art; contemporary Latin American painting; the major area represented is American painting from Colonial days to the present, incl. an engaging group of primitives.

• Metropolitan Museum and Art Center, 1212 Anastasia; 20th C. sculpture, contemporary painting of the Americas; Oriental and primitive arts; Tues., Thurs.–Sat. 10–5; Wed. 10–5 and 7–10; Sun. 12–5; closed Mon., holidays; fee; 305 442-1448.

Jacksonville: Cummer Gallery of Art 1958
829 Riverside Ave., 32204
(904 356-6857)
Tues.-Fri. 10-4; Sat. 12-5; Sun. 2-5; closed Mon., holidays.
No charge

A mixed collection, with objects dating from ancient times to the present in a variety of media; European and American paintings predominate, along with decorative arts material, incl. tapestries; ☛ Compendious Wark Collection of Meissen porcelain, from the pioneering works of Johann Friedrich Böttger early in the 18th C. to the most elaborate courtly pieces, in great variety and with fine examples, many of interesting historical provenance; Bernini's marble bust of Richelieu, the famous statesman and cardinal who ruled France under Louis XIII.

• Jacksonville Art Museum, 4160 Boulevard Center Dr.; painting, sculpture, decorative arts; Pre-Columbian and African objects; Oriental ceramics; Tues.-Wed., Fri. 10-4; Thurs. 10-10; Sat.-Sun. 1-5; closed Mon., holidays, month of Aug.; no charge; 904 398-8336.

Sarasota: John and Mable Ringling Museum of Art 1930
5401 Bayshore Rd., 33580; Box 1838, 33578
(813 355-5101)
Mon.-Fri. 9-10; Sat. 9-5; Sun. 11-6; closed holidays. Fee; Sat. no charge

A somewhat miscellaneous collection, with strong areas in European Baroque painting, sculpture, and decorative arts, which form an exuberant and impressive display; there are also early Cypriot artifacts, American 20th C. paintings; drawings and prints; a nearby building houses the Ringling Museum of the Circus, while the original Ringling house, built in the twenties, shows a valiant disregard for architectural propriety in its exterior design and a determined and successful pursuit of opulence in its interiors. ☛ Rubens paintings and Rubens-designed tapestry cartoons show both his vigorous mastery and the quality of the work of his assistants; two Tiepolo ceilings, one in the foyer of the delightful little ★ 18th C. theater from Asolo, near Venice; ★ Veronese's *Rest on the Flight into Egypt,* with its acrobatic angels gathering figs for the holy family from the tree under which they are resting, and a benevolently observant donkey.

West Palm Beach: Norton Gallery and School of Art 1940
1451 S. Olive Ave., 33401
(305 832-5194)
Tues.-Fri. 10-5; Sat., Sun. 1-5; closed Mon., holidays. No charge

A selective and interesting collection expressing the Nortons' enthusiasm for and knowledge of 19th and 20th C. European and American painting and sculpture; classic Chinese sculpture, jades,

bronzes, ceramics; and European painting from the 15th to the 18th C. ☛ Braques, Matisses, and Cézanne's portrait of his son; early Chinese bronzes.

• Winter Park: The Morse Gallery of Art, 133 E. Welbourne Ave. (mailing address: 151 E. Welbourne Ave., 32789); a glass collection, including not only Tiffany glass but also stained-glass windows, paintings, and furniture designed by him; Tues.–Sat. 9:30–4; Sun. 1–4; closed Mon., holidays; no charge; 305 644-3686.

GEORGIA

Atlanta: The High Museum of Art 1905
1280 Peachtree St. NE, 30309
(404 892-3600)
Tues.–Sat. 10–5; Sun. 12–5;
closed Mon., holidays. No charge

Kress Collection of Old Masters; European and American painting through the early 20th C. Mc-Burney Collection of European and American Decorative arts from late 17th to early 20th C.; 18th C. porcelains; African arts; prints and drawings; 19th–20th C. photographs; most interesting and varied part of the collection is devoted to American painting from Colonial times to the present. ☛ Charles Willson Peale's *Senator William H. Crawford of Georgia,* painted in 1818 when the artist was 77, a portrait of the then Secretary of the Treasury and one of Peale's best performances; Thomas Worthington Whittredge's *Landscape in the Harz Mountains* (a smaller version is in Detroit), derived from a sketching trip in 1852; a fine group of Inness landscapes; ★ Prendergast's lovely watercolor *Procession, Venice* (1899).

• Athens: Georgia Museum of Art, The University of Georgia, Jackson St., North Campus, 30602 (Athens is about 65 m. E of Atlanta); the Holbrook Collection of 19th–early 20th C. American paintings, incl. examples by the Hudson River School painters and beyond. Mon.–Fri. 8–5; Sat. 9–12; Sun. 2–5; closed holidays, Christmas week; no charge.

Savannah: Telfair Academy of the Arts and Sciences 1875
121 Bernard St., 31401; Box 10081, 31412 (912 232-1177)
Tues.–Sat. 1–5; Sun. 2–5; closed Mon., holidays. Fee

The Academy occupies a fine house, with more recent additions, designed in 1818 by William Jay for the Telfair family; the collection is primarily American, with paintings, furniture, and decorative arts from Colonial times on; Waring Collection of prints; Chinese export and English porcelain. ☛ A fine collection of Savannah-made silver of the 18th–19th C., early 20th C. American paintings. (*Note:* The Telfair Academy also owns and operates the handsome Owens-Thomas House, 124 Abercorn St., a similar Regency-like

design by Jay, with fine furnishings; Sun.-Mon. 2-5; Tues.-Sat. 10-5; closed Sept., major holidays; fee; 912 233-9743.)
• Much of the city of Savannah is a historic district of great beauty and architectural distinction; inquire at the Historic Savannah Foundation, William Scarborough House, 41 W. Broad St., 31401; Box 1733, 31402; 912 233-7787. It is a model of what citizen participation can do, not only to preserve but also to bring a community back to life.
• Ships of the Sea Maritime Museum, 503 E. River St., 31401; an interesting maritime collection housed in a restored cotton warehouse on Savannah's historic riverfront; daily 10-5; closed holidays; fee; 912 232-1511.
• For information on the many historic sites and buildings throughout Georgia operated by the state, write to the Parks, Recreation & Historic Sites Division, Georgia Department of Natural Resources, 270 Washington St., SW, Atlanta, GA, 30334.

HAWAII

Honolulu Academy of Arts 1922
900 S. Beretania St., 96814
(808 538-3693)
Tues.-Wed., and Fri.-Sat.
10-4:30; Thurs. 11-4:30 and 7-9;
Sun. 2-5; closed Mon., holidays.
No charge

Housed in a historic building of great distinction and inviting atmosphere designed by Bertram G. Goodhue in 1927; a fine and varied general collection, strong in Far Eastern arts; ancient Near Eastern and Mediterranean arts; medieval art; European and American arts; Kress Collection of Italian Renaissance painting; Michener Collection of Japanese prints; arts of Africa, Oceania, the Americas.
☞ Beautifully designed and planted courtyards in Far Eastern style complement such outstanding Chinese paintings as ★ *The Hundred Geese* scroll, attributed to Ma Fen, c. 1200; Hung-jen's superb brush drawing *The Coming of Autumn,* 17th C. Ch'ing Dynasty; fine Japanese screens; and also, curiously and satisfyingly, Monet's late, magical *Water Lilies,* painted in his own garden in the early 1920s.
• Contemporary Arts Center of Hawaii, 605 Kapiolani Blvd., 96813; changing exhibitions; the collection of 20th C. works by Hawaiians is distributed throughout the office building, of which the Center occupies a small part; Mon-Fri. 8-5; Sat. 8:30-12; closed Sun., holidays; no charge; 808 525-8047.
• Bernice Pauahi Bishop Museum, 1355 Kalihi St., Box 19000-A, 96819; founded in 1889, the museum has varied and important scientific and historical collections, incl. a photographic archive and anthropological material pertaining to the culture of the islands;

34

also on display is the historic four-masted, full-rigged ship *The Falls of Clyde,* berthed at Pier 4, Ala Moana Blvd.; daily 9–5; closed Christmas; fee; 808 847-3511.

• There are several historic sites and buildings on Oahu and the other islands. In Honolulu note esp. Iolani Palace, the only official royal palace in the U. S. (364 S. King St., Box 2259, 96804; 808 536-3552; phone ahead for reservations; fee), and Queen Emma's Summer Palace (2913 Pali Hwy., 96817; 808 595-3167; daily except holidays 9–4) with furnishings and historical collections relating to King Kamehameha IV and Queen Emma; inquire for other historic sites maintained by the Daughters of Hawaii.

IDAHO

Boise Gallery of Art 1931
670 S. Julia Davis Dr., 83702
(208 345-8330)
Tues.–Fri. 10–5; Sat.–Sun. 12–5; closed Mon., holidays. No charge

Situated in Julia Davis Park, the museum's collection mainly consists of the work of Idaho artists; American and European painting, sculpture, graphic arts; Japanese netsuke and other Far Eastern objects. (*Note:* Also in Julia Davis Park are several historic buildings, stagecoaches, fire engines, the Union Pacific locomotive known as *Big Mike,* and the State Historical Society Museum, which houses historical, archival, Indian, and other collections.)

• Idaho City, about 40 m. NE of Boise, on State Rt. 21, is a historic site, a ghost town left over from the Gold Rush of the 1860s.

Moscow: The Appaloosa Museum 1973
Box 8403, 83843 (208 882-5578)
Mon.–Fri. 8–5; closed holidays; weekends by appointment. No charge

Collections devoted to the history of the Appaloosa horse and the Nez Perce Indians who bred them.

Moscow: University of Idaho Museum 1963
University Campus, 83843
(208 885-6480)
Mon.–Fri. 9–4; closed Sat., Sun. month of Aug., university holidays. No charge

African, Near Eastern, Philippine, and North American native arts.

ILLINOIS

Carbondale: University Museum 1869
Southern Illinois University,
Faner 2469, 62901 (618 453-5388)
Mon.–Fri. 10–4; Sun. 1:30–4:30; closed university and national holidays. No charge

European paintings, drawings, prints from 13th C. to present; American 18th–20th C. arts; 19th–

20th C. photograph collection; Oceanic arts; the greatest strength is in the 20th C.; also decorative arts and archaeological, geological, and historical collections.

Champaign: Krannert Art Museum 1961
500 E. Peabody Dr., University of Illinois, 61820 (217 333-1860)
Tues.-Sat. 9-5; Sun. 2-5; closed Mon., holidays. No charge

A general museum with a growing historical collection in major fields; Trees and Krannert collections of Old Masters; Moore Collection of decorative arts; Ewing Collection of Malayan textiles; ancient and Pre-Columbian arts; strong representation of 20th C. European and American painting, sculpture, prints, drawings, and crafts; esp. strong in contemporary American arts and crafts. ☛ A delightful Constable, *A View on the Stour Estuary Opposite Mistley* (1813); Delacroix's *Interior of the Dominican Convent at Madrid* (c. 1832), shadowy and somewhat theatrical; and a disturbingly poignant Murillo, *Christ after the Flagellation,* a dramatic example of Counter-Reformation painting.
• Urbana, about 15 m. NW of Champaign, has the World Heritage Museum, University of Illinois, 484 Lincoln Hall, 702 S. Wright St., 61801; large collection of Sumerian tablets and other archaeological material, numismatic and glass collections; his-

torical and art collections; during academic year, Mon.-Fri. 9-5; Sun. 2-5; summer, Mon.-Fri. 11-3:30; closed weekends; closed when university is not in session and holidays; no charge; 217 333-2360.

Chicago: The Art Institute of Chicago 1879
Michigan Ave. at Adams St., 60603 (312 443-3600)
Mon.-Wed., Fri. 10:30-4:30; Thurs. 10:30-8; Sat. 10-5; Sun., holidays 12-5; closed Christmas. Donation requested; Thurs. no charge

One of the world's great museums, with superb collections in virtually all fields of art; especially strong in Old Masters, Impressionists, Far Eastern, and American art; one of the most complete and distinguished graphics collections anywhere. ☛ ★ El Greco's magnificent *Assumption of the Virgin* (1577) with its inner spiritual agitation; ★ Seurat's Pointillist masterpiece *Sunday Afternoon on the Island of La Grande Jatte* (1884-86), and ★ Caillebotte's evocative *Paris, a Rainy Day* (1877), charmingly reflecting aspects of Paris at the time of emerging Impressionism; the great Spanish *Ayala Altar* of 1396 is but one of many outstanding medieval works; Goya's narrative panels of *The Capture of Maragato by Fray Pedro* (c. 1807); Guardi's poetic view of *The Grand Canal, Venice;* ★ Rembrandt's fascinating psychological study of

36

a *Young Girl at an Open Half-Door* (1645); Mary Cassatt's classic *The Bath* (c. 1891); the marvelous study collection chronicling the succession of styles in Western art, from the late 13th C. to the late 1930s, provided by the Thorne miniature rooms.

Chicago: Museum of Contemporary Art 1967
237 E. Ontario St., 60611
(312 280-2660)
Tues.–Sat. 10–5; Sun., holidays 12–5; closed Mon., major holidays. Fee

A lively center of contemporary arts, with changing exhibitions; film, lecture, and concert series; and a growing collection of recent experimental works in different media. ☞ Bacon's agonized and agonizing *Man in Blue Box,* a terrifying commentary on the artist's view of the contemporary human condition.

Chicago: University of Chicago, Oriental Institute Museum 1919
1155 E. 58th St., 60637
(312 753-2475)
Tues.–Sat. 10–4; Sun. 12–4; closed Mon., holidays. No charge

One of the great collections in the Western world of archaeology and art of the ancient Near East, Assyria, Egypt, Babylonia, Palestine, Syria, Anatolia, Iran, Nubia, Coptic and Early Christian cultures, and Islam. ☞ Sumerian sculpted figures with wide eyes staring into infinity (c. 2700–2500 B.C.); fragments of curiously mannered Egyptian wall paintings from the Akhenaten period (c. 1360 B.C.); and Luristan bronzes from the 9th to the 7th C. B.C.

• Balzekas Museum of Lithuanian Culture, 4012 S. Archer Ave., 60632; 312 847-2441; daily 1–4; closed Christmas, New Year's; fee.

• Chicago Historical Society, Clark St. at North Ave., 60614; 312 642-4600; Mon.–Sat. 9:30–4:30; Sun. 12–5; closed holidays; fee except Mon.; Chicago and Illinois history; Lincoln and Civil War material; folk art; decorative arts; photographic archive; graphics; painting and sculpture; changing exhibits and active program.

• Chicago Public Library Cultural Center, 78 E. Washington St., 60602; 312 269-2820 or 269-2837; Mon.–Thurs. 9–7; Fri. 9–6; Sat. 9–5; Sun. 1–5; extensive military collections, especially Civil War; painting, sculpture, graphics, photographs, musical instruments; changing exhibits.

• The David and Alfred Smart Gallery of the University of Chicago, 5550 S. Greenwood Ave., 60637; 312 753-2121; Tues.–Sat. 10–4, Sun. 12–4; closed Mon., months of Aug. and Sept., holidays; no charge; general collection, ancient to modern; decorative arts; photography; Far Eastern arts; exhibits.

• Dusable Museum of African

American History, 740 E. 56th Pl., 60637; 312 947-0600; Mon.-Fri. 9-5; Sat.-Sun. 1-5; closed Christmas, New Year's; small fee; African and Afro-American arts, archive.

• Field Museum of Natural History, Roosevelt Rd. at Lake Shore Dr., 60605; 312 922-9410; winter: Mon.-Thurs., Sat. 9-4; Fri. 9-9; spring and fall: Mon.-Thurs., Sat. 9-5; Fri. 9-9; summer: Mon.-Thurs., Sat. 9-6; Fri. 9-9; fee except Fri.; fine primitive art collections, especially Native American; Malvina Hoffman's impressive bronzes depicting racial types of the world, in which scientific accuracy is given life and dignity by the sculptor's humanism.

• Martin d'Arcy Gallery of Art, 6525 N. Sheridan Rd., 60626; 312 274-3000; Mon., Wed., Fri. 12-4; Tues., Thurs. 12-4 and 6:30-9:30; Sun. 1-4; closed holidays and when university is not in session; no charge; Western art from the 12th to 18th C.; goldsmithwork; textiles; painting; sculpture. ☛ Stained glass from Canterbury Cathedral; a 16th C. Nuremberg jewel box exhibiting elaborate goldsmithwork, believed to have belonged to Queen Christina of Sweden; and a panel in opus anglicanum, the rare English medieval embroidery, of the *Coronation of the Virgin* (c. 1480) from a cope.

• Maurice Spertus Museum of Judaica, 618 S. Michigan Ave., 60605; 312 922-9012; Mon.-Thurs. 10-5; Fri. 10-3; Sun. 10-4; closed Sat., Jewish and national holidays; fee except Fri.; Jewish ceremonial art, decorative arts, archive.

• Morton B. Weiss Museum of Judaica, 1100 Hyde Park Blvd., 60615; 312 924-1234; Mon.-Fri. 9-4:30; closed weekends, national and some Jewish holidays; collections pertaining to American Jewish history and its roots in Europe and Asia.

• Polish Museum of America, 984 N. Milwaukee Ave., 60622; 312 384-3352; daily 1-4; closed holidays; no charge; Paderewski and Kosciusko memorabilia; crafts; costumes; military and religious objects.

• Swedish American Museum Association of Chicago, 5248 N. Clark St., 60640; 312 728-8111; paintings, tools, and artifacts illustrating the life of Swedish immigrants in America. (*Note:* The Swedish Pioneer Historical Society, [5125 N. Spaulding Ave., 60625; 312 583-5722; Mon.-Fri. 8:30-4 by appointment; no charge; closed holidays.] has important archives on Swedish life and achievements in the U.S.)

• Rockford: The Time Museum, 7801 E. State St., Box 5285, 61108; 815 398-6000; Tues.-Sun. 10-6; closed Mon., holidays; fee; a collection of timekeeping devices from 1250 B.C. to present.

(*Note:* For information on the many historic buildings operated

by the state of Illinois, inquire of the Department of Conservation, Division of Land and Historic Sites, 605 Stratton Office Bldg., 400 S. Spring St., Springfield, IL, 62706; 217 782-1801.)

INDIANA

Bloomington: Indiana University Art Museum 1963
Fine Arts Bldg., Room 007, 47405
(812 337-5445)
Tues. 9–9, Wed.–Sat. 9–5; Sun. 1–5; closed Mon., holidays.
No charge

Fine general collection housed in a new I. M. Pei building, ranging from ancient to contemporary art, including painting, sculpture, decorative arts, prints and drawings; Egyptian, Greek, and Roman sculpture; coins, glass; Western fine and decorative arts from the 14th to the 20th C.; African, Oceanic, Pre-Columbian arts; Far Eastern arts. ☛ A fine group of West and Central African masks; a pair of Japanese 18th C. screens by Maruyama Ōkyo, *Persimmon Tree and Birds in Snow* and *Wild Ducks and Bamboo;* Pannini's picturesque *Landscape with Ruins* (c. 1715); ★ Monet's early, lyrical *Seine at Argenteuil* of 1874 and Caillebotte's *Riverbank in the Rain* of the following year highlight a fine late 19th C. French collection; a 3rd–4th C. Haniwa horse; Stuart Davis' lively and impressive mural of 1938, *Swing Landscape.*

Evansville Museum of Arts and Science 1926
411 S.E. Riverside Dr., 47713
(812 425-2406)
Tues.–Sat. 10–5; Sun. 12–5; closed Mon., holidays. No charge

A general collection, with European painting from the Baroque through the 19th C., and 20th C. American painting and crafts; regional arts and crafts. ☛ An unusual piece of Lincoln memorabilia, a wooden cabinet made by the future president at age 16 to hold his commonplace books.

Fort Wayne Museum of Art 1922
1202 W. Wayne St., 46804
(219 422-6467)
Tues.–Thurs., Sun. 1–5; Fri. 11–5; Sat. 10–5; closed Mon., holidays. No charge

A limited collection, with examples of Egyptian, Greek, and Roman art; medieval art; African art; and 20th C. painting, sculpture, and prints.
• Greentown Glass Museum, 112 N. Meridian St. (mailing address: 508 E. Main St., Greentown, IN, 46936; 317 628-7511; Memorial Day–Labor Day, Tues.–Fri. 1–4; Sat.–Sun. 1–5; closed otherwise; no charge (donation accepted); a glass collection primarily devoted to the productions of the Indiana Tumbler and Goblet Co. of Greentown from 1894 to 1903.

Indianapolis Museum of Art
1883
1200 W. 38th St., 46208
(317 923-1331)
**Krannert Pavilion: Tues.–Sun.
11–5; Lilly Pavilion of Decorative
Arts: Tues.–Sun. 1–4; closed
Mon., holidays. No charge**

An outstanding general collection, ranging in time from prehistory to the present and geographically from the Far East to the West; especially strong in Chinese, primitive, and American art; Old Masters; late 19th C. French painting; European and American decorative arts; Turner watercolors. ☛ ★ Two superb 12th C. Spanish Romanesque frescoes from San Baudelio de Berlanga; Caravaggio's *Sleeping Cupid;* Seurat's limpid *Port of Gravelines;* Benjamin West's *Woodcutters in Windsor Park* (West was an American Quaker who become the second president of the Royal Academy); Cézanne's *House in Provence,* 1885–86; ★ A coffee tray, containing a landscape of Abbotsford, painted by Turner while its owner, Sir Walter Scott, was entertaining the artist at a picnic on the grounds (the tray was Turner's present to his famous host); and don't miss the superbly landscaped grounds, laid out by the Olmstead brothers, sons and successors to the famous designer of Central Park in New York City. (*Note:*

There is a very fine Children's Museum in Indianapolis—with varied collections, hands-on activities, and a carousel—at 3000 N. Meridian St., Box 88126, 46208; [317 924-5431]; Memorial Day–Labor Day: Mon.–Sat. 10–5; Sun. 12–5; Labor Day–Memorial Day: Tues.–Sat. 10–5; Sun. 12–5; closed Mon.; closed major holidays; no charge.)

Muncie: Ball State University Art Gallery 1936
2000 University Ave., 47306
(317 285-5242)
**Sept.–May: Mon.–Thurs. 9–4:30
and 7–9; Fri. 9–4:30; Sat.–Sun.
1:30–4:30; June–Aug.: Mon.–Fri.
9–4:30; Sat.–Sun. 1:30–4:30.
Closed evenings during
quarter-semester breaks,
holidays. No charge**

The collection's strong areas include: Italian Renaissance paintings and furniture; 19th C. American painting; contemporary European and American paintings, drawings, and prints; and the Ball-Kraft Collection of Roman glass; there are also Far Eastern porcelains, English 18th–19th C. ceramics and decorative arts. ☛ Two small Constables, *Hampstead Heath* and *Windsor Castle;* an almost miniature *Portrait of Erasmus* by Holbein; Watteau's *Portrait of Frère Blaise;* and two Fragonards.

Notre Dame: The Snite Museum of Art 1842
O'Shaughnessy Hall, University of Notre Dame, 46556
(219 283-4266)

A growing general collection; strongest in Italian Renaissance, French, and English 18th C. painting, as well as contemporary art; Far Eastern and Pre-Columbian arts; contains a collection of the works of sculptor Ivan Meštrović, artist-in-residence during his last years. ☞ Ruisdael's *Watermill,* with its typically luminous sky and slightly melancholy atmosphere; Raeburn's vigorous portrait of *John Paterson of Leith;* and Bonington's spacious Venetian scene entitled *A Procession on the Quay* (1827), a major work of this short-lived but very gifted English painter.

Richmond: Art Association of Richmond 1897
McGuire Memorial Hall, 350 Whitewater Blvd., 47374
(317 966-0256)
Labor Day–June 6: Mon.–Fri. 9–4; Sun., holidays 1–4; closed major holidays, two weeks at Christmas. No charge

An active art center with a small permanent collection. Contains some European but primarily American paintings, many by Indiana and local artists. ☞ A *Self-Portrait* of 1914 by William Mer-ritt Chase, well-known painter and teacher, whose bravura brush-work almost rivals that of Sargent, his contemporary.

Terre Haute: Sheldon Swope Art Gallery 1942
25 S. 7th St., 47807
(812 238-1676)
Sept. 2–July 31: Tues.–Sun. 2–5; closed Mon., month of Aug., holidays. No charge

A painting collection strongest in 20th C. American Realism, along with some contemporary work, including some from the local area; some Far Eastern and European examples. ☞ American Scene painters, of the thirties, incl. Benton and Wood; the unexpected Baroque theatricality of Van Dyck's *Treachery of Delilah,* c. 1617–20.

IOWA

Cedar Falls: University of Northern Iowa Gallery of Art 1978
Indiana and Minnesota Sts., 50614 (319 272-2077)
Mon. 9–12, 1–5, 7–9; Tues., Thurs. 9–12, 1–5; Wed. 8–12, 1–5; Sat. 1–4; closed Sun., Mon., holidays. No charge

European and American painting, sculpture, and graphic arts from the late 19th C. to the present, incl. examples of such classic artists

as Cézanne, Cassatt, Bonnard, Braque, Matisse, Renoir, and Tobey.

Cedar Rapids Art Center 1905
324 Third St. SE, 52301
(319 366-7503)
**Tues., Wed., Fri.–Sat. 10–5;
Thurs. 10–8:30; Sun. 2–5; closed
Mon., holidays. No charge**

Works by native son and region-alist painter Grant Wood domi-nate a collection of primarily American paintings and graphics of the later 19th and 20th C.

Davenport Art Gallery 1925
1737 Twelfth St., 52804
(319 326-7804)
**Tues.–Sat. 10–4:30; Sun. 1–4:30;
closed Mon., holidays. No charge**

An interesting combination of collections, incl. Haitian art, His-panic-American painting, fine prints (both Eastern and Western), and a definitive collection of the works of Iowan painter, Grant Wood.

**Decorah: Vesterheim,
Norwegian-American
Museum** 1877
502 W. Water St., 52101
(319 382-9681)
**May–Oct.: daily 9–5; Nov.–Apr.:
daily 10–4; closed major holidays.
Fee**

An ethnic collection, incl. historic buildings, illustrating the life of Norwegian immigrants in the New World.

Des Moines Art Center 1933
Greenwood Park 50312
(515 277-4405)
**Tues.–Sat. 11–5; Sun., holidays
12–5; closed Mon., major
holidays. No charge**

Collections are housed in a building designed by Eero Saar-inen, with a new wing designed by I. M. Pei. 20th C. and contempo-rary American art predominate, along with a few examples of classic European modernists who influenced American develop-ments; small groups of Far East-ern, ancient, and African art. ☛ Contains one member of Rodin's group sculpture, *The Burghers of Calais;* the pioneer American modernist Macdonald-Wright, is represented by *Abstrac-tion on Spectrum* (1914–17), illus-trating his theories of Synchro-nism; a palace door carved by the Nigerian Arowogun of Osi just after the turn of the century; one version of Monet's *Cliffs at Étretat.*
• Salisbury House, 4025 Tona-wanda Dr., 50312; 515 279-9711; Mon.–Fri. 8–4:30; Labor Day-Memorial Day, also open Sat. 9–12; closed Sun., holidays; fee; a historic house/museum with 15th–17th C. furnishings, incl. tapestries, decorative arts, and a few Old Masters.

Fort Dodge: Blanden Memorial Art Gallery 1931
920 Third Ave. S, 50501
(515 573-2316)
Tues.-Wed., Fri.-Sun. 1-5;
Thurs. 1-8:30; closed Mon.,
holidays. No charge (donation accepted)

A small, select collection, primarily of 20th C. masters, incl. fine examples of Beckmann, Miró, Chagall, and Klee; some Far Eastern and contemporary graphics; Oriental decorative arts. ☛ Prendergast's oil *Edge of the Woods* and his watercolor *Central Park* make an interesting comparison; Miró's lively and fantastic *Cry of the Gazelle at Daybreak*.
• Fort Dodge Historical Museum, Museum Rd., 50501; 515 573-4231; May 3-Oct. 11, daily 9-5; fee; historic buildings, collections.

Iowa City: University of Iowa Museum of Art 1967
Riverside Dr., 52242
(319 353-3266)
Mon.-Sat. 10-5; Sun. 12-5;
closed holidays. No charge

An interesting mixed collection, incl. 20th C. European paintings; 18th C. English silver; Chinese jade; African, Oceanic, and Pre-Columbian art; Tibetan and Indian bronzes. ☛ Pollock's *Mural* (1943); a hushed *Still Life* by Morandi.

Marshalltown: Central Iowa Art Association 1946
Fisher Community Center, Box 352, 50158 (515 753-9013)
Mon.-Sat. 8-5; Sun. 2-5; closed holidays. No charge

A collection almost entirely made up of French paintings of the Impressionist period, incl. Degas, Bonnard, Cassatt, Pissarro, Matisse, Sisley, Monet; also sculpture and ceramics. ☛ Matisse's *Portrait of Mme. Matisse.*

Mason City: Charles H. MacNider Museum 1964
303 Second St., 50401
(515 423-9563)
Tues., Thurs. 10-9; Wed.; Fri.-Sat. 10-5; Sun. 2-5; closed Mon., holidays. No charge

A collection primarily made up of 20th C. American painting, incl. works by Dove, Benton, Maurer, Shahn, and Levine. ☛ Burchfield's watercolor *Sunburst in November* (1960), with its highly developed personal calligraphy, so different from that of Sam Francis in his *No. 30, Paris* (1957-58).

Mount Vernon: Armstrong Gallery 1853
Cornell College, 52314
(319 895-8811)
Mon.-Fri. 9-4; Sun. 2-4; closed Sat., holidays, summer months, college holidays. No charge

Contains the Sonnenschein Collection of Baroque art; the Whiting Glass Collection; and a collection of the drawings and prints of Thomas Nast, the famous cartoonist whose courageous crusade against political corruption in post-Civil War America did much to reveal the depths of the Teapot Dome scandal and led him to take on Tammany Hall.

Spillville: Bily Clock Exhibit 1965
Spillville, 52168 (319 562-3569)
May-Oct.: daily 8-5:30; Apr.:
daily 10-4; Mar. and Nov.: Sat.-
Sun. 10-4; all other times by
appointment; closed holidays. Fee

A collection of hand-carved clocks displayed in the former home of the famous composer Antonin Dvořák.

KANSAS

Chanute: Martin and Osa
Johnson Safari Museum 1961
16 S. Grant St. 66720
(316 431-2730)
Mon.-Sat. 10-5; Sun. 1-5; closed
Mon., holidays. Fee

A collection of African objects from more than 30 tribal groups in West Africa; photographs and archives of African exploration by the Johnsons.

Lawrence: Spencer Museum of
Art 1928
University of Kansas, 66045
(913 864-4710)
Tues.-Sat. 9:30-4:30; Sun.
1-4:30; closed Mon., major
holidays. No charge

A selective, comprehensive collection, from ancient to modern, with fine examples of European medieval, Renaissance, Baroque, and Rococo art; Old Master prints and drawings; American painting and decorative arts; Korean ceramics; Japanese prints; and contemporary painting. ☛ Fine French Romanesque capitals; ★ A pair of life-sized South German painted and gilded figures of *Saints Cosmas and Damian,* carved with great virtuosity by Joseph Götch (such works are rare in this country); Homer's vigorously painted oil *Cloud Shadows;* a mysterious *haniwa* grave-guardian figure in terra-cotta of the Tumulus Period (350-550 A.D.).

Sedan: Emmett Kelly Historical
Museum 1965
Sedan, 67361 (316 725-3470)
Spring and fall: Sat.-Sun. 1-5;
summer: Tues.-Sun. 1-5; other
days by appointment. No charge
(donation accepted)

A clown and circus collection with memorabilia of the great clown Emmett Kelly.

Wichita: Edwin A. Ulrich Museum of Art 1974
Wichita State University, Box 46, 67208 (316 689-3017)
Wed. 9:30–8; Thurs.–Fri. 9:30–5; Sat.–Sun., holidays 1–5; closed Mon., Tues., holidays. No charge

A fine and varied collection of American painting and sculpture, mainly late 19th and 20th C., with important European, African, Pre-Columbian additions. ☞ Louise Nevelson's brooding *Night Tree* in Cor-Ten steel; a group of Ernest Trova's enigmatic and polished sculptures; and, unexpectedly and delightfully, Hogarth's handsome portrait of *Lavinia, Duchess of Bolton* (c. 1745).

Wichita Art Museum 1935
619 Stackman Dr., 67203
(316 268-4621)
Tues.–Sat. 10–4:50; Sun. 1–4:50; closed Mon., holidays. No charge

An outstanding collection of American painting, sculpture, prints, and drawings forming the Murdock and Naftzger collections; paintings, drawings, and sculpture of the Old West by Charles M. Russell; sculpture and drawings by Ivan Meštrović—all displayed in an interesting building by Edward Larrabee Barnes. ☞ ★ Copley's memorable portraits of the patriots *Mr. and Mrs. James Otis* from the early 1760s; Eakins'

Starting Out After Rail, fresh and breezy (another version exists in Boston); ★ Glackens' delightful *Luxembourg Gardens* as well as other outstanding works of The Eight; a rare Feke portrait; a fine Ryder; Prendergast's poetic *As Ships Go Sailing By.*

KENTUCKY

Berea College Art Department Galleries 1855
Berea, 40404
(606 986-9341, ext. 520)
Fall and Spring terms: Mon.–Fri. 8–5; Sun. 2–5; phone for other hours; closed holidays. No charge

An interesting teaching collection made up of the Kress Collection of Renaissance painting and sculpture, the Metzger Collection of medieval and Renaissance textiles, and the Titcomb Collection of Far Eastern art; a fine print collection; American paintings; Doris Ullmann's photographs of Appalachia; Appalachian crafts. (The college also has an Appalachian Museum.)

Harrodsburg: Shakertown at Pleasant Hill 1961
Rt. 4, 40330 (606 734-5411)
Daily 9–5; closed Christmas. Fee

A Shaker village museum with historic buildings and collections of the earlier 19th C.

45

Lexington: International Museum of the Horse 1978
Iron Works Rd. (mailing address: Rt. 6, Iron Works Pike, 40511)
(606 233-4303)
Memorial Day–Labor Day: daily 9–7; Sept.–May: daily 9–5. No charge

A collection devoted entirely to the horse, worldwide and throughout history.

Lexington: University of Kentucky Art Museum 1975
Rose and Euclid Sts., 40506
(606 258-5716)
Tues.–Sun. 12–5; closed Mon., holidays. No charge

A collection strongest in American and European art of the 19th and 20th C., but also including Pre-Columbian, African, and Far Eastern art; prints and drawings. ☛ An impressive Kwakiutl Indian totem pole. (The university also has a large Photographic Archives documenting the history of photography, of Kentucky, and of the Appalachian region; it is housed in the university libraries; Mon.–Sat. 8–4:30 [606 258-8634].)
• The Headley–Whitney Museum, 4435 Old Frankfort Pike, 40511; a collection devoted to gems, jewels, goldsmithwork, Far Eastern porcelains, shells, plus some paintings; Wed.–Sun. 10–5; closed Mon., Tues., major holidays; fee; 606 255-6653.
• The Living Arts and Science Center, 362 Walnut St., 40508; a children's museum of art and science with a lively program; Mon.–Fri. 9–5; Sat. 10–4; closed Sun., holidays; no charge; 606 252-5222.

Louisville: American Saddle Horse Museum Association 1962
730 W. Main St., 40202
(502 585-1342)
Mon.–Sat. 10–4; Sun. 1–5; closed holidays, Derby Day. Fee

A collection showing the evolution of the horse, portraits of champions; carriages.

Louisville: J.B. Speed Art Museum 1925
235 S. Third St., 40208
(502 636-2893)
Tues.–Sat. 10–4; Sun. 2–6; closed Mon., holidays. No charge

An important comprehensive collection, ancient to modern, East and West; especially strong in European painting, sculpture, and decorative arts from the Middle Ages to the present; American painting and decorative arts; Far Eastern art; American Indian arts; French and Flemish tapestries; Kentuckiana. ☛ Rubens' superbly accomplished sketch of *The Triumph of the Eucharist* for one of the series of tapestries he designed for the Convent of the Descalzas Reales in Madrid; Brancusi's landmark essay in abstraction, the bronze head of *Mlle. Pogany* (1913); an exquisitely conceived and produced ★ Italian

46

bronze of the early 16th C. depicting a spirited *Horse and Rider,* which has something of the power and expression of Leonardo's masterful preparatory drawings for equestrian monument projects and for his famous lost Florentine fresco of the *Battle of Anghiari,* which marked a turning point in the development of Western art; the impressive 19th C. American folk art sculpture of *The Chief of the Mechanics' Volunteer Fire Brigade of Louisville,* formerly mounted atop the firehouse and rotated to point in the direction of every fire for which the brigade was called out.

• Allen R. Hite Institute, Third St., Belknap Campus, University of Louisville, 40292; an American and European collection, primarily consisting of graphics and paintings from the 15th C. to the present; Mon.-Fri. 9-4:30; closed weekends, holidays; no charge; 502 588-6794.

Louisville: Kentucky Derby Museum 1962
700 Central Ave., 40208
(502 634-3261)
Daily 9:30-4:30; racing days, 9-11; closed during spring and fall racing season, holidays, Derby Day. No charge

Located on the grounds of famous Churchill Downs racetrack, where the Derby is run; houses a collection of memorabilia, trophies, etc., relating to that classic race.

• Louisville Art Gallery, 301 W. York St., 40203; a children's museum; Sept.-May: Mon.-Sat. 9-5; June-Aug.: Mon.-Fri. 9-5; closed Sun., holidays; no charge; 502 583-7062.

• Photographic Archives, University of Louisville Libraries, 40292; a comprehensive collection illustrating the history of photography, incl. illustrated books; Mon.-Fri. 8:30-12, 1-5; closed weekends, holidays; no charge; 502 588-6752.

• For information concerning Kentucky's historic houses and sites, consult the Kentucky Historical Society, Broadway at the St. Clair Mall, Box H, Frankfort, 40602 (502 564-3016); headquarters in the Old Kentucky State Capitol, Frankfort, and the Kentucky Dept. of Parks, Division of Museums and Shrines, Capital Plaza Tower, Frankfort; 40601.

Murray: Clara M. Eagle Gallery 1971
**Murray State University,
University Station, 42071**
(502 762-3784)
**Mon.-Fri. 7:30-9; Sat. 10-4; Sun. 1-4; closed university holidays.
No charge**

Jackson Print Collection and the Asian Cultural Exchange Collection of Asian art and artifacts.

Owensboro Museum of Fine Art 1977
901 Frederica St., 42301
(502 685-3181)
Mon.-Fri. 10-4; Sat.-Sun., holidays 1-4; closed major holidays. No charge

Contemporary American art, 19th C. regional painting and graphics from the Midwest; 18th C. English painting and decorative arts; 18th C. Chinese ceramics.

South Union: Shaker Museum at Shakertown 1960
Rt. 68, 42283
(502 542-4167)
Mother's Day-Labor Day:
Mon.-Sat. 9-5; Sun. 1-5; Sept.-
Oct.: Sat. 9-5; Sun. 1-5; closed
Nov.-Apr. Fee

Historic Shaker buildings and artifacts.

LOUISIANA

Baton Rouge: Anglo-American Art Museum 1960
Memorial Tower, Louisiana State University, 70803
(504 388-4003)
Mon.-Fri. 9-4:30; Sat. 9-12
and 1-4:30; Sun. 1-4:30; closed
holidays. No charge

Largely a decorative arts collection illustrating the impact of English styles on American arts; also painting, sculpture, graphic arts. ☛ Peter Monomy's serene and accurately detailed *Man o'War and Other Vessels in a Calm Sea* (c. 1730); Rembrandt Peale's *Portrait of John Hoskins Stone,* governor of Maryland (1797-98), a fine example of the work of this gifted

member of the artistic Peales of Philadelphia; Adrien Persac's *The Steamboat Princess* (1861), a unique view of the cabin of a Mississippi River steamboat by the major visual reporter of the southern Louisiana scene in the decade before the War Between the States.
• Louisiana Arts and Science Center, 100 S. River Rd., Box 3373, 70821; housed in the renovated Illinois Central Railway Station overlooking the Mississippi River, the center contains a collection of Tibetan, Eskimo, American Indian, and Egyptian objects; Meštrović sculptures; Tues.-Sat. 10-5; Sun. 1-5; closed Mon., major holidays; fee; 504 344-9463.

New Orleans: The Historic New Orleans Collection 1966
533 Royal St., 70130
(504 523-7146)
Tues.-Sat. 10-5; closed Sun.,
Mon., holidays, Mardi Gras. Fee

A voluminous collection documenting life in New Orleans and the lower Mississippi valley since Colonial times, incl. oils, watercolors, drawings, prints, maps, mss., and various publications; housed in the historic Merieult House of 1792 located in the Vieux Carré; a model historical collection delightfully displayed in a sympathetically converted dwelling.

LOUISIANA

CREOLE-ACADIAN TOUR

MILES
0 40

GULF OF MEXICO

MISSISSIPPI RIVER

LAKE PONTCHARTRAIN

New Orleans

Reserve ⑱

Baton Rouge

Clinton ①

Jackson ②

St. Francisville ③

New Roads ④

Opelousas ⑤

Lafayette ⑥

Crowley ⑦

Abbeville ⑧

New Iberia ⑨

St. Martinville ⑩

Jeanerette ⑪

Franklin ⑫

Morgan City ⑬

Thibodaux ⑭

Napoleonville ⑮

Burnside ⑯

Vacherie ⑰

Darrow

I-10

10

67

10

US 190

US 167

US 90

13

14

14

31

1

18

44

20

24

US 90

N

palacios

LOUISIANA

Creole-Acadian Tour

Southern Louisiana is particularly rich in history involving the French and Spanish. It was to this area that the Acadians, French settlers in what became Canada's Maritime Provinces, were deported by the British in 1755. Their language and culture, now called Cajun, flourishes among the remains of a rich past. French Royalists fled to this area to escape the French Revolution. The Creoles are the descendants of these French refugees. New Orleans itself is still largely a French city in architecture and flavor, with many fascinating monuments remaining. Natchitoches, 100 m. NW of New Orleans, is also a center of Creole culture. The following tour through south central Louisiana, with its many important and interesting monuments, reflects the dignity and color of Creole life and the continuity of the French tradition. The tour starts at Baton Rouge and finishes at New Orleans.

Note: Many of the houses on the tour are privately owned, so hours and fees vary; according to latest reports, all are open to the public. Approximate mileage and routes are provided between points of interest.)

1. *Clinton:* Court House Square, with the 1840 Court House and Lawyers' Row, a charming composition of distinguished Greek Revival buildings (30 m. from Baton Rouge N on Rt. 67).

2. *Jackson:* Asphodel, a Greek Revival plantation house of the 1820s (private, open by appointment; 8 m. W on State 10 to State 68).

3. *St. Francisville* on the east bank of the Mississippi is the site of several fine houses, among the most outstanding of which are: Oakley (c. 1799), with fine Federal furnishings, where Audubon stayed while painting many of his famous *Birds of America* (4½ m. E on State 965 via US 61, in Audubon State Commemorative Area; fee); and Rosedown (1834–44), a fine house surrounded by superb gardens (1 m. NE on State 10 at US 61; private; fee). (*Note:* Catalpa, with 30-acre gardens, is on State 61 as is The Cottage, with plantation outbuildings, and The Myrtles, with fine ironwork; all are private.)

4. *New Roads:* Parlange (c. 1750), an outstanding example of the French raised cottage, still inhabited by descendants of the builder after eight generations (6 m. S on State 10 to State 1; fee).

5. *Opelousas,* established as a French trading post in 1750, with the Jim Bowie Museum, 163 W. Landry Street, housing relics of the famous scout who invented the Bowie knife (S to US 190, 35 m. W to Opelousas.)

6. *Lafayette,* an Acadian town, where the Lafayette Museum occupies the home of Alexandre Mouton, an early governor of Louisiana, at 1122 Lafayette Street; Art Center for Southwestern Louisiana, with collections of 19th and early 20th C. Louisiana arts; both free (25 m. S via US 167).

7. *Crowley,* a center of rice production, has a Rice Museum on US 90; the Blue Rose Museum, 5 m. SW, occupies an Acadian cottage (c. 1860) and has a collection of decorative arts of the area.

8. *Abbeville,* a town laid out by the Abbé Mégret in the 18th C. after a town in

Provence, with the church of Ste. Marie Magdaleine on the Place Magdaleine, a center of Cajun life (28 m. S via State 13 and E on State 14).

9. *New Iberia,* on the beautiful Bayou Teche, a city rich in Spanish and Acadian tradition has one of the great Southern houses, Shadows-on-the-Teche, 217 E. Main St., built between 1831 and 1834 by David Weeks, a planter, with fine gardens and furnishings representing five generations (25 m. E. on State 14; fee). (*Note:* Dulcito (1788), off US 90, showing Spanish influence, and Justine, an 1822 cottage barged to its present location on State 96, may be visited by appointment.)

10. *St. Martinville,* in the Longfellow-Evangeline State Park area, is another Acadian center. It was a Royalist refuge after the French Revolution. The Acadian House Museum (c. 1780), was the home of Pelletier de la Houssaye, French commandant of the Poste des Attakapas, as the town was named before it became St. Martinville (8 m. N via State 31; fee). (*Note:* The font and sanctuary lamp in St. Martin-de-Tours church were gifts of Louis XVI and Marie Antoinette.)

11. *Jeanerette:* Albania (1837–42) was built by Charles Grevemberg, a Royalist refugee, in classic style, with a three-story spiral staircase (S via State 31 to New Iberia, SE via US 90; 18 m.).

12. *Franklin,* a center for sugar, carbon black, and ships; is the site of Oaklawn Manor (1827; rebuilt after a fire in the 1920s), an impressive Classical Revival structure (SE via US 90; Oaklawn is 5 m. NW of Franklin at Irish Bend).

13. *Morgan City,* a major shrimping port in an area rich in French tradition (18 m. SE via US 90).

14. *Thibodaux,* an agricultural center; is the site of Chief Justice Edward Douglass White's Cottage (c. 1830) in six-acre Edward Douglass White Park (30 m. E via US 90, NE from Gibson via State 20 and 24; White Cottage is 6 m. N via State 1).

15. *Napoleonville:* Madewood (1840–48), a fine stuccoed brick Classical Revival house, temple-fronted in an impressive style (18 m. NW via State 1, 2 m. S at Bayou Lafourche on State 308).

16. *Burnside-Darrow:* Ashland-Belle Hélène (1841), a powerfully simple house in a Romantic design, with piers instead of columns (6 m. NW of Darrow via State 22); and Houmas House (1840), River Road (State 44), gracious and knowingly restored, with fine gardens and furnishings (26 m. N via State 1 to Darrow-Burnside area).

17. *Vacherie:* Oak Alley (1837–39), a superb house at the end of an allée of oaks of unbelievable girth and grandeur (S and E 35 m. on State 18; the house is 2½ m. W of Vacherie).

18. *Reserve:* San Francisco Plantation (1853–56), built in a wildly Romantic design obviously influenced by the style of the Mississippi riverboats that often passed this site (E via State 18 to ferry near Norco, W via State 44; 35 m.; New Orleans is 25 m. E via US 61, and Baton Rouge is 50 m. W via US 61, NW via I-10).

Louisiana State Museum 1906
751 Chartres St., 70116
(504 568-6968)
**Tues.–Sun. 9–5; closed Mon.,
holidays. Fee except for senior
citizens and school tours**

A rich historical collection containing a great variety of objects in different media; immensely important and interesting historic buildings, incl. The Cabildo (1795), The Presbytère (1795), The Lower Pontalba Building (1850), The Mme. John's Legacy (1788), and others; Chennault Collection of Asian Art; extensive archives housing mss., records, photographs, prints, decorative arts, and crafts. ☞ Nearby Jackson Square, a purely French design recalling its former name of Place d'Armes, dominated by the cathedral, one of the finest pieces of urban design in the New World, the frontispiece of the picturesque Vieux Carré; the Gallier House of 1857 now a decorative arts museum, former home of the distinguished architect James Gallier, Jr. (1118–32 Royal St., 70116; 504 523-6722; Mon.–Sat. 10–4:30; fee); the Hermann-Grima House of 1831, with a decorative arts collection and garden (820 St. Louis St., 70112; 504 525-5661; Mon., Tues., Thurs., Sat. 10–3:30; Sun. 1–4:30; closed Wed., holidays; fee).

New Orleans Museum of Art 1910
**Lelong Ave., City Park, Box
19123, 70179** (504 488-2631)
**Tues.–Sun. 10–5; closed Mon.,
major holidays. Fee**

A large and varied collection containing outstanding works by Degas; the Kress Collection of Italian Renaissance and Baroque painting; the Hyams Collection of Barbizon and Salon paintings; Pre-Columbian and Hispanic Colonial painting and sculpture; 20th C. European and American art; Japanese painting of the Edo period; the Billups Collection of glass, ancient to modern; the Kiam Collection of African, Native American, and Oceanic arts; art by 19th–20th C. Louisiana artists; Whitney Collection of Chinese jade; European and American decorative arts; the Harrod Collection of silver. ☞ Degas Gallery, esp. the moving ★ *Portrait of Estelle Musson Degas,* the blind wife of the artist's brother, arranging flowers, painted when Degas visited his relatives in New Orleans in 1872–73; Veronese's richly colored *Sacra Conversazione;* the Baron Gros' oil sketch of *Napoleon Visiting the Plague-Stricken at Jaffa* (1804), in which the hopelessness of the plague victims is vividly recorded; *The Head of a Sun God or Priest* from Copan, a fiercely impressive stone sculpture of the

classic Mayan period; a Hawaiian *War God* in wood, brought back from his third voyage (1778–79) by Captain James Cook.

St. Martinsville: Acadian House Museum 1926
Box 497, 70582 (318 394-3754)
Mon.-Sat. 9–5; Sun. 1–5; closed holidays. Fee except for small children, senior citizens, and school groups with reservations.

Historic buildings and collections illustrating Acadian life; located in Longfellow–Evangeline State Park.

Shreveport: The R. W. Norton Art Gallery 1946
4747 Creswell Ave., 71106
(318 865-4201)
Tues.-Sun. 1–5; closed Mon., holidays. No charge

Housed in a contemporary building located in its own handsome park, the collection is highlighted by works of the Old West by Remington and Russell; 19th-20th C. European and American painting; American Colonial silver; American glass; Wedgwood. ☛ Outstanding group of animal sculptures by Barye, one of the foremost animaliers of all time; Paul Revere silver; the set of 6 16th C. Flemish tapestries illustrating events of the Second Punic War; Audubon's 5-volume, double elephant folio

Birds of America, 1827–38, one of the great artistic-scientific achievements with 435 hand-colored plates instinct with life.

MAINE

Bath: Maine Maritime Museum 1963
963 Washington St., 04530
(207 443-6311)
Mid-May–mid-Oct.: daily 10–5. Rest of year, two buildings open Sat., Sun. 10–5. Fee varies with season; summer fee incl. boat ride on the Kennebec River

An important and diverse historical collection illustrating the maritime heritage of Bath and the Kennebec River, one of the great shipbuilding centers of America; historic buildings incl. the Sewall House and Winter Street center, with varied exhibitions; Percy & Small Shipyard; and the Apprenticeshop and small craft center, with actual construction taking place; restoration of the steam tug *Seguin* and the famous Arctic exploration schooner *Bowdoin.* ☛ Boat ride on the river in the launch *Sasanoa,* with water views of the Bath Iron Works, the shipyard where nuclear frigates are constructed. (*Note:* Because of the nature of the technology involved, the yard is not open to visitors; ask at the museum about launchings,

however, as they are open to the public and are intensely interesting.)

The Boothbay Theatre Museum
1957
Corey Lane, 04537
(207 633-4536)
Mon.-Sat. by appointment; tours daily at 10 and 3. Fee

The 1784 Nicholas Knight-Corey House contains a varied collection of theater memorabilia from the 18th C. to the present.

Brunswick: Bowdoin College Museum of Art 1811
Walker Art Bldg., 04011
(207 725-8731)
**July-Labor Day: Tues.-Sat. 10-5 and 7-8:30; Sun. 2-5; Sept.-June: Tues.-Fri. 10-4; Sat. 10-5; Sun. 2-5; closed Mon., holidays.
No charge**

Established in 1811 with the bequest of James Bowdoin III and housed in the landmark building designed by McKim, Mead & White in 1894, a small but extraordinarily fine collection, incl. American Colonial and Federal portraits and decorative arts; Old Master prints and drawings; Warren Collection of classical antiquities; Molinari Collection of medals and plaquettes, primarily Renaissance through the 18th C.; Kress Study Collection; Assyrian sculpture; Far Eastern ceramics; African and Pre-Columbian sculpture; 19th-20th C. American painting, sculpture, drawings, and prints, incl. works and memorabilia of Winslow Homer. ☛ ★ Feke's memorable full-length, life-sized *Portrait of General Samuel Waldo,* perhaps the greatest portrait painted in America before Copley; the remarkable series of Bowdoin family portraits; ★ Pieter Brueghel the Elder's sensitive, panoramic *View of Waltersburg,* drawn in sepia during his return trip from Italy in the early 1550s; the series of five monumental Assyrian reliefs of the 9th C. B.C.; the Walker Art Building itself, with its historically important murals by Kenyon Cox, John La Farge, Elihu Vedder, and Abbott Thayer.

Lewiston: Treat Gallery 1959
Bates College, College St., 04240
(207 783-6535)
**Mon.-Fri. 1-4:30 and 7-8; Sun. 2-5; closed Sat., holidays.
No charge**

The Marsden Hartley Memorial Collection of paintings, drawings, prints, and mss.; European and American paintings, drawings, prints, and photographs; Far Eastern art; decorative arts. ☛ Marsden Hartley material, reflecting the artist's search for himself through the arts and finally finding himself in his native Maine.

54

**Ogunquit: Museum of Art of
Ogunquit** 1951
Shore Rd., 03907 (207 646-8827)
**July-Labor Day: Mon.-Sat.
10:30-5; Sun. 1:30-5; closed July
4 and remainder of year.
No charge**

A small, interesting 20th C.
American collection of painting,
drawing, and sculpture, effective-
ly shown in a seaside setting, con-
taining many works associated
with Maine. ☞ Works of Tobey,
Graves, Marin; and Flannagan's
Morning, carved from fieldstone
and leaving as much of the natu-
rally weathered surface as possible
to suggest his feelings of closeness
to the natural world. (*Note:* The
Barn Gallery, Shore Rd. at Borne's
Lane, 03907, also has interesting
art exhibits; 207 646-5370; mid-
June-mid-Sept., Mon.-Sat. 10-5;
Sun. 2-5; no charge for exhibits;
donation for programs.)

**Orono: University of Maine at
Orono Art Galleries** 1865
Carnegie Hall, 04469
(207 581-7165)
**Mon.-Fri. 8-4:30; closed
weekends, major holidays.
No charge**

A collection primarily of Ameri-
can 20th C. art associated with
Maine; sculpture, drawing, prints;
European arts. ☞ Inness' *The Elm,*
atmospheric and serene; Marin's
brilliant *A Bit of Cape Split;*

Hassam's nostalgic *Acorn Street,
Boston.*

**Poland Spring: The Shaker
Museum** 1931
Sabbathday Lake, 04274
(207 926-4597)
**May 30-Labor Day: Tues.-Sat.
10-4:30; closed Mon., holidays,
and remainder of year. Fee**

A Shaker village museum, with
fine historical and decorative arts
collections, run by Shakers; an In-
stitute for Shaker Studies; fascina-
ting Shaker technology and crafts.

**Portland: Joan Whitney Payson
Gallery of Art** 1977
**Westbrook College, 716 Stevens
Ave., 04103** (207 797-9546)
**Tues.-Fri. 10-4; Sat.-Sun. 1-5;
closed major holidays. No charge**

A fine, select collection of Euro-
pean and American painting and
drawing, esp. outstanding in Post-
Impressionist works and modern
American art.

Portland Museum of Art 1882
**111 High St., Box 4018, Sta. A,
04101** (207 775-6148)
Call for hours. Fee

Primarily an American collection
of paintings, sculptures, prints,
drawings; historic McLellan-
Sweat House (1800), with contem-
porary furnishings, decorative
arts; Japanese prints and other ob-

jects. ☞ Outstanding group of Winslow Homers; new I. M. Pei building.

• Maine Historical Society, 485 Congress St., 04101; with the historic Wadsworth–Longfellow House of 1785, the boyhood home of the poet, next door; interesting historical collections, incl. paintings, prints, drawings, photographs, decorative arts; Mon.–Fri. 9–5; closed weekends, major holidays; no charge; 207 774-1822. (*Note:* Portland has other historic buildings, esp. the Morse–Libby House, 109 Danforth St., 04101, a picturesque Romantic Victorian design with period furnishings [207 772-4841; mid-June–Labor Day, Tues.–Sat. 10–4; fee]; and the much earlier Tate House of 1755, 1270 Westbrook St., Stroudwater with period interiors and furnishings [207 772-2023; Mon.–Sat., 11–5; Sun. 1:30–5; June 1–July 1 and Sept. 15–Oct. 15, by appointment; closed holidays; fee].)

Rockland: William A. Farnsworth Library and Art Museum 1935
19 Elm St., 04841
(207 596-6457)
June–Sept.: Mon.–Sat. 10–5; Sun. 1–5. Oct.–May: Tues.–Sat. 10–5; Sun. 1–5; closed Mon.; closed holidays throughout the year. No charge

An American collection from the late 18th C. to recent times, incl. paintings, prints, drawings, decorative arts, and historical objects.

☞ Paintings by such classic Americans as Fitz Hugh Lane, the outstanding marine artist, as well as Homer, Marin, and Prendergast; a considerable group of paintings by N. C. Wyeth, the famous illustrator, his son Andrew, and Andrew's son James. (*Note:* The historic Farnsworth House, a Romantic design of c. 1850, is also open for inspection.)

Searsport: Penobscot Marine Museum 1936
Church St., 04974
(207 548-6634)
Memorial Day–Oct. 15: Mon.–Sat. 9:30–5; Sun. 1–5; closed holidays and remainder of year. Fee

A fine maritime collection displayed in three shipmasters' houses and the town's original town hall; a rich variety of paintings, prints, models, shipbuilding tools, charts, navigational instruments, logs, and other mss. and objects. ☞ A vigorously carved and properly ornery 19th C. ★ *Eagle,* which once stood defiantly atop the pilothouse of a Penobscot Bay vessel.

Waterville: Colby College Museum of Art 1959
Mayflower Hill, 04901
(207 873-1131)
Mon.–Sat. 10–12 and 1–4:30; Sun. 2–4:30; closed holidays. No charge

A fine collection, primarily of

American arts from the Colonial period to the present, incl. the Jette American Heritage Collection of folk art; the Jette Collection of American painters of the Impressionist period; the Pulsifer Memorial Collection of Homer watercolors; the Cummings Collection of American folk art; the John Marin Collection; the d'Amico Print Collection; the Bernat Collection of Far Eastern ceramics and calligraphy; Old Master graphics; decorative arts. ☛Very impressive ★ *Portrait of Silas Ilsley* (c. 1840) by an anonymous but very gifted painter; a genially roaring carved wooden lion (c. 1835) from Newbury, Vermont; a breezy *Maine Coastal Scene* by Alfred T. Bricher; a fascinating and fluid drawing of *The Birth of the Virgin* by Lodovico Carracci (c. 1600).

MARYLAND

Annapolis: United States Naval Academy Museum 1845
Academy Campus, 21402
(301 267-2108)
Daily, 9–5; closed major holidays.
No charge

A fascinating, varied collection documenting the history of the American Navy, with paintings, prints, sculpture, decorative arts, flags, charts, instruments, uniforms, ship models, and memorabilia. ☛ Vigorous *Washington* figurehead carved for the 64-gun ship of that name launched in Portsmouth, NH, in 1816, perhaps by the distinguished Greek Revival architect Solomon Willard.

• Hammond-Harwood House, 19 Maryland Ave., 21401; a very distinguished historic house designed in 1774 by William Buckland; fine furnishings and decorative arts collection. Nov.–Mar.: Tues.–Sat. 10–4; Sun. 1–4; Apr.–Oct.: Tues.–Sat. 10–5; Sun. 2–5; closed Christmas, New Year's; fee; 301 269-1714. (*Note:* Buckland, also designer of Gunston Hall, VA, was a virtuoso woodcarver; note the superb detailing, always crisply chiselled.)

(*Note:* Historic Annapolis, 18 Pinckney St., 21401, with headquarters in the Slicer–Shiplap House [c. 1713], administers more than a half dozen historic properties, perhaps the most distinguished of which is the William Paca House [1765], a palatial Georgian mansion located at 186 Prince George St., with a beautiful and spacious landscape setting; phone ahead for further information; 301 267-7619. For those who are interested, the Annapolis Historic District is worth exploring, as many fine 18th C. houses remain, among them the impressive Chase-Lloyd House of 1769, also designed by Buckland, where Francis Scott Key and Mary Tayloe Lloyd were married in 1802, now a home for elderly ladies. There are also fine historic buildings on the cam-

pus of nearby St. John's College, chartered 1784–85; the picturesque State House, completed in 1779, the oldest in continuous use, is redolent of history.)

The Baltimore Museum of Art
1914
Art Museum Dr., 21218
(301 396-7101)
Tues.–Sat. 11–5 year round; additional hours Sept.–May: Thurs. evenings 7–10; Sun. 1–5. Closed holidays. No charge

An outstanding museum whose holdings are made up of a group of various collections displayed separately; though the range is from ancient to modern, East to West, the greatest strengths are in the classic modern field; the Cone Collection, a group of remarkable works assembled by the Cone sisters with the advice of Gertrude Stein; the May Collection, the Benesch Collection of contemporary drawings; a fine American collection, with a series of period rooms illustrating a century of stylistic development in Maryland; Old Masters in the Epstein, Jacobs, and Eisenberg collections; the small but fine Levy Collection of Far Eastern art; The Wurtzburger Collection of the arts of the Americas, Africa, and Oceania; the Woodward Collection celebrating the thoroughbred racehorse; European and American decorative arts; drawings, prints, and photographs; contemporary sculpture in the Wurtzburger Sculpture Garden; 1st–3rd C.

mosaics from Antioch; Maryland silver in the White Collection; important textiles. ☛ Matisse's famous, once notorious *Blue Nude* (1907) from the Cone Collection, a modern classic but a shocker in its day; Van Dyck's superbly colorful and romantic *Rinaldo and Armida* (1629), an amorous episode from Tasso's epic poem *Jerusalem Delivered;* Rembrandt's portrait of his son *Titus,* who died young, like his mother; Picasso's portrait of the redoubtable ★ *Dr. Claribel Cone,* who formed the remarkable collection that is a chief treasure of the museum.

Baltimore Seaport and Maritime Museum
Pier 4, Pratt St., 21202
Labor Day–June 20: Sat. 10–5; Sun. 12–5; June 21–Labor Day: daily 10–6; closed holidays. Fee

A maritime museum with a considerable historical collection and a number of historic ships and small watercraft. (*Note:* The USS *Constellation,* launched at Baltimore in 1797, the first commissioned ship of the original U. S. Navy, is docked nearby, and is open to the public Labor Day–June 19, Mon.–Sat. 10–4; Sun. 12–5; June 20–Labor Day, Mon.–Sat. 10–6; Sun. 12–6; fee; for those with a sense of history and a feeling for the sea and sail, it is a joy to board *The Yankee Racehorse,* as she was called for her unusual turn of speed, as is also the case with her sister ship, the USS *Constitution* in Boston.)

Baltimore: Peal Museum 1931
225 Holliday St., 21202
(301 396-3523)
Phone for hours.

Baltimore's municipal museum, housed in the 1814 building established by Rembrandt Peale, the oldest original museum building in the U. S.; the interesting and varied collection documents the history of Baltimore; paintings by members of the Peale family; archives; photographs; mss.; historic buildings, incl. the Washington Monument, the Old Town Meeting House (1781), and the Carroll Mansion (1812), at 800 E. Lombard St.

Baltimore: Walters Art Gallery
1931
600 N. Charles St., 21201
(301 547-9000)
Mon. 1–5; Tues.–Sat. 11–5; Sun. 2–5; closed holidays. No charge.

The collection, the personal achievement of the two Walters, father and son, spanning nearly a century, ranges throughout the world of art but is best known for its extraordinary medieval treasures and Byzantine and Islamic objects, incl. remarkable mss., the Hamad Treasure of 6th C. Byzantine liturgical goldsmithwork, Early Christian liturgical vessels, virtually unequaled Renaissance enamels and jewelry; Old Master paintings through the 19th C.; Greek, Roman, Etruscan art; Far Eastern art; American 19th C.

paintings; Far Eastern art. ☛ Raphael's classic *Virgin of the Candelabra;* Bellini's *Madonna and Child Enthroned with Saints,* limpid in color, serene in spirit; Tiepolo's handsome and dramatic *King Jurgurtha Brought Before Sulla;* Turner's atmospheric and picturesque *Raby Castle;* ★ Mid-13th C. stained glass from St.-Germain-des-Près in Paris, with its wonderfully rich blues.

• The Maryland Historical Society, 201 W. Monument St., 21201, has fine period rooms, decorative arts, paintings, architectural drawings, mss., memorabilia, a Chesapeake Bay maritime collection; Sept.–May: Tues.–Sat. 11–4; Sun. 1–5; June–Aug.: Tues.–Sat. 11–4; closed major holidays; fee; 301 685-3750.

(*Note:* Of the several historic districts in Baltimore, perhaps the two most interesting are that at Fells Point, Aliceanna and Wolf Sts., on the harbor, the original seaport where the USS *Constellation* was built, still complete with churches, markets, warehouses, and houses of merchants, shipbuilders, shipowners, and seamen; and that of Mt. Vernon Place, with its historic houses, park, sculptures, and Washington Monument. For information, inquire of the Visitors Center of the Baltimore Area Convention and Visitors Council, 102–104 St. Paul St., 21202; 301 727-5688.

Of the many historical buildings and sites, among the most memorable are: the Basilica of the As-

sumption of the Virgin Mary, Mulberry and Cathedral Sts., dedicated in 1831 and designed by Benjamin Latrobe, an outstanding architect of the early republic, in a monumental Classical Revival style, with a fine, spacious interior; and the Fort McHenry National Monument, Fort Ave. at Locust Point, about 3 m. from the center of town via East Fort Ave., whose 25-hour merciless bombardment by the British during the War of 1812 inspired the young Francis Scott Key to compose the national anthem; Oct. 15–May 15, daily 9–5; May 15–Memorial Day, and Labor Day–Oct. 15, daily 9–6; Memorial Day–Labor Day, 9–8; closed New Year's Day; no charge; 301 962-4290. The Star-Spangled Banner House, where Mary Pickersgill made the flag that flew over Fort McHenry, is at 844 E. Pratt St., 21202; phone 301 837-1793 for information.)

Hagerstown: Washington County Museum of Fine Arts 1929
City Park, Box 423, 21740
(301 739-5727)
Tues.–Sat. 10–5; Sun., holidays 1–6; closed Mon., major holidays. No charge

American 19th–20th C. paintings; European arts from the Renaissance; Far Eastern jade, ceramics, and other objects; American glass and other decorative arts. ☛ Sully's urbane *Portrait of Daniel Webster,* whose fierce brow was likened to Mt. Monadnock in his native New Hampshire by a contemporary; Church's glowing *Sunset on the Hudson;* Inness' brooding *Coming Storm, Montclair, New Jersey.*

(*Note:* The Washington County Historical Society, 135 W. Washington St., 21740, administers several historic properties; for information phone 301 797-8782.)

Rockville: Judaic Museum 1969
6125 Montrose Rd., 20852
(301 881-0100)
Mon.–Thurs. 12–4 and 7:30–9:30; Sun. 2–5; closed Fri., Sat., Jewish and national holidays. No charge

A Judaic collection, incl. archaeological, anthropological, ethnological, archival, and folkloric material.

St. Michaels: Chesapeake Bay Maritime Museum 1965
Box 636, 21663 **(301 745-2916)**
Oct.–Dec.: Tues.–Sun., holidays 10–4; Jan.–Mar.: Sat.–Sun., holidays 10–4; closed Mon.–Fri.; Apr.–Aug.: daily 10–5; closed Christmas and New Year's. Fee

The collection includes an aquarium, paintings, prints, historic artifacts, small craft; decoys; two reconditioned sailing vessels, the *Lenard,* the last surviving round-bottomed, gaff-rigged oyster sloop, and the *Lockwood,* the last chunk-built bug-eye with the original rig left on the Bay; the museum is located on the site of an old ship-

yard where a battle of the War of 1812 was fought, with early 19th C. buildings and a lighthouse.

Solomons: Calvert Marine Museum 1969
Solomons (at the foot of Calvert Peninsula), Box 97, 20688
(301 326-3719)
Mon.-Sat. 10-5; Sun. 1-5; closed major holidays. No charge

A collection devoted to maritime history, with small craft, marine paintings and prints, nautical objects, photograph and ms. archive; model-making shop; commercial fisheries collection; 1883 Drum Point Lighthouse.
(*Note:* The Maryland National Park and Planning Commission, 8787 Georgia Ave., Silver Spring, 20907, administers a large number of historic houses and other properties throughout the state; Mon.-Fri. 9–5 except for major holidays; for information write to above address or phone 301 565-7540.)

MASSACHUSETTS

Amherst: Mead Art Museum 1821
Amherst College, 01002
(413 542-2335)
Sept.-June: Mon.-Fri. 10-4:30; Sat.-Sun. 1-5; July: Tues.-Sun. 1-4; closed Mon.; closed month of Aug., major holidays. No charge

A fine general art collection, with high points in American art from Copley to present; the Rotherwas Room of 1611, a fine Elizabethan interior with oak paneling; outstanding American and European decorative arts; examples of the art of virtually all periods and media, East and West, ancient to modern. Assyrian stone reliefs from the palace of Ashurnazirpal II at Nimrud, ninth C. B.C. (compare these with others of similar source, also brought back in the 1850s, in the collections at Bowdoin, Dartmouth, Middlebury, Williams, University of Vermont, and Yale); a superb set of Louis XVI furniture, upholstered in Gobelins tapestry designed by the painter Boucher; an urbane and dashingly painted Gainsborough, *Lord Jeffrey Amherst,* "the soldier of the king," and the college's patron saint; Thomas Cole's picturesque and evocative pair of Romantic canvases, ★ *Past* and *Present* (1838), with preparatory sketches of great charm.
• University Gallery, University of Massachusetts at Amherst, Fine Arts Center, 01003, has a collection of primarily American 20th C. arts, incl. photographs, graphics; Sept. 6-June 9: Tues.-Fri. 11-:30; Sat.-Sun. 2-5; closed Mon., Christmas; no charge; 413 545-3670.

Andover: Addison Gallery of American Art 1931
Phillips Academy, 01810
(617 475-7515)
Tues.-Sat. 10-5; Sun. 2:30-5; closed Mon., major holidays. No charge

An outstanding collection of American art, painting, sculpture, drawing, prints, photographs, decorative arts; ship models; videotapes. ☛ ★ Homer's epic oil *Eight Bells* (1886), in which you can feel the heave of the waves and smell the sea; Eakins' *Portrait of Professor Henry A. Rowland* (1891), a work whose frame, in the artist's own words, is "ornamented with the lines of the spectrum and with coefficients and mathematical formulae relating to light and electricity, all original with Professor Rowland and selected by himself."

• In North Andover, about 5 miles N, are the Merrimack Valley Textile Museum, 800 Massachusetts Ave., 01845 (617 686-0191); Tues.–Fri. 9–4; Sat.–Sun. 1–5; closed Mon., major holidays; fee), with a textile industry collection; and the North Andover Historical Society, 153 Academy Rd., 01845 (617 686-4035), which administers several interesting historic houses and other buildings; inquire for information.

Boston: Isabella Stewart Gardner Museum 1900
2 Palace Rd., 02115
(617 566-1401)
Sept.–June: Tues. 1–9:30; Wed.–Sun. 1–5:30; July–Aug.: Tues.–Sun. 1–5:30; closed Mon., major holidays, Sun. before Labor Day. No charge (donation accepted)

Fenway Court, in the style of a 15th C. Venetian palace, is the personal creation of Mrs. Gardner as the ideal setting for her remarkable art collection, largely assembled with the advice of the late, great scholar Bernard Berenson (known as "BB"), yet entirely representative of her own discerning taste; the collection ranges through time and the world of the arts, and is arranged just as Mrs. Gardner left it. ☛ The high points of the collection include some of the world's greatest works of art. ★ Titian's masterpiece, considered by many the finest piece of painting in the New World, *The Rape of Europa;* Vermeer's rare and magical *The Concert;* Giotto's *Presentation of the Child Jesus in the Temple,* one of a half dozen or so works of this great medieval master on this side of the Atlantic; Botticelli's mystical ★ *Madonna of the Eucharist,* one of the loveliest of all Renaissance paintings, in which the wheat and grapes symbolize the bread and wine of the mass, Christ's sacrifice, whence the feeling of slight melancholy that pervades the picture, and the wonderful ★ Display of flowers, esp. in the courtyard; there are frequent concerts—inquire for dates and hours.

Boston: Museum of Fine Arts 1870
Huntington Ave., 02115
(617 267-9300)
Tues., Thurs.–Sun. 10–5; Wed. 10–10; closed Mon., major holidays. Fee except Sat. 10–12; children under 16 no charge

One of the world's great museum collections, ranging throughout the entire panorama of world art; esp. strong in Far Eastern, ancient, Egyptian, Greek, and Roman art; American painting and decorative arts; Old Masters, Impressionists, and Post-Impressionists; French and Flemish tapestries, Coptic, Peruvian, Near Eastern, European, and American textiles; American silver; Mason Collection of ancient musical instruments; prints and drawings; the three Karolik collections of American arts; ship models. ☛ ★ Minoan gold and ivory *Snake Goddess* (c. 1600–1500 B.C.), whose face suggests a portrait, probably from the palace treasury at Knossos; the Greek marble ★ *Head of Aphrodite* (late 4th C. B.C.), meltingly lovely; compare with the Etruscan terracotta *Portrait of a Roman* (late 1st C. B.C.), sculpted with uncompromising naturalism, and the memorable limestone ★ Bust of *Prince Ankh-haf,* son-in-law of Cheops, the pharaoh who built the Great Pyramid (c. 2600 B.C.); the 12th C. frescoed apse from Catalonia in northwest Spain, with its awesome Christ in Glory; the mid-13th C. ★ *Nine Dragon Scroll* by Ch'en Jung, one of the greatest of Chinese painters, celebrating the immense and mysterious forces of nature, Renoir's idyllic *Le Bal à Bougival* (1883); Paul Revere's Liberty Bowl, with its admirably cocky and spirited inscription that tells so much about the determination of our patriot ancestors.

• Ancient and Honorable Artillery Company of Massachusetts, founded 1638, Faneuil Hall, 02109; a historical military collection of extraordinary interest because of its age and association with the Revolution; Mon.–Fri. 10–4; closed weekends, major holidays, 2 weeks in Oct.; no charge; 617 227-1638.

• Boston National Historical Park, Charlestown Navy Yard, Boston, 02129; though its headquarters are in Charlestown, the park includes monuments of remarkable historic interest, incl. the Old North Church from whose steeple Paul Revere received his message to ride; the USS *Constitution,* berthed in the Charlestown Navy Yard; the Bunker Hill Monument; the Paul Revere House and the adjoining Pierce-Hichborn House on North Square; Faneuil Hall, where so much history was made; the Old South Meeting House of 1729, at Washington and Milk Sts.; the Old State House of 1713, at 206 Washington St., the headquarters of The Bostonian Society; phone 617 242-5642, and under separate listings for the various sites; also see below under Boston Historic Districts.

• Boston Public Library, Copley Square, 02117; extremely important and interesting murals by Edwin Austin Abbey, John Singer Sargent, and Puvis de Chavannes; also paintings, a world-famous

collection of prints and drawings, historic dioramas; 617 536-5400 (in a landmark McKim, Mead & White building; note Richardson's superbly designed and composed Trinity Church at the other end of the square); 617 536-5400.

• Children's Museum, Museum Wharf, 300 Congress St., 02210; an outstanding children's museum, with many participatory exhibits on arts and sciences, located in a historic building, shared with the Museum of Transportation, on Boston's picturesque waterfront; open 7 days; hours vary with seasons; closed major holidays; fee; 617 426-6500.

• Museum of Afro-American History, 8 Smith Court, 02114; mailing address, Dudley Station, Box 5, Roxbury, MA, 02119; a fine historical and archival collection located in the 1806 African Meeting House, the oldest extant black church in the U. S.; Sun.–Fri. 11–5; closed Sat., major holidays; small fee; guided tours on the Black Heritage Trail, $5; phone 617 445-7400 for information. (*Note:* the Museum of Fine Arts operates the Museum of the National Center of Afro-American Artists, 300 Walnut St., with works by Afro-American artists; phone 617 442-8014 for information.)

• Boston is tremendously rich in historic monuments, buildings, sites, and areas; the districts of Beacon Hill, with Bulfinch's famous State House and numerous historic houses, from the newly restored and developed area from Faneuil Hall and Quincy Market to the waterfront, are particularly rewarding and interesting; for information on Boston historical sites, the Freedom Trail, and other landmarks, inquire of the Boston Visitors' and Information Center, Tremont and West Sts. (617 426-4984); the Boston and Massachusetts Information Desk, State House, Beacon Hill; the Greater Boston Chamber of Commerce, 125 High St.; and the Greater Boston Convention and Tourist Bureau, 9000 Boylston St.

• The Society for the Preservation of New England Antiquities [SPNEA], 141 Cambridge St., 02114, with headquarters in the first Harrison Gray Otis House designed by Bulfinch, administers historic houses and sites throughout New England, incl. many of the most important examples of early architecture and furnishings extant; as a pioneer in historic preservation and restoration, SPNEA has set an admirable example for other groups across the continent; for information call 617 227-3956; the Otis House contains an important library, archive, and collection of historic objects and materials.

The Brockton Art Museum/Fuller Memorial 1969
Oak St., 02401 (617 588-6000)
Tues.–Sun. 1–5; Sun. 1–6; closed Mon., holidays. No charge (donation accepted)

(Continued on p. 68)

MASSACHUSETTS

BOSTON AREA NORTH
American Arts and History

MILES 0 — 10

BOSTON – ANDOVER, 30 M.
ANDOVER – TOPSFIELD, 15 M.
TOPSFIELD – GLOUCESTER, 25 M.
GLOUCESTER – SALEM, 20 M.
SALEM – BOSTON, 20 M.

N

MERRIMACK R.

ATLANTIC OCEAN

N.H.
MASS.

③ North Andover

Ipswich

② Andover

④ Topsfield

133

⑤ Gloucester

28

⑥ Beverly

127

1A

Reading ①

Salem ⑦

Marblehead

Saugus ⑧

1A

CHARLES R.

Boston

① READING, en route to Andover, Rt. 28, Reading Antiquarian Society Historic House
② ANDOVER
Addison Gallery of American Art
Andover Historical Society
③ NORTH ANDOVER, en route to Topsfield
Merrimack Valley Textile Museum North Andover Historical Society's historic houses
④ TOPSFIELD, Parson Capen House
⑤ GLOUCESTER
Cape Ann Historical Association Hammond Castle Museum
⑥ BEVERLEY, en route to Salem, Rts. 127 & 1A
Beverley Historical Society's historic house
⑦ SALEM, Essex Institute & historic houses
Peabody Museum Salem Maritime National Historic Site
House of the Seven Gables Ropes Mansion
⑧ SAUGUS, en route to Boston
Saugus Ironworks National Historic Site

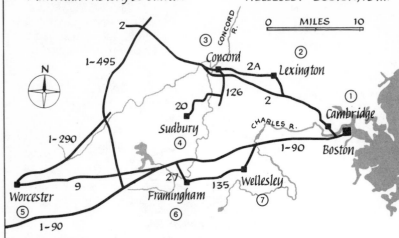

MASSACHUSETTS

BOSTON AREA WEST
General Art
American History & Culture

BOSTON - CAMBRIDGE, 5 M.
CAMBRIDGE - LEXINGTON, 10 M.
LEXINGTON - CONCORD, 7 M.
CONCORD - WORCESTER, 40 M.
WORCESTER - WELLESLEY, 35 M.
WELLESLEY - BOSTON, 15 M.

MILES

N

CONCORD R.

2

3

Concord

2

Lexington

I-495

2A

126

20

2

CHARLES R.

Sudbury

4

I-90

Boston

I-290

1

Cambridge

27

Wellesley

Worcester

9

Framingham

135

7

5

6

I-90

① CAMBRIDGE
Fogg Art Museum Longfellow National Historic Site
(Note: The famous glass flowers are in the Harvard Botanical Museum)

② LEXINGTON
Lexington Historical Society & historic houses
Museum of the American National Heritage Battle Green

③ CONCORD
Concord Antiquarian Society Ralph Waldo Emerson Memorial Association
Thoreau Lyceum Orchard House, home of the Alcott family
Minute Man National Historic Park

④ SUDBURY, en route to Worcester via Rt.126 S to 20, W to Sudbury
Wayside Inn

⑤ WORCESTER
Worcester Art Museum
Higgins Armory Museum Worcester Historical Museum

⑥ FRAMINGHAM
en route to Wellesley, just S of Rt. I-90
Danforth Museum

⑦ WELLESLEY
Wellesley College Museum

palacios

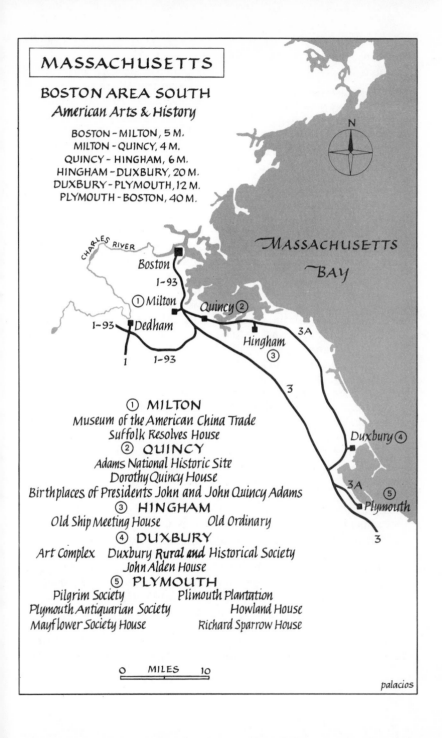

MASSACHUSETTS

BOSTON AREA SOUTH
American Arts & History

BOSTON – MILTON, 5 M.
MILTON – QUINCY, 4 M.
QUINCY – HINGHAM, 6 M.
HINGHAM – DUXBURY, 20 M.
DUXBURY – PLYMOUTH, 12 M.
PLYMOUTH – BOSTON, 40 M.

CHARLES RIVER

Boston
I-93
① Milton
I-93 Dedham
1 I-93

Quincy ②

MASSACHUSETTS
BAY

N

3A

Hingham
③

3

Duxbury ④

3A

⑤
Plymouth

3

① MILTON
Museum of the American China Trade
Suffolk Resolves House
② QUINCY
Adams National Historic Site
Dorothy Quincy House
Birthplaces of Presidents John and John Quincy Adams
③ HINGHAM
Old Ship Meeting House Old Ordinary
④ DUXBURY
Art Complex Duxbury Rural and Historical Society
John Alden House
⑤ PLYMOUTH
Pilgrim Society Plimouth Plantation
Plymouth Antiquarian Society Howland House
Mayflower Society House Richard Sparrow House

0 MILES 10

palacios

A collection of 19th C. American painting; Sandwich glass; special exhibits.

Cambridge: Fogg Art Museum
1891; opened 1895
32 Quincy St., Harvard University, 02138 (617 495-2387)
Mon.-Fri. 9-5; Labor Day-June 30 also open Sat. 10-5; Sun. 2-5; closed holidays. No charge

An outstanding collection, the most comprehensive and largest of any university in the hemisphere, ranging throughout the history of art, ancient to modern, East to West, but esp. strong in drawings and prints of all eras; Romanesque sculpture, Italian Renaissance and pre-Renaissance paintings, French 19th C. painting, Chinese sculpture, stones and bronzes, jades, ceramics; Japanese prints; American painting; also silver and other arts. ☛ A series of carved capitals (c. 1130) from Moûtier-Saint-Jean, fine examples of Burgundian Romanesque; a group of *bozzetti* by Bernini, especially his *Kneeling Angel,* a marvelously fluid and sensitive sketch for a heroic-sized figure for a gilt-bronze altar he sculptured for the Chapel of the Sacrament in St. Peter's in Rome; ★ Lucas van Leyden's delightful and enrapt *Angel* on a hilltop, probably a fragment of a lost *Annunciation to the Shepherds;* sculptured reliefs from Persepolis, suggesting the formality of oriental ritual in the ancient Persian imperial court; the splendid ★ Grace Cup by John Coney (c. 1700), one of the finest pieces of Colonial silver extant.

• Busch-Reisinger Museum, 29 Kirkland St., 02138; 617 495-2338 or 495-2317; Harvard's museum of Germanic culture contains notable works from Central and Northern Europe. esp. medieval, Renaissance, and Baroque objects, with archival material relating to the Bauhaus, the famous art school in Weimar founded in 1919 by architect Walter Gropius and closed by the Nazis; winter, Mon.-Sat. 9-4:45; summer, Mon.-Fri. 9-4:45; closed holidays; fee. (*Note:* The justly famous "Glass Flowers" consisting of the miraculously detailed Blaschka glass models of plants, may be seen in Harvard's Botanical Museum on Oxford St., Mon-Sat. 9-4:30; Sun. 1-4:30; fee except Mon.; closed major holidays; 617 495-2326. The Peabody Museum of Archaeology and Ethnology, 11 Divinity Ave., has fine examples of Native American, Oceanic, and other primitive arts; Mon.-Sat. 9-4:15; Sun. 1-4:15; closed major holidays; fee; 617 495-2248.)

• Francis Russell Hart Nautical Museum, Massachusetts Institute of Technology, 77 Massachusetts Ave., 02139; a maritime collection of models, drawings, prints, photographs, and other material; phone 617 253-4444 for information; no charge.

• Semitic Museum, 6 Divinity Ave., 02138; devoted to Semitic languages and history; materials

from Near Eastern excavation; admission by appointment; for information call 617 495-4631.

Deerfield: Historic Deerfield 1952
The Street, 01342 (413 774-5581)
Mon.-Sat. 9:30-4:30; Sun.
1-4:30; closed major holidays. Fee

A historic village museum of great interest, with a dozen restored and preserved historic buildings, most of which are on original sites; fine collection of furnishings, decorative arts, paintings, silver, pewter, textiles, costumes, ceramics, artifacts; located in the beautiful setting of a tree-lined street with broad lawns in a living village. ☛ The Ashley House (c. 1732), with its vigorous and distinctive Connecticut Valley-style pedimented doorway, fine interiors, esp. the front parlor. (*Note:* The Indian House Memorial, also on Main Street, and the Memorial Hall Association, on Memorial Street, are independent of Historic Deerfield but are a part of the Deerfield scene, as is the charming campus, with historic buildings and the Hilson Gallery, of Deerfield Academy, a fine secondary school founded in 1797.)

Duxbury: Art Complex 1967
189 Alden St., Box 1411, 02332
(617 934-6634)
Fri.-Sun. 2-5; closed Mon.-
Thurs., holidays. No charge

Housed in a modern building designed by artist Ture Bengtz, the collection contains Far Eastern, European, and American paintings; prints; Shaker furniture and artifacts; a Japanese Tea House, where the tea ceremony is performed on occasion during the summer (inquire for schedule): a historic house, the Major Judah Alden House of 1790. (*Note:* The Duxbury Rural and Historical Society, located in the King Caesar House of 1808 [Box 176, Snug Harbor Station, 02332; 617 934-5286] has a varied historical collection; the John Alden House [105 Alden St., 02332; 617 934-2788] was built by John Alden and his third son, Jonathan, in 1653, and is maintained by the descendants of John and Priscilla ["Speak for yourself, John"] Alden; both are open from the last Saturday in June through Labor Day, 1-4, other times by appointment. Duxbury is just a few miles north of Plymouth, a historically very rich area, and can be seen enroute.)

Essex Shipbuilding Museum 1976
Main St., 01929 (617 768-7541)
May-Oct.: Wed., Sat., Sun. 1-4;
closed other days, months of
Nov.-Apr. Fee

A collection of shipbuilding tools, models, artifacts, memorabilia, and photographs related to shipbuilding and local history.

Fall River: Battleship
Massachusetts 1965
Battleship Cove, 02721
(617 678-1100)
Daily 9-5; closed Thanksgiving,
Christmas. Fee

A historic ship museum comprising the battleship *Massachusetts,* the submarine *Lionfish,* and the destroyer *Joseph P. Kennedy, Jr.,* plus a PT Boat museum and library.

Fall River: Marine Museum at Fall River 1968
70 Water St., 02722 (617 674-3533)
Day after Labor Day-June 28:
Mon.-Fri. 9-5; Sat.-Sun. and
holidays 10-5; June 29-Labor Day:
daily 9-8; closed Thanksgiving,
Christmas, New Year's. Fee

Housed in a restored machine shop, the collection documents the history of the Fall River Line, with many models, paintings, posters, prints, photographs, and other memorabilia.

Fitchburg Art Museum 1925
Merriam Parkway, 01420
(617 345-4207)
Sept.-June: Tues.-Sat. 10-5;
Sun. 2-5; closed July-Aug.,
major holidays; phone for
additional hours. No charge

European and American paintings, decorative arts, drawings, and prints, mostly 19th C.; French provincial furniture; ceramics, glass, textiles; sculpture.

Framingham: Danforth Museum 1973
123 Union Ave., 01701
(617 620-0050)
Wed.-Sun. 1-4:30; closed Mon.-
Tues. No charge

A regional fine arts museum and art center housing a small but growing collection comprising late 19th and early 20th C. American paintings; European and American prints; changing exhibits; educational programs.

Gloucester: Cape Ann Historical Association 1876
27 Pleasant St., 01930
(617 283-0455)
June 1-Oct. 1: daily 1-5; Oct.-
May; Wed., Fri.-Sun. 1-5; Thurs.
1-5 and 6-9; closed Mon.-Tues;
closed holidays year round. Fee

In a period house, a wonderful collection of the paintings and drawings of Fitz Hugh Lane, America's greatest marine painter before Winslow Homer; fine examples of antique furniture, ceramics, glass, silver; historic objects, prints. ☛ ★ Admirable Fitz Hugh Lane works, combining a sense of light and atmosphere with a nautical accuracy approved of by his seafaring neighbors ★ The figurehead of the schooner *Diadem,* launched in 1855, in the form of a sea serpent's head, said to be a likeness of the serpent that spent some days in Gloucester Harbor in that year.

Gloucester: Hammond Castle Museum 1931
80 Hesperus Ave., 01930
(617 283-2080)
Apr.-Nov.: Tues.-Sun. 10-4;
Dec.-March: Tues., Thurs.-Sun.
10-4; closed Wed.; closed Mon.
year round except Mon. holidays;
closed Thanksgiving, Christmas,
New Year's. Fee

In a romantic castle designed as his home by John Hayes Hammond, Jr., inventor of electronic systems, a collection of medieval art, American decorative arts, and a unique pipe organ also designed by Hammond and used for concerts.

Grafton: Willard House and Clock Museum 1971
Willard St., 01519 (617 839-3500)
Tues.-Sat. 10-4; Sun. 1-5; holidays 1-4; closed Mon., major holidays. Fee

In the Willard House and original Clock Shop, a collection of clocks made by Benjamin, Simon, Ephraim, and Aaron Willard, with family possessions, tools, artifacts, and an archive.

Harvard: Fruitlands Museum 1914
R.R. 2, Box 87, Prospect Hill Rd., 01451 (617 456-3924)
June-Sept.: Tues.-Sun. 1-5; closed Mon., major holidays, remainder of year. Fee

In the farmhouse occupied by Bronson Alcott and the transcendentalists, a historical collection relating to their utopian experiment; a Shaker House of 1794, with Shaker arts and artifacts; an American Indian museum; a picture gallery, with good Hudson River School paintings and primitive portraits.

Lincoln: De Cordova and Dana Museum and Park 1948
Sandy Pond Rd., 01773
(617 259-8355)
Tues., Thurs. 10-5; Wed. 10-9:30; Sat. 12-5; Sun. 1:30-5; closed Mon., major holidays. Fee

In a castle in a handsomely landscaped park near Concord and Lexington, a contemporary collection, primarily of New England artists, with changing exhibits and an active cultural program.

Milton: Museum of the American China Trade 1964
215 Adams St., 02186
(617 696-1815)
Tues.-Sun. 1-4; closed Mon., holidays. Fee

In a historic house of 1833, a fascinating collection of Far Eastern export arts, ceramics, furniture, paintings, lacquerware, silver; library and archives documenting the China Trade from the Revolution to the turn of the century, incl. a remarkable 19th C. ★ Photograph collection illustrating various aspects of the China Trade, esp. the lives and activities of Americans in the Far East.

Nantucket Historical Association 1894
Old Town Building, Union St., Box 1016, 02554 (617 228-1894)
June 15-Oct. 15; daily (incl. holidays) 10-5; phone for other hours. Fee

A historical collection primarily concerning Nantucket maritime affairs, particularly whaling; paintings, prints, documents, artifacts; library, archive, memorabilia; several historic houses and other buildings; the lightship *Nantucket.*

New Bedford Whaling Museum 1903
18 Johnny Cake Hill, 02740
(617 997-0046)
Mon.-Sat. 9-5; Sun. 1-5; closed major holidays. Fee

Artifacts of all kinds associated with whaling; ship carvings, scrimshaw; paintings, prints, documents; a half-scale model of the *Lagoda,* a whaleship of the 1840s; library and archive.

Newburyport: The Custom House Maritime Museum of Newburyport 1969
25 Water St., 01950
(617 462-8681)
Mon.-Sat. 10-4:30; Sun. 2-5; closed major holidays. Fee

Located in a historic building, the Custom House designed by Robert Mills in 1835, is a collection of arts and artifacts relating to the maritime history of the Merrimac Valley, China Trade, Europe, and the South Seas in the 19th C.; Colonial portraits, decorative arts; the library and memorabilia of Pulitzer Prize-winner John P. Marquand. (*Note:* The Caleb Cushing House

of 1808, 98 High St., with the same hours, fee, has fine Federal furnishings, a sampler collection, and — because Cushing was America's first envoy to China — Far Eastern material.)

Northampton: Smith College Museum of Art 1920
Elm St. at Bedford Terrace, 01063
(413 584-2700, ext. 2236)
During academic year: Tues.-Sat. 11-4:30; Sun. 2-4:30; June weekdays by appointment; July-Sept.: Tues.-Sat. 1-4; closed Mon., major holidays. No charge

A fine general art collection, ranging from ancient to modern and from East to West, but with special strengths in French 19th-20th C. painting; there are fine American paintings from Colonial times to the present, and an unusually rich collection of prints and drawings. ☞ Late Roman portrait head of the *Emperor Gallienus,* 3rd C. A.D. whose remote gaze reflects the increasing inwardness of Early Christian and medieval art; *Old Man Writing by Candlelight* (c. 1627), a fascinating study of light by Terbrugghen, a Utrecht artist who brought Caravaggio's chiaroscuro back to Holland, laying the foundation for the development of Rembrandt; Rodin's *Walking Man* (1911), daringly headless, thus representing Everyman; three of Seurat's studies for The Art Institute of Chicago's great *Sunday*

Afternoon on the Island of La Grande Jatte, esp. that of the woman with the monkey. (*Note:* The Northampton Historical Society [58 Bridge St.; 617 584-6011] administers four historic buildings ranging from the 17th to the 19th C.)

Pittsfield: The Berkshire Museum 1903
39 South St., 01201
(413 443-7171)
Sept.–June: Tues.–Sat. 10–5; Sun. 1–5; July–Aug. also open on Mon. 10–5; closed major holidays. No charge

An art, science, and local history museum, with Old Master paintings, the Spaulding Collection of Chinese art, the Hahn collection of English and American silver. ☛ ★ Patinir's early 16th C. painting of *The Flight into Egypt,* with its lyrical landscape full of delightful detail, and the wood the Holy Family are about to enter suggesting both refuge and possible peril; Bierstadt's *Giant Redwoods,* recording the awesome grandeur of the still untouched primeval forests of California. (*Note:* The Berkshire Athenaeum Public Library [1 Wendell Ave.; 413 442-1559] and the Berkshire County Historical Society, located next to the museum, have memorabilia collections of Herman Melville, author of *Moby Dick,* who lived and worked in the area.)

Pittsfield: Hancock Shaker Village, Shaker Community 1960
Rt. 20, Pittsfield Albany Rd., Box 898, 01202 (413 443-0188)
June–Oct., daily 9:30–5; closed Nov.–May. Fee

A historic village museum, with 18 restored buildings dating back to 1780; Shaker art, artifacts, furniture, crafts; library and archive. ☛ Visit the famous round stone barn.

Plymouth: The Pilgrim Society 1820
75 Court St., 02360
(617 746-1620)
Daily 9:30–4:30; closed major holidays. Fee

Pilgrim Hall, built in 1824 after the design of Alexander Parris for the Pilgrim Society, contains a historical collection of great importance, with examples of 17th C. furniture and furnishings that belonged to the Pilgrims, incl. silver, pewter, arms and armor, portraits, books, and documents. ☛ Medieval-looking flat and decorative *Portrait of Elizabeth Paddy Wensley* (c. 1675), a great rarity because of its early date; the composition is carried out with delicacy and grace, and the attractive though sober likeness has a somewhat ghostly presence because of the timeworn condition of the paint surface; compare with the Freake portraits in Worcester, which are similar in style and date,

and the anon. *Alice Mason* of 1670 (Adams National Historic Site, Quincy), one of the most delightful children's portraits in American art.

Parting Ways: The Museum of Afro-American Ethnohistory
1974
130 Court St. Rear, 02361
(617 746-6028)
Mon.-Fri. 9-9; other times by appointment. No charge

A center for the study of Afro-American history, with a collection of records relating to an early black Plymouth family.

Plymouth: Plimouth Plantation
1947
Warren Ave., Box 1620, 02360
(617 746-1622)
Daily 9-5.

A living history museum, with a reconstruction of the Plymouth Colony as originally built by the Pilgrims in 1627, complete with fortified meetinghouse, houses and gardens, and a full-sized reproduction of the *Mayflower;* there are demonstrations of crafts by costumed guides, who also perform the customary everyday tasks of the early 17th C.; the collections include archaeological artifacts, decorative arts, a library, and an archive. (*Note:* For information regarding the several important and interesting historic houses and other buildings in Plymouth, inquire of the Plymouth Area Chamber of Commerce, 85 Samoset St., 02360, which has illustrated guides containing all necessary practical information; the Visitor Center, N. Park Ave., has similar information; the Plymouth Antiquarian Society, located in the Spooner House [27 North St., 02360; 617 746-9697], administers several historic houses with period furnishings.)

Provincetown Art Association and Museum 1914
460 Commercial St., 02657
(617 487-1750)
Daily 12-4 and 7-10; closed major holidays. Fee

A collection of American paintings, from the 1890s to the present, by artists associated with Provincetown. ☛ Paintings by Charles W. Hawthorne, who conducted a summer art school there during the earlier decades of this century; the beautifully brushed paint surfaces and the reflective mood of his pictures deserve more attention than they often get.

Roxbury: National Center of Afro-American Artists
Roxbury St., John Eliot Sq., 02119 (617 445-7400)
Sun.-Fri. 9-5; closed Sat., major holidays. Fee

Associated with the Museum of the National Center of Afro-American Artists, 300 Walnut Ave., and the Museum of Afro-American History, Smith Court,

of which it is a branch, both in Boston; a collection of tribal objects and paintings by black Americans.

Salem: Essex Institute 1848
132 Essex St., 01970
(617 744-3390)
June 1–Oct. 15: Mon.–Sat.
9–4:30; Sun. and holidays 1–5;
Oct. 16–May 31: Tues.–Sat.
9–4:30; Sun. and holidays 1–5;
closed major holidays. Fee
(inquire about hours and fees at the various historic houses)

A regional history museum, with fine collections of decorative arts and furniture; library and archive pertaining to Essex County history and personalities; the institute administers six historic houses, all of great quality: the John Ward House (1638); the Crowninshield-Bentley House (1727); the Gardner-Pingree House (1805) and the Peirce-Nichols House (1782), both superb designs of Samuel McIntire, with his inimitable carved interior trim; the Assembly House (1782), remodeled by McIntire in 1792; the Andrew-Safford House (1818). ☞ ★ Brick Federal-style house designed and built by McIntire for Captain John Gardner, perhaps the finest work of this distinguished architect, designer, and craftsman, also noted for his fine furniture and, in his own day, as a gifted musician, "a capital performer on the flute"; and Smibert's life-sized, full-length ★ Portrait of the doughty *Sir William Pepperell,* bandy-legged and full of character, pointing to the scene of his victory at Louisburg in 1745, the year of the portrait.

Salem: Peabody Museum of Salem 1799
East India Sq., 01970
(617 745-9500 and 745-1876)
Mon.–Sat. 9–5; Sun. 1–5; closed major holidays. Fee

A uniquely important collection documenting the global voyages of Salem vessels and the worldwide interests of the Salem captains and shipowners; outstanding maritime collections, with ship models, remarkable figureheads, and other ship carvings; art and artifacts of the Pacific Islands, the Far East, and India; paintings, prints, logs, charts, and other documents; decorative arts, furniture; library. ☞ ★ East India Marine Hall, the handsome Classical Revival building of 1824; the formidable Hawaiian war god donated in 1846, an extraordinary work of frightening power; the ★ Cabin furniture and furnishings from *Cleopatra's Barge,* Captain George Crowninshield's famous yacht, all in the McIntire style though made just after his death.

Salem Maritime National Historic Site 1937
Custom House, Derby St., 01970
(617 744-4323)
Daily 8:30–5 except for major holidays. No charge

Located on Salem harbor, once the leading seaport in the Colonies and the early Republic, the Custom House (1819) has a fine McIntire *Eagle* (Nathaniel Hawthorne was Surveyor of the Port in the 1840s); Derby Wharf; the Elias Haskett Derby House; the Hawkes House, designed by McIntire about 1780; plus all the other buildings and equipment necessary for an important and active commercial port of the 18th and early 19th C.

(*Note:* Salem is a marvelously rich historic town; a walk down Chestnut Street, one of the most beautiful residential streets in North America, is a satisfying and exhilarating experience. For information about the many historic houses and other buildings, inquire at the Chamber of Commerce, Hawthorne Blvd. at Washington Sq., or at the Essex Institute. Among the many notable houses are the House of the Seven Gables [1668], 54 Turner St., made famous by Nathaniel Hawthorne's novel of the same name; the Witch House [1642], 310 1/2 Essex St., home of one of the judges at the infamous witchcraft trials of 1692; the Retire Beckett House [1655]; the Hathaway House [1682]; and the Hawthorne House [1750], where the novelist was born in 1804. All are grouped around the House of the Seven Gables. Pioneer Village, a reproduction of the original Salem settlement of 1630, is in Forest River Park on Clifton Ave., Salem Willows, near the junction of Rts. 1A and 129; open daily.)

Sandwich Glass Museum 1907
129 Main St., Box 103, 02563
(617 888-0251)
Apr. 1-Nov. 1, daily 9:30-4:30; closed Nov. 2-March 31. Fee

A collection of American glass, mostly of the type produced in Sandwich.

(*Note:* The Hoxie House, reputed to have been built in 1637, and Dexter's Grist Mill, a working 17th C. mill, are located on Water St., Rt. 130; open daily from mid-June through Sept.; 617 888-1173.)

Sharon: Kendall Whaling Museum 1956
Everett St., Box 297, 02067
(617 784-5642)
Mon.-Fri. 1-4; closed weekends, holidays. Fee

A maritime collection, with emphasis on the history of whaling; ship carvings, mss., prints, paintings. ☛ Handsome figurehead attributed to Samuel McIntire.

South Hadley: Mount Holyoke College Art Museum 1875
College Campus, 01075
(413 538-2245)
Academic year: Mon.-Fri. 11-5; Sat.-Sun. 1-5; summer: Wed.-Sun. 11-4 (closed Mon.-Tues.); closed college vacations, holidays. No charge

A fine, selective, general collection in which all major fields and periods of world art are represented; esp. strong in ancient, medieval, Renaissance, and Far

Eastern art, plus prints and drawings. ☛ Exquisite Greek bronze statuette of a *Standing Youth* (c. 470 B.C.), full of the controlled vitality of Greek art as it entered its greatest period; Inness' superbly spacious landscape of *The Conway Meadows* (1876), the study for which is in Fort Worth; ★ Prendergast's deliciously painted watercolor of a *Festival Day, Venice.* (Hugh Stebbins designed the eminently successful new museum building.)

Springfield: George Walter Vincent Smith Art Museum 1889
222 State St., 01103
(413 733-4214)
Tues. 12–9; Wed.–Sun. 12–5; closed Mon., major holidays. No charge

19th C. American paintings; Far Eastern decorative arts, esp. Japanese arms and armor, lacquerwork, metalwork, jades, ceramics, and paintings. ☛ Works of several Hudson River School painters, esp. Church's brilliant *Scene in the Catskills* (1851).

Springfield: Museum of Fine Arts 1933
49 Chestnut St., 01103
(413 732-6092)
Tues. 12–9; Wed.–Sun. 12–5; closed Mon., holidays. No charge

Situated on a quadrangle shared with the George Walter Vincent Smith Art Museum, the Connecticut Valley Historical Museum, the Springfield City Library, and the Science Museum, the Museum of Fine Arts has a general art collection, with emphasis on European painting and sculpture since the 14th C., American painting since Colonial times, Chinese bronzes and ceramics, Japanese prints, Italian chiaroscuro prints, American prints; decorative arts. ☛ ★ *Historical Monument of the American Republic* (c. 1876), by the American primitive painter Erastus Salisbury Field, a curious and fascinating vision filled with idiosyncratic idealism, painted in commemoration of the hundredth anniversary of American independence at the scale of 9 by 13 feet; Willem Kalf's virtuoso Dutch *Still Life* of the later 17th C., richly detailed and textured; Claude's roughly contemporary *Roman Forum,* full of the romantic atmosphere of a lost golden age.

(*Note:* The Connecticut Valley Historical Museum, next door at 194 State Street, 01103, has interesting period rooms and exhibits of painting, decorative arts, and crafts of the valley; library and archive; Tues. 12–9; Wed.–Sun. 12–5; closed Mon., holidays; no charge; 413 732-3080.)

Sturbridge: Old Sturbridge Village 1938
01566 (off I-86 on US 20)
(617 347-3362)
Apr.–Oct.: daily 9:30–5:30; Nov.–Mar.: Tues.–Sun. 10–4; closed New Year's, Christmas. Fee

A village and living history museum, with outstanding collections of arts and artifacts, tools, crafts, decorative arts, plus more than 100 period buildings of the 18th and 19th C., with working farms, crafts shops, gardens, orchards, fields, and meadows, in which costumed staff members reenact the daily and seasonal activities of early 19th C. New England. ☛ Fine collection of wrought iron in the Blacksmith House; a mid-18th C. painted wall panel from Southbridge containing a portrait of Moses Marcy—decked out in pre-Revolutionary uniform, with cocked hat, holding a generously proportioned wine glass—proudly surrounded by pipe, punch bowl, ledger, house, sailing vessel, and a curiously disinterested bird.

Waltham: American Jewish Historical Society 1892
2 Thornton Rd., 02154
(617 891-8110)
Mon.-Fri. 9–5; Sun. 2–5; closed Sat., national and Jewish holidays; closes early on Fri., Nov.-Mar. No charge

18th C. portraits and memorabilia of American Jewish families; early 20th C. Yiddish theater material; Yiddish motion pictures; ceremonial objects; library; archive.

Waltham: Rose Art Museum
1961
Brandeis University, 415 South St., 02254 (617 647-2402)

A general arts museum housing a selective collection, with special strengths in European and American 20th C. painting and sculpture in the Riverside Museum and Weill collections; the Slosberg Collection of Oceanic art; the Rose Collection of early ceramics; Pre-Columbian, American Indian, and African art. ☛ Collection of Tantric Buddhist arts of Tibet.

The Wellesley College Museum
1883
Jewett Arts Center, Wellesley Campus, 02181
(617 235-0320, ext. 314)
Mon.-Sat. 10–5; Sun. 2–5; closed mid-June–Aug., holidays. No charge

The Arts Center designed by Paul Rudolph contains one of the finest college collections, with special strengths in ancient art, Renaissance sculpture, and Baroque painting; European and American 19th–20th C. painting and sculpture; prints and drawings. ☛ A particularly fine ancient Roman copy of the life-sized marble *Torso of an Athlete* (c. 60 B.C.), which retains much of the controlled dynamism of 5th C. Greek work; the classic Cubist *Mother and Child* of

1921 by Fernand Léger, suggesting a mechanistic "Madonna and Child" for the technological age.

Williamstown: Sterling and Francine Clark Art Institute 1950
225 South St., Box 8, 01267
(413 458-8109)
Tues.–Sun. 10–5; closed Mon., major holidays. No charge

A distinctive and personal collection of great quality and interest; esp. strong in 19th C. French painting and sculpture; outstanding English, Continental, and American silver, incl. several pieces by Paul Revere; very fine drawings and prints from the Renaissance to the early 20th C.; European decorative arts, incl. fine French furniture and Continental porcelain. ☛ Among the small but very distinguished group of Old Masters, ★ Piero della Francesca's *Madonna Enthroned with Angels* (c. 1465), its timelessness enhanced by the architectural geometry of the composition, a characteristic of this rare master; Turner's broadly painted *Rockets and Blue Lights (Close at Hand) to Warn Steamboats of Shoal Water* (1840), showing him to be a precursor of the Impressionists; a group of Degas' tautly modeled bronzes; a wonderful gallery of Renoirs; outstanding Winslow Homers, esp. his late, epic ★ *Eastern Point, Prout's Neck* (1900).

Williamstown: Williams College Museum of Art 1926
Main St., 01267 (413 597-2429)
Academic year: Mon.–Fri. 9–5; Sat.–Sun. 1–5; summer: daily 1–5; closed college and legal holidays. No charge

Housed in Lawrence Hall, a handsome Classical Revival building, built in 1846, a general collection of world art stretches from classical antiquity to the 20th C., the Far East to Europe and America, and incl. Pre-Columbian, Oceanic, and African examples; fine European and American decorative arts; Spanish Renaissance and Baroque painting and furniture; Southeast Asian sculpture; distinctive 18th C. American painting and decorative arts; fine contemporary works in various media. ☛ *The Annunciation* by the 17th C. Spaniard Juan de Valdés Leal of Seville, painted with the agitated emotionalism typical of Iberian Baroque art; a 10th C. Cambodian *Goddess* in red sandstone, its stylization suggesting its original architectural function; the 9th C. B.C. Assyrian reliefs from Nimrud, companions to those in Amherst, Bowdoin, Middlebury, Dartmouth, and Yale.

(*Note:* The Chapin Library of Rare Books, in Stetson Hall, has an outstanding collection, with some fine illuminated mss., Dürer's

Apocalypse series of woodcuts, and other treasures; 413 597-2462.)

Worcester Art Museum 1896
55 Salisbury St., 01608
(617 799-4406)
Tues.-Sat. 10-5; Sun. 2-5;
closed Mon., major holidays.
Fee except Wed.

A fine collection of the arts of the world, tracing artistic developments across 50 centuries in chronologically arranged galleries; particular strengths in ancient art; mosaics from the 1st to the 6th C.; Old Masters; medieval arts; Far Eastern arts; American art since Colonial times. ☛ A life-sized and sensuously modeled Egyptian limestone female torso dating from the 4th Dynasty, with the formal dignity befitting a princess; a 12th C. Romanesque seated ★ *Madonna and Child* from Autun, carved in wood and conveying a hieratic presence; Piero di Cosimo's mischievous fantasy of *The Discovery of Honey* by Bacchus, attended by a rambunctious and disorderly crew of satyrs and others, typical of the work of this quirky and curious Renaissance Florentine painter; the French Romanesque Chapter House of the Priory of St. John from Poitier (1160-75), one of the very few such medieval interiors to be found intact in a New World museum; a remarkable pair of ★ Portraits of *John Freake* and his wife,

Elizabeth, holding their daughter Mary, painted in Boston about 1674 by an anon. artisan of skill and sensitivity though without formal academic training, creating shy but memorable likenesses, echoes from what today seems an unutterably remote past.

Worcester: Higgins Armory Museum 1928
100 Barber Ave., 01606
(617 853-6015)
Tues.-Fri. 9-4; Sat. 11-5; Sun.
1-5; closed Mon., major holidays.
Fee

An outstanding collection of medieval, Renaissance, and Baroque arms and armor; objects and materials pertaining to the armorer's craft, tracing the history of iron and steel work from the earliest times to the present; stained glass, tapestries, paintings, and other works of art.

MICHIGAN

Ann Arbor: The University of Michigan Museum of Art 1946
Alumni Memorial Hall, S. State and S. University Sts., 48109
(313 764-0395)
June 1-Aug. 31: Mon.-Sat. 11-5;
Sun. 1-5; Sept. 1-May 31: Mon.-
Sat. 9-5; Sun. 1-5; closed holidays,
Christmas week. No charge

A fine collection of Western art from the 6th C. to the present; Old Masters, sculpture, decorative

arts; American painting and sculpture from the 18th C. to the present; important collections of Chinese and Japanese art; a strong and growing collection of prints and drawings, with a comprehensive representation of Whistler; Near Eastern ceramics and other objects. ☛ Guercino's *Esther Before Ahasuerus* (1639), a handsome and vigorous example of Italian Baroque painting; compare Philippe de Champaigne's equally handsome *Christ Healing the Deaf-Mute,* showing both the greater classicism of much French painting of the same period and, in its austerity and directness, the artist's identification with Jansenism, an important reform movement within the Catholic Church; a particularly brilliantly illuminated *Shah-namah,* a Persian ms. of the Timurid Period (15th C.) full of exotic fantasies of a mythic past, produced for imperial and court circles.

• Kelsey Museum of Ancient and Mediaeval Archaeology (a part of the university), 434 S. State St., 48109; 313 764-9304; Sept.–June: Mon.–Fri. 9–4; Sat.–Sun. 1–4; July–Aug.: Tues.–Fri. 11–4; Sat.–Sun. 1–4; closed Mon. in summer, university holidays; no charge; important archaeological collections of Roman and Coptic Egypt, Greek and Roman inscriptions, Coptic and Islamic textiles, and Roman sculpture.

• Stearns Collection of Musical Instruments, Stearns Bldg.,

University of Michigan, 2005 Baits Dr., 48109; 313 763-4389 and 764-6527; Wed.–Sun. 1–5 during university sessions; no charge.

Bloomfield Hills: Cranbrook Academy of Art Museum 1927 **500 Lone Pine Rd., Box 801, 48013** (313 645-3312) **Tues.–Sun. 1–5; closed Mon., holidays. Fee**

In a handsomely landscaped setting, with a museum building designed by Eliel Saarinen, a contemporary collection of sculpture, painting, textiles, ceramics, and other crafts. ☛ Sculptures of Carl Milles, esp. his famous *Orpheus Fountain.*

Dearborn: Greenfield Village and Henry Ford Museum 1929 **Oakwood Blvd., 48121** (313 271-1620) **Winter: Mon.–Fri. 9–5; Sat.– Sun., holidays 9–6; summer: daily 9–6; closed Thanksgiving, Christmas, New Year's. Fee**

A Disneyland of Americana, the 14-acre Henry Ford Museum houses tremendous collections of arts, crafts, artifacts, and technology; 100 historic structures of various kinds from the 17th to the 20th C., incl. houses, shops, and mills; demonstrations of crafts and manufactures; a lively program of varied activities, incl. country fairs, parades, antique automobile rallies—you name it! ☛ Extraordinary collections of

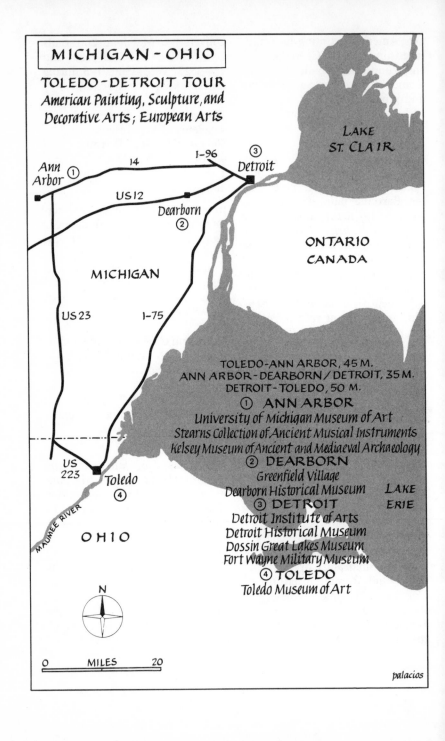

MICHIGAN - OHIO

TOLEDO - DETROIT TOUR
American Painting, Sculpture, and
Decorative Arts ; European Arts

LAKE
ST. CLAIR

Ann
Arbor ①

14

I-96

③
Detroit

US 12

Dearborn
②

ONTARIO
CANADA

MICHIGAN

US 23

I-75

TOLEDO-ANN ARBOR, 45 M.
ANN ARBOR - DEARBORN / DETROIT, 35 M.
DETROIT - TOLEDO, 50 M.
① ANN ARBOR
University of Michigan Museum of Art
Stearns Collection of Ancient Musical Instruments
Kelsey Museum of Ancient and Mediaeval Archaeology
② DEARBORN
Greenfield Village
Dearborn Historical Museum
③ DETROIT
Detroit Institute of Arts
Detroit Historical Museum
Dossin Great Lakes Museum
Fort Wayne Military Museum
④ TOLEDO
Toledo Museum of Art

US
223 Toledo
④

MAUMEE RIVER

OHIO

LAKE
ERIE

N

O MILES 20

palacios

American decorative arts, assembled in such quantities that sequences show stylistic evolution from decade to decade, along with regional and individual makers' variations.

The Detroit Institute of Arts 1885
5200 Woodward Ave., 48202
(313 833-7900)
Tues.-Sun. 9:30-5:30; closed Mon., major holidays. No charge (donation accepted)

An encyclopedic collection of the arts of the world since the earliest times, with outstanding strengths in Old Master paintings, esp. of northern Europe; French 18th C. decorative arts; Renaissance art; the ancient world; American arts since Colonial times; fine prints and drawings; important French-Canadian arts, esp. silver; extensive African art. ☞ Diego Rivera murals incongruously and unexpectedly located in a court of totally beaux arts propriety; Pieter Brueghel the Elder's marvelous *Wedding Dance* (1566), so lively and earthy that you are likely to overlook the beautifully painted surface; Caravaggio's curiously powerful *Conversion of the Magdalen* (1597-98), a moment frozen in time; ★ Jan van Eyck's tiny, miraculous *St. Jerome in His Study* (1442), with a pensive lion sharing the saint's mood; ★ Whistler's famous *Nocturne in Black and Gold: Falling Rocket* (c. 1874), cause of the notorious lawsuit with the critic John Ruskin and a precursor of nonobjective art; ★ Poussin's idyllic vision of *Selene and Endymion* (1635), with Apollo's triumphant chariot of the sun scattering the shades of night.

Dossin Great Lakes Museum 1948
Belle Isle, 48207 (313 267-6440)
Wed.-Sun. 10-5:45; closed Mon., Tues., holidays. No charge (donation accepted)

A maritime museum (a branch of the Detroit Historical Museum, 5401 Woodward Ave., 48202; 313 833-1805) pertaining to shipping on the Great Lakes, with extensive historical collections, incl. decorative arts.

(*Note:* Detroit has a good Children's Museum, located at 67 E. Kirby St., 48202 [313 494-1210; June-Sept., Mon.-Fri. 8:15-4:45; Oct.-May, Mon.-Fri. 8:15-4:45, Sat. 9-4; closed Sun., holidays], with a collection incl. folk arts and natural history, an African Heritage Room, and an active cultural program.)

East Lansing: Kresge Art Center Gallery 1959
Auditorium and Physics Rds., Michigan State University, 48824
(517 355-7631)
Sept. 16-June 14: Mon., Wed.-Fri. 9:30-4:30; Tues. 12-8; Sat.-Sun. 1-4; June 15-Sept. 15: Mon.-Fri. 10-4; Sat.-Sun. 1-4; closed holidays. No charge

A small but growing general collection of art from early times to the present, with examples of European Renaissance and Baroque painting and sculpture, plus American contemporary art; a good collection of prints and drawings from the 16th C. to the present. ☞ Zurbarán's intense and somber *Vision of St. Anthony of Padua* (c. 1630), a fine example of the Spanish Baroque.

Flint Institute of Arts 1928
DeWaters Art Center, 1120 E. Kearsley St., 48503
(313 234-1695)
Tues. 10–5 and 7–9; Wed.–Sat. 10–5; Sun. 1–5; closed Mon., national holidays, evenings in summer. No charge

19th–20th C. European and American painting, sculpture, prints, and drawings; 16th–18th C. European decorative arts; Far Eastern arts; 18th–19th C. Germanic glass; textiles, decorative arts; contemporary graphic arts, photography; American 19th C. furniture and decorative arts. ☞ Cropsey's serene and panoramic *Hudson River View in Summer* (1884); compare with Sisley's Impressionist view, *Lisière d'un Bois en Automne,* painted the previous year yet totally different in vision as well as in style.

Grand Rapids Art Museum 1911
155 N. Division St., 49503
(616 459-4676)

Tues., Thurs.–Sat. 10–5; Wed. 10–9; Sun. 1–5; closed Mon., national holidays. No charge (donation accepted)

Renaissance, French 19th C., American 19th–20th C., and German Expressionist paintings; sculpture; decorative arts; Staffordshire pottery; an extensive collection of prints and drawings since the Renaissance. (*Note:* The museum is in the process of moving its exhibitions from the Greek Revival Pike House (1844) in the Heritage Hill District to the refurbished Beaux Arts Federal Building downtown.)
• Calvin College Center Art Gallery, 1801 East Beltline SE, 49506 (616 949-4000; Mon.–Fri. 9–9; Sat. 10–4; closed Sun., college vacations; no charge) has a collection incl. 17th C. Dutch paintings, 19th C. Dutch drawings; 20th C. European and American prints, drawings, paintings, and sculpture.
• Grand Rapids Public Museum, 54 Jefferson St., 49503 (616 456-3977; Mon.–Fri. 10–5; Sat., Sun., holidays 1–5; closed Christmas; no charge except for planetarium, which is closed in Aug.) has historical collections and historic buildings.

Holland: Baker Furniture Museum 1940
E. Sixth St., 49423 (616 392-8761)
Mon.–Sat., holidays 10–5; Sun. 1–5. Fee

A collection devoted to furniture and furniture design, with examples of European, American, and Far Eastern furniture from the 17th through the 19th C.; decorative arts, carvings; antique tools.

Kalamazoo Institute of Arts 1924
314 S. Park St., 49007
(616 349-7775)
Tues.-Wed. and Fri.-Sat. 10-5;
Thurs. 10-5 and 7-9; Sun. 1-5.
No charge (donation)

In a building designed by Skidmore, Owings & Merrill in 1961, a collection of 20th C. American painting, sculpture, drawings, prints, photographs, and ceramics.
• Kalamazoo Public Museum, 315 S. Rose St., 49007 (616 345-7092; Mon.-Tues., Fri. 9-5:30; Wed.-Thurs. 9-9; Sept.-May, Sun. 2-6; closed Sat., national holidays; no charge) has Far Eastern and Egyptian objects; glass.
• Western Michigan University Art Department, Sangren Hall, 49008 (616 383-6136; Mon.-Fri. 10-5; Sat. 10-12; closed Sun., holidays; no charge) has a growing print collection, with emphasis on print techniques, primarily of contemporary European and American artists.

Muskegon Museum of Art 1911
296 W. Webster St., 49440
(616 722-2600)
Tues.-Sat. 10-5; closed Sun., Mon., holidays. No charge

European and American painting and sculpture, prints, drawings, decorative arts, textiles, photographs; African and Far Eastern art. ☛ Lucas Cranach's portrait of his friend *Martin Luther* (1537), one of several he painted, an interesting document; Edward Hopper's *New York Restaurant* (c. 1922), a fine early example of Hopper's direct, cool, unromantic vision.

Olivet: Armstrong Museum of Art and Archaeology
Olivet College, 49076
(616 749-7000)
Mon.-Fri. 10-4 while college is in session; closed weekends, holidays. No charge

Melanesian and African art; Thai sculpture; 20th C. prints and mss.; American Indian arts; artifacts from Sumeria, Lebanon, and the Philippines.

Saginaw Art Museum 1947
1126 N. Michigan Ave., 48602
(517 754-2491 and 754-2492)
Tues.-Sat. 10-5; Sun. 1-5; closed Mon., holidays. No charge

Old Master and other European painting up to the present; American painting; sculpture, esp. by John Rogers; Far Eastern arts; English silver and porcelain; Japanese prints; etchings by

Charles Adam Platt; textiles and other decorative arts. ☞ Genre sculptures by Rogers, the three-dimensional equivalent of the paintings of Mount and Bingham, and a very interesting technical achievement as well.

MINNESOTA

Duluth: Tweed Museum of Art
1950
2400 Oakland Ave., University of Minnesota, 55812 (218 726-8222)
Mon.-Fri. 8-4:30; Sat.-Sun. 2-5; closed holidays. No charge

French 19th C. painting, esp. the Barbizon School; 19th and early 20th C. American painting; prints and drawings, sculpture, decorative arts. ☞ Commanding bronze by Jacques Lipchitz of *Daniel Greysolon, Sieur du Luth,* founder of the city. (You can't miss it! It's 9 feet tall and effectively guards the entrance.) A fine marine by Homer, *Watching the Sea;* Inness' *Approaching Storm,* in which one can see how effectively he transformed the romantic realism of the Hudson River School into a subjective, emotional expression.

• The St. Louis County Historical Society, 506 W. Michigan St., 55802 (218 722-8011; Mon.-Sat. 10-5, Sun. 1-5; closed holidays; fee) has, among much historical material, paintings by the out-standing American genre painter Eastman Johnson.

The Minneapolis Institute of Arts
1912
2400 Third Ave. S., 55404
(612 870-3046)
**Tues.-Wed. and Fri.-Sat. 10-5; Thurs. 10-9; Sun., holidays 12-5; closed Mon., major holidays.
Fee**

In a McKim, Mead & White building recently imaginatively enlarged by the eminent Japanese architect Kenzo Tangé, an out-standing general collection, with special strengths in European painting from Old Masters to the present; American painting and decorative arts; Pillsbury Collection of Chinese bronzes; Pillsbury–Searle jades; Gale Collection of Japanese prints and paintings; drawings and prints from the 17th C. to the present; European and American period rooms; African, Oceanic, Pre-Columbian, and Native American arts; European and American sculpture and decorative arts; textiles; photographs. ☞ A Shang Dynasty *Tsun in the Form of an Owl* (1st millennium B.C.), a particularly fine example of the superb vigor and extraordinary technical mastery of these early Chinese bronzes; Hogarth's pointed and amusing *Sleeping Congregation* (1728); Rembrandt's poignant *Suicide of Lucretia,* painted in 1666, three years before

his own death; Paul Revere's *Templeman Tea Service* (1792), showing the increasing Classicism then coming into style; Chardin's beautifully painted and composed symbolic still life, *Attributes of the Arts* (1765).

Minneapolis: University Gallery
1934
110 Northrop Memorial Auditorium, University of Minnesota, 84 Church St. SE, 55455
(612 373-3424)
Mon., Wed., Fri. 11–4; Tues., Thurs. 11–8; Sun. 2–5; closed university holidays. No charge

In galleries located on the 3rd and 4th floors of the Northrop Memorial Auditorium, a collection primarily consisting of 20th C. American art; European painting and decorative arts; ancient vases; prints from the 17th C. to present. ☛ Outstanding collections of two American modernists, Marsden Hartley and Alfred H. Maurer.

Minneapolis: Walker Art Center
1879
Vineland Place, 55403
(612 375-7500)
Summer: Tues.–Sat. 10–8; Sun. 11–5; winter: Tues., Thurs.–Sat. 10–5; Wed. 10–8; Sun. 11–5; closed Mon., holidays. No charge

In a handsome plum-colored brick fortress designed by Edward Lar rabee Barnes, in tandem with the Tyrone Guthrie Theater, an outstanding collection of 20th C. world art, esp. strong in sculpture; American 19th C. painting; Far Eastern jades. ☛ *Sky Cathedral Presence* (1951) and a group of other sculptures by Louise Nevelson, one of the most powerful and imaginative of today's leading artists; David Smith's *Cubi IX* (1961) of polished and abraded stainless steel, a brutally commanding work by an artist generally considered a world leader in contemporary sculpture.

• Minneapolis College of Art and Design Gallery, 133 E. 25th St., 55404 (612 870-3285; Mon.–Fri. 9–9; Sat. 9–5; Sun. 12–8; closed holidays; no charge) has a collection, primarily American, of 20th C. paintings, prints, and sculpture.

• WARM, Women's Art Registry of Minnesota, 414 1st Ave. N, 55401 (612 332-5672; Tues.–Fri. 11–4; Sat. 12–5; closed Sun.–Mon.; no charge) has an archive of information on women artists of WPA, of Minnesota, and of the U. S.

Moorhead: Plains Art Museum
1960
521 Main Ave., Box 37, 56560
(218 236-7171)
Wed.–Sat. 10–12 and 1–5; Sun. 1–5; closed Mon., Tues., major holidays. No charge (donation accepted)

African, Oceanic, Pre-Columbian, Eskimo, and North and South American Indian art; Persian glass and ceramics; 19th-20th C. sculptures, paintings, drawings, prints, and photographs.

St. Paul: Minnesota Museum of Art 1927
St. Peter St. at Kellogg Blvd., 55102 (612 224-7431)
Tues.-Fri. 10-5; Sun. 1-5; closed Sat., holidays. No charge

European and American 20th C. drawings and prints; Far Eastern art; African and Northwest Coast Indian art; painting and sculpture; contemporary crafts. ☞ A Japanese *Haniwa Horse* in terracotta (A.D. 350-550) and other interesting Far Eastern objects; outstanding collection of 20th C. American drawings. (*Note:* The permanent collection is installed in an Art Deco building, at the above address. In the museum's Landmark Center galleries, 75 W. 5th St., 55102 [Tues.-Sat. 10-5; Sun. 1-5] changing exhibitions are presented.)
• Hamline University Galleries, Department of Art, 1536 Hewett St., 55104 (612 641-2387 and 641-2800; Mon.-Fri. 8-10; closed weekends, holidays; closed Dec. 15-Jan. 3; no charge) primarily has late 19th and 20th C. paintings, drawings, prints, and sculptures. (*Note:* The Minnesota Historical Society, 690 Cedar St., 55101 [612 296-2747] administers many

historic buildings and sites throughout the state; inquire at above address.)

MISSISSIPPI

Jackson: Mississippi Museum of Art 1911
Pascagoula and Lamar, Box 1330, 39205 (601 960-1515)
Tues.-Thurs., Sat. 10-4; Fri. 10-8; Sun. 11-4; closed Mon., holidays. No charge

19th-20th C. American painting, with emphasis on Mississippi artists; late 18th to early 19th C. British paintings; American Indian baskets; the Lobanov-Rostovsky Collection of theatrical design.

Laurel: Lauren Rogers Library and Museum of Art 1923
Fifth Ave. and 7th St., Box 1108, 39440 (601 428-4875)
Tues.-Sat. 10-12; Sun. 1-5; closed Mon., holidays. No charge

19th-20th C. European and American paintings, prints, sculpture; 18th-19th C. European and American furniture and decorative arts; Gardner Collection of Indian baskets; Georgian silver; oriental artifacts. ☞ Robert Henri's *The Brown Wrap* (1911), an informal portrait by the leader of The Eight (also called the Ash Can School), a fine painter and influential teacher.

University: University Museums
1977
University of Mississippi, 38677
(601 232-7073)
Tues.–Sat. 10–4; Sun. 1–4; closed Mon., national holidays.
No charge

A varied collection, incl. the Robinson Memorial Collection of Greek and Roman pottery; coins and sculpture; architectural fragments and inscriptions; Roman glass; Sumerian clay tablets; Egyptian objects; Southern graphics.

MISSOURI

Columbia: Museum of Art and Archaeology 1957
University of Missouri, 1 Pickard Hall, 65201 (314 882-3591)
Tues.–Sun. 12–5; closed Mon., holidays. No charge

Art and artifacts from the ancient Mediterranean world; South and Southeast Asian sculpture; Chinese and Japanese art; Pre-Columbian, Oceanic, and African art; European and American paintings, drawings, and prints from the 15th C. to the present; Kress Study Collection of Old Masters.
• The State Historical Society, 3 Elmer Ellis Library Bldg., University of Missouri, Hitt and Lowry Sts., 65201 (314 443-3165; Mon.–Fri. 8–4:30; closed weekends, holidays; no charge) has a small collection of American paintings, including George Caleb Bingham's oil painting *Watching the Cargo* (1849), a riverboat scene by one of our foremost genre painters and recorders of life on the frontier.

Kansas City: William Rockhill Nelson Gallery and Atkins Museum of Fine Arts 1933
4525 Oak St., MO 64111
(816 561-4000)
Tues.–Sat. 10–5; Sun. 2–6; closed Mon., major holidays. Fee except on Sundays

In an appropriately handsome building located in a beautifully landscaped park, a splendid collection of the arts of the world, from Sumerian times (3rd millennium B.C.) to the present, East and West, highlighted by the justly world-famous collection of Chinese art, from early bronzes and jades to 19th C. paintings and ceramics; Japanese and other Eastern art; arts of the ancient Mediterranean basin and the Near and Middle East; Western art from the Middle Ages to the present; outstanding American arts; period rooms; decorative arts; prints and drawings; Oceanic, Pre-Columbian, and African art. ☞ A monumental limestone relief of the *Empress and Her Attendants,* Northern Wei Dynasty (c. A.D. 522), from the famous cave temples at Lungmen, Honan, superbly sophisticated and courtly in design (the section

with the emperor is in the Metropolitan Museum of Art in New York City); the impressive *Portrait of Hammurabi,* a head carved in obdurate diorite (c. 2040 B.C.) of the first Babylonian lawgiver; Caravaggio's striking and powerful *St. John the Baptist* (1602–4), showing his disturbing, earthy naturalism and the use of dramatic lighting for expressive effect; ★ Poussin's riotous and decorative painting of *The Triumph of Bacchus,* god of wine, full of pagan as well as vinous spirits, commissioned by that eminent 17th C. French churchman Cardinal Richelieu (*The Triumph of Neptune,* from the same series, is in Philadelphia); ★ Bingham's *Canvasing for a Vote* (1852), a record of frontier politicking, just one of a group of his works.

The Saint Louis Art Museum
1907
Forest Park, 63110
(314 721-0067)
**Tues. 2:30–9:30; Wed.–Sun.
10–5; closed Mon., New Year's,
Christmas. No charge (donation
requested for special exhibitions
except on Tues.)**

A fine general collection, from the ancient Near East to the present, East and West, with greatest strengths in European art, from Old Masters to the 20th C.; the entire range of American painting;

American and European sculpture and decorative arts; outstanding prints and drawings; Oceanic, Pre-Columbian, and African art; arts of the Far and Middle East. ☛ *The Satyr,* a marble statue by Montorsoli, a follower of Michelangelo, carved with such an expert hand that it was long attributed to the master himself; ★ John Greenwood's amusing if scarcely edifying *Sea Captains Carousing in Surinam* (1757–58), in which almost all the rowdy participants are portraits of the artist's friends; Matisse's classic *Bathers with a Turtle* (1908).

**St. Louis: Washington University
Gallery of Art, Steinberg Hall**
1881
**Forsyth and Skinker Campus,
63130** (314 889-5490)
**Mon.–Fri. 10–5; Sat., Sun. 1–5;
closed holidays. No charge**

European paintings from Old Masters to modern; American 19th–20th C. painting, sculpture; prints and drawings; ancient art; decorative arts; coins and medals. ☛ Bingham's famous and much reproduced *Daniel Boone Leading Settlers Through the Cumberland Gap* (1851–52), painted by an artist who lived on the frontier and knew the great wilderness scout; Sanford Gifford's *Rheinstein* (1872–74), a lovely example of American Luminism.

Springfield Art Museum 1946
1111 E. Brookside Dr., 65807
(417 866-2716)
**Sept.–June: Tues.–Wed. and
Fri.–Sat. 9–5; Thurs. 9–5 and
6:30–9; July–Aug.: Tues.–Sat.
9–5; Sun. 1–5; closed holidays.
No charge**

18th–20th C. painting, primarily American; sculpture, drawings, prints, decorative arts; Oceanic, Pre-Columbian, and Native American arts; photography. ☛ A fine, airy, splashy watercolor of an *Oak Tree* (1931) located on the tiny Maine island in Small Point Harbor that John Marin bought with the proceeds from the first sales of his pictures in New York City—to the considerable dismay of his dealer, who thought he should have invested in something more practical.(*Note:* Information about the several historic buildings administered by the state may be obtained from the Division of Parks and Historic Preservation, Missouri Department of Natural Resources, Box 176, Jefferson City, MO 65101.)

MONTANA

**Great Falls: C. M. Russell
Museum** 1953
1201 Fourth Ave. N, 59401
(406 452-7369)

**May 16–Sept. 14: Mon.–Sat.
10–5; Sun. 1–5; Sept. 15–May 15:
Tues.–Sat. 10–5; Sun. 1–5; closed
Mon., major holidays. Fee**

Art of the Old West, with a large group of Russell's paintings and bronzes. (*Note:* The MacKay Collection of Russell's work is housed in the Montana Historical Society, 225 N. Roberts St., Helena, MT, 59601.)

NEBRASKA

**Lincoln: Sheldon Memorial Art
Gallery** 1963
**University of Nebraska, 12th and
R Sts., 68588** (402 472-2461)
**Tues. 10–10; Wed.–Sat. 10–5;
Sun. 2–5; closed Mon., major
holidays. No charge**

In a handsome building designed by Philip Johnson, a collection primarily of American art of the late 19th and 20th C., incl. paintings, sculpture, graphic arts, photographs. ☛ Significant groups of paintings by Robert Henri, Alfred Maurer, Marsden Hartley and, particularly interesting, by Albert Blakelock, a contemporary of Eakins and Homer, a tragic but very gifted painter whose personal, romantic variations on themes in nature paralleled his love of music.

Omaha: Joslyn Art Museum 1931
2200 Dodge St. NE, 68102
(402 342-3300)
Tues.–Sat. 10–5; Sun. 1–5; closed
Mon., holidays. Fee except Sat.
morning.

A varied general collection of world art, with special strengths in European painting since the Renaissance, American painting from Copley to the 20th C., paintings of the Old West and the Indians of the Great Plains; ancient art; sculpture, decorative arts, graphics; Native American art, esp. Aleutian and Eskimo; historical collections. ☛ One of the great Titians, ★ *Man with a Falcon,* painted in the 1530s, a fascinating informal portrait whose subject has been identified as the distinguished Venetian general and diplomat Giorgio Carnaro, beautifully and freely brushed, richly luminous in color, both Olympian and subtle in concept; important collections of paintings of Indians and the Old West by A. J. Miller, Charles Bodmer, George Catlin, and Seth Eastman.

NEW HAMPSHIRE

Canterbury Shaker Village 1961
E of US 93, about 10 m. N of
Concord, 03224 (603 783-9822)
Mid-May to mid-Oct., Tues.–Sat.
9–4. Fee (phone ahead to check
hours and fees)

Founded on a hilltop in 1792 by Elder Clough, a follower of Mother Ann Lee, and restored in recent years, with displays of Shaker arts and crafts in a number of buildings open to the public; like those in Hancock, MA, and Sabbathday Lake, ME, it is still a living Shaker community.

Cornish: Saint-Gaudens National
Historic Site 1926
St.-Gaudens Rd., Cornish
(mailing address: RR 2, Windsor,
VT 05089) (603 675-2175)
End of May–Oct. 31, daily
8:30–4:30. Small fee

In this small Connecticut River Valley town, located about 35 m. S of Hanover, Augustus Saint-Gaudens, one of the leading American sculptors of the turn of the century, had a house and studio where a large collection of his sculptures are preserved, along with all the working apparatus of his very active and productive studio; also contains works of fellow artists of the area.

Hanover: Hood Museum 1769
Dartmouth College, 03755
(603 646-2808)
Open daily; hours vary with
individual gallery units involved.
No charge

In galleries in the handsome Hopkins Center, and in Carpenter and Wilson halls, a varied collec-

tion, strongest in 19th-20th C. European and American arts; Old Masters; Assyrian reliefs from the palace of Ashurnazirpal II at Nimrud (9th C. B.C.; related to those at Amherst, Bowdoin, Middlebury, Williams, University of Vermont, and Yale); Chinese bronzes and ceramics; Pre-Columbian, Oceanic, and African art. ☞ Famous frescoes in Baker Library painted by José Clemente Orozco, the powerful Mexican muralist, from 1932 to 1934; a magnificent silver ★ Monteith (punch bowl with a scalloped edge) made in Boston by Nathaniel Hurd and Daniel Henchman and presented to the college in 1773 by John Wentworth, Colonial governor of New Hampshire and a trustee. (*Note:* Time permitting, you might also wish to inspect Dartmouth's beautiful and historic campus.)

Manchester: The Currier Gallery of Art 1917
192 Orange St., 03104
Tues.-Wed. and Fri.-Sat. 10-4;
Thurs. 10-10; Sun. 2-5; closed
Mon., national holidays.
No charge

A fine, small collection handsomely presented in a Renaissance-style building situated in a garden setting; European arts from the 14th to the 20th C.; American art since Colonial times; important American decorative arts, esp.

silver, pewter, glass, and New Hampshire furniture. ☞ A tapestry from a hunting series woven in Tournai (c. 1500; two others are in the Corcoran Gallery of Art in Washington, D.C.) illustrating the visit of a group of gypsies to the lord and lady of the castle, while the hunt goes on in the background, a superb example of high Gothic design; a memorable series of landscapes that are a delight to compare and contrast: Ruisdael's *Egmond-by-the-Sea* (1648), with the picturesque blasted tree to dramatize the depth of the view; Constable's atmospheric, lovingly observed *Dedham Mill;* Corot's *Grez-sur-Loing,* painted in the 1850s; and, finally, Monet's sparkling *Seine at Bougival* (c. 1870), a painting on the threshold of Impressionism.

NEW JERSEY

Montclair Art Museum 1912
3 S. Mountain Ave., 07042
(201 746-5555)
Sept.-June: Tues.-Sat. 10-5;
Sun. 2-5; closed Mon., major
holidays. No charge

A collection strong in American painting since Colonial times; American Indian art; Far Eastern objects, incl. Japanese prints; European and American drawings and prints; decorative arts, costumes. ☞ ★ Group of paintings by

George Inness, for some time a resident of Montclair, who transformed the Hudson River School tradition into a subjective and personal expression; a portrait that has been identified as a *Self-Portrait* (c. 1728) by John Smibert, the Scottish artist who settled in Boston to become the leading portraitist in America of his generation.

The Newark Museum 1909
49 Washington St., 07101
(201 733-6600)
Daily 12–5; closed major holidays. No charge

A somewhat miscellaneous collection of arts and sciences, with particular strength in American painting from Colonial times to the present, American sculpture and decorative arts, and American folk art; Schaefer Collection of ancient glass; Tibetan collection; African and Oceanic art; Federal and Victorian period rooms; New Jersey arts and crafts. ☛ Hiram Powers' *Greek Slave,* the hit of the famous Crystal Palace Exhibition held in London in 1851 and the most famous sculpture of the period, was also shown in many American cities, incl. Boston, where men and women viewed it on alternate days for modesty's sake because the poor girl was nude! (another version in the Corcoran Gallery of Art); Childe Hassam's *Gloucester,* light and airy, showing the influence of Impressionism in a lightening of the palette, typical of many American painters at the turn of the century.

New Brunswick: Rutgers University Art Gallery 1966
Voorhees Hall, Hamilton St., 08903 (201 932-7237 and 932-7096)
Aug. 16–May 30: Mon.–Tues. and Thurs.–Fri. 10–4:30; Sat.–Sun. 12–5; June 1–Aug. 15: Mon.–Tues. and Thurs.–Fri. 10–4; Sun. 1–4; closed Wed., major holiday weekends; also closed Sat. June 1–Aug. 15. No charge

A collection spanning the history of art, with special strength in 19th C. French and American prints, American painting from Colonial times to the present; 18th–19th C. English painting; sculpture; decorative arts; medieval paintings, tapestries. ☛ Benjamin West's *Rinaldo and Armida* (1766), a delightfully romantic interpretation of an episode from Tasso's epic *Jerusalem Delivered,* showing West's distinctive color and sense of fantasy.

Princeton: The Art Museum 1882
Princeton University, 08544
(609 452-3788)
Academic year: Tues.–Sat. 10–4; Sun. 1–5; Summer: Tues.–Sat. 10–4; Sun. 2–4; closed Mon., holidays. No charge

A distinguished comprehensive collection covering ancient to modern art, East to West, with a

rich representation of classical antiquities, medieval arts, Northern European and Italian Renaissance painting, 18th–19th C. French painting and sculpture, Chinese paintings and bronzes. ☛Medieval stained glass of the *Martyrdom of St. George* (1st half of 13th C.) from Chartres Cathedral, showing the incredible, glowing richness of French glass of this great period; Bosch's nightmarish *Christ Before Pilate,* frightening and unforgettable; an extraordinary group of Classical mosaics; a beautifully painted pair of Chardins displaying the *Attributes of the Architect* and *Attributes of the Painter,* symbolic still lifes by one of the great masters of the 18th C. (*Note:* The Putnam Collection of contemporary monumental sculpture is scattered about the campus; see esp. examples by Calder, Moore, and Nevelson.)

Trenton: New Jersey State Museum 1890
205 W. State St., 08625
(609 292-6300)
Mon.–Fri. 9–4:45; Sat.–Sun., holidays 1–5; closed major holidays. No charge

Collections of art, archeology, cultural history; decorative arts; science and natural history; material relating to New Jersey history; a group of fine 20th C. American and European paintings and sculpture. ☛ A rare and very interesting pair of bronze reliefs by Thomas Eakins of *The Battle of Trenton* and *The American Army Crossing the Delaware* (1892–95), showing that one of our greatest painters was also one of our best sculptors; two mosaic murals by Ben Shahn, plus his complete graphic output, Calder's stabile *The Red Sun,* the model for the tremendous sculpture he did in Mexico City for the Olympic Games.

NEW MEXICO

Albuquerque: Art Museum, The University of New Mexico 1963
Fine Arts Center, 87131
(505 277-4001)
Academic year: Tues.–Fri. 10–5; Sat.–Sun. 1–5; summer: Tues.–Fri. 10–3; Sat.–Sun. 1–5; closed Mon., holidays. No charge

Important collections of 19th–20th C. photographs and prints, with special emphasis on lithography; American painting since the turn of the century, with emphasis on artists who worked in New Mexico; Spanish Colonial arts, incl. silver; sculpture. ☛ Outstanding examples of photographic pioneers of the 19th C.
• Albuquerque Museum, 2000 Mountain Rd., NW, Box 1293, 87103; 505 766-7878; Tues.–Fri. 10–5; Sat.–Sun. 1–5; closed holidays; no charge; historical and arts collections, with emphasis on the Southwest; Native American and Spanish Colonial arts and crafts.

• Maxwell Museum of Anthropology, University of New Mexico, Roma and University NE, 87131; 505 277-4404; Mon.-Fri. 9–4; Sat. 10–4; Sun. 1–5; closed holidays; no charge; fine Southwestern collections, incl. Navajo and other textiles, silver, baskets; Mimbres and Pueblo pottery; musical instruments; Pakistani textiles and jewelry.

Roswell Museum and Art Center
1937
100 W. 11th St., 88201
(505 622-4700)
Mon.-Sat. 9–5; Sun., holidays, 1–5; closed New Year's, Christmas. No charge

American 20th C. paintings; the Witter Binner Collection of Chinese paintings, jades, bronzes, and Pre-Columbian art; Southwest Indian arts; European and American prints; Dr. Robert H. Goddard's rocket collection. ☞ Paintings by Peter Hurd and Henriette Wyeth, his wife; Hurd—landscapist, portrait painter, and printmaker—is the leading artistic interpreter of the West, while Wyeth's poetic vision and distinctive color sense are uniquely her own.

Santa Fe: Museum of Fine Arts
1909
On the Plaza, Box 2087, 87501
(505 827-2351)
Daily 9–4:45; closed Mon., major holidays, mid-Oct.-mid-March. No charge

A varied collection of American art, mostly by 20th C. Indian and Anglo artists associated with New Mexico. ☞ Santa Fe paintings by Robert Henri and John Sloan, both members of The Eight, and by Marsden Hartley and John Marin. (*Note:* The Museum of Fine Arts is a division of the Museum of New Mexico, which also includes the Museum of International Folk Art, 706 Camino Lejo [505 827-2544; open identical hours] and New Mexico State Monuments, about which ask at the Museum of Fine Arts.)

• The Wheelright Museum of the American Indian, 704 Camino Lejo, Box 5153, 87502; 505 982-4636; Nov.-Apr.: Tues.-Sat. 10–5; Sun. 1–5; closed Mon.; May-Oct.: Mon.-Sat. 10–5; Sun. 1–5; closed major holidays; no charge; American Indian arts and artifacts; musical recordings of Navajo ceremonials; reproductions of Navajo sand paintings; textiles, silver. (*Note:* The Wheelright Museum is next door to the Museum of International Folk Art; see above note.)

(*Note:* Santa Fe is a very historic city, with many interesting buildings and sites. See esp. the Palace of the Governors (c. 1610) on the Plaza, which marked the end of the historic Santa Fe trail; the Mission of San Miguel nearby; and the Santuario de Nuestra Senora de Guadalupe, at 100 Guadalupe St., 87532 [505 988-2027; Tues.-Sat.

NEW MEXICO

TAOS – SANTA FE – ALBUQUERQUE TOUR
American Indian Arts and Culture
Spanish Missions and Historic Buildings

TAOS – ESPANOLA, 54 M. ESPANOLA – SANTA FE, 25 M.
SANTA FE – ALBUQUERQUE, 60 M.

① TAOS
Millicent A. Rogers Museum Kit Carson Memorial Foundation
Harwood Foundation of the University of New Mexico
Ranchos de Taos Mission Taos Pueblo is 3 m. N

COLORADO
N.M.

② ESPANOLA
San Juan Pueblo San Ildefonso Pueblo Nambe Pueblo

③ SANTA FE
Institute of American Arts Museum Wheelright Museum
Old Cienega Village Museum Palace of the Governors
Santuario de Nuestra Señora de Guadalupe San Miguel Mission

④ BETWEEN SANTA FE AND ALBUQUERQUE
Santo Domingo Pueblo San Felipe Pueblo
Sandia Pueblo Jemez Pueblo, Zia Pueblo,
and Santa Ana Pueblo are on Rt. 44 NW

⑤ ALBUQUERQUE
Maxwell Museum of Anthropology
San Felipe de Neri Mission and Isleta Pueblo
are on Rt. 47 S
Laguna Pueblo is W on Rts. 40 & 66
Acoma Pueblo is via Rt. 23 S

Taos Pueblo
Taos ①
Ranchos de Taos
RIO GRANDE 68
San Juan Pueblo
Espanola ②
San Ildefonso Pueblo Nambe Pueblo
US 84
Santa Fe ③
I-25
Santo Domingo Pueblo
San Isidro Pueblo Jemez Pueblo
Zia Pueblo 44 ④
Santa Ana Pueblo San Felipe Pueblo
Sandia Pueblo Bernalillo
N
I-40 & US 66 422 ⑤
Laguna Pueblo I-40 Albuquerque
23 San Felipe de Neri Mission
47
Acoma Pueblo Isleta Pueblo

0 MILES 40

9-4; closed Sun.; no charge], built around 1760 by Santa Fe Indians, a handsome and distinguished example of New Mexico architecture. The Barrio de Analco Historic District, De Vargas St. and vicinity, is one of the oldest settled areas in the country, full of houses in the local style, many very old and still occupied by Hispanic-Americans. The "Old Cienega Village" Museum, Rt. 2, Box 214, 87501 [505 471-2261; open the first Sunday of each month from April 1 to Nov. 1, 8-5], a village museum about 10 m. SW on US 85, has many historic buildings.)

Taos: Millicent A. Rogers Museum 1956
Box A, 87571 (505 758-2462)
May 1-Oct. 31: daily 9-5; Nov. 1-Apr. 30: Tues.-Sun. 10-4; closed Mon.; major holidays and San Geronimo Day; fee.

A considerable collection of American Indian arts and artifacts, prehistoric to recent times, with emphasis on the Southwest; the arts of the Hispanic Southwest. • The Harwood Foundation of the University of New Mexico, 25 Ledoux St., Box 766, 87571; 505 758-3063; Mon., Thurs. 10-8; Tues.-Wed., Fri. 10-5; Sat. 10-4; closed major holidays; no charge; works of artists associated with Taos since 1898; Hispanic arts; decorative arts; Indian arts; Persian miniatures. (*Note:* The Stables Gallery, Box 198, 87571

[505 758-2036; daily 10-5 except major holidays and Williams Day, no charge] shows the work of contemporary Taos artists. Taos is also a rich historic center, with many reminders of a colorful past; see esp. the Kit Carson Memorial Foundation, Old Kit Carson Rd., 87571 [505 758-4741; winter: daily 8-5; spring, summer, and fall: daily 8-6; closed major holidays; fee], with several historic buildings, historical and art collections. The very picturesque Taos Pueblo and the Mission of San Geronimo ruins are 3 m. N of town; the pueblo is still inhabited.)

NEW YORK

Albany Institute of History and Art 1791
125 Washington Ave., 12210
(518 463-4478)
Tues.-Sat. 10-4:45; Sun. 2-5; closed Mon., holidays. No charge

An outstanding collection of fine and decorative arts related to Albany and the Hudson River, with a remarkable series of early Hudson River Valley portraits, furniture, silver, and other decorative arts; 19th C. paintings and sculpture; period rooms; library and archive. ☛ Portraits by the Patroon Painters, esp. the full-length painting of ★ *Ariaanje Coeymans* (c. 1723), with its Baroque grand-manner composition borrowed from a European en-

graving and reinterpreted with primitive flatness, with the gaunt figure dressed in her Sunday best and holding a rose; compare with *Mrs. Petrus Vas,* done about the same time but very differently primitive, austerely elegant and very feminine; also *Pau de Wandelaer* (c.1725) a fine group of Hudson River School painters, esp. Thomas Cole's delightful sketches; robust and idiosyncratic Hudson River Valley silver of the Colonial period. (*Note:* The New York State Museum, situated on the colossal Empire State Plaza, 12230 [518 474-5877; daily 10–5 except major holidays; no charge] has historical collections, incl. decorative arts, art of New York artists, Shaker arts and crafts, and American Indian arts. Among historic sites: Cherry Hill, 523 1/2 S. Pearl St., 12202 [518 434-4791; Tues.–Sat. 10–4; Sun. 1–4; closed Mon., major holidays; fee]; the handsome mansion of the patroon Philip van Rensselaer [1787] and the Schuyler Mansion, 27 Clinton St., 12202 [518 474-3953; Wed.–Sun. 9–5; closed Mon., Tues., major holidays, no charge]; the home of General Philip Schuyler [c. 1760]; both have interesting furnishings and interiors. The Schuyler Mansion is but one of the many historic buildings administered by the state through the New York State Office of Parks and Recreation, Division for Historic Preservation, Executive Dept., Agency Bldg. No. 1, Nelson A. Rockefeller Empire State Plaza, 12238 [518 474-0468], where information may be obtained.)

Binghamton: Roberson Center for the Arts and Sciences 1954
30 Front St., 13905
(607 772-0660)
Tues.–Thurs. 10–5; Fri. 10–10; Sat.–Sun. 12–5; closed Mon., major holidays. No charge

A small, diverse art collection, incl. American paintings and decorative arts. ☛ Inness' gently brooding *Autumn Landscape* (1875), reflecting his mystical view of nature.
• The University Art Gallery of the State University of New York at Binghamton, Fine Arts Bldg., SUNY Campus, Vestal Parkway, 13901 (607 798-2634; Mon.–Fri. 9–4:30; Sat.–Sun. 1–4:30; closed university holidays; no charge) has a small collection, incl. the Romano Roman Coin Collection, a Wedgwood collection, the Horne Collection of Chinese art, and modern graphics.

Buffalo: Albright-Knox Art Gallery 1862
1285 Elmwood Ave., 14222
(716 882-8700)
**Tues.–Sat. 10–5; Sun., holidays 12–5; closed Mon., Thanksgiving, Christmas, New Year's.
No charge (donation accepted)**

A large and diverse collection, primarily Western, with outstand-

ing strength in 19th–20th C. American, Latin-American, and European painting and sculpture. ☛ Gauguin's revolutionary *Yellow Christ* (1889) and his haunting ★ *Spirit of the Dead Watching* (1892), full of spine-tingling tension; a gallery of immense Abstract Expressionist canvases by Clyfford Still; a sculpture court in the new wing designed by Gordon Bunshaft of Skidmore, Owings & Merrill.

• Burchfield Center—Western New York Forum for American Art, 1300 Elmwood Ave. (opposite the Albright-Knox Art Gallery), a part of the State University of New York at Buffalo, 14222 (716 878-6011; Mon.–Sat. 10–5; Sun. 1–5; closed holidays; no charge) has a large collection of Charles Burchfield's (1893–1967) works, personal papers, sketches, and designs, plus a growing collection of works and data on artists of western New York; Burchfield's imaginative and visionary watercolors are always well worth seeing.

Canajoharie Library and Art Gallery 1929
Erie Blvd., 13317
(518 673-2314)
Mon.–Wed., Fri. 9:45–4:45; Thurs. 9:30–8:30; Sat. 9:30–1:30; closed Sun., holidays. No charge

A very fine small collection of classic American paintings, ranging from Copley and Stuart to Hopper, Wyeth, and Burchfield. ☛ Group of about 20 Winslow Homers; Eakins' sympathetic and perceptive portrait of *Mrs. M. S. Stokes* (1903), touching and convincing.

Canton: Richard F. Brush Art Gallery of St. Lawrence University 1967
Romoda Dr., 13617
(315 379-6003)
Mon.–Fri. 8–5; closed weekends, college recess, holidays. No charge

A mixed collection, incl. primarily 19th–20th C. American paintings, prints, and sculpture; Old Master prints; folk art; African art; Roman coins; works by Frederic Remington.

Cold Spring Harbor: Whaling Museum Society 1936
Main St., Box 25, 11724
(516 367-3418)
Memorial Day–Labor Day, daily 11–5; closed the rest of the year, major holidays. Fee

Maritime collections, with emphasis on whaling; models, artifacts, scrimshaw; conservation.

Cooperstown: New York State Historical Association 1899
Fenimore House, Lake Rd., 13326
(607 547-2533)
May 1–Oct. 31, daily 9–5; inquire about winter schedule. Fee

An important collection of American painting, sculpture, graphics, and decorative arts, plus

folk art and historical material. ☞ ★ Extraordinary collection of life masks of the founding fathers and other great Americans of the pre–Civil War era by John Henri Isaac Browere (1790–1834), a remarkable gallery that incl. Jefferson and John Adams; ★ *Francis O. Watts with Bird* (1805) a charming children's portrait by John Brewster, Jr., a deaf-mute and itinerant, who painted particularly sympathetic children's portraits; Joseph H. Davis' delightful miniature watercolor of *The Caverly Family of Stafford, New Hampshire* (c. 1836); profile portraits in pastel and mixed media by Ruth Henshaw Bascom, a minister's wife, who took many profiles of her family and friends throughout New England and in the South in the 1830s. (*Note:* The association also administers the Farmers' Museum nearby, and is a center for American studies in a particularly beautiful setting; the Historical Society of Early American Decoration has a collection of decorative arts; inquire at Fenimore House. The National Baseball Hall of Fame is on Main St., Cooperstown; 607 547-9988.)

The Corning Museum of Glass
1951
Corning Glass Center, 14830
(607 937-5371)
Daily 9–5; closed major holidays. Fee

A world center for research in glass, with an outstanding historical collection from the earliest times to the present. (*Note:* Also in the Center, the Corning Glass Company conducts tours and demonstrations of glassblowing and manufacture; phone 607 937-5371 or inquire at museum. The Corning Museum also administers the Rockwell-Corning Museum, located nearby on Baron Steuben Pl., which has painting and sculpture of the Old West.)

Deansboro: Musical Museum
1948
Deansboro, 13328
(315 841-8774)
April 1–Dec. 31, daily 10–5; closed holidays. Fee

A musical-instrument collection, with examples of such mechanical devices as street organs, music boxes, and nickelodeons.

Elmira: Arnot Art Museum 1913
235 Lake St., 14901
(607 734-3697)
Sept. 1–June 30: Tues.–Fri. 10–5; Sat. 9–5; Sun. 2–5; July 1–Aug. 31: Tues.–Fri. 10–5; Sat., Sun. 2–5; closed Mon., national holidays. No charge

A small collection of Old Masters and classic American paintings of real interest, displayed in the Greek Revival house of the museum's founding family. ☞ Claude Lorrain's *Ulysses Discovering Himself to Nausicaa,* a fine example of this important Classical 17th C.

artist; a picturesque Hobbema landscape with a mill; Barbizon painters; Thomas Cole's serene *Autumn in the Catskills* (1827), a lovely example of the work of the founder of the Hudson River School.

Glens Falls: Hyde Collection
1952
161 Warren St., 12801
(518 792-1761)
Feb.–Dec.: Tues.–Wed. and Fri.–Sun. 2–5; other times by appointment; closed Mon., Thurs., month of Jan., holidays. Fee

A small but distinguished collection of Old Masters, European paintings from the 14th to the 20th C., European and American decorative arts, sculpture, drawings; a library of rare books; tapestries. ☛ Outstanding Homer watercolors; ★ Botticelli's enchanting little *Annunciation* of the 1470s, with the lyric choreography of Gabriel's fluttering wings and draperies and Mary's graceful gesture of submissiveness, staged in a Renaissance portico—despite its somewhat damaged condition, one of the loveliest pieces of Florentine 15th C. painting in America; a drawing on tinted paper believed to be a preliminary study for Leonardo da Vinci's portrait of *Mona Lisa,* in the Louvre which was unfortunately so overworked by restorers in the late 19th C. that it is only a ghost of its original self, but fascinating nonetheless because of its relationship to one of the world's greatest artists and most famous paintings; Rubens' luminous oil sketch of a *Negro's Head,* painted in the early 1620s.

Goshen: Hall of Fame of the Trotter 1951
240 Main St., Box 590, 10924
(914 294-6330)
Mon.–Sat. 10–5; Sun. 1:30–5; closed holidays. No charge

Collections, both historical and artistic, pertaining to the trotting horse and racing.

Hamilton: The Picker Art Gallery
1966
Charles A. Dana Creative Arts Center, Colgate University, 13346
(315 824-1000, ext. 632 or 634)
Mon.–Fri. 10–5; Sat.–Sun., holidays 1–5; closed academic recess. No charge

In a building designed in 1966 by Paul Rudolph, a diverse collection of Western art, incl. photography as well as painting, sculpture, prints, drawings; its high point is the Luis de Hoyos Collection of Pre-Columbian art, mostly Guerrero stone sculptures.

Hempstead: Emily Lowe Gallery
1963
Hofstra University, 11550
(516 560-3275 or 560-3276)
Sept.–May: Tues. 10–9; Wed.–Fri. 10–5; Sat.–Sun. 1–5; closed Mon., major holidays. No charge

Collection incl. 15th–20th C. European painting and sculpture; American painting and sculpture; 18th–20th C. prints and drawings; Japanese and Indian sculpture; African, Oceanic, and Pre-Columbian arts.

Huntington: Heckscher Museum
1920
Prime Ave., 11743
(516 351-3250)
Tues.–Fri. 10–5; Sat.–Sun. 1–5; closed Mon., holidays. No charge

A small collection, primarily of Western painting from the 16th through the 20th C., with emphasis on 19th–20th C. American artists, esp. late 19th C. landscapists. ☛ Courbet's *Depth of the Forest,* in saturated greens, painted with the artist's typical rugged brushwork and naturalistic "concern for things seen," in his own words; compare with Eakins' *Cello Player* of a quarter century later, equally concerned with things seen but also with so much more in human terms.

Ithaca: Herbert F. Johnson Museum of Art 1973
Cornell University, 14853
(607 256-6464)
Tues.–Sun. 10–5; closed Mon., major holidays, Christmas recess. No charge

In a handsome and well-situated building designed by I. M. Pei, a varied collection, esp. strong in Far Eastern art, with paintings,

sculptures, and ceramics from China, Japan, Korea, and Southeast Asia; an important print collection, from Old Masters to the present; fine 19th–20th C. European and American drawings; photographs; American 19th–20th C. painting and sculpture. ☛ ★ Daubigny's delightfully fresh *Fields in June* (1874), anticipating something of the Impressionists' immediacy of vision; the superbly carved Japanese *Amida Buddha,* of the late Heian period (901–1185), showing the mastery of wood typical of the best of Japanese sculpture of the classic periods.

Kingston: Senate House State Historic Site 1887
312 Fair St., 12401 (914 338-2786)
Wed.–Sun. 9–5; closed Mon., Tues., major holidays. No charge

In an interesting historic building of the late 17th C., a historical collection, incl. paintings by John Vanderlyn and other artists of the Hudson River Valley, as well as a restored Victorian house.

Mountainville: Storm King Art Center 1960
Old Pleasant Hill Rd., 10953
(914 534-3115)
Mid-May–Oct., Mon., Wed.–Sun. 2–5:30. No charge (donation accepted)

The collection contains paintings, drawings, and prints, but is well known for its monumental con-

temporary sculptures effectively displayed in a parklike setting. ☞ Impressive group of sculptures by David Smith.

New Paltz: College Art Gallery
State University College, 12561
(914 257-2439)
Mon.-Fri. 10-4; Sun. 1-4; closed Sat., university holidays.
No charge

A growing collection comprising 19th-20th C. American paintings and prints; German Expressionist watercolors and prints; Japanese prints and other Far Eastern objects; Pre-Columbian artifacts.
• Huguenot Historical Society, 6 Brodhead Ave., 12561 (914 255-1660; mid-May–Oct. 30: Wed.–Sun. 10-4; closed Mon., Tues., major holidays, remainder of year; fee.) administers 17th, 18th, and early 19th C. historic buildings displaying period furnishings, plus objects and an archive pertaining to the French Huguenot and Dutch settlers of the Hudson River Valley.

New York City: American Craft Museum 1956
44 W. 53rd St., 10019
(212 397-0630)
Tues.-Sat. 10-5; Sun., holidays 11-5; closed Mon., major holidays. Fee

A collection of the work of American craftsmen in various media since the turn of the century; a lively program of changing and traveling exhibitions and publications; a center for information on, and the study of, American crafts.

New York City: American Museum of Natural History 1869
Central Park West at 79th St., 10024 (212 873-1300)
Mon.-Tues. and Thurs.-Fri. 10-4:45; Wed. 10-9; Sat.-Sun., holidays 10-5; closed Thanksgiving, Christmas. Fee

One of the world's greatest museums devoted to natural history, with extraordinary collections of the arts of American Indians, Eskimos, the Pre-Columbian Americas, Oceania, Africa, with esp. rich collections of the remarkable creations of Indians of the Northwest Coast. ☞ Extraordinary painted Tlingit blankets from the Chilkat River area, with symbolic designs of great power and subtlety in black, yellow, and blue; spectacular shamans' headdresses, masks, and helmet masks, esp. ★ Kwakiutl transformation masks, which represent different aspects of the same spirit or different spirits, one contained within another, carved with great boldness and expressing an awesome sense of the supernatural.

New York City: Asia Society Gallery 1956
725 Park Ave., 10021
(212 288-6400)
Tues.-Wed., Fri. 10-5; Thurs. 10-8:30; Sat. 10-5; Sun. 1-5; closed Mon., major holidays, and often between exhibitions (inquire for specific schedule). Fee

In a distinguished new building designed by Edward Larrabee Barnes, the Rockefeller Collection of Far Eastern art is magnificently displayed, along with changing exhibits of differing phases and aspects of Asian art; a remarkable photographic collection and archive.

New York City: The Brooklyn Museum 1823
188 Eastern Pkwy., 11238
(212 638-5000)
Wed.–Sat. 10–5; Sun. 12–5; holidays 1–5; closed Mon., Tues., New Year's, Christmas.
No charge (donation accepted)

One of the great museums of North America, with collections ranging from ancient to modern, East to West. Special strengths in Egyptian and classical arts; Middle Eastern and Far Eastern arts; European and American graphics; and American arts, incl. outstanding paintings, sculpture, decorative arts, and period rooms; Pre-Columbian, African, American Indian, and other primitive arts. ☛ Outdoor sculpture garden containing fragments of architectural decoration from demolished buildings in New York City; remarkable Egyptian galleries; 12 large Assyrian reliefs (c. 880B.C.) in alabaster from Ashurnazirpal II's palace at Nimrud; Hudson River portrait of *John Van Cortlandt* (c. 1730) ★ The Victorian parlor (c.1853) from the Milligan house in Saratoga, delightfully furnished in Rococo Revival style; Eakins'

William Rush Carving the Allegorical Figure of the Schuylkill (1908)—as in Rush's day a century earlier, Eakins' use of nude models in his art classes rocked Philadelphia.

• The Brooklyn Children's Museum, 145 Brooklyn Ave. at St. Mark's Ave., 11213 (212 735-4400; Mon., Wed.–Fri. 1–5; Sat.–Sun., holidays, and school vacations 10–5; closed Tues.; no charge) is the oldest children's museum in the world; housed in a fascinating building, with spectacular participatory exhibits, incl. learning environments, flowing water, and people tubes.

• New Muse Community Museum of Brooklyn, 1530 Bedford Ave., 11213 (212 774-2900; Tues.–Fri., Sun. 2–6; Sat. 10–6; closed Mon., black and national holidays; no charge) is a center for black studies, with an important photographic collection and archive.

New York City: The Cloisters 1938
Fort Tryon Park, 10040
(212 923-3700)
Tues.–Sat. 10–4:45; Sun., holidays 1–4:45; closed Mon.; Sun. and holiday hours, May–Sept., 12–4:45. No charge (donation accepted)

This uptown branch of the Metropolitan Museum of Art is one of the world's great treasure-houses of European medieval art, housed in a modern building sympathetically designed in medieval style, and

containing many parts of ancient structures, on a spectacular site high above the Hudson River. ☛ ★ Series of *Unicorn Tapestries* (c. 1499), a great monument of late medieval art, superb in design and vibrant with freshly observed naturalistic detail; the ★ *Mérode Altarpiece,* (c. 1425), by the outstanding late Gothic Flemish master Robert Campin—full of symbolic detail, from mousetraps and bronze pots to flowers, all orchestrated into a very complex composition, both ideologically as well as pictorially, and consummately realized; various cloisters with their authentic medieval gardens.

New York City: Cooper-Hewitt Museum, The Smithsonian Institution's National Museum of Design 1897
2 E. 91st St., 10028 (212 860-6868)
Tues. 10–9; Wed.–Sat. 10–5; Sun. 12–5; closed Mon., major holidays. Fee except after 5 P.M. on Tues.

Housed in the Carnegie mansion (1901), an extraordinary collection of decorative arts, incl. furniture, wallpaper, fabrics, metalwork, ceramics, drawings, prints, and publications pertaining to design in general and architecture in particular; largest group of Winslow Homer drawings anywhere, plus hundreds of sketches by Frederic Edwin Church and other late 19th C. artists. ☛ Remarkable collec-

tion of architectural drawings, esp. Italian 18th–19th C.

New York City: El Museo del Barrio 1969
1230 Fifth Ave., 10029
(212 831-7272)
Tues.–Sun. 10:30–4:30; closed Mon., holidays. No charge (donation accepted)

A collection pertaining to the culture of Puerto Rico, incl. graphics, paintings, photography, cinema, etc. ☛ Outstanding collection of Puerto Rican santos, carved and polychrome figures from the 18th C. to recent times.

New York City: The Frick Collection 1920
1 E. 70th St., 10021
(212 288-0700)
Sept.–May: Tues.–Sat. 10–6; Sun., holidays 1–6; June–Aug.: Wed.–Sat. 10–6; Sun., holidays 1–6; closed Mon., New Year's, July 4, Thanksgiving, Christmas. Fee (children under 10 not admitted; 10–16 admitted only with an adult)

World-famous Old Master paintings; 17th–18th C. sculpture, decorative arts; prints and drawings; still shown in the handsome house where Henry Clay Frick lived with his collection. ☛ ★ Bellini's *St. Francis in Ecstasy* (c. 1480), with its idyllic sunlit landscape; Piero della Francesca's austere and monumental *St. John the Evangelist,*

another magnificent work of the Italian Renaissance; Duccio's *Temptation of Christ,* full of the elevated spirit and grace of the High Middle Ages in Siena; ★ Rembrandt's mysterious and touchingly youthful *Polish Rider* mounted on his awkward, skeletal horse in a darkling landscape.

New York City: The Grey Art Gallery and Study Center 1958
New York University,
33 Washington Pl., 10003
(212 598-7603)
Tues., Thurs. 10–6:30; Wed.
10–8:30; Fri. 10–5; Sat. 1–5;
closed Sun., Mon., holidays.
Summer, Mon.–Fri. 11–7; closed
Sat., Sun. No charge

20th C. painting, sculpture, drawings, and prints by American and European artists; Grey Collection of contemporary art from the Near and Far East.

New York City: Hispanic Society of America Museum 1904
Broadway at 155th St., 10032
(212 926-2234)
Tues.–Sat. 10–4:30; Sun. 1–4;
closed holidays. No charge

A collection of Iberian arts since prehistoric times, incl. outstanding works by Spain's greatest artists; a large library of Spanish, Portuguese, and Hispanic-American culture and history. ☛ ★ Goya's portrait of the *Duchess of Alba* in black (1797), significantly signed "Goya Alone," which he kept for years as a reminder of his stay with the duchess on her estate in southern Spain; El Greco's ethereal *Holy Family.*

New York City: Jacques Marchais Center of Tibetan Art 1946
338 Lighthouse Ave., Staten Island,
10306; mailing address: 161 E. 91st
St., New York, NY,
10028 (212 987-3478)
April–May, Sept.–Nov., Sat.–Sun.
1–5; June–Aug., Fri.–Sun. 1–5;
other times by appointment; closed
holidays. Fee

One of the largest collections of Tibetan Buddhist art in the West, housed in two stone buildings designed in the style of a Tibetan monastery; also Chinese, Japanese, Nepalese, Indian, and Southeast Asian arts. ☛ Terraced gardens, with lotus pond, overlooking the Lower Bay of New York Harbor.
• The Museum of Archaeology in Staten Island, 631 Howard Ave., 10301 (212 273-3300; Mon.–Thurs. 10–4:30, Sun. 1–4:30; closed Fri., Sat., holidays, month of Aug.; no charge) has a collection of artifacts from the ancient Near East, the Far East, classical antiquity, and the New World.
• The Staten Island Historical Society, 441 Clarke Ave., 10306 (212 351-1611) maintains historic buildings, incl. the Richmondtown Restoration, and historical collections; inquire for hours and charges.

• Sailors' Snug Harbor Cultural Center, 914 Richmond Terrace, with handsome, classical-style buildings (1831) in a parklike setting overlooking the water, is now a cultural center open to the public; 212 448-2500.

New York City: The Jewish Museum 1904
1109 Fifth Ave., 10028
(212 860-1888)
Mon.-Thurs. 12–5; Sun. 11–6; closed Jewish and major national holidays. Fee

A branch of the Jewish Theological Seminary of America, the museum has an extensive collection of ceremonial objects, drawings, paintings, prints, sculpture, textiles, coins and medals, mss., publications, and other Judaica; an active center for the study of and instruction in producing Jewish ceremonial objects. ☞ Treasure of the lost Jewish congregation of Danzig; an Egyptian stone head (c. 1000 B.C.) that once belonged to Sigmund Freud.

New York City: The Metropolitan Museum of Art 1870
Fifth Ave. at 82nd St., 10028
(212 879-5500)
Tues. 10–8:45; Wed.-Sat. 10–4:45; Sun., holidays 11–4:45; closed Mon. Fee

One of the world's greatest treasure-houses of the arts of all periods and cultures, from prehistoric times to the present, with collections so vast that it is impossible to characterize them in any detail. Houses the Temple of Dendur, dating from around the beginning of the Christian era, saved from flooding when the Aswan Dam was built, given by the Egyptian government, reassembled with its pylon as it had stood on the west bank of the Nile; the newly installed American Wing, with remarkable collections, from Colonial times to the present, of painting, sculpture, decorative arts, period rooms, and architectural fragments, all in a handsome setting; the recently completed and superbly realized Astor Court, a recreation of a classic Chinese garden court of the Ming Dynasty, made by Chinese craftsmen of Chinese materials, incl. the nature-sculpted rocks from Lake Tai. ☞ Among individual works (following the order of the museum's excellent *Guide*), ★ Thomas Cole's panoramic *The Oxbow of the Connecticut River Near Northampton* (1836), by the founder of the Hudson River School; his pupil ★ Frederic E. Church's awesome *Heart of the Andes* (1859); ★ George Caleb Bingham's evocative and silent *Fur Traders Descending the Missouri;* glazed brick relief of fierce, *Striding Lions* from 6th C. B.C. Babylon; the beguiling painted wood figure of a *Girl Bearing Offerings* from a 6th Dynasty Egyptian tomb (c. 2050

B.C.); Giotto's masterful little panel of *The Nativity,* early 14th C.; the realistically-detailed *Crucifixion* attributed to Jan van Eyck, the 15th C. founder of the Flemish School; Brueghel's joyous *The Harvesters* (1565); ★ El Greco's only landscape, his eerie *View of Toledo;* Velazquez's portrait of his young Black assistant, *Juan de Pareja* (1650); the Sung Dynasty Chinese painting of *The Tribute Horse;* the 5th C. Greek pot, a calyx-krater, with a painting by Euphronios; the splendid 16th C. illuminated Iranian ms. of the *Shah-nameh,* or the *Book of Kings;* the 12th C. French *Madonna and Child Enthroned* from Auvergne (contrast its austere grandeur with the tender *Madonna and Child* [15th C.] from Poligny in Burgundy); Picasso's powerful portrait of his friend and patron *Gertrude Stein* (1906), the famous American writer who lived in Paris.

New York City: Museum of American Folk Art 1961
49 W. 53rd St., 10019
(212 581-2474)
Wed.–Sun. 10:30–5:30; Tues. 10:30–8; closed major holidays. Fee (no charge after 5:30 on Tues.)

A delightful and lively collection of American folk painting, sculpture, needlework, weaving, and other crafts from Colonial times to the early 20th C., reflecting a variety of cultural traditions; a growing library and archive. ☛ *Gabriel Weathervane* (c. 1840), perhaps from New England, in painted iron, with the angel enthusiastically blowing his horn; a touchingly patriotic and imaginative gate in the form of the American flag, made at the time of the nation's centennial; a painted wood and metal figure of *Father Time,* appropriately hoary-bearded and looking like an Anglo bulto, whose sickle rings a bell—a work of unknown purpose, provenance, and date; a fine group of patchwork and embroidered quilts.

New York City: Museum of the American Indian, Heye Foundation 1916
Broadway at 155th St., 10032
(212 283-2420)
Tues.–Sat. 10–5; Sun. 1–5; closed Mon. and legal holidays. Fee

A tremendous collection of arts and artifacts of Native American cultures, from the Arctic to Tierra del Fuego and from the Atlantic to the Pacific; photographic and other archives, books, mss. ☛ Wampum belt given by William Penn to the Indians in 1683 to solemnize his treaty with them, which allowed the foundation of the colony of Pennsylvania; a pre-17th C. stone figure once owned by Thomas Jefferson; Peruvian weavings (3rd–1st C. B.C.) of extraordinary brilliance and sub-

tlety of color and design, miraculously preserved thanks to dry air and high altitudes.

New York City: Museum of the City of New York 1923
Fifth Ave. at 103rd St., 10029
(212 534-1672)
Tues.–Sat. 10–5; Sun. 1–5; closed Mon., New Year's, Christmas. No charge

A rich and extensive art and history collection reflecting the cultural variety of New York, from its Dutch settlement to the present; 17th–20th C. period rooms; painting, sculpture, prints, drawings; furniture, silver, and other decorative arts; theatre, maritime, and fire-fighting collections; dolls and toys; extensive archive and library. ☛ John Trumbull's sober and solid *Portrait of Alexander Hamilton,* the source of the engraved likeness appearing on 10-dollar bills; Duncan Phyfe Room, with its superlative examples of the handsome and formal furniture designed and made by this admirable early 19th C. New York craftsman, whose taste and quality dominated the field throughout the country for many years; *Figurehead of Andrew Jackson*, carved in 1834 for the USS *Constitution,* "Old Ironsides"; remarkable 10-room dollhouse, with many original paintings in miniature by outstanding artists of the early 20th C., incl. Marcel Duchamps' *Nude Descending a Staircase,* the shocker of the famous Armory Show of 1913.

New York City: The Museum of Modern Art 1929
11 W. 53rd St., 10019
(212 956-6100)
Mon.–Tues. and Fri.–Sun. 11–6; Thurs. 11–9; closed Wed., Christmas. Fee (donation only on Tues.)

The most extensive and representative collection extant, illustrating the course of Western art from Impressionism to the present, incl. architecture, industrial design, and photography, as well as painting, sculpture, drawings, prints, and decorative arts; important library and archive. ☛ Most of the key documents of the development of modern art are here, but note esp. ★ Van Gogh's moving and brilliant *Starry Night*, painted in southern France in 1889, a year before his suicide; Matisse's *Red Studio* (1911), in which the artist records the objects and works in his own studio, thus creating a symbolic self-portrait; Rousseau's haunting *Sleeping Gypsy;* Maillol's marvelously assured, voluminous, and affirmative sculptures in the handsome sculpture garden.

New York City: The New-York Historical Society 1804
170 Central Park West, 10024
(212 873-3400)
Tues.–Fri., Sun. 1–5; Sat. 10–5; closed Mon., holidays. Fee

A remarkably rich collection of American arts and historical objects since Colonial times, with

special reference to New York City and New York State. ☛ Original Audubon watercolors for his extraordinary lifework, the *Birds of America* (1827–38), full of amazing verve and vivid observation; ★ Thomas Cole's allegorical series entitled *The Course of Empire* (1835–36), showing in epic style and extraordinary detail the development of man in five stages, from *The Savage State* and the *Arcadian or Pastoral State* through *The Consummation of Empire* to *Destruction* and final *Desolation,* a Virgilian landscape where, in the words of Bryant's *Thanatopsis,* "the dead reign . . . alone," a memorable expression of the sense of the passage of time and life's brevity that recurs throughout the Romantic movement.

New York City: The Pierpont Morgan Library 1924
29 E. 36th St., 10016
(212 685-0008 and 685-0610)
Sept. 2–July 31: Tues.–Sat.
10:30–5; Sun. 1–5; closed Mon.,
holidays, Sun. in July. Fee

In a Renaissance-style palazzo designed in 1906 by McKim, Mead & White, one of the world's greatest collections of rare books, illuminated mss., Old Master and other drawings and prints, as well as some outstanding paintings, sculptures, and decorative arts; extraordinary incunabula (books printed before 1501), book bindings from late classical times to the present, music mss., and early children's books. ☛ A 10th C. illuminated Beatus *Apocalypse,* with abstract and very expressionistic illustrations in Romanesque style; a 9th C. *Gospel Book* from Rheims, sumptuously inscribed entirely in gold; the *Missal of Abbot Berthold,* an extremely fine 13th C. ms. complete with its original gem-studded binding; the exquisite little *Book of Hours of Catherine of Cleves* of the 15th C., with its jewel-like illuminations; a pair of small *tondo* wedding portraits of Martin and Catherine Luther by Cranach.

New York City: The Solomon R. Guggenheim Museum 1937
1071 Fifth Ave., 10028
(212 860-1300)
Tues. 11–8; Wed.–Sun., holidays
11–5; closed Mon. except
holidays, Christmas; fee except
Tues. evenings 5–8

★ A spectacular building designed by Frank Lloyd Wright houses an important collection of modern art, with special emphasis on the abstract and the nonobjective, including painting, sculpture, drawings, and prints; research library. ☛ Remarkably comprehensive group of paintings by the pioneer modernists Kandinsky and Klee, showing the evolution of Kandinsky's style from the decorative colorism of traditional Russian art to nonobjective Expressionism, and Klee's imaginative adaptations of the styles of primitive painters and children.

111

New York City: The South Street Seaport Museum 1967
203 Front St., 10038
(212 766-9020)
Daily 11–6. Fee for vessels; area, galleries and shops no charge

A complex of buildings, ships, and docks, with restored period buildings and several vessels; maritime and historical collections, models, artifacts, archive. ☛ Impressive square-rigged ship *Wavertree;* four-masted bark *Peking;* the entire complex represents a picturesque restoration of a 19th C. New York City waterfront.

New York City: Whitney Museum of American Art 1930
945 Madison Ave., 10021
(212 570-3600)
Tues. 11–8; Wed.–Sat. 11–6; Sun., holidays 12–6; closed Mon., Christmas. Fee except Tues. 5–8

Housed in a somewhat quirky building designed by Marcel Breuer in 1966, a comprehensive collection of 20th C. American painting, sculpture, drawings, and prints, incl. the contents of the studio, archive, and personal collection of the painter Edward Hopper. ☛ Prendergast's delightful watercolor vision of *Central Park* (1901); Hopper's lonely and evocative oil *Early Sunday Morning* (1930); Stuart Davis' jazzy and lively *The Paris Bit* (1959); Alexander Calder's amusing and playful wire sculpture of *The Brass* *Family* (1929), a swift, linear sketch in three dimensions anticipating his mobiles.
• International Center of Photography, 1130 Fifth Ave., 10028; representative work of 150 internationally recognized 20th C. photographers; Tues. 11–8; Wed.–Sun. 11–5; closed Mon., New Year's, Christmas; fee except Tues. 5–8; 212 860-1777.
• Library and Museum of the Performing Arts, Shelby Cullom Davis Museum, a branch of the New York Public Library, 111 Amsterdam Ave., 10023; archives, documents, tapes, and recordings pertaining to the performing arts; Mon., Thurs. 10–8; Tues., Fri. 10–6; Sat. 12–6; closed Wed., Sun., holidays; no charge; 212 870-1613.
• The Schomburg Center for Research in Black Culture, a branch of the New York Public Library, 515 Lenox Ave., 10037; archive containing documents, photographs, graphics, etc., plus library of black cultural history and creative achievement; Mon.–Wed. 12–8; Thurs.–Sat. 10–6; summer hours may vary; closed Sun., holidays; no charge; 212 862-4000.
• The Ukrainian Museum, 203 Second Ave., 10003; Ukrainian cultural, artistic, and crafts collection; Wed.–Sun. 1–5; closed Mon., Tues., New Year's, Ukrainian Easter, Easter, Thanksgiving, Ukrainian Christmas, Christmas; 212 228-0110.

• Walter Hampden-Edwin Booth Theatre Collection and Library at the Players, 16 Gramercy Pk., 10003; collections pertaining to the stage in America and England; Mon.-Fri. 10-5; closed holidays; no charge; 212 228-7610.

• Yeshiva University Museum, 2520 Amsterdam Ave., 10033; Jewish ceremonial objects, scrolls, mss., photographs, books; Tues.-Thurs. 11-5; Sun. 12-6; otherwise by appointment; closed Jewish holidays, July, Aug.; fee; 212 960-5390, 960-5429, or 960-5268.

Ogdensburg: Remington Art Museum 1923
303 Washington St., 13669
(315 393-2425)
Oct.-May: Mon.-Sat. 10-5; June-Oct.: Mon.-Sat. 10-5; Sun. 1-5; otherwise closed; also closed legal holidays. Fee

Paintings, drawings, prints, archive of Frederick Remington, American painter of the Old West; plus other paintings, decorative arts.

Old Chatham: The Shaker Museum 1950
Shaker Museum Rd., 12136
(518 794-9100)
May-Oct., daily 1-5:30; closed major holidays, Nov.-April. Fee

Historic buildings, Shaker arts, crafts, interiors, archive.

Oneonta: The Museums at Hartwick College 1928
Hartwick College Campus, 13820
(607 432-4200)
Yager Museum, Mon.-Fri. 10-4; Anderson Center for the Arts, Mon.-Fri. 1-4. No charge

Paintings, sculpture, and graphics from the Renaissance to the present; in the Anderson Center, arts and artifacts of Native American cultures of the Americas in the Yager Museum.

Poughkeepsie: Vassar College Art Gallery 1865
Raymond Ave., 12601
(914 452-7000)
Mon.-Sat. 9-5; Sun. 1-5; closed major holidays and college recesses except by appointment. No charge

Medieval-to-modern European painting; American 19th-20th C. painting; Old Master-to-modern prints and drawings; sculpture, decorative arts; classical antiquities; Pratt Collection of Far Eastern art. ☞ Hubert Robert's *Octavian Gate and Fishmarket* (1784), a picturesque souvenir of his 1754 visit to Rome, where in the company of the great printmaker Piranesi and the *veduta* painter Pannini, he explored the city and its environs; a delightful group of paintings of the Hudson River School from Cole onwards; outstanding collections of Rem-

brandt and Dürer prints; Francis Bacon's frightening and anguished *Study for a Portrait of a Pope* (1953).

Purchase: Neuberger Museum
1968
State University of New York at
Purchase, 10577 (914 253-5087)
Tues.-Fri. 10-4; Sat.-Sun. 1-5;
closed holidays. No charge

In a building designed by Philip Johnson in 1972, the Neuberger Collection of 20th C. painting, sculpture, drawings, and prints, primarily American; Rickey Collection of Constructivist art; Hirshberg Collection of African art; 19th C. American painting; art of New Guinea.

Rochester: International Museum
of Photography at George
Eastman House 1949
900 East Ave., 14607
(716 271-3361)
Tues.-Sun. 10-4:30; closed Mon.,
Christmas, New Year's. Fee

A leading collection representing the history of photography from its earliest beginnings to the present; cinema collection; outstanding library and archive.

Rochester: Memorial Art
Gallery 1913
University of Rochester,
490 University Ave., 14607
(716 275-3081)

Tues. 2-9; Wed.-Sat. 10-5; Sun. 1-5; closed Mon., national holidays. Fee except Tues. 5-9

A fine general collection esp. strong in Western art from the Middle Ages to the present, with ancient Near Eastern, Pre-Columbian, African, and Far Eastern arts and classical antiquities well represented; European and American decorative arts. ☛ Handsomely installed medieval collection, with a frescoed apse from a chapel in Auvergne; Pietro Paolini's *Portrait of a Man Holding a Woodcut by Dürer* (1637) showing the artist's preoccupation with perspective, which he shared with Dürer, and the use of an ingenious device of his own invention for ensuring accuracy of projection; ★ Winslow Homer's *Studio in an Afternoon Fog,* painted in Prout's Neck in 1894 when he was at the height of his powers and completing the late, epic sea pieces that are the climax of his art.

• Temple B'rith Kodesh Museum, 2131 Elmwood Ave., 14618; a collection of Judaica; Mon.-Thurs., Sat. 9:30-5; Fri. 9:30 A.M.-10:30 P.M.; Sun. 9:30-12; closed Jewish holidays; no charge.

Southampton: The Parrish Art
Museum 1898
25 Job's Lane, 11968
(516 283-2118)
Tues.-Sat. 10-5; Sun. 1-5; closed
Mon., holidays. No charge

A general collection whose major

strengths are in Western painting from the Renaissance to the 20th C.; Chinese ceramics, Japanese prints, Tibetan tankas (religious paintings on fabric), sculpture, and graphic arts. ☛ The largest public collection of the works of William Merritt Chase, the distinguished late 19th C. American painter whose brilliant bravura style rivaled that of his contemporary, John Singer Sargent.

Stony Brook: The Museums at Stony Brook 1935
Stony Brook, 11790
(516 751-0066)
Wed.–Sun. and most Mon. holidays 10–5; closed other Mon.; closed Tues., Thanksgiving, Christmas, New Year's; special hours for historic buildings. Fee

Collections illustrating many aspects of 19th C. American life, incl. paintings, drawings, prints, decorative arts, costumes, carriages, wildfowling decoys, and historic buildings. ☛ ★ Paintings, drawings, and memorabilia of William Sidney Mount, a leading genre painter of the 19th C., a congenial personality, and a capital fiddler.

Syracuse: Everson Museum of Art of Syracuse and Onondaga County 1896
401 Harrison St., 13202
(315 474-6064)
Tues.–Fri. 12–5; Sat. 10–5; Sun. 12–5; closed Mon., major holidays. No charge

In a spectacular building designed by I. M. Pei in 1968, a predominantly American collection of paintings ranging from the 18th C. to the present; the largest and most varied collection of 20th C. ceramics in this hemisphere; English paintings and ceramics; Far Eastern arts; primitive arts; videotapes; photographs. ☛ ★ A fine example of the innocent, idyllic vision, inspired by Isaiah 11:6, of *The Peaceable Kingdom* by the Quaker painter and preacher Edward Hicks (c. 1840), in which the sober and wondering lion seems to be a kind of symbolic self-portrait; a particularly interesting *Corn Husking* (1860) by Eastman Johnson, one of the most outstanding American genre painters of the 19th C.

Syracuse: University Art Collection 1880
Sims Hall, 13210
(315 423-4097/8)
Tues.–Sun. 12–5; closed Mon. during exhibitions, holidays. No charge

The collection is strongest in 19th–20th C. American painting, sculpture, and graphic arts; African and Indian sculpture, textiles; decorative arts; often displayed in part in the Joe and Emily Lowe Art Gallery, but also exhibited elsewhere on campus and at the Everson Museum (see above).

(*Note:* Syracuse is also the home of the Canal Museum, Weighlock

Bldg., Erie Blvd., E, 13202 [315 471-0593, Mon.-Fri. 12-5; Sat. 10-5; closed Sun., holidays], with interesting exhibits pertaining to the canal system of New York State, and of the Canal Society of New York State, 311 Montgomery St., 13202 [315 422-9948, by appointment]; no charge for either.)

Utica: Munson-Williams-Proctor Institute 1919
310 Genesee St., 13502
(315 797-0000)
Tues.-Sat. 10-5; Sun. 1-5; closed Mon., holidays. No charge

Housed in an austerely handsome Philip Johnson building, a fine collection strongest in 18th-19th C. American painting and 20th C. American and European painting and sculpture; decorative arts; Pre-Columbian, Greek, and Iranian arts; prints and drawings; archive of central New York architecture. ☛ ★ Thomas Cole's famous series of four paintings, *The Voyage of Life* (1839-40) (a second series is in the National Gallery); Arthur B. Davies' lyric *Apennines* (the museum also has two sets of murals by Davies, extraordinarily interesting documents in the evolution of modern art in America because of Davies' leading role in the landmark exhibitions of The Eight in 1908 and the Armory Show of 1913); a very early and rare Copley children's portrait, a youthful and impressive attempt to work in the grand European manner by a wonderfully gifted young Colonial painter; Maillol's ravishingly lovely *Ile-de-France* torso, with a unique gold patination; Mondrian's *Horizontal Tree* and Duchamp-Villon's powerful bronze *Horse,* both important milestones of 20th C. art; ★ Fountain Elms, a unique restored 1850 Italian villa-style house designed by William Woolett, Jr.

Yonkers: The Hudson River Museum 1924
Trevor Park-on-Hudson, 511 Warburton Ave., 10701
(914 963-4550)
Wed.-Sat. 10-5; Sun. 1-5; closed Mon., Tues., holidays. No charge (donation accepted)

A general museum, with art collections strongest in American 19th-20th C. painting, sculpture, graphics, decorative arts, and photography; Red Grooms' amusing environment *The Bookstore* (1979); Dan Flavin's experimental fluorescent light installations. ☛ Hiram Powers' marble *Eve Disconsolate* (1871), a famous work by a sculptor who was considered a world leader in his field.

NORTH CAROLINA

Beaufort: Hampton Mariners Museum 1975
120 Turner St., 28516
(919 728-7317)
Mon.–Fri. 9–5; Sat. 10–5; Sun. 2–5; closed New Year's, Christmas. No charge

A maritime and marine museum, with a collection of ship models, nautical artifacts, and traditional small craft; library and boat shop.

Chapel Hill: The Ackland Art Museum 1958
University of North Carolina, Columbia and Franklin Sts., 27514 (919 966-5736)
Tues.–Sat. 10–5; Sun. 2–6; closed Mon., national holidays. No charge

A general art collection, with European and American paintings, sculptures, and drawings from the Middle Ages through the 20th C.; 15th–20th C. prints; classical antiquities; decorative arts; photographs. ☛ An impressive Greek female head of the 2nd C. B.C., an extraordinarily rare life-sized bronze; two outstanding examples of Florentine Mannerism of the 16th C., Bronzino's painting of *The Madonna and Child with St. John* (esp. interesting because its unfinished state reveals his method). ★ A terra-cotta *bozzetto* by Giovanni da Bologna showing the river god on the Oceanus fountain in the Boboli Gardens in Florence, a very stylish and ani-mated work by the leading sculptor of the period; Degas' *Spanish Dancer,* one of the three sculptures cast in bronze during the artist's lifetime.

Charlotte: The Mint Museum of Art 1933
501 Hempstead Pl., Box 6011, 28207 (704 334-9723)
Tues.–Fri. 10–5; Sat.–Sun. 2–5; closed Mon., holidays. No charge

Housed in the first U. S. branch mint (1835), an art collection emphasizing painting, sculpture, and decorative arts since the Renaissance, esp. 18th C. English and 19th–20th C. European and American painting; a ceramic collection surveying the development of this art from ancient Chinese times to the late 18th C.; Pre-Columbian and African art; coins and mint artifacts. ☛ A *sacra conversazione,* Ridolfo Ghirlandaio's *Madonna and Child with Four Saints* (c.1515), a *tondo* with a fine Renaissance landscape providing a handsome setting for the sculpturally realized group of figures, a work typical of the Florentine tradition; *Agriculture Aided by Arts and Commerce*, painted by the American Benjamin West for the lodge at Windsor used by Queen Charlotte, George III's consort, after whom the city was named; an 18th C. sedan chair designed by the famous Scottish Classical Revival architects Robert and James Adam.

Durham: Duke University Museum of Art 1968
Box 6877, College Station, 27708
(919 684-5135)
Mon.-Fri. 9-5; Sat. 10-1; Sun. 2-5; closed national holidays. No charge

Medieval and Renaissance sculpture and decorative arts; Renaissance and later bronzes; classical antiquities; Far Eastern art; Pre-Columbian and African sculpture; Peruvian textiles; Navajo rugs; the complete wood engravings after Winslow Homer for *Harper's Weekly.* ☞ ★ *A 13th C. Head of the Virgin* from the relief of *The Adoration of the Magi* on the rood screen of Chartres Cathedral, a remarkable, typical, and fine work; an exceedingly rare Pre-Columbian fresco fragment of a *Singing Quetzal Bird* (A.D. 400–600) from Teotihuacán, Mexico, in near-mint condition.

• Museum of Art, North Carolina Central University, Box 19555, 27707 (919 683-6211; Tues.-Fri. 9-5, Sun. 2-5; closed Sat., Mon., and holidays; no charge) has a collection of 20th C. art emphasizing the work of minority American artists, predominantly black; African and Oceanic art.

Greensboro: Weatherspoon Art Gallery 1942
University of North Carolina, McIver Bldg., Walker Ave., 27412
(919 379-5770)

Tues.-Fri. 10-5; Sat.-Sun. 2-6; closed Mon., university holidays and vacations. No charge

A predominantly 20th C. collection of painting, sculpture, and graphic art, plus oriental and ethnographic art; Cone Collection of bronzes and prints by Matisse and his contemporaries; Dillard Collection of American works on paper. ☞ Louise Nevelson's *East River Cityscape* (1965), made of painted wood, a good, early example of her imaginative and personal style; a sculpture court with a fine bronze by Saul Baizerman, a pioneering modern sculptor whose monumental forms hammered in huge copper sheets are impressive and should be better known.

• Heritage Center, North Carolina Agricultural and Technical State University, 27411 (919 379-7874; Mon.-Fri. 9-5; otherwise by appointment; no charge) has a collection of arts and crafts from more than 30 African nations, as well as New Guinea and Haiti.

Hickory: The Hickory Museum of Art 1944
3rd St. and 1st Ave., NW, 28601
(704 327-8576)
Mon.-Fri. 10-5; Sun. 3-5; closed Sat., major holidays, month of Aug. No charge

Though the collection contains examples of European art since the Renaissance, as well as South American and Far Eastern works,

its strength is in 19th-20th C. American painting, with outstanding examples by members of the Hudson River School and later painters influenced by Impressionism. ☛ A fine Luminist canvas by Kensett, *Landscape with Mountains*, serene and spacious; a *Pastoral Scene* by Durand, carefully observed, lovingly detailed, firmly painted, and, like the Kensett, far from today's troubled world.

Raleigh: North Carolina Museum of Art 1956
107 E. Morgan St., 27611
(919 733-7568)
Tues.–Sat. 10–5; Sun. 2–6; closed Mon., holidays. No charge

In a brand new building designed by Edward Durrell Stone, a collection of European and American painting, sculpture, and decorative arts; ancient, Pre-Columbian, and African art; Kress Collection of Old Masters; North Carolina Collection. ☛ *The Peruzzi Altarpiece* (c. 1330) by Giotto and his assistants, a rare and very important work from the hand and workshop of one of the world's greatest masters, who changed the course of Western art; Raphael's *St. Jerome Punishing the Heretic Sabinian*, a small but significant panel from the hand and studio of another great Italian master; a group of works by Rubens, incl. a violently active *Bear Hunt* that

looks forward to Géricault and Delacroix; a fine Raeburn portrait of *Major General Andrew Hay* (a portrait of the general's charming wife is in Omaha); a rugged and atmospheric Ruisdael, *Wooded Landscape with a Waterfall;* a superbly crafted bronze *Neptune* by Benvenuto Cellini, the famous Mannerist sculptor and goldsmith, best described in his scandalous and highly entertaining *Autobiography*. (*Note:* The North Carolina Division of Archives and History, 109 E. Jones St., 27611 [919 733-7305] administers historic sites, houses, and other buildings throughout the state, many with fine furnishings and interesting historical collections; phone or write for information.)

Wilmington: USS *North Carolina* Battleship Memorial 1961
Cape Fear River on Eagles Island, 28401; mailing address: Box 417, 28402 (919 762-1829)
Winter: daily 8–sunset; summer: daily 8–8. Fee

The famous battlewagon and objects pertaining to World War II.

Winston-Salem: Old Salem 1950
Drawer F, Salem Station, 27108
(919 723-3688)
Mon.–Sat. 9:30–4:30; Sun. 1:30–4:30; closed Christmas. Fee

A beautifully restored and lived-in Moravian town, founded in 1766,

consisting of 18th and early 19th C. houses and other buildings, incl. shops, plus the Museum of Early Southern Decorative Arts, 924 S. Main St., 27101 (919 722-6148; same hours), with 15 beautifully furnished period rooms dating from the 17th C. through 1820, and five galleries showing arts and crafts, incl. silver, pewter, and other metalwork, paintings, textiles, and historic artifacts. ☛ The Single Brothers' House (1771), a picturesque example of central European architecture, looking very much at home in its delightful village setting; the kitchen of the Salem Tavern (1784) must be one of the most attractive and inviting 18th C. rooms extant; in the museum there are four pastel portraits by Henrietta Johnston (c. 1715-17), America's first known woman artist; a charming *View of Charles Town* (1774) by the Charlestonian Thomas Leitch; and the painstakingly executed interiors of the period rooms; the village itself is a delight to explore and experience.

Winston-Salem: Reynolda House 1964
Reynolda Rd., Box 11765, 27106
(919 725-5325)
Tues.-Sat., holidays 9:30-4:30;
Sun. 1:30-4:30; closed Mon.,
Thanksgiving, Christmas, New
Year's. Fee

In the former house, surrounded by gardens, of R.J. Reynolds, founder of the Reynolds Tobacco Company, a small but fine collection of American art, primarily paintings, from the 18th C. to the present. ☛ Thomas Cole's *Home in the Woods* (1847), reflecting the Hudson River School's pantheistic feeling for nature; a fine work by Frederic E. Church (Cole's only pupil), *The Andes of Ecuador* (1855), panoramic in vision, spacious, and airy; compare it with the more sketchily handled *Old Hunting Grounds* (1864) by Worthington Whittredge, another very accomplished member of the school.

OHIO

Akron Art Museum 1920
70 E. Market St., 44308
(216 376-9185)
Tues.-Fri. 12-5; Sat. 9-5; Sun.
1-5; closed Mon., holidays.
No charge

A collection of Western art, primarily 20th C. American and European painting, shown in a newly renovated former post office, an Italian Renaissance-style turn-of-the-century building successfully redesigned by architect Peter van Dijk.

Cambridge: Degenhart Paperweight and Glass Museum 1978
Off Rt. 22 at intersection of I-77;
mailing address: Box 112, 43725
(614 432-2626)
Apr.-Oct.: Mon.-Sat. 9-5; Sun.
1-5; Nov., Mar.: Fri.-Sat. 10-4;
Sun. 1-4; Dec., Feb.: Sat. 10-4;
Sun. 1-4; closed major holidays
and month of Jan. Fee

A collection of 19th–20th C. American glass. (*Note*: The Cambridge Glass Museum, 812 Jefferson Ave., 43725 [614 432-3054; Mon.–Sat. 1–4; fee] has a collection of over 4,000 pieces of Cambridge glass.)

The Canton Art Institute 1935
1001 Market Ave., N, 44702
(216 453-7666)
Tues.–Thurs. 9–5 and 7–9; Fri.–Sat. 9–5; Sun. 2–5; closed Mon., Thanksgiving, Christmas, New Year's. No charge

American, Italian, and Spanish painting; 18th–19th C. English and American portraits; American 20th C. art; sculpture, decorative arts, graphic arts; stereographs and other photographs. ☞ One of a number of Bertholdi's *bozzetti* for *The Statue of Liberty* in New York Harbor; a delightful painting of *The Arch, Washington Square, New York*, by William Glackens, a member of The Eight who exhibited in the memorable exhibition at the Macbeth Gallery in 1908.

Cincinnati Art Museum 1881
Eden Park, 45202
(513 721-4204)
Tues.–Sat. 10–5; Sun. 1–5; closed Mon., major holidays. Fee except Sat.

One of the major museums, with a comprehensive general collection of great distinction, ranging in time from the ancient Near East to the present and in space from the Far East to the New World (both hemispheres); esp. strong in Near Eastern and American arts, medieval art, Old Masters, drawings and prints, and musical instruments. ☞ An Egyptian New Kingdom (1567–1085 B.C.) bronze *Lioness* with rock crystal eyes, a superb example of Egyptian naturalism; a wild mixture of Greek and Near Eastern elements in the Nabataean limestone figure (8th–7th B.C.) of *Zeus-Hadad* from Jordan; Darius the Great's gold *Libation Bowl* (522–485 B.C.); an austere and impressive French Romanesque ★ *Madonna* (c. 1130) on painted wood; the famous Nuremberg Amati (1619), a viola made by Nicolò Amati, teacher of Stradivari and Guarnieri; a gallery full of Gainsboroughs, incl. *The Cottage Door* and a delightful tiny *Gypsy Scene*; a notable group of ★Corots, with views of *Mantes* and the Huguenot port city of *La Rochelle;* Titian's *Philip II of Spain* (c.1560), showing the freer handling typical of his mature style (compare it with Velazquez's masterful *Philip IV,* painted three quarters of a century later—both superlative paintings, full of verve, marvelously controlled; or with Goya's diabolically revealing portrait in the Taft Museum, of the dissolute harridan *Queen Maria Luisa* (c. 1799); Cincinnati has an admirable display of Spanish painting; Grant Wood's stinging satire *Daughters of Revolution,* as smug and superior, if more morally virtuous, than Goya's queen.

Cincinnati: The Taft Museum
1932
316 Pike St., 45202
(513 241-0343)
Mon.-Sat. 10–5; Sun., holidays
2–5; closed Thanksgiving,
Christmas. No charge

In the handsome Martin Baum House of 1820, the former home of Nicholas Longworth and later of the Charles Phelps Tafts, a small but fine and varied collection of decorative arts of both the East and the West, European paintings, and fine American furnishings. ☞ A ruggedly picturesque and breezy Hobbema, *Landscape with Cattle and Figures* (contrast it with Gainsborough's 18th C. treatment of the same subject); de Hooch's *Music Lesson* (compare the Cincinati Art Museum's attractive outdoor *Game of Skittles*— another painting of the same subject is in St. Louis); three fine Turners; spectacular Renaissance jewelry and Chinese porcelains; an admirably designed garden largely laid out by Nicholas Longworth, colorful politician, loyal booster of his city, and patron of the famous American Neoclassic sculptor Hiram Powers.

• The Hebrew Union College Gallery of Art and Artifacts, 3101 Clifton Ave., 45220 (513 221-1875; Mon.–Fri. 11–4; Sun. 2–4; no charge; closed Jewish and national holidays) has a collection of Jewish ceremonial objects and other Judaica.

Cleveland Museum of Art 1913
11150 East Blvd., 44106
(216 421-7340)
Tues., Thurs.-Fri. 10–6; Wed.
10–10; Sat. 9–5; Sun. 1–6; closed
Mon., major holidays. No charge

A great collection reflecting the cultural expression of the world's major civilizations, arranged in chronological order, with one of the finest Far Eastern collections anywhere, outstanding medieval art, classical antiquities, Old Masters and later American arts from Colonial times to the present; fine drawings and prints; decorative arts. ☞ ★ Early Christian marbles telling the story of *Jonah and the Whale* in four episodes; the ★ Guelph Treasure of medieval objects, incl. the marvelous *Gertrudis Portable Altar* (c. 1040), a masterpiece of goldsmithwork presented by Countess Gertrude to the cathedral of St. Blasius in Brunswick, Lower Saxony; Zurbarán's curious *Holy House of Nazareth* (c. 1630), with its strange, bleak lighting, mysterious spiritual overtones, and magical still-life detail; Caravaggio's brutally dramatic *Crucifixion of St. Andrew*, painted a few years earlier, showing the combination of naturalism and chiaroscuro that profoundly influenced the subsequent course of Western art; John Singleton Copley's tense and direct portrait of his friend, Boston silversmith *Nathaniel Hurd* (c. 1765); Albert Pinkham Ryder's

haunting vision of *Death on a Pale Horse* (c. 1910); the fabulously rare and beautiful Chinese lacquered wood *Cranes and Serpents* (Period of the Warring States 481-221 B.C.) from the tombs at Ch'ang-sha; the South Indian ★ *Shiva Nataraja, Lord of the Dance* (Chola Period, c. A.D. 1000), who performs his cosmic dance within a flaming mandorla in a lordly, almost arrogant affirmation of life, a sculpture in copper patinated by time and earth chemistry to a rich green.

• St. Mary's Ethnic Museum, 3256 Warren Rd., 44111 (216 941-5550; Mon.-Fri. 8:30-4:30; Sun. 10-1; closed Sat., holidays; no charge) has a collection of Romanian folk art.

• The Salvador Dali Museum in Beechwood, 24050 Commerce Park Rd., 44122 (216 464-0372; Tues.-Sat. 10-12; 1-4; closed Sun., Mon., legal holidays; no charge) has a collection of some 50 oils, a large group of drawings, watercolors, and prints, plus other material relating to the famous Spanish Surrealist.

Columbus Museum of Art 1878
480 E. Broad St., 43215
(614 221-6801)
Tues., Thurs., Fri., Sun. 11-5; Wed. 11-8:30; Sat. 10-5; closed Mon., major holidays. Fee except Tues.

Primarily a collection of 16th-20th C. European and 19th-20th C.

American art, with a growing collection of Far Eastern ceramics and modern sculpture; medieval decorative arts; Old Masters; a gallery of paintings by native Columbian George Bellows. ☞ Fine group of Marins, Demuths, and Prendergasts; Rubens' great—and very large—altarpiece *Christ Triumphant Over Sin and Death* (1618) is a glorious piece of painting entirely by the artist's own hand; Élisabeth Vigée-Lebrun's charming portrait of *Varvara Ivanovna Narishkine* (1800), painted during her 5-year stay in Russia, shows her sitter in Neoclassic costume, then the latest fashion.

Dayton Art Institute 1919
Forest and Riverview Aves., 45401
(513 223-5277)
Tues.-Fri., Sun. 12-5; Sat. 9-5; closed Mon., holidays. No charge

In a handsome, Renaissance-style building, with arcaded courtyards, recalling 16th C. palaces in Italy, a collection of Far Eastern, Indian, and Pre-Columbian art, Old Masters, and a growing American collection: Native American, Oceanic, and African art. ☞ A fine bronze depicting *Parvati* (Chola Period, A.D. 850-1310), consort of Shiva (who dances so magnificently at the Cleveland Museum of Art), herself in a symbolic dance posture; an awesome Chimu *Mummy Mask* (c. 1100-1400), in hammered gold, from Peru; a fine Italian Baroque canvas by Mattia

Preti, an artist rarely found in New World collections, of *The Empress Faustina Visiting St. Catherine of Alexandria in Prison* (c. 1645-50); a fascinating Monet painting of *Water Lilies* (1903), anticipating the very large and important studies of his last years, which link him with environmental aspects of recent modernism.

Newark: National Heisey Glass Museum 1973
6th and Church Sts., Box 27, 43055 (614 345-2932)
March-Dec.: Tues.-Sun. 1-4; closed Mon.; Jan.-Feb.: Wed., Sat.-Sun. 1-4; closed Mon.-Tues.; closed holidays. Fee

A collection devoted to the productions of A. E. Heisey & Company glassware.

Oberlin: Allen Memorial Art Museum 1917
Oberlin College, Lorain and Main Sts., 44074 (216 775-8665)
Write or phone for museum bulletin listing hours, schedule of events. No charge

The original Cass Gilbert building, designed in Renaissance style and added to twice, contains a fine college collection representing major periods of world art, with strengths in Northern European painting, Old Master prints, Spanish painting, and French 19th C. art; a Kress Collection of 15th and 16th C. Italian art; 20th C. art. ☞ An untypically romantic Courbet, *Castle of Chillon, Evening;* Benjamin West's informal little cabinet portrait of *General Kosciusko* (1797), the Polish patriot who fought with the Americans in the Revolution; Cézanne's solidly constructed *Viaduct at L'Estaque* (c. 1882), showing him in the process of evolving the geometric style that led to Cubism; a Joseph Cornell box, *Phases of the Moon,* done in the late 1950s, a fine example of the cryptic but always interesting work of a very gifted and individualistic American experimenter.

Oxford: Miami University Art Museum 1978
Patterson Ave., 45056 (513 529-2232)
Tues.-Sun. 12-5; closed Mon., national and university holidays. No charge

Ancient, Islamic, African, and Pre-Columbian art; Gandaran sculpture; European and American decorative arts; Old Master-to-modern prints; 20th C. American painting, sculpture, and graphic arts.

The Toledo Museum of Art 1901
2445 Monroe St., Box 1013, 43697 (419 255-8000)
Tues.-Sat. 9-5; Sun. 12-5; closed Mon., holidays. No charge

A fine collection of Old Masters, incl. paintings and prints; medieval arts; Spanish and French paintings; European decorative arts and period rooms; American art; one of the greatest collections of glass in the world, ranging from

ancient times to the present, housed in a special installation—a museum within a museum—and expertly displayed. ☞ ★ Thomas Cole's romantic *The Architect's Dream* (1840), a proto-Surrealist architectural fantasy by the founder of the Hudson River School; ★ Van Gogh's glowing *Wheat Field* (1888); fine Islamic glass and a Spanish Toledo flagon (c. 1500); an absolutely splendid and glowing Rubens, *The Crowning of St. Catherine* (1633).

Wooster: College of Wooster Art Museum 1930
E. University St., 44691
(216 264-1234, ext. 388)
Mon.–Fri. 9–12 and 1–4:30; Sun. 2–5; closed Sat., major holidays, June 16–Sept. 14. No charge

A fine collection of European and American prints, ranging from the Renaissance to the 20th C., formed by the distinguished American etcher John Taylor Arms; Persian decorative arts; Chinese paintings and bronzes; African sculpture; pottery from the ancient Near East.

Youngstown: The Butler Institute of American Art 1919
524 Wick Ave., 44502
(216 743-1711)
Tues.–Sat. 11–4; Sun. 12–4; closed Mon., major holidays. No charge

In an Italianate building designed by McKim, Mead & White in 1919, an extensive and varied American collection from Colonial times to the present, with ceramics, prints, Native American arts, watercolors, and drawings. ☞ Compare Joseph Badger's stiff and naive portrait of *Mrs. Daniel Rea* (1750) with Copley's portrait of her, with a child, painted 7 years later, an early work that nevertheless shows his growing power and vision; Winslow Homer's *Snap the Whip* (1872), a landmark in American genre painting; ★ Whistler's beautiful *Thames from Battersea Bridge,* painted in his inimitable poetic style.

OKLAHOMA

Anadarko: Southern Plains Indian Museum and Crafts Center 1947
Highway 62 E, Box 749, 73005
(405 247-6221)
Oct.–May: Tues.–Sat. 9–5; Sun. 1–5; closed Mon.; June–Sept.: Mon.–Sat. 9–5; Sun. 1–5; closed major holidays. No charge

Historic and contemporary arts and crafts of the tribes of the Southern Plains.

Bartlesville: Woolaroc Museum 1929
State Highway 123 (mailing address: Rt. 3, 74003)
(918 336-6747)
Apr. 1–Oct. 31: daily 10–5; Nov. 1–Mar. 31: Tues.–Sun. 10–5; closed Mon., Thanksgiving, Christmas. No charge

In a large wildlife preserve where buffalo, deer, and cattle roam, a collection of art and artifacts of the American Indians ranging from prehistoric to modern times; paintings and other objects pertaining to the Old West; the Colt-Patterson Gun Collection. ☞ Frederic Remington's dramatic *The Last Stand* (1890), an icon of the spirit of the Old West.

Canton: Cheyenne and Arapaho Museum and Archives 1977
Box 19B, Star Rt., 73772
(405 886-3479)
Mon.-Fri. 10-5; Sat.-Sun. 12-5; closed holidays. No charge

Historical collections and records relating to these Indian tribes.

Claremore: J. M. Davis Gun Museum 1965
Fifth and Highway 66 (mailing address: Box 966, 74017)
(918 341-5707)
Mon.-Sat. 8:30-5; Sun. 1-5; closed Thanksgiving, Christmas. No charge

A mixed historical and regional collection, with firearms and other weapons, Indian artifacts, objects of the Old West, and sculptures by John Rogers.

Muskogee: Five Civilized Tribes Museum 1966
Agency Hill on Honor Heights Dr., 74401 (918 683-1701)
Mon.-Sat. 10-5; Sun. 1-5; closed major holidays. Small fee

Arts, artifacts, photographs, documents, and books relating to the Cherokee, Choctaw, Chickasaw, Creek, and Seminole tribes.

Norman: Museum of Art 1936
University of Oklahoma, 410 W. Boyd St., 73019 (405-325-3272)
Tues.-Fri. 10-4; Sat. 10-1; Sun. 1-4; closed Mon., legal and university holidays. No charge

A collection incl. mostly 20th C. American and European art; primitive and Far Eastern art; prints, photographs, and sculpture.

Oklahoma City: National Cowboy Hall of Fame and Western Heritage Center 1955
1700 N.E. 63rd St., 73111
(405 478-2250)
Labor Day-Memorial Day: daily 9:30-5:30; Memorial Day-Labor Day: 8:30-6; closed Thanksgiving, Christmas, New Year's. Fee

Among many other features, a good collection of artists who worked in the West, with paintings, drawings, and sculptures by Remington and Russell, and artists associated with Taos, plus others.
• Oklahoma Art Center, Fair Park, 3113 Pershing Blvd., 73107 (405 946-4477. Art Center: Tues.-Sat. 10-5;, Sun. 1-5; closed Mon., holidays; call for hours of branch buildings; fee) has a collection of American paintings, drawings, prints, and decorative arts, incl. Early American glass.

• Oklahoma Museum of Art, 7316 Nichols Rd., 73120 (405 840-2759; Tues.-Sat. 10-5; Sun. 1-5; closed Mon., major holidays; fee) has a collection of European and American art slanted toward realism and naturalism, plus tapestries, furnishings, ceramics, and graphic arts. (*Note:* The Oklahoma Historical Society, Historical Bldg., 73105 [405 521-2491] administers many historic sites, buildings, and branch museums throughout the state; phone or write for specific information. Additional American Indian collections may be seen in: Ponca City Cultural Center Museum, 1000 E. Grand, 74601 [405 765-6123], with artifacts of the Ponca, Kaw, Otoe, Asage, and Tonkawa tribes; in Stroud, at the Sac and Fox Tribal Museum, Rt. 2, Box 246, 74079 [918 968-3526]; in Tahlequah, at the Cherokee National Historical Society, Cherokee Heritage Center, Box 515, 74464 [918 456-6007]; and in Wewoka, at the Seminole Nation Museum, 524 S. Wewoka Ave., 74884 [405 257-5580].)

Tulsa: Philbrook Art Center 1938
2727 S. Rockford Rd., Box 52510, 74152 (918 749-7941)
Tues.-Sat. 10-5; Sun. 1-5; closed Mon., holidays. Fee

In an Italianate Renaissance-style palazzo, a varied collection, incl. the Kress gift of Italian 14th-18th C. paintings and sculptures; the Clubb Collection, containing more Old Masters as well as paintings by

Americans; paintings and sculptures of the Old West; fine and select Native American arts, ancient to modern; and contemporary Indian art; ancient and classical art; Far Eastern art; Southeast Asian ceramics; African sculpture; and European and American decorative arts. ☛ ★ A wide-eyed *Bishop-Saint Blessing* by the delightful Venetian Renaissance painter Vittore Carpaccio; Thomas Moran's wildly romantic, dramatic, and immense machine entitled *The Spirit of the Indian,* executed in the late 19th C.

Tulsa: Thomas Gilcrease Institute of American History and Art
1942
1400 North 25 West Ave., 74127 (918 581-5311)
Mon.-Sat. 9-5; Sun., holidays 1-5; closed Christmas. No charge

An extraordinary collection, formed with great vigor and imagination by Thomas Gilcrease (who was part Cree Indian) to celebrate the epic of America from prehistoric to modern times, with works of art in all media, plus mss., maps, books, documents, and artifacts so numerous that a new system of computerized cataloguing has been devised to make the wealth of material accessible; the classic artists of the Old West are represented more fully than anywhere except the Smithsonian Institution; the great Americans form a small national

portrait gallery; Native American arts from the entire Western Hemisphere. ☛ Audubon's *Wild Turkey,* a symbol of the wilderness; a *Self-Portrait* (1825) by George Catlin, who gave up a law career to devote his life to painting the appearance and folkways of the American Indians; ★ Thomas Eakins' impressive portrait of *Frank Hamilton Cushing* (1895), who was a student of Indian lore; Cortez's proclamation of the Spanish conquest of Mexico; Columbus' letter to his son from the New World; General Joseph Warren's hasty note to his friend Paul Revere instructing him to take his famous ride.

• World Museum/Art Center, 1440 E. Skelly Dr., Box 7572, 74105 (918 743-6231; daily 10–6; closed Christmas; fee) has a general collection incl. European and American painting and sculpture, Oceanic and African art, Far Eastern and Southeast Asian art, and prints; a photographic archive of Indian chiefs; decorative arts, plus miscellaneous objects.

OREGON

Astoria: Columbia River Maritime Museum 1962
1788 Marine Dr., 97103
(503 325-2323)
**May–Sept.: daily 10:30–5; Oct.–
Apr.: Tues.–Sun. 10:30–4:30;
closed Mon., Thanksgiving,
Christmas. Fee**

A nautical collection containing models, navigational instruments, small craft, paintings, prints, and photographs.

Eugene: Museum of Art 1930
University of Oregon, 97403
(503 686-3027)
**Tues.–Sun. 12–5; closed Mon.,
mid–Aug. to late Sept., university
and major holidays. No charge**

A strong collection of Far Eastern art and the arts of the entire Pacific basin; contemporary European and American painting, sculpture, graphic arts, decorative arts; Persian miniatures; African art; Syrian glass; contemporary artists of the Pacific Northwest. ☛ A collection of the works of Morris Graves. ★ Spectacular *Imperial Jade Memorial Pagoda,* commissioned in 1709 by the Emperor K'ang Hsi to celebrate the birth of his son, the future Emperor Ch'ien Lung, a work made of moss-in-snow jade, with 80 wind bells, and measuring 70 inches high.

• Butler Museum of American Indian Art, 1155 W. 1st St., 97402 (503 345-7055; Tues.–Sat. 10–5; closed Mon., major holidays; fee) has a considerable collection of Native American arts representing the 9 cultural areas of North America (Southwest, California, Northwest Coast, Eskimo and Athabascan, Plateau, Great Basin, Plains, Woodlands, and Southeast).

Portland Art Museum 1892
1219 S.W. Park Ave., 97205
(503 226-2811)
**Tues., Sat.–Sun. 12–5; Wed., Fri.
12–10; closed Mon., national
holidays. No charge (donation
accepted)**

Distinguished Native American arts from the Northwest; Pre-Columbian arts and art of the Camaroons, unique in America; Kress Collection of Renaissance painting and sculpture; Far Eastern art; European and American painting and sculpture; Ethiopian crosses; classical antiquities; prints and drawings. ☛ A *Standing Horse* in wood, a pre-Han (before 206 B.C.) Chinese tomb figure, is wonderfully preserved; a Tlingit *Wolf Hat* from Juneau, made of carved and painted wood, a superb sculpture; Renoir's sparkling *Seine at Argenteuil* (1873); two charming small Fragonards. ★ A brilliant still life by the 17th C. Dutchman Willem Kalf, one of the greatest masters of the genre.

PENNSYLVANIA

Allentown Art Museum 1959
**Fifth and Court Sts., Box 117,
18105** (215 432-4333)
**Sept.–May 5: Tues.–Sat. 10–5;
Sun. 1–5; May 6–Sept. 15:
Tues.–Sat. 10–4; Sun. 1–5; closed
Mon., holidays. No charge**

Kress Collection of Renaissance and Baroque paintings and sculpture from Italy, Holland, and Germany; 19th–20th C. American paintings and prints; a fine period room, the library of a Frank Lloyd Wright house (1914) from Minneapolis, the last of Wright's Prairie-style houses. ☛ Lucas Cranach's authoritative portrait of *The Elector George of Saxony,* very Northern in its naturalistic detail; Frans Hals' bravura *Young Fisherman,* with its slashing brushwork and beautifully sketched background vista of figures on a shore, with sailboats in the breezy distance; ★ Canaletto's lovely *View of the Piazzetta, Venice,* with the slanting light of late afternoon casting long shadows across the pavement and glowing on the pink-and-white marble facade of the Doges' Palace, an 18th C. vision of the Venice of Casanova, Goldoni, and Pergolesi; Michener Collection, 20th C. American paintings.

**Bethlehem: Lehigh University Art
Galleries** 1864
**Ralph Wilson Gallery (Alumni
Memorial Bldg.) and DuBois
Gallery (Maginnes Hall), 18015**
(215 861-3615)
**Wilson Gallery: Mon.–Fri. 9–5;
Sat. 9–12; Sun. 2–5; DuBois
Gallery: normal academic hours
Mon.–Sat.; closed national
holidays, Sun. during academic
vacations and summer. No charge**

Since the collection rotates between the two galleries, there is a

great deal to see; 18th–20th C. American and French paintings and 18th–19th C. English painting; European and American prints; Chinese porcelains; Etruscan bronzes; photographs.

(*Note:* Historic Bethlehem, 510 Main St., 18018 [215 691-5300] administers a number of historic sites and properties containing historic artifacts; the Moravian Museum of Bethlehem, 66 W. Church St., 18018 [215 867-0173] also has collections of historic artifacts pertaining to the Moravians; inquire for hours and fees.)

Chadds Ford: Brandywine River Museum 1971
Box 141, Rt. 1, 19317
(215 388-7601 or 459-1900)
Daily 9:30–4:30; closed Christmas. Fee

Housed in ★ Hoffman's Mill (1864) on the Brandywine River, a collection of American paintings, drawings, and prints by artists associated with this picturesque region, notably the well-known illustrators, Howard Pyle and N. C. Wyeth, plus Andrew and James Wyeth. ☞ N. C. Wyeth's vigorous and tremendously successful illustrations for such classics as *Treasure Island, Kidnapped, The Last of the Mohicans, King Arthur,* and *Robin Hood.*

Columbia: Museum of the National Association of Watch and Clock Collectors 1971
514 Poplar St., Box 33, 17512
(717 684-8261)

Mon.–Fri. 9–4; Sat. 9–5; closed Sun., holidays. Fee

A horological collection illustrating timekeeping from the sundial to the atomic clock; Beeler escapement collection; library, archive, and file of patents.

Greensburg: The Westmoreland County Museum of Art 1949
221 N. Main St., 15601
(412 837-1500)
Tues.–Sat. 10–5; Sun. 1–5; closed Mon., holidays. No charge

18th–20th C. American paintings, drawings, prints, sculpture, and decorative arts; 18th–19th C. Pennsylvania folk art; four Victorian period rooms, two 18th C. English paneled rooms; 18th–19th C. European paintings and drawings, plus modern European prints; American and European toys from the 19th to the mid-20th C.

Loretto: Southern Alleghenies Museum of Art 1975
Saint Francis College Mall, Box 8, 15940 (814 472-6400)
Tues.–Fri. 9:30–4:30; Sat.–Sun. 1:30–5:30; closed Mon., holidays. No charge

In an ingeniously remodeled gymnasium, a permanent collection of 19th–20th C. American art is displayed in its entirety from December through February and only partially the rest of the year, when changing exhibitions are staged. ☞ A fine early Cassatt, *The*

130

Somber One (1872), an oil painted not long after she had gone to Paris to study, showing her pre-Impressionist manner.

Merion: Barnes Foundation 1922
300 N. Latch's Lane at Lapsley
Rd., Box 128, Merion Station,
19066 (215 667-0290)
Fri.-Sat. 9:30-4:30; Sun. 1-4:30.
Fee (*Note:* Visitors without reservations are limited to 100 persons on Fri. and Sat. and 50 on Sun.; children under 12 not admitted, those between 12 and 15 admitted only with an adult; phone or write for reservations, allowing enough time for mailed reply)

An extraordinary collection formed by the terrible-tempered Dr. Albert Barnes, of Argyrol fame, under the advice of his boyhood friend William Glackens, the distinguished American painter and member of The Eight; included are Old Masters, 19th-20th C. European and American painters; Chinese, Persian, classical, Egyptian, Middle Eastern, Native American, and African art; decorative arts, incl. fine wrought iron; marvelous drawings and prints—all still shown as Barnes arranged them, stacked to the ceilings in unexpected combinations. ☛ ★ Matisse's monumental mural of *The Dance II* (1932-33) (*Dance I,* completed a year earlier, is in the Museé de l'art moderne in Paris; for Matisse the subject seems almost that of the dance of Siva, the dance of life, which recurs in his

work); a comparison of Cézanne's *Nudes in a Landscape* with Matisse's *Joie de Vivre* will point up the profound difference in temperament between these two great French masters, though they share a basically classical approach; Van Gogh's *Postman Roulin,* painted in pulsating brushstrokes; note how distinctively the mosaic-like paintings of Maurice Prendergast hold their own in very proud company, and observe the captivating quality of the rarely seen work of his brother, Charles; enjoy the unlikely but stimulating juxtapositions effected by Dr. Barnes throughout—it is quite an experience!

• The Buten Museum of Wedgwood, 246 N. Bowman Ave., 19066 (215 664-6601; Oct.-June: Tues.-Thurs. 2-5; Sat. 10-1; or by appointment; fee) has a comprehensive collection of Wedgwood, plus other English wares, dating from 1759 to the present; there are 10,000 examples of Wedgwood alone.

Philadelphia: Pennsylvania
Academy of the Fine Arts 1805
Broad and Cherry Sts., 19102
(215 972-7600)
Tues.-Sat. 10-5; Sun. 1-5; closed
Mon., Thanksgiving, Christmas,
New Year's. Fee

In a picturesque and very handsome ★ Victorian building designed in 1876 by Frank Furness for the Philadelphia Centennial, a remarkable collection of American art from the 18th C. to the

present, with major examples by each artist. ☛ ★ Charles Willson Peale's *The Artist in His Museum* (1822), in which he displayed the first habitat groups and the mastodon he exhumed himself (also a *Self-Portrait,* done two years later, showing his interest in trompe l'oeil effects); a *Self-Portrait* in terra-cotta by William Rush (c. 1822), the first American sculptor of distinction, whose figureheads were world-famous (his other works are in the Philadelphia Museum of Art); Thomas Eakins' *Portrait of Walt Whitman* (1887), who remarked that "Tom painted me as I really am"; Benjamin West's famous *William Penn's Treaty with the Indians* (1778), which appears in so many backgrounds of Hicks' primitive and endearing versions of *The Peaceable Kingdom* (compare with West's later *Death on a Pale Horse* (1817, executed in his fully developed and wildly dramatic Romantic style); Homer's classic drama of wild nature, *The Fox Hunt* (1893); ★ John Vanderlyn's tenderly painted *Ariadne Asleep on the Island of Naxos* (1812), the best nude by an American for many a decade, and a landmark in American art.

Philadelphia Museum of Art 1876
26th St. and Benjamin Franklin
Pkwy., Box 7646, 19101
(215 763-8100)
Wed.–Sun. 10–5; closed Mon.,
Tues., holidays. Fee

In a classical, temple-fronted building in Fairmount Park, one of the great art collections in the New World, incl. the Johnson Collection of masterpieces from the 12th to the 19th C. and the Arensberg and Gallatin collections continuing the same standard into the 20th C.; Kress Collection of Barberini tapestries designed by Rubens; extensive collection of medieval arts; outstanding Kretzschmar von Lienbusch Collection of arms and armor; European and American period rooms; Far, Middle, and Near Eastern art; the Geesey Collection of Pennsylvania German folk art; European and American decorative arts; American painting and sculpture; primitive art; drawings, prints, and the Stieglitz Center Collection of photographs. ☛ ★ An incredibly detailed little Jan van Eyck painting of *St. Francis Receiving the Stigmata*, probably painted in Bruges in the 1430s with the assistance of a magnifying glass, a grand achievement at an infinitesimal scale; an intensely moving ★ *Crucifixion with the Virgin and St. John* by Jan's slightly younger contemporary, the Flemish master Rogier van der Weyden; a 13th C. stained-glass panel from Sainte-Chapelle in Paris (a medieval masterpiece built by St. Louis); a Japanese ceremonial teahouse and a Buddhist temple in a garden planted with fir and bamboo; the Great Hall from Madura, India; ★ Poussin's superb *Birth of Venus* (c. 1635), constructed like a great

132

oratorio, painted for Cardinal Richelieu and later owned by Catherine the Great (compare with Cézanne's late *Large Bathers* [1898–1905], also carefully constructed but without the Baroque virtuosity and nuance of the Poussin); the outstanding group of paintings by the Philadelphian Thomas Eakins; Marcel Duchamp's famous, and once infamous—*Nude Descending a Staircase* (1912), a landmark in modern art. (*Note:* The museum also administers the Rodin Museum, 22nd St. and Benjamin Franklin Parkway [Wed.–Sun. 10–5; no charge], which houses the largest collection of the great sculptor's works outside Paris, as well as historic houses in Fairmount Park and elsewhere.)

Philadelphia: The University Museum 1889
University of Pennsylvania, 33rd and Spruce Sts., 19104
(215 243-4000)
Tues.–Sat. 10–5, Sun. 1–5; closed Mon., national holidays; Sun. in summer. Fee

A treasure-house of ancient and primitive art from all over the world, incl. the most important collection of Native American gold extant and the most complete representation of West African art in the Americas; as a result of more than 275 expeditions, there are extraordinary collections from the ancient Near, Middle, and Far East, Southeast Asia, the Americas, the Pacific, Europe, Africa, and the Mediterranean Basin. ☛ From fabulous Ur in Mesopotamia, the gold and lapis lazuli ★ *Ram in a Thicket* (c. 2500 B.C.), depicting a rearing animal, sacred to the god Tammuz, symbolizing the male principle in life and possessing a demonic power; a most sensitively sculptured wooden mask in the form of ★ A deer's head (c. A.D. 1000), made by Indians and found at Key Marcos, Florida; Chinese reliefs of 6 wonderfully spirited horses, 2 of which were ordered by the T'ang Emperor T'ai'tsung in 644 for his tomb; a marvelous series of ★ Benin bronzes.

• Afro-American Historical and Cultural Museum, 7th and Arch Sts., 19106 (215 574-3671; Tues.–Sat. 10–5, Sun. 12–6; closed Mon., holidays, Martin Luther King's birthday; fee) has a collection of African art and work by black artists.
• American Swedish Historical Foundation-Museum, 1900 Pattison Ave., 19145 (215 389-1776; Tues.–Fri. 10–4, Sat. 12–4; closed Sun., Mon., holidays; fee) has collections pertaining to the Swedish contribution to the cultural life of America.
• The Athenaeum of Philadelphia, 219 S. 6th St., E. Washington Sq., 19106 (215 925-2688; Mon.–Fri. 9–5; closed weekends, bank holidays; no charge) occupies a particularly fine Romantic-style Italianate Revival ★ building designed by John Notman in 1845,

with furnishings of the period and fine paintings and sculptures.

• Drexel Museum Collection, Drexel University, 32nd and Chestnut Sts., 19104 (215 895-2424; Mon.-Fri. by appointment; closed holidays, weekends; no charge) has a varied textile collection, plus American and European paintings and decorative arts.

• Independence National Historical Park, 313 Walnut St., 19106, with a Visitor Center at 3rd and Chestnut Sts. (215 597-7132; daily 9-5; no charge) contains important historic buildings, incl. famous Independence Hall with the Liberty Bell and, in the restored Greek Revival Second National Bank of the United States (1818-24) designed by William Strickland, a fine collection of American Colonial and Federal portraits.

• Museum of American Jewish History, 55 N. 5th St., Independence Mall E., 19106 (215 923-3811; Mon.-Fri. 10-4, Sun. 11-5; closed Sat., national and Jewish holidays; fee) has artifacts and ceremonial objects since Colonial times.

• The Philadelphia Maritime Museum, 321 Chestnut St., 19106 (215 925-5439; Mon.-Sat. 10-5; Sun. 1-5; closed major holidays; no charge) has ship models, figureheads and other ship carvings, paintings, prints, drawings, plus weapons and other maritime artifacts.

• The Please Touch Museum, a children's museum at 1910 Cherry St., 19103, with a branch at 9th and Market Sts., 19107 (215 963-0667; Tues.-Sat. 10-4:30, Sun. 12:30-4:30; closed Mon., holidays; fee) has a varied collection of objects appealing to children, plus lively programs. (*Note:* Philadelphia has so many historic sites and buildings that it is impractical to list all of them. Several, in Fairmount Park and elsewhere, are administered by the Philadelphia Museum of Art; others are a part of Independence National Historical Park. The Philadelphia Convention and Visitors Bureau Tourist Center, 1525 J. F. Kennedy Blvd. [215 864-1976] has literature and information, incl. a schedule of the Cultural Loop Bus that stops at many historic sites throughout the city. The Philadelphia Society for the Preservation of Landmarks, 321 S. 4th St., 19106 [215 925-2251] also administers several important and interesting historic houses.)

Pittsburgh: The Frick Art Museum 1970
7227 Reynolds St., 15208
(412 371-7766)
Wed.-Sat. 10-5:30; Sun. 12-6; closed Mon., Tues., holidays incl. Good Friday. No charge

Italian, Flemish, and French painting; sculpture and decorative arts; 18th C. Chinese porcelains; French 18th C. furniture; tapestries; 18th C. Russian parcel gilt silver.

Pittsburgh: Museum of Art, Carnegie Institute 1896
4400 Forbes Ave., 15213
(412 622-3131 or 622-3200)
Tues.-Sat. 10-5; Sun. 1-5; closed Mon., national holidays.
No charge (donation accepted)

European painting, sculpture, and decorative arts from the Renaissance to the 20th C.; American arts since Colonial times; ancient and classical art; Far Eastern and Southeast Asian art; African, Pre-Columbian, and Native American art. ☛ A large T'ang *Horse*, mettlesome and grand, fashioned of glazed pottery, from an 8th C. Chinese princely tomb; ★ Nicola d'Ancona's *Madonna and Child with Saints Leonard, Jerome, John the Baptist, and Francis*, highly decorative, mannered, elegant, and a touch provincial, with St. Jerome's lion reduced to the size of a tomcat, a glimpse of a panoramic landscape at the lower right, and the Christ Child very specifically blessing the tiny kneeling donor at the lower left; Winslow Homer's *The Wreck* (1896), the first work acquired by the museum; Pissarro's two views of Pontoise, *The Crossroads* and *Street* (1872), luminous and lovely; ★ Van Gogh's serene *Plain of Auvers* (1890), the year of his suicide; compare it with Cézanne's monumental *Landscape near Aix, the Plain of the Arc*, painted 3 or 4 years later; Monet's engulfing *Water Lilies* (1920-21); and a magnificent display of European decorative arts in the Ailsa Mellon Bruce galleries.

• Fisher Collection, 711 Forbes Ave., 15219 (412 562-8300; Mon.-Fri. 9-4; closed weekends, holidays; no charge) has a collection of 17th-18th C. paintings and other works dealing with the subject of alchemy as the predecessor of modern science, an appropriate subject for the Fisher Scientific Company, which owns the collection.

Reading Public Museum and Art Gallery 1904
500 Museum Rd., 19611
(215 371-5850)
Winter: Mon.-Fri. 9-5; Sat. 9-12; Sun. 2-5; summer: Mon.-Fri. 9-4, Sun. 2-5, closed Sat.; closed holidays. No charge

Among a diversity of other collections, Renaissance to 18th C. European paintings; American 19th-20th C. paintings, incl. outstanding works. ☛ Thomas Birch's delightful early genre scene *Winter* (1838); one of several views, like musical variations, of the spectacular South American volcano *Cotopaxi*, painted by Frederic Church in the 1850s.

Scranton: Everhart Museum of Natural History, Science, and Art 1908
Nay Aug Park, 18510
(717 346-7186)
Tues.-Sat. 10-5; Sun. 2-5; closed Mon., major holidays. No charge

Among many other collections, American folk arts; American and European painting, Dorflinger glass; and Native American, Oceanic, African, and oriental objects.

University Park: Museum of Art
1963
The Pennsylvania State
University, 16802
(814 865-7672)
Tues.–Sun. 11–4:30; closed Mon., national holidays, Dec. 26–31.
No charge

An interesting collection of American and European paintings, sculpture, drawings, and prints, with some emphasis on Pennsylvania artists; Far Eastern ceramics, paintings, and prints; some ancient, Near Eastern, and African arts; ancient Peruvian and contemporary European and Japanese studio pottery; European posters from 1890 to 1930; thoughtfully planned temporary exhibitions. (*Note:* Pennsylvania is rich in historic sites, buildings, and collections, dozens of which are administered by the Pennsylvania Historical and Museum Commission, 3rd and North Sts., Box 1026, Harrisburg, 17120 [717 787-2891]; among those of particular architectural and artistic interest are: William Penn Memorial Museum, Harrisburg; Ephrata Cloister, Ephrata, a fascinating group of European medieval buildings a few miles NE of Lancaster; Graeme Park, a stone house, reflecting a Swedish influence, built in 1721 by Sir William Keith, Royal Governor of Pennsylvania, with rich Georgian interiors, located in Horsham, Montgomery County, in SE Pennsylvania; Hope Lodge on Bethlehem Pike, a grand Georgian manor built in 1723 in the style of Sir Christopher Wren, located in Fort Washington, near Philadelphia.)

RHODE ISLAND

Newport: Redwood Library and Athenaeum 1747
50 Bellevue Ave., 02840
(401 847-0292)

★ In a very distinguished building completed by Peter Harrison in 1748, a working library with a fine small collection of paintings, incl. works by Gilbert Stuart, Robert Feke, Charles Willson Peale and his son Rembrandt, with a large group by Charles Bird King. (Peter Harrison also designed King's Chapel in Boston, and the magnificent ★ Touro Synagogue, 85 Touro St., in Newport, dedicated in 1763, the oldest in America.) (*Note:* 18th C. Newport rivaled Boston in wealth and pride, and there are many preserved and restored buildings to prove it, such as Richard Munday's Old Colony House [1742], his Trinity Church [1725–26], and many others; for information consult The Preservation Society of Newport County, 118 Mill St., 02840 [401 847-

136

1000], which also administers the group of millionaires' palaces for which Newport is famous, and the Newport Historical Society, 82 Touro St., 02840 [401 846-0813], which has fine historical and decorative arts collections. The Visitor Bureau, 93 Thames St., has maps and tour information.)

Providence: Museum of Art, Rhode Island School of Design 1877
224 Benefit St., 02903
(401 331-3511)
Winter: Tues.–Wed. and Fri.–Sat. 10:30–5; Sun., holidays 2–5; Thurs. 1–9; closed Mon.; summer: Wed.–Sat. 11–4; closed Sun.–Tues., month of Aug., July 4, Thanksgiving, Christmas, New Year's. No charge

A fine, selective collection, outstanding in classical and medieval art, English and other drawings, European porcelain, Japanese prints, Western painting from the 15th to the 20th C., American decorative arts, and Far Eastern art. ☛ Roman sculptures and frescoes; Etruscan and Greek jewelry; a Romanesque stone figure of ★ *St. Peter* from the great abbey church at Cluny; Monet's light-drenched *Bassin d'Argenteuil* (c. 1872) (compare it with ★ Manet's *Le Repos,* painted in the same year, for which the artist's sister-in-law, the distinguished painter Berthe Morisot, posed—a lovely picture and a great Manet).

SOUTH CAROLINA

Charleston: Gibbes Art Gallery 1858
135 Meeting St., 29401
(803 722-2706)
Tues.–Sat. 10–5; Sun. 1–5; closed Mon., national holidays. Fee

Portraits from Colonial times to the 19th C., plus miniature portraits; Far Eastern, European, and American decorative arts; sculptures; Japanese prints; contemporary painting and prints. ☛ A fine pair of portraits by Thomas Sully of *Mr. Robert Gilmor* and the delightful ★ *Mrs. Robert Gilmor* (1823); Rembrandt Peale's stirring portrait of the forceful Southern leader *John C. Calhoun;* pastel portraits by Henrietta Johnson, America's first woman artist, done in the early years of the 18th C.

• Patriots Point Naval and Maritime Museum, Patriots Point, Box 986, Mt. Pleasant, 29464 (803 884-2727; daily 9–6; fee) displays naval and maritime artifacts housed in the aircraft carrier USS *Yorktown. (Note:* Charlestown is full of historic monuments. The Charlestown Museum, 360 Meeting St., 29403 [803 722-2996] has fine decorative arts material of local provenance and administers several historic properties as branch museums. The Historic Charlestown Foundation, 51 Meeting St., 29401 [803 723-1623] has similar collections and historic properties. The Gibbes Art Gallery

137

and the two other historical institutions can provide detailed information. The Old Slave Mart Museum, 6 Chalmers St. [803 722-0079], has rich material on the history of the slave trade and of blacks in America. Drayton Hall, Ashley River Rd., 29407, a property of the National Trust for Historic Preservation, is one of the great houses in America, dating from 1738–42.)

Columbia Museums of Art and Science 1950
1112 Bull St., 29201
(803 799-2810)
Mon.–Fri. 10–5; Sat.–Sun. 1–5; closed Mon., major holidays.
No charge

A fine Kress Collection of Italian Renaissance and Baroque painting, along with other European painting and decorative arts; Spanish Colonial arts; English furniture; American painting; graphic arts. ☛ ★ Washington Allston's luminous *Coast Scene on the Mediterranean*. (*Note:* The South Carolina Department of Parks, Recreation, and Tourism, Box 113, 1205 Pendleton St., 29201 [803 758-3622] administers many historic sites and buildings throughout the state, while the Historic Columbia Foundation, 1616 Blanding St., 29201 [803 252-7742] operates several historic houses in the city.)

Greenville: Bob Jones University Collection of Sacred Art 1951
University Campus, 29614
(803 242-5100)
Tues.–Sun. 2–5; closed Mon., New Year's, July 4, Dec. 20–25.
No charge

A collection of European paintings from the 13th through the 19th C., all with Christian subject matter, including examples by many of the great masters of European art, with accompanying decorative arts material in galleries of spectacular decor. ☛ Three fine Veroneses and a *Holy Family with St. John* by Vincenzo Catena, another Renaissance Venetian painter; a dashingly painted and vividly composed Tintoretto depiction of *The Visit of the Queen of Sheba to Solomon*, another outstanding work of the Venetian Renaissance; and two important Caravaggesque works, Orazio Gentileschi's *The Martyrs Valeriano, Tiburzio, and Cecelia*, and an even more dramatically illuminated *Holy Family in the Carpenter's Shop* by his contemporary, the Dutchman Gerard van Honthorst. (*Note:* In the adjacent War Memorial Chapel are displayed a group of religious canvases painted by the American Quaker Benjamin West for a projected chapel at Windsor, ordered built by George III, which was never completed owing to the king's deteriorating mental state; they are big, operatic, decorative

works in West's advanced Romantic style — definitely worth seeing.)

Greenville County Museum of Art 1959
420 College St., 29601
(803 271-7570)
Mon.-Sat. 10-5; Sun. 1-5; closed major holidays. No charge

A collection of North American painting, sculpture, drawings, prints, and crafts; Magill Collection of the works of Andrew Wyeth. ☞ ★ A fine, early Washington Allston, *Landscape with Bridge and a File of Horsemen* (1798).

SOUTH DAKOTA

Pierre: Robinson Museum 1901
Memorial Bldg., 57501
(605 773-3797)
Mon.-Fri. 8-5; Sat. 10-5; Sun. 1-5; closed legal holidays. No charge

Historical collections pertaining to the exploration and settlement of the Great Plains, and to the arts and culture of the Plains tribes. ☞ ★ A carved wooden *Horse Effigy*, a masterpiece of 19th C. Sioux sculpture expressing the spirit and motion of a leaping horse, perhaps used in the Victory Dance.

Rapid City: Sioux Indian Museum and Crafts Center 1939
Box 1504, 57709 (605 348-8834)
June-Sept.: Mon.-Sat. 9-5; Sun. 1-5; Oct.-May: Tues.-Sat. 10-5; Sun. 1-5; closed Mon.; closed Thanksgiving, Christmas, New Year's. No charge

A historical collection related to the traditional social and ceremonial aspects of Sioux tribal culture; contemporary Native American arts and crafts.

Vermillion: The Shrine to Music Museum 1973
Box 194, The University of South Dakota, 57069 (605 677-5306)
Mon.-Fri. 9-4:30; Sat. 10-4:30; Sun. 2-4:30; closed national holidays. No charge

A collection of more than 3,000 European, American, and non-Western musical instruments; musicological material.

TENNESSEE

Chattanooga: Hunter Museum of Art 1951
Bluff View, 37403 (615 267-0968)
Tues.-Sat. 10-4:30; Sun. 1-4:30; closed Mon., holidays. No charge (donation accepted)

18th, 19th, and 20th C. American painting, sculpture, drawings, and prints, with a sculpture garden

overlooking the Tennessee River. ☞ ★ Childe Hassam's *French Tea Garden* (1910), showing the influence of Monet's Impressionist style; a fine group of Burchfields; works by The Eight.

• Houston Antiques Museum, 201 High St., 37403 (615 267-7176; Tues.–Sat. 10–4:30; Sun. 2–4:30; closed Mon., holidays; fee) has a collection of largely 19th C. European and American decorative arts, with an emphasis on glass and porcelain; plus quilts and other textiles.

Memphis: Brooks Memorial Art Gallery 1913
Overton Park, 38112
(901 726-5266)
Tues.–Sat. 10–5; Sun. 1–5; closed Mon., Thanksgiving, Christmas, New Year's. No charge

The collection incl. a Kress Collection of Italian Renaissance painting and sculpture, European art from the 14th C. to the present; American painting from the 18th C. to the present; American and Japanese prints; Far Eastern arts; Egyptian objects; plus glass and other decorative arts. ☞ ★ A fine, large Canaletto canvas of *The Grand Canal;* Hogarth's portrait of *Miss Ann Hogarth,* affectionately but coolly observed and marvelously painted; ★ *The Temple of the Sibyl at Tivoli,* a fine picture by Richard Wilson, who has been called the father of British landscape painting; a wonderfully fresh *Springtime at Eragny* (1885) by Pissarro.

Memphis: The Dixon Gallery and Gardens 1976
4339 Park Ave., 38117
(901 761-5250)
Tues.–Sat. 11–5; Sun. 1–5; closed Mon., holidays. Fee

In a most attractive ★ Garden setting, the spacious porticoed house with an appropriate addition displays a fine collection of European and American painting of the 18th, 19th, and early 20th C., with an emphasis on French Impressionism, along with fine furniture and decorative arts, primarily English. ☞ Good examples of the works of Monet, Sisley, and Pissarro; a lovely ★ Corot, *Le Paveur de la Route de Chailly* (1830); a distinguished Mary Cassatt, *The Visitor—Left Profile* (c. 1880); enjoy the parklike and inviting gardens, very English in style.

Nashville: Fisk University Museum of Art 1949
18th Ave. & Jackson St. N, 37203
(615 329-8685)
Sept.–May: Mon.–Fri. 9–12 and 1–5; closed weekends, months of June–Aug. No charge (donation accepted)

African sculpture, Afro-American arts; photographs by Alfred Stieglitz. ☞ Georgia O'Keeffe's handsome *Radiator Building—Night, New York* (1927), an early landmark in her mature work; ★ Henry O. Tanner's deeply felt *Three Marys* (c. 1890), a good example of the work of a gifted black pupil of Thomas Eakins who spent

most of his life in the more sympathetic environment of Paris.

• The Nashville Parthenon, Centennial Park, 37203 (615 259-6358; Mon.–Sat. 8–4:30; Sun. 1–4:30; closed national holidays; no charge). Housed in a reproduction of the Parthenon originally built for the city's centennial, a small collection of American 19th C. painting, plus Pre-Columbian material from Mexico and Peru. ☞ Benjamin West's *Venus Teaching Cupid* (c. 1800), an example of the Romantic style developed by the American Quaker who became second president of the Royal Academy in London and painter to King George III; Winslow Homer's *Rab and the Girls,* showing his genre style of the later 19th C.

• The Tennessee Botanical Gardens and Fine Arts Center, Cheekwood, Cheek Rd., 37205 (615 352-5310; Tues.–Sat. 10–5; Sun. 1–5; closed Mon., holidays; fee), SW of downtown Nashville, in beautifully planted and landscaped grounds, a large house converted into an art center, with a small collection of American paintings, prints, and varied furnishings and decorative arts material.

• Vanderbilt University Art Gallery, 23rd and West End Ave., Box 1801, 37235 (615 322-2831; during school term, Mon.–Fri. 1–4; Sat., Sun. 1–5; closed school holidays; no charge), in a picturesque Victorian building dating from 1880, a small general collection containing Old Master prints, and Far Eastern arts.

(*Note:* The Association for the Preservation of Tennessee Antiquities, 110 Leake Ave., 37205 [616 352-8247], housed in the Belle Meade Mansion of 1853, administers a number of historic sites and buildings with decorative arts and historic collections; inquire for information.)

TEXAS

Austin: Archer M. Huntington Art Gallery 1963
University of Texas, 23rd and San Jacinto Sts., 78712
(512 471-7324)
Mon.–Sat. 9–5; Sun. 1–5; closed school holidays. No charge

Houses the Michener Collection of modern American painting; contemporary Latin-American arts; Smith Collection of Western American art; European and American 15th–20th C. drawings and prints; Battle Collection of casts of classical sculpture.

Corpus Christi: Art Museum of South Texas 1960
1902 N. Shoreline Dr., 78402
(512 884-3844)
Tues.–Sat. 10–5; Sun. 1–5; closed Mon., holidays. No charge

In a handsome building designed by Philip Johnson in 1972, a collection primarily of 20th C. American painting, sculpture, graphic arts, and photographs, with outdoor sculpture court overlooking the sea.

• The Japanese Art Museum, 426

S. Staples St., 78401 (512 883-1303; Mon.-Fri. 10–12 and 1–4; Sun. 2–5; other times by appointment; closed Sat., holidays; fee) has a collection of Japanese decorative arts, incl. porcelain, lacquer, metalwork; architectural models of famous buildings; Buddhist paintings.

Dallas Museum of Fine Arts 1909
Fair Park, 75226 (214 421-4187)
Tues.-Sat. 10–5; Sun., holidays 1–5; closed Christmas. No charge

A general collection with special strengths in Pre-Columbian art, African sculpture, plus Oceanic and Far Eastern arts; European and American modern art; Old Masters and American paintings. ☞ Olmec jades and other objects; Peruvian gold; a terra-cotta *Seated Man with Shoulder Tabs* (A.D. 600–800), probably from Veracruz, a particularly vivid figure suggesting a portrait, with interlaced breastplate and bracelets; Brancusi's abstract *Beginning of the World* (c. 1920), in polished marble and metal; a fine ★ Matisse collage, *Ivy in Flower* (1953), completed the year before he died, showing the wonderful spirit with which he took up this medium while confined to his bed by illness at a time when he could no longer paint.

Dallas: McCord Theatre
Collection 1933
Southern Methodist University,
75275 (214 692-2400)

Tues.-Wed. 2–4 or by
appointment. No charge

A theater collection specializing in material pertaining to the stage in Texas.

Dallas: Meadows Museum and
Sculpture Court 1965
Owen Fine Arts Center, Southern
Methodist University, 75275
(214 692-2727 and 692-2740)
Mon.-Sat. 10–5; Sun. 1–5; closed
New Year's, Christmas.
No charge

A fine and very interesting collection devoted to Spanish paintings, drawings, and prints from the Renaissance to the present; modern sculpture from Rodin to the present. ☞ A rare and impressive Ribera portrait of *A Knight of Santiago,* done in the 1630s; ★ Vazquez' touching portrait of Philip IV's *Queen Mariana,* homely as a mud fence but a feeling person made all the more vulnerable by her elaborate hairstyle; ★ Goya's extraordinary and frightening depiction of *The Madhouse at Saragossa* (1792–93) painted after the artist had become isolated through sudden deafness and was plagued by terrible sounds in his unhearing ears.
• Mexican American Cultural Heritage Center, Dallas Independent School District, 2940 Singleton Blvd., Rooms 213 and 214, 75212 (214 630-1680; Mon.-Fri. 8–4:30; closed weekends, school holidays; no charge) has Mexican

142

arts and crafts, folk dance material, textiles, and costumes.

El Paso Museum of Art 1959
1211 Montana Ave., 79902
(915 541-4040)
Tues.–Sat. 10–5; Sun. 1–5; closed Mon., national holidays.
No charge

Kress Collection of Renaissance and Baroque art; European and American arts; Pre-Columbian art; art of the Old West and Mexico; contemporary art of the Rio Grande area. ☞ A mystical, lyrical, and slightly melancholy late Botticelli, *Madonna and Child,* a *tondo* panel; ★ Bernardo Bellotto's *Entrance to a Palace* (c.1770), a capriccio painted when the Venetian artist, nephew and pupil of Canaletto, was in Poland.

Fort Worth: Amon Carter Museum of Western Art 1961
3501 Camp Bowie Blvd., Box 2365, 76113 (817 738-1933)
Tues.–Sat. 10–5; Sun., holidays 1–5:30; closed Mon., Thanksgiving, 2 days during Christmas, New Year's.
No charge

In a distinguished building designed by Philip Johnson in 1961, a collection, primarily American, of paintings and sculpture from the 19th C. to the present, with an emphasis on works pertaining to the Old West; an important print collection. ☞ ★ *Boston Harbor,* by the Luminist painter Fitz Hugh Lane, the best American marine painter before Winslow Homer; ★ Martin Johnson Heade's powerful and impressive *Thunderstorm Over Narragansett Bay* (1868); outstanding groups of Remingtons and Russells, both sculptures and paintings, note esp. the former's *A Dash for the Timber* (1889), considered by many to be his masterpiece.

Fort Worth Art Museum 1901
1309 Montgomery St., 76107
(817 738-9215)
Tues. 10–9; Wed.–Sat. 10–5; Sun. 1–5; closed Mon., holidays.
No charge

Also facing Carter Square, like the Amon Carter Museum and the Kimbell Art Museum, this collection specializes in 20th C. European and American painting, sculpture, drawings, prints, and photographs. ☞ Among the earliest paintings the museum has acquired, Eakins' *The Swimming Hole* (1883), a major work by a prominent American artist; *Whistle Stop* (1977), a collage and assemblage by Robert Rauschenberg.

Fort Worth: Kimbell Art Museum 1972
Will Rogers Rd. W, Box 9440, 76107 (817 332-8451)
Tues.–Sat. 10–5; Sun. 1–5; closed Mon., major holidays.
No charge

★ In a very successful building, one of the last designed by Louis I. Kahn, a marvelous eclectic collection of masterpieces from around the world, spanning prehistoric times to Picasso, shown with tremendous effectiveness in the uninterrupted space of Kahn's cycloidal vaults. ☞ ★ *The Barnabas Altarpiece* (c. 1250), the oldest surviving English panel painting, in a graceful Gothic style suggesting medieval illuminations; ★ Duccio's magisterial *Raising of Lazarus,* a panel from his great *Maestà* altarpiece, painted between 1308 and 1311 for the cathedral of Siena, one of the world's masterpieces; together with three fine portraits, Gainsborough's early, very Dutch-looking *Suffolk Landscape* (1755), showing his debt to Hobbema et al. in the evolution of the English landscape school; compare it with the atmospheric ★ Van Goyen *View of Arnhem,* painted a little over a century earlier, and the Van Ruisdael *Landscape with the Ruins of Egmond Abbey* of 20 years later; J. M. W. Turner's *Glaucus and Scylla* (1841) shows him pushing the landscape tradition toward, and perhaps even past, Impressionism even though that movement was not to emerge for more than 30 years; superb sculptures from Cycladic times through 4th C. B.C. Greece, to Bourdelle, Rodin's pupil, to Maillol, and incl. the East as well.

Galveston: Rosenberg Library 1900
2310 Sealy Ave., 77550
(713 763-8854)
Mon.–Thurs. 9–9; Fri.–Sat. 9–6;
closed Sun., San Jacinto Day (Apr. 21), national holidays.
No charge

The library incl. three galleries displaying art from the 18th to the 20th C.; painting, sculpture, graphic and decorative arts; material relating to Galveston's maritime history. ☞ An oil by the Hudson River School painter Worthington Whittredge, *Along the Platte River, Colorado,* painted during or shortly after his trip to the West in 1865.

Houston: The Bayou Bend Collection 1956
1 Westcott St., Box 13157, 77019
(713 529-8773)
By reservation, Tues.–Fri. 10–4:30;
Sat. 10–1:30; 2nd Sun. of each month except Mar. 1–5;
closed month of Aug., major holidays. No charge

A branch of the Museum of Fine Arts of Houston, in the former house of Ima Hogg, who, with great care and taste, spent several years amassing one of the finest collections of ★ American decorative arts, from the Pilgrim period in the early 17th C. to the Victorian era of the mid-19th C., with American paintings from 1700–1840, plus English ceramics handsomely

displayed. ☛ ★ A robust and vigorous silver tankard made around 1700 by Jeremiah Dummer of Boston, one of the great American silversmiths; Charles Willson Peale's *Self-Portrait with Wife, Rachel, and Daughter, Angelica Kauffmann Peale* (c. 1788), a charming record of a leading American painter of the period who named his children after great painters (and they all painted well!). Compare with a fine early ★ Feke *Portrait of Ann McCall* and Copley's later, more completely realized *Mrs. Paul Richards* to understand something of the American vision and sense of individualism. (*Note:* because of the domestic arrangement of the 24 period rooms, like those at Winterthur, it isn't possible to open the house like a museum; hence reservations are necessary—and it is very much worth a visit!)

Houston: The Museum of Fine Arts, Houston 1900
1001 Bissonet St., Box 6826, 77005
(713 526-1361)
Tues.–Sat. 10–5; Sun. 12–6; closed Mon., national holidays.
No charge

A distinguished, comprehensive collection of world art dating back to prehistoric times, with special strengths in contemporary art; Old Masters and later European and American painting and sculpture; Far Eastern art; Pre-Columbian and American Indian art; Oceanic and African art; decorative arts of Europe and America. ☛ ★ An extremely impressive Greek bronze of a *Youth*, 7½ feet tall; an involving, deeply devotional ★ *Madonna and Child* by the great Flemish master of the late Middle Ages, Rogier van der Weyden (compare it with the similar spirit of the stylistically utterly different Giovanni Bellini *Madonna* [c. 1465], like that in the Kimbell Art Museum); a pair of Canaletto *Views of the Grand Canal* (c.1720) (compare with Guardi's *Santa Maria della Salute,* so ethereal in contrast to Canaletto's delightfully observed factuality); Cézanne's classic *Portrait of the Artist's Wife;* the vast open spaces of Mies van der Rohe's classic modern Cullinan Hall and Brown Pavilion.

• Sarah Campbell Blaffer Gallery, University of Houston, 4800 Calhoun Rd., 77004 (713 749-1329; Tues.–Sat. 10–6; Sun. 1–6; closed Mon., month of Aug., holidays, New Year's week; no charge) has European paintings from the Renaissance to the present; contemporary arts, incl. Mexican graphics; and Pre-Columbian art. (*Note:* The Rothko Chapel, 3900 Yupon St., 77006, is a landmark in modern art, with its totally abstract large paintings by the late Mark Rothko, works that invite meditation, and Barnett Newman's *Broken Obelisk,* 25-foot-high steel structure reflected in the

pool in front, a memorial to Martin Luther King, Jr. The Institute for the Arts of Rice University, Box 1892, 77001 [713 527-4858; Tues.-Sat. 10–5; Sun. 12–6] has a good, small collection, but the institute is noted for the quality and interest of its temporary exhibitions with excellent accompanying catalogues; closed between exhibits.)

San Antonio: Marion Koogler McNay Art Institute 1950
6000 N. New Braunfels, 78209
(512 824-5368)
Tues.–Sat. 9–5; Sun. 2–5; closed Mon., major holidays. No charge

Except for the largely medieval Oppenheimer Collection, and folk art of the Southwest, the museum has an excellent representation of modern-to-contemporary art of Europe and America; fine graphic arts; decorative arts. ☛ Maillol's classic bronze *Nymphe* (1930); Gauguin's contemplative *Self-Portrait with an Idol,* painted in the South Seas around 1893 (compare Cézanne's roughly contemporary *Portrait of Henri Gasquet,* and don't miss the Cézanne *Houses on the Hill,* very abstract and solidly constructed, vigorously brushed; a group of fine American watercolors, incl. works by Marin and Demuth.

San Antonio Museum of Art 1981
200 W. Jones Ave., 78215
(512 226-5544)
Sept.–May: daily 10–5; June–Aug.: daily 10–6; closed major holidays, Battle of Flowers. Fee

Located in the historic Lone Star Brewery on the San Antonio River, the museum representing one of three parts of the Art Association, has a collection of American art, esp. from Texas and the Southwest, as well as contemporary American art; photography and graphic art; sculpture garden; decorative arts. (*Note:* San Antonio has many historic buildings, incl. historic houses operated by the Museum Association, 3801 Broadway, 78209 [512 826-0647]. The San Antonio Conservation Society, 107 King William St., 78204 [512 224-6163] oversees a number of other houses in a historic district near the San Antonio River. The Spanish Governor's Palace, 105 Military Plaza, 78205 [512 224-0601; Mon.–Sat. 9–5; Sun. 10–5; small fee] is a restored historic building (1722) with historical and decorative arts displays. Of the three Spanish missions, the Alamo is the most famous because of its role in the heroic defense by 188 Americans, incl. Col. James Bowie and Davy Crockett, against a 5,000-man Mexican army for two weeks in the Texas War for Independence (1836). The Misión Nuestra Señora de la Purísima Concepción de Acuña (1731–55), 807 Mission Rd., on the San Antonio River, is the oldest unrestored stone church in the nation [open daily]. ★ The Misión San

146

José y San Miguel de Aguayo, 6539 San José Dr., 78214 [512 922-2731; open daily; small fee; 6 ½ m. S on US 281] is architecturally the most distinguished structure, with a superb portal and an atmospheric interior. The San Antonio Convention and Visitors Bureau, Box 2277, 78298, has information on all historic buildings, sites, and events.)

Snyder: Diamond M. Foundation Museum 1950
Diamond M. Building, 909 25th St., Box 1149, 79549
(915 573-6311)
Wed.-Fri. 9-12 and 1-4; Sat.-Sun. 1-4; other times by appointment. No charge

A collection primarily devoted to the art of the Old West, with paintings, bronzes, Currier & Ives lithographs, and other objects.

UTAH

Salt Lake City: Utah Museum of Fine Arts 1951
104 AAC, University of Utah, 84112 (801 581-7332)
Mon.-Fri. 10-5; Sat., Sun. 2-5; closed national holidays. No charge

The only public general art museum in the state has 19th C. French and American landscapes, 18th C. French decorative arts, 17th-18th C. English paintings and decorative arts, Italian Renaissance paint

ings and furniture, Egyptian antiquities, contemporary graphics, and Buddhist objects. (*Note:* Salt Lake City has historic buildings owned by the Church of Latter-Day Saints, 50 E. North Temple, 84150, incl. the famous Tabernacle; the spectacularly romantic Temple, with its picturesque spires and finials; and Beehive House, 67 E. South Temple, which served as Brigham Young's home and office from 1854 to 1877 and contains period furnishings; open Mon.-Sat. 9:30-4:30; Sun. 10-2:30; closed major holidays; 801 531-2672.)

Springville Museum of Art 1903
126 E. 400 St., 84663
(801 489-9434 or 489-9435)
Wed. 10-9; Tues., Thurs.-Sat. 10-5; Sun. 2-5; closed Mon., holidays. No charge

A collection largely of early 20th C. American painting and sculpture, incl. a considerable collection of sculptures by Cyrus E. Dallin, who studied in Paris with Rosa Bonheur and specialized in American Indians (his *Appeal to the Great Spirit* is placed in front of the Museum of Fine Arts, Boston).

VERMONT

Bennington Museum 1876
W. Main St., 05201
(802 447-1571)
Daily 9-5; closed Thanksgiving, months of Dec.-Feb. Fee

Primarily a history museum of the region, the collections incl. Rockingham, Flint Enamel, Parian, and Blue and White pottery made in Bennington; a large collection of American glass; paintings and decorative arts; and Grandma Moses paintings and memorabilia. ☞ The oldest Stars and Stripes American flag in existence. (*Note:* The museum has two historic buildings, the Eagle Rock School House [1838], which Grandma Moses attended, and the Old Academy Library [1821].)

Burlington: Robert Hull Fleming Museum 1931
University of Vermont,
Colchester Ave., 05401
(802 656-2090)
Mon.-Fri. 9-5; Sat.-Sun. 1-5; closed national holidays.
No charge

A general collection of world art, with special strengths in 19th-20th C. American art; Native American, Oceanic, and African art; ancient, medieval, and Far Eastern art; 19th C. European paintings, furniture, and decorative arts; Pre-Columbian ceramics and textiles; graphic arts; costumes. ☞ A life-sized alabaster Assyrian relief of a *Winged God* from Ashurnazirpal II's palace (883–859 B.C.; compare with those in Amherst, Bowdoin, Dartmouth, Middlebury, and Williams); a fine bronze ★ *Head of a Queen Mother,* 18th C. Benin, Nigeria; a miniature portrait of Ethan Allen, the Vermont hero of Revolutionary times, by Edward Malbone, America's greatest miniaturist; a collection of the famous "Groups" of John Rogers, the mid-19th C. sculptor of genre scenes.

Middlebury: Johnson Gallery 1968
Middlebury College, 05753
(802 388-2762)
Sun.-Fri. 12-5; Sat. 9-5; closed Sun., major holidays. No charge

A small, general teaching collection; the college also owns one of a series of Assyrian alabaster reliefs, *Winged Deity* (9th C. B.C.), of which other examples are in Amherst, Bowdoin, Dartmouth, and Williams.

St. Johnsbury Athenaeum
Library, 1871; **Art Gallery,** 1873
30 Main St., 05819
(802 748-8291)
Mon., Fri. 9:30-8; Tues.-Thurs., Sat. 9:30-5; closed Sun., national holidays. No charge

★ A handsome period setting for a permanent collection of about 100 works of primarily 19th C. American art, housed in a fine example of Romantic 19th C. architecture. ☞ Bierstadt's huge, dramatic *Domes of the Yosemite,* purchased from the artist in 1867; *The Emigrant Train, Colorado* (1872) by Samuel Colman, an oil by a founder and first president of the American Water-color Society; a fine *View from South Mountain in the Catskills* (1875), by the Luminist painter Sanford Gifford.

148

Shelburne Museum 1947
US Rt. 7, 05482 (802 985-3346)
Mid-May–late Oct.: daily 9–5;
winter: open by appointment. Fee

An unusual and highly interesting general museum, housed in 35 restored Early American buildings on a beautiful 100-acre site overlooking Lake Champlain, with excellent collections of American fine, folk, and decorative arts; Old Master and Impressionist paintings and drawings; European sculpture; Native American arts; a large transportation collection, incl. the side-wheeler SS *Ticonderoga;* tools and artifacts; maritime collection, with paintings, prints, figureheads and other ship carvings; architecture and period rooms. ☛ ★ Stagecoach Inn with its collections of American folk art; Lighthouse Gallery (a real lighthouse), with its maritime collections; Webb Gallery of American art, with a fine collection ranging from early Colonial times through much of the 19th C.; Webb Memorial, with its outstanding Old Masters and 19th C. European and American paintings.

Waitsfield: Bundy Art Gallery
5 m. S of Waitsfield on Rt. 100,
Box 19, 05673
Mon.–Sat. 10–5; Sun. 1–5; closed
holidays, month of Nov.
No charge

In the Mad River Valley, better known to skiers than to art lovers, a distinguished collection of contemporary arts in and around a modern building in a rural country setting, where an active art program, incl. changing exhibitions, concerts, and other activities, is carried on, often outdoors during summer. (*Note:* Vermont has many historic sites and buildings, many with collections of great interest, plus a generous share of the few covered bridges still extant; for information inquire at the State of Vermont Division for Historic Preservation, Pavilion Building, Montpelier, 05602, and/or the Vermont Historical Society, Vermont Museum, same address [802 828-2291].)

VIRGINIA

Charlottesville: University of
Virginia Art Museum 1935
Thomas H. Bayly Memorial
Bldg., Rugby Rd., 22903
(804 924-3592)
Tues.–Sun. 1–5; closed Mon.,
holidays. No charge
(donation accepted)

European and American art in the Jeffersonian era; 17th–18th C. European and 19th C. American paintings; Far Eastern art; American Indian and African art; contemporary American art; graphics. ☛ *Natural Bridge, Virginia,* a work once owned by Jefferson, painted in 1852 by the distinguished Hudson River School painter Frederic E. Church. ★ In addition to the

museum, look at and admire the superbly planned campus designed by Jefferson, elegantly detailed and conceived at human scale; note esp. the Rotunda, with its handsome interior space. (*Note:* Monticello, the house that Jefferson designed and redesigned for himself, VA, Rt. 53, Box 316, 22902 [804 293-2158; open daily except Christmas; fee] is nearby, a fascinating and beautiful place of great interest. Ash Lawn (1799), the house Jefferson designed for James Monroe, Rt. 6, Box 37, 22901; [804 293-9539; open daily except for major holidays] is also nearby.)

Hampton: The College Museum
1905
Hampton Institute, 23668
(804 727-5308)
Mon.-Fri. 8–5; Sat.-Sun. 10–4; closed national holidays.
No charge

A collection of African, Oceanic, Asian, and American Indian art, with contemporary Afro-American and African works. (*Note:* Hampton, the second oldest English settlement after Jamestown, is located in a very historic area, incl. Norfolk, with its Chrysler Museum at Norfolk; Newport News, with The Mariners Museum; Portsmouth, with the Portsmouth Naval Museum; Yorktown; plus many historic sites and buildings nearby, not far from Williamsburg, Jamestown, and the James River Plantations.)

Lynchburg: Randolph-Macon Woman's College Art Gallery
1920
2500 Rivermont Ave., 24503
(804 846-7392)
Mon. 2–4; Tues.-Fri. 10–5 and 2–4; Sun. 2–5; closed holidays.
No charge

A small collection containing some fine European and American paintings and American graphic arts.

Newport News: The Mariners Museum 1930
Museum Dr., 23606
(804 595-0368)
Mon.-Sat. 9–5; Sun. 12–5; closed Christmas. Fee

A comprehensive maritime collection, with paintings, drawings, prints, ship carvings, models, weapons, small watercraft, along with a library and extensive archive of charts, logs, photographs, etc.

Norfolk: Chrysler Museum at Norfolk 1933
Olney Rd. and Mowbray Arch, 23510 (804 622-1211)
Tues.-Sat. 10–4; Sun. 1–5; closed Mon., major holidays. No charge

A large and varied general collection, with examples of art dating back to ancient Near Eastern civilizations and spanning the Far East and the New World; richest in the field of Old Master and French 19th C. paintings, American paintings from Colonial times to the

present, and a very large collection of glass, ancient to modern. ☛ A lively oil by William Glackens, a member of The Eight, entitled *The Shoppers* (1907), showing the artist's interest in the everyday life of the city, which led overly-delicate critics to describe such work as belonging to the Ash Can School of painting; a Corot *Landscape in a Thunderstorm* (1856), whose atmospheric effects anticipate Impressionism; two grand-manner Rubens portraits and Bernini's *Bust of the Savior* (c. 1679), carved the year before his death, are among the outstanding examples of the Baroque; ★ Renoir's charming portrait of the *Daughters of Durand-Ruel* (1882) displays his developed and scintillating Impressionist style. (*Note:* The museum operates three historic houses, the most important historically being the Adam Thoroughgood House [1650]. Phone for hours of houses.)

• The Amphibious Museum, Naval Amphibious Base, Little Creek, 23521 (804 464-8130; Sat.-Sun. 1-5; otherwise by appointment; closed major holidays; no charge) has maritime collections pertaining to amphibious warfare.

Portsmouth Naval Museum 1949
2 High St., Box 850, 23705
(804 393-8591)
Tues.-Sat. 10-5; Sun.,
Thanksgiving 2-5; closed Mon.,
New Year's, Christmas.
No charge

A maritime collection pertaining to the history of the naval shipyard and the naval history of the area, incl. the USS *Merrimac* of Civil War fame, rechristened the CSS *Virginia* by the Confederate Navy.

Richmond: Valentine Museum
1892
1015 E. Clay St., 23219
(804 649-0711)
Tues.-Sat. 9:30-5; Sun. 1:30-5;
closed Mon., major holidays. Fee

Various historical collections of decorative arts material, strong in textiles and costumes, prints, and photographs, plus paintings, sculpture, and American Indian artifacts.

Richmond: Virginia Museum of Fine Arts 1934
Boulevard and Grove Ave., 23221
(804 257-0844)
Tues.-Sat. 11-5; Sun. 1-5; closed Mon., major holidays. Small fee for adults; children no charge

A fine general art museum, ancient to modern, East to West, justly admired for the installation and presentation of its collections in historical-cultural units, beautifully arranged in a series of galleries with small introductory areas; Old Master paintings; European decorative arts, incl. spectacular Russian imperial jewels made by Peter Carl Fabergé, goldsmith to the last two czars and one of the greatest jewelers of all time; Indian, Nepalese, and Tibetan arts; Byzantine and

medieval art; American painting and decorative arts. ☛ A dashingly painted late Rubens panel of *Pallas and Arachne* of the late 1630s. ★ A section of a stained-glass window from Chartres, with most of the original Gothic glass still intact in the original leading. ★ A gusty Van Goyen 17th C. landscape of a lowering *Thunderstorm over Haarlem* (compare it with Constable's 19th C. rendering of *The Ponds at Hampstead Heath,* very different in style but expressing the same unity of vision in recording the spectacle of nature). ★ An extremely powerful Roman sculpture of Caligula, the brutal Roman emperor. (*Note:* This is the only art museum with an active theater as a part of its program; inquire about the specific schedule; the quality is high.) Richmond is full of history, and there are many worthwhile historic buildings and collections. Check with the Association for the Preservation of Virginia Antiquities, 2705 Park Ave., 23220 [804 359-0239], which administers 10; the Division of State Parks, 1201 State Office Bldg., Capitol Square, 23219 [804 786-2132], which administers several thoughout the state; the Historic Richmond Foundation, 2407 E. Grace St., 23223 [804 643-7407], which is responsible for the preservation and restoration of dozens of houses around St. John's Church. The Richmond Information Center, 6th St. at the Colosseum [804 770-2051], and the Greater Richmond Chamber of Commerce, 616 E. Franklin St., have information concerning hours and fees. Don't forget Capitol Square, with Jefferson's serene and beautiful ★ Capitol, which launched the Classical Revival in architecture, and the Governor's Mansion [1811–12], designed by Alexander Parris, Charles Bulfinch's pupil.)

Williamsburg: Colonial Williamsburg 1926
Goodwin Bldg., 23185
(804 229-1000)
Daily 9–5. Fees vary with buildings

A unique preservation project and village museum in Virginia's beautiful Colonial capital, with 88 preserved and restored buildings dating from 1693 to 1837, and 50 reconstructed 18th C. buildings; outstanding period furnishings and collections; craft shops and demonstrations; inns and taverns; a tremendously varied program of exhibits and activities for all interests; study collections of 17th–18th C. cultural artifacts illustrative of life in tidewater Virginia; remarkable archives and library. ☛ Williamsburg has so much to see that there is something for everyone, regardless of age or interest; just wandering down the broad, shaded streets, unpolluted by plastic or neon, and enjoying the sight of well-kept lawns, dooryards, and gardens is a delight, but go inside, too, and visit the ★ Abby Aldrich Rockefeller Folk Art Cen-

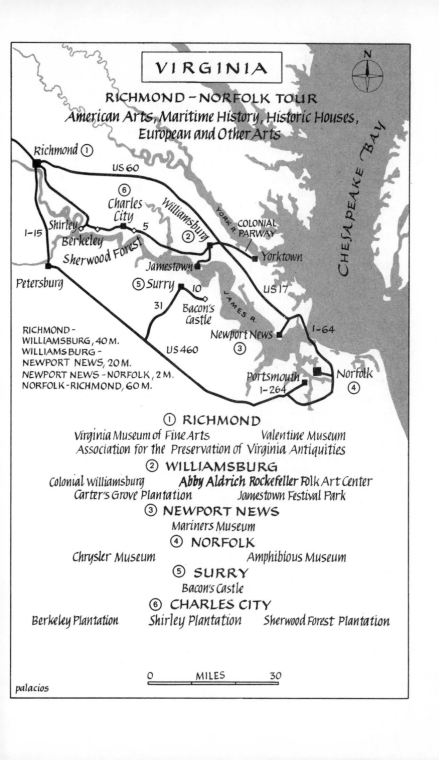

VIRGINIA

RICHMOND – NORFOLK TOUR
American Arts, Maritime History, Historic Houses, European and Other Arts

N

CHESAPEAKE BAY

Richmond ①

US 60

⑥
Charles City

Williamsburg

YORK R.

COLONIAL PARWAY

Shirley
Berkeley
Sherwood Forest
5
②

I-15

Jamestown

Yorktown

Petersburg

⑤ Surry
10

JAMES R.

US 17

31
Bacon's Castle

Newport News
③

I-64

RICHMOND –
WILLIAMSBURG, 40 M.
WILLIAMSBURG –
NEWPORT NEWS, 20 M.
NEWPORT NEWS – NORFOLK, 2 M.
NORFOLK – RICHMOND, 60 M.

US 460

Portsmouth
I-264

Norfolk
④

① RICHMOND
Virginia Museum of Fine Arts Valentine Museum
Association for the Preservation of Virginia Antiquities

② WILLIAMSBURG
Colonial Williamsburg Abby Aldrich Rockefeller Folk Art Center
Carter's Grove Plantation Jamestown Festival Park

③ NEWPORT NEWS
Mariners Museum

④ NORFOLK
Chrysler Museum Amphibious Museum

⑤ SURRY
Bacon's Castle

⑥ CHARLES CITY
Berkeley Plantation Shirley Plantation Sherwood Forest Plantation

0 MILES 30

palacios

ter, 307 S. England St. (daily 12–6 in winter, 12–8 in summer; no charge [donation]), with its lively Everyman's arts; marvel at the formal magnificence of the Governor's Palace; tour all the other houses, large and small, rich and poor, which show a stylistic unity and reflect the cultural richness of 18th C. life, as at nearby Carter's Grove Plantation (daily 9–5, closed Jan., Feb.; fee), a very fine 1750 house also administered by Colonial Williamsburg, superbly furnished, in period setting. Visit state-run Jamestown Festival Park, with reproductions of the *Susan Constant*, the *Godspeed*, and the *Discovery*, the three small vessels that brought the colonists over in 1607, and the Jamestown Island area a few miles away, on Colonial Parkway (VA, Rt. 31, open daily; fee). Yorktown, also full of history, is a dozen or so m. E of Williamsburg. Berkeley Plantation, Sherwood Forest Plantation, and Shirley Plantation are in Charles City County, 20 m. N on VA Rt. 2 en route to Richmond. The College of William and Mary, located in Williamsburg, is the second oldest American institution of higher learning after Harvard; it has a beautiful campus, with Wren-style buildings. The Williamsburg Visitor's Center, on Colonial Parkway and VA Rt. 132, has information about the area.

WASHINGTON

Bremerton: Naval Shipyard Museum 1954
Washington State Ferry Terminal Bldg.; mailing address: 1145 Titt Ave., 98310 (206 377-3546)
Daily 12–4; closed holidays.
No charge

A maritime collection pertaining to the history of the Puget Sound Naval Shipyard; USS *Missouri*.

Goldendale: Maryhill Museum of Fine Arts 1922
Hwy. 14, 98620 (509 773-4792)
Mar. 15–Nov. 15, daily 9–5;
otherwise closed. Fee

European and American painting, sculpture, and decorative arts in a collection that also incl. Rodin drawings and sculpture, Northwest Coast Indian arts, icons and other ecclesiastical objects, textiles, and memorabilia of Queen Marie of Romania.

Pullman: Museum of Art 1974
Washington State University, 99164 (509 335-1910)
Mon., Fri. 10–4 and 7–10, Tues.-Thurs. 10–4; Sat.–Sun. 1–5;
closed Aug. 1–Sept. 15, 2 weeks during Christmas, first 2 weeks in June. No charge

A selective collection of late 19th C. and 20th C. American paintings, and art of the Pacific Northwest since the mid 19th C. ☛ Paintings of the Ash Can School (also known as The Eight).

Seattle: Charles and Emma Frye Art Museum 1952
704 Terry Ave., 98104; mailing address: Box 3005, 98114
(206 622-9250)
Mon.-Sat. 10–5; Sun., holidays 12–6; closed Thanksgiving, Christmas. No charge

A very personal collection, largely consisting of Munich School academic paintings from 1850 to 1925, relieved by a few French and American late 19th and 20th C. paintings—all hung in a crowded fashion determined by the donors, giving the whole a period look. ☛ Two fine European pre-Impressionists, Johan Barthold Jongkind's *Moonlight Scene,* with a luminous sky typical of this often underrated Dutch artist, and Eugène Boudin's contemporary *View of the Harbor at Le Havre,* freely painted and full of movement; for contrast, glance at Franz von Stück's *Sin.*

Henry Art Gallery 1927
University of Washington, 15th Ave. NE and NW 41st St., 98195
(206 543-2280)
Mon.-Wed., Fri. 10–5; Thurs. 10–5 and 7–9; Sat.-Sun. 1–5; closed university holidays. Fee

A collection of 19th–20th C. European and American paintings, drawings, and prints; African art; Japanese folk art; American contemporary ceramics; outstanding collection of works by Northwest Coast artists, esp. Mark Tobey and Morris Graves. ☛ ★ A spacious *Adirondack Lake* (1870) by Winslow Homer; Morris Graves' *Chalice with Moon,* in his distinctive, poetic, Zen-inspired style.

Seattle Art Museum 1917
Volunteer Park, 98112
(206 447-4710)
Tues.-Wed., Fri.-Sat. 10–5; Thurs. 10–9; Sun., holidays 12–5; closed Mon., major holidays. Fee except Thurs.

In a distinctive Art Deco building dating from the thirties, in a park setting with a spectacular view, a varied general collection of world art, incl. outstanding examples from China, Japan, and India; Western art since ancient times; Old Masters; Nepalese, Southeast Asian, Korean, and Islamic art; European and American art up to the present; Pre-Columbian and African art; European decorative arts, with an emphasis on porcelain. ☛ ★ Monumental Chinese tomb guardian figures, dating from the 12th to the 17th C., which line the entrance walk as they once lined the ceremonial way to imperial tombs; a particularly impressive *Haniwa Warrior,* a Japanese 6th C. grave figure of the Late Kofun period, in painted pottery; an amusing, pot-bellied T'ang ceramic figure of an *Armenian Merchant with a Wineskin* (8th C.). ★ A magical, early 17th C. hand scroll in ink with gold and silver, painted by Tawaraya Sōtatsu, with calligraphy by the poet Hon-ami Kōetsu, combined in a

uniquely Japanese art form. (*Note:* The museum's contemporary collection is mainly shown downtown in the Modern Art Pavilion, Seattle Center, 2nd and Thomas Sts., 98112 [same telephone number and hours.])

• Wing Luke Memorial Museum, 414 8th Ave. S., 98104 (206 623-5124; Tues.–Fri. 11–4:30; closed weekends, Mon., holidays; no charge) has ethnic collections relating to Chinese settlers in Seattle and the American Northwest.

Tacoma Art Museum 1890
12th and Pacific Ave., 98402
(206 272-4258)
Mon.–Sat. 10–4; Sun., holidays 12–5. No charge

American 20th C. art, with some emphasis on the arts of the Northwest and The Eight; Japanese prints; American glass, ceramics, and other decorative arts. A distinguished ★ Maurice Prendergast watercolor, *Coast Scene at Newport* (1905), executed in his beautifully fresh, mosaic-like style.

WEST VIRGINIA

Charleston: Sunrise Foundation 1961
746 Myrtle Rd., 25314
(304 344-8035)

Fall, winter, spring: Tues.–Sat. 10–5; Sun. 2–5; closed Mon.; summer: Tues.–Sat. 10–4; closed Sun.–Mon.; closed national holidays. No charge

In a former residence in a parklike setting, a collection primarily consisting of 19th–20th C. American painting, sculpture, drawings, prints, and decorative arts; Native American, Oceanic, and African arts; natural history displays.

• West Virginia Department of Culture and History, Capitol Complex, 25305 (304 348-0232; Mon.–Fri. 9–9; Sat., Sun., holidays, 1–9; closed Christmas; no charge) has extensive and varied historical collections, incl. fine, folk, and decorative arts of the area.

Huntington: The Huntington Galleries 1947
2033 McCoy Rd., 25701
(304 529-2701)
Tues.–Sat. 10–4; Sun. 1–5; closed Mon., New Year's, Christmas. No charge

In an art center in a wooded setting, with a large 1970 addition by Walter Gropius of Bauhaus fame, a collection of 19th C. European paintings; 19th–20th C. American paintings and sculpture; European and American drawings and prints; English 18th C. silver; 19th–20th C. American glass, plus American decorative arts; Dean

Collection of Firearms; Pre-Columbian art; Turkish prayer rugs.

WISCONSIN

Baraboo: Circus World Museum
1959
426 Water St., 53913
(608 356-8341)
**Mid-May-mid-Sept.: daily
9:30-6; closed remainder of year.
Fee**

On the site of the winter quarters of the Ringling Bros. Circus (1884–1918), a large circus collection consisting of 149 circus wagons, railway cars, and other objects, with archives, posters, programs, prints, photographs; steam calliope; and a program incl. live circus performances.

**Beloit: Theodore Lyman Wright
Art Center** 1892
Beloit College, 53511
(608 365-3391)
**Mon.-Fri. 9-5; Sat. 11-5; Sun.
1-5; closed college holidays.
No charge**

A selection of Far Eastern art, incl. Korean pottery; European and American painting, sculpture, and graphic arts, incl. German Expressionist drawings and prints; photography.

Kenosha Public Museum 1933
5608 10th Ave., 53140
(414 656-6026)
**Mon.-Fri. 9-5; Sat. 9-12; Sun.
1-4; closed national holidays.
No charge**

In the Old Post Office Building, a small collection that incl. Far Eastern decorative arts; primitive arts from North America, Africa, and Oceania; paintings. ☛ ★ A late painting by George Loring Brown, *The Bay of Naples* (1874), a member of the Hudson River School whose work was much admired by Nathaniel Hawthorne.

**Madison: Elvehjem Museum of
Art** 1962
**University of Wisconsin
800 University Ave., 53706**
(608 263-2246)
**Mon.-Sat. 9-4:45; Sun. 11-4:45;
closed major holidays. No charge**

One of the three largest university museums in the country, with an outstanding collection of world art dating back to ancient times, with special strengths in classical coins and marbles; European painting, sculpture, and decorative arts from the Renaissance through the 19th C.; American painting, sculpture, and decorative arts from the 18th C. to the present; an unusual and unexpected collection of Socialist Realist (read propagandistic) paintings from the USSR given by alumnus Joseph E. Davies, a

former American ambassador to Russia, along with a collection of icons; ancient glass; Far Eastern and European porcelains; Indian miniatures; a large and important collection of drawings and prints from the Renaissance to the present; Pre-Columbian and African artifacts. ☛ ★ An appealing carved and painted wood processional figure from Austria of *Christ Riding a Donkey*, still Gothic in style and spirit, though sculptured in the mid-15th C. for use on Palm Sunday; a fine and rare marble *tondo* ★ relief of *The Madonna and Child* (late 15th C.) by the Florentine sculptor, Benedetto da Maiano (compare the clarity of form and expression with the murky Mannerism of *The Adoration of the Shepherds,* painted a century later by Giorgio Vasari, another Florentine best known for his famous *Lives of the Most Eminent Painters, Sculptors, and Architects*); look twice at the ★ Russian icons—there are some very fine examples of this sophisticated, abstract, and deeply devotional art.

Madison Art Center 1901
Civic Center, 211 State St., 53703
(608 257-0158)
Tues.-Thurs., Sat. 10-5; Fri. 10-9; Sun. 1-5; closed Mon., national holidays. No charge

A varied collection strong in prints, from Old Masters to the present, incl. Japanese prints; 19th C. European and American paintings; a growing collection of experimental contemporary art.

Manitowoc Maritime Museum
1969
809 S. 8th St., 54220
(414 684-0218)
Open daily; June 1-30, daily 9-5; July 1-Sept. 30, daily 9-6; Oct. 1-May 31, Mon.-Fri. 9-5; Sat.-Sun. 10-4. Fee

A maritime collection, with emphasis on submarines and Great Lakes shipping; models, artifacts, archive; historic submarine, USS *Cobia.*

Milwaukee Art Museum 1888
750 N. Lincoln Memorial Drive, 53202 (414 271-9508)
Tues., Wed., Fri.-Sat. 10-5; Thurs. 12-9; Sun. 1-6; closed Mon., major holidays. Fee

In a landmark building, overlooking Lake Michigan, designed by Eero Saarinen in 1957, with a sizable 1975 addition, a large collection, primarily Western, from Egyptian times to the present, with the emphasis on European and American art from the 19th C. to the present; the Ash Can School; Haitian art; German Expressionist art; Old Masters; sculpture, decorative arts, graphic arts, photography; archive of the Prairie School of Architecture. ☛ Francisco de Zurbarán's mystical *St. Francis* (1631-32); an early Fragonard, still

Boucher-like, of a *Shepherdess* (c. 1750); a fine example of Eastman Johnson's mature period of genre painting, *The Old Stage Coach* (1871); a modern-to-contemporary sculpture collection, starting with Rodin's powerful, tragic, pioneering *Walking Man*. (*Note:* Villa Terrace, an Italianate house nearby, contains the center's decorative arts, with English and American period rooms, and a Shaker collection.)
• Marquette University Committee on the Fine Arts, 402 Varsity Bldg., 1324 W. Wisconsin Ave., 53233 (414 224-7290; Mon.–Fri. 8–8; Sun., some holidays 1–4; special exhibitions Sept.–May: Mon., Wed., Fri. 2–4; Tues., Thurs. 2–4 and 7–9; closed major holidays; no charge) has a collection that incl. 16th–19th C. European paintings; regional and international 20th C. works; graphics, sculpture, and decorative arts.
• Charles Allis Art Museum, 1630 E. Royall Pl., 53202 (414 278-8295; Wed.–Sun. 1–5; Wed. also 7–9; closed Mon., Tues., major holidays; no charge) is a palatial Tudor-style house (1909) with a collection of French 18th C. decorative arts; Barbizon School paintings; 19th C. American landscapes; classical, Far, and Near Eastern objects; prints and drawings.
(*Note:* The University of Wisconsin at Milwaukee has Art History Galleries [414 963-4330 or 963-4060; Mon., Tues., Thurs., Fri. 1–

4; Wed. 6–9; closed holidays; no charge], with Greek and Russian icons and liturgical objects, and Fine Arts Galleries in the School of Fine Arts, 2400 E. Kenwood Blvd., 53211 [414 963-4946; Mon., Tues., Thurs., Fri. 10–4; Wed. 6–9; Sun. 1–4; closed Sat., major holidays, no charge], with a largely 20th C. collection of paintings, sculpture, graphic arts, photographs, some Far Eastern objects, and Old Master prints.)

Neenah: John Nelson Bergstrom Art Center and Mahler Glass Museum 1963
165 N. Park Ave., 54956
(414 722-3348)
Sept.–May: Wed.–Fri. 12–4:30; Sat.–Sun. 1–4:30; closed Mon.–Tues.; June–Aug.: Tues.–Fri. 12–4:30; Sat.–Sun. 1–4:30; closed Mon.; closed holidays except Easter. No charge

A glass collection strong in antique glass paperweights.

Oshkosh: Paine Art Center and Arboretum 1947
1410 Algoma Blvd., 54901; mailing address: Box 1097, 54902
(414 235-4530)
Memorial Day–Labor Day: Tues.–Sun. 1–4:30; closed Mon.; Labor Day–Memorial Day: Tues., Thurs., Sat., Sun. 1–4:30; closed Mon., Wed., Fri.; closed holidays. No charge

In a Tudor-style mansion located

in a beautifully planted and landscaped setting, handsomely furnished English period rooms from the 15th C. to the Victorian era, plus a collection strong in Barbizon School, English 18th–19th C., and American 19th C.; Russian and Greek icons; decorative arts. ☞ ★ A beautifully serene and spacious landscape, *Morning on the Oise* (1866), by Charles François Daubigny, a friend of Corot and Monet, who linked the Barbizon School with the Impressionist movement; among several George Innesses, note esp. his late, tumultuous, stormy ★ *Off the Coast of Cornwall* (1887), where the brushwork expresses the turbulence of wind and water; the fine, free Homer watercolor of *Lake St. John, Canada* (1895), is comparatively restrained and understated.

• Oshkosh Public Museum, 1331 Algoma Blvd., 54901 (414 424-0452; Tues.–Sat. 9–5; Sun. 1–5; closed Mon., national holidays; no charge) has, among historical and natural historical collections, paintings, sculpture, and decorative arts material, incl. china and glass.

Port Washington: Sunken Treasures Maritime Museum 1976
Box 64, 53074 (414 284-3857)
Memorial Day–Labor Day: daily 10–8; Sept.–Oct.: Sat.–Sun. 10–7; closed weekdays, major holidays. Fee

A collection pertaining to Great Lakes shipping, with dioramas of sunken ships.

WYOMING

Big Horn: Bradford Brinton Memorial Museum 1960
Box 23, 82833 (307 672-3173)
May 15–Labor Day, daily 9–5; otherwise by appointment. No charge

On the edge of the Big Horn National Forest several miles outside of Sheridan, a ranch house furnished with paintings and sculpture of the Old West, American Indian arts and crafts, rare books, and historic documents pertaining to the American West.

Cody: Buffalo Bill Historical Center 1917
West End of Main St., Box 1000, 82414 (307 587-4771)
Mar.–Apr. and Oct.–Nov.: Tues.–Sun. 1–5; closed Mon.; May, Sept.: daily 8–5; June–Aug., daily 7–10; closed Dec.–Feb., major holidays. Fee

Near the eastern entrance to Yellowstone National Park, the center is comprised of four parts: the Plains Indian Museum, with a collection of arts and artifacts of the Plains tribes; the Whitney Gallery of Western Art, with a good historical collection of paintings and sculptures pertaining to the Old West; the Buffalo Bill Historical Center, with memorabilia of that colorful personality; and the Winchester Museum, with an extensive collection, formerly shown in New Haven, CT, of Winchester

firearms. ☛ Bierstadt's grandiose *Yellowstone Falls* (c. 1860), an example of the romantic panoramas this Hudson River School artist painted of scenery of the American West, to great critical and popular acclaim; ★ Remington's tautly expressed *Night Herder,* painted late in the century; compare it with Russell's all-out cowboys-and-Indians dramatics in *The Attack on the Wagon Train* to understand a fundamental difference between these two artists of the Old West.

Laramie: University of Wyoming Art Museum 1960
Fine Arts Center, N. 19th St. and Willet, Box 3138, 82071
(307 766-2374)
During university session: Sun.-Fri. 1:30–5; summer school session: Sun.-Fri. 1–4:30; closed Sat., university holidays.
No charge

A collection primarily consisting of 19th–20th C. American paintings, sculpture, and graphic arts. ☛ *La Femme aux Fleurs*, an example of the Second Empire style of Alfred Stevens, an accomplished and fashionable Belgian painter (not to be confused with the English sculptor of the same name!) rarely represented in American collections.

Rock Springs: Community Fine Arts Center 1938
400 C. St., 82901
(307 362-6212)

Winter: Mon.-Fri. 1–5 and 6:30–8:30; Sat. 2–5; summer: Mon.-Fri. 1–5 and 6–8; Sat. 2–5; closed Sun., major holidays.
No charge

In a remodeled Mormon church, a collection of American 20th C. painting, sculpture, and graphic arts acquired over a 30-year period by students of Rock Springs High School. ☛ A fine and sensitive Raphael Soyer, *Girl in a Brown Jacket,* of the early 1940s; Norman Rockwell's *New Year's Eve* of the same period; Grandma Moses' delightful and cheerful *Staunton, Virginia* (1946).

PUERTO RICO

Ponce: Museo de Arte de Ponce 1950
Ave. Las Americas, Box 1492, 00731
(809 842-6215 and 840-1510)
Mon., Wed.-Fri. 10–12 and 1–4; Sat. 10–4; Sun. 10–5; closed Tues., New Year's, Good Friday, Three Kings Day, Christmas.
Fee

In a picturesque Hispanic-style building, a collection of primarily European paintings and sculptures, with an emphasis on the Mediterranean countries; decorative arts, incl. glass and Far Eastern ceramics; archeological artifacts of the native cultures of the island.

161

San Juan: Museo de Bellas Artes
1967
**Calle del Santo Cristo de la Salud
253, 00901** (809 723-2320)
**Mon., Wed., Fri. 9-12 and
1-4:30; Sat.-Sun., holidays 9-5;
closed Tues., Thurs., New Year's,
Good Friday, Christmas.
No charge**

In a distinguished 18th C. historic house, a collection of European, American, and Puerto Rican paintings, sculptures, and graphic arts. (*Note:* Puerto Rico has a very venerable and colorful history, of which many fascinating examples remain in the form of historic buildings and fortifications; for example, around San Juan Harbor, in the Zona Historica, and at the San Juan National Historic Site, administered by the National Park Service, where information is available; also check with the Instituto de Cultura Puertorriquena, Box 4184, San Juan, PR, 00905.)
• Ateneo Puertorriqueno, Ponce de Leon, Stop 1, 00902 (809 724-8608; Mon.-Fri. 9-9; Sat. 9-5; closed Sun., national and local holidays; no charge) has a collection of paintings and other arts of Puerto Rico, incl. historical and scientific material, and a large library covering all aspects of Puerto Rican history and culture.
• La Casa del Libro, Calle de Cristo 255, 00903 (809 723-0354; Mon.-Fri. 11-5; closed weekends, national and local holidays; no charge) has an important collec-

tion pertaining to bookmaking, calligraphy, typography, papermaking, design, and binding—all well displayed in a historic 18th C. Colonial town house; library and archive.

AMERICAN SAMOA

**Pago Pago: Jean P. Haydon
Museum** 1971
**Box 1540, Pago Pago, American
Samoa, 96799
Mon.-Fri. 10-4; Sat. 10-12; closed
Sun., holidays. No charge**

Housed in an early 20th C. post office building, a collection of arts, crafts, artifacts, and various cultural and historical materials pertaining to Samoa.

CANADA

ALBERTA

Banff: Luxton Museum 1953
Birch Ave., T0L 0C0
(403 762-2388)
**Fall, winter, spring, Tues.-Sun.
10-12 and 1:30-5; closed Mon.;
summer, daily 9-9; closed New
Year's, Christmas, Dec. 26. Fee**

A collection of arts, artifacts, and other material pertaining to the culture and history of the Plains Indians.

The Edmonton Art Gallery 1924
**2 Sir Winston Churchill Sq., T5J
2C1** (403 429-6781)
**Mon.-Wed., Sat. 10:15-5;
Thurs.-Fri. 10:15-10; Sun.,
holidays 1:15-5; closed New
Year's, Christmas. No charge**

In an interesting modern building, a collection of Canadian painting, sculpture, and graphic arts from the early 19th C. to the present; international contemporary arts; photography; crafts; Junior Gallery for young people.
• Ring House Gallery, University of Alberta, T6G 2E2 (403 432-5818; Mon., Wed., Fri. 11-4; Thurs. 11-9; Sun. 2-5; closed Tues., holidays; no charge) has a growing collection of fine and decorative arts and antiquities.

BRITISH COLUMBIA

**Burnaby: The Simon Fraser
Gallery** 1971
Simon Fraser University, V5A 1S6
(604 291-4266)
**Mon. 1:30-4, 5-8; Tues.-Fri. 10-1
and 2-4; closed weekends,
holidays. No charge**

Painting, sculpture, and graphic arts by Canadian artists; Eskimo prints and drawings; international graphic arts.
• Burnaby Art Gallery, 6344 Gilpin St., V5G 2J3 (604 291-9441; Mon., Tues., Thurs., Fri. 10-5; Wed. 10-9; Sat., Sun. 12-5; closed Christmas; no charge) has a collec-

tion primarily of Canadian prints, with some paintings and other objects; the gallery sponsors an active arts program in a former residence located in handsome Century Park.

**Campbell River and District
Museum** 1958
1235 Island Hwy., V9W 2C7
(604 287-3103)
**May 15-Sept. 15: Tues.-Sat.
10-4; Sept. 16-May 14: Tues.-
Sat. 1-4; closed Sun., Mon.,
holidays. No charge**

A collection of Northwest Coast Indian art, including the Kwakiutl, Coast Salish, and Nootka; historic photograph archive.

**Prince Rupert: Museum of
Northern British Columbia** 1924
**McBride St. and First Ave., Box
669, V8J 3S1** (604 624-3207)
**May 15-Aug. 31: daily 9-9; Sept.
1-May 14: Mon.-Sat. 9-4; closed
Sun.; closed holidays. No charge**

Northwest Coast Indian arts and artifacts, incl. totem poles, weapons, etc.

**Skidegate: Queen Charlotte
Islands Museum** 1976
Second Beach, V0T 1S0
(604 559-4643)
**Oct.-May: daily 1-5; June-Sept.:
Mon.-Fri. 9-12 and 1-5; Sat.-
Sun. 1-5 (all hours subject to
change); closed legal holidays.
No charge (donation accepted)**

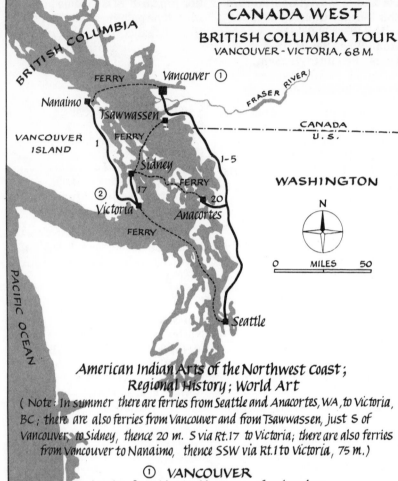

CANADA WEST

BRITISH COLUMBIA TOUR
VANCOUVER - VICTORIA, 68 M.

BRITISH COLUMBIA

FERRY — Vancouver ①

FRASER RIVER

Nanaimo

Tsawwassen

CANADA
U.S.

VANCOUVER ISLAND

FERRY

Sidney

I-5

WASHINGTON

1

17

FERRY

② Victoria

20

Anacortes

N

FERRY

O MILES 50

PACIFIC OCEAN

Seattle

American Indian Arts of the Northwest Coast; Regional History; World Art
(Note : In summer there are ferries from Seattle and Anacortes, WA, to Victoria, BC; there are also ferries from Vancouver and from Tsawwassen, just S of Vancouver, to Sidney, thence 20 m. S via Rt.17 to Victoria; there are also ferries from Vancouver to Nanaimo, thence SSW via Rt.1 to Victoria, 75 m.)

① VANCOUVER
University of British Columbia Museum of Anthropology
Vancouver Art Gallery Vancouver Museum Vancouver Maritime Museum
Vancouver Public Aquarium Vancouver Gastown Historic District
(Fort Langley National Historic Park, with the Hudson Bay Company Post Museum,
15 m. SE via Rt.1A)

② VICTORIA
Art Gallery of Greater Victoria Maltwood Art Museum and Gallery
Maritime Museum of British Columbia
(Fort Rodd National Historic Park, with the last of the large forts on the Pacific coast,
just W of Victoria)

On the site of a historic Haida Indian Village, a collection of the arts and crafts of the Haida and other groups of the area; archeological and natural history material.

Vancouver: The University of British Columbia Museum of Anthropology 1948
6393 Northwest Marine Dr., V6T 1W5 (604 228-5087)
Winter: Tues. 12–9; Wed.–Sun. 12–5; summer: Tues. 12–9; Wed.–Sun. 12–7; closed Mon., holidays. Fee

A fine collection of Northwest Coast Indian arts and artifacts; Far Eastern art; tribal ethnographic material.

The Vancouver Art Gallery 1931
1145 W. Georgia St., V6E 3H2
(604 682-5621)
Tues., Thurs.–Sat. 10–5; Wed. 10–10; Sun. 1–5; closed New Year's, Christmas. No charge

Mainly Canadian paintings, drawings, and prints, with an emphasis on West Coast artists; 18th to early 20th C. British oils and watercolors; contemporary American prints.

Vancouver Maritime Museum 1958
1905 Ogden St., mailing address: 1100 Chestnut St., V6J 3J9
(604 736-4431)

Winter: daily 10–5; summer: daily 10–9. Fee

A maritime collection with large and small historic vessels, models, paintings, photographs, artifacts, and archival material pertaining to shipping on the Northwest Coast.
• Vancouver Museum, 1100 Chestnut St., V6J 3J9 (604 736-4431; daily 10–9; fee) has, among varied historical and natural history collections, Northwest Coast and other Indian artifacts and archeological material.
(*Note:* The Vancouver Public Aquarium, Box 3232, Stanley Park, V6B 3X8 [summer, daily 9–9; winter, daily 10–5; fee] is unusually fine, with displays of everything from live belugas and dolphins to crocodiles.)

Victoria: Art Gallery of Greater Victoria 1945
1040 Moss St., V8V 4P1
(604 384-4101)
Mon.–Wed., Fri.–Sat. 10–5; Thurs. 10–9; Sun. 1–5; closed Mon., holidays. Fee

A fine, varied collection that incl. European painting, sculpture, and decorative arts from the Renaissance through the 19th C.; Canadian, American, and European contemporary arts; Far Eastern arts from China and Japan; the arts of Tibet, India, Persia; primitive arts.

Maritime Museum of British Columbia 1953
30 Bastion Sq., V8W 1I9
(604 385-4222)
Labor Day–June 30: Mon.–Sat. 10–4; Sun. 12–4; July 1–Labor Day: daily 10–6; closed New Year's, Christmas. Fee

A collection of paintings, prints, models, ship carvings, weapons, and other maritime artifacts, both naval and merchant marine; library and archive.

• Maltwood Art Museum and Gallery, University Centre University of Victoria, Box 1700, V8W 2Y2 (604 477-6911; Mon.–Sat. 10–4, Sun. 12–4; closed university holidays; no charge) has a collection of recent Canadian arts, Far Eastern and European decorative arts, European paintings, graphic arts, and costumes.

MANITOBA

Churchill: Eskimo Museum 1944
242 La Verendyre St., R0B 0E0
(204 675-2541)
Mon.–Sat. 9–12 and 1–5; Sun. 1–4. No charge

In this extreme northern settlement on Hudson Bay, a museum devoted to the arts, crafts, culture, and history of the Eskimos, with artifacts of the Pre-Dorset, Dorset, and Thule cultures, plus contemporary Inuit arts and artifacts.

Selkirk: Marine Museum of Manitoba 1972
Box 7, R1A 2B1 (204 482-7761)
May–Sept.: Mon.–Sat. 10–6; Sun. 11–7; closed Oct.–Apr. Fee

Nautical artifacts displayed in two historic Lake Winnipeg vessels.

The Winnipeg Art Gallery 1912
300 Memorial Blvd., R3C 1V1
(204 786-6641)
Tues.–Sat. 11–5; Sun. 12–5; closed Mon., major holidays. No charge

A fine collection of Canadian and Eskimo art; medieval and Renaissance German paintings; Flemish tapestries; prints and drawings from the Renaissance to the present; contemporary European, Canadian, and American art.

• Gallery 1 1 1, University of Manitoba, R3T 2N2 (204 474-9367; May–mid-Sept.: Mon.–Fri. 8:30–4:30; closed weekends; mid-Sept.–Apr.: Mon., Thurs.–Fri. 9–5; Tues.–Wed. 9–5 and 6–9; Sat. 9–12; closed Sun.; closed holidays; no charge) has a collection of international contemporary painting, sculpture, and prints.

• Manitoba Museum of Man and Nature, 190 Rupert Ave., R3B 0N2 (204 956-2830; mid-May–mid-Sept.: Mon.–Sat. and holidays 10–9; Sun. 12–9; mid-Sept.–mid-May: Mon.–Sat. 10–5; Sun. and holidays 12–6; fee) has fine collections of Northwest Coast, Eskimo, and other Native American cultures.

NEW BRUNSWICK

**Caraquet: Village Acadien —
Outdoor Museum** 1971
Box 820, E0B 1K0
(506 732-5350)
Daily 10–6. Fee

In this small port on Chaleur Bay, a collection of Acadian arts and artifacts in a museum located on the site of an early 18th C. Acadian village.

**Fredericton: Beaverbrook Art
Gallery** 1959
703 Queen St., Box 605, E3B 5A6
(506 455-6551)
**June 1–Sept. 7: Tues.–Sat. 10–7;
Sun. 12–7; Sept. 8–May 31:
Tues.–Sat. 10–5; Sun. 12–5;
closed New Year's, Christmas.
Fee**

A collection primarily consisting of 18th–20th C. British painting; Canadian painting; English prints, porcelains, sculpture, and decorative arts.

Moncton: Acadian Museum 1886
**University of Moncton, Edifice
Clement Cormier, E1A 3E9**
(506 858-4082)
Inquire for hours

A historical collection pertaining to Acadian culture and crafts. (*Note:* The university also has an art gallery displaying examples of Canadian arts; inquire for hours.)

NEWFOUNDLAND

St. John's: Art Gallery 1961
**Memorial University of
Newfoundland, Arts and Culture
Centre, Prince Philip Dr. and
Allendale Ave., A1C 5S7**
(709 737-8209)
**Tues.–Sun. 12–10; closed Mon.,
Good Friday, Easter, Dec.
24–Jan. 1. No charge**

A collection primarily consisting of contemporary Canadian artists but also incl. historic-to-contemporary folk arts of Newfoundland and Labrador.

NOVA SCOTIA

Cheticamp: Acadian Museum
1963
**Main St., Iverness Co., Box 98,
B0E 1H0** (902 224-2170)
**June 15–Sept. 30, Mon.–Sat. 8–9;
Sun. 9–6; closed Oct. 1–June 14.
No charge (donation accepted)**

In this Northwest coastal community, just S of Cape Breton Highlands National Park, a museum devoted to Acadian history, with arts, crafts, and cultural artifacts.

**Grand Pré National Historic
Park** 1922
Grand Pré, B0P 1M0
(902 542-3631)
**June 15–Oct. 15: daily 9–6; Oct.
16–June 14: daily 8:30–5.
No charge**

St. Charles Church, burned at the time of the deportation of the Acadians in 1755, has been restored, and a museum devoted to Acadian history and culture has been established on this historic site.

Halifax: Art Gallery of Nova Scotia 1975
6152 Coburg Rd., Box 2262, B3J 3C8 (902 424-7542)
Mon., Wed., Fri., Sat. 10-5:30; Tues., Thurs. 10-9; Sun. 12-5:30.
No charge

In connection with the picturesque and historic Citadel, there are history and military displays; the Art Gallery contains a collection of Nova Scotian folk arts, as well as Canadian and other paintings, sculpture, drawings, and prints. (*Note:* There are a number of historic buildings in Halifax and scattered about Nova Scotia; many are administered by the Nova Scotia Museum, 1747 Summer St., Halifax, E3H 3A6 [902 429-4610]; the Nova Scotia Travel Bureau, Dept. of Trade and Industry, Halifax, also has information.)

Wolfville: Acadia University Art Gallery 1838
Main St., B0P 1X0
(902 542-2201, ext. 373)
Tues.-Thurs. 10-1, 2-5; Fri., Sun. 2-5.
No charge

Collection incl. 20th C. Canadian paintings and drawings; marine paintings; Eskimo sculpture; artifacts and textiles from Southeast Asia and Africa.

ONTARIO

Hamilton: Art Gallery of Hamilton 1914
123 King St. W, L8P 4S8
(416 527-6610)
Tues., Wed., Fri., Sat. 10-5; Thurs. 10-5 and 7-9; Sun. 1-5; closed Mon., July 1, Christmas, New Year's, Good Friday.
No charge

One of the important art collections in North America, with outstanding examples of Canadian art; 20th C. British and American painting, sculpture, drawings, and prints; French Impressionists. ☛ ★ Collection of the Group of Seven, the pioneering group of Canadian painters who contributed so much to the development of the arts in the earlier decades of this century.

Kingston: Agnes Etherington Art Centre 1957
Queens University, University St., K7L 3N6 (613 547-6551)
Tues., Thurs., 10-5 and 7-9; Wed., Fri.-Sun. 10-5; closed Mon., Christmas, New Year's, Good Friday, Labor Day.
No charge

A fine collection of 19th–20th C. Canadian painting, sculpture, and prints; European paintings since the 17th C.; European prints and drawings; 18th C. British silver.

Kleinburg: The McMichael Canadian Collection 1965
L0J 1C0 (416 893-1121)
Tues.–Sun., Mon. holidays
12–5:30; closed Mon. except holidays. No charge

A dozen miles or so NW of Toronto, overlooking the Humber River Valley, a fine collection of Canadian painting featuring works by the Group of Seven; Eskimo and Northwest Coast Indian arts, and arts of the Woodland tribes.

London: McIntosh Gallery 1942
University of Western Ontario,
N6A 3K7 (519 679-3181)
Sept.–Apr.: Mon.–Tues., Fri.
10–5; Wed.–Thurs. 10–5 and 7–9;
Sat.–Sun. 2–5; May–Aug.:
Mon.–Fri. 10–4; Sun. 2–5; closed
Sat.; closed Canadian holidays.
No charge

A collection mainly of 19th–20th C. Canadian art, incl. paintings, drawings, prints; 19th–20th C. European and British art; sculpture.

Ottawa: National Gallery of Canada 1880
Elgin St., K1A 0M8
(613 992-3110)
Daily 10–5 except closed Mon.
Sept.–Apr. No charge

An outstanding collection of Canadian painting, sculpture, decorative and graphic arts from the 17th C. to the present; European paintings from Old Masters to the modern period; American painting and sculpture; important prints and drawings from the Old and New Worlds; photographs.
☛ ★ A beautiful, glowing Corot, *The Bridge at Narni* (1827), plus a preparatory drawing, one of the loveliest Corots on this side of the Atlantic; Daumier's compassionate *Third-class Carriage* c. 1865 (another version is in the Metropolitan Museum of Art, and a drawing is in the Walters Art Gallery, Baltimore); two large, fine Canaletto Venetian views and a group of spirited Guardi drawings; an outstanding set of masterful Tiepolo drawings; a lyrical Claude Lorrain view of *The Temple of Bacchus, Evening* (c. 1650), plus several landscape and figure studies, esp. *A Tall Tree with a Man Climbing;* ★ Constable's *Salisbury Cathedral from the Bishop's Grounds* (c. 1823) (compare this with the versions in The Frick Collection and the Metropolitan Museum of Art).

National Museum of Man 1845
Victoria Memorial Museum
Bldg., Metcalfe and McLeod Sts.,
K1A 0M8 (613 992-3497)
Labor Day–June: Tues.–Sun.
10–5; closed Mon.; July–day
before Labor Day: daily 10–5;
closed Christmas. No charge

Along with outstanding collections pertaining to history and folk culture, there are fine collections of the arts and crafts of Native Americans, esp. Northwest Coast Indians and Eskimos.

• National Film Board of Canada Photo Gallery, Still Photography Division, Tunney's Pasture, K1A 0N1 (613 992-7494; daily 12–6; closed Good Friday, Christmas, New Year's; no charge) has a growing collection of photographs by Canadian photographers.

Owen Sound: Tom Thompson Memorial Gallery and Museum of Fine Art 1967
840 1st Ave. W (Mailing address: Box 312), N4K 5P5
(519 376-1932)
Sept.–June: Tues., Thurs., Sat.–Sun. 12–5, Wed.; Fri. 12–5 and 7–9; closed Mon.; July–Aug.: Mon.–Tues., Thurs., Sat.–Sun. 12–5; Wed., Fri. 12–5 and 7–9; closed national holidays. Fee

The core of the collection is the work of Tom Thompson, a member of the Group of Seven and a pioneer in Canadian painting, incl. paintings, drawings, and memorabilia; also represented is the work of other Canadian artists of this century; Native American arts and crafts. ☛ The work of Tom Thompson; in a way somewhat parallel to the Hudson River School painters, Winslow Homer, and the Region-

alists of the thirties in the U. S., Thompson and the other members of the Group of Seven rediscovered and celebrated the Canadian natural scene.

• County of Grey—Owen Sound Museum, 975-6th St. E, N4K 1G9 (519 376-3690; July–Aug.: Mon.-Sat. 9–5; Sun. 1–5; Sept.–June: Tues.–Fri. 9–5; Sat.–Sun. 1–5; closed Mon.; closed mid-Dec.-mid-Jan.; fee) has arts and crafts of the Ojibway, plus historic buildings and collections.

Sarnia Public Library and Art Gallery 1955
124 Christina St. S, N7T 2M6
(519 337-3291)
June–Sept.: Mon.–Fri. 9–9; Sat. 9–5:30; Sun. 1–5; Oct.–May: Mon.–Fri. 9–9; Sat. 9–5:30; Sun. 2–5; closed holidays. Fee

In this community on Lake Huron, across the St. Clair River from Port Huron, Michigan, a municipal gallery with a collection of Canadian art, mostly paintings by the Group of Seven and contemporary artists; some sculpture; Eskimo art.

Sudbury: Laurentian University Museum and Arts Centre 1967
John St. off Paris Overpass, P3E 2C6 (705 674-3271)
Tues., Fri. 12–9; Wed.–Thurs., Sat.–Sun. 12–5; closed Christmas, New Year's, Good Friday, Boxing Day. No charge

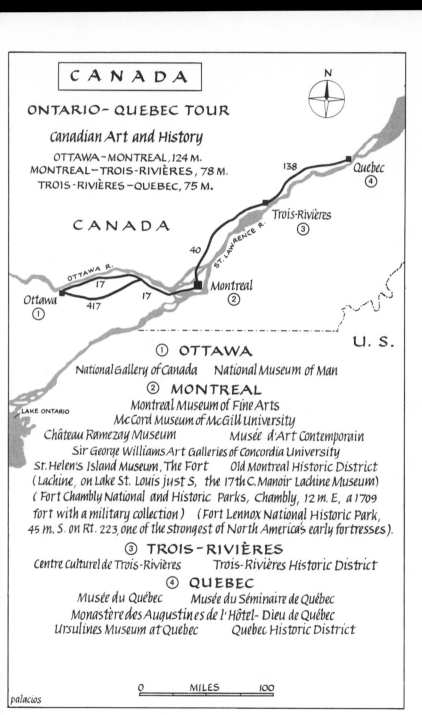

CANADA

ONTARIO - QUEBEC TOUR

Canadian Art and History

OTTAWA - MONTREAL, 124 M.
MONTREAL - TROIS-RIVIÈRES, 78 M.
TROIS-RIVIÈRES - QUEBEC, 75 M.

N

CANADA

OTTAWA R.

17

417 17

40 ST. LAWRENCE R.

138 Quebec ④

Trois-Rivières ③

Montreal ②

Ottawa ①

LAKE ONTARIO

U. S.

① OTTAWA
National Gallery of Canada National Museum of Man
② MONTREAL
Montreal Museum of Fine Arts
McCord Museum of McGill University
Château Ramezay Museum Musée d'Art Contemporain
Sir George Williams Art Galleries of Concordia University
St. Helen's Island Museum, The Fort Old Montreal Historic District
(Lachine, on Lake St. Louis just S, the 17th C. Manoir Lachine Museum)
(Fort Chambly National and Historic Parks, Chambly, 12 m. E, a 1709
fort with a military collection) (Fort Lennox National Historic Park,
45 m. S. on Rt. 223, one of the strongest of North America's early fortresses).

③ TROIS-RIVIÈRES
Centre Culturel de Trois-Rivières Trois-Rivières Historic District
④ QUEBEC
Musée du Québec Musée du Séminaire de Québec
Monastère des Augustines de l' Hôtel- Dieu de Québec
Ursulines Museum at Quebec Quebec Historic District

0 MILES 100

In this active mining center N of Georgian Bay, in a picturesque stone mansion, a growing university collection of 20th C. Canadian painting, sculpture, and graphic arts, plus Eskimo art.

Toronto: Art Gallery of Ontario 1900
317 Dundas St. W, M5T 1G4
(416 977-0414)
Tues., Fri.-Sun. 11-5:30; Wed.-Thurs. 11-9. Fee

An outstanding collection of Western art, particularly strong in Italian 15th-18th C., Dutch 17th C., French 17th-20th C., British 18th-20th C., and Canadian and American 19th-20th C. paintings, sculpture, drawings, and prints; the largest and most comprehensive collection of the sculptures, drawings, and prints of the outstanding contemporary British sculptor Henry Moore. ☛ Work of Henry Moore, a remarkable collection; The Grange, a handsome historic house built in 1817; an airy ★ Constable landscape, *Helmington Park, Suffolk,* typical in its dewy freshness and windy skies; Van Dyck's *Daedalus and Icarus* (c. 1620), a handsome mythological scene instead of the usual grand-manner Baroque portraits he was famous for; contrast with Poussin's essentially Classical treatment of *Venus Presenting Acneas with Arms Forged by Vulcan* (Acneas was Venus's son and Vulcan was her husband, but not Acneas' father—a great deal of classical mythology can be read as Olympian soap opera!); Sir Joshua Reynolds' insightful portrait of *Horace Walpole,* the distinguished English 18th C. writer.

Toronto: Marine Museum of Upper Canada 1958
Exhibition Pl., M6K 3C3
(416 595-1567)
Mon.-Sat. 9:30-5; Sun., holidays 12-5; closed Christmas, Boxing Day, New Year's, Good Friday. Fee

Collections pertaining to the history of shipping on the Great Lakes and the St. Lawrence River.

Toronto: Royal Ontario Museum 1912
100 Queen's Park, M5C 2C6
(416 978-3692)
July-Aug.: Mon.-Sat. 10-9; Sun. 12-8; Sept.-June: Mon., Wed., Sat. 10-6; Tues. 10-9; Sun. 12-8; closed Christmas, New Year's. Fee

One of the world's great museums, with far-ranging collections in various scientific fields; magnificent collections of art of the Far, Middle, and Near East, and the classical and Islamic worlds; European arts since the Middle Ages; Native American arts of the Americas, incl. extensive collections from Mexico, the American Southwest, the Northwest Coast, Woodlands, and Subarctic; African arts; a large collection of Canadian arts and crafts since the 17th

C. ☞ ★ Extraordinary Chinese arts, probably the most extensive outside China, with remarkable examples of all major periods and mediums—a tremendous experience. (*Note:* The Canadian collection is housed in the Canadiana Building, 14 Queen's Park Crescent W.)

• Ukrainian Museum of Canada, (U.W.A.C.), Eastern Branch, 620 Spadina Ave., M5S 2H4 (416 923-3318; open on request; no charge) has ethnic collections.

• Taras H. Shevchenko Museum, 42 Roncesvalles Ave., M6R 2K3 (416 535-1063; last Sun. in June–Aug., Sun. 12–5; other times by appointment; no charge) has additional Ukrainian ethnic collections.

(*Note:* The Toronto Historical Board, Exhibition Park, M6K 3C3 [416 595-1567] administers several historic buildings and sites.)

Windsor: The Art Gallery of Windsor 1943
445 Riverside Dr. W, N9A 6T8
(519 258-7111)
Tues., Thurs.–Sat. 10–5; Wed. 10–10; Sun. 1–5; closed Mon., holidays. No charge

Housed in a handsomely converted brewery warehouse on the river across from Detroit, an extensive collection of Canadian painting, sculpture, drawings, and prints from the 18th C. to the present; Eskimo carvings and prints; children's gallery; sculpture court.

PRINCE EDWARD ISLAND

Charlottetown: Confederation Centre Art Gallery and Museum 1964
Box 848, C1A 7L9
(902 892-2464)
Labor Day–July 1: Tues.–Sat. 10–5; Sun. 2–5; closed Mon.; July 1–Labor Day: daily 10–8; closed Easter, Christmas, New Year's. No charge (donation accepted)

In an impressive new cultural center, an extensive collection of Canadian painting, sculpture, graphic and decorative arts up to the present; distinctive contemporary crafts from the 10 provinces and territories of Canada; textiles; ceramics.

Miscouche: Acadian Museum of Prince Edward Island 1964
Miscouche, C0B 1T0
(902 436-5614)
May–Sept.: Mon.–Sat. 10–12 and 1–7; Sun. 1–6; closed Oct.–Apr. Fee

Historical collections illustrating Acadian life and culture.

QUEBEC

Joliette: Le Musée d'Art de Joliette 1947
145 rue Wilfrid-Corbeil, J6E 3Z3
(514 756-0311)
Tues.–Thurs. 12–5; Sat.–Sun. 2–5; closed Mon., Fri., holidays. Fee

Associated with the Seminaire de Joliette, a community some 50 m. N of Montreal, a new museum with Canadian painting and sculpture; medieval sculpture; European painting and sculpture from the Renaissance through the 18th C.; Byzantine art; Russian icons; sacred art of Quebec; European and Canadian decorative arts.

The Montreal Museum of Fine Arts 1860
3400 avenue du Musée, H3G 1K3
(514 285-1600)
Tues.-Sun. 11-5; closed Mon., Good Friday, St. John the Baptist's Day, Confederation Day, Labor Day, Victoria Day, Christmas, New Year's. Fee except for senior citizens and the handicapped.

A fine, far-ranging, selective but general art collection of Western art, incl. European Old Masters to the present, Canadian art since the early days, Far and Middle Eastern art, Peruvian and other primitive arts of the Americas, European decorative arts, prints and drawings, textiles. ☛ ★ A curious, enigmatic Poussin, *Man Pursued by a Snake* (1643-44), with its veiled central figure looking out at us, and an empty, almost lunar landscape; an incredibly tempestuous Guardi *Storm at Sea*; a splendid Rubens animal painting, *The Leopards* (c. 1615); a Ruisdael *Bleaching Grounds near Haarlem* (a smaller version is in the Wadsworth Atheneum, Hartford), more skyscape than landscape, with the familiar Dutch scene lying flat and low beneath a sky whose tremendous sweep of clouds so impressed the great English landscapist John Constable (contrast this with the big Corot, *L'Île Heureuse*, done in the vague and dreamy style much collected in earlier years); a fine, small Bonington *View of the Seashore;* two delightful ★ Turner watercolors, *A Gothic Abbey*, and a Yorkshire landscape entitled *Wensleydale;* an impressive group of aristocratic British portraits by Reynolds, Raeburn, Lawrence (contrast the Goya *Portrait of Altamirano*, roughly contemporary but belonging to another world).
• Château Ramezay Museum, rue de Notre-Dame 280 E. rue, H2Y 1C5 (514 861-7182; Tues.-Sun. 10-4:30; closed Mon., Easter, Christmas, New Year's; fee) has interesting Canadian historical collections, with 18th C. formal and rustic furniture and other decorative arts, numismatic and Indian collections—all shown in a picturesque historic house (1705).
• McCord Museum, McGill University, 690 Sherbrooke St. W, H3A 1E9 (514 392-4778; Wed.-Sun. 11-5; closed Mon., Tues., holidays; no charge) has an outstanding collection illustrating the cultural history of Canada, with costumes, prints, paintings, artifacts, and objects and records of various kinds, incl. photographs.
• Musée d'Art Contemporain, Cité du Havre, H3C 3R4 (514

873-2878; Tues.-Wed., Fri.-Sun. 10-6; Thurs. 10-10; closed Mon., Christmas, Dec. 26, New Year's, Jan. 2; no charge) has a very large and impressive collection of European and American works from the 1940s to the present, with a strong emphasis on Canadian art, esp. from Quebec, shown in the former International Gallery of Montreal's world's fair, Expo '67.

• Sir George Williams Art Galleries, Concordia University, 1455 blvd. de Maisonneuve, H3G 1M8 (514 879-5917; Mon.-Fri. 11-9; Sat. 11-5; closed Sun., Aug., university holidays; no charge) has a collection of art, incl. decorative arts and photography, illustrating the course of Canadian art since early times.

• The St. Helen's Island Museum, The Fort, Box 1024, Station A, H3C 2W9 (514 861-6738; May–Sept.: daily 10-5; Sept.-May: Tues.-Sun. 10-5; closed Mon.; inquire about holiday schedule; fee) located on historic St. Helen's Island in the St. Lawrence, a military, maritime, and colonial history museum housed in the Old Fort, with varied and colorful collections and a lively program of activities, incl. parades and military maneuvers, during the summer.

(*Note:* Montreal has many historic buildings and sites of great interest; Old Montreal, bounded by McGill, Berri, Notre-Dame Sts., and the river, has much that has been preserved or restored; inquire at the Montreal Convention and Visitors Bureau, 1270 Sherbrooke St. W [514 842-6684] for information; inquire at the Montreal Museum of Fine Arts for details on walking tours; note esp. the St. Sulpice Seminary, Place d'Armes, the oldest building extant (1685) and the ★ Church of Notre-Dame-de-Bonsecours, St. Paul St., the oldest church still standing (1771), with its ship models left by sailors as expressions of thanks and hope.)

Quebec: Musée du Québec, I 1922 **rue Wolfe, Parc des Champs de Bataille, G1R 5H3**
(418 643-2150)
Daily 9-5; closed legal holidays and religious feasts. No charge

A collection of art and artifacts related to the history and culture of Canada, esp. of Quebec, with furniture and decorative arts made by craftsmen of the province dating from the 17th C. to the present. ☛ Sequence of furniture and goldsmithwork, continuing a French tradition, made by Quebec craftsmen over the centuries.

(*Note:* Quebec is an utterly fascinating and charming city, full of historic buildings and sites, esp. the Lower Town along the St. Lawrence; for information inquire of the Information Centre, Picard House, rue St.-Pierre. Further information centers are at the Department of Tourism, 12 rue Ste.-Anne [418 643-2280] and the Urban Community Tourism and Convention Service, 60 rue d'Auteuil

[418 692-2471]. Note especially the Monastère des Augustines de l'Hôtel-Dieu de Québec, 32 rue Charlevoix, which was built in 1695, with collections on display daily; Notre-Dame-des Victoires, built in 1688 on the site of Champlain's trading post; the Chevalier House and the Hazeur House, both originally built in the 17th C.; and much more.)

SASKATCHEWAN

Regina: Norman MacKenzie Art Gallery 1953
University of Regina, College Ave. at Cornwall St., S4S 0A2
(306 352-5801)
Mon., Tues., Fri. 12–5; Wed.-Thurs. 12–5 and 7–10; Sat.-Sun., holidays 1–5; closed Labor Day, Nov. 11, Christmas, Boxing Day, New Year's, Good Friday.
No charge

A teaching collection of mainly 19th–20th C. European paintings, drawings, and prints, a growing collection of 19th–20th C. Canadian paintings and graphic arts, and 20th C. American paintings.

Saskatoon: Mendel Art Gallery and Civic Conservatory 1964
950 Spadina Crescent E, Box 569, S7K 3L6 (306 664-9610)
Daily 10–10; closed Good Friday, Christmas. No charge

Primarily a collection of 20th C. Canadian art; Eskimo sculptures and prints; decorative and graphic arts.

• Museum of Ukrainian Culture, 202 Avenue M S, S7M 2K4 (May 1-Labor Day: Mon.-Fri. 9-6; weekends and during winter by appointment; donation accepted) has ethnic collections, as does the Ukrainian Museum of Canada, 910 Spadina Crescent E, S7K 3H5 (306 244-3800; Tues.-Sun. 1-4:30; closed Mon., Easter, Christmas; fee), which also has branch museums in Toronto, Winnipeg, Edmonton, and Vancouver. (*Note:* For information on historic buildings, sites, and collections administered by the Canadian federal government, inquire of Parks Canada, Department of the Environment, National and Historic Parks Branch, National Historic Sites Service, Ottawa, Ontario.)

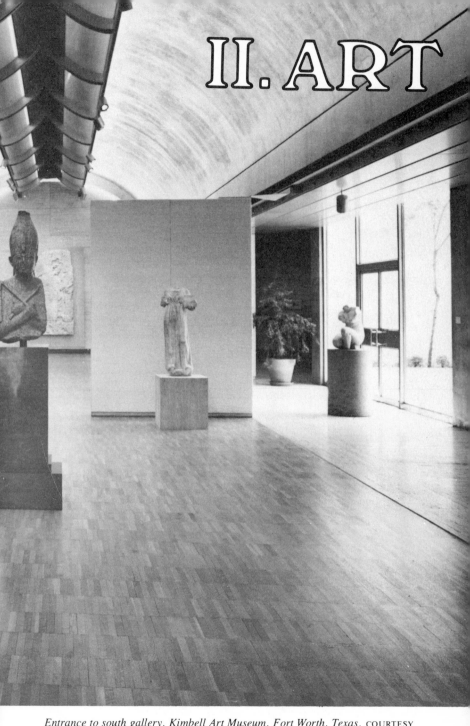

II. ART

Entrance to south gallery, Kimbell Art Museum, Fort Worth, Texas. COURTESY
OF THE KIMBELL ART MUSEUM

(top) Bust of Lucius Verus. COURTESY OF THE ROYAL ONTARIO MUSEUM, TORONTO, CANADA

(left) Silver tetradrachm of Naxos. Bearded head of Dionysos. COURTESY OF THE ROYAL ONTARIO MUSEUM, TORONTO, CANADA

(right) Late Geometric ship krater. COURTESY OF THE ROYAL ONTARIO MUSEUM, TORONTO, CANADA

1) The Ancient World

ASSYRIAN
BABYLONIAN
AND NEAR EASTERN
(c. 7000- c. 500 B.C.)

EGYPTIAN
(c. 3500-30 B.C.)

AEGEAN: MINOAN, CYCLADIC, MYCENAEAN
(c. 3000- c. 1200 B.C.)

GREEK: ARCHAIC TO ROMAN DOMINATION
(c. 1200 B.C.- c 200 A.D.)

ETRUSCAN
(c. 800- c. 200 B.C.)

ROMAN
(c. 700 B.C.- c. 300 A.D.)

II. ART
1. The Ancient World

With each decade of exploration and excavation, the beginnings of man are pushed back further and further in time. Reliable dating methods, such as carbon 14, have enabled us to establish sequences of events with increasing clarity, and the computer has made it possible to organize a vast body of otherwise largely miscellaneous data into coherent form. As a result, the era of historic time has become briefer in relation to the whole panorama of geologic time and prehistoric development. Despite a high degree of uncertainty, the latter has begun to assume recognizable shapes and patterns. We now know, for example, that Jericho, in troubled Palestine, was already thousands of years old when Joshua "fit the battle" and "the walls come tumbling down" at the blast of the biblical hero's trumpets. We also know that, of necessity, long-lost periods preceded such extraordinary artistic and cultural achievements as the superb, sophisticated bronzes of the Shang Dynasty in China (see the introduction to section 6), which was still a mythical period to yesterday's scholar.

When we consider the ancient civilizations of the Near East and the Mediterranean basin, we are now aware as never before of how little we know of their ultimate origins. The ancient areas of the world are peppered with unexcavated sites, holding who knows what wonderful secrets of art and history. What we do know as a result of archaeological digs may well be only the tip of the iceberg, yet it is enough to give us a sense of the immense sweep of time and the epic histories of these ancient peoples and empires, our pioneering ancestors of today's global village.

This epic quality is matched by the spirit of many of the early explorers-in-time whose work created the modern science of archaeology. Heinrich Schliemann, for example, sought adventure in California after the gold

rush of '49 before devoting the rest of his life to a search for Homeric Greece. A pastor's son who made a fortune as a grocer, he was so captivated by Homer that in spite of the universal disdain of contemporary scholars, he clung to his belief in the poet's accuracy, applying the latter's verses to his digs in the field, and amazingly discovered Troy.

Like Schliemann, all the great early explorers in this field seem to have been incurable romantics at heart, as are, I suspect, even the most strictly scientific researchers of our own generation. It takes a visionary to see the whole instead of the parts, to image great cities in sunbaked, windswept desert sites, to sense a common human denominator in all the disparate and miscellaneous evidence of potsherds and fragments of carving, slivers of bone and broken beads. Through the scholarly yet imaginative methods of exhibiting such objects used in today's museums, many recently developed, archaeologists share their vision with us.

The arts arose concurrently with the birth of civilization because they were essential to religion, symbolically expressing man's belief in and relation to forces beyond himself. From the fourth millenium on, the valleys of the Tigris and the Euphrates in Mesopotamia (modern Syria and Iraq) and the Nile in Egypt were the sites of the emergence of two great ancient civilizations. Egypt was a monolithic kingdom, renowned for the changeless nature of its social structure over centuries. It was in Mesopotamia that the great shift from prehistory to history was accomplished, a result of the influence of centuries of prior development in that area and in Anatolia (modern Turkey), as well as the evolution of city-states into the empires of Sumeria, Babylonia, and Assyria, the splendor of whose estate was expressed in their arts. Other empires followed. Persia, with its magnificent capital at Persepolis, expanded

183

around 500 B.C. and overwhelmed the older states; its incursion into the West was finally stopped by the Greeks in the fourth century B.C.

At about the same time that Egypt and Mesopotamia began to emerge into history, the equally rich Minoan civilization, named for the legendary King Minos, was evolving; its center was in Crete and its economy was based on maritime trade. Because of their control of the seas and active trade, the Minoans were in a position to know the civilizations of the land-bound empires, to absorb what was useful, and to transmit influences from the eastern Mediterranean world to the Greek mainland and beyond.

Cycladic art, which flourished on the Greek islands about 2500 B.C., was an aspect of Early Minoan art, with its marble statuettes of the Neolithic mother goddess, elegantly abstracted to thin, flat forms, looking as if they had been worn and polished by the action of the surrounding sea. Some time around 2000 B.C. the potter's wheel appeared, and strikingly handsome Middle Minoan pottery, boldly decorated with marine forms, was shipped over what was then the known world. Perhaps around 1600 B.C., after a violent earthquake, came the Late Minoan period, representing the full flowering of Minoan culture, centered in the great palace at Knossos in Crete, whose vivacious arts reflected a life-style at once vigorous and sophisticated. Just as the height of Minoan culture seems to have arrived with an earthquake, it also seems to have ended about 1400 B.C. with another, so gigantic that it altered the geography of the eastern Mediterranean. Relics of this ancient catastrophe are even now being excavated on the tiny island of Santorini in the Aegean Sea.

The mainland aspects of Minoan civilization were comparatively undisturbed, however, and Mycenaean art—named for the city of Mycenae, where Schliemann also carried out excavations—flourished from about 1500 B.C. until the Dorian invasions of c. 1200 B.C. The traditions of these invaders from the northwest combined with the mainland culture inherited from the Minoans to form the culture of Greece, which reached its height by the fifth century B.C. in Athens, the city of Pericles. The brilliance of Greek civilization was based on a humanistic ideal of the individual, disciplined in mind and body, participating to the fullest in the life of the city-state and living in harmony with nature in a society that was essentially dynamic in its awareness and acceptance of change. Though often heroic in spirit and content, Greek art is human in scale

and form. Even the gods and goddesses are expressions of this basic humanism, the great legacy of Greece to the Western world.

While Alexander the Great (356–323 B.C.) and his successors were spreading the Greek ideal through their conquest of Persia, Egypt, Judea, and as far east as India, thereby creating the Hellenistic world, Rome was consolidating herself as the leading Latin power. She conquered the Etruscans (a mysterious people with spirited though esoteric arts), the Greek and Phoenician colonists, and other groups that had gained a foothold on the Italian mainland, as well as the native Italic tribes; then she subdued Sicily, Carthage (in North Africa), Macedonia, and Greece. Within a century of Alexander's death, Augustus, Julius Caesar's great-nephew and adopted son, had established himself as the first Roman emperor, whose domain extended from Britain and Spain to Syria and Egypt. During his reign (probably 4 B.C.) Jesus of Nazareth was born, an event of which Augustus was undoubtedly as unaware as was his successor, Tiberius, of Jesus' crucifixion c. A.D. 29. With the evolution of the Roman Empire, there developed an ideal of unity that was passed on to subsequent ages, appearing in the Middle Ages in the Holy Roman Empire and the concept of a universal church, an ideal that still survives today in the United Nations. As the successor to Greece, Rome disseminated classical culture, adding the tradition of Roman realism to the arts and its societal counterpart of Roman law to Western polity.

The spirit of the Romantic movement, which fostered an interest in the exotic and the remote in time and place, coincided with the development of scientific archaeology to make the nineteenth and early twentieth centuries periods rich in discoveries of ancient civilizations. As a result, many American museums have fine examples of the arts of the classical world, Egypt, and the ancient Near East, ranging from coins and seals to monumental sculpture, from delicate Arretine ware to robust sarcophagi, from Egyptian wall reliefs to rare Hellenistic mural paintings; something, surely, for everyone's taste, and enough variety so that all but the professional scholar can make fascinating discoveries.

Note: For detailed information on museum addresses, phone numbers, hours, and fees consult Part I of this guide.

ALABAMA

Birmingham: Birmingham Museum of Art (Reeves Collection of Palestinian artifacts and sculpture; Paleolithic to Byzantine ceramics, Egyptian artifacts).

CALIFORNIA

Los Angeles: Los Angeles County Museum of Art (Egyptian, Hellenistic, Graeco-Roman, and Roman sculpture, plus other antiquities; Hellenistic silver; 5 great Assyrian reliefs; ancient Near Eastern artifacts).

Malibu: J. Paul Getty Museum (the building is a re-creation of the Roman 1st C. B.C. Villa dei Papyri at Herculaneum; Greek and Roman antiquities from 6th C. B.C. to 3rd C. A.D.; Etruscan art, Greek bronze hero attributed to Lysippos; Roman Lansdowne Herakles from the Emperor Hadrian's villa at Tivoli; Mazarin Venus; Greek Amazon head from temple of Hera, Argos; Falling Niobid relief; Hellenistic marble head of Alexander; mosaic pavement of Orpheus from a villa near Vienne on the Rhône in France).

Pasadena: Norton Simon Museum (Near Eastern and classical antiquities).

Sacramento: Crocker Art Museum (Babylonian clay tablets from before 1st millennium B.C.; Greek vases; Roman glass).

San Francisco: The Fine Arts Museums of San Francisco—M. H. de Young Memorial Museum and the California Palace of the Legion of Honor (Egyptian, Greek, and Roman arts).

San Jose: Rosicrucian Egyptian Museum and Art Gallery (Assyrian, Babylonian, and Egyptian arts; Coptic textiles; clay tablets, scrolls, scarabs; reproduction of a 12th Dynasty Egyptian tomb; mummies; sarcophagi).

Santa Barbara: Santa Barbara Museum of Art (Greek, Roman, and Egyptian sculpture and arts). □ University Art Museum, Santa Barbara (Luristan bronzes; ancient Near Eastern artifacts, pottery).

Stanford: Stanford University Museum and Art Gallery (Egyptian arts from pre-dynastic to Saitic; antiquities; Cypriot collection).

CONNECTICUT

Hartford: Wadsworth Atheneum (antique bronzes; Roman fresco portraits).

New Haven: Yale University Art Gallery (artifacts from Dura Europos; antiquities; ancient Near Eastern arts).

FLORIDA

Sarasota: John and Mable Ringling Museum of Art (Cypriot antiquities).

ILLINOIS

Chicago: The Art Institute of Chicago (Egyptian and classical antiquities).
☐ University of Chicago, Oriental Institute Museum (rich collection of ancient Near Eastern arts and artifacts; sculpture; ivories; pottery from Egypt, Assyria, Babylonia, Sumeria, Syria, Palestine, Anatolia, Nubia, and Iran).

INDIANA

Bloomington: Indiana University Art Museum (Egyptian, Greek, Roman sculpture, decorative arts).

Fort Wayne: Fort Wayne Museum of Art (Egyptian, Greek, and Roman arts).

Indianapolis: Indianapolis Museum of Art (classical arts).

Muncie: Ball State University Art Gallery (Ball–Kraft Collection of Roman glass).

Notre Dame: The Snite Museum of Art University of Notre Dame (Iranian pottery).

MAINE

Brunswick: Bowdoin College Museum of Art (Assyrian reliefs; Greek, Roman, and Egyptian antiquities).

MARYLAND

Baltimore: Baltimore Museum of Art (2nd–6th C. mosaics from Antioch). Walters Art Gallery (antiquities, ancient arts; classical sculpture, Roman sarcophagi; Egyptian and ancient Near Eastern arts; Etruscan objects).

MASSACHUSETTS

Amherst: Mead Art Museum (Near Eastern and classical antiquities; Assyrian reliefs from the palace at Nimrud).

Boston: Museum of Fine Arts (Asiatic, Egyptian, Greek, Roman, and Near Eastern collections; outstanding Old Kingdom Egyptian sculptures; classical coins, gems, seals, jewelry; Roman sculpture and portraiture; Greek head of Aphrodite; Minoan snake goddess; Greek vases).

Cambridge: Fogg Art Museum (Greek and Roman sculptures, vases, coins; Egyptian antiquities; Persepolis sculptures).

Northampton: Smith College Museum of Art (antiquities; marble portrait head of the Roman emperor Gallienus, 3rd C. A.D.).

South Hadley: Mount Holyoke College Art Museum (ancient arts, pottery, glass, coins).

Wellesley: The Wellesley College Museum (Greek and Roman sculpture).

Williamstown: Williams College Museum of Art (Assyrian reliefs; Egyptian minor arts; Greek and Roman pottery and glass).

Worcester: Worcester Art Museum (Egyptian, Greek, and Roman sculpture; mosaics from Antioch; female torso, Egyptian 4th Dynasty (2680–50 B.C.); early dynastic Sumerian statuette (3000–2500 B.C.); Greek black-figure vases; Roman bronze portrait of a woman).

MICHIGAN

Ann Arbor: Kelsey Museum of Ancient and Mediaeval Archaeology (extensive collection of ancient Near Eastern artifacts; Coptic artifacts; classical inscriptions).

Detroit: The Detroit Institute of Arts (Egyptian, Greek, Assyrian, and Iranian objects; Cycladic *Man Playing a Syrinx*).

East Lansing: Kresge Art Center Gallery (ancient artifacts and antiquities from Sumeria, Lebanon).

MINNESOTA

Minneapolis: The Minneapolis Institute of Arts (antiquities and ancient artifacts; ancient vases).

MISSOURI

Columbia: Museum of Art and Archaeology (artifacts of the Near East, Egypt, Coptic Egypt, and the mediterranean region; pottery, glass; 6th C. B.C. bronze blazon from a Greek shield; casts of Roman sculpture).

Kansas City: William Rockhill Nelson Gallery and Atkins Museum of Fine Arts (Persepolis sculptures; Babylonian sculptures; Egyptian, Greek, Etruscan, and Roman arts; Egyptian wood statue from Saqqara, 5th Dynasty).

St. Louis: The Saint Louis Art Museum (Etruscan, Greek, and Near Eastern arts; Egyptian art; sculpture, textiles).

NEBRASKA

Omaha: Joslyn Art Museum (Egyptian, Greek, and Roman art).

NEW HAMPSHIRE

Hanover: Hood Museum (Assyrian reliefs; classical archaeological collections, incl. Roman relief of *Eros with Nereids, Tritons, and Seahorses;* mosaics).

NEW JERSEY

Newark: The Newark Museum (classical coins and antiquities; Schaefer Collection of ancient glass).

Princeton: The Art Museum (Greek and Roman arts; Near Eastern collection; mosaics from Antioch).

NEW YORK

Buffalo: Albright–Knox Art Gallery (antiquities, ancient sculptures).

New York City: The Brooklyn Museum (extensive collection of important Egyptian arts, pre-dynastic through Coptic; Assyrian reliefs; Greek and Roman art; pre-Islamic and Middle Eastern antiquities). ☐ The Metropolitan Museum of Art (arts of the ancient Near East, Egypt, Greece, and Rome; Anatolia, Sumeria, Akkad; sculpture, pottery, tablets, and metalwork; Sumerian statuette from Square Temple, Tel Asmar; gold, jewelry, seals; figure of Gudea, governor of Lagash, 3rd Dynasty of Ur; Assyrian human-headed bull from the palace of Ashurnasirpal II; Luristan bronzes; Babylonian brick relief of striding lions; Persepolis reliefs; Iranian head of an ibex in bronze; silver head of a Sasanian king, 4th C. A.D.; Temple of Dendur, saved from the flooding of the Aswan dam; red-figure krater by Euphronios; Greek vases, sculpture, coins, seals; Pompeian murals; Roman sarcophagi).

Rochester: Memorial Art Gallery (Egyptian, Greek, Roman, Etruscan, and Mesopotamian arts).

Utica: Munson–Williams–Proctor Institute (small collection of Greek objects).

NORTH CAROLINA

Chapel Hill: The Ackland Art Museum (Egyptian and classical objects; 2nd C. B.C. bronze Greek head).

Charlotte: The Mint Museum of Art (ancient Near Eastern and Mediterranean arts; Egyptian 4th Dynasty reliefs).

Raleigh: North Carolina Museum of Art (Egyptian Old Kingdom reliefs; Greek and Roman antiquities).

OHIO

Canton: The Canton Art Institute (ancient Near and Middle Eastern pottery).

Cincinnati: Cincinnati Art Museum (arts of Egypt, Greece, Rome, and the ancient Near East; Nabataean sculptures from Jordan; Persepolis reliefs; gold libation bowl of Darius the Great, c. 500 B.C.; 6th C. B.C. Greek bronze bull; sculpture, ceramics, glass, textiles).

Cleveland: Cleveland Museum of Art (ancient arts and antiquities of Egypt, Greece, Rome, the Near and Middle East; sculpture, ceramics, glass, textiles).

Dayton: Dayton Art Institute (Graeco–Roman Aphrodite, marble; antiquities).

Oberlin: Allen Memorial Art Museum (Mesopotamian, Egyptian, Etruscan, and Roman arts).

Toledo: The Toledo Museum of Art (extraordinary examples of ancient glass; antiquities; ceramics).

OREGON

Portland: Portland Art Museum (Lewis Collection of classical antiquities).

PENNSYLVANIA

Philadelphia: The University Museum (ancient Near Eastern, Syro-Palestinian, Egyptian, and Mediterranean arts and artifacts; sculptures, tablets, seals, ceramics, metalwork; Minoan, Mycenaean, and Cypriot antiquities; Sumerian *Ram in a Thicket* (*Billy Goat and Tree*), c. 600 B.C., in gold, enamel, etc.; Egyptian and Nubian stones and bronzes; gold and ivory).

Pittsburgh: Museum of Art, Carnegie Institute (antiquities, ancient artifacts).

RHODE ISLAND

Providence: Museum of Art, Rhode Island School of Design (classical art and numismatics; Greek and Roman sculpture; Roman murals and portrait busts; Greek and Etruscan jewelry; bronzes, pottery).

TEXAS

Austin: Archer M. Huntington Art Gallery (Battle Collection of plaster casts of Greek and Roman sculpture).

Dallas: Dallas Museum of Fine Arts (ancient Mediterranean arts; Greek marbles; Etruscan pottery and gold).

Fort Worth: Kimbell Art Museum (classical sculpture).

Houston: The Museum of Fine Arts, Houston (antiquities; Greek bronze Ephebus, 7½ feet tall—a spectacular piece).

VERMONT

Burlington: Robert Hull Fleming Museum (ancient arts and artifacts).

VIRGINIA

Norfolk: Chrysler Museum at Norfolk (arts of Egypt, Greece, Rome, and the ancient Near East).

Richmond: Virginia Museum of Fine Arts (arts of Egypt, Greece, and Rome).

WASHINGTON

Seattle: Seattle Art Museum (Egyptian, Greek, and Roman arts and archaeology).

WISCONSIN

Madison: Elvehjem Museum of Art (Greek and Roman coins; classical antiquities; archaeological collections).

CANADA

ONTARIO

Toronto: Royal Ontario Museum (Egyptian, Greek, and Roman arts and archaeology).

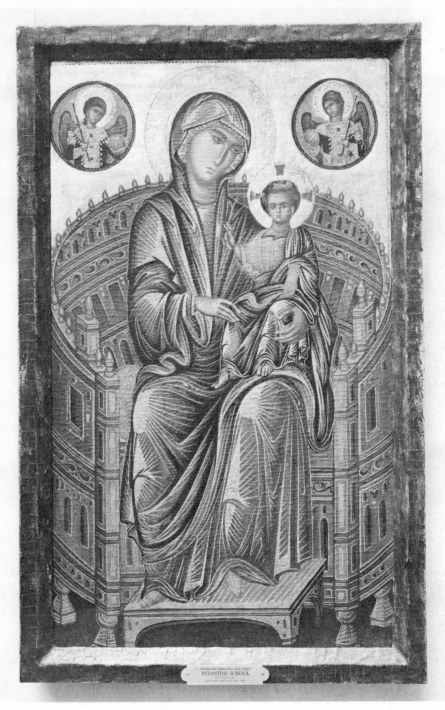

Madonna and Child on a Curved Throne. COURTESY OF THE NATIONAL GAL-
LERY OF ART, WASHINGTON, D.C.

2) Early Christian, Byzantine, and Islamic Art

(c. 300- c. 1700)

2. Early Christian, Byzantine, and Islamic Art

During the waning years of the pre-Christian era and the first and second centuries A.D., the austere paganism of the old Roman world gradually gave way before an influx of mystery religions from the East, brought back from remote parts of the empire by returning legionnaires. They included the worship of such exotic deities as Cybele, an earth goddess from Asia Minor; Isis, Horus, and Osiris from Egypt; Dionysus and Orpheus from Greece; and Mithras from Persia—all accompanied by ecstatic rituals. No matter how faddish and outrageous some of these cults may have seemed, they had elements in common. All, in one fashion or another, envisioned a spirit world and a life after death of a very different kind from the old plutonic underworld, haunted by souls that twittered like bats and could be summoned up, as Odysseus had done, by offerings of blood. All demanded an initiation, which was often elaborate, into the mystery of the cult, and all emphasized the salvation of the individual soul.

Both the popularity of these cults and the common message they proclaimed indicated a profound philosophical change marking the end of the classical world and the beginning of a new era. People became increasingly preoccupied with cultivating an inner spiritual life, their attention shifting from the material things of this world to a hope for betterment in the next. The old Roman realism in art inherited from the days of the republic was replaced by an increasingly expressionistic and nonliteral style, as artists attempted to portray the inner life through symbol and allusion.

Christianity, also newly arrived from the East, throve in this atmosphere of change. At first primarily a faith of the poor, practiced in secret to

194

avoid persecution, it became officially recognized by the empire as a result of an edict issued in 303 by the emperor Constantine. From its early artistic expression in catacomb murals, gold glass paintings, portraits, and small sculpture, it rose to great heights with the flowering of the empire in the East and during the medieval era, from the Romanesque through the Gothic periods, in the West.

In the meantime, Islam (which means "surrender to the will of Allah," the one god), the faith founded by Mohammed in 622, flourished from the seventh century in the Near East (c. 715 in Spain), through the sixteenth century in Persia, and even to the end of the seventeenth century in India—more than two hundred years after the Renaissance had supplanted the Middle Ages in Europe. Because of the beliefs of its founder, Islamic art is generally nonfigural except for certain small-scale works, notably Persian and Mogul miniatures, a vivid and highly sophisticated court art of the Islamic emperors. In addition to the arts, a major contribution of Islamic civilization was the preservation of classical learning, especially science and technology, during the Dark Ages in Europe, as exemplified by handsomely illuminated treatises and superbly designed and executed astronomical and other scientific instruments. Even during the heyday of Islamic civilization, however, the Moslem world had begun to fracture along national as well as sectarian lines, with a resulting cultural stagnation and eclipse only now beginning to be alleviated by the oil-powered political resurgence of the Islamic states.

Early Christian art is primarily an art of transition—to the Byzantine style in the East and to the Romanesque style in the West. Islamic art, the product of a totally different civilization, belongs to another tradi-

195

tion and culture. The Crusades brought these worlds in direct confrontation, and the influence of Islam on the West in architecture, music, and the minor arts, as well as in science and philosophy, was profound, to say nothing of the more salubrious and civilized life-style brought back to Europe by the returning crusaders.

Because of its comparatively brief time span, Early Christian art is fairly rare. Consequently there are not many examples in American museums. Both Byzantine and Islamic art, however, are well represented in many American collections, with Dumbarton Oaks in Washington, D.C., recognized as a world center for Byzantine studies, just as the Oriental Institute of the University of Chicago is acknowledged as a center for study of the ancient Near East.

CONNECTICUT
Hartford: Wadsworth Atheneum (Early Christian bronzes).

DISTRICT OF COLUMBIA
Washington: Dumbarton Oaks Research Library and Collection (4th–15th C. Byzantine bronzes, ivories, enamels, jewelry, goldsmithwork, and textiles). Freer Gallery of Art (Byzantine ivories and other objects).

ILLINOIS
Chicago: University of Chicago, Oriental Institute Museum (Early Christian and Islamic objects).

MARYLAND
Baltimore: Walters Art Gallery (remarkable Byzantine and Islamic collections; perhaps the finest collection of Byzantine enamels in the U.S.; most complete collection extant of Early Christian liturgical objects; Hamad Treasure of 6th C. Byzantine liturgical vessels).

MASSACHUSETTS
Boston: Museum of Fine Arts (Coptic Christian weavings; Byzantine and Islamic objects; coins and textiles).

Northampton: Smith College Museum of Art (marble portrait head of the Roman emperor Gallienus, 3rd C. A.D.).

South Hadley: Mount Holyoke College Art Museum (coins, glass, pottery).

MICHIGAN
Ann Arbor: Kelsey Museum of Ancient and Mediaeval Archaeology (Coptic and Islamic textiles).

MINNESOTA

Minneapolis: The Minneapolis Institute of Arts (Islamic collections).

MISSOURI

Kansas City: William Rockhill Nelson Gallery and Atkins Museum of Fine Arts (Near Eastern arts).

St. Louis: The Saint Louis Museum (Near Eastern arts).

NEW HAMPSHIRE

Hanover: Hood Museum, Dartmouth College (Early Christian mosaics).

NEW YORK

New York City: The Metropolitan Museum of Art (important Islamic collections, with an Islamic interior plus fountain; Islamic decorative arts, textiles, ceramics, coins, mss.; Early Christian sculpture and miscellaneous objects). The Pierpont Morgan Library (Byzantine mss.).

OHIO

Cincinnati: Cincinnati Art Museum (Near Eastern arts; Islamic arts; textiles, coins, mss.; Early Christian sculpture).

Cleveland: Cleveland Museum of Art (Near Eastern arts; Islamic arts; mss.; Early Christian marble sculptures illustrating the *Story of Jonah* in a fascinating continuous narrative).

Toledo: The Toledo Museum of Art (Islamic glass; note esp. the Spanish flagon from Toledo, c. 1500).

PENNSYLVANIA

Philadelphia: Philadelphia Museum of Art (Byzantine and Islamic objects).

RHODE ISLAND

Providence: Museum of Art, Rhode Island School of Design (Byzantine and Islamic arts).

VIRGINIA

Norfolk: Chrysler Museum at Norfolk (Near Eastern arts).

Richmond: Virginia Museum of Fine Arts (Byzantine arts; Islamic objects).

CANADA

QUEBEC

Joliette: Le Musée d'Art de Joliette (Byzantine and Russian art).

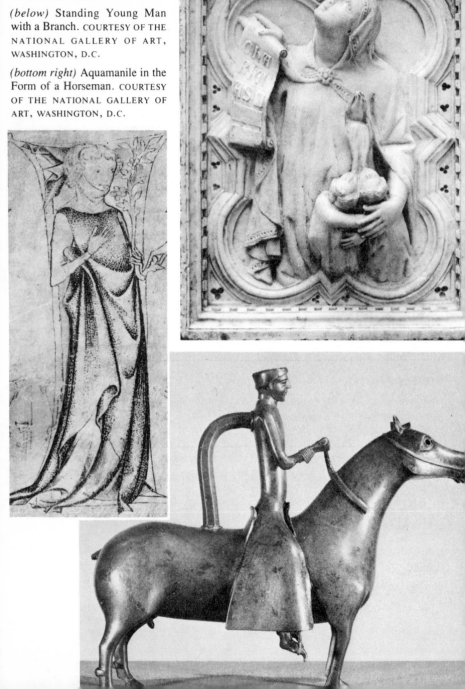

(top right) Charity *by Giovanni di Balduccio.* COURTESY OF THE NATIONAL GALLERY OF ART, WASHINGTON, D.C., SAMUEL H. KRESS COLLECTION

(below) Standing Young Man with a Branch. COURTESY OF THE NATIONAL GALLERY OF ART, WASHINGTON, D.C.

(bottom right) Aquamanile in the Form of a Horseman. COURTESY OF THE NATIONAL GALLERY OF ART, WASHINGTON, D.C.

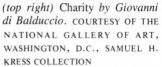

3) The Middle Ages

EARLY MIDDLE AGES: DARK AGES, CAROLINGIAN, AND OTTONIAN
(c. 400- c. 1000)

ROMANESQUE
(c. 1000- c. 1150)

GOTHIC
(1140- c. 1500)

3. The Middle Ages

The complex culture and art of the Middle Ages were the result of the dynamic combination of three great traditions: the classical past of Greece and Rome; the exalted mysticism of the Near East; and the vigorous tribal heritage of the barbarian North. After the transitional Early Christian period (c.300–c.500), the early Middle Ages (c.400–c.1000)—sometimes called the Dark Ages—saw the disintegration of the Roman Empire under the onslaught of barbarian tribes from the East and North, during what is often called the Migration Period (376–750). It was a time of political and social chaos during which Christianity was the unifying force in Europe. As the tribes settled, kingdoms gradually emerged, Visigothic in Spain, Frankish and Burgundian in western Europe, Vandal in North Africa, Ostrogothic and Lombard in Italy. Danes and Anglo-Saxons invaded the British Isles, while the Vikings raided and harried the coasts on their way to the conquests of Sicily and of Normandy, the base from which they launched their successful assault against England in 1066. Adventuring eastward into Russia, the Norsemen formed the first Russian state at Novgorod in 862; pushing southeastward into the Byzantine Empire in the ninth century, they formed the famous Varangian Guard that protected the emperor's person.

In art, all of the tribes shared a heritage of the Animal Style, a tradition of abstract design based on animal shapes translated into sinuous line and form, often of great power, which centuries earlier had spread from Central Asia eastward to the Pacific and westward into Europe.

Celtic Ireland had been isolated by the pagan invasions of England and the Continent. From the fifth century, when the Irish were converted to Christianity, to the time of Charlemagne, who was crowned Holy Roman Emperor by the pope in 800, the Irish church, founded on an Eastern

monastic system, enjoyed a golden age of learning and a flourishing of the arts. Irish (or Irish-trained) missionaries spread eastward into Britain and Scotland and across the Channel to Europe, founding monasteries from Iona, the Holy Isle off the western shores of Scotland, and Lindisfarne in Northumbria to St. Gall in Switzerland and Bobbio in Italy. After the establishment of the See of Canterbury by St. Augustine in 596 on the order of Pope Gregory the Great, the Celtic and Roman churches were reconciled. Thereafter churchmen trained in Irish foundations were among the cultural and religious leaders of Europe, and the strange, passionate Irish-Celtic style, which produced some of the most beautiful manuscripts and goldsmithwork known, enriched the mainstream of medieval art.

The degree of unity achieved in western Europe by Charlemagne did not long outlast him, but the ensuing periods—the Carolingian (to c. 900) and the Ottonian, named for the emperor Otto the Great (912–973)—produced remarkable works of art, from manuscripts and ivories to monumental sculptures and churches. The Romanesque period (c. 1000–c. 1150) saw a dramatic flowering of all the arts during a time of tremendous activity, almost as though, with the Crusades and pilgrimages, a new migration period had begun. As artists and craftsmen traveled the pilgrimage road, ideas and design concepts accompanied them. Churches were built everywhere. The rich variety of the Romanesque style was equally apparent in illuminated manuscripts, carved ivories, and spectacular goldsmithwork.

With the dedication of the abbey church of St.-Denis in Paris in 1140, the Gothic style was born. The round arches, heavy vaulting, and rugged masonry of the Romanesque style, reminiscent of the Roman con-

struction that gave it its name, were supplanted by the soaring verticality made possible by the pointed arch, the hallmark of Gothic architecture. The cathedrals of Europe—with their profusion of sculpture and stained glass, and their treasures of painted altar panels, goldsmithwork, tapestries, embroidered vestments, and illuminated manuscripts—remain the crowning achievement of an era that ended with the birth of the modern world, with the emergence of the Renaissance in Italy at the beginning of the fifteenth century.

Despite the anonymity of most medieval art, the personalities of some artists resound through their work down through the ages. Giotto speaks to us through his frescoes in Assisi, Florence, and Padua; Nicola and Giovanni Pisano through their sculptures in Pisa and Siena; and Jan and Hubert van Eyck through their famous altarpiece in Ghent. (All of these artists are represented in American museums.) It was the age of *Beowulf* and *The Song of Roland*, of St. Augustine's *City of God*, of Dante and Chaucer, when the great universities were founded, replacing the monasteries as the primary centers of education and scholarship, and when the school of Chartres was the "Institute for Advanced Studies" and the Bell Laboratory of its time. Above all, it was an age of faith during which countless individuals gave form and expression to that faith with a dazzling variety and vitality in all the arts.

Although America has no ancient cathedrals, it does have picturesque examples of the Gothic Revival of the nineteenth century. More important, however, are the extraordinary collections of medieval art in all media. The Cloisters, a branch of the Metropolitan Museum of Art in New York, and the medieval galleries of the Cleveland Museum are the most outstanding repositories. The Pierpont Morgan Library in New York is world famous for its illuminated manuscripts, and the Walters Art Gallery in Baltimore is noted for its ivories, enamels, and goldsmithwork. Scattered throughout many other museums are superb examples of medieval art, exciting discoveries for anyone interested in this incredibly rich period.

CALIFORNIA

Los Angeles: Los Angeles County Museum of Art (sculpture, painting, decorative arts; Gothic tapestries, Hispano-Moresque pottery, textiles).

Malibu: J. Paul Getty Museum (late medieval paintings).

Pasadena: Norton Simon Museum (painting, sculpture, decorative arts).

San Francisco: The Fine Arts Museums of San Francisco—M. H. de Young Museum and California Palace of the Legion of Honor (painting, sculpture, decorative arts; Apocalypse tapestries, 1375–80, the oldest important French tapestry series extant—housed in the California Palace of the Legion of Honor).

CONNECTICUT

Hartford: Wadsworth Atheneum (sculpture, painting, tapestries, arms and armor, decorative arts, metalwork, mss.).

New Haven: Yale University Art Gallery (Italian late medieval painting, sculpture, decorative arts; prints and drawings; Gentile da Fabriano, *Madonna and Child*).

DISTRICT OF COLUMBIA

Washington: National Gallery of Art (painting, sculpture; Petrus Christus, *The Nativity* [c. 1445], lovingly detailed; Duccio, *Nativity with the Prophets Isaiah and Ezekiel* [1308–11], austere, with Sienese grace; Master of the Saint Lucy Legend, *Mary, Queen of Heaven* [c. 1485], as triumphant as a flourish of trumpets).

HAWAII

Honolulu: Honolulu Academy of Arts (medieval arts; decorative arts).

ILLINOIS

Chicago: The Art Institute of Chicago (painting, sculpture, decorative arts; Gerard David's gentle and reverent *Lamentation at the Foot of the Cross*).

INDIANA

Indianapolis: Indianapolis Museum of Art (fine collection of painting, sculpture, decorative arts; Romanesque frescoes from San Baudelio in Berlanga, Spain, with others in Cincinnati and The Cloisters, New York City; tapestries).

KANSAS

Lawrence: Spencer Museum of Art (sculpture, painting, decorative arts; Romanesque sculptured capitals from France; Late Gothic standing *Madonna and Child* in wood by Riemenschneider).

MARYLAND

Baltimore: Walters Art Gallery (superlative collection of medieval sculpture, painting, ivories, goldsmithwork, enamels; remarkable mss., decorative arts, tapestries, and other textiles; arms and armor).

MASSACHUSETTS

Boston: Isabella Stewart Gardner Museum (painting, sculpture, decorative arts; architectural sculptures; Simone Martini altarpiece in Late Gothic International Style; 13th C. French stained glass; Giottö's rare and impressive little *Presentation of the Christ Child in the Temple* could be enlarged to the size of his frescoes without loss; tapestries, embroideries, and other textiles—all in the setting of a 15th C. Venetian palace planned by Mrs. Gardner).
□ Museum of Fine Arts (sculpture, painting, goldsmithwork, ivories, enamels, tapestries and other textiles, alabasters, bronzes; Proto-Renaissance sculptures inspired by the humanist emperor Frederick II; Duccio triptych of *The Crucifixion*; Romanesque chapel with Catalan frescoes; "wild men of the woods" tapestry; Celtic house shrine; Mosan enamels; architectural sculptures).

Cambridge: Fogg Art Museum (sculpture, decorative arts, painting; Romanesque and Gothic capitals; panels by Spinello Aretino; Spanish Romanesque triple-figured pier with addorsed saints, a fine example of Pilgrimage Road sculpture).

Gloucester: Hammond Castle Museum (architectural sculpture, sculpture, painting, decorative arts—mainly Gothic—in a picturesque medieval-style setting, originally the house of John Hayes Hammond, Jr., scientist and inventor; Romanesque bishop's throne, strongly Byzantine in style, from southern Italy; Romanesque and Gothic sculptures; late medieval carved wooden house facades; tapestries and vestments).

Williamstown: Williams College Museum of Art (painting, sculpture, decorative arts; French stained glass).

Worcester: Higgins Armory Museum (handsome collection of arms and armor, tapestries, stained glass, decorative arts). □ Worcester Art Museum (painting, sculpture, tapestries and other textiles, decorative arts; architectural sculptures; 12th C. French Romanesque chapter house; Gothic tapestry of *The Last Judgment*; Italian 13th C. frescoes of *The Last Supper* and *The Crucifixion* from Spoleto, showing Byzantine influence; Late Gothic International Style *Madonna in the Rose Garden*, by a Veronese painter, is a delight; an exalted 12th C. *Virgin and Child* in wood from the cathedral city of Autun in Burgundy).

MICHIGAN

Ann Arbor: The University of Michigan Museum of Art (painting, sculpture, decorative arts).

Detroit: The Detroit Institute of Arts (fine collection of painting, sculpture, armor, tapestries, decorative arts; Van Eyck's magical *St. Jerome in His Study*, with its beautifully realized still-life details, showing both saint and lion equally pensive).

MISSOURI

Kansas City: William Rockhill Nelson Gallery and Atkins Museum of Fine Arts (painting, sculpture, tapestries, ivories, goldsmithwork; a French cloister with Romanesque sculpted capital wellhead; mss.; decorative arts).

St. Louis: The Saint Louis Art Museum (painting, sculpture, decorative arts; Late Gothic paneled room from Morlaix in Brittany; Romanesque capitals; a 12th C. painted wood *Madonna*, perhaps from Auvergne).

NEW HAMPSHIRE

Manchester: The Currier Gallery of Art (sculpture, painting; 15th C. Tournai tapestry, alive with vivid detail).

NEW JERSEY

Princeton: The Art Museum, Princeton University (sculpture, painting, decorative arts; architecture; rare and beautiful stained glass from Chartres).

NEW YORK

New York City: The Cloisters (constructed in the form of a medieval monastery, with cloisters and other architectural features, incl. interiors, brought over from various parts of Europe; the entire museum, located on a spectacular site overlooking the Hudson River, is devoted to medieval art, and is one of the world's great collections; Romanesque and Gothic sculpture, goldsmithwork, ivories, enamels, mss., textiles, paintings, decorative arts; Romanesque hall; Gothic chapel; the Unicorn tapestries, one of the greatest series in the world; the Antioch Chalice). ☐ The Metropolitan Museum of Art (outstanding collection of medieval sculpture, painting, goldsmithwork, ivories, enamels, tapestries; remarkable arms and armor; decorative arts; carved and painted oak 12th C. *Madonna and Child* from Auvergne; 12th C. stone *Head of King David* from the cathedral of Notre-Dame in Paris; 15th C. painted stone *Madonna* from Poligny, Burgundy; Mosan and other enamels; extraordinary goldsmithwork collection; red velvet chasuble embroidered in gold, pearls, and colored silk in opus anglicanum [c. 1400], a superb example of English work). ☐ The Pierpont Morgan Library (outstand-

ing medieval mss.; drawings, incunabula; Gutenberg and Caxton publications; bejeweled ms. covers; paintings, decorative arts).

Rochester: Memorial Art Gallery, University of Rochester (capitals, ivories, enamels, goldsmithwork, stained glass, mss.; a remarkable frescoed apse from a chapel in Auvergne; sculptures, tapestries, and other textiles).

NORTH CAROLINA

Raleigh: North Carolina Museum of Art (Kress Collection of late medieval painting; early 14th C. Peruzzi Altarpiece, a polyptych by Giotto and assistants, one of a half dozen of his works in the New World).

OHIO

Cincinnati: Cincinnati Art Museum (fine collection of sculpture, painting, decorative arts; 12th C. Spanish wooden tomb figure of Don Sancho Saiz de Carillo; Romanesque Spanish apse frescoes from San Baudelio de Berlanga—compare The Cloisters' [New York City] frescoes from the same site).

Cleveland: Cleveland Museum of Art (outstanding collection of medieval arts, architectural elements, stained glass, painting, sculpture, goldsmithwork, ivories, textiles, ceramics; capitals and other architectural sculptures; Guelph Treasure).

Toledo: The Toledo Museum of Art (medieval arts, sculpture, painting, decorative arts, mss., glass).

PENNSYLVANIA

Philadelphia: Philadelphia Museum of Art (painting, sculpture, architecture, decorative arts; Romanesque cloister; sculpted doorways; European painting since the 12th C.; tapestries; Jan van Eyck's miraculous *St. Francis Receiving the Stigmata*, only 5 inches square, obviously painted with a magnifying glass, a late medieval masterpiece; Rogier van der Weyden's deeply moving *Christ on the Cross with the Virgin and St. John*).

RHODE ISLAND

Providence: Museum of Art, Rhode Island School of Design (medieval arts, painting, sculpture, decorative arts, mss.; monumental Spanish crucifix carved in wood [c. 1300]).

SOUTH CAROLINA

Greenville: Bob Jones University Collection of Sacred Art (medieval religious arts, painting, sculpture, liturgical objects, interiors).

TEXAS

Fort Worth: Kimbell Art Museum (painting, sculpture; Barnabas Altar [c.

1250], a unique English painting done in a formal style, with affinities to ms. illuminations of the period).

Houston: The Museum of Fine Arts, Houston (painting, sculpture, decorative arts; liturgical objects; goldsmithwork; late medieval paintings; tapestries).

VERMONT

Burlington: Robert Hull Fleming Museum (medieval arts, painting, sculpture).

VIRGINIA

Norfolk: Chrysler Museum at Norfolk (medieval arts, sculpture, painting, decorative arts).

Richmond: Virginia Museum of Fine Arts (medieval arts, sculpture, painting, decorative arts).

WASHINGTON

Seattle: Seattle Art Museum (painting, decorative arts).

CANADA

ONTARIO

Toronto: Royal Ontario Museum (medieval arts of Britain and the Continent; decorative arts).

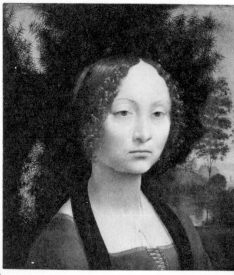

(top) Daniel in the Lion's Den (detail) *by Peter Paul Rubens*. COURTESY OF THE NATIONAL GALLERY OF ART, WASHINGTON, D.C.

(bottom left) Lorenzo de Medici *by Andrea del Verrocchio*. COURTESY OF THE NATIONAL GALLERY OF ART, WASHINGTON, D.C.

(bottom right) Ginevra de'Benci *by Leonardo da Vinci*. COURTESY OF THE NATIONAL GALLERY OF ART, WASHINGTON, D.C.

4) The Renaissance and the Baroque
(c. 1400- c. 1800)

4. The Renaissance and the Baroque

The Renaissance originated in Florence in the early years of the fifteenth century, its spirit of humanism and individualism providing a strong contrast to the prevailing atmosphere of the Middle Ages, which lingered for a century or more in the North. It was a time of private patronage, in which the Medici family, de facto rulers of the Florentine republic, set a magnificent example. The lamp of classical antiquity, relit by the enthusiasm of the artists and scholars of the Renaissance, revealed the vividness and beauty of the world and placed intrinsic value on the individual's experience of it. Life in this world was seen as more than just a preparation for the next. It was an age of discovery, both geographically and empirically, when voyagers reached the New World, explored Africa, and circled the globe; when Copernicus announced the heliocentric theory, and Leonardo's mind ranged through the universe of ideas.

The distinction between art and science was blurred, because the artist demanded scientific knowledge for the realization of his ideals—since geometry and mathematics seemed necessary for the clear and factual representation of the world as he saw it. Through his vision, ordered by such scientific principles as those of perspective, the Renaissance artist sought not merely to record a scene but to create a factually accurate reconstruction of it, realized with the three-dimensionality of architecture, plus a fourth dimension of subtly reflected inner life.

The Renaissance spread from Florence throughout Italy, with Rome emerging as the center of the High Renaissance of the sixteenth century largely through papal patronage led by Leo X, the Medici pope, until each city or state developed its own school of painting, sculpture, and architec-

ture. As the personalities of Brunelleschi, Donatello, and Verrocchio dominated the early Renaissance in Florence, those of Leonardo, Michelangelo, and Raphael were outstanding in sixteenth-century Rome and Giorgione and Titian in sixteenth-century Venice.

As the century progressed, the style known as Mannerism evolved. Tintoretto and El Greco were perhaps its best known proponents. This art was characterized by deliberate distortions of form and space and an unnaturalistic use of color, qualities derived from an exaggerated emphasis on certain aspects of the great High Renaissance masters—hence the name Mannerism. Mannerism was transitional to the Baroque, the dominant style of the seventeenth and eighteenth centuries throughout Europe, as well as in the New World.

In the North the International Style emerged around 1400, contemporaneous with the Renaissance in Florence. It was a mannered, elegant style of painting marked by curvilinear pattern, unreal space, lack of mass, and a wealth of realistic detail similar to that of many late medieval manuscripts. The full flowering of the Late Gothic occurred next in the North, contemporaneous with the early Renaissance in Italy, with such outstanding artists as Hubert and Jan van Eyck, the Master of Flémalle (Robert Campin of Tournai?), Rogier van der Weyden, Hugo van der Goes, and Hieronymous Bosch. In the late fifteenth and sixteenth centuries the Renaissance reached northern Europe, heralded by the paintings and prints of Albrecht Dürer, the portraiture of Hans Holbein the Younger, and the spacious landscapes and antically detailed studies of peasant life of Pieter Brueghel the Elder.

Leading Baroque artists were, in Italy, the painters Caravaggio and Tiepolo, and the architect and sculptor Gian Lorenzo Bernini; in the North Rubens in Flanders, Rembrandt and Hals in Holland; Van Dyck, Wren, Jones, and Hogarth in England; in Spain, Velázquez; in France, Poussin and Claude Lorrain; with Boucher, Watteau, and Fragonard representing the final phase of the French Baroque, the Rococo.

The Renaissance had, for chronological reasons, little if any effect on the New World, but the Baroque did leave its mark. The cathedrals, churches, and palaces of Hispanic America were largely designed in an exuberant, seventeenth-century manner, while the architecture of Bulfinch, the portraiture of Feke and Copley, and the townscapes of Williamsburg, Annapolis, Charleston, Boston, and Salem—to name but a few—owe much to the more classical aspects of the Baroque style of eighteenth-century England.

American museums are particularly rich in Renaissance and Baroque art, including painting and sculpture by outstanding masters. There are also fine collections of tapestries, furniture, and all manner of decorative arts that flourished during this period, especially goldsmithwork, and, in the seventeenth and eighteenth centuries, porcelain. Because of the extensive collecting carried out by many Americans since the middle of the nineteenth century, most larger city museums rival their European counterparts in quality and variety, while almost every museum with a general historical collection has significant examples.

ALABAMA

Birmingham: Birmingham Museum of Art (painting, sculpture; *The Battle of Pavia* [Flemish, c. 1525], naive but knowing; Rubens' celebratory *Ceres and Pomona*).

ARIZONA

Phoenix: Phoenix Art Museum (painting, sculpture; Carlo Dolci's *Salome with the Head of John the Baptist*, lively, stagy Baroque).

Tucson: University of Arizona Museum of Art (painting and sculpture; colossal Gallego retable; Old Masters).

CALIFORNIA

Berkeley: University Art Museum (painting, incl. Rubens, Caracciolo, Savoldo).

Los Angeles: Los Angeles County Museum of Art (a large collection of Old Masters, incl. Hals' oval *Portrait of a Man in a Black Hat*, a splendid example of his bravura style; Rembrandt, incl. a striking *Raising of Lazarus*; Rubens; a fine Van Dyck courtly portrait; Ruisdael's *Landscape with Dunes*, with an opalescent sky; Fra Bartolommeo's sculpturesque *Holy Family*, in classic High Renaissance style; sculpture; decorative arts; drawings and prints). ☐ University Galleries (15th–18th C. European paintings in the Hammer and Fisher collections of Old Masters).

Malibu: J. Paul Getty Museum (Old Masters, incl. Titian, Tintoretto, Veronese's 2 paintings representing *Allegories of Navigation*, with powerful, brooding figures; Hogarth's amusing moralizing paintings of *Before* and *After the Seduction*; Canaletto; Gainsborough; sculpture; superb French furniture, tapestries, decorative arts in high style).

Pasadena: Norton Simon Museum (an outstanding collection of Old Masters incl. a delicately painted Memling, *Blessing Christ*; Poussin's *Camillus and the Schoolmaster of Palerii*; Raphael's *Madonna with a Book*; Rubens; Rembrandt; a tiny Watteau, *Reclining Nude*; Van Goyen's *Skaters*; sculptures; tapestries; decorative arts).

Sacramento: Crocker Art Museum (early Renaissance to 18th C. painting, sculpture, decorative arts; Old Master drawings, incl. Dürer, Rembrandt, Rubens, Ruisdael; a Fragonard sketch of the Villa d'Este done when he and Hubert Robert were living there).

San Diego: San Diego Museum of Art (European painting, esp. Spanish, incl. Goya, Zurbarán, El Greco, Velázquez; decorative arts). □ Timkin Art Gallery (17th–18th C. Gobelin tapestries, Old Masters incl. a Claude *Pastoral Landscape;* Ruisdael's *View of Haarlem;* Rembrandt; Rubens; Ribera's *Wise Man;* Brueghel's marvelous *Parable of the Sower,* with its cosmic distances and aerial perspective).

San Francisco: The Fine Arts Museums of San Francisco (paintings, sculpture, decorative arts, tapestries; Fragonard's *Self-Portrait;* very fine Louis XVI salon in the California palace of the Legion of Honor; Old Masters, sculpture, decorative arts in the M. H. de Young Memorial Museum).

Santa Clara: de Saisset Art Gallery and Museum (French furniture and decorative arts; Baroque tapestries; prints and drawings).

Santa Barbara: University of California, Santa Barbara Art Museum (Sedgwick Collection of 15th–17th C. Old Masters; Renaissance to 18th C. drawings).

Stanford: Stanford University Museum and Art Gallery (17th–18th C. Italian painting and furniture; 17th C. Flemish genre paintings).

COLORADO

Denver: Denver Art Museum (Italian Renaissance and Baroque paintings, incl. Tintoretto and Veronese; Lucas van Leyden tapestry, *December,* from the series of *Months,* made for the Barberini Palace).

CONNECTICUT

Hartford: Wadsworth Atheneum (fine Baroque and Rococo collections; Francavilla's Mannerist, heroic-sized marble of *Venus Attended by a Nymph and Satyr;* paintings by Caravaggio, Goya, El Greco, Poussin, Rembrandt, Rubens, Guardi).

New Haven: Yale University Art Gallery (Jarves and Griggs Collection of Italian Renaissance painting, containing classic examples). *

DISTRICT OF COLUMBIA

Washington: National Gallery of Art (superlative collection of painting and sculpture; great group of Rembrandts, Van Dycks, English portraits, Goyas, Titians, Tintorettos, Tiepolos; Vermeers; de la Tour; Rubens, incl. *Daniel in the Lion's Den,* with some of the noblest lions in art; Botticelli's superbly orchestrated *Adoration of the Magi,* with members of the Medici family participating; Leonardo da Vinci's *Ginevra de' Benci,* unique this side of the

Atlantic, as subtle a psychological portrait as it is as a masterpiece of painting; della Robbia sculptures; Donatello's Martelli *David;* Verrocchio's terracotta bust of *Lorenzo de' Medici:* outstanding Old Master drawings and prints; decorative arts).

FLORIDA

Coral Gables: Lowe Art Museum (Kress Collection of Renaissance, Baroque, and Rococo painting; sculpture).

Jacksonville: Cummer Gallery of Art (Italian, Dutch, German, Flemish, and French painting; sculpture; prints; drawings; Bernini's marble bust of *Cardinal Richelieu;* outstanding Meissen porcelain).

Miami: Villa Vizcaya Museum and Gardens (European Baroque and 18th C. furniture and decorative arts; spectacular original period palace interiors reinstalled in a properly palatial setting, with beautifully landscaped gardens).

Sarasota: John and Mable Ringling Museum of Art (fine collection of Baroque and Rococo painting, sculpture, decorative arts; Rubens tapestries; 18th C. theater from Asolo, Italy; impressive Rubens paintings; Poussin's handsome *Holy Family;* Veronese's *Rest on the Flight into Egypt,* in splendid color, with delightfully gymnastic attending angels; plus works by Rembrandt, Hals, Canaletto; and Tiepolo).

GEORGIA

Atlanta: The High Museum of Art (Kress Collection, incl. Giovanni Bellini's *Madonna and Child;* Tiepolo's *Offerings by the Vestals to Juno;* and Cranach's *Portrait of a Man).*

HAWAII

Honolulu: Honolulu Academy of Arts (Kress Collection of Italian Renaissance painting; decorative arts).

ILLINOIS

Champaign: Krannert Art Museum (fine Old Master paintings, drawings, and prints; Rubens' small *Banquet of Tereus;* Murillo's *Christ after the Flagellation;* 2 saints by Tiepolo).

Chicago: Art Institute of Chicago (European Renaissance and Baroque painting, sculpture, decorative arts; El Greco's *Assumption of the Virgin;* Tiepolo paintings based on Ariosto's *Orlando Furioso,* recounting the story of Rinaldo and Armida; Italian Renaissance painting and sculpture; outstanding prints and drawings).

INDIANA

Bloomington: Indiana University Art Museum (Kress Collection of Renaissance and Baroque paintings; fine drawings, incl. Claude, Fragonard, and Watteau).

Indianapolis: Indianapolis Museum of Art (Renaissance and Baroque painting, sculpture, decorative arts; strong in Italian, Spanish, and Dutch painting, incl. Caravaggio, Velázquez; Goya, El Greco; Hals' *Self-Portrait*; Titian's small portrait of the great Italian poet Ariosto; 17th–18th C. French painting and decorative arts).

Muncie: Ball State University (Italian Renaissance painting, sculpture, decorative arts; Fragonard portrait).

Notre Dame: Snite Museum of Art, University of Notre Dame (Italian Renaissance painting and sculpture; Italian, Dutch, and Flemish Baroque painting).

KANSAS

Lawrence: Spencer Museum of Art (small collection of painting and sculpture, incl. 2 life-sized carved lindenwood figures of Saints Cosmas and Damian, white and gilded, ascribed to Joseph Götsch, among the best South German Rococo sculptures in America).

KENTUCKY

Louisville: J. B. Speed Art Museum (Italian, French, Spanish, and Netherlandish painting; Rubens, Veronese, Jordaens, Goya; 16th C. Italian bronze horse and rider).

LOUISIANA

New Orleans: New Orleans Museum of Art (Kress Collection of Italian Renaissance and Baroque painting; a late Giovanni Bellini *Madonna*, painted with the assistance of his follower Catena).

MAINE

Brunswick: Bowdoin College Museum of Art (Molinari Collection of medals and plaquettes; master prints and drawings, incl. a masterful Brueghel alpine landscape).

MARYLAND

Baltimore: Baltimore Museum of Art (Baroque painting, incl. Van Dyck, Hals, Rembrandt's *Portrait of His Son Titus*; sculpture; decorative arts). ☐ Walters Art Gallery (Italian Renaissance and Baroque painting and sculpture;

Raphael's *Madonna of the Candelabra;* Bellini, Veronese, Lippi; Laurana's *Piazza of an Italian City*, a rare painting by an outstanding architect and sculptor; unique collections of Renaissance jewelry and enamels).

Hagerstown: Washington County Museum of Fine Arts (16th–17th C. Flemish, Dutch, and Italian Old Masters).

MASSACHUSETTS

Amherst: Mead Art Museum (paintings, sculpture, decorative arts; Rother-was Room, a fine example of an Elizabethan interior; prints and drawings).

Boston: Isabella Stewart Gardner Museum (fine collection in a building modeled after a Venetian palace, always with superb flowers in the courtyard; Raphael portrait; Titian's incomparable *Rape of Europa;* Rembrandt's *Self-Portrait* as a young man; Vermeer's *The Concert*). ☐ Museum of Fine Arts (Old Masters of all major schools, Tintoretto's *Nativity;* Rubens' *Queen Thomyris Receiving the Head of Cyrus*, and a portrait of *Muley Ahmad;* El Greco, Velázquez, Rembrandt, Hals, Poussin; Donatello's relief of the *Madonna and Child with Angels;* Italian pottery).

Cambridge: Fogg Art Museum (Early Italian, Flemish, and Spanish paintings; Fra Angelico's *Crucifixion;* Rubens, Dürer, Filippo Lippi; Bernini's *bozzetto* of a *Kneeling Angel* and other terra-cottas; important sculptures and decorative arts).

Springfield: Springfield Museum of Fine Arts (Old Master paintings, incl. van Goyen's atmospheric *River View with Leyden in the Distance;* Ruisdael's more dramatic *Landscape near Dordrecht;* fine Kalf and Chardin still lifes; Claude's *View of the Forum* in Rome; a very handsome Bellotto view near Dresden).

Wellesley: Wellesley College Museum (painting, sculpture, drawings, prints; Magnasco's emotional *St. Bruno in Ecstasy;* Salvator Rosa, Marco Ricci, and other Italian Baroque artists; a small bronze by the Mannerist Giovanni da Bologna of the *Rape of the Sabine Women*, the colossal original of which is in the Loggia de' Lanzi in the Piazza della Signoria, Florence).

Williamstown: Williams College Museum of Art (Italian Renaissance painting and sculpture; 16th–18th C. European art; Ribera's formidable *Executioner;* Panini's early *Roman Ruins*, with its familiar details). ☐ Sterling and Francine Clark Art Institute (outstanding Renaissance-to-18th C. paintings, drawings, and prints; the austere silence of Piero della Francesca's *Madonna*).

Worcester: Worcester Art Museum (16th–18th C. Old Masters, incl. Rembrandt, El Greco, Guardi, Canaletto, Van Goyen, Turner; Hogarth portraits; Gainsborough's charming *Portrait of the Artist's Daughters;* Poussin's *Flight*

into Egypt; Ruisdael's *The Y on a Stormy Day;* a few earlier masters, incl. Piero di Cosimo's curious, satiric *Discovery of Honey,* a fantastic interpretation of a story from Ovid by a rare and eccentric Florentine; decorative arts).

MICHIGAN

Ann Arbor: University of Michigan Museum of Art (painting, sculpture, decorative arts; drawings, and prints).

Detroit: Detroit Institute of Arts (Old Masters, with outstanding Northern European paintings; incl. Brueghel's justly famed *Wedding Dance;* 2 predella panels by Raphael; Poussin's lyrical *Selene and Endymion;* 4 Tiepolos, 3 Titians, 4 Tintorettos; Caravaggio's intense and enigmatic *Conversion of the Magdalene;* fine Rubens group; Ruisdael's darkly moving *Cemetery,* the poet Goethe's favorite picture).

East Lansing: Kresge Art Center Gallery (15th C. European sculpture; 16th C. prints and drawings; 17th C. paintings).

MINNESOTA

Minneapolis: Minneapolis Institute of Arts (Old Master paintings and drawings; a tiny Fra Angelico *St. Benedict;* Poussin's *Death of Germanicus;* Rembrandt's *Lucretia;* Rubens' sketch of *The Crowning of the Prince of Wales by England, Scotland, and Wales;* sculptures; decorative arts).

MISSOURI

Kansas City: William Rockhill Nelson Gallery and Atkins Museum of Fine Arts (Kress Collection of Old Masters; Titian and Tintoretto portraits; 2 Claude landscapes; Canaletto view of the *Piazza San Marco;* a Van Goyen skating scene; Poussin's *Triumph of Bacchus,* with preliminary drawing; sculpture, prints, decorative arts).

St. Louis: St. Louis Art Museum (outstanding paintings and sculpture; marble *Satyr* by Montorsoli, Michelangelo's assistant in the Medici Chapel sculptures; Cranach's *Judgment of Paris,* with flirtatious little nudes; David's tiny *tondo Annunciation;* Guardi's airy *Entrance to the Grand Canal;* de Hooch's *Game of Skittles;* plus other Old Masters; decorative arts).

NEBRASKA

Omaha: Joslyn Art Museum (small collection of Renaissance painting and decorative arts; one of the great Titians, *Man with a Falcon,* a portrait yet so much more).

218

NEW JERSEY

Princeton: The Art Museum, Princeton University (paintings and drawings, esp. strong in the Italian school; Bosch's frightening *Christ Before Pilate;* a pair of fascinating Chardin still lifes, *Attributes of the Architect* and *Attributes of the Painter;* Cranach's *Venus and Amor;* Tintoretto's *Hermit in the Forest*, plus a fine drawing for his frescoes in the School of San Rocco, Venice; a sketch of the Duchess of Alba from Goya's Madrid sketchbook; a small Rubens *Death of Adonis;* drawings by Tiepolo, Claude, and others).

NEW YORK

New York City: The Brooklyn Museum (painting, sculpture, decorative arts; Old Master drawings and prints; paintings by Goya, Hals, Hobbema). □ Cooper–Hewitt Museum, The Smithsonian Institution's National Museum of Design (design and decorative arts in depth: fine drawings and prints). □ The Frick Collection (Old Masters, incl. Bellini's *St. Francis in Ecstasy*, with its wonderful Italian landscape; David's tender *Deposition;* great Van Dycks, incl. his portrait of the famous animal painter *Frans Snyders;* Holbeins, incl. a portrait of *Erasmus;* Rembrandt's mysterious and noble *Polish Rider;* Fragonard room, with fine furniture; Vermeers; Piero della Francesca's *St. John;* a superb collection of Renaissance bronzes, and much more). □ Hispanic Society of America Museum (extremely fine Spanish collection, incl. El Greco, Velázquez, and Goya; prints and drawings; decorative arts). □ The Metropolitan Museum of Art (one of the world's great collections, incl. Old Master paintings, drawings, prints, sculpture, decorative arts; 2 Raphaels, 2 dozen Rembrandts; Vermeer, Poussin; Veronese's enigmatic and sumptuous *Mars and Venus United by Love;* Bronzino's elegant Mannerist *Portrait of a Young Man;* El Greco's tremendous *View of Toledo;* Velázquez's *Juan de Pareja*, his black friend and assistant; intarsia study from Gubbio; Blumenthal Patio; Luca della Robbia's *Madonna and Child* in terra-cotta; Faenza terra-cotta *Lamentation;* and much more). □ The Pierpont Morgan Library (Old Master drawings, illuminated Renaissance mss., painting, sculpture, decorative arts).

Rochester: Memorial Art Gallery of the University of Rochester (Old Masters, sculpture, decorative arts).

NORTH CAROLINA

Raleigh: North Carolina Museum of Art (Kress Collection of paintings).

OHIO

Akron: Stan Hywet Hall (16th and 17th C. Flemish tapestries, 18th C. English portraits).

Cincinnati: Cincinnati Art Museum (15th–18th C. Old Masters; sculpture, decorative arts; Botticelli's little *Judith;* Claude's *Artist Studying from Nature;* El Greco's *Crucifixion with a View of Toledo;* a rare and fascinating Mantegna; a gallery of Gainsboroughs; and much more). ☐ The Taft Museum (Old Masters; esp. Dutch and English painting, incl. Rembrandt, Hals, Turner; Renaissance jewelry; Italian majolica and other decorative arts).

Cleveland: Cleveland Museum of Art (Old master paintings, drawings, and prints; sculpture; decorative arts; Botticelli's *tondo Madonna;* a Fine Canaletto Venetian view; Goyas; a Hobbema; El Grecos; a pair of Guardis celebrating a papal visit to Venice in 1782; Poussin's *Return to Nazareth;* fine Tiepolos; Tintoretto's *Baptism;* Titian's luminous *Adoration of the Magi;* and much more).

Columbus: Columbus Museum of Art (Old Master paintings, drawings, and prints; Sebastiano del Piombo's double portrait of *Ferdinando d'Avalos and His Wife Vittoria Colonna*, philosopher, patroness, intellectual, and the lifelong platonic love of Michelangelo, for whom he wrote some of his greatest poems; Rubens' *Christ Triumphant;* Sir Joshua Reynolds' wistful *Collina;* a fine small Turner watercolor).

Dayton: Dayton Art Institute (small collection of Old Masters; Canaletto's *Pantheon, Rome;* 4 Reynolds portraits; a Rubens study; Ruisdael's *Waterfall Before a Castle*).

Oberlin: Allen Memorial Art Museum (small Old Masters collection; drawings, prints, decorative arts; Kress Collection of 15th and 16th C. Italian paintings; Ribera's *Beggar;* Chardin still life; Claude's *Harbor Scene;* Hobbema; Van Goyen; a Hogarth portrait of an architect; Turner).

Toledo: The Toledo Museum of Art (Old Master paintings, drawings, and prints; sculpture; decorative arts; outstanding glass collection; Bellini's *Christ Carrying the Cross;* Rubens' impressive *Crowning of St. Catherine;* a Gainsborough landscape; Zurbarán; Goya's tapestry cartoon depicting *Children with a Cart;* a Turner Venetian view; a delightful portrait of a *Man with a Wineglass*, probably by Velázquez).

OKLAHOMA

Tulsa: Philbrook Art Center (Kress Collection of Italian 15th–18th C. painting and sculpture; Canaletto's *View of Dresden*, a fascinating view of the Ba-

roque capital of the king-electors of Saxony; an interesting portrait of *Horatio Nelson* as a young officer, attributed to Gainsborough; a Raeburn portrait).

OREGON

Portland: Portland Art Museum (Kress Collection of Renaissance art; Bronzino and Boucher portraits; striking Kalf still life; a Cranach *Madonna*; 2 Fragonard portraits of children; a Raeburn portrait; a tiny Turner watercolor).

PENNSYLVANIA

Allentown: Allentown Art Museum (Kress Collection of paintings, drawings, and prints; a Lotto *St. Jerome*; Canaletto's sparkling view of *The Piazzetta, Venice*).

Philadelphia: Philadelphia Museum of Art (Old Master paintings, drawings, and prints; sculpture; a Botticelli portrait and 4 predella panels; Rogier van der Weyden's magnificent and moving *Crucifixion*; Poussin's *Baptism* and *Triumph of Neptune and Amphitrite*; a glowing Claude landscape; a marvelous group of Rubenses; 4 fine Ruisdaels; and much more).

Pittsburgh: The Frick Art Museum (Old Master paintings, decorative arts, and tapestries; Fragonards, incl. a delightful, freely executed sketch for *The Pursuit*, in The Frick Collection in New York City; Tintoretto's *Susanna and the Elders* in a magical garden). ☐ Museum of Art, Carnegie Institute (a small Old Master group; decorative arts; prints).

RHODE ISLAND

Providence: Museum of Art, Rhode Island School of Design (16th–18th C. paintings, sculpture, porcelains; a Tiepolo ceiling; Tintoretto scenes from Tasso's famous epic *Jerusalem Delivered*; prints and drawings).

SOUTH CAROLINA

Columbia: Columbia Museums of Art and Science (Kress Collection of 16th–18th C. painting: a Tintoretto portrait with a view of the papal fortress of Castel Sant'Angelo, Rome, in the background; prints; English furniture; Botticelli's *Adoration of the Child*; Canaletto and Guardi Venetian views).

Greenville: Bob Jones University Collection of Sacred Art (Botticelli *tondo Madonna*; Cranach's frivolous *Salome*; a Memling *Madonna*; Poussin's *Holy Family*; Fra Bartolommeo; Tintoretto; Titian).

TENNESSEE

Memphis: Brooks Memorial Art Gallery (Kress Collection of Italian Renaissance painting and sculpture; 16th–18th C. Northern European painting and sculpture; 17th–18th C. English painting; decorative arts; Van Dyck's *Por-*

221

trait of *Queen Henrietta Maria;* Canaletto view on the Grand Canal, Venice; a Van Goyen river scene; a Hobbema landscape; Hogarth's lovely portrait of his sister Ann; 4 Reynolds portraits).

TEXAS

Dallas: Dallas Museum of Fine Arts (a small collection of Old Master paintings and prints; Van Dyck's *Countess of Oxford;* Dürer and Rembrandt prints). ☐ Meadows Museum and Sculpture Court (Spanish paintings and prints, incl. a Velázquez *Philip IV,* Goyas, Zurbarán, Murillo; fine editions of all of Goya's sets of prints).

El Paso: El Paso Museum of Art (Kress Collection of 14th–17th C. art; decorative arts; a Botticelli *Madonna tondo;* a fine *Madonna,* with a delightful glimpse of landscape, by Bellini's pupil Previtali; a melancholy *St. Catherine* by Artemisia Gentileschi; Canaletto's *View of the Molo, Venice,* with the ducal palace; a Rigaud grand-manner portrait).

Fort Worth: Kimbell Art Museum (outstanding painting, sculpture, drawings, and prints; a Bellini *Madonna,* with a signature in beautiful Renaissance lettering and a still life of an open book on a marble parapet; Goya's portrait of the bullfighter *Pedro Romero;* Van Goyen's *View of Arnhem* with its misty sky; Rubens' *Triumph of David* and small portrait of the *Duke of Buckingham;* Tintoretto's dramatic *Raising of Lazarus;* a dashingly painted Hals portrait; Turner's *Glaucus and Scylla;* plus much more).

Houston: The Museum of Fine Arts, Houston (Kress Collection of Old Masters; Straus Collection of Renaissance painting and sculpture; decorative arts; prints and drawings; a Bellini *Madonna;* a very fine, small Memling *Portrait of a Woman,* with beautifully painted coif; 2 small Venetian views by Canaletto; Claude's *Pastoral Landscape with a Natural Arch;* Rogier van der Weyden; Panini; a Holbein miniature *Portrait of Sir Henry Guilford*).

VIRGINIA

Norfolk: Chrysler Museum at Norfolk (Old Masters; decorative arts; a wild little Bosch *Temptation of St. Anthony;* an oval Guardi *Naval Battle* in a horrendous storm; 2 Lawrence portraits; 2 Rubens portraits; Tiepolo's small oval sketch for a ceiling of the *Glorification of Francesco Barbaro;* a large Veronese *Madonna*).

Richmond: Virginia Museum of Fine Arts (Old Master paintings, sculpture, decorative arts; Goya's admirable portrait of a handsome and wary Spanish general; Claude's *Battle on a Bridge,* with a lyrical landscape undisturbed by the clash of arms; Gainsborough's delightful *Charlton Children;* Hobbema's *River Landscape*).

WASHINGTON

Seattle: Seattle Art Museum (Kress Collection of Renaissance and Baroque painting and sculpture; a small Brueghel painting of *Dancing Peasants*— compare its earthiness and vigor with Cranach's chic *Judgment of Paris*; Canaletto's grand view of the *Bacino di San Marco*, with its vivid little figures suggesting characters in a Goldoni comedy; an unusual Guardi *Holy Family*; a fine, rare Dürer drawing; a vigorous Goya, *Beggar with Dog*).

WISCONSIN

Madison: Elvehjem Museum of Art (Italian and Northern Old Masters; sculpture; decorative arts; prints and drawings; marble *tondo* of a *Madonna and Child* by Benedetto da Maiano).

CANADA

ONTARIO

Ottawa: National Gallery of Canada (Old Master painting and sculpture; decorative arts; 2 Canaletto Venetian views; a pair of Chardin genre portraits; a group of drawings by Claude and a rare nude by Dürer; Van Dyck's *Daedalus and Icarus*; 2 Poussin paintings and a possible drawing; Guardi paintings and drawings; a Raphael drawing of a praying saint; Rembrandt paintings, prints, and a drawing; fine Tiepolo drawings; a Titian portrait; Turner's inimitably titled *Shoeburyness Fishermen Hailing a Whitstable Hoy*; and much more).

Toronto: Art Gallery of Ontario (Italian 15th–18th C.; Dutch 17th C.; French 17th–18th C.; and English 18th C. Old Masters; sculpture; drawings and prints; decorative arts; a *Coast View* by Claude; an atmospheric Van Goyen *View of Rhenen* with a luminous sky; Poussin's *Venus, Mother of Aeneas, Presenting Him with Arms Forged by Vulcan*, painted in the artist's mythological mode; Reynolds' *Portrait of Sir Horace Walpole*, the famous English writer; Turner watercolors).

QUEBEC

Montreal: The Montreal Museum of Fine Arts (Old Masters, incl. Goya's *Portrait of Altamirano*; an El Greco portrait; a Guardi *Storm at Sea*, with wildly tossing vessels; a Hogarth *Portrait of a Little Girl*; Poussin's enigmatic *Man Pursued by a Snake*; a group of Raeburn portraits—he invariably had the healthiest-looking subjects; Reynolds portraits; Rubens' vivid *Leopards*; Ruisdael's mostly skyfilled *Bleaching Grounds Near Haarlem*; Tiepolo's *Apelles Painting the Portrait of Campaspe*, with lovely Rococo color; Turner watercolors).

223

(above) Woman with Amphora and Pomegranates *by Henri Matisse.* COURTESY OF THE NATIONAL GALLERY OF ART, WASHINGTON, D.C.

(left) Head of a Woman *by Amedeo Modigliani.* COURTESY OF THE NATIONAL GALLERY OF ART, WASHINGTON, D.C.

5) The Modern World
(c. 1800-1982)
NINETEENTH CENTURY:
 ROMANTICISM
 REALISM
 IMPRESSIONISM
 AMERICAN ART

TWENTIETH CENTURY:
 POST-IMPRESSIONISM
 EXPRESSIONISM
 AND MORE RECENT DEVELOPMENTS

5. The Modern World

In the prevailing spirit of Romanticism that permeated much of the nineteenth century there was initially a rediscovery of the classical world. At first it took the form of a Greek revival, inspired by recent finds at Herculaneum and Pompeii, the struggles of contemporary Greeks for freedom from the Turks, and the pioneering writings on Greek art of Johann Joachim Winckelmann, the first of the great German art historians. Thereafter a general Neoclassicism in architecture, sculpture, and design—even extending to fashion—prevailed throughout Europe, from Russia to Italy, as well as in America, where the movement started with Jefferson's new State Capitol for Virginia (1785–89) modeled upon the Maison Carrée at Nîmes. The dream of the founding fathers to recreate the civilization of Periclean Greece in the New World, symbolized by Jefferson's concept, led to the Classical Revival's becoming the first national style of the new republic.

In European painting Jacques Louis David (1748–1825) of France and Francisco Goya (1746–1828) of Spain were the two giants whose widely divergent styles—David's stark Classicism and Goya's powerfully imaginative and personal expression—dominated the first quarter of the nineteenth century. While Corot and a group known as the Barbizon School were painting in direct response to nature, much as were their contemporaries in America, Ingres continued David's Classicism in France. The exoticism and color of Géricault and Delacroix expressed their brand of Romanticism. Paralleling the writing of Balzac and Flaubert, by midcentury, Realism emerged as the dominant trend. The leaders, Daumier and Courbet, were followed by Manet, Monet, and the Impressionists, with whom Cézanne had exhibited in 1874 in the first Impressionist show;

Cézanne had not yet begun to interpret nature in terms of geometric forms in anticipation of the advent of Cubism in 1907, the year after his death. Meanwhile the Salon des Refusés of 1863 showed how completely the creative energies of the period were adopting experimental forms not tolerated by the conservative Academy.

In England, though the tradition of aristocratic portraiture continued throughout the nineteenth century, the most notable development was in landscape, with John Constable (1776–1837) anticipating aspects of Impressionism with his broad and airy canvases, and J. M. W. Turner's (1775–1851) personal yet cosmic vision looking still further into the future. The foundation, in 1848, of the Pre-Raphaelite Brotherhood combined art and literature with the growing interest in the Middle Ages, reflected in the Gothic Revival in architecture. These trends were fostered by John Ruskin's critical writings and by William Morris and the craft movement.

In America, though the portrait continued to be important, the nineteenth-century is characterized by the primacy of landscape, with the romantic rediscovery of the American countryside, as seen in the works of the Hudson River School of painters led by Thomas Cole (1801–48). The period also saw a flourishing school of genre painting, with a parallel rediscovery of the picturesqueness of everyday life in America recorded in the nostalgic spirit of Stephen Foster's haunting melodies. Unlike landscape painting abroad, however, the American scene was painted as if it were a revelation from the hand of the Creator, untouched by man, an attitude shared by Emerson and the transcendentalists.

During the last two decades before the outbreak of the Civil War in 1861, America saw a flowering of art and literature. Hawthorne, Melville, Longfellow, Poe, Cooper, Irving, Thoreau, and Whitman produced important works. Their writings often show a concern similar to that of the painters: the relation of man and nature in the New World. The limitless frontiers of time suggested by the ocean's vast expanse were also reflected in the New World experience, in which modern man, with his centuries-old European heritage, met Stone Age man face to face in the latter's natural domain.

America emerged from the Civil War profoundly changed both socially and economically. The new tycoons of industry replaced the merchants and shipowners as patrons of the arts. Lacking the assured taste of their predecessors, they preferred European to American art. Collecting became largely a matter of conspicuous consumption carried out in a highly competitive spirit. In the face of the rampant materialism of the postwar years, the painter James Abbott McNeill Whistler, like the writer Henry James, retreated to Europe. The three artistic giants of the later nineteenth century—the painters Thomas Eakins, Winslow Homer, and Albert Pinkham Ryder—withdrew from the urban centers to continue, in solitude, their work with traditional themes; Eakins with portraiture and genre, Homer with genre, and land- and seascape, and Ryder with haunting visions that exemplified the inward-looking tradition of fantasy—another recurring aspect of the American creative mind.

As was the case in Europe during the first half of the nineteenth century, American sculpture was in the deep freeze of Neoclassicism. Togaed males of relentless factuality, and classically draped females—either similarly realistic or else summarily idealized to look like the countless Phrynes, Proserpines, and Graces—were turned out in profusion by dozens of totally forgettable practitioners who descended on Rome in the 1830s, following such world-famous contemporaries as the Dane Thorwaldsen, and the Americans, Horatio Greenough and Hiram Powers. The latter's famous *Greek Slave*, the best-known sculpture of the period, was not nude, as she appeared, but was "clothed in her own virtue," as was certified by five clergymen from Cincinnati.

The native American Realist tradition was carried on by a group of sculptors who stayed at home, among whom John Quincy Adams Ward

and Thomas Ball were leaders. Augustus Saint-Gaudens (1848–1907) and Daniel Chester French (1850–1931) were outstanding in the latter part of the century. Their numerous and eclectic works dominated the white-columned vistas of the 1893 World's Columbian Exposition held in Chicago, which also marked the emergence of the famous beaux-arts architectural partnership of McKim, Mead, and White, who housed American millionaires in suitable grandeur for some decades thereafter. The greatest American sculptor of the century, however, was Dr. William Rimmer of Boston (1816–79). Perhaps even more knowledgeable as an anatomist than Thomas Eakins, he produced little, but his few works have a tragic grandeur and evocative power matched by few, if any, sculptors of the century except Rodin.

Twentieth-century American art began in 1906 with an exhibition held in New York entitled "Eight Americans," which introduced the Ash Can School, painters concerned with the actualities of teeming urban life. In 1913 the famous Armory Show revealed to unsuspecting Americans what had recently been going on in Europe, incl. "all the cock-eyed isms," as the American regionalist painter Thomas Hart Benton called them. It was a period of continuing crisis coupled with an explosion of artistic developments: Expressionism, with Matisse and the Fauves in France; The Bridge, and The Blue Rider in Germany, where Kandinsky, a Russian member of the latter group, devoted himself entirely to nonobjective painting from 1910 on; Cubism, beginning with Picasso in 1906; the abstract geometric canvases of Mondrian, a Dutchman, a few years later; fantasy, with the development of Dadaism in the works of Duchamp, Surrealism in those of Ernst, Dali, and Miró; and, emerging at midcentury, Action Painting with Jackson Pollock and other members of what came to be called the New York School. Action Painting had a worldwide impact and was followed by a myriad of other movements—Color-Field Painting; Pop Art, with its mundane imagery; Op Art and Photorealism, exploiting new directions in visual perception—that continue to proliferate.

Rodin and Maillol were the two French sculptors who dominated the field at the start of the century, the powerful naturalism of the former contrasting with the timeless classicism of the latter. Brancusi, a Rumanian pupil of Rodin explored the reduction of form to its symbolic core, a direction also pursued by Henry Moore, England's greatest twentieth-

century sculptor. In the meantime, sculptural expressionism, derived from Matisse's vigorous formal reductions, continued to appear in a number of guises. Russian Constructivism, consisting of three-dimensional assemblage, was a form explored by both Alexander Calder (1898–1976) and his younger contemporary David Smith (1906–65), whose stainless steel totems, looking as if they were factory-made, eliminate all overt reference to natural form. Calder, by contrast, was a pioneer in the field of kinetic art. His works, whether mobiles or stabiles, always involve biomorphic form thereby echoing the natural world and suggesting a recurring theme central to American art and literature.

The United States is fortunate in having a considerable number of museums with significant holdings in twentieth-century and modern art, the leader being the Museum of Modern Art in New York. The Solomon R. Guggenheim Museum in New York is housed in a building designed by Frank Lloyd Wright, which is itself a work of modern art. There are also remarkable collections at the Albright-Knox Art gallery in Buffalo, largely due to the enthusiasm of the late Seymour Knox; in Philadelphia, with the Arensberg and Gallatin collections; in New Haven, at the Yale Art Gallery, whose Société Anonyme Collection was formed by Katherine Drier on the advice of the artists Marcel Duchamp and Man Ray; the Baltimore Museum, with the extraordinary collections of the Cone sisters; the University Museum in Berkeley and the Norton Simon Museum in Pasadena, California; and the Hirschhorn Museum in Washington, D.C.—in addition to all the museums of modern and contemporary art across the country.

The collections of nineteenth-century art follow a different configuration. Since Americans were among the first collectors of Impressionist and Post-Impressionist art, often following the advice of distinguished contemporary American artists, there are remarkable holdings at the Art Institute of Chicago; the Barnes Foundation in Merion, Pennsylvania; the Walker Art Center in Minneapolis; the Museum of Fine Arts in Houston. Nineteenth-century American arts are represented in most large city museums. They are also in the collections of the Albany Art Institute, Albany, New York; the New-York Historical Society in New York City; Cooperstown, New York; Shelburne, Vermont; the Pennsylvania Academy of the Fine Arts, Philadelphia; and in many specialized institutions as well. The most complete and outstanding collections remain those in Chicago, Boston, and the Metropolitan Museum in New York.

230

ARIZONA

Phoenix: Phoenix Art Museum (19th–20th C. European and American art; contemporary art of the Americas).

Tempe: Arizona State University Art Collections (19th–20th C. American art).

Tucson: University of Arizona Museum of Art (Gallagher Collection of contemporary European and American painting and sculpture; Pfeiffer Collection of American painting; Lipchitz maquettes).

ARKANSAS

Little Rock: Arkansas Art Center (19th–20th C. European and American art).

CALIFORNIA

Berkeley: University Art Museum (20th C. European and American arts; Hans Hofmann paintings and archive).

La Jolla: La Jolla Museum of Contemporary Art (paintings by John Marin and Marsden Hartley).

Long Beach: Long Beach Museum of Art (20th C. European and American art; *Der Blaue Reiter*).

Los Angeles: The Frederick S. Wight Art Gallery of the University of California at Los Angeles (19th–20th C. European and American art; sculpture garden). ☐ Los Angeles County Museum of Art (19th C., classic moderns, Americans; Impressionists, Expressionists; Rodin sculptures). ☐ University Galleries, University of Southern California (European and American art, incl. graphic art and photographs).

Pasadena: Norton Simon Museum (classic moderns; Picasso; sculpture).

San Francisco: The Fine Arts Museums of San Francisco—M. H. de Young Museum and California Palace of the Legion of Honor (19th to mid-20th C. American painting; classic European moderns; Rodin sculptures). San Francisco Museum of Modern Art (incl. contemporary West Coast art).

Santa Barbara: Santa Barbara Museum of Art (19th–20th C. American painting).

Stanford: Stanford University Museum and Art Gallery (Rodin collection, plus other moderns).

COLORADO

Denver: The Denver Art Museum (classic 19th–20th C. European and American painting).

CONNECTICUT

Hartford: Austin Arts Center, Trinity College (McMurray Collection of 19th

C. American art). Wadsworth Atheneum (19th–20th C. classic moderns; Calder stabile).

New Haven: Yale University Art Gallery (19th–20th C. American painting; Société Anonyme Collection of pioneering modernists).

New Britain: The New Britain Museum of American Art (19th–20th C. American art; Hudson River School paintings).

New London: Lyman Allyn Museum (19th C. American paintings).

Ridgefield: The Aldrich Museum of Contemporary Art (experimental contemporary art).

DELAWARE

Wilmington: Delaware Art Museum (classic American 19th C. painters, 19th–20th C. illustrators; Brandywine School).

DISTRICT OF COLUMBIA

Washington: Corcoran Gallery of Art (fine collection of American 19th and early 20th C. painting and sculpture, prints; experimental contemporary artists). ☐ Freer Gallery of Art (in addition to one of the world's great oriental collections, also houses a large collection of Whistler's works, incl. the famous Peacock Room). ☐ Museum of Modern Art of Latin America. ☐ National Gallery of Art (classic 19th C. European and American painting; outstanding contemporary art in East Building). ☐ National Museum of American Art (vast and varied American collections, from the early 19th C. to the present, incl. archival material and memorabilia). ☐ The Phillips Collection (selective, outstanding collection of 19th–20th C. moderns).

FLORIDA

Coral Gables: Metropolitan Museum and Art Center (20th C. sculpture; Latin American and American painting).

Jacksonville: Cummer Gallery of Art (American 19th C. painting).

GEORGIA

Atlanta: The High Museum of Art (19th–20th C. American painting).

HAWAII

Honolulu: Contemporary Arts Center of Hawaii.

ILLINOIS

Carbondale: University Museum, Southern Illinois University (19th–20th C. European and American art).

Champaign: Krannert Art Museum (European and American 20th C. art).

Chicago: The Art Institute of Chicago (outstanding collection of European and American art of major schools and masters from the 19th C. to present). Museum of Contemporary Art.

INDIANA

Bloomington: Indiana University Art Museum (outstanding modern paintings).

Indianapolis: Indianapolis Museum of Art (fine collection of classic modern painters; strongest in Europeans; American painting and sculpture).

Notre Dame: The Snite Museum of Art (contemporary paintings).

Terre Haute: Sheldon Swope Art Gallery (American Regionalists, Realists, and other painters).

IOWA

Cedar Rapids: Cedar Rapids Art Center.

Davenport: Davenport Art Gallery (19th–20th C. painting, primarily American; Grant Wood collection).

Des Moines: Des Moines Art Center (American 20th C. classic modern painters; European moderns).

Fort Dodge: Blanden Memorial Art Gallery (small, select collection of 20th C. European and American artists).

Iowa City: University of Iowa Museum of Art (late 19th and 20th C. European and American painters).

KANSAS

Lawrence: Spencer Museum of Art (small collection of recent and contemporary art).

Wichita: Edwin A. Ulrich Museum of Art (19th–20th C. American art). Wichita Art Museum (distinguished Murdock Collection of American painting; Naftzger collections of American and European prints and drawings and of Charles M. Russell paintings and sculpture).

KENTUCKY

Louisville: J. B. Speed Art Museum (classic late 19th and early 20th C. European and American modernists).

LOUISIANA

New Orleans: New Orleans Museum of Art (good collection of 19th–20th C. European and American painting and sculpture).

MAINE

Brunswick: Bowdoin College Museum of Art (American 19th and early 20th C. painting; Winslow Homer collection).

Ogunquit: Museum of Art of Ogunquit (contemporary American art collection).

Orono: University of Maine at Orono Art Galleries (primarily 20th C. art associated with Maine).

Portland: Joan Whitney Payson Gallery of Art (modern European and American paintings and drawings). □ Portland Museum of Art (19th–20th C. American painting; European moderns).

Rockland: William A. Farnsworth Library and Art Museum (primarily 19th–20th C. American art; Andrew Wyeth paintings; Louise Nevelson works and archive).

Waterville: Colby College Museum of Art (American 19th–20th C. art; Jette American Heritage Collection of 19th C. painting; John Marin collection; Jette Collection of American painters of the Impressionist period; Cummings Collection of American folk art).

MARYLAND

Baltimore: Baltimore Museum of Art (Cone Collection of classic European moderns, esp. Matisse; Benesch Collection of contemporary drawings; 19th C. French works on paper; 19th C. American painters; Wurtzburger sculpture garden). □ Walters Art Gallery (19th C. American and European painting; large collection of sculptures, drawings, and paintings by French 19th C. sculptor Antoine Louis Barye—other examples in the Corcoran, Washington, Norton Gallery, West Palm Beach, Florida).

MASSACHUSETTS

Amherst: Mead Art Museum (American and European painting).

Andover: Addison Gallery of American Art (distinguished collection of American art from the 17th C. to the present).

Boston: Museum of Fine Arts (outstanding examples of American 19th C. art in Karolik collections, incl. painting, drawing, and sculpture; 19th and early 20th C. classic European moderns; contemporary art). (*Note:* The Institute of Contemporary Art housed in a handsome Romanesque Revival building located at 955 Boylston St., has changing exhibits; 617 266-5152.)

Cambridge: Fogg Art Museum (outstanding 19th C. classic modern artists; drawings). (*Note:* The Busch-Reisinger Museum of Germanic culture, with

234

a small but interesting modern collection, is a branch of the Fogg Art Museum located at 29 Kirkland St., a short walk.)

Northampton: Smith College Museum of Art (19th–20th C. European and American painting and sculpture).

Springfield: Springfield Museum of Fine Arts (19th and some 20th C. European and American painting).

Waltham: Rose Art Museum (good collection of late 19th and 20th C. European and American painting and sculpture).

Wellesley: The Wellesley College Museum (late 19th and 20th C. collection of painting, sculpture, drawings, and prints).

Williamstown: Sterling and Francine Clark Art Institute (a fine, selective collection of 19th and earlier 20th C. European and American art). (*Note:* The Williams College Museum of Art has some fine American and European later 19th and 20th C. paintings. The Chapin Library in Stetson Hall is the college's rare book library and has an unusually fine collection, with works by Dürer, Blake, and contemporary artists.)

Worcester: Worcester Art Museum (19th–20th C. European and American painting and sculpture; the Dial Collection of drawings and watercolors, incl. some paintings).

MICHIGAN

Ann Arbor: The University of Michigan Museum of Art (19th–20th C. American and European painting and sculpture).

Detroit: The Detroit Institute of Arts (fine American 19th C. collection; 19th–20th C. European and 20th C. American paintings, sculptures, drawings, and prints).

Flint: Flint Institute of Arts (19th–20th C. European and American painting, sculpture, drawings, and prints).

MINNESOTA

Duluth: Tweed Museum of Art (19th C. French and American painting; Lipchitz's bronze statue of *Daniel Greysolon*, *Sieur du Luth* greets visitors at the entrance).

Minneapolis: The Minneapolis Institute of Arts (19th–20th C. European and American paintings). □ University Gallery (20th C. painting and sculpture). Walker Art Center (outstanding European and American modern painting, sculpture, drawings, and prints).

MISSOURI

Kansas City: William Rockhill Nelson Gallery and Atkins Museum of Fine Arts (American and European 19th–20th C. art).

St. Louis: The Saint Louis Art Museum (American 19th–20th C. painting; European late 19th and early 20th C. painting). □ Washington University Gallery of Art (19th–20th C. European and American painting and sculpture).

NEBRASKA

Lincoln: Sheldon Memorial Art Gallery (primarily American 20th C. painting and sculpture; sculpture court).

Omaha: Joslyn Art Museum (19th–20th C. European and American paintings).

NEW HAMPSHIRE

Hanover: Hood Museum (19th–20th C. European and American painting, sculpture, drawings, and prints).

Manchester: The Currier Gallery of Art (19th–20th C. European and American art).

NEW JERSEY

Montclair: Montclair Art Museum (American 19th–20th C. paintings).

Newark: The Newark Museum (19th–20th C. American painting).

Princeton: The Art Museum (19th–20th C. art; the Putnam Memorial Collection of contemporary sculpture is scattered around the campus).

NEW MEXICO

Roswell: Roswell Museum and Art Center (20th C. American painting and sculpture: European and American prints; Peter Hurd and Henriette Wyeth paintings).

NEW YORK

Albany: Albany Institute of History and Art (American 19th C. painting and sculpture).

Buffalo: Albright-Knox Art Gallery (19th–20th C. European and American arts, with an extensive contemporary collection).

Cooperstown: New York State Historical Association (American 19th C. painting and sculpture).

Corning: Rockwell-Corning Museum (19th C. American art of the West).

Huntington: Heckscher Museum (19th C. American painting).

Ithaca: Herbert F. Johnson Museum of Art (19th–20th C. European and American art).

New York City: The Brooklyn Museum (outstanding American 19th–20th C. collections; European painting and sculpture). ☐ The Grey Art Gallery and Study Center (Grey Collection of contemporary art). ☐ Metropolitan Museum of Art (outstanding comprehensive collection of 19th–20th C. European and American art in great depth and variety in one of the world's great collections). ☐ The Museum of Modern Art (most comprehensive and largest international collection of experimental modern art, from the classic masters of the later 19th C. to the present). ☐ Museum of the City of New York (19th C. American painting, sculpture, and decorative arts). ☐ The New-York Historical Society (outstanding collection of 19th C. American painting, sculpture, prints, drawings, and decorative arts, with special emphasis on New York artists and craftsmen). ☐ The Solomon R. Guggenheim Museum (outstanding collection of painting, sculpture, prints, and drawings of the last century, with emphasis on experimental and nonobjective art; the building, Frank Lloyd Wright's only design carried out in New York City is an important and idiosyncratic work of modern art in itself). ☐ Whitney Museum of American Art (outstanding collection of American painting, sculpture, prints, and drawings from the late 19th C. to the present).

Poughkeepsie: Vassar College Art Gallery (American and European painting; Hudson River School; drawings and prints).

Purchase: Neuberger Museum (Neuberger Collection of 20th C. painting, sculpture, drawings, prints, and photographs; Rickey Collection of Constructivist art).

Rochester: Memorial Art Gallery of the University of Rochester (19th–20th C. European and American painting and sculpture, incl. contemporary works).

Syracuse: Everson Museum of Art of Syracuse and Onondago County (19th–20th C. American and English painting, sculpture, drawings, and prints; 20th C. ceramics and photographs). ☐ Syracuse University Art Collection (largely 20th C. American painting, sculpture, drawings, and prints).

Utica: Munson-Williams-Proctor Institute (19th–20th C. American painting, sculpture, decorative arts, prints, and drawings; 20th C. European painting and sculpture).

NORTH CAROLINA

Chapel Hill: The Ackland Art Museum (19th-20th C. European and American painting, sculpture, drawings, prints, and photographs).

Raleigh: North Carolina Museum of Art (mainly 19th and early 20th C. American art; sculpture, decorative arts).

OHIO

Akron: Akron Art Museum (American and European painting, sculpture, prints, and photographs from the mid-19th C. to the present).

Cincinnati: Cincinnati Art Museum (19th to early 20th C. European and American painting, sculpture, prints and drawings). (*Note:* The Contemporary Art Center, 115 E. 5th St., has no collections but an active exhibition program; 513 721-0390)

Cleveland: Cleveland Museum of Art (19th–20th C. European and American art in a varied and compendious collection in all media). (*Note:* The Salvador Dali Museum is located in Beechwood.)

Columbus: Columbus Museum of Art (19th–20th C. American and European painting and sculpture; Howald Collection of French and American modern art; George Bellows collection; prints and drawings; sculpture court).

Dayton: Dayton Art Institute (select collection of contemporary painting, sculpture, and prints).

Oberlin: Allen Memorial Art Museum (mainly 19th–20th C. French and American painting).

Toledo: The Toledo Museum of Art (19th–20th C. French and American painting; classic moderns; European and American glass; sculpture, drawings, prints).

Youngstown: The Butler Institute of American Art (19th and early 20th C. American painting; regional ceramics),

OKLAHOMA

Tulsa: Philbrook Art Center (selected 19th–20th C. European and American paintings; contemporary Indian painting). □ Thomas Gilcrease Institute of American History and Art (mainly 19th C. painting and sculpture of the American West).

OREGON

Eugene: Museum of Art (contemporary American art of the Northwest; Morris Graves collection; European art; prints).

Portland: Portland Art Museum (19th–20th C. European and American painting and sculpture; sculpture court).

PENNSYLVANIA

Chadds Ford: Brandywine River Museum (American painting, watercolors, drawings, and prints by artists associated with the region from Howard Pyle to James Wyeth; book illustrators).

Merion: Barnes Foundation (outstanding collection of European and American modern art, with an emphasis on the classic modern masters to c. 1950).

Philadelphia: Pennsylvania Academy of the Fine Arts (19th–20th C. American painting and sculpture in a varied and important collection). □ Philadelphia Museum of Art (outstanding 19th–20th C. modern masters, many in the Arensberg, Gallatin, and Stern collections; extraordinary group of Marcel Duchamps paintings). (*Note:* The Philadelphia Museum of Art runs the nearby Rodin Museum, which has a large collection of his sculptures and drawings.)

Pittsburgh: Museum of Art, Carnegie Institute (19th–20th C. European and American painting, incl. many classic examples; sculpture court).

RHODE ISLAND

Providence: Museum of Art, Rhode Island School of Design (19th–20th C. American and European classic moderns; Pilavin Collection of 20th C. American art; Day Collection of Modern Latin-American art).

SOUTH CAROLINA

Greenville: Greenville County Museum of Art (mainly 20th C. American moderns; Magill Collection of Andrew Wyeth).

TENNESSEE

Memphis: Brooks Memorial Art Gallery (19th C. American painting and sculpture; 20th C. international painting and sculpture; prints). □ The Dixon Gallery and Gardens (mainly 19th and early 20th C. French classic moderns; prints; all housed in a delightful garden setting).

TEXAS

Austin: Archer M. Huntington Art Gallery (Michener Collection of 20th C. American painting; contemporary Latin-American art; Smith Collection of Western American art; prints and drawings). (*Note:* The LaGuna Gloria Art Museum at First Federal Bldg., 3809 W. 35th St. [512 458-8191] has 20th C. American art and changing exhibitions.)

Dallas: Dallas Museum of Fine Arts (some 19th C. European and American art, but mainly 20th C. international art; sculpture court; drawings and prints;

Latin-American art). (*Note:* The Meadows Museum and Sculpture Court has Spanish modern art and modern sculpture.)

Fort Worth: Fort Worth Art Museum (mainly American 19th–20th C. painting and sculpture). (*Note:* Also on Carter Square are the Amon Carter Museum of Western Art, with Western Americana, and the Kimbell Art Museum, with masterpieces of world art, incl. some 19th and early 20th C. examples.)

Houston: The Museum of Fine Arts, Houston (19th C. classic moderns; major contemporary painting and sculpture; collection mainly shown in the Brown Pavilion, itself a contemporary work of art designed by Mies van der Rohe). (*Note:* The Contemporary Arts Museum across the street stages lively exhibitions.)

San Antonio: Marion Koogler McNay Art Institute (modern art collection; late 19th C. classics; contemporary painting, sculpture, drawings, prints; pioneer American moderns).

VERMONT

St. Johnsbury: St. Johnsbury Athenaeum (American paintings of the Hudson River School in a 19th C. period collection and installation).

Shelburne: Shelburne Museum (housed in 35 restored buildings, the collection incl. cultural artifacts; American 19th C. painting; folk sculpture; decorative arts; French Impressionist paintings and drawings).

VIRGINIA

Charlottesville: University of Virginia Art Museum (19th–20th C. and contemporary American art).

Norfolk: Chrysler Museum at Norfolk (19th C. classic moderns; recent and contemporary work; 19th–20th C. glass).

Richmond: Virginia Museum of Fine Arts (19th–20th C. American and European art; prints and drawings).

WASHINGTON

Seattle: Seattle Art Museum (contemporary European and American art; work of Northwest Coast artists). (*Note:* The main museum building, with its outstanding oriental collections, is in Volunteer Park. The Henry Art Gallery has 19th–20th C. paintings, photographs, and prints; contemporary ceramics, sculpture.)

WEST VIRGINIA

Huntington: The Huntington Galleries (19th–20th C. American painting, sculpture, glass; 19th C. English and French paintings).

WISCONSIN

Milwaukee: Milwaukee Art Museum (mainly European and American 19th–20th C. arts housed in a lakeshore building designed by Eero Saarinen).

WYOMING

Cody: Buffalo Bill Historical Center (19th C. art of the American West).

CANADA

ALBERTA

Edmonton: The Edmonton Art Gallery (Canadian art; international contemporary arts).

BRITISH COLUMBIA

Vancouver: The Vancouver Art Gallery (modern art, mostly Canadian painting).

MANITOBA

Winnipeg: The Winnipeg Art Gallery (Canadian arts).

NEWFOUNDLAND

St. John's: St. John's Art Gallery (20th C. painting and sculpture; contemporary Canadian arts).

ONTARIO

Hamilton: Art Gallery of Hamilton (Canadian, British, French, and American painting, sculpture, drawings, prints).

Ottawa: National Gallery of Canada (modern European, Canadian, and American painting, sculpture, drawings, prints, and photographs).

Toronto: Art Gallery of Ontario (French, British, Canadian, and American painting, sculpture, drawings, and prints; largest public collection in this hemisphere of sculpture and other work by Henry Moore).

PRINCE EDWARD ISLAND

Charlottetown: Confederation Centre Art Gallery and Museum (Canadian painting, drawings, prints, decorative arts).

QUEBEC

Montreal: The Montreal Museum of Fine Arts (European, Canadian, and American arts). (*Note:* The Musée d'Art Contemporain has a contemporary collection and changing exhibitions, as has the Sir George Williams Art Galleries and the Musée du Québec.)

SASKATCHEWAN

Regina: Norman MacKenzie Art Gallery (European and Canadian paintings, drawings, prints, sculpture). (*Note:* The Dunlop Art Gallery in the Regina Public Library, 23111 12th Ave., also has Canadian drawings, prints, and paintings [306 569-7576].)

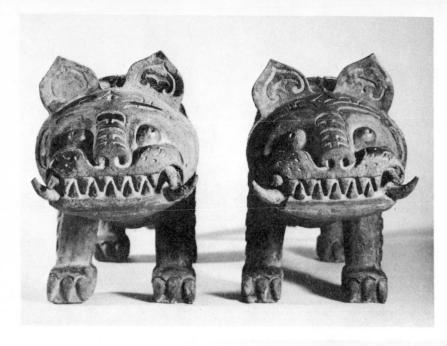

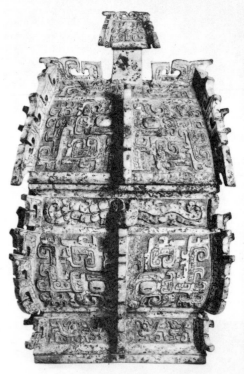

(top) Tiger, Chinese Bronze. COURTESY OF THE FREER GAL-LERY OF ART, SMITHSONIAN INSTITUTION, WASHINGTON, D.C.

(bottom) Ceremonial vessel with cover, Chinese Bronze. COUR-TESY OF THE FREER GALLERY OF ART, SMITHSONIAN INSTITUTION, WASHINGTON, D.C.

6) The Far and Middle East
(c. 3000 B.C. -1982)
CHINA
(c.1500 B.C.- c. 1900)
JAPAN
(c. 3000 B.C. -1982)
KOREA
(c. 3000 B.C.- c. 1900)
SOUTHEAST ASIA
(c. 300 B.C.- c. 1700)
INDIA
(c. 3000 B.C.- c. 1800)

6. The Far and Middle East

Among the earliest influences from the East was the Animal Style, which originated in prehistoric Central Asia and was introduced into the course of Western art by the barbarian tribes which overran Europe from the fourth to the ninth centuries A.D. This style also had a vital formative effect on Chinese art of the early dynasties. In classical times oriental objects found their way into Roman Europe via established trade routes, and in the Middle Ages textiles, porcelain, and glass from the Far East became part of many a church treasury. Oriental porcelains enjoyed a tremendous vogue in Baroque Europe, creating a taste for *chinoiserie* and inspiring the development of Western porcelain manufactures. Constantinople and Venice were the great emporia through which goods from the Orient entered Europe until the fall of the Eastern Empire to the Turks in 1453 and the discovery of alternate trade routes in the fifteenth and sixteenth centuries. The China Trade, started by the Portuguese and the Dutch in the sixteenth century, was dominated by the French and British in the seventeenth and eighteenth; the Americans joined in the nineteenth, and oriental wares became commonplace in Western households. Objects from Japan reached Europe in increasing numbers during the second half of the century, and the fascinating popular art of the Japanese print notably influenced the painting of Whistler and other artists of Impressionist and Post-Impressionist persuasions.

Today, with swift modern communications and the internationalization of the art world, the arts of the East, from India to China and Japan, have come to be admired for their own sake, not merely as picturesque artifacts of quaint and alien cultures.

As they did along the Tigris/Euphrates and the Nile, early civilizations emerged in Neolithic times in the river valleys of Asia, the most impor-

tant being those on the Indus in northwest India, now Pakistan, and on the Yellow River in north central China. Between 3000 and 1000 B.C. recognizable cultures had developed. The Aryan invasions of India, starting about 2000 B.C., made a break in the cultural evolution of the subcontinent, however, so that the history of Indian art really starts with the Maurya Empire in the third century B.C. Although Buddhism is now virtually extinct in India, a great part of Indian art has been inspired by that faith, founded by Siddhartha, the Buddha, who was born near the Nepal border about 563 B.C. Buddhism was introduced into China by missionaries from Central Asia and later, at about the beginning of the Christian era, from India. From China, Buddhism followed trade and invasion routes into Korea and finally, in the fifth century A.D., into Japan. In the meantime, Hinduism underwent a renascence so that, with Jainism, it became one of the two dominant religions of India. As in the Middle Ages in the West, throughout the Eastern world the arts have been either religious in purpose or, when secular, have been pervaded by attitudes deeply influenced by religion.

The adventures of Alexander the Great in the fourth century B.C. left their mark on Eastern art, producing in Gandhara, near Afghanistan, a hybrid style of great quality. However, the major aspects of Indian art—sinuous line, flowing form, sensuous expression, and a sense of movement—prevail throughout, whatever the outside influences, as was appropriate to a civilization whose symbol of the life force was the dance of Siva. Many of the same qualities inform the arts of southeast Asia, of Thailand and Cambodia, the latter adding an elongated elegance and more stately rhythm. The Moslem conquest, beginning in the late twelfth century, introduced yet another dimension to Indian and Middle Eastern art, especially notable in architecture and manuscript illumination.

Despite war and invasion, the art of China maintained a striking consistency throughout more than three thousand years. Its philosophical basis is the belief that man is a part of, not apart from, nature. An assumption underlying Chinese art is that with contemplation, nature reveals itself to the artist as a dynamic flow, constantly changing, whose symbol is the beneficent dragon in all its awesome grandeur. In China from early times, landscape painting was a favorite form for the expression of the artist's, the poet's, and the philosopher's empathic view of the world.

Although there are remains of earlier pottery, and several recently discovered sites date back to the fourth millennium B.C., according to present knowledge Chinese art begins with the Shang Dynasty (c. 1523–1027 B.C.) with a series of bronze vessels of superb craftmanship. Produced for specific religious functions, they are the first known examples of basic forms which prevailed for centuries. The Chou Dynasty (c. 1027–256 B.C.) carried on this tradition with a yet greater sophistication in the animal-based motives. Throughout succeeding dynasties, the use of bronze and jade continued, along with lacquer and porcelain, while painting on scrolls, horizontal or hanging, progressed through generations of masters from the fourth century until the fall of the once-proud empire at the turn of the present century.

The cultural development of Japan owes much to the influence of the older civilizations of China and Korea, yet a strong native tradition prevailed. Japan's art history begins with the long Jomon period, a hazy time historically, extending from perhaps 3000 B.C. into the Christian era. It is best known from about the third century A.D. for the creation of striking pottery guardian figures called *haniwa*, made of rolls of clay in a tubular form, fired to a biscuit brown. As elsewhere in Asia, Buddhism in Japan was an important inspiration for art. Shinto, the aboriginal religion derived from primitive animism, continued, however, although it influenced architecture more than the other arts since it did not demand pictorial expression. The reverence for nature it engendered influenced both landscape painting and garden design. Japanese artists also excelled in narrative scrolls depicting delightful satiric subjects with animals playing the parts of people, in lacquer, in bronze and wood

sculpture, in porcelain, in textiles, and finally, in the popular woodblock print which flourished especially during the first half of the nineteenth century. In recent years the Japanese have been working in the international styles of modernism, while maintaining an esthetic which reflects basic aspects of their native artistic traditions. The arts of modern China, on the other hand, are bound by the political conventions of so-called Socialist Realism, the propagandizing art which is all that is recognized in most Communist countries.

Because of American participation in the China Trade, there are many fine examples of oriental art in American museums, large and small. Particularly distinguished collections are those in Boston's Museum of Fine Arts, the Freer Gallery of Art in Washington, D.C., the Nelson Gallery-Atkins Museum in Kansas City, the Cleveland Museum, the Asian Art Museum of San Francisco, the Metropolitan Museum in New York, the Art Institute of Chicago, and the Seattle Museum. The Peabody Museum in Salem, Massachusetts, founded in 1799, has many oriental objects brought back by American China Trade, while the Museum of the American China Trade in Milton, Massachusetts, has extensive collections and other records of that colorful chapter in East-West relations.

CALIFORNIA

Los Angeles: Los Angeles County Museum of Art (Nepalese fabrics, artifacts; Indian paintings; Central Asian artifacts; oriental sculpture and porcelains).

Pasadena: Pacific Asia Museum (oriental textiles, scrolls, screens, ceramics).

Sacramento: Crocker Art Museum (Korean ceramics, oriental arts).

San Diego: San Diego Museum of Art (Japanese, Chinese and other oriental arts; Indian and Persian miniatures).

San Francisco: Asian Art Museum of San Francisco, The Avery Brundage Collection (Far and Middle Eastern arts; Chinese and Japanese sculpture, ceramics, painting; Korean and Southeast Asian arts).

Santa Barbara: Santa Barbara Museum of Art (oriental sculpture, porcelain, painting, musical instruments).

Santa Clara: de Saisset Museum (Chinese arts, oriental porcelains).

CONNECTICUT

Hartford: Wadsworth Atheneum (oriental ceramics, decorative arts).

New Haven: Yale University Art Gallery (Far Eastern art).

New London: Lyman Allyn Museum (oriental art, Chinese ceramics).

FLORIDA

Coral Gables: Lowe Art Museum (oriental paintings, sculpture, bronzes).

Jacksonville: Cummer Gallery of Art (oriental arts, porcelain, jade, *inro, netsukes).*

HAWAII

Hilo: Lyman House Memorial Museum (oriental objects, ceramics).

Honolulu: Honolulu Academy of Arts (Asiatic painting, sculpture, ceramics, bronzes, lacquer, furniture, decorative arts; Michener Collection of Japanese prints; textiles).

ILLINOIS

Carbondale: University Museum (Asiatic arts).

Champaign: Krannert Art Museum (Ewing Collection of Malayan textiles).

Chicago: The Art Institute of Chicago (Chinese, Japanese, Indian, Middle Eastern arts; sculpture, ceramics, scrolls, screens, paintings, textiles).

INDIANA

Bloomington: Indiana University Art Museum (Chinese, Japanese, Southeast Asian paintings, sculpture, ceramics, textiles, prints).

Fort Wayne: Fort Wayne Museum of Art (Japanese prints).

Indianapolis: Indianapolis Museum of Art (outstanding oriental arts collection of medium size).

IDAHO

Boise: Boise Gallery of Art (oriental art, *netsukes*).

KANSAS

Lawrence: Spencer Museum of Art (oriental arts, decorative arts).

KENTUCKY

Louisville: J. B. Speed Art Museum (oriental decorative arts).

LOUISIANA

Baton Rouge: Louisiana Arts and Science Center (Tibetan religious art).

New Orleans: New Orleans Museum of Art (oriental arts, Whitney collection of Chinese jade, Japanese Edo period paintings).

MAINE

Brunswick: Bowdoin College Museum of Art (oriental ceramics).

Portland: Portland Museum of Art (Japanese prints and sword fittings).

MARYLAND

Hagerstown: Washington County Museum of Fine Arts (Chinese paintings, ceramics, jade).

MASSACHUSETTS

Boston: Museum of Fine Arts (Chinese, Japanese, Korean, Indian sculpture, paintings, scrolls, screens, ceramics, textiles; Japanese scroll of *The Burning of the Sanjo Palace*; Chinese *Nine Dragon Scroll*; *Dancing Siva*; Indian miniatures; jades and bronzes; Chinese export porcelain).

Cambridge: Fogg Art Museum (Chinese sculpture, bronzes, jade, paintings, Japanese arts; Cambodian sculpture; oriental ceramics).

Milton: Museum of the American China Trade (Asian export art, 1784–1900; porcelain, paintings, furniture, metalware, lacquer, silver, textiles, decorative arts; archive of historic documents, accounts, logs, photographs).

Pittsfield: The Berkshire Museum (Spaulding Collection of Chinese Art).

Salem: Peabody Museum of Salem (Chinese export China Trade goods, art and artifacts of India).

Springfield: George Walter Vincent Smith Art Museum (Asiatic arts from the 17th, 18th, 19th C.; Chinese and Japanese painting and sculpture; Chinese

jade bronzes; Japanese lacquer, ivories, porcelains, decorative arts).
□ Museum of Fine Arts (Far Eastern arts; painting, sculpture, decorative arts; Japanese prints, Far Eastern archaeology).

Wellesley: The Wellesley College Museum (oriental paintings, sculpture).

Williamstown: Williams College Museum of Art (oriental sculpture and painting).

Worcester: Worcester Art Museum (oriental sculpture, paintings, decorative arts).

MICHIGAN

Ann Arbor: The University of Michigan Museum of Art (Far Eastern art from ancient to modern times; sculpture, painting, decorative arts).

Detroit: The Detroit Institute of Arts (oriental sculpture, painting, decorative arts).

Flint: Flint Institute of Arts (Chinese painting, ceramics, bronzes, jade, ivories).

MINNESOTA

Minneapolis: The Minneapolis Institute of Arts (oriental painting, sculpture, decorative arts).

MISSOURI

Columbia: Museum of Art and Archaeology (Chinese and Japanese arts, objects from Southern and Southeast Asia).

Kansas City: William Rockhill Nelson Gallery and Atkins Museum of Fine Arts (Chinese sculpture, painting, scrolls, decorative arts in one of the great Far Eastern collections; extremely fine Chinese paintings, incl. a heroic-sized 14th C. fresco; outstanding Chinese furniture; early pottery, jade).

St. Louis: The Saint Louis Art Museum (Chinese, Japanese, and Middle Eastern arts; sculpture, painting, decorative arts, incl. early bronzes, ceramics; Han clay figures and groups in a fascinating installation).

NEW JERSEY

Newark: The Newark Museum (arts of Tibet).

Princeton: The Art Museum (prehistoric to early dynastic Chinese bronzes; Chinese painting and other arts; Chinese, Japanese, and Indian sculpture).

NEW MEXICO

Roswell: Roswell Museum and Art Center (Witter Bynner Collection of Chinese art; painting, jade, in a small but distinguished collection sympathetically installed).

NEW YORK

New York City: The Metropolitan Museum of Art (a smashing collection of Far Eastern art from prehistoric times to the 19th C.; Chinese bronzes, sculpture, painting, ceramics; Japanese arts from the Heian period to the 19th C., painting, sculpture, scrolls, screens, ceramics; the arts of Tibet, Nepal, Korea, Central Asia; arts of India and Kashmir; monumental Chinese mural painting of the Buddha and attendants, c. 1300, from Shansi; the Sung painting *The Tribute Horse*; Momoyama screens; *inro*; Gandharan sculptures). ☐ Jacques Marchais Center of Tibetan Arts, Staten Island (Tibetan and Buddhist arts, garden; sculpture, painting, ritual objects).

Poughkeepsie: Vassar College Art Gallery (oriental ceramics, jade, decorative arts),

Rochester: Memorial Art Gallery (oriental arts, painting, sculpture, ceramics, decorative arts; Japanese prints).

Syracuse: Everson Museum of Art of Syracuse and Onondaga County (Chinese and other oriental ceramics). The Joe and Emily Lowe Art Gallery (Korean ceramics, Sella to Yi; Indian sculpture and textiles).

OHIO

Cincinnati: Cincinnati Art Museum (Far Eastern arts; sculptures, painting, textiles, ceramics, decorative arts; *The Five Sages of Shang Shan* by Ma Yüan, 1190–1224, Indian arts, sculpture).

Cleveland: Cleveland Museum of Art (a rich and various collection of Far Eastern arts; Chinese, Japanese, Indian arts; Chinese painting, Japanese painting; sculpture, incl. a unique group of 7th and 8th C. Japanese wood sculptures; outstanding early Chinese bronzes, Sung period porcelains; Southeast Asian arts, ceramics, decorative arts).

Columbus: Columbus Museum of Art (Chinese and Japanese ceramics).

OKLAHOMA

Tulsa: Philbrook Art Center (Taber Collection of oriental art; Shinenkan Collection of Japanese screens and scrolls; Gilbert Collection of Southeast Asian ceramics).

OREGON

Eugene: Museum of Art (Warner Collection of oriental art, with objects from China, Japan, Southeast Asia; Gandharan and Indian sculpture; Chinese funerary jade; pottery; Korean sculpture and other arts).

PENNSYLVANIA

Philadelphia: Philadelphia Museum of Art (Far Eastern and Indian arts; outstanding Indian sculpture; Far Eastern and Indian period rooms, painting, sculpture, decorative arts; Japanese garden with teahouse and temple; Southeast Asian sculptures; Chinese 18th C. rock crystal).

RHODE ISLAND

Providence: Museum of Art, Rhode Island School of Design (oriental arts, textiles; Abby Aldrich Rockefeller Collection of Japanese prints).

TEXAS

Dallas: Dallas Museum of Fine Arts (Japanese arts, decorative arts, prints).

Fort Worth: Kimbell Art Museum (outstanding examples of Chinese, Japanese, Indian arts; sculpture, scrolls, ceramics).

Houston: The Museum of Fine Arts, Houston (oriental arts).

VERMONT

Burlington: Robert Hull Fleming Museum (oriental arts).

VIRGINIA

Norfolk: Chrysler Museum (Far Eastern arts, painting, sculpture, and decorative arts incl. glass).

WASHINGTON

Seattle: Seattle Art Museum (outstanding collection of Far Eastern art; Chinese, Japanese, incl. *haniwa* tomb figures; Indian arts; sculpture, incl. fine bronzes; Chinese tomb guardian animals; painting, ceramics, decorative arts).

Tacoma: Tacoma Art Museum (Japanese prints).

WISCONSIN

Madison: Madison Art Center (Japanese prints; oriental arts).

Oshkosh: Paine Art Center and Arboretum (Chinese sculpture, bronzes, porcelains, jade).

CANADA

BRITISH COLUMBIA

Victoria: Art Gallery of Greater Victoria (oriental arts, decorative arts).

ONTARIO

Toronto: Royal Ontario Museum (extraordinarily rich and varied Far Eastern arts from prehistoric times; sculpture, painting; bronzes; ceramics; jade; arts of China, Japan, Central Asia, Southeast Asia).

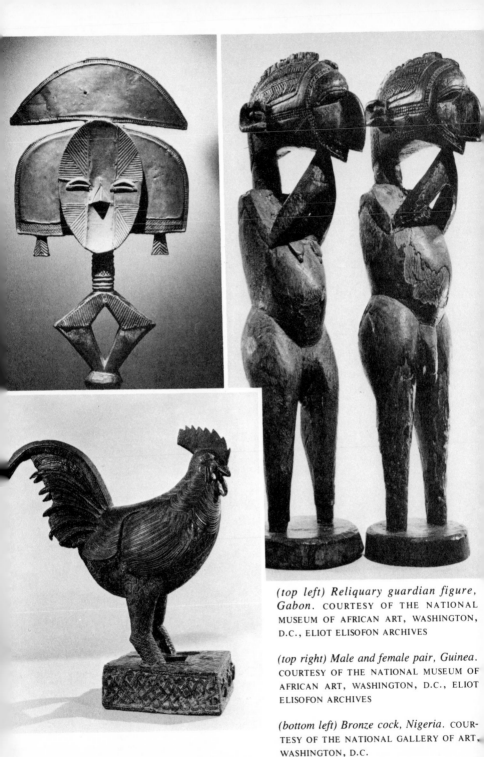

(top left) Reliquary guardian figure, Gabon. COURTESY OF THE NATIONAL MUSEUM OF AFRICAN ART, WASHINGTON, D.C., ELIOT ELISOFON ARCHIVES

(top right) Male and female pair, Guinea. COURTESY OF THE NATIONAL MUSEUM OF AFRICAN ART, WASHINGTON, D.C., ELIOT ELISOFON ARCHIVES

(bottom left) Bronze cock, Nigeria. COURTESY OF THE NATIONAL GALLERY OF ART, WASHINGTON, D.C.

7) Primitive Art
PRE-COLUMBIAN
AFRICAN
OCEANIC
AND NATIVE AMERICAN
(c. 1200 B.C.- c. 1900)

7. Primitive Art

From the late 1880s, a small group of artists, beginning with Van Gogh and Gauguin, and continuing with Brancusi, Matisse, Picasso, and others, recognized the crippling effects on art and life of the industrialized world in which they lived, and began to explore different directions. As a result "a new will to abstraction" appeared in European art. Their search led them to rediscover the arts of other cultures and other times, and from then on, many of the objects collected by anthropologists and archaeologists came to be seen as works of art instead of as savage artifacts, a process which led to the recognition of the American Museum of Natural History, for example, as being one of the important art museums of America.

Although the style of such objects may seem strange to us because they are the products of non-European, often preliterate, tribal societies, they began to be understood as symbolic expressions, vigorous and monumental, based on a vital relation of man and nature, a kind of spiritual ecology which has been lost in the West. In this way the influence of primitive art, even more remote from us in culture than in time or place, entered the stream of the arts flowing into our own times. One result of this is especially important, not just for artists but for all of us: for the first time in history no creative human expression, wherever or whenever manifested, is any longer wholly alien to us. Thus our potentialities for shared creative experience are dramatically enlarged.

Included in this group are the arts of Pre-Columbian Central and South America—of the Mayas and Aztecs of Mexico, and their mysterious predecessors, among them the Olmecs and Toltecs; of the Incas and other civilizations of South America; of sub-Saharan Africa from prehistoric

times; of Oceania, including the Polynesian, Melanesian, and Micronesian congeries of cultures in the widely scattered Pacific islands; of the American Indians, Eskimos, and related peoples in the New World. The cultures included here date from before the third millennium B.C. up to yesterday and sometimes today, and comprise examples of the utmost variety and diversity of character. Yet all share an organic view of man's relation to the natural world which gains added interest with our increasing awareness of the problems which must be faced if today's global village is not to turn into tomorrow's global death camp.

We are fortunate in having a considerable number of outstanding collections of primitive arts in America, including the tremendous Rockefeller Collection in the Metropolitan Museum in New York; the Museum of the American Indian, also in New York, with the largest holdings of North American Indian arts and artifacts in the world; the University Museum of the University of Pennsylvania in Philadelphia, with remarkable collections of North, Central, and South American Indian and also African arts; the Oceanic and African collections in the M. H. de Young Memorial Museum, San Francisco; the Taylor Museum collection of American Indian art in the Colorado Springs Fine Arts Center; the African, Oceanic, and American Indian collections in Denver; the Museum of African Art in Washington, D.C., now a branch of the Smithsonian Institution; the Indian collection in the Philbrook Art Center, Tulsa; the African art in the Dallas Museum of Fine Arts. In addition there are fine objects and smaller collections of primitive art to be found in a variety of locations, from the Peabody Museum in Salem, Massachusetts, to the Seattle Art Museum on the West Coast, with its tribal African art.

ALABAMA

Birmingham: Birmingham Museum of Art (Pre-Columbian arts; Inca gold, Chimu period; Indian tribal arts; Zapotec rain god urn, Mexican, 8th C.).

ALASKA

Anchorage: Anchorage Historical and Fine Arts Museum (Alaskan art and artifacts; outstanding Eskimo and Indian arts, masks, sculpture, baskets).

ARIZONA

Flagstaff: Museum of Northern Arizona (Indian arts and artifacts, prehistoric to modern, from over 2,000 years; crafts, cultural objects; *kachinas*; Navaho rugs; dioramas). Fort Valley Rd., Rt. 4, 86001; mailing address: Rt. 4, Box 720; 602-774-5211; daily 9–5; fee.

Phoenix: The Heard Museum (American Indian arts; arts from Africa, Asia, Oceania, the Upper Amazon). □ Pueblo Grande Museum (Indian artifacts, archaeology). 4619 E. Washington, 85034; 602-275-3452; Mon.–Sat. 9–4:45; Sun. 1–4:45; closed major holidays; small fee.

Tucson: Arizona State Museum (comprehensive collection of Southwestern archaeology, artifacts; dioramas; remains of a 10,000-year-old mammoth with display showing how it was killed by Indians). Tucson Museum of Art (Pre-Columbian, Mexican, and Southwest Indian).

ARKANSAS

Fayetteville: University of Arkansas Museum (prehistoric Arkansas Indian artifacts; American Indian objects; arts of Africa and Oceania), 72701; 501-575-3555; Mon.–Sat. 9–5; Sun. 1–5; closed Christmas; no charge.

CALIFORNIA

Berkeley: Robert H. Lowie Museum of Anthropology (American Indian arts, artifacts).

La Jolla: La Jolla Museum of Contemporary Art (Oceanic, African, Pre-Columbian arts).

Los Angeles: The Frederick S. Wight Art Gallery of the University of California at Los Angeles (Welcome Collection of Oceanic art; Wood Collection of Pre-Columbian art).

Sacramento: Crocker Art Museum (Pre-Columbian arts, ceramics).

San Diego: San Diego Museum of Man (Pre-Columbian archaeology, American Indian of the Southwest; Peruvian artifacts). 1350 El Prado, Balboa Park, 92101; 714-239-2001; daily 10–4:30; closed New Year's, Thanksgiving, Christmas; fee.

Stanford: Stanford University Museum and Art Gallery (Pre-Columbian American collection).

COLORADO

Denver: The Denver Art Museum (American Indian SW collection; Pre-Columbian Peruvian collection; African art).

CONNECTICUT

Hartford: Wadsworth Atheneum (Pre-Columbian art).

New Haven: Yale University Art Gallery (Olson Collection of Pre-Columbian art; Linton Collection of African sculpture).

DISTRICT OF COLUMBIA

Dumbarton Oaks Research Library and Collection (important Pre-Columbian collection superbly installed in Philip Johnson wing). ☐ Museum of African Art (outstanding collection).

FLORIDA

Fort Lauderdale: Museum of Art (African sculpture, ceramics, textiles, baskets; Mai-Kai Oceanic collection; Pre-Columbian collection). 426 E. Las Olas Blvd., 33301; 305-463-5184; Tues.–Sat. 10–4:30; Sun. 12–5; closed holidays; fee.

Jacksonville: Jacksonville Museum of Arts and Sciences (African art; Pre-Columbian collection). 1025 Gulf Life Dr., 32207; 904-396-7062; Oct.–Aug.: Tues.–Fri. 9–5; Sat. 11–5; Sun. 1–5; closed holidays; fee.

Orlando: Loch Haven Art Center (extensive Pre-Columbian collection; 3,000 years of Latin American cultural history). 2416 North Mills Ave., 32803; 305-896-4231; Tues.–Fri. 10–5; Sat. 12–5; Sun. 2–5; closed holidays; no charge.

GEORGIA

Atlanta: The High Museum of Art (African sculpture).

Blakely: Kolomoki Mounds Museum (archaeological collection from 13th C. Indian burial mounds and village site). Rt. 1, 31723; 912-723-5296; Tues.–Sat., holiday Mondays 9–5; Sun. 2–5:30; closed other Mon., Thanksgiving, Christmas; fee.

HAWAII

Honolulu: Honolulu Academy of Arts (Oceanic, African, Pre-Columbian American art).

ILLINOIS

Carbondale: University Museum, Southern Illinois University (extensive Oceanic collection).

Champaign: Krannert Art Museum (Pre-Columbian art; Ewing Collection of Malayan textiles).

Chicago: The Art Institute of Chicago (extensive collections Pre-Columbian, Oceanic, and African art). □ Field Museum of Natural History (artifacts from Indian cultures of the Americas; African and Oceanic arts).

Normal: The University Museums (art and artifacts of Africa, Oceania; Pre-Columbian to contemporary Central American, North American). Illinois State University, 61761; 309-829-6331; phone for hours; no charge.

INDIANA

Bloomington: Indiana University Art Museum (African, Oceanic, and Pre-Columbian collections).

Fort Wayne: Fort Wayne Museum of Art (West African sculpture, African arts; American Indian baskets, artifacts).

Indianapolis: Indianapolis Museum of Art (collections of Oceanic, African, and Pre-Columbian arts).

Notre Dame: The Snite Museum of Art, University of Notre Dame (Pre-Columbian sculptures; Peruvian textiles, pottery; Central American and Mexican objects).

IOWA

Des Moines: Des Moines Art Center (Pre-Columbian, Oceanic, African collections).

Iowa City: University of Iowa Museum of Art (African, Oceanic, and Pre-Columbian arts).

KANSAS

Topeka: Gallery of Fine Arts, Topeka Public Library (Ashanti gold weights; West African wood sculpture). 1515 W. 10th, 66604; 913-233-2040, ext. 26; Memorial Day–Labor Day: Mon.–Fri. 9–9; Sat. 9–6; Labor Day–Memorial Day: Mon.–Fri. 9–9; Sat. 9–6; Sun. 2–6; closed major holidays; no charge.

Wichita: Edwin A. Ulrich Museum of Art, Wichita State University (primitive art of the Americas and Africa). □ The Indian Museum (Native American art and artifacts). □ Mid-American All-Indian Center, 650 N. Seneca, 67203; 316-262-5221; Mon.–Sat. 10–5; Sun. 1–5; closed holidays; fee. Wichita Art Museum (Kurdian Collection of Pre-Columbian Mexican artifacts).

KENTUCKY

Highland Heights: Museum of Anthropology (contemporary West African arts; contemporary Southwestern Indian arts; Huichol Indian collection). University Drive, Northern Kentucky University, 41076; 606-292-5252; Aug. 21–May 9: Mon.–Fri. 8:30–4; other times by appointment; closed university holidays; no charge.

Lexington: University of Kentucky Art Museum (Pre-Columbian and African arts).

Louisville: J. B. Speed Art Museum (Indian artifacts).

MAINE

Brunswick: Bowdoin College Museum of Art (African and Pre-Columbian sculpture).

Orono: Anthropology Museum, University of Maine (ethnological objects from Oceania, Africa, North and South America, the Arctic, Greenland). □ Anthropology Dept., 04473; 207-581-7102; Mon.–Fri. 9–3:30; closed university recesses, major holidays; no charge.

MARYLAND

Baltimore: Baltimore Museum of Art (The Wurtzberger Collection of Pre-Columbian, American Indian, African, Oceanic arts). □ Gallery of Art, Morgan State University (African and New Guinean sculptures). □ Carl Murphy Fine Arts Center, Coldspring Lane and Hillen Rd., 21239; 301-444-3030; Mon.–Fri. 9–5; Sat.–Sun., holidays by appointment; closed Easter, Thanksgiving, Christmas; no charge.

College Park: University of Maryland Art Gallery (African sculpture). Art/Sociology Bldg., 20742; 301-454-2763; Mon.–Tues. and Thurs.–Fri. 10–4; Wed. 10–9; Sat.–Sun. 1–5; no charge.

MASSACHUSETTS

Boston: Museum of Fine Arts (Peruvian textiles).

Cambridge: Peabody Museum of Archaeology and Ethnology (artifacts from the Americas, Pre-Columbian and later; American Indian cultural objects). Harvard University, 11 Divinity Ave., 02138; 617-495-2248; Mon.–Sat. 9–4:15; Sun. 1–4:15; fee.

Salem: Peabody Museum of Salem (American Indian artifacts; arts of Oceania).

Williamstown: Williams College Museum of Art (African and Pre-Columbian collections).

Worcester: Worcester Art Museum (Pre-Columbian gold and other objects).

MICHIGAN

Ann Arbor: The University of Michigan Museum of Art (African collections).

Detroit: The Detroit Institute of Arts (African arts).

Flint: Flint Institute of Arts (African collection).

Grand Rapids: Grand Rapids Public Museum (Hopewell Mound material). 54 Jefferson St., 49503; 616-456-3977; Mon.–Fri. 10–5; Sat.–Sun., holidays 1–5; no charge.

Olivet: Armstrong Museum of Art and Archaeology (primitive arts from Melanesia and Africa; American Indian arts; artifacts from the Philippine Islands).

MINNESOTA

Minneapolis: The Minneapolis Institute of Arts (Oceanic, African, Pre-Columbian collections).

Moorhead: Plains Art Museum (African, Oceanic, Pre-Columbian, and North and South American Indian art; Eskimo sculpture).

Park Rapids: North Country Museum of Arts (Nigerian arts, crafts, and artifacts).

Pipestone: Pipestone National Monument (Indian ceremonial pipes and objects of pipestone). Box 727, 56164; 507-825-5463; Winter: daily 8–5; Summer: daily 8 A.M.–9 P.M.; closed Christmas, New Year's; no charge.

St. Paul: Minnesota Museum of Art (African arts; Northwest Coast Indian collection; masks).

MISSISSIPPI

Jackson: Mississippi Museum of Art (Native American basket collection).

Natchez: Grand Village of the Natchez Indians (Indian artifacts from excavated site). 400 Jefferson Davis Blvd., 39120; 601-446-6502; Mon.–Sat. 9–5; Sun. 1:30–5; closed major holidays; no charge.

MISSOURI

Columbia: Museum of Art and Archaeology, University of Missouri (African, Central, and South American, and Oceanic arts).

Kansas City: William Rockhill Nelson Gallery and Atkins Museum of Fine Arts (American Indian, Pre-Columbian, and African arts).

St. Joseph: St. Joseph Museum (ethnological collections of the North American Indian; Meso-American and Philippine Islands objects). 11th and Charles St., 64501; 816-232-8471; Apr.–Sept.: Mon.–Sat. 9–5; Sun., holidays 2–5; Oct.–Mar.: Tues.–Sat. 1–5; Sun., holidays 2–5; closed major holidays; small fee.

St. Louis: Museum of Science and Natural History (Pre-Columbian North American Indian artifacts; Missouri Indian archaeology). Oak Knoll Park, 63105; 314-726-2888; Nov.–Mar.: Tues.–Sat. 9–5; Sun. 1–5; Apr.–Oct.: daily 9–5; closed major holidays; no charge. □ The Saint Louis Art Museum (Oceanic and African primitive arts; Pre-Columbian North, Central, and South American objects).

Springfield: Springfield Art Museum (Pre-Columbian and Oceanic arts).

MONTANA

Billings: Yellowstone Art Center (Larson Collection of African sculpture). 401 N. 27th St., 59101; Tues.–Wed., Fri. 11–5; Thurs. 11–5 and 7–9; Sat.–Sun. 12–5; closed major holidays; no charge.

Browning: Museum of the Plains Indian and Crafts Center (historic and contemporary arts of the Plains tribes). U.S. Hwy. 89, 59417; mailing address: Box 400; 406-338-2230; June 1–Sept. 30: daily 9–5; Oct. 1–May 31: Mon.–Fri. 10–4:30; closed New Year's Day, Thanksgiving, Christmas; no charge.

St. Ignatius: Flathead Indian Museum (American Indian arts from the major tribes). Box 460, 59865; 406–745–2951; Apr.–Sept.: daily 9–9; Oct.–Mar.: daily 9–5:30; closed New Year's Day, Christmas; fee.

NEBRASKA

Omaha: Joslyn Art Museum (American Indian collection, esp. Aleutian and Eskimo art; American Indian masks; Haida mask of a European, complete with freckles, a trader or seaman).

NEW HAMPSHIRE

Hanover: Hood Museum, Dartmouth College (Pre-Columbian, African, and Oceanic collections).

NEW JERSEY

Montclair: Montclair Art Museum (Rand Collection of American Indian art).

Newark: The Newark Museum (American Indian collection).

Princeton: The Art Museum (African sculpture; Pre-Columbian collection incl. Mayan funerary vases).

NEW MEXICO

Albuquerque: Maxwell Museum of Anthropology, University of New Mexico (Southwest Indian arts and crafts; Andean archaeological collection; Navaho and other Southwestern Indian weaving, silver; Mimbres and Pueblo pottery; American Indian baskets).

Church Rock: Red Rock Museum (arts and crafts of prehistoric Zuni, Navaho, Hopi, Anasazi, Rio Grande Pueblos, Apache, and Plains Indians). Red Rock State Park; mailing address: Box 328, 87311; 505-722-5564; Mon.-Fri. 8-5; Sat.-Sun. by appointment; closed holidays; no charge.

Mesilla: Gadsden Museum (Indian artifacts from the Southwest; pottery, baskets; Apache, Navaho, and Jemez Pueblo objects; deerskin paintings; beadwork; peace medals. Barker Rd. and Hwy 28, Box 147, 88046; 505-526-6293; daily 9-11 and 1-5; closed major holidays; no charge.

Roswell: Roswell Museum and Art Center (Pre-Columbian and American Indian collections; Southwestern Indian arts).

Santa Fe: Institute of American Indian Arts Museum (archaeological Indian artifacts, contemporary Indian arts and crafts). 1300 Cerrillos Rd., 87501; 505-988-6281; Mon.-Sat. 9-5; Sun. 1-5; no charge. ☐ Museum of Fine Arts (extensive Indian arts with esp. emphasis on the Southwest tribes). ☐ The Wheelright Museum of the American Indian (Native American arts; Navaho sand painting reproductions; recordings of Navaho ceremonies).

Taos: The Harwood Foundation of the University of New Mexico (Native American artifacts; Pueblo and Rio Grande rugs). ☐ Kit Carson Memorial Foundation (prehistoric Indian culture of the Southwest). ☐ Millicent A. Rogers Museum (prehistoric and historic Southwestern and Plains Indian arts).

NEW YORK

Albany: The New York State Museum (Indian objects from New York State).

New York City: American Museum of Natural History (superb collections of Native American arts, esp. strong in Northwest Coast tribes; Woodland Indian masks; Pre-Columbian Central and South American collections; Eskimo sculpture; archival and historic photographic collection of Native American culture; 64'6" carved and painted Bella Bella war canoe, the largest and finest of its kind, a unique symbol of the seafaring culture of the Northwest Coast). ☐ The Brooklyn Museum (Pre-Columbian Central and South American collections; American Indian arts; African art; Oceanic art; outstanding collec-

tions in the major fields of primitive arts, with gold, sculpture, textiles, pottery, masks, totems). ☐ El Museo del Barrio (Pre-Columbian collection). ☐ The Metropolitan Museum of Art (in a new wing, the Rockefeller and other collections of primitive art, incl. Oceanic, African, New Guinean, Pre-Columbian arts; esp. Sepik River, Asmat sculptures; Benin bronzes, Dogon, Bambara, Senufo, and other African sculptures; Mexican, Central, and South American arts; Panamanian, Costa Rican, and Colombian gold; Peruvian silver, textiles, and featherwork). ☐ Museum of the American Indian, Heye Foundation (very extensive collections of Native American arts from all of North America, Mexico and Central America, South America and the Caribbean Islands; pottery, gold; sculpture, masks, textiles, beadwork, painted skins).

Niagara Falls: Native American Center for the Living Arts (Native American archaeological and ethnographic collections of North America; contemporary Native American arts from Mexico, United States, Canada). 25 Rainbow Mall, 14301; 716-284-2427; Mon.–Fri. 10–5; Sat.–Sun. 12–5; Summer: daily 10 A.M.–9 P.M.; fee.

Oneonta: The Museums at Hartwick College (Yager Museum Collection of upper Susquehanna Indian artifacts and Southwest basketry and pottery; Furman Collection of Mexican, Central American, and South American artifacts; Sandel Collection of Ecuadorian and Peruvian arts).

Purchase: Neuberger Museum (Hirshberg Collection of African art).

Rochester: Memorial Art Gallery of the University of Rochester (Pre-Columbian and African art).

Salamanca: Seneca-Iroquois National Museum (prehistoric, historic, and contemporary Seneca-Iroquois crafts). Box 442, Broad St. Extension, 14779; 716-945-1738; Mon.–Sat. 10–5; Sun. 12–5; closed major holidays; no charge.

Schenectady: The Schenectady Museum (Native American, African, Australian, New Guinea Highlands collections). Nott Terrace Heights, 12308; 518-382-7890; Tues.–Fri. 10–4:30; Sat.–Sun. 12–5; closed major holidays; no charge.

Syracuse: Everson Museum of Art of Syracuse and Onondaga County (Pre-Columbian, African, and American Indian collections). ☐ Syracuse University Art Collection (African collection).

Utica: Munson-Williams-Proctor Institute (Pre-Columbian collection).

NORTH CAROLINA
Charlotte: The Mint Museum of Art (Pre-Columbian and African objects).

Cherokee: Museum of the Cherokee Indian (Cherokee arts, artifacts, relics). U.S. Rt. 441; mailing address: Box 770-A, 28719; 704-497-3481; June 15–Sept. 1: Mon.–Sat. 9–8; Sun. 9–5:30; Sept. 1–June 15: daily 9–5:30; closed Christmas; fee.

Durham: Duke University Museum of Art (African sculpture, Pre-Columbian art, Peruvian textiles, Navaho rugs). Museum of Art, North Carolina Central University (Oceanic, African sculpture and artifacts).

Greensboro: Heritage Center (arts and crafts from over thirty-one African countries, New Guinea, Haiti).

Laurinburg: Indian Museum of the Carolinas (American Indian arts).

Winston-Salem: Museum of Man, Wake Forest University (North and South American Indian arts, African and Oceanic collections).

OHIO

Chillicothe: Mound City Group National Monument (Hopewell Indian culture artifacts, 200 B.C.–500 A.D.). 16062 State Rt. 104, 45601; 614-774-1125; Memorial Day–Labor Day: daily 8–8; day after Labor Day–day before Memorial Day: daily 8–5; closed New Year's, Thanksgiving, Christmas; no charge.

Cincinnati: Cincinnati Art Museum (African arts, South American Indian collection, North and Central American Indian arts, art of Africa and the South Pacific).

Cleveland: Cleveland Museum of Art (primitive arts of major cultural regions). Cleveland Museum of Natural History (Native American arts; Eskimo sculpture—note esp. *Chanting Shaman*). Wade Oval, University Circle, 44106; 216-231-4600; Mon.–Sat. 10–5; Sun. 1–5:30; closed major holidays; fee.

Columbus: Columbus Museum of Art (primitive arts of the South Pacific, American Indian arts). □ Ohio Historical Center (Pre-Columbian Indian arts of Ohio and the Midwest). Interstate 71 and 17th Ave., 43211; 614-466-1500; call for hours; no charge.

Dayton: Dayton Art Institute (Pre-Columbian collection).

Oxford: Miami University Art Museum (Pre-Columbian and African art).

Wooster: College of Wooster Art Museum (African art).

Youngstown: The Butler Institute of American Art (painting and drawing of American Indians).

Zanesville: Zanesville Art Center (arts of South Seas, Australia, and New Zealand; Mexican art; African art). 620 Military Rd., 43701; 614-452-0741;

Feb. 16–Dec. 15: Mon.–Thurs., Sat.–Sun. 1–5; closed Dec. 16–Feb. 15, holidays; no charge.

OKLAHOMA

Bartlesville: Woolaroc Museum (American Indian artifacts).

Canton: Cheyenne and Arapaho Museum and Archives (historical and tribal collections).

Muskogee: Five Civilized Tribes Museum (traditional Indian arts by members of the Cherokee, Choctaw, Chickasaw, Creek, and Seminole tribes).

Norman: Museum of Art, University of Oklahoma (primitive arts collection).

Tahlequah: Cherokee National Historical Society (Cherokee artifacts and historical collection).

Tulsa: Philbrook Art Center (Field Collection of American Indian baskets and pottery, Lawson Collection of American Indian costumes and artifacts, Philbrook Collection of American Indian painting, Gussman Collection of African sculpture). □ Thomas Gilcrease Institute of American History and Art (extensive collections of Indian sculpture and painting, cultural objects of the Five Civilized Tribes, Native American arts from the Arctic to Mexico).

Wewoka: Seminole Nation Museum (crafts of Seminole and Creek Indians). 524 S. Wewoka Ave., 74884; 405-257-5580; daily 1–5; closed Dec. 24–25, month of Jan.; no charge.

OREGON

Eugene: Butler Museum of Amerian Indian Art (Native American arts from c. 1800 representing the major cultural areas of North America; sculpture, pottery, baskets, textiles, masks, costumes). □ Museum of Art, University of Oregon (West African art).

Klamath Falls: Favell Museum of Western Art and Indian Artifacts (American Indian collection of baskets, pottery, quillwork, beadwork, sculpture). 125 W. Main St.; mailing address: Box 165, 97601; 503-882-9996; Mon.–Sat.: 9:30–5:30; closed Sun.; fee.

Newport: Burrows House and Log Cabin Museum (Indian artifacts, costumes, crafts, carvings). 545 S.W. Ninth, 97365; 503-265-7509; June–Sept.: Tues.–Sun. 11–5; Oct.–May: Tues.–Sun. 11–4; closed major holidays; no charge.

Portland: Portland Art Museum (Pre-Columbian arts; Rasmussen Collection of Northwest Indian art; Ethiopian crosses; Gebaur Collection of Cameroon West African art).

PENNSYLVANIA

Philadelphia: Afro-American Historical and Cultural Museum (African sculpture and artifacts). ☐ The University Museum, University of Pennsylvania (North, Central, and South American arts and artifacts; African, Oceanic, and Australian collections; prehistoric carved deer-head mask from Key Marcos, Florida; Pre-Columbian gold from Costa Rica, Colombia, Peru, etc.; African masks, sculpture).

Scranton: Everhart Museum of Natural History, Science, and Art (American Indian, African, and Oceanic collections).

RHODE ISLAND

Bristol: Haffenreffer Museum of Anthropology (American Indian, Arctic, Central, and South American, Pacific, and African collections). Mt. Hope Grant, 02809; 401-253-8388; June–Aug.: Tues.–Sun. 1–5; closed Mon.; Sept.–Nov., Apr.–May 5: Sat.–Sun. 1–5; closed Mon.–Fri.; also closed May 6–31; small fee.

SOUTH DAKOTA

Crazy Horse: Indian Museum of North America (American Indian arts). Avenue of the Chiefs, Black Hills, 57730; 605-673-4681; daily: daylight to dark; fee.

Marvin: American Indian Culture Research Center (Maria pottery, Native American artifacts).

Pierre: Robinson Museum (collection of Plains Indian arts, Sioux running horse effigy).

Rapid City: Sioux Indian Museum and Crafts Center (historic and contemporary arts of the Sioux and other Plains tribes).

St. Francis: Buechel Memorial Lakota Museum (crafts and artifacts of the Rosebud and Pine Ridge Sioux). St., Francis Indian Mission, 350 S. Oak St., 57572; 605-747-2828; Memorial Day–Labor Day: daily 9–5; other times by appointment; no charge.

Sioux Falls: The Center for Western Studies (Native American arts and artifacts). Augustana College, 29th and S. Summit, 57197; 605-336-4007; Mon.–Fri.: 8–3; no charge.

TEXAS

Dallas: Dallas Museum of Fine Arts (Pre-Columbian, Oceanic, and African arts; Schindler Collection of African art; African masks).

El Paso: El Paso Museum of Art (Pre-Columbian art of the Americas).

Fort Worth: Kimbell Art Museum (Olmec, Aztec, and Mayan sculpture; African sculpture).

Houston: Museum of American Architecture and Decorative Arts (African and Pre-Columbian art). ☐ Houston Baptist University, 7502 Fondren Rd., 77074; 713-774-7661; Tues.–Thurs. 10–4; closed Fri.–Mon.; no charge. ☐ The Museum of Fine Arts, Houston (American Indian arts; Pre-Columbian, Oceanic, and African art). ☐ Sarah Campbell Blaffer Gallery (Pre-Columbian artifacts).

Longview: Caddo Indian Museum (Caddo artifacts).

Panhandle: Carson County Square House Museum (Indian archaeology and artifacts).

San Antonio: San Antonio Museum Association (Indian arts collection). Witte Memorial Museum, 3801 Broadway, 78209; 512-826-0647; Mon.–Fri. 9–9; Sat.–Sun. 10–6; fee.

UTAH

Boulder: Anasazi Indian Village State Historical Monument (artifacts of the Kayenta Anasazi culture 1050–1200 A.D.). Box 393, 84716; 801-335-7308; Memorial Day–Labor Day: daily 8–6; Labor Day–Memorial Day: daily 8–5; closed major holidays; no charge.

Fort Duchesne: Ute Tribal Museum (Ute Indian arts). Hwy 40, Bottle Hollow Resort, 84026; 801-722-4992; Mon.–Fri. 8:30–5; in summer also Sat.–Sun. 12–6; closed other times; no charge.

Provo: Brigham Young University Fine Arts Collection (Pre-Columbian, Indian arts). F-303 Harris Fine Arts Center, 84602; 801-378-2881; Mon.–Fri. 8–5; closed weekends, holidays; no charge. ☐ Museum of Peoples and Cultures (Navaho, Hopi, Apache, and other Southwest Indian artifacts). Brigham Young University, 84602; 801-678-6112; Mon.–Fri. 8–5; no charge.

VERMONT

Burlington: Robert Hull Fleming Museum (Pre-Columbian and other primitive arts).

St. Johnsbury: Fairbanks Museum and Planetarium (North American, Polynesian, and African ethnological objects). Main and Prospect Sts., 05819; 802-748-2372; closed major holidays; phone for hours and fees.

VIRGINIA

Charlottesville: University of Virginia Art Museum (African sculpture; American Indian art).

Richmond: Virginia Museum of Fine Arts (Pre-Columbian art of the Americas).

WASHINGTON

Ellensburg: Museum of Man (artifacts, ethnographic material from New Guinea, Northwest Coast, Mexico, Western Plateau, San Blas Islands, Southwest). Central Washington University, Dept. of Anthropology, 98926; 509-963-3201; Mon.–Fri. 9–4; closed weekends, major holidays; no charge.

Goldendale: Maryhill Museum of Fine Arts (Northwest Indian artifacts).

Pullman: Museum of Anthropology (archaeological collections from Alaska and Northwest; Indian baskets; objects from West Africa, New Guinea, and South America). Dept. of Anthropology, Washington State University, 99164; 509-335-8556; Mon.–Fri. 10–4; no charge.

Seattle: Costume and Textile Study Center (Pre-Columbian Peruvian textiles). School of Nutritional Sciences and Textiles, DL-10 University of Washington, 98195; 206-543-1739; by appointment; no charge. ☐ Seattle Art Museum (Pre-Columbian and African art). ☐ Thomas Burke Memorial, Washington State Museum (Northwest Coast Indian artifacts; ethnological material of the Pacific Rim and Islands). ☐ University of Washington, 98195; 206-543-5590; Mon.–Wed., Fri. 10–6; Thurs. 10–10; Sat.–Sun. 10–4:30; closed university holidays; no charge.

Tacoma: Washington State Historical Society (Northwest Indian artifacts). 315 N. Stadium Way, 98403; 206-593-2830; Tues.–Sat. 9:30–5; Sun. 2–5; closed holidays; no charge.

Toppenish: Toppenish Museum (Yakima Indian artifacts; baskets). 1 S. Elm, 98948; 509-865-4510; Wed.–Sat. 2–6; other times by appointment; no charge.

WEST VIRGINIA

Charleston: Sunrise Foundation (Native American, African, and Oceanic artifacts).

Huntington: The Huntington Galleries (Pre-Columbian ceramics).

WISCONSIN

Beloit: Logan Museum of Anthropology (North American archaeology; North African artifacts). Beloit College, 53511; 608-365-3391, ext. 305; Mon.–Fri. 9–4:30; Sat. 9:30–12:30; Sun. 1:30–4:30; closed university recesses, mid-May–Aug.; no charge.

Madison: Elvehjem Museum of Art (Pre-Columbian and African sculpture and artifacts).

PUERTO RICO

San Juan: Museo de la Fundacion Arqueologica, Antropologica E Historica de Puerto Rico (Indian artifacts of various periods found in Puerto Rico). Calle Norzagary 11, 00936; mailing address: Apartado 2058, 00904; 809-723-3590; Tues.–Sat. 10–5; Sun. 12–7; closed New Year's, Christmas; no charge.

AMERICAN SAMOA

Pago Pago: Jean P. Haydon Museum (Samoan cultural objects).

CANADA

ALBERTA

Banff: Luxton Museum (arts of the Plains Indians).

BRITISH COLUMBIA

Abbotsford: Matsqui-Abbotsford Museum (Salish Indian artifacts). 2313 Ware St., V2S 2B9; 604-853-0313; Mon.–Sat. 10–12 and 1–4; no charge (donations accepted).

Alert Bay: Alert Bay Museum (Kwakiutl Indian artifacts). Fir St.; mailing address: Box 208, V0N 1A0; Sept.–June: Mon., Wed. 7–9; Fri.–Sat. 1:30–4; closed Sun., Tues., Thurs.; July–Aug.: daily 1:30–4; no charge.

Atlin: Atlin Museum (Tlingit Indian artifacts).

Burnaby: The Simon Fraser Gallery (Eskimo graphics).

Campbell River: Campbell River and District Museum (Kwakiutl, Coast Salish, West Coast Nootka, Northwest Coast Indian artifacts).

Dawson Creek: Dawson Creek Museum Art Gallery (Indian and Eskimo crafts; Indian costumes).

Hazelton: Ksan Indian Village and Museum (Northwest Coast Indian artifacts).

Prince Rupert: Museum of Northern British Columbia (Northwest Coast Indian arts, totem poles).

Skidegate: Queen Charlotte Islands Museum (Haida Indian artifacts).

MANITOBA

Churchill: Eskimo Museum (Pre-Dorset, Dorset, and Thule artifacts).

Winnipeg: Manitoba Museum of Man and Nature (artifacts from western Canada).

NEWFOUNDLAND

St. John's: Newfoundland Museum (archaeological objects of native peoples). Duckworth St. A1C 1G9; 709-737-2460; Tues.–Wed., Fri.–Sun. 10–6; Thurs. 10–9; closed Mon.; no charge.

ONTARIO

Burlington: Joseph Brant Museum (Iroquois artifacts, memorabilia of Chief Joseph Brant). 1240 North Shore Blvd., E., L7S 1C5; 416-634-3556; Mon.–Sat. 10–5; Sun. 1–5; fee.

Golden Lake: Algonquin Museum (Indian artifacts). Via Algonquin Park, K0J 1X0; 613-625-2027; daily 10–8; fee.

Ottawa: National Museum of Man (archaeological and ethnographic Canadian collections).

Toronto: Royal Ontario Museum (Canadian archaeological and ethnographic collections, incl. Eskimo arts, arts of major cultural areas of the Americas).

Windsor: The Art Gallery of Windsor (Eskimo prints and carvings).

QUEBEC

Montreal: The Montreal Museum of Fine Arts (Northwest Coast Indian and Eskimo arts).

SASKATCHEWAN

Moose Jaw: Moose Jaw Art Museum and National Exhibition Centre (Plains Indians artifacts). Crescent Park, S6H 0X6; 306-692-4471; June 30–Sept. 30: Tues.–Sun. 12–5 and 7–9; Oct. 1–May 30: Tues. 12–5 and 7–9; Thurs.–Fri. 2–5 and 7–10; Sat.–Sun. 12–5; closed holidays; no charge.

Saskatoon: Mendel Art Gallery and Civic Conservatory (Eskimo art).

Design for a window (hunting scene) by Christoph Murer. COURTESY OF THE
NATIONAL GALLERY OF ART, WASHINGTON, D.C.

8) Decorative Arts of Europe and America

GENERAL
ARMS AND ARMOR
CERAMICS
FURNITURE
GLASS
GOLDSMITHWORK
MUSICAL INSTRUMENTS
TEXTILES

8. Decorative Arts of Europe and America

It is one of the more attractive aspects of human beings that, whatever their cultural background, they tend to create necessary and useful objects in a manner transcending pure functionalism. This is shown in the extra attention that transforms a quilt, for example, which would keep one just as warm without any embellishment whatsoever, into a colorful and carefully designed work of distinctive craft. For the very reason that it goes beyond the practical, the quilt becomes a statement of a sense of self, of pride, of the dignity of life, and of hope and faith in the future. No matter how intricate or delicate, cups and goblets are for drinking; whatever their material or form, spoons, knives and forks, and plates and saucers are for eating. However thronelike, chairs were made to fit the human posterior, which has not changed all that much over the centuries. No matter how grand, beds were made for sleeping and making love, for dying and being born. Their particular human dimension is a vital and rewarding aspect of the multiplicity of objects listed in this section.

There are many rich collections of decorative arts in this country, especially those containing American arts. Shelburne, Vermont; Sturbridge, Massachusetts; Cooperstown, New York; Greenfield Village in Dearborn, Michigan; Winterthur, Delaware; historic Williamsburg, Virginia; and Bayou Bend in Houston, Texas—these are outstanding among historic and restored village museums having general collections. The American Wing of the Metropolitan Museum of Art in New York, the Museum of Fine Arts in Boston, the Chicago Art Institute, and the Yale Art Gallery are particularly distinguished in also covering the entire American field, while the regional collections are too numerous to mention here. All are the result of the efforts of individuals trying, in the same

spirit of those dedicated to historic and natural preservation, to conserve enough to show how our ancestors lived, the better to understand the past of which we are, whether we are interested or not, the end product to date. The philosophy which inspired this movement evolved only recently, starting in general after World War I, barely in time to rescue a significant number of period objects from the still-prevalent American notion that the new is better anyway. The old American confusion of change with progress, of innovation with invention, is still at work, but an equally strong strain of determined individualism has led to the rescue of these relics important for all of us.

European decorative arts collections are another matter. Americans have long believed that the imported is better and more desirable than the domestic product, so when they were rich enough, from Colonial times on down, people imported works of British and Continental craftsmanship, to say nothing of curios from the Far East and elsewhere. It was this prejudice which led to the identification of all the really handsome furniture inherited by some of our older families as English, even though it was actually produced in Newport (Rhode Island), Boston, New York, Charleston (South Carolina), or elsewhere on these shores. Increased scholarship has identified American schools and makers and has separated the native product from the imported. Meanwhile the elegance of European styles attracted American collectors and contributed to the wealth of furniture, furnishings, porcelain, glass, tapestries, goldsmithwork, and all the other paraphernalia found in manor house, château, schloss, and palazzo, which provided such admirable evidence of conspicuous consumption for those who desired it and is of such general appeal in its artistry, variety, and vigorous and picturesque ensemble. All

279

the large city museums have extensive holdings, with more specialized collections of fine quality to be found in every part of the country—from Corning, New York, an international center for the study of glass, to the Cummer Gallery in Jacksonville, Florida, with its remarkable Meissen porcelains, and from Getty's formidable assemblage of French furniture and other objects in Malibu on the West Coast to the arms and armor of the John Woodman Higgins Armory in Worcester, Massachusetts.

Although there are examples of decorative arts of many other periods earlier than the Middle Ages, they are usually listed under another category, such as Greek, Roman, or Japanese, as is the case in this guide. (Please look also under Section 10, "Special Collections," for related categories.) Therefore the following section includes objects from medieval times to the present under the various headings of "Arms and Armor," "Ceramics" (including porcelain), "Furniture and Furnishings," "Glass," "Goldsmithwork and Other Metalwork," "Musical Instruments," and "Textiles" (including Oriental rugs, costumes, tapestries, etc.). In other words, this section is a lovely miscellany of all sorts of interesting and beautiful objects, almost all basically utilitarian in nature, but raised by craftsmanship and design to the realm of art. There is something out there for every conceivable taste and interest. Good luck in finding it!

CALIFORNIA

Pasadena: Norton Simon Museum (European collections).

San Marino: Huntington Library, Art Gallery and Botanical Garden (English collections).

COLORADO

Denver: The Denver Art Museum (French Gothic, English Tudor, Spanish Baroque, and other collections).

CONNECTICUT

Hartford: Wadsworth Atheneum (English and American collections, esp. Connecticut; Pilgrim collection).

New Haven: Yale University Art Gallery (primarily American collections, from Colonial times to the present).

DELAWARE

Winterthur: Henry Francis Du Pont Winterthur Museum (the premier collection of American decorative arts to the mid-19th C.).

DISTRICT OF COLUMBIA

Washington: Corcoran Gallery of Art (European collection). ☐ National Gallery of Art (European and American collections). ☐ National Museum of American Art (extensive and diverse American collection).

FLORIDA

Jacksonville: Cummer Art Gallery (European and American collections).

St. Petersburg: Museum of Fine Arts of St. Petersburg (European and American collections). 255 Beach Dr., N, 33701; 812-896-2667; Tues.–Sat. 10–5; Sun. 1–5; closed New Year's, Christmas; donations accepted.

Sarasota: John and Mable Ringling Museum of Art (European collection).

GEORGIA

Atlanta: The High Museum of Art (McBurney Collection, 1670–1920).

Savannah: Telfair Academy of the Arts and Sciences (American collection).

HAWAII

Honolulu: Honolulu Academy of Arts (Western collection, esp. 18th C. English and French).

ILLINOIS

Champaign: Krannert Art Museum (small but good general collection).

Chicago: The Art Institute of Chicago (European and outstanding American collections from the 17th C.).

INDIANA

Indianapolis: Indianapolis Museum of Art (American and European collections, primarily French).

KENTUCKY

Louisville: J. B. Speed Art Museum (English, Continental, American collections).

MAINE

Brunswick: Bowdoin College Museum of Art (fine small American collection).

MARYLAND

Baltimore: Baltimore Museum of Art (general collection, c. 1500 to recent, esp. Maryland decorative arts). □ Walters Art Gallery (great medieval and Renaissance collections).

MASSACHUSETTS

Amherst: Mead Art Museum (American and European collections, incl. Elizabethan English).

Andover: Addison Gallery of American Art (fine American collection of 17th–19th C.).

Boston: Museum of Fine Arts (superb American and French collections).

Cambridge: Fogg Art Museum (small, fine English and American furniture and silver collections).

Springfield: George Walter Vincent Smith Art Museum (general collection).

MICHIGAN

Detroit: The Detroit Institute of Arts (European Renaissance to 19th C. and American collections).

MISSOURI

Kansas City: William Rockhill Nelson Gallery and Atkins Museum of Fine Arts (European and American collections).

St. Louis: The Saint Louis Art Museum (European and American collections).

NEBRASKA

Omaha: Joslyn Art Museum (European and American collections).

NEW HAMPSHIRE

Hanover: Hood Museum (primarily American collection).

Manchester: The Currier Gallery of Art (fine, small American collection).

NEW JERSEY

Newark: The Newark Museum (fine American collection).

NEW YORK

Albany: Albany Institute of History and Art (fine American collection, esp. New York state).

Buffalo: Albright-Knox Art Gallery, The Buffalo Fine Arts Academy (fine general collection).

Cooperstown: New York State Historical Association (good American collection).

New York City: The Brooklyn Museum (outstanding general collection). □ Cooper-Hewitt Museum. □ The Smithsonian Institution's National Museum of Design (outstanding general collection). □ The Frick Collection (European collection). □ Hispanic Society of America Museum (fine Spanish collection). □ The Metropolitan Museum of Art (one of the world's grandest general collections). □ Museum of the City of New York (fine American collection). □ The New-York Historical Society (fine American collection).

Rochester: Memorial Art Gallery of the University of Rochester (European and American collections).

OHIO

Cincinnati: Cincinnati Art Museum (fine European and American collections).

Cleveland: Cleveland Museum of Art (fine European and American collections).

Toledo: The Toledo Museum of Art (fine European and American collections; one of the world's great collections).

PENNSYLVANIA

Philadelphia: Philadelphia Museum of Art (outstanding American and European collections).

RHODE ISLAND

Providence: Museum of Art, Rhode Island School of Design (fine American collection; esp. New England).

283

TEXAS

Houston: The Bayou Bend Collection (outstanding American collection).

VIRGINIA

Richmond: Virginia Museum of Fine Arts (general collection).

Williamsburg: Colonial Williamsburg (outstanding 18th C. American collection).

CANADA

ONTARIO

Toronto: Royal Ontario Museum (general collections).

Arms and Armor

This includes collections of military hardware of various periods, mostly from the eighteenth century to date. A few, like the Metropolitan Museum of Art in New York and the Higgins Armory Museum in Worcester, have outstanding examples of battle and parade armor, for both horses and men, from the late Middle Ages to the seventeenth century and also the finest of early weaponry. The majority of those listed, however, pertain to the lively history of the conquest and settlement of the United States and Canada, and to subsequent wars in which our two nations were engaged. Some are devoted largely to handguns, often including those made notorious by the murderous proclivities of their owners. Since ceremonial swords were often made by goldsmiths, a few particularly fine examples are to be found in silver collections (see Goldsmithwork in this same section).

ARKANSAS

Berryville: Saunders Memorial Museum (large collection of small arms, incl. guns of famous characters; Col. C. Benton Saunders collection). 113-15 Madison St., 72616; 501-423-2563; daily 9–5; closed Nov. 1–March 15; fee.

Washington: Old Washington Historic State Park, 71862; 501-983-2684; Mon., Wed.–Sat. 9–4; Sun. 1–5; closed Tues., major holidays; fee.

CALIFORNIA

Dorris: Herman's House of Guns. 204 S. Oregon St., 96023; 916-397-2611; by appointment; no charge.

Los Angeles: Natural History Museum of Los Angeles County. 900 Exposition Blvd., 90007; 213-744-3414; Tues.–Sun. 10–5; closed New Year's, Thanksgiving, Christmas; fee.

CONNECTICUT

Wilton: Craft Center Museum. 78 Danbury Rd., 06897; 203-762-8363; March–Dec.: Mon.–Fri. 10–4; closed holidays, months of Jan.–Feb.; no charge.

DISTRICT OF COLUMBIA

Washington: National Rifle Association Firearms Museum. 1600 Rhode Island Ave., N.W., 20036; 202-828-6194; daily 10–4; closed major holidays; no charge.

GEORGIA

Fort Benning: National Infantry Museum. U.S. Army Infantry Center, 31905; 404-544-4762; Tues.–Fri. 10–4:30; Sat.–Sun. 12:30–4:30; closed New Year's, Thanksgiving, Christmas; no charge.

KENTUCKY

Fort Knox: Patton Museum of Cavalry and Armor. Keyes Park, 40121; mailing address: Box 208, 502-624-3812; daily 9–4:30; closed Dec. 24–25, Dec. 31–Jan. 1; no charge.

Frankfort: Kentucky Military History Museum. E. Main St., Box H, 40602; 502-564-3265; Mon.–Sat. 9–4; Sun. 1–5; closed major holidays; no charge.

MARYLAND

Baltimore: Walters Art Gallery.

MASSACHUSETTS

Boston: Ancient and Honorable Artillery Company of Massachusetts.

Springfield: Springfield Armory. National Historic Site Armory Center, 01105; 413-734-6477; daily 8–4:30; closed New Year's, Thanksgiving, Christmas; no charge.

Worcester: Higgins Armory Museum.

NEW YORK

Corning: The Rockwell Museum.

Ilion: Remington Gun Museum. Catherine St., 13357; 315-894-9961; Mon.-Sat. 9-4:30; no charge.

New York City: The Metropolitan Museum of Art. The New-York Historical Society. New York City Police Academy Museum. 235 E. 20th St., 10003; 212-477-9753; Mon.-Fri., call for hours; no charge.

Ticonderoga: Fort Ticonderoga. Box 390, 12883; 518-585-2821; mid-May-June, Sept.-mid-Oct.: daily 9-5; July-Aug.: daily 9-6; closed mid-Oct.-mid-May; fee.

West Point: West Point Museum (one of the largest collections of military arms and objects). U.S. Military Academy, 10996; 914-938-3201; daily, holidays 10:30-4:15; closed New Year's, Christmas; no charge.

OHIO

Wright-Patterson AFB: United States Air Force Museum. 45433; 513-255-3284; Mon.-Fri. 9-5; Sat.-Sun. 10-6; no charge.

OKLAHOMA

Claremore: J. M. Davis Gun Museum.

PENNSYLVANIA

Boalsburg: Pennsylvania Military Museum. 28th Division Shrine, Box 148, 16827; 814-466-6263; EDT: Wed.-Sat. 9-5; Sun. 12-5; EST: Wed.-Sat. 10-4:30; Sun. 12-4:30; closed holidays; fee.

Philadelphia: War Library and Museum of the Military Order of the Loyal Region of the United States. 1805 Pine St., 19103; 215-735-8196; Mon.-Fri. 10-4; closed holidays; fee.

Strasburg: Eagle Americana Shop and Gun Museum. R.D. 1, 17579; 717-687-793; Apr. 1-Oct. 31: Mon.-Fri. 10-5; Sat.-Sun., holidays 10-7; closed Nov. 1-March 31; fee.

RHODE ISLAND

Newport: Newport Artillery Company Museum. 23 Clarke St., 02840; mailing address: Box 14; 401-846-8488; Apr.-Sept.: Tues.-Sun. 10-3:30; Sept.-March: Sat. 1-3:30; other times by appointment; no charge.

SOUTH CAROLINA

Charleston: Powder Magazine. 79 Cumberland St., 29401; 803-722-3767; Oct.-Aug.: Mon.-Fri. 9:30-4; closed weekends, major holidays, month of Sept., first Tues. in Nov.-June; fee.

TEXAS

Fort Hood: Second Armored Division Museum. 76546; 817-685-3570; Mon.–Tues., Thurs.–Fri. 9–5; Wed. 12:30–5; Sat. 10–4:30; Sun. 12–4:30; closed holidays; no charge.

Harlingen: Confederate Air Force. Rebel Field, 78550; 512-425-1057; Mon.–Sat. 9–5; CDT: Sun. 12–5; CST: Sun. 1–6; fee.

Hillsboro: Confederate Resarch Center and Gun Museum. Box 619, 76645; 817-582-2555; Mon.–Fri. 8–5; no charge.

VERMONT

Windsor: American Precision Museum, Association. 196 Main St., 05089; 802–674–5781; Memorial Day–Nov. 1; Mon.–Fri. 9–5; Sat.–Sun. & holidays 10:30–4:30; fee (illustrating the beginning of the "American system" of manufacturing).

VIRGINIA

Newport News: The War Memorial Museum of Virginia. 9285 Warwick Blvd. Huntington Park, 23607; 804-247-8523; Mon.–Sat. 9–5; Sun. 1–5; closed New Year's, Christmas; fee.

Quantico: United States Marine Corps Aviation Museum. Brown Field Marine Corps Base, 22134; 703-640-2607; Tues.–Fri. 10–4; Sat. 10–9; Sun., holidays 10–4; no charge.

Richmond: Virginia Museum of Fine Arts.

PUERTO RICO

San Juan: Museum of Military and Naval History. Fort San Jeronimo beside Caribe Hilton Hotel, 00905; 809-724-0700; Tues.–Wed., Fri. 9–5; Sat. 9–6; closed Sun., Mon., Thurs., holidays; fee.

CANADA

BRITISH COLUMBIA

New Westminster: The Regimental Museum/The Armory. 530 Queens Ave., V3L 1K3; 604-526-5116; Mon. 9–12 and 1–3; Wed., Fri. 1–3; other times by appointment; closed holidays; no charge.

Vedder Crossing: Canadian Military Engineers Museum. Canadian Forces School of Military Engineering Local 263, MPO 612, C.F.B. Chilliwack, V0X 2E0; 604-858-3311; Local 261; Sun. 1–4:30; Summer: Mon.–Fri. 10–4; small fee.

MANITOBA

Shilo: Royal Canadian Artillery Museum. Canadian Forces Base, R0K 2A0; 204-765-2282; June 1–Oct. 1: daily 2–4; Oct. 2–May 31: Mon.–Fri. 2–4; no charge.

Winnipeg: Royal Winnipeg Rifles Museum. 969 St. Mathews Ave., R3G 0J7; 204-783-0880; Tues., Thurs. 8 P.M.–10 P.M.; Sat. 10–2; no charge.

NOVA SCOTIA

Halifax South: The Army Museum, Halifax Citadel. Box 3666; B3J 3K6; 902-422-5979; Summer: daily 9–8; Winter: daily 10–5; no charge.

ONTARIO

Borden: Base Borden Military Museum and Worthington Park. Canadian Forces Base, L0M 1C0; 705-424-1200; Mon.–Fri. 9–12 and 1–4:30; Sat.–Sun. 1:30–4; no charge.

London: The Royal Canadian Regiment Museum. Wolsely Hall, Wolsely Barracks, N5Y 4T7; 519-679-5173; Mon.–Fri. 9–11 and 1–4; Wed. 7–9; closed Sat., Sun., holidays, Dec. 21–Jan. 2; no charge.

Ottawa: Canadian War Museum. 330 Sussex Dr. K1A 0M8; 613-996-1422; May 1–Labor Day: Mon.–Sat. 9–5; Sun. 1–5; Labor Day–Apr. 30: Tues.–Sat. 9–5; Sun. 1–5; closed Mon.; no charge.

QUEBEC

Montreal: Royal Canadian Ordnance Corps Museum. 6560 Hochelaga St.; mailing address: Box 6109, H3C 3H7; 514-255-8811; Mon.–Fri. 10–3; Sat.–Sun., holidays by appointment; no charge.

Ceramics

The institutions listed in this section have collections of American or European pottery or porcelain. Native American, Pre-Columbian, African, ancient, Asiatic, and other wares are listed in preceding pages. All the larger museums and a great majority of others have collections of ceramics. Those listed here are particularly extensive, including useful study series or especially outstanding examples.

The title of this subsection, "Ceramics," has been chosen purely for convenience since it covers various categories and suggests nothing of the fascinating variety involved—from the most sumptuous of Continental and English porcelains to picturesque cottage earthenware, and, in America, from the handsome formality of Tucker's creations to characteristic regional wares, many of which are still insufficiently appreciated.

ALABAMA

Birmingham: Birmingham Museum of Art (Wedgwood, European porcelain).

ARIZONA

Tempe: Arizona State University Art Collections (outstanding American pottery).

CALIFORNIA

Los Angeles: Los Angeles County Museum of Art (European porcelain and other).

San Francisco: The Fine Arts Museums of San Francisco (European porcelain). M. H. de Young Museum, Golden Gate Park.

Santa Clara: Triton Museum of Art (Elmer collection of Majolica). 1505 Warburton Ave., 95050; 408-248-4585; Tues.–Fri. 12–4; Sat.–Sun. 12–5; closed holidays; no charge.

CONNECTICUT

Hartford: Wadsworth Atheneum (extraordinary European porcelain).

DELAWARE

Winterthur: Henry Francis Du Pont Winterthur Museum (American and European wares).

DISTRICT OF COLUMBIA

Washington: National Gallery of Art (European wares). ☐ National Museum of American History (comprehensive general collections).

FLORIDA

Jacksonville: Cummer Gallery of Art (finest Meissen porcelain collection in the country).

GEORGIA

Savannah: Telfair Academy of the Arts and Sciences (English hard and soft paste porcelain).

ILLINOIS

Chicago: The Art Institute of Chicago (European and American wares).

KANSAS

Wichita: Wichita Art Museum (European porcelain and *faience*).

LOUISIANA

Shreveport: The R. W. Norton Art Gallery (Wedgwood collection).

MASSACHUSETTS

Boston: Museum of Fine Arts (outstanding English and Continental porcelain).

Cambridge: Fogg Art Museum (Wedgwood and other wares).

Waltham: Rose Art Museum, Brandeis University (Rose collection of early ceramics).

MICHIGAN

Detroit: The Detroit Institute of Arts (European and American).

Grand Rapids: Grand Rapids Art Museum (Staffordshire pottery).

MISSOURI

Kansas City: William Rockhill Nelson Gallery and Atkins Museum of Fine Arts (Burnap collection of English pottery, medieval to 19th C.).

St. Louis: The Saint Louis Art Museum (European and American examples).

NEW JERSEY

Camden: Campbell Museum (china, glass and silver soup tureens and bowls from 500 B.C. to present). Campbell Place, 08101; 609-964-4000; Mon.–Fri. 9–4:30; closed holidays; no charge.

NEW YORK

New York City: Cooper-Hewitt Museum, The Smithsonian Institution's National Museum of Design (fine European and American examples; archival

and research material). ☐ The Metropolitan Museum of Art (outstanding large collection of European and American wares).

Syracuse: Everson Museum of Art of Syracuse and Onondaga County (outstanding contemporary collection).

OHIO

Cincinnati: Cincinnati Art Museum (European porcelain; Rookwood pottery, a local ware of Art Nouveau design).

Cleveland: Cleveland Museum of Art (fine general collection).

East Liverpool: East Liverpool Museum of Ceramics. 400 E. 5th St. at Broadway, 43920; 216-386-6001; Wed.–Sat. 9:30–5; Sun. 12–5; closed Dec.–Feb., holidays; fee.

PENNSYLVANIA

Merion: The Buten Museum of Wedgwood (Wedgwood and other English wares, dating from 1759 to present).

Philadelphia: Philadelphia Museum of Art (European and Tucker porcelain).

SOUTH CAROLINA

Columbia: The University of South Carolina McKissick Museums (regional pottery). McKissick Library Bldg., 29208; 803-777-7251; Mon.–Fri. 9–4; Sun. 1–5; closed holidays, Sat.; no charge.

Edgefield: Pottersville Museum (local stoneware). Rt. 2, Box 4, 29824; 803-637-3333; Mon.–Sat. 9–6; Sun. 2–6; no charge.

TEXAS

Houston: The Bayou Bend Collection (American wares).

VERMONT

Bennington: Bennington Museum (Bennington pottery and Rockingham, Flint Enamel, Parian, Blue and White porcelain).

CANADA

ONTARIO

Toronto: Royal Ontario Museum (English, Continental and Canadian wares).

Furniture and Furnishings

Following are those collections which are strong in furniture, but you will find that almost all of them have other kinds of decorative arts as well. Non-Western furniture may be found in the appropriate sections elsewhere, this subsection being devoted to European and American objects from the Middle Ages to the present. Since all historic houses, most historic buildings, and all historical societies have furnishings, their inclusion would have swollen this category beyond reason or usefulness, so I refer you to the excellent guides available in libraries and bookstores.

ALABAMA

Mobile: The Fine Arts Museum of the South at Mobile (southern furniture).

ARIZONA

Phoenix: Phoenix Art Museum (American and European collections).

CALIFORNIA

Los Angeles: Los Angeles County Museum of Art (American and European collections).

Malibu: J. Paul Getty Museum (superb French 18th C. collection).

Pasadena: Norton Simon Museum (European collection).

San Francisco: The Fine Arts Museums of San Francisco, M. H. de Young Museum, Golden Gate Park (American and European collections, particularly French).

San Simeon: Hearst San Simeon State Historical Monument (collection of all classic periods). Rt. 1, Box 8, 93452; 805-927-4621; daily 8:20–3:20; closed New Year's, Thanksgiving, Christmas; fee.

Santa Clara: de Saisset Art Gallery and Museum (French 18th C. collection).

CONNECTICUT

Hartford: Wadsworth Atheneum (European and American collections).

New Haven: Yale University Art Gallery.

New London: Lyman Allyn Museum (Connecticut furniture, 18th–19th C.).

Riverton: The Hitchcock Museum (early and mid-19th C. furniture, located in an 1829 church). 06065; 203-379-1003; June 1–Oct. 31: Tues.–Sat. 10–5; Nov. 1–May 31: Sat. 10–5; no charge.

DELAWARE

Winterthur: Henry Francis Du Pont Winterthur Museum.

DISTRICT OF COLUMBIA

Washington: Diplomatic Reception Rooms, Department of State (superb American collection). 2201 "C" St., NW, 20520; 202-632-0298; reservations only for Mon.–Fri. 9:30, 10:30, and 3; phone or write Dept. of State; no charge. ☐ National Museum of American Art, Smithsonian Institution: Renwick Gallery.

FLORIDA

Jacksonville: Cummer Gallery of Art (European and American collections).

Miami: Villa Vizcaya Museum and Gardens (Italian collection).

Sarasota: John and Mable Ringling Museum of Art (European collection).

GEORGIA

Savannah: Telfair Academy of the Arts and Sciences (furniture from Colonial times on).

ILLINOIS

Chicago: The Art Institute of Chicago (outstanding American collection).

INDIANA

Indianapolis: Indianapolis Museum of Art (European and American collections).

KENTUCKY

Louisville: J. B. Speed Art Museum (European and American collections).

LOUISIANA

New Orleans: Louisiana State Museum (southern American collection).

MAINE

Brunswick: Bowdoin College Museum of Art (American 18th C. collection).

MARYLAND

Baltimore: Baltimore Museum of Art (American and European collections; Maryland furniture). ☐ Walters Art Gallery (European collection).

MASSACHUSETTS

Andover: Andover Historical Society (American collection). 97 Main St., 01810; 617-475-2236; Wed., Sun. 2–4; other times by appointment; closed holidays; small fee.

293

Boston: Isabella Stewart Gardner Museum (Italian collection). ☐ Museum of Fine Arts (American 17th–19th C.; French 18th C.).

Concord: Concord Antiquarian Society. 200 Lexington Rd., 01742; 617-369-9609; Mon.–Sat. 10–4:30; Sun. 2–4:30; fee.

Deerfield: Historic Deerfield (American 17th–18th C. collection).

Gloucester: The Hammond Castle Museum (medieval and American collections).

Plymouth: The Pilgrim Society (outstanding collection of Pilgrim material). ☐ Plimoth Plantation (17th C. American collection).

Salem: Essex Institute (American, Salem collection).

Springfield: George Walter Vincent Smith Art Museum.

Sturbridge: Old Sturbridge Village (American 19th C. collection).

Williamstown: Williams College Museum of Art (Spanish and American collections).

Worcester: Worcester Art Museum (European and American collections).

MICHIGAN

Dearborn: Greenfield Village and Henry Ford Museum (very extensive collections of American objects).

Detroit: The Detroit Institute of Arts (European and American collections).

MINNESOTA

Minneapolis: The Minneapolis Institute of Arts (American and European collections).

MISSOURI

Kansas City: William Rockhill Nelson Gallery and Atkins Museum of Fine Arts (European and American collections).

St. Louis: The Saint Louis Art Museum (medieval and later European and American collections).

NEBRASKA

Omaha: Joslyn Art Museum (European and American collections).

NEW HAMPSHIRE

Concord: New Hampshire Historical Society. 30 Park St., 03301; 603-225-3381; Mon.–Tues., Thurs.–Fri. 9–4:30; Wed. 9–8; no charge.

Manchester: The Currier Gallery of Art (American 18th–19th C. collection).

NEW YORK

Albany: Albany Institute of History and Art (American 18th–19th C. collection).

Buffalo: Albright-Knox Art Gallery.

Cooperstown: New York State Historical Association (American, especially N.Y. State collections).

New York City: The Cloisters (medieval collection). ☐ Cooper-Hewitt Museum. ☐ The Smithsonian Institution's National Museum of Design. ☐ The Frick Collection (European collection). ☐ The Metropolitan Museum of Art (outstanding American and European collections). ☐ Museum of the City of New York (18th–19th C. American, esp. New York). ☐ The New York Historical Society (American 18th–19th C.)

Rochester: Memorial Art Gallery of the University of Rochester (medieval to 19th C. collections).

OHIO

Cincinnati: Cincinnati Art Museum.

Cleveland: Cleveland Museum of Art (American and European collections).

PENNSYLVANIA

Philadelphia: Philadelphia Museum of Art (European and American collections, esp. Philadelphia objects).

RHODE ISLAND

Providence: Museum of Art, Rhode Island School of Design. Rhode Island Historical Society (Newport furniture). 52 Power St., 02906; 401-331-8575; Tues.–Sat. 11–4; Sun. 1–4; closed Mon., holidays; fee.

SOUTH CAROLINA

Charleston: Gibbes Art Gallery.

Columbia: Columbia Museums of Art and Science (Neuhoff Collection of English furniture).

TENNESSEE

Memphis: Brooks Memorial Art Gallery (European and American furniture).

TEXAS

Houston: The Bayou Bend Collection (outstanding American collection). ☐ The Museum of Fine Arts, Houston (European and American collections).

UTAH

Salt Lake City: Utah Museum of Fine Arts (English 17th–18th C. furniture).

VERMONT

Shelburne: Shelburne Museum.

VIRGINIA

Norfolk: Chrysler Museum at Norfolk, Olney Rd. and Mowbray Arch.

Richmond: Valentine Museum (European and American collections, medieval to 19th C.).

Williamsburg: Colonial Williamsburg, Goodwin Bldg. (outstanding American collection).

CANADA

ONTARIO

Ottawa: National Gallery of Canada (Canadian and European collections).

Toronto: Royal Ontario Museum (European collection).

QUEBEC

Montreal: The Montreal Museum of Fine Arts.

Quebec: Musée du Québec, I (Canadian and French collections).

Glass

Since glass is everywhere, the following collections are listed because they significantly represent some aspect of this enormous field or because their collections are large and compendious or contain particularly important and interesting examples. For the benefit of collectors, a number of the collections of regional productions are included also.

CALIFORNIA

Los Angeles: Los Angeles County Museum of Art (European glass).

Sacramento: Crocker Art Museum (Roman glass).

DISTRICT OF COLUMBIA

Washington: National Museum of American Art (American glass). ☐ National Museum of American History (general collection of American glass).

FLORIDA

St. Augustine: Lightner Museum (American glass incl. Tiffany). City Hall Museum Complex King St., 32084; 904-829-9677; daily 9–5; closed Christmas; fee.

Winter Park: The Morse Gallery of Art (outstanding Tiffany glass).

INDIANA

Greentown: Greentown Glass Museum (local and Indiana glass, esp. productions of the Indiana Tumbler and Goblet Co. of Greentown from 1894 to 1903).

LOUISIANA

New Orleans: New Orleans Museum of Art (Melvin P. Billups Glass Collection).

MASSACHUSETTS

Andover: Addison Gallery of American Art.

Brockton: The Brockton Art Museum (Early American and Sandwich glass).

Chatham: Chatham Historical Society (Sandwich glass). Box 381, 02633; 617-945-2493; June 16–Sept. 26: Mon.–Wed., Fri. 2–5; closed July 4, Labor Day, Sept. 27–June 15; fee.

Chelmsford: Chelmsford Historical Society. 40 Byam Rd., 01824; 617-256-2311; Apr.–mid-Dec.:·Mon.–Fri. by appointment; Sun. 2–4; fee.

Concord: Concord Antiquarian Society. 200 Lexington Rd., 01742; 617-369-9609; Mon.–Sat. 10–4:30; Sun. 2–4:30; fee.

Sandwich: Sandwich Glass Museum (American Sandwich glass).

MICHIGAN

Dearborn: Greenfield Village and Henry Ford Museum (comprehensive collection of American glass).

Detroit: The Detroit Institute of Arts (German goblets, 200 antique paperweights).

MISSOURI

St. Louis: The Saint Louis Art Museum (La Farge stained glass windows, other glass).

NEW JERSEY

Millville: Wheaton Historical Association (New Jersey glass). Wheaton Village, 08332; 609-825-6800; daily 10–5; closed major holidays; fee.

Newark: The Newark Museum (the Schaefer Collection of ancient glass).

Princeton: The Art Museum, Princeton University (medieval stained glass from Chartres Cathedral).

NEW YORK

Corning: Corning Glass Center (a world center of glass research, incl. The Corning Museum of Glass).

New York City: The New-York Historical Society (American glass).

OHIO

Cambridge: The Cambridge Glass Museum (over 4,000 pieces of local glass). ☐ Degenhart Paperweight and Glass Museum (19th–20th C. American glass).

Cincinnati: Cincinnati Art Museum (European and American glass).

Columbus: Ohio Historical Center (Ohio glass).

Findlay: Hancock Historical Museum (Ohio glass). 422 W. Sandusky St., 45840; 419-423-4433; March–Dec.: Fri.–Sun. 1–4; closed Mon.–Thurs., Jan.–Feb.; no charge.

Newark: National Heisey Glass Museum (A. E. Heisey & Co. glassware).

Toledo: The Toledo Museum of Art (outstanding collection of European and American glass).

OKLAHOMA

Tulsa: Philbrook Art Center (American glass).

PENNSYLVANIA

Philadelphia: Philadelphia Museum of Art (European and American glass).

TENNESSEE

Chattanooga: Houston Antiques Museum (European and American glass).

VERMONT

Bennington: Bennington Museum (Early American blown, pressed, patterned, and art glass; MacCall Gallery, over 1,200 patterns of pressed glass goblets).

CANADA

Goldsmithwork and Other Metalwork

Goldsmithwork includes objects in silver and sometimes in other metals as well, occasionally with ornamentation of enamel, semiprecious and precious stones, or other materials. The common denominator is the high degree of craftsmanship and the essential respect for fine materials, with the resulting sense of value, that are involved. Goldsmiths ranked highest among craftsmen, and in the days before banks they were virtually bankers in their communities, since plate (meaning solid silver, whether plated with gold or not) was capital. Because they worked for the middle class on up to royalty, theirs was a special and demanding clientele, and their work stood for status as well as wealth. Today we can enjoy goldsmithwork not only for its use of beautiful materials, but also for what it tells us of the dignity and state of other societies in other ages, with a consistency of style which expresses the community of shared ideals in less pluralistic and divergent times.

For European goldsmithwork from ancient times to the Renaissance and for that of other cultures, please check the appropriate sections of the guide. The following list includes collections mainly of European and American silver dating from the seventeenth through the nineteenth centuries. Since many museums have examples of gold and silver, often fine ones, only those with more substantial collections are included.

ALABAMA

Birmingham: Birmingham Museum of Art (de Lamarie, Bateman, and other English silver).

CALIFORNIA

Los Angeles: Los Angeles County Museum of Art (European and American collections).

Malibu: J. Paul Getty Museum (European collection).

Pasadena: Norton Simon Museum.

San Francisco: Fine Arts Museums of San Francisco, M. H. de Young Museum, Golden Gate Park (American and European collections).

CONNECTICUT

Hartford: Wadsworth Atheneum (European and American silver).

New Haven: Yale University Art Gallery (superb American silver; Garvan collection).

DELAWARE

Winterthur: Henry Francis Du Pont Winterthur Museum (outstanding American silver and pewter).

DISTRICT OF COLUMBIA

Washington: National Gallery of Art (European silver). ☐ National Museum of American History.

GEORGIA

Savannah: Telfair Academy of Arts and Sciences (American silver, incl. Southern, esp. Savannah).

ILLINOIS

Chicago: The Art Institute of Chicago (outstanding American silver and pewter).

INDIANA

Indianapolis: Indianapolis Museum of Art (European and American silver).

MAINE

Brunswick: Bowdoin College Museum of Art (American silver).

MARYLAND

Baltimore: Walters Art Gallery (European and American silver). ☐ Baltimore Museum of Art (European and American silver, incl. Maryland makers).

300

MASSACHUSETTS

Amherst: Mead Art Museum (American silver and pewter).

Andover: Andover Historical Society (American silver and pewter).

Boston: Museum of Fine Arts (one of the great collections of American silver, with many Revere pieces, incl. the Liberty Bowl; English and Continental silver).

Cambridge: Fogg Art Museum (European and American silver).

Deerfield: Historic Deerfield (fine American silver and pewter).

Pittsfield: The Berkshire Museum (Hahn Collection of silver).

Plymouth: The Pilgrim Society (Early American pewter).

Springfield: George Walter Vincent Smith Art Museum.

Sturbridge: Old Sturbridge Village (19th C. American pewter and tinware).

Williamstown: Sterling and Francine Clark Art Institute (one of the great collections of English, Continental and American; note esp. work by Paul de Lamarie). ☐ Williams College Museum of Art.

Worcester: Worcester Art Museum.

MICHIGAN

Dearborn: Greenfield Village and Henry Ford Museum (outstanding collection of American silver and pewter).

Detroit: The Detroit Institute of Arts (European and American silver; outstanding French Canadian silver).

MINNESOTA

Minneapolis: The Minneapolis Institute of Arts (Revere and other American and European silver).

MISSOURI

Kansas City: William Rockhill Nelson Gallery and Atkins Museum of Fine Arts (American and European silver).

St. Louis: The Saint Louis Art Museum (American and European silver; Altha Collection of English silver).

NEW HAMPSHIRE

Hanover: Hood Museum (silver monteith by Hurd and Henchman, and other American silver).

Manchester: The Currier Gallery of Art (very fine New England silver; note esp. John Coney's sweetmeat box—compare with those in Boston).

NEW JERSEY

Montclair: Montclair Art Museum (Whitney silver collection).

Newark: The Newark Museum (American silver).

NEW YORK

Albany: Albany Institute of History and Art (early Hudson River Valley silver).

Buffalo: Albright-Knox Gallery (general silver collection).

Cooperstown: New York State Historical Association (American silver, esp. New York makers).

New York City: The Brooklyn Museum (outstanding European and American silver). ☐ The Metropolitan Museum of Art (one of the very great collections of European and American silver). ☐ Museum of the City of New York (fine collection of New York silversmiths). ☐ The New York Historical Society.

Rochester: Memorial Art Gallery (European and American silver).

OHIO

Cincinnati: Cincinnati Art Museum (European and American silver).

Cleveland: Cleveland Museum of Art (European and American silver).

Toledo: The Toledo Museum of Art (European and American silver).

OREGON

Portland: Portland Art Museum (Nunn and Cabell Collection of English silver).

PENNSYLVANIA

Philadelphia: Philadelphia Museum of Art (outstanding American and other silver, including Philadelphia and Pennsylvania makers).

RHODE ISLAND

Providence: Museum of Art, Rhode Island School of Design.

TENNESSEE

Chattanooga: Houston Antiques Museum (American pewter).

TEXAS

Houston: The Bayou Bend Collection (American silver). ☐ The Museum of Fine Arts, Houston (American and European silver).

VIRGINIA

Norfolk: Chrysler Museum at Norfolk (American and European silver).

Richmond: Valentine Museum (American silver). ☐ Virginia Museum of Fine Arts (American and European silver).

Williamsburg: Colonial Williamsburg, Goodwin Bldg. (extensive collection of American silver and pewter).

WASHINGTON

Seattle: Seattle Art Museum (European and American silver).

WEST VIRGINIA

Huntington: The Huntington Galleries (English 18th C. silver).

CANADA

ONTARIO

Toronto: Royal Ontario Museum (English and European silver).

QUEBEC

Quebec: Musée du Québec (English and French Canadian silver).

Musical Instruments

Many museums have examples of musical instruments. The following, however, are larger, more varied collections than most. They are primarily, but far from exclusively, Western. For Eastern and other examples, please consult the appropriate previous sections, where the collections listed often include instruments among other objects.

ARKANSAS

Eureka Springs: Miles Musical Museum. Hwy 62 W, 72632; 501-253-8961; May 1–Nov. 1: daily 9–5; closed Nov.–May; fee.

CALIFORNIA

Santa Barbara: The Santa Barbara Museum of Art.

CONNECTICUT

New Haven: Yale University Collection of Musical Instruments.

MASSACHUSETTS

Boston: Museum of Fine Arts (Leslie Lindsey Mason Collection). □ The New England Conservatory of Music (617-262-1120) and the Boston Symphony (617-266-1492) also have collections which can sometimes be seen; phone for information.

MICHIGAN

Ann Arbor: Stearns Collection of Musical Instruments, University of Michigan.

NEW JERSEY

Newark: The Newark Museum.

NEW YORK

Deansboro: Musical Museum.

New York City: The Metropolitan Museum of Art.

OHIO

Cincinnati: Cincinnati Art Museum.

Cleveland: Cleveland Museum of Art.

SOUTH DAKOTA

Vermillion: The Shrine to Music Museum.

Textiles

Virtually all major museums have textile collections of some importance, while many have costumes also. The following museums are listed because they have particularly strong or varied collections or because they are study centers in some major area of the textile field.

CALIFORNIA

Los Angeles: Los Angeles County Museum of Arts.

COLORADO

Denver: The Denver Art Museum (Neusteter Institute of Fashion, Costume, and Textiles research center).

DELAWARE

Winterthur: Henry Francis Du Pont Winterthur Museum.

DISTRICT OF COLUMBIA

Washington: National Museum of American History. ☐ The Textile Museum.

ILLINOIS

Chicago: The Art Institute of Chicago.

INDIANA

Indianapolis: Indianapolis Museum of Art.

MASSACHUSETTS

Boston: Museum of Fine Arts.

Cambridge: Fogg Art Museum.

North Andover: Merrimack Valley Textile Museum. 800 Massachusetts Ave., 01845; 617-686-0191; Tues.–Fri. 9–4; Sat.–Sun. 1–5; closed major holidays; fee.

Springfield: George Walter Vincent Smith Art Museum.

MICHIGAN

Detroit: The Detroit Institute of Arts.

MISSOURI

St. Louis: The Saint Louis Art Museum (Continental and American embroideries).

NEW YORK

New York City: The Brooklyn Museum. ☐ Cooper-Hewitt Museum. ☐ The Smithsonian Institution's National Museum of Design. ☐ The Metropolitan Museum of Art. ☐ Scalamandre Museum of Textiles. 950 Third Ave., 10022; 212-361-8500; Mon.–Fri. 9–5; no charge.

OHIO

Cincinnati: Cincinnati Art Museum.

Cleveland: Cleveland Museum of Art.

PENNSYLVANIA

Philadelphia: Philadelphia Museum of Art (Kress Collection of Barberini tapestries).

VIRGINIA

Richmond: Valentine Museum. Virginia Museum of Fine Arts.

WASHINGTON

Seattle: Costume and Textile Study Center. School of Nutritional Sciences and Textiles, DL-10, University of Washington, 98195; 206-543-1739; by appointment only; no charge.

CANADA

ONTARIO

Toronto: Royal Ontario Museum.

An Oriental Ruler on a Throne *by Albrecht Dürer*. COURTESY OF THE NATIONAL
GALLERY OF ART, WASHINGTON, D.C.

9) Prints and Drawings
(pre-1400-1982)

9. Prints and Drawings

The word "print" has been much abused of late, often being used to refer to colored reproductions of paintings for example. The "original print," with which we are concerned here, is an impression made by a nonmechanical, graphic process that is under the artist's control at all stages of its production.* In most cases, the artist examines and passes on each individual impression, often numbering them up to a decided total, a figure which used to be calculated by the durability of the plate or block, to eliminate poor or worn impressions. Today, when many plates are steel-coated and can stand up almost indefinitely, the number of the edition is arbitrarily limited to ensure value. Thus 32/100 means that the print in hand is the thirty-second of an edition of one hundred. Proofs, properly labeled as such, are impressions pulled from the plate before numbering to check quality. If, as in many etchings, the work evolves through several stages called states—reworkings of the plate— this fact may be noted in the numbering also.

Artists sometimes sign *in* the print, as in the case of Rembrandt, where the signature is engraved with the design, or (as is more common later) prints are signed individually by hand in the margin as the artist personally checks each impression. During the last few decades a pernicious practice has sprung up, mostly among European artists, Picasso among them, of having a design mechanically reproduced along with a signature in the margin which looks as though it had been added by the artist, but which was actually printed. There is no telling how many such "prints" have

*The Print Council of America, 527 Madison Avenue, New York, N.Y., 10022, has an invaluable small publication on prints and print techniques, with a thoughtful discussion of their history and contemporary problems. It is entitled *What Is an Original Print?*

been produced this way, although they are often sold in handsome port-folios, sometimes themselves in numbered editions with introductory printed matter, looking as if the reproductions included had been limited in number and controlled by the artist. These are prints only in the other sense of the word, in that they are mechanical reproductions, mass-produced, and have nothing whatsoever to do with the original print, which is what concerns us here.

Shortly after 1450, some clever German craftsman from the Rhineland—perhaps Johann Gutenberg, as tradition has it—began to print books with movable, cast-iron type, an invention of incalculable importance. A long history lies behind this notable event, starting in the Near East perhaps five millennia ago, with the Sumerian invention of stone seals, carved with both text and picture, which printed inscriptions in relief on clay. The use of such seals moved eastward, finally reaching China, where they were inked to print on silk. In the second century A.D. the Chinese in-vented paper, more satisfactory than Egyptian papyrus, far less costly than parchment or vellum. By about 800 they were printing books and pictures from woodcut blocks, and within two more centuries they had invented and started to print with movable type. Somehow, probably along the interminable trade routes across Central Asia, their invention reached Europe. From about 1400 to 1500 block books were produced in some quantity. These are illustrated books printed from blocks cut in relief—woodcuts—a block to a page. Crude though such books were, they have been much valued by scholars and collectors as *incunabula* (from the Latin for swaddling clothes, hence infancy) because of their position at the beginning of the history of the book.

In the Low Countries and perhaps also in Germany, the use of the wood-cut technique to produce prints in quantity began—an extraordinary event in history since it brought pictures within everybody's reach. A single carved block could yield hundreds of prints which could then be sold at the printer's shop or hawked through the streets for a few cents apiece. By 1500 first-rate artists were designing for this first popular print medium, and there were many expert anonymous carvers to produce the blocks.

Chiaroscuro woodcuts, popular in Italy and Flanders in the late Renaissance, were made like any color woodcut, with a block for each color, but were printed in various shades of monochrome, with the key block carrying the basic structure of the design in a darker tone. The result somewhat resembles a wash drawing, often with very beautiful and subtle results.

The wood engraving differs from the woodcut in that whereas the latter uses a block cut plankwise with the grain flat, the former uses the end grain, usually composed of boxwood because of its hardness and density. The artist engraves the design with a burin or graver, cutting away the lights and leaving the darks as in a woodcut. Thomas Bewick (1753–1828), the English printmaker and illustrator, was a leading practitioner, as was his more famous contemporary, William Blake (1757–1827), the artist, poet, and mystic.

Engraving and woodcut are the two primary print media, although the former, because of its greater flexibility and refinement, seems to have attracted major talents at once. The technique had been known from classical antiquity when it was used for the decoration of metal, such as the backs of bronze mirrors, with lines incised with a burin or graver. It was not a very great step to ink the engraved metal, wipe the surface to leave the ink only in the engraved lines, and to print it on paper, slightly dampened in order to receive the ink better. Because of the nature of the art, goldsmiths were common among the earliest engravers whose work began to appear in Northern Europe in the early years of the fifteenth century.

Etching is a form of engraving in which the lines are etched with acid rather than being cut by hand directly into the metal plate. The artist coats

the plate with a soft waxlike covering, cuts the design through the coating with a burin or other sharp point, and then bathes the plate in an acid which eats away the metal only where it has been exposed by the burin. This process can be carried out any number of times to add refinement to the plate. Each of these different stages constitutes what is called a state. If additions are made by engraving directly on the plate, or if the whole plate is produced this way, the process is called drypoint. The hand-driven burin leaves a burr on the edges of the incised line, allowing softer effects in the print, but the burr rapidly wears off with printing—hence the special value to collectors of an early state or an early print in the dry-point medium. In an engraving, any burr the burin may leave is polished off before printing. Both Rembrandt and Piranesi were masters of etching with all its refinements.

Albrecht Dürer (1471–1528) of Nuremberg, the greatest artist of the Northern Renaissance, was also one of the pre-eminent masters of the copper engraving and the woodcut, which he raised to new heights of quality and expression. The nearly impossible demands he made on the block cutters, many of whom he trained in his studio, were met with a technical virtuosity and command which have rarely, if ever, been equaled.

Mezzotint is the invention of Ludwig von Siegen in the seventeenth century. In a mezzotint the copper plate is covered with a dense pattern of fine lines cut in the surface with a rocker, a tool with a segmental, toothed bottom, so that a print from the prepared plate would be entirely black. The artist polishes away the roughness with a burnisher or scraper to create light areas. The medium is therefore tonal rather than linear and thus lends itself especially well to the reproduction of paintings. Details may be engraved with the burin or drypoint to add definition to the design.

Aquatint is another tonal medium which uses a plate bitten into a fine granular pattern by acid working through a specially prepared protective ground. By biting away the plate in successive acid baths as the ground is scratched through by the artist to develop the design, working from light to dark, the print is completed. As with mezzotint, aquatint is a medium scarcely ever used alone because of its broadly tonal character.

Lithography, invented by Aloys Senefelder in 1798, originally used, as its name implies, a polished stone slab on which the artist drew directly with a greasy chalk, pencil, or wash. The stone (or more recently the metal plate, often zinc) was then dampened, and when greasy ink was applied with a roller, it would not take on the wet surfaces, but only on the greasy areas. The possible results are extremely varied, so the medium has had a great appeal for artists as well as for commercial use—in posters for example—since it can be used with color as well. Goya, Daumier, and Manet employed it masterfully.

Soft-ground etching, a later development, makes use of a ground mixed with tallow or some other such substance, so that when the artist draws on thin paper laid directly on the grounded plate, the ground sticks to the paper wherever the pencil has pressed on it. When the paper is carefully stripped off and the drawn design is exposed to acid, the result, understandably, usually looks like a pencil drawing.

Monotype is yet another print medium but is rarely used since the printing process destroys the design on the plate and each prepared plate, usually ink on glass, yields but a single print. The result has a certain graphic quality, however, which the drawing lacks. Monet, among others, used this medium occasionally.

Serigraphy, or silk-screen printing, is a modern technique, related to stencil, which provides for great variety and control. It can produce innumerable prints and thus enjoys great popularity. A stretched screen of fine fabric, originally silk but now generally nylon, is prepared by the artist in such a way that, when ink or thin paint is evenly rolled over it, only the area of the screen carrying the design remains permeable, allowing the ink or color to pass through to the paper below. In color serigraphs a separate screen is used for each tone, as in the color woodcut. Because screens may be made in large sizes, the serigraph is often on a far larger scale than most other prints except for some lithographs. Because of its character, serigraphy readily lends itself to commercial use, such as in applying designs and mottos to T-shirts, a use which is sufficiently inartistic as to lie beyond the parameters even of Pop Art.

Just a few words about reproductive prints in another sense: beginning in the seventeenth century many paintings were copied in engraving or

mixed print media in black and white, thus giving great currency to the compositions of artists both famous and less well known. The only reasonably accomplished works John Singleton Copley ever saw in Boston before leaving for England on the eve of the American Revolution were such reproductive engravings. He developed his remarkable style largely through studying them. We are not concerned here with reproductive prints, but with reproductive engravings; their historical significance and the distinction between them and original prints are both important.

Everybody knows what drawings are—original works in pencil, pen, brush and ink, charcoal, chalk, etc. Silverpoint was a favorite medium in the fifteenth and sixteenth centuries, drawn with a fine silver wire used like a lead or graphite pencil to make indelible light gray strokes of great fineness, usually on a prepared, tinted ground. Drawings need not be in black and white only. They may be drawn in sanguine, a traditional reddish brown chalk, or in some other color, on tinted paper heightened with white or touched with watercolor, gouache, or pastel. As long as they are predominantly drawn—i.e., achieved with line—they are listed as drawings.

One often encounters the terms "sketch" and "study" in connection with drawings. A sketch refers to an artist's quick impression of a whole composition he intends to paint or otherwise produce in a larger, finished form. A study, on the other hand, is a drawing, often highly developed, of a detail from a projected whole. Sketches may also be in clay, wax, or some other three-dimensional medium, often serving the same purpose for the sculptor as for the painter. Sculptural studies are less common than sketches.

Although a cartoon today means to most people a drawing with a humorous or satirical subject, in art history it usually retains its original meaning (from *cartone,* Italian for a large sheet of paper or pasteboard) of a full-sized drawing, in detail, used to transfer a design directly to a wall, canvas, panel, or other prepared surface for a painting, or used by tapestry makers to guide their weaving. Cartoons in this sense are understandably rare but are also important and interesting.

Obviously it is necessary to know something about the various print

313

techniques in order to understand the results properly and be able to discriminate between those qualities inherent in the medium and those which are the artist's own. So many of the world's greatest artists, from East and West alike, have worked in print media that this artistic category embraces a tremendous number and great variety of works. There are so many important print collections in America that it is possible to list only the largest.

Drawings are also produced in great quantity, but since each drawing is unique, their numbers are fewer. Yet drawings have a more personal quality in that they are the immediate expression of the artist, without the intervention of any technique other than that of working directly with the chosen medium, whatever it may be. There are many outstanding collections of drawings, although inevitably comprising fewer numbers than in the case of prints; and libraries of fine books, both block-books and later forms, are too numerous to single out.

Many of the various graphic techniques described above have been used in the production of books ever since the printed book emerged around the middle of the fifteenth century, modeled on the handwritten manuscript which it soon replaced. By about 1500 the book had become an independent art form, combining the demanding crafts of type designer, type cutter, printer, binder, and often the illustrator. During the sixteenth century, book production became increasingly standardized and perfected throughout the Old World, with a few examples being printed in the New World as well. The printer-bookseller, like Aldus of Venice, Plantin of Antwerp, the Elzevirs of Leiden, and Benjamin Franklin of Philadelphia, emerged as the ancestor of the modern publisher. The skills of the great typographers, such as Tory and Garamond in France, Bodoni in Italy, and Caslon and Baskerville in England, produced volumes of such distinction that they remain a challenge to this day in their unity of design and craftsmanship. Great painters and architects added their contribution also, from Palladio, Poussin, and Rubens to Maillol, Matisse, and Picasso. The history of the book, because of its unique combination of form and content, is the history of civilization, and it provides a fascinating field of study in which rewarding discoveries can still be made.

314

The graphics category then is very rich, enough so that it is even possible still to collect in this field without necessarily owning banks or coming from Saudi Arabia. As in all the arts, however, the first step is to train the eye through looking, and prints and drawings provide an excellent field in which to begin. The more one looks, the more one sees; and a whole new world of sensation, awareness, and understanding is opened. It is an illuminating experience. Enjoy!

ALABAMA

Birmingham: Birmingham Museum of Art (European and American prints and drawings). □ Visual Arts Gallery (19th, 20th C. American prints and drawings). Art Dept. University Sta., University of Alabama, 35294; 205-934-4941; Mon.-Fri. 1-6; other times by appointment; closed major holidays; no charge.

Huntsville: Huntsville Museum of Art (American graphic arts). 700 Monroe St. SW, 35801; 205-534-4566; Tues., Wed., Fri.-Sat. 10-5; Thurs., 10-5 and 7-9; Sun., holidays 1-5; no charge.

Mobile: The Fine Arts Museum of the South at Mobile (19th, 20th C. drawings and prints; Wellington Collection of wood engravings).

Montgomery: Montgomery Museum of Fine Arts (American prints and drawings).

ARIZONA

Tempe: Arizona State University Art Collections (American and European prints, Rembrandt and Dürer prints).

Tucson: University of Arizona Museum of Art (American and European contemporary prints; Fragonard drawings; Rembrandt and Goya etchings; Dürer engravings, woodcuts).

CALIFORNIA

Berkeley: University Art Museum (oriental and Western prints and drawings).

La Jolla: La Jolla Museum of Contemporary Art (contemporary drawings and prints).

Los Angeles: Los Angeles County Museum of Art (Western prints and drawings from the late Middle Ages, oriental prints and drawings). □ The Frederick S. Wight Art Gallery of the University of California at Los Angeles (Grunwald Center for the Graphic Arts, prints and drawings from 15th C. to present). □ University Galleries, University of Southern California (European prints and drawings; 15th-20th C.; American prints and drawings).

Oakland: Mills College Art Gallery (international graphics). 5000 MacArthur Blvd., Box 9973, 94613; 415-430-2164; Sept.-May: Tues.-Sun. 10-4; closed Mon.; also closed months June-Aug.; no charge.

Pasadena: Norton Simon Museum (European prints and drawings).

Sacramento: Crocker Art Museum (15th-20th C. master drawings).

San Francisco: The Fine Arts Museums of San Francisco (good general Western collection).

316

San Jose: San Jose Museum of Art (American prints). 110 S. Market St., 95113; 408-294-2787; Tues.–Sat. 10–4:30; Sun. 12–4; no charge.

San Marino: Huntington Library, Art Gallery, and Botanical Gardens (British and French drawings and prints, rare books, mss.).

Santa Barbara: University Art Museum, Santa Barbara, University of California (prints, architectural drawings). ☐ Santa Barbara Museum of Art (European and American watercolors; prints and drawings Renaissance to present).

Santa Clara: de Saisset Museum (Kolb Collection of 17th, 18th C. graphics; Hogarth, Dürer).

COLORADO

Colorado Springs: Colorado Springs Fine Arts Center (Western prints and drawings).

Denver: The Turner Museum (watercolors, prints, proofs, drawings by J. M. W. Turner, Thomas Moran). 773 Downing, 80218; 303-832-0924; Sun. 1–6; other times by appointment; no charge.

CONNECTICUT

Hartford: Wadsworth Atheneum (master prints and drawings; Lifar Collection of ballet design and costumes).

Middletown: Davison Art Center, Wesleyan University (prints from early 15th C. to present).

New Britain: The New Britain Museum of American Art (American prints and drawings).

New Haven: Yale University Art Gallery (Old Master and modern prints and drawings). ☐ Yale Center for British Art (tremendous collection of drawings, prints, rare books, 16th–19th C.).

New London: Lyman Allyn Museum (Old Master drawings; European and American drawings and prints).

Storrs: The William Benton Museum of Art (Walter Landauer collection of Kaethe Kollwitz prints and drawings). University of Connecticut, 06268; 203-486-4520; Mon.–Sat. 10–4:30; Sun., holidays 1–5; Summer: Mon.–Sat. 11–4; Sun. 1–5; no charge.

DELAWARE

Wilmington: Delaware Art Museum (American illustration collection; Howard Pyle, N. C. Wyeth).

DISTRICT OF COLUMBIA

Washington: Corcoran Gallery of Art (American and European drawings and prints). ☐ Dimock Gallery, George Washington University (Joseph Pennell prints). Lower Lisner Auditorium, 20006; 202-676-7091; Mon.–Fri. 10–5; no charge. ☐ Dumbarton Oaks Research Library and Collection (rare mss. and books on gardening, landscape architecture). ☐ Folger Shakespeare Library (theater collection, mss). 201 E. Capitol St., 20003; 202-546-4800; Library Mon.–Sat. 8:45–4:45; Gallery: Mon.–Sat. 10–4; no charge. ☐ Freer Gallery of Art (oriental drawings, prints, Whistler etchings). ☐ Howard University Gallery of Art (Afro-American and American graphics). 2455 6th St., NW, 20059; 202-636-7047; Mon.–Fri. 9–5; closed holidays; no charge. ☐ Library of Congress (vast collection of American prints and drawings) 10 First St., SE, 20540; 202-287-5000; Mon.–Fri. 8:30–9:30; Sat., Sun., holidays 8:30–6; no charge. ☐ Museum of Modern Art of Latin America (Latin American contemporary graphics). ☐ National Museum of American Art (American prints and drawings). ☐ National Gallery (Old Master prints and drawings in an outstanding collection). ☐ National Museum of American History (a large varied collection). Truxtun-Decatur Naval Museum (nautical prints).

FLORIDA

Orlando: Loch Haven Art Center (African graphics). 2416 North Mills Ave., 32803; 305-896-4231; Tues.–Fri., 10–5; Sat. 12–5; Sun. 2–5; closed holidays; no charge.

St. Petersburg: Museum of Fine Arts of St. Petersburg (American and European drawings and prints). 255 Beach Dr. N, 33701; 813-896-2667; Tues.–Sat. 10–5; Sun. 1–5; fee.

Sarasota: John and Mable Ringling Museum of Art (prints illustrating circus history, etc.).

GEORGIA

Atlanta: The High Museum of Art (American prints).

Savannah: Telfair Academy of the Arts and Sciences (18th–20th C. European and American prints and drawings).

HAWAII

Honolulu: Honolulu Academy of Arts (European and American prints, Michener Collection of Japanese prints).

ILLINOIS

Carbondale: University Museum (European and American drawings and prints with emphasis on the 19th–20th C.).

Champaign: Krannert Museum (European and American 20th C. prints and drawings).

Chicago: Chicago Art Institute (extensive collection of European Old Master prints and drawings, American prints and drawings to present).

INDIANA

Bloomington: Indiana University Art Museum (European and American prints and drawings, Japanese prints).

Elkhart: Midwest Museum of American Art (American and Canadian prints and drawings). 429 S. Main St., 46515; mailing address: Box 1812, 219-293-6660; Tues.–Wed., Fri. 11–5; Thurs. 11–5 and 7–9; Sat.–Sun. 1–4; fee.

Fort Wayne: Fort Wayne Museum of Art (European and American prints, Japanese prints).

Indianapolis: Indianapolis Museum of Art (European and American prints and drawings, Turner drawings and watercolors, Japanese prints).

Muncie: Ball State University Art Gallery (19th–20th C. prints and drawings).

Notre Dame: The Snite Museum of Art, University of Notre Dame (European and American prints and drawings).

South Bend: The Art Center (European and American prints and drawings). 120 S. St. Joseph St., 46601; 219-284-9102; Warner Gallery: Tues.–Sun. 12–5; Upper Level Gallery: Tues.–Fri. 12:30–4; Sat.–Sun. 12–5; no charge.

Terre Haute: Sheldon Swope Art Gallery (19th–20th C. American drawings and prints).

IOWA

Cedar Rapids: Cedar Rapids Art Center (19th–20th C. American prints, Regionalist prints, works of Grant Wood).

Davenport: Davenport Art Gallery (John Steuart Curry lithographs).

Fort Dodge: Blanden Memorial Art Gallery (19th–20th C. European and American prints and drawings).

Mount Vernon: Armstrong Gallery (drawings and prints by Thomas Nast).

KANSAS

Lawrence: Spencer Museum of Art (European and American prints and drawings).

Topeka: Gallery of Fine Arts, Topeka Public Library (20th C. American prints; prints by Kansas artists; WPA prints of 1920s and 1930s). 1515 W. 10th, 66604; 913-233-2040, ext. 26; Mon.–Fri. 9–9; Sat. 9–6; Labor Day-Memorial Day: Mon.–Fri. 9–9; Sat. 9–6; Sun. 2–6; no charge.

Wichita: Edwin A. Ulrich Museum of Art, Wichita State University (European and American prints and drawings). □ Wichita Art Museum (Naftzger Collection of American and European prints and drawings; Naftzger Collection of Charles M. Russell drawings).

KENTUCKY

Lexington: University of Kentucky Art Museum (14th–20th C. prints and drawings).

Louisville: Allen R. Hite Institute (15th–20th C. prints and drawings). □ J. B. Speed Art Museum (European and American prints).

LOUISIANA

New Orleans: The Historic New Orleans Collection (archive of prints, drawings, watercolors, maps, 18th–19th C.). □ Tulane University Art Collection (19th–20th C. European and American prints; architectural drawings; Japanese prints). □ Tulane University Library, 7001 Feret St., 70118; 504-865-6695; Mon.–Fri. 8:30–5; Sat. 10–12; closed Sun., holidays, Mardi Gras; no charge.

MAINE

Brunswick: Bowdoin College Museum of Art (Old Master and American prints and drawings; Winslow Homer prints and drawings; Brueghel the Elder drawing, *View of Waltersburg*).

Lewiston: Treat Gallery, Bates College (Marsden Hartley drawings and prints).

Portland: Joan Whitney Payson Gallery of Art (European and American drawings). □ Portland Museum of Art (19th C. American prints and drawings, Japanese prints).

Waterville: Colby College Museum of Art (John Marin and Winslow Homer watercolors; d'Amico print collection).

MARYLAND

Baltimore: Baltimore Museum of Art (Old Master prints and drawings; 19th C. French, esp. Matisse; American 19th–20th C. prints and drawings). ☐ Peale Museum (Baltimore historic prints). ☐ Walters Art Gallery (A. J. Miller series of watercolor sketches of the Old West; American and European prints and drawings).

MASSACHUSETTS

Amherst: Mead Art Museum (Old Master prints and drawings). ☐ Amherst College, 01002; 413-542-2335; Sept.–June: Mon.–Fri. 10–4:30; Sat., Sun. 1–5; Summer: daily 1–4; no charge. ☐ University Gallery, University of Massachusetts at Amherst (20th C. prints and drawings).

Andover: Addison Gallery of American Art (American prints and drawings).

Boston: Boston Public Library (Wiggins print collection, American and European prints and drawings). ☐ Massachusetts Historical Society (Thomas Jefferson architectural drawings, Paul Revere prints, and New England historic prints). 1154 Boylston St., 02215; 617-536-1608; Mon.–Fri. 9–4:45; closed third Mon. in Feb. and April, last Mon. in May, holidays; no charge. ☐ Museum of Fine Arts (extremely fine, large collection of European and American prints and drawings from the Middle Ages to the present).

Brookline: Frederick Law Olmsted National Historic Site (Frederick Law Olmsted archive, plans, drawings, lithographs of landscape design). 99 Warren St., 02146; 617-566-1689; phone for hours.

Cambridge: Busch-Reisinger Museum (Lyonel Feininger archive, prints, drawings; German schools prints). ☐ Fogg Art Museum (Old Master drawings and prints; Rembrandt, Rubens, Dürer; Pollaiulo: *Battle of Naked Men*, landmark Renaissance engraving; Degas lithographs; Manet monotypes).

Gloucester: Cape Ann Historical Association (Fitz Hugh Lane drawings).

Lincoln: De Cordova and Dana Museum and Park (contemporary American drawings and prints).

Lowell: Lowell Art Association (Whistler etchings). 243 Worthen St., 01852; 617-452-7641; Tues.–Sun. 1–4; fee.

Milton: Museum of the American China Trade (prints, watercolors pertaining to the China Trade).

Northampton: Smith College Museum of Art (Old Master prints and drawings; American prints and drawings).

Provincetown: Provincetown Art Association and Museum (Bicknell engravings; prints and drawings of local artists of Provincetown school).

Salem: Peabody Museum of Salem (prints and drawings, esp. maritime, 18th–19th C.).

South Hadley: Mount Holyoke College Art Museum (Old Master and later prints and drawings).

Springfield: Museum of Fine Arts (prints and drawings, European and American).

Wellesley: The Wellesley College Museum (Old Master and later prints and drawings).

Williamstown: Sterling and Francine Clark Art Institute (Old Master prints and drawings). ☐ The Chapin Library of Rare Books, Williams College (rare books, 15th–20th C. prints).

Worcester: Worcester Art Museum (Dial collection of Post-Impressionist prints and drawings, Bancroft collection of Japanese prints, Old Master and later prints and drawings).

MICHIGAN

Ann Arbor: The University of Michigan Museum of Art (Old Master and later prints and drawings).

Bloomfield Hills: Cranbrook Academy of Art Museum (19th C. prints).

Detroit: The Detroit Institute of Arts (Old Master and later prints and drawings).

East Lansing: Kresge Art Center Gallery (16th C. prints and drawings).

Flint: Flint Institute of Arts (19th C. European and American prints and drawings).

Grand Rapids: Calvin College Center Art Gallery (20th C. prints and drawings). Grand Rapids Art Museum (drawings, master prints, and drawings).

Kalamazoo: Kalamazoo Institute of Arts (20th C. American prints and drawings).

Olivet: Armstrong Museum of Art and Archaeology (20th C. prints).

MINNESOTA

Minneapolis: The Minneapolis Institute of Arts (Old Master and later prints and drawings). ☐ Walker Art Center (20th C. prints and drawings).

Moorhead: Plains Art Museum (19th–20th C. prints and drawings).

St. Paul: Minnesota Museum of Art (20th C. drawings and prints, esp. American contemporary).

MISSOURI

Kansas City: William Rockhill Nelson Gallery and Atkins Museum of Fine Arts (Old Master and later prints and drawings).

St. Joseph: Albrecht Art Museum (Drawing America collection, Engraving America and other print collections). 2818 Frederick Blvd., 64506; 816-233-7003; Tues.–Fri. 10–4; Sat.–Sun. 1–4; closed major holidays; fee.

St. Louis: The St. Louis Art Museum (Old Master and later prints and drawings, American prints and drawings). Washington University Gallery of Art, Steinberg Hall (16th–20th C. prints).

NEBRASKA

Omaha: Joslyn Art Museum (drawings and watercolors of the Old West; Miller, Bodmer, etc.; prints and drawings).

NEW HAMPSHIRE

Hanover: Hood Museum, Dartmouth College (European and American drawings, prints, posters).

Manchester: The Currier Gallery of Art (Old Master and later prints).

NEW JERSEY

Montclair: Montclair Art Museum (19th–20th C. American prints and drawings).

New Brunswick: Rutgers University Art Gallery (19th C. French drawings and prints; 19th–20th C. American prints and drawings).

Princeton: The Art Museum, Princeton University (Old Master and later prints and drawings, American prints and drawings).

NEW MEXICO

Albuquerque: Art Museum, The University of New Mexico (19th–20th C. European prints and drawings).

Las Cruces: University Art Gallery, New Mexico State University (Mexican 19th–20th C. prints). Box 3572, 88003; 505-646-2545; Mon.–Fri. 11–4; Sun. 2–4; closed university holidays; no charge.

Roswell: Roswell Museum and Art Center (European and American prints, Peter Hurd lithographs and drawings, Henriette Wyeth drawings).

Santa Fe: Institute of American Indian Arts Museum (American Indian graphics). 1300 Cerrillos Rd., 87501; 505-988-6281; Mon.–Sat. 9–5; Sun. 1–5; closed holidays; no charge.

NEW YORK

Albany: Albany Institute of History and Art (American 19th C. prints and drawings, esp. pertaining to Hudson River Valley school).

Binghamton: The University Art Gallery of the State University of New York at Binghamton (graphics of CoBra group).

Buffalo: Albright-Knox Gallery (Old Master to 20th C. prints and drawings). □ Burchfield Center—Western New York Forum for American Art (prints and drawings by Charles Burchfield, western New York artists).

Canton: Richard F. Brush Art Gallery of St. Lawrence University (Old Master prints, Frederic Remington prints, 20th C. prints).

Cooperstown: New York State Historical Association, Fenimore House (American 19th C. prints and drawings; folk art drawings, watercolors).

Glens Falls: Hyde Collection (Old Master prints and drawings).

Hempstead: Emily Lowe Gallery (18th–20th C. prints and drawings).

Ithaca: Herbert F. Johnson Museum of Art (Old Master and later prints and drawings).

New Paltz: College Art Gallery, State University College (Japanese prints; Chinese prints; 19th–20th C. American prints).

New York City: American Museum of Natural History (Titian Ramsay Peale sketchbooks and watercolors of South Pacific and Antarctic expedition, 1838–42, and other natural history drawings). □ The Brooklyn Museum (Old Master prints and drawings, American 19th–20th C. prints and drawings). □ Cooper-Hewitt Museum, The Smithsonian Institution's National Museum of Design (American 19th C. drawings, watercolors, designs, architectural drawings; Winslow Homer watercolors, Frederic E. Church watercolors, Hudson River School artists' drawings; American prints; European prints and designs). □ El Museo del Barrio (Puerto Rican and other graphics). □ The Frick Collection (Old Master prints and drawings). □ Hispanic Society of America Museum (Goya and other Spanish artists' prints). □ The Metropolitan Museum of Art (one of the world's greatest collections of prints and drawings, representing virtually every school and period and major artist from the Renaissance to the present; esp. notable are drawings by Rembrandt, Goya, Tiepolo, Guardi, Leonardo, Michelangelo, Titian, Dürer, Rubens, on up to modern masters). □ The Museum of Modern Art (extraordinary col-

lection of European and American prints and drawings from the later 19th C. to contemporary; Rouault lithographs, Picasso drawings and prints, Matisse drawings and prints; Maillol, Degas, Manet, Monet, Cassatt, etc. prints). ☐ The New York Public Library (Old Master and later prints). ☐ The Pierpont Morgan Library (Old Master and later prints and drawings; medieval and Renaissance mss.; Gutenberg and Caxton publications; 9th C. Lindau Gospels, *The Book of Hours* of Catherine of Cleves, beautifully illuminated; outstanding Old Master drawings). ☐ The Schomburg Center for Research in Black Culture (prints, drawings, archives). ☐ The Solomon R. Guggenheim Museum (later 19th and 20th C. prints and drawings, esp. Kandinsky and Klee). ☐ Whitney Museum of American Art (American prints and drawings; Edward Hopper prints, drawings, archive).

Ogdensburg: Remington Art Museum (prints and drawings by Frederic Remington).

Poughkeepsie: Vassar College Art Gallery (Old Master and later prints and drawings, esp. Rembrandt and Dürer).

Purchase: Neuberger Museum (20th C. drawings and prints).

Rochester: Memorial Art Gallery of the University of Rochester (Old Master and later prints and drawings).

Southampton: The Parrish Art Museum (William Merritt Chase drawings, prints, archive; Japanese prints).

Stony Brook: The Museums at Stony Brook (William Sidney Mount drawings, prints, archive).

Syracuse: Everson Museum of Art of Syracuse and Onondaga County (18th–20th C. American drawings and prints). ☐ The Joe and Emily Lowe Art Gallery (19th–20th C. American graphics).

Utica: Munson-Williams-Proctor Institute (European, Japanese, and American prints; Burchfield, Demuth, Davies, watercolors).

NORTH CAROLINA

Chapel Hill: The Ackland Art Museum (15th–20th C. prints, medieval to modern drawings).

Charlotte: The Mint Museum of Art (Renaissance to modern prints).

OHIO

Akron: Akron Art Museum (European and American prints, 1850 to present).

Cincinnati: Cincinnati Art Museum (Old Master prints and drawings; American and European graphics, mss.).

Cleveland: Cleveland Museum of Art (outstanding collection of prints and drawings; Old Masters to contemporary, European and American; rare books and mss.). □ The Salvador Dali Museum (Dali drawings, prints).

Columbus: Columbus Museum of Art (16th–20th C. European prints and drawings; American graphics; George Bellows lithographs). □ Ohio Historical Center (historical drawings and prints pertaining to Ohio and the Midwest). Interstate 71 and 17th Ave., 43211; 614-466-1500; Mon.–Sat. 9–5; Sun. 10–5; no charge.

Dayton: Fine Arts Gallery at Wright State University (contemporary drawings and prints, European and American). Col. Glenn Hwy., 45431; 513-873-2896; Mon.–Tues., Fri. 9:30–5; Wed.–Thurs. 9:30–9; Sat. 10–5; closed Sun., holidays; no charge.

Oberlin: Allen Memorial Art Museum (European and American prints and drawings).

Oxford: Miami University Art Museum (Old Master and modern prints).

Toledo: The Toledo Museum of Art (Old Master and later prints and drawings; rare books, mss.).

Wooster: College of Wooster Art Museum (John Taylor Arms Collection of European and American prints).

Youngstown: The Butler Institute of American Art (American drawings and prints from Colonial times to present, American drawings, maritime prints).

OKLAHOMA

Oklahoma City: Oklahoma Art Center (Frank Collection of German Expressionist graphics, prints and drawings by Oklahoma artists). □ Oklahoma Museum of Art (Old Master to modern graphics).

OREGON

Eugene: Museum of Art (American print collection, drawings and watercolors of Morris Graves, contemporary European prints).

Portland: Portland Art Museum (Gilkey Collection of prints and drawings).

PENNSYLVANIA

Allentown: Allentown Art Museum (19th–20th C. American prints and drawings).

Bethlehem: Lehigh University Art Galleries (American and European 19th–20th C. prints).

Chadds Ford: Brandywine River Museum (drawings and watercolors by American illustrators; Howard Pyle and N. C. Wyeth; drawings by Andrew and James Wyeth).

Greensburg: The Westmoreland County Museum of Art (American drawings and prints; *Fraktur*).

Philadelphia: Afro-American Historical and Cultural Museum (prints and drawings by black artists). 7th and Arch Sts., 19106; 215-574-3671; Tues.–Sat. 10–5; Sun. 12–6; fee. □ Free Library of Philadelphia (Borneman Collection of German-American *Fraktur*; Elkins Collection of Dickens drawings and illustrations; collection of Arthur Rackham, Kate Greenaway, Beatrix Potter, and other illustrators; original children's book illustrations). Logan Square, 19103; 215-686-5322; Mon.–Wed. 9–9; Thurs.–Fri. 9–6; Sat. 9–5; Sun. 1–5; no charge. □ The Philadelphia Maritime Museum (marine prints and drawings). □ Philadelphia Museum of Art (outstanding collection of prints and drawings, from Old Masters to modern; Pennsylvania German *Fraktur*; 18th–20th C. European and American prints and drawings).

Pittsburgh: Museum of Art, Carnegie Institute (Japanese prints; European and American drawings, watercolors, prints).

RHODE ISLAND
Providence: Museum of Art, Rhode Island School of Design (Rockefeller Collection of Japanese prints; Old Master prints and drawings; English watercolors and drawings, 18th–19th C.—Sandby, Girtin, Cozzens, Rowlandson, Turner, Ruskin, Constable).

SOUTH CAROLINA
Charleston: Gibbes Art Gallery (American and Japanese prints).

TENNESSEE
Memphis: The Dixon Gallery and Gardens (19th–early 20th C. prints, esp. French and American Impressionists).

TEXAS
Austin: Archer M. Huntington Art Gallery (15th–20th C. prints and drawings).

Dallas: Dallas Museum of Fine Arts (American and European prints and drawings).

Fort Worth: Amon Carter Museum of Western Art (Remington and Russell drawings and prints). □ Kimbell Art Museum (Old Master and later prints and drawings).

327

Houston: The Museum of Fine Arts, Houston (European and American prints and drawings). □ Sarah Campbell Blaffer Gallery (contemporary Mexican graphics; European and American 20th C. prints).

Orange: Stark Museum of Art (Paul Kane drawings and watercolors of the Old West). 712 Green Ave., 77630; mailing address: Box 1897; 713-883-6661; Wed.–Sat. 10–5; Sun. 1–5; closed Mon.–Tues., holidays; no charge.

San Antonio: Marion Koogler McNay Art Institute (19th–20th C. American and European prints).

VERMONT

Burlington: Robert Hull Fleming Museum (Old Master and later prints).

Shelburne: Shelburne Museum (drawings and prints; American primitive drawings and watercolors).

VIRGINIA

Newport News: The Mariners Museum (large collection of marine drawings and prints).

Richmond: Virginia Museum of Fine Arts (Old Master to modern prints and drawings).

WASHINGTON

Seattle: Henry Art Gallery (European and American drawings and prints). □ Seattle Art Museum (drawings and prints, with special emphasis on artists of the Northwest).

Tacoma: Tacoma Art Museum (Japanese prints; American prints).

WEST VIRGINIA

Huntington: The Huntington Galleries (American and European prints and drawings).

WISCONSIN

Beloit: Theodore Lyman Wright Art Center (German Expressionist prints and drawings; American and European prints).

Madison: Elvehjem Museum of Art (American and European prints). □ Madison Art Center (Mexican, European, and American prints).

Milwaukee: Milwaukee Art Museum (19th–20th C. European and American prints).

CANADA

ALBERTA
Edmonton: The Edmonton Art Gallery (Canadian prints).

BRITISH COLUMBIA
Vancouver: The Vancouver Art Gallery (Canadian and American prints; prints and drawings by British Columbian artists).

ONTARIO
Hamilton: Art Gallery of Hamilton (Canadian, British, French, and American prints).

Ottawa: National Gallery of Canada (Old Master and later drawings and prints, Canadian and American).

Owen Sound: Tom Thompson Memorial Gallery and Museum of Fine Art (drawings and prints by Thompson; Canadian prints).

Toronto: Art Gallery of Ontario (Old Master drawings and prints; European, Canadian, and American drawings and prints). □ Royal Ontario Museum (Japanese prints; Canadian prints).

QUEBEC
Montreal: The Montreal Museum of Fine Arts (European and Canadian prints).

SASKATCHEWAN
Regina: Dunlop Art Gallery (Canadian prints and drawings). Regina Public Library, 2311-12th Ave., S4P 0N3; 306-569-7576; Mon.–Fri. 9:30–9; Sat. 9:30–6; Sun. 1:30–5; no charge. □ Norman MacKenzie Art Gallery (European and Canadian prints and drawings).

(top) Duck decoy. Sleeper by Mitchell La France. COURTESY OF THE ABBY ALDRICH ROCKEFELLER FOLK ART CENTER, WILLIAMSBURG, VIRGINIA

(bottom) Fruit with Fruit Knife *by Shailer.* COURTESY OF THE NATIONAL GALLERY OF ART, WASHINGTON, D.C.

10) Special Collections

CHINA TRADE
CIRCUS
CLOCKS
COINS AND MEDALS
ETHNIC ART
FOLK ART
THE HORSE
MARITIME ART
THE OLD WEST
PHOTOGRAPHY
THEATER

10. Special Collections

This is the most varied section in the guide. It was necessary to gather together somewhere all those disparate categories of objects which range beyond periods, defy chronology or school, or otherwise demand special attention.

Women's art has been suggested as a category, but works by women are everywhere, and there are no segregated collections of importance. There is, however, useful research being done in this field, as shown by several recent publications and by the work of WARM, the Women's Art Registry of Minnesota (4114 1st Ave. N, Minneapolis, 55403; 612-332-5672), which has an archive of women artists throughout the country as well as in Minnesota. The Inventory of American paintings, the National Museum of American Art, and the Archive of American Art are major resources. For outstanding individual women artists, consult the artists' listing in Part III.

This section includes listings of China Trade, circus, coin, clock, ethnic, American folk art, horse, maritime, Old West, photography, and theater collections.

Check under Section 8, "Decorative Arts of Europe and America," for related categories, such as ceramics, glass, furniture and furnishings, etc. "Antiques" has not been employed as a category because it is a term applied so loosely these days, even to the point of being used to describe objects produced during the author's lifetime, in defiance of the United States Customs' decree of some years ago demanding a date of origin of 1830 or earlier, or the more recently accepted definition of being a hundred or more years old.

China Trade

There are examples of Chinese export porcelain and sometimes of other Far Eastern export material in most of the larger museums, such as Boston's Museum of Fine Arts, The Metropolitan Museum of Art, and the Museum of the City of New York, and Chicago's Art Institute, and in most of the historical societies in the seaport towns of the East Coast, especially in the Northeast. Several maritime museums also have export objects. The following institutions have particularly interesting and varied examples:

CONNECTICUT
Mystic: Mystic Seaport Museum.

DELAWARE
Winterthur: Henry Francis Du Pont Winterthur Museum.

MASSACHUSETTS
Ipswich: Ipswich Historical Society. 53 S. Main St., 01938; 617-356-2811; April 15–Nov. 1: Tues.–Sat. 10–5; Sun. 1–5; closed Mon.; also closed Nov. 2–April 14; fee.

Milton: Museum of the American China Trade.

Newburyport: The Custom House Maritime Museum of Newburyport.

Salem: Peabody Museum of Salem.

PENNSYLVANIA
Philadelphia: Robert W. Ryerss Library and Museum. Burholme Park, Cottman and Central Aves., 19111; 215-745-3061; Wed.–Sun. 10–5; closed Mon., Tues., holidays; no charge. □ The Stephen Girard Collection. Girard College, Corinthian and Girard Aves., 19121; 215-787-2600; Thurs. 2–4 and by appointment; no charge.

RHODE ISLAND
Providence: Rhode Island Historical Society. 52 Power St., 02906; 401-331-8575; Tues.–Sat. 11–4; Sun. 1–4; closed major holidays; fee.

Circus Museums

The world has had circuses for centuries, although there have been significant changes since Nero's time, and such entrepreneurs as the great P. T. Barnum and the Ringling Brothers have added a typical American extravagance. The circus has been a subject for artists—Seurat, Rouault, Léger, Picasso, and Calder, among others—and comprises a variety of traditional arts and mysteries, including mime, juggling, buffoonery, acrobatics, animal training, pageantry, and costume design. Its processions hark back to the *trionfi* of the Renaissance and earlier and still retain a Baroque opulence in the splendor of fanciful costumes, exotic animals, and multidecibel sound effects which reach some kind of exalted apogee with that incomparable noise producer, the steam calliope. The vehicles of the circus procession, encrusted with carvings and glowing with gilding, are the result of the skills of sculptors, carriage makers, and carriage painters; they rival in magnificence the famous triumph of the Emperor Maximilian designed by the great Northern Renaissance artist, Albrecht Dürer. There may be some to whom all this does not appeal, but the rest of us will find much of interest and delight in the following museums devoted to the various traditions which make up the magical world of the circus.

CONNECTICUT
Bridgeport: P. T. Barnum Museum. Museum of Art, Science and Industry.

FLORIDA
Sarasota: John and Mable Ringling Museum of Art.

KANSAS
Sedan: Emmett Kelly Historical Museum.

NEW YORK
Somers: Somers Historical Society (memorabilia of pioneer circus, Elephant Hotel). Mailing address: Box 336, 10589; 914-277-4977; Fri. 2–4 or by appointment.

an Antonio: Hertzberg Circus Collection. 210 W. Market St. 78205; 512-299-7810; Mon.–Sat. 9–5:30; Sun. and holidays 1–5; closed Sun. in Nov.–April, holidays; no charge.

WISCONSIN

araboo: Circus World Museum.

Clocks

Almost every museum with any kind of decorative arts collection has imepieces of some sort, and there is hardly a historic house without everal examples. The following institutions have highly specialized collections or numbers of outstanding examples.

CALIFORNIA

San Francisco: California Academy of Sciences. Golden Gate Park, 94118; 415-221-5100, summer: daily 10–9; other seasons: daily, 10–5; closed major holidays; fee.

CONNECTICUT

Bristol: American Clock and Watch Museum.

DELAWARE

Winterthur: Henry Francis Du Pont Winterthur Museum.

DISTRICT OF COLUMBIA

Washington: National Museum of American History.

ILLINOIS

Rockford: The Time Museum (1,500 timepieces from 1240 B.C. to date).

IOWA

Spillville: Bily Clock Exhibit.

MASSACHUSETTS

Grafton: Willard House and Clock Museum.

Sturbridge: Old Sturbridge Village.

MICHIGAN

Dearborn: Greenfield Village and Henry Ford Museum.

NEW YORK

New York City: The Frick Collection. □ The Metropolitan Museum of Art.

OHIO

Cincinnati: Cincinnati Art Museum.

PENNSYLVANIA

Columbia: Museum of the National Association of Watch and Clock Collectors (timekeeping from the sundial to the atomic clock; Beeler escapement collection).

Coins and Medals

This category also includes the small metal reliefs, usually bronze and often gilded, called plaquettes; pilgrimage badges, often of pewter or lead; tokens; and other related objects. If anyone unfamiliar with numismatics questions that such small objects can be of artistic interest, I urge him or her to look at an example of the Syracusan Demareteion of 480 B.C., with the head of the fountain nymph Arethusa surrounded by sporting dolphins (there is a lovely example in Boston) or at medals by the Italian Renaissance master Pisanello (the National Gallery and the Metropolitan Museum of Art have several), and all doubts will vanish. Since a great many museums, particularly older university museums and those strong in ancient art, have some coins and medals, only those with especially large collections are listed here.

CALIFORNIA

Santa Barbara: University Art Museum, Santa Barbara.

COLORADO

Colorado Springs: Museum of the American Numismatic Association.

DISTRICT OF COLUMBIA

Washington: National Museum of American History.

MAINE

Brunswick: Bowdoin College Museum of Art.

MASSACHUSETTS

Boston: Museum of Fine Arts.

Cambridge: Fogg Art Museum (ancient coins, Egyptian antiquities).

NEW HAMPSHIRE

Hanover: Hood Museum.

NEW JERSEY

Newark: The Newark Museum.

Princeton: The Art Museum, Princeton University.

NEW YORK

New York City: The American Numismatic Society. Broadway and 155th St., 10032; 212-234-3130; Tues.–Sat. 9–4:30; Sun. 1–4; closed Mon., holidays; no charge. ☐ The Metropolitan Museum of Art.

NORTH CAROLINA

Charlotte: The Mint Museum of Art.

CANADA
QUEBEC

Montreal: Château Ramezay Museum.

Ethnic Collections

The variety of traditions brought to the New World over the centuries has incalculably enriched the culture of North America. Demanding social pressures have led many national, racial, and religious groups to neglect their native languages and modify their customs in an effort to conform to new ideas and new standards and to participate more fully in a new society. But fortunately there was also a strong tendency to per-

sist in carrying on traditional beliefs, folkways, and arts. In the television-saturated, increasingly homogenized world of today, we can be especially grateful for such an admirable display of character and can see that a vital human continuity of pride and respect underlies all the dramatic differences of style and expression. In a real sense, then, ethnic art represents the roots of the diverse society of today, something we can all appreciate whatever our own backgrounds may be.

The following list comprises only those ethnic groups which came from abroad; for the arts of Native Americans, please refer to Section 8.

ACADIAN

LOUISIANA
St. Martinsville: Acadian House Museum.

MAINE
Van Buren: Acadian Village. U.S. Rt. 1, 04785; daily June–Labor Day; closed remainder of year; fee.

CANADA

NEW BRUNSWICK
Caraquet: Village Acadien—Outdoor Museum. E0B 1K0; 506-727-3269; Jan.–June, Sept.: Mon.–Sat. 10–5; Sun. 1–5; July–Aug.: Mon.–Sat. 1–8; Sun. 1–5; fee.

Moncton: Acadian Museum.

NOVA SCOTIA
Cheticamp: Acadian Museum.

PRINCE EDWARD ISLAND
Miscouche: Acadian Museum of Prince Edward Island.

BLACK ART
Afro-American Collections

CALIFORNIA
San Francisco: San Francisco African American Historical and Cultural Society.

DISTRICT OF COLUMBIA
Washington: Anacostia Neighborhood Museum. ☐ Museum of African Art.

MASSACHUSETTS
Boston: Museum of Afro-American History.

NEBRASKA
Omaha: Great Plains Black Museum. 2213 Lake St., 68110; 402-344-0350; Mon.–Fri. 8–5; other times by appointment; closed holidays; small fee.

NEW YORK
New York City: The African-American Institute. 833 United Nations Plaza, 10017; 212-949-5666; Mon.–Fri. 9–5; Sat. 11–5; closed holidays; no charge (donations accepted).

PENNSYLVANIA
Philadelphia: Afro-American Historical and Cultural Museum.

SOUTH CAROLINA
Charleston: The Old Slave Mart Museum.

CHINESE

CALIFORNIA
Fiddletown: Chinese Museum, Chew Kee Store. Box 12, 95629; 209-296-4519; by appointment; no charge (donations accepted).

Oroville: Oroville Chinese Temple. 1500 Broderick St., 95965; 916-533-1496; Memorial Day–Labor Day: daily 10–11:30 and 1–4:30; Labor Day–Memorial Day: Mon.–Tues., Fri.–Sun. 10–11:30 and 1–4:30; closed Dec. 1–Jan. 15; fee.

San Francisco: Chinese Culture Center Gallery.

CZECH

TEXAS
Temple: Slavonic Benevolent Order of the State of Texas. 520 N. Main, 76501; mailing address: Box 100, 76501; 817-773-1575; Mon.–Fri. 8–12; other times by appointment; closed holidays; no charge.

DUTCH

MICHIGAN

Holland: Netherlands Museum. 8 E. 12th St., 49423; 616-392-9084; Oct.–April: Mon.–Sat. 9–5; May–Sept. 15: Mon.–Sat. 9–5; Sun. 11:30–5; closed major holidays; small fee (Nov. 15–April 1, no charge).

NEW YORK

Albany: Albany Institute of History and Art.

Cooperstown: New York State Historical Association.

New York City: Museum of the City of New York.

Tarrytown: Sleepy Hollow Restorations. 150 White Plains Rd., 10591; 914-631-8200; daily 10–5; closed holidays; fee.

GERMAN SEPARATISTS

DELAWARE

Winterthur: Henry Francis Du Pont Winterthur Museum.

ILLINOIS

Chicago: The Art Institute of Chicago.

INDIANA

New Harmony: Historic New Harmony. Church and West Sts.; mailing address: Box 248, 47631; 812-682-4488; daily 9–5; closed New Year's, Christmas; fee.

KANSAS

Goessel: Mennonite Immigrant Historical Foundation. 202 Poplar, 67053; 316-367-8200; Tues.–Sun. 1–5; closed Easter, Memorial Day, Christmas; fee.

North Newton: Mennonite Library and Archives. 67117; 316-283-2500; Mon.–Fri. 8–5; closed holidays; no charge.

MICHIGAN

Dearborn: Greenfield Village and Henry Ford Museum.

MISSOURI

Hermann: Deutschheim State Historic Site.

NEBRASKA

Lincoln: Museum of American Historical Society of Germans from Russia. 631 D St., 68502; 402-477-4524; Mon.–Fri. 9:30–4:30; other times by appointment; no charge.

NEW YORK

New York City: The Brooklyn Museum. The Metropolitan Museum of Art.

NORTH CAROLINA

Winston-Salem: Historic Bethabara. 2147 Bethabara Rd., 27106; 919-924-8191; Easter–Nov. 30: Mon.–Fri. 9:30–4:30; Sat.–Sun. 1:30–4:30; closed Dec. 1–Easter; no charge. Old Salem.

OHIO

New Philadelphia: Schoenbrunn Village State Memorial. US Rt. 250, 44663; 216-339-3636; May 23–Sept. 6: Wed.–Sat. 9:30–5; Sun. 12–5; closed holidays; fee.

Zoar: Zoar Village State Memorial. 44697; 216-874-3011; May 23–Labor Day: Wed.–Sat. 9:30–5; Sun. 12–5; Labor Day–Oct.: Sat. 9:30–5; Sun. 12–5; fee.

PENNSYLVANIA

Ambridge: Old Economy Village. 14th and Church Sts., 17120; 412-266-4500; EST: Tues.–Sat. 10–4:30; Sun. 12–4:30; EDT: Mon.–Sat. 9–5; Sun. 12–5; fee.

Bethlehem: Moravian Museum of Bethlehem.

Doylestown: Mercer Museum of Bucks County Historical Society. Pine and Ashland Sts., 18901; 215-345-0210; phone for hours and fees.

Ephrata: Ephrata Cloister. 632 W. Main St., 17522; 717-733-6600; EST: Tues.–Sat. 10–4:30; Sun. 12–4:30; EDT: Tues.–Sat. 9–5; Sun. 12–5; closed holidays; fee.

Harrisburg: Pennsylvania Historical and Museum Commission. 3rd and North Sts.; mailing address: Box 1026, 17120; 717-787-2891; phone for hours.

Hershey: Hershey Museum of American Life. One Chocolate Ave., 17033; 717-534-3439; Memorial Day–Labor Day: daily 10–6; Labor Day–Memorial Day: Tues.–Sun. 10–5; closed major holidays; fee.

Lancaster: Pennsylvania Farm Museum of Landis Valley. 2451 Kissel Hill Rd., 17601; 717-299-7556; May–Oct.: Tues.–Sat. 9–4:30; Sun. 12–4:30; Nov.–April: Tues.–Sat. 10–4:30; Sun. 12–4:30; fee.

Lenhartsville: Pennsylvania Dutch Folk Culture Society. 19534; 215-562-4803; April–May, Sept.–Oct.: Sat. 10–5; Sun. 1–5; June–Aug.: Mon.–Sat. 10–5; Sun. 1–5; fee.

Merion: Barnes Foundation.

Pennsburg: Schwenkfelder Museum. Seminary St., 18073; 215-679-7175; by appointment; no charge.

Philadelphia: Free Library of Philadelphia.

Reading: Historical Society of Berks County. 940 Centre Ave., 19601; 215-375-4375; Museum: Tues.–Sat. 9–4 (closed Sun.); Library: Tues.–Wed., Fri.–Sat. 9–2 (closed Thurs., Sun.); closed major holidays; fee.

CANADA

MANITOBA

Steinbach: Mennonite Village Museum. Box 1136, R0A 2A0; 204-326-9661; May, Sept.: daily 10–5; June daily 10–7; July–Aug. daily 9–9; fee.

HISPANIC

CALIFORNIA

Fresno: Fresno Arts Center. 3033 E. Yale Ave., 93703; 209-485-4810; Mon.–Tues., Thurs.–Sun. 10–4:30; Wed. 7–9:30; closed major holidays; no charge.

Los Angeles: Southwest Museum (Spanish Colonial and Mexican artifacts).

San Francisco: The Mexican Museum. 1855 Folsom St., 94103; 415-621-1224; Tues.–Sun. 12–5; closed holidays; no charge.

DISTRICT OF COLUMBIA

Washington: Museum of Modern Art of Latin America.

NEW YORK

New York City: Hispanic Society of America Museum.

TEXAS
Dallas: Mexican American Cultural Heritage Center.
San Antonio: Spanish Governor's Palace.

HUGUENOT

NEW YORK
New Paltz: Huguenot Historical Society.

JEWISH

ARIZONA
Phoenix: Judaica Museum of Temple Beth Israel (ceremonial arts from 1600 to today; Israeli philatelic collection, oldest congregation in Phoenix area). 3310 Tenth Ave., 85013; 602-264-4428; call for hours; no charge.

CALIFORNIA
Berkeley: Judah L. Magnes Memorial Museum.

Los Angeles: Hebrew Union College Skirball Museum. 3077 University Mall, 90007; 213-749-3424; Tues.–Fri. 11–4; Sun. 10–5; no charge. ☐Simon Weisenthal Center for Holocaust Studies. 9760 W. Pico Blvd.; 213-553-9036; Mon.–Thurs. 10:30–4:30; Fri. 9:30–2:30; Sun. 11–4.

CONNECTICUT
New Haven: Yale University Art Gallery (objects from Dura Europos, Yale's Roman-Syrian dig).

DISTRICT OF COLUMBIA
Washington: B'Nai B'Rith Klutznick Museum. 1640 Rhode Island Ave., 20036; 202-857-6600; Sun.–Fri. 9–4; closed Sat., holidays; no charge.

ILLINOIS
Chicago: Maurice Spertus Museum of Judaica.

MARYLAND
Rockville: Judaic Museum.

MASSACHUSETTS
Cambridge: Semitic Museum.

Waltham: American Jewish Historical Society (portraits etc. of 18th C. Jewish families, Yiddish theater of early 20th C., motion pictures).

NEW YORK

New York City: The Jewish Museum. □ Yeshiva University Museum (Jewish ceremonial objects of silver and other metals; textiles and costumes, archives, etc.). □ Synagogue Architectural and Art Library (ceremonial objects and works of Jewish art).

Rochester: Temple B'Rith Kodesh Museum. 2131 Elmwood Ave., 14618; 716-224-7060; Mon.–Thurs., Sat. 9:30–5; Fri. 9:30 A.M.–10:30 P.M.; Sun. 9:30–12; no charge.

OHIO

Cincinnati: The Hebrew Union College Gallery of Art and Artifacts.

PENNSYLVANIA

Philadelphia: Museum of American Jewish History.

LITHUANIAN

ILLINOIS

Chicago: Balzekas Museum of Lithuanian Culture.

NORWEGIAN

IOWA

Decorah: Vesterheim, Norwegian-American Museum.

MINNESOTA

Northfield: Norwegian-American Historical Association. 55057; 507-663-3221; Mon.–Fri. 9–5; Sat.–Sun., holidays by appointment; no charge.

POLISH

ILLINOIS

Chicago: Polish Museum of America.

ROMANIAN

OHIO

Cleveland: St. Mary's Ethnic Museum.

RUSSIAN

ALASKA
Juneau: Alaska State Museum. Subport, Pouch FM, 99811; 907-586-1224; Winter: Mon.–Fri. 9–5; Sat.–Sun. 1–5; Summer: Mon.–Fri. 9–9; Sat.–Sun. 1–9; closed holidays; no charge.

Sitka: Sheldon Jackson Museum.

CALIFORNIA
San Diego: Timken Art Gallery (Russian icons).

San Francisco: Museum of Russian Culture.

NEW YORK
New York City: Nicholas Roerich Museum. 319 W. 107th St., 10025; 212-864-7752; Mon.–Fri., Sun. 2–5; closed Sat., holidays; no charge.

SHAKER

KENTUCKY
Harrodsburg: Shakertown at Pleasant Hill.

South Union: Shaker Museum at Shakertown.
MAINE
Poland Spring: The Shaker Museum.

MASSACHUSETTS
Duxbury: Art Complex.

Pittsfield: Hancock Shaker Village, Shaker Community.

NEW YORK
Old Chatham: The Shaker Museum.

OHIO
Shaker Heights: Shaker Historical Museum. 16740 S. Park Blvd., 44120; 216-921-1201; Tues.–Fri. 2–4; Sun. 2–5; closed Sat., Mon., holidays; no charge.

SWEDISH

ILLINOIS
Bishop Hill: Bishop Hill State Historic Site. Box D, 61419; 309-927-3345; daily 9–5; closed holidays; no charge.

Chicago: Swedish American Museum Association of Chicago. □ Swedish Pioneer Historical Society.

MAINE

New Sweden: New Sweden Historical Society. Rt. 161, 04762; 207-896-3018; Sept.–May: by appointment; June–Aug.: Mon.-Sat. 11-5; Sun. 2-5; no charge.

MINNESOTA

Minneapolis: American-Swedish Institute. 2600 Park Ave., 55407; 612-871-4907; Tues.–Sat. 1-4; Sun. 1-5; closed holidays; fee.

PENNSYLVANIA

Philadelphia: American Swedish Historical Foundation Museum.

SWISS

WEST VIRGINIA

Helvetia: Helvetia Museum. 26224; 304-924-5552; Sat.–Sun. 12-4 and by appointment; closed Oct.–May; no charge.

WISCONSIN

New Glarus: Chalet of the Golden Fleece. 618 2nd St., 53574; 608-527-2614; May–Oct.: daily 9-4:30; closed Nov.–April; fee. □ Swiss Historical Village. 6th Ave. and 7th St., 53574; 608-527-2317; May 1–Oct. 31: daily 9-5; closed Nov. 1–April 30; fee.

UKRAINIAN

NEW YORK

New York City: The Ukrainian Museum.

OHIO

Cleveland: Ukrainian Museum-Archives. 1202 Kenilworth Ave., 44113; 216-661-3038; Sat. 9-12; other times by appointment; no charge.

CANADA

ONTARIO

Toronto: Ukrainian Museum of Canada (U.W.A.C.). Eastern Branch, 620 Spadina Ave., M5S 2H4; 416-923-3318; open on request only; no charge.

Saskatoon: Museum of Ukrainian Culture. □ Ukrainian Museum of Canada.

American Folk Art

American folk art is the work of nonacademic professionals or of amateurs following traditional craft principles and their own lively instincts. It expresses the vision of an unschooled but not necessarily unsophisticated eye and seeks the essential aspects of a subject interpreted with decorative purpose, not merely a likeness of externals.

Folk art includes work of the itinerant and village artist, the ship carver, the decoy maker, the potter, the tombstone cutter, the scrimshander, and the needleworker; it also includes the fancy pieces of the glassblower and the blacksmith, chalkware, weathervanes, shop figures and signs, ship and horse portraits, and a miscellany of objects made by hand ranging in quality from the superb to the execrable. Although there are genuine folk artists living today, the genre reached its peak before the Civil War during the period when America suddenly changed from an agricultural and trading nation to an industrial power, and the machine replaced the artisan, to the advantage of convenience and to the detriment of the less material qualities of life.

Many folk artists followed ethnic traditions brought from the Old World, so please also check under the "Circus Museums," "Ethnic Collections," and "Maritime Museums" subheadings.

ALABAMA

Decatur: The Art Gallery, John C. Calhoun State Community College. Room 237, Fine Arts Bldg., 35601; mailing address: Box 2216; 205-353-3102; Mon.-Fri. 8-3; no charge.

CALIFORNIA

La Jolla: Mingei International Museum of World Folk Art. Box 553, 92038; 714-453-5300; Mon.-Thurs., Sat. 11-5:30; Sun. 2-5; closed major holidays; no charge.

Los Angeles: Craft and Folk Art Museum. 5814 Wilshire Blvd., 90036; 213-937-5544; Tues.–Thurs., Sat.–Sun. 11–5; Fri. 11–8; no charge.

DISTRICT OF COLUMBIA

Washington: National Gallery of Art.

MAINE

Waterville: Colby College Museum of Art.

MASSACHUSETTS

Boston: Museum of Fine Arts.

Sturbridge: Old Sturbridge Village.

NEW JERSEY

Newark: The Newark Museum.

NEW YORK

New York City: The Metropolitan Museum of Art. ☐Museum of American Folk Art.

VERMONT

Shelburne: Shelburne Museum.

VIRGINIA

Williamsburg: Abby Aldrich Rockefeller Folk Art Center.

CANADA

QUEBEC

Ville Saint-Laurent: Musee d'Art de Saint-Laurent. 615 Blvd. Sainte-Croix, H4L 3X6; 514-747-7367; Tues.–Fri., Sun. 11–5; no charge.

The Horse

The horse has been man's servant and companion in peace and war for centuries, and it early took on the further significance of embodying with a particular nobility the fiery animal force of nature, the most sublime expression of this in art being the famous golden horses of St. Mark in Venice. Man has long admired, and no doubt envied that marvelous force and the beauty that goes with it—there is hardly a more thrilling sight anywhere than horses running free, with manes and tails flying, whether

in the green fields of Ireland or Kentucky, the deserts of the American West or the misty water meadows of the Camargue—and fine steeds, from the blood-sweating horses of Han in ancient China to the Pony Express rider's tough mustang, have become as much the stuff of legend as Bellerophon's winged Pegasus and Apollo's celestial chargers, and their equally mythic relative, the mystic unicorn. Horses have traditionally lent their special dignity to the pageantry of the courts of kings and princes, as the picturesque choreography of the Lipizzaner stallions still attests, and to our own holiday parades. It is no wonder, then, that entire museums have been devoted to the horse, the major such institutions being listed here.

ARIZONA

Patagonia: Stradling Museum of the Horse (equine and Indian museum, horse accoutrements from all over the world). Box 413, 85624; 602-394-2264; daily, holidays 9–5; small fee.

Tucson: Arabian Horse Museum. 4633 E. Broadway, Suite 131, 85711; 602-326-1515; Mon.–Fri. 9–5; no charge.

IDAHO

Moscow: The Appaloosa Museum.

KENTUCKY

Lexington: International Museum of the Horse.

Louisville: American Saddle Horse Museum Association. ☐ Kentucky Derby Museum.

NEW YORK

Goshen: Hall of Fame of the Trotter.

Saratoga Springs: National Museum of Racing. Union Ave., 12866; 518-584-0400; Jan.–March: Mon.–Fri. 10–4; April–May, Oct.–Nov.: Mon.–Fri. 9:30–5; Sat. 12–5; June 15–Sept. 15: Mon.–Fri. 9:30–5; Sat.–Sun. 12–5; Aug. racing season: daily 9:30–7; closed major holidays; no charge.

Maritime Museums

The sea is a compelling aspect of our heritage, no matter how far from its shores we may happen to live. One has only to note what a vital part

nautical terminology plays in our everyday expression from "pulling up anchor" or "casting off" to "trying another tack" or "taking a reef." Many of us take regular note of when the sun is "over the yardarm," and at one time or another we are all inclined to "damn the torpedoes and go full speed ahead." We are fortunate in the richness of our nautical tradition, and there are museums which preserve and present almost every aspect of it, from the anonymous heroism of whaling or of fishing off the Grand Banks to the naval history of World War II, and a marvelous variety of vessels, from pinkies and heeltappers to clipper ships and battlewagons, has been carefully restored and preserved and is available for our study and enjoyment.

CALIFORNIA

Monterey: Allen Knight Maritime Museum. 550 Calle Principal; mailing address: Box 805, 93940; 408-375-2553; summer: Tues.–Fri. 10–12 and 1–4; Sat.–Sun. 2–4; Sept. 15–June 15: Tues.–Fri. 1–4; Sat.–Sun. 2–4; no charge.

San Diego: San Diego Maritime Museum (incl. *The Star of India*, a squarerigger, the oldest merchant vessel afloat).

San Francisco: National Maritime Museum (incl. the *Baclutha*, formerly known as *Star of Alaska*). ☐San Francisco Maritime State Historic Park, Fisherman's Wharf, foot of Hyde St.

CONNECTICUT

Groton: Submarine Force Library and Museum. Box 700, Naval Submarine Base, Groton, 06340; 203-449-3174; by appointment only; closed major holidays; phone for hours.

Mystic: Mystic Seaport Museum.

New London: The Tale of the Whale Museum. ☐U.S. Coast Guard Museum.

DISTRICT OF COLUMBIA

Washington: Truxtun-Decatur Naval Museum.

GEORGIA

Savannah: Ships of the Sea Maritime Museum.

HAWAII

Honolulu: *The Falls of Clyde* (the first four-masted square-rigger to carry the Hawaiian flag; owned by the Bernice Pauahi Bishop Museum, 808-847-3511; phone for hours). Pier 5, Ala Moana Blvd.

Pearl Harbor: Pacific Submarine Museum (USS *Arizona* Memorial, built over the sunken hull of the battleship sunk in the Japanese attack of Dec. 7, 1941). Naval Submarine Base, 96860; 808-471-0632; Wed.–Sun. 9:30–5; no charge.

MAINE

Bath: Maine Maritime Museum.

Searsport: Penobscot Marine Museum.

MARYLAND

Annapolis: United States Naval Academy Museum.

Baltimore: Baltimore Seaport and Maritime Museum (USS *Constellation*, a frigate of the original U. S. Navy).

St. Michaels: Chesapeake Bay Maritime Museum.

Solomons: Calvert Marine Museum.

MASSACHUSETTS

Boston: Boston National Historical Park (incl. USS *Constitution*, "Old Ironsides," of the original U. S. Navy). □ Boston Tea Party Ship and Museum.

Cambridge: Francis Russell Hart Nautical Museum.

Essex: Essex Shipbuilding Museum.

Fall River: Battleship *Massachusetts*. Marine Museum at Fall River.

Nantucket: Whaling Museum (branch of Nantucket Historical Association). Steamboat Wharf, 02554; June 15–Oct. 1: daily, 10–5; small fee.

New Bedford: New Bedford Whaling Museum.

Newburyport: The Custom House Maritime Museum of Newburyport.

Salem: Peabody Museum of Salem (the reconstructed interior of the cabin of Capt. George Crowninshield's famous yacht, *Cleopatra's Barge*, with furniture in McIntyre style).

Sharon: Kendall Whaling Museum.

MICHIGAN

Detroit: Dossin Great Lakes Museum.

Douglas: Steamship *Keewatin*. Tower Marine, Lake Kalamazoo; mailing address: Box 511, 49406; 616-857-2151; May 1–Oct. 1: daily 10–4:30; no charge.

MINNESOTA

Winona: Steamboat *Julius C. Wilkie* River Center. Levee Park, 55987;

507-452-4570; June 1–Sept. 30: Mon.–Fri. 9–5; Sat.–Sun., holidays 1–5; closed Oct.–June; May by appointment; fee.

NEW JERSEY

Atlantic City: Historic Gardner's Basin. N. New Hampshire Ave. and the Bay, 08401; 609-348-2880; daily 9:30–5:30; closed New Year's, Christmas; fee.

NEW YORK

Cold Spring Harbor: Whaling Museum Society (incl. showings of film *Portrait of the Whale*).

New York City: The South Street Seaport Museum (the square-rigged ship *Wavertree*; the colossal barque *Peking*; but esp. the restored area).

NORTH CAROLINA

Wilmington: USS *North Carolina* Battleship Memorial.

OHIO

Vermillion: Great Lakes Historical Society Museum. 480 Main St., 44089; 216-967-3467; Spring, Summer and Fall: daily 11–5; Winter, Sat.–Sun. 11–5.

PENNSYLVANIA

Philadelphia: Philadelphia Maritime Museum (USS *Olympia*, Admiral Dewey's flagship in the Spanish-American War).

RHODE ISLAND

Newport: Naval War College Museum (incl. the frigate *Rose*, a reconstruction of the founding ship of the U. S. Navy). Coasters Harbor Island, 02840; King's Dock, off America's Cup Ave.; Jan.–May: Mon.–Fri. 9–4; June–Aug.: Mon.–Fri. 9–4; Sat.–Sun. 12–4; closed Oct.–Dec.; no charge.

VIRGINIA

Newport News: The Mariners Museum.

Portsmouth: Portsmouth Naval Museum.

WASHINGTON

Bremerton: Naval Shipyard Museum.

Friday Harbor: The Whale Museum. 61 First St. N; mailing address: Box 1154, 98250; 206-378-4710; Mon., Wed.–Sun. 10–5; Tues. 10–6; closed major holidays; fee.

Kirkland: Northwest Seaport. Kirkland waterfront; June–Aug.: Tues.–Thurs. 12–5; Fri.–Sun. 12–9; Sept.–May: Tues.–Sat. 12–5; fee.

The Old West

The farther the frontier was pushed westward, the more remote it became from the longer-established cities and towns of the East and Midwest; and the more remote, the more romantic became the stuff of myth and folklore. With our predilection for violence, we made heroes of bandits and gunslingers, bank robbers and murderers. As we brutally harassed and displaced the Indian, we sometimes made him a hero too. Despite this mythologizing, some genuine heroes emerged and still stand, from the anonymous pioneer and Pony Express rider and such tough and straightforward characters as Daniel Boone and Kit Carson, and the explorers Meriwether Lewis and William Clark, to Sequoya the great Cherokee, the Sauk leader Black Hawk, and Chief Joseph of the Nez Percé. Writers from Irving and Cooper to Wister, Gray, and L'Amour have written about the endless horizons and colorful life of the West; painters, sculptors, and illustrators like Remington and Russell have glorified the cowboy; and artists like Catlin and Eastman have recorded for all time the largely vanished folkways of the Indian. Hollywood has exploited the apparently endless possibilities of the Western from the days of the silent film to today, the unceasing conflict of good guys and bad guys who could refreshingly be told apart, if there were any doubt in one's mind, by the color of their hats. This rich conglomeration of history and myth, of the heroic and the tragic, and of the noble and the tawdry informs this lively category of the Old West.

ARIZONA

Flagstaff: Northern Arizona Pioneers' Historical Society. Box 1968, Fort Valley Rd., 86001; 602-774-6272; Mon.–Sat. 9–5; Sun. 1:30–5; no charge.

Phoenix: The Arizona Museum. 1002 W. Van Buren St., 85007; 602-253-2734; Sept.–May: Wed.–Sun. 10–4; June–July: Wed.–Sun. 9–12; no charge.

Tucson: Arizona Heritage Center. 949 E. 2nd St., 85719; 602-882-5774; Mon.–Sat. 9–5; Sun. 1–5; closed holidays; no charge.

COLORADO

Boulder: Leanin' Tree Museum of Western Art.

Golden: Buffalo Bill Memorial Museum. Rt. 5; mailing address: Box 950, 80401; 303-526-0747; May 1–Sept. 30: daily 9–5; Oct. 1–April 30: Tues.–Sun. 9–4; no charge.

CONNECTICUT

New Haven: Yale University Art Gallery.

DISTRICT OF COLUMBIA

Washington: National Museum of American Art. ☐ National Gallery of Art.

MARYLAND

Baltimore: Walters Art Gallery.

MICHIGAN

Detroit: Detroit Historical Museum. 5401 Woodward Ave., 48202; 313-833-1805; Tues., Thurs.–Sat. 9:30–5; Wed. 1–9; Sun. 1–5; closed holidays; no charge (donations accepted).

MISSOURI

St. Louis: Missouri Historical Society. Lindel and De Baliviere, 63112; 314-361-1424; Tues.–Sun. 9:30–4:45; closed Mon., holidays; no charge. ☐Washington University Gallery of Art, Steinberg Hall.

MONTANA

Great Falls: C. M. Russell Museum.

Helena: Montana Historical Society. 225 N. Roberts, 59601; 406-449-2694; Winter: Mon.–Fri. 8–5; Sat. 9–5; Summer: Mon.–Fri. 8–6; Sat.–Sun. 10–6; closed New Year's, Thanksgiving, Christmas; no charge.

NEBRASKA

Gering: Oregon Trail Museum. Box 427, 69341; 308-436-4340; Summer: daily 8–8; Winter: daily 8–4:30; no charge except in summer.

Omaha: Joslyn Art Museum.

NEW MEXICO

Taos: The Kit Carson Memorial Foundation.

NEW YORK

Corning: Rockwell-Corning Museum.

Ogdensburg: Remington Art Museum.

TEXAS

Austin: Archer M. Huntington Art Gallery.

Fort Worth: Amon Carter Museum of Western Art.

Houston: The Museum of Fine Arts, Houston.

WYOMING

Big Horn: Bradford Brinton Memorial Museum.

Cody: Buffalo Bill Historical Center.

Photography

Today, when there is no question of the acceptance of photography as an artistic medium, we are inclined to forget that serious questions about its legitimacy were still being raised not too many years ago. New art form though it may be, it has its established old masters, whose example has done so much to raise the general level of photography among amateurs and professionals alike. Most of the larger art museums have photographic collections, many of them comprehensive. A few museums are largely devoted to the art. The major collections follow.

ARIZONA

Flagstaff: Northern Arizona Pioneers' Historical Society. Box 1968, Fort Valley Rd., 86001; 602-774-6272; Mon.–Sat. 9–5; Sun. 1:30–5; no charge.

Phoenix: Phoenix Art Museum.

Tucson: Center for Creative Photography. 843 E. University, 85719; 602-626-4636; Mon.–Fri. 9–5; Sun. 12–5; closed major holidays; no charge.

CALIFORNIA

Berkeley: University Art Museum.

La Jolla: La Jolla Museum of Contemporary Art.

Monterey: Monterey Peninsula Museum of Art Association. 559 Pacific St., 93940; 408-372-7591; Tues.–Fri. 10–4; Sat.–Sun. 10–4; no charge.

Novato: Marin Museum of the American Indian (Curtis Indian photos). 2200 Novato Blvd., 94948; mailing address: Box 864; 415-897-4064; Tues.–Sat. 10–4; Sun. 12–4; small fee.

Riverside: California Museum of Photography. Watkins House, University of California at Riverside, 92521; 714-787-5924; Mon.–Sat. 10–3; closed university holidays; no charge.

San Francisco: San Francisco Museum of Modern Art.

COLORADO

Boulder: Boulder Historical Society Museum. 1655 Broadway at Arapahoe
80302; 303-449-3464; Tues.–Fri. 10–4; Sat. 12–4; Sun. 1–4; small fee.

DISTRICT OF COLUMBIA

Washington: Corcoran Gallery of Art. Library of Congress. 10 First St., SE
20540; 202-287-5000; Mon.–Fri. 8:30–9:30; Sat.–Sun., holidays 8:30–6
closed Christmas, New Year's; no charge. ☐ National Museum of History

GEORGIA

Atlanta: The High Museum of Art.

ILLINOIS

Carbondale: University Museum, Southern Illinois University.

Chicago: The Art Institute of Chicago. ☐ Chicago Historical Society. ☐ The
David and Alfred Smart Gallery of the University of Chicago. ☐ Museum
of Contemporary Art.

INDIANA

Elkhart: Midwest Museum of American Art. 429 S. Main St., 46515
219-293-6660; Tues.–Wed., Fri. 1–5; Thurs. 11–5; and 7–9; Sat.–Sun. 1–4
fee.

KENTUCKY

Lexington: Photographic Archives. University of Kentucky Libraries, 40506
606-258-8634; Mon.–Fri. 8–4:30; Sat.–Sun. varies; closed holidays; no
charge.

Louisville: Photographic Archives, University of Louisville Libraries.

LOUISIANA

New Orleans: Louisiana State Museum. ☐ New Orleans Museum of Art

MARYLAND

Baltimore: The Baltimore Museum of Art.

MASSACHUSETTS

Amherst: University Gallery, University of Massachusetts at Amherst.

Andover: Addison Gallery of American Art.

Cambridge: Hayden Gallery and MIT Permanent Collection. Committee of
the Visual Arts, Room 7-145, 14W-11, MIT, 02139; 617-253-4680; daily
10–4; additional hours Wed., 6 P.M.–9 P.M.; closed university holidays; no
charge. ☐ Fogg Art Museum.

Milton: Museum of the American China Trade.

Northampton: Smith College Museum of Art.

MICHIGAN

Kalamazoo: Kalamazoo Institute of Arts.

MINNESOTA

Minneapolis: The Minneapolis Institute of Arts.

MISSOURI

St. Louis: The Saint Louis Art Museum.

Springfield: Springfield Art Museum.

NEBRASKA

Lincoln: Sheldon Memorial Art Gallery.

NEW JERSEY

Princeton: The Art Museum, Princeton University.

NEW MEXICO

Albuquerque: Art Museum, The University of New Mexico.

Santa Fe: Museum of Fine Arts.

Taos: Kit Carson Memorial Foundation.

NEW YORK

Albany: Albany Institute of History and Art.

New York City: American Museum of Natural History. ☐ The New York Public Library, Astor, Lenox, and Tilden Foundations. ☐ The New York Historical Society. ☐ The Museum of Modern Art. ☐ International Center of Photography.

Rochester: International Museum of Photography at George Eastman House (one of the most important collections in the field).

Syracuse: Everson Museum of Art of Syracuse and Onondaga County.

OHIO

Akron: Akron Art Museum.

Canton: The Canton Art Institute (stereographs and other photographic memorabilia).

Cincinnati: Cincinnati Art Museum.

Cleveland: Cleveland Museum of Art.

OKLAHOMA

Norman: Museum of Art, University of Oklahoma.

357

PENNSYLVANIA

Philadelphia: Philadelphia Museum of Art.

Pittsburgh: Museum of Art, Carnegie Institute.

TENNESSEE

Nashville: Vanderbilt University Art Gallery.

TEXAS

Beaumont: Beaumont Art Museum. 1111 Ninth St., 77702; 713-832-3432; Tues.–Fri. 10–5; Sat.–Sun. 2–5; closed holidays; no charge.

Corpus Christi: Art Museum of South Texas.

Fort Worth: Amon Carter Museum of Western Art. ☐ Fort Worth Art Museum.

Houston: The Museum of Fine Arts, Houston.

Wichita Falls: Wichita Falls Museum and Art Center. 2 Eureka Circle, 76308; 817-692-0923; Mon.–Sat. 9:30–4:30; Sun. 1–5; closed holidays; no charge.

VIRGINIA

Richmond: Virginia Museum of Fine Arts. ☐ Valentine Museum.

WASHINGTON

Bellingham: Whatcom Museum of History and Art. 121 Prospect St., 98225; 206-676-6981; Tues.–Sun. 12–5; closed holidays; no charge.

Seattle: Henry Art Gallery (19th and 20th C. American and European photographs and prints).

WISCONSIN

Beloit: Theodore Lyman Wright Art Center, Beloit College.

Madison: Madison Art Center.

CANADA

ALBERTA

Edmonton: The Edmonton Art Gallery.

ONTARIO

Ottawa: National Gallery of Canada.

Theater Collections

This category includes memorabilia, playbills, costumes, stage designs,

scripts, scores, documents, diaries, photographs, drawings, paintings, prints, inventories, reminiscences, and just about everything pertaining to the theater, whether comedy, tragedy, opera, musical, vaudeville, or burlesque. Because of the great popularity of theatrical history, there are many smaller collections across the country which could not, for obvious practical reasons, be included here among the major and more comprehensive ones.

COLORADO

Denver: Central City Opera House Association. 1615 California St., 80202; 303-623-7167; fall, winter, spring: Fri.–Tues. 11–4; summer: daily 10–5; closed major holidays; fee.

Leadville: Tabor Opera House Museum. 306-310 Harrison Ave.; mailing address: 815 Harrison Ave., 80461; 303-486-1147; June–Oct.: Sun.–Fri. 9–5:30; Nov.–May by appointment; fee.

FLORIDA

Sarasota: John and Mable Ringling Museum of Art (theater history).

KENTUCKY

Fort Mitchell: Vent Haven Museum (ventriloquial figures). 33 W. Maple, 41011; 606-341-0461; May 1–Sept. 30 by appointment; no charge.

MAINE

Boothbay: The Boothbay Theatre Museum.

MASSACHUSETTS

Harvard: Harvard Historical Society. 01451; July–Sept.: Sat.–Sun. 2–5; no charge.

Waltham: American Jewish Historical Society (Yiddish theater collections and cinema).

MICHIGAN

Detroit: The Detroit Institute of Arts.

NEW YORK

New York City: Walter Hampden-Edwin Booth Theatre Collection and Library of the Players. ☐ Library and Museum of the Performing Arts, Shelby Cullom Davis Museum, Lincoln Center.

TEXAS

Dallas: McCord Theatre Collection.

(right) Self-Portrait *by Rembrandt van Rijn.* COURTESY OF THE
NATIONAL GALLERY OF ART, WASHINGTON, D.C.

(above) Self-Portrait *by Judith Leyster.* COURTESY OF THE
NATIONAL GALLERY OF ART, WASHINGTON, D.C.

III. ARTISTS

III. ARTISTS

The following section includes painters, sculptors, printmakers, and expert craftsmen and designers in the decorative arts. No two people could ever agree on exactly who should be included in such a list. I have, therefore, consulted the *Encyclopedia of World Art*, 15 vols. (New York: McGraw-Hill, 1968) and based my choices on those artists whom the august panels of art historians consulted by the editors of that multivolume and useful publication felt deserved a special article. I have, however, added some Americans, because this is, after all, a guide to American museums, using the classic reference work by George C. Groce and David H. Wallace, *The New-York Historical Society's Dictionary of Artists in America,* 1564–1860 (New Haven: Yale University Press, 1957), as an aid. I have also omitted some artists because they are not, as far as I have been able to ascertain, sufficiently represented in American collections to merit inclusion, and I have excluded others because they seemed too obscure to warrant the arduous task of tracking them down.

The present list is comprehensive enough so that most users of this guide will find a majority, if not all, of those artists about which they are most interested. All of those usually considered "Old Masters" are present, along with a good many others, among whom I hope your personal favorites have been included.

The list is alphabetical, with locations by state, city, and institution. Dates for individual works appear when available. Artists' dates and other such data are those generally accepted. For more detailed information, I refer

you back to the two titles mentioned above. For specific works on individual artists and stylistic periods, consult the card catalog of your local library. In addition, you will find, in the course of your travels, that many museums have published useful and interesting works—catalogs, monographs, and articles—devoted to innumerable aspects of various arts and artists.

Paintings are oil on canvas unless otherwise noted. Titles are given in their generally accepted form, and attributions are those of the owning institution. Use the margins and the blank pages at the back of the book to note your own favorites and personal discoveries. I would be grateful to have your suggestions for additional listings in future editions of this guide.

Key to Museum Listings

The italicized word(s) indicate the collections in which the works of art mentioned in Part III are located. Museums sufficiently identified in the references given have not been included. Abbreviations have been avoided as unnecessarily cryptic. Wherever possible, the traditional method of referring to a museum by the name of the city in which it is located or the name by which it is generally known has been followed; where the name of a city or state forms part of the museum's official name, the city name has not been repeated in the same listing. For further information about any of the institutions listed, consult Part I.

Albany Institute of History and Art, NY
Art Museum, University of New Mexico, *Albuquerque,* NM
Allentown Art Museum, PA
Museum of *American Folk Art,* New York, NY
Mead Art Museum, *Amherst* College, MA
Amon Carter Museum of Western Art, Fort Worth, TX
Addison Gallery of American Art, Phillips Academy, *Andover,* MA
University of Michigan Museum of Art, *Ann Arbor*
Atlanta High Museum of Art, GA
Baltimore Museum of Art, MD
Barnes Foundation, Merion, PA
Bayou Bend Collection, Houston, TX
Bennington Museum, VT
University Art Museum, University of California, *Berkeley*
Birmingham Museum of Art, AL
Bernice Pauahi *Bishop* Museum, Honolulu, HI
Indiana University Art Museum, *Bloomington*
Museum of Fine Arts, *Boston,* MA
Bowdoin College Museum of Art, Brunswick, ME
Brandywine River Museum, Chadds Ford, PA
Brooklyn Museum, NY
Albright-Knox Art Gallery, *Buffalo,* NY
Robert Hull Fleming Museum, University of Vermont, *Burlington*
California Palace of the Legion of Honor, San Francisco
Museum of Art, *Carnegie* Institute, Pittsburgh, PA
Ackland Art Museum, University of North Carolina, *Chapel Hill*
Art Institute of *Chicago,* IL
Cincinnati Art Museum, OH
Sterling and Francine *Clark* Art Institute, Williamstown, MA
Cleveland Museum of Art, OH
Buffalo Bill Historical Center, *Cody,* WY
Colby College Museum of Art, Waterville, ME
Columbia Museum of Art and Science, SC
Columbus Museum of Art, OH
Cooper-Hewitt Museum, The Smithsonian Institution's National
 Museum of Design, New York, NY
New York State Historical Association, *Cooperstown*
Corcoran Gallery of Art, Washington, DC
Corning Museum of Glass, NY

Cranbrook Academy of Art, Bloomfield Hills, MI
Cummer Gallery of Art, Jacksonville, FL
Dallas Museum of Fine Arts, TX
Denver Art Museum, CO
Des Moines Art Center, IA
Detroit Institute of Arts, MI
M. H. *de Young* Museum, San Francisco, CA
Tweed Museum of Art, University of Minnesota, *Duluth*
Dumbarton Oaks Research Library and Collection, Washington, DC
International Museum of Photography at George *Eastman House,*
 Rochester, NY
Edmonton Art Gallery, AL
Arnot Art Museum, *Elmira,* NY
El Paso Museum of Art, TX
Elvehjem Museum of Art, University of Wisconsin, Madison, WI
Museum of Art, University of Oregon, *Eugene*
Fogg Art Museum, Harvard University, Cambridge MA
Fort Wayne Museum of Art, IN
Fort Worth Art Museum, TX
Freer Gallery of Art, Washington, DC
Frick Art Museum, Pittsburgh, PA
Frick Collection, New York, NY
Isabella Stewart *Gardner* Museum, Fenway Court, Boston, MA
J. Paul *Getty* Museum, Malibu, CA
Thomas *Gilcrease* Institute of American History and Art, Tulsa, OK
Hyde Collection, *Glens Falls,* NY
Greenfield Village and Henry Ford Museum, Dearborn, MI
Westmoreland County Museum of Art, *Greensburg,* SC
Bob Jones University Collection of Sacred Art, *Greenville,* SC
Solomon R. *Guggenheim* Museum, New York, NY
Wadsworth Atheneum, *Hartford,* CT
Hill-Stead Museum, Farmington, CT
Hirshhorn Museum and Sculpture Garden, Washington, DC
Hispanic Society of America, New York, NY
Honolulu Academy of Arts, HI
Houston Museum of Fine Arts, TX
Huntington Library, Art Gallery and Botanical Gardens,
 San Marino, CA
Indianapolis Museum of Art, IN

Herbert P. Johnson Museum of Art, Cornell University, *Ithaca,* NY

William Rockhill Nelson Gallery and Atkins Museum of Fine Arts, *Kansas City,* MO

Kimbell Art Museum, Fort Worth, TX

Krannert Art Museum, University of Illinois, Champaign

La Jolla Museum of Contemporary Art, CA

Lauren Rogers Library and Museum of Art, *Laurel,* MS

University of Nebraska Art Galleries, Sheldon Memorial Art Gallery, *Lincoln*

Los Angeles County Museum of Art, CA

J. B. Speed Art Museum, *Louisville,* KY

Currier Gallery of Art, *Manchester,* NH

Brooks Memorial Art Gallery, *Memphis,* TN

Metropolitan Museum of Art, New York, NY

Milwaukee Art Center, WI

Minneapolis Institute of Arts, MN

Mint Museum of Art, Charlotte, NC

M I T Hayden Gallery, Massachusetts Institute of Technology, Cambridge

Museum of *Modern* Art, New York, NY

Montclair Art Museum, NJ

Montgomery Museum of Fine Arts, AL

Montreal Museum of Fine Arts, PQ

Pierpont *Morgan* Library, New York, NY

Mount Holyoke College Art Museum, South Hadley, MA

Ball State University, *Muncie,* IN

Muskegon Museum of Art, MI

National Academy of Design, New York, NY

National Gallery of Art, Washington, DC

National Museum of American Art, Washington, DC

National Portrait Gallery, Washington, DC

Newark Museum, NJ

New Britain Museum of American Art, CT

Lyman Allen Museum, *New London,* CT

New Orleans Museum of Art, LA

New-York Historical Society, New York, NY

Chrysler Museum at *Norfolk,* VA

Norton Gallery and School of Art, West Palm Beach, FL

Snite Museum of Art, University of *Notre Dame,* IN
Oakland Museum, CA
Allen Memorial Art Museum, *Oberlin* College, OH
Remington Art Museum, *Ogdensburg,* NY
Museum of Art of *Ogunquit,* ME
Joslyn Art Museum, *Omaha,* NE
Oriental Institute, University of Chicago, IL
University of Maine at *Orono* Art Galleries
Paine Art Center and Arboretum, *Oshkosh,* WI
National Gallery of Canada, *Ottawa,* ON
Norton Simon Museum, *Pasadena,* CA
Pennsylvania Academy of the Fine Arts, Philadelphia
Philadelphia Museum of Art, PA
Phillips Collection, Washington, DC
Phoenix Art Museum, AZ
Berkshire Museum, *Pittsfield,* MA
Portland Art Museum, OR
Art Museum, *Princeton* University, NJ
Museum of Art, Rhode Island School of Design, *Providence*
Musée de *Quebec,* PQ
North Carolina Museum of Art, *Raleigh*
Reading Public Museum, PA
Rhode Island Historical Society, Providence
Virginia Museum of Fine Arts, *Richmond,* VA
John and Mable *Ringling* Museum of Art, Sarasota, FL
Memorial Art Gallery, *Rochester,* NY
Abby Aldrich *Rockefeller Folk Art* Center, Williamsburg, VA
Roswell Museum and Art Center, NM
Royal Ontario Museum, Toronto, ON
Rutgers University Art Gallery, New Brunswick, NJ
Crocker Art Museum, *Sacramento,* CA
St. Louis Art Museum, MO
Minnesota Museum of Art, *St. Paul*
San Antonio Museum of Art, TX
San Diego Museum of Art, CA
Fine Arts Museums of *San Francisco,* CA
Rosicrucian Egyptian Museum and Art Gallery, *San Jose,* CA
Santa Barbara Museum of Art, CA
de Saisset Art Gallery and Museum, University of *Santa Clara,* CA

Museum of New Mexico, *Santa Fe*
Seattle Art Museum, WA
Shelburne Museum, VT
R. W. Norton Art Gallery, *Shreveport,* LA
Smith College Museum of Art, Northampton, MA
Springfield Museum of Art, MA
Stanford University Museum and Art Gallery, CA
Museums at *Stony Brook,* L.I., NY
William Benton Museum of Art, University of Connecticut, *Storrs*
Old *Sturbridge* Village, MA
Everson Museum of Art of Syracuse and Onondaga County,
 Syracuse, NY
Taft Museum, Cincinnati, OH
Telfair Academy of Arts and Sciences, Savannah, GA
University Art Collections, Arizona State University, *Tempe*
Sheldon Swope Art Gallery, *Terre Haute,* IN
Timken Art Gallery, San Diego, CA
Toledo Museum of Art, OH
Art Gallery of Ontario, *Toronto*
Treat Gallery, Bates College, Lewiston, ME
New Jersey State Museum, *Trenton*
Tucson Museum of Art, AZ
Philbrook Art Center, *Tulsa,* OK
University Museum, University of Pennsylvania, *Philadelphia*
Munson-Williams-Proctor Institute, *Utica,* NY
Vancouver Art Gallery, BC
Vassar College Art Gallery, Poughkeepsie, NY
Walker Art Center, Minneapolis, MN
Walters Art Gallery, Baltimore, MD
Wellesley College Museum, MA
Whitney Museum of American Art, New York, NY
Wichita Art Museum, KS
Williams College Museum of Art, Williamstown, MA
Colonial *Williamsburg,* VA
Delaware Art Museum, *Wilmington*
Henry Francis Du Pont *Winterthur* Museum, DE
Worcester Art Museum, MA
Yale University Art Gallery, New Haven, CT
Yale Center for British Art, New Haven, CT
Butler Institute of American Art, *Youngstown,* OH

Albright, Ivan Le Lorraine (1897-)

The son of a successful portrait painter, Albright grew up in his father's studio. Assignment as a medical draftsman in World War I profoundly influenced his style toward the intricately wrought surfaces and emphasis on textural detail that suggest the inner, emotional dimension characteristic of all his work. A fine draftsman and printmaker, he is represented in practically all print rooms, while his paintings are in many museums, the largest group by far being in his native Chicago. Other works are in Detroit, Fort Wayne, Hartford, the Metropolitan, and Milwaukee.

CHICAGO: *"That Which I Should Have Done I Did Not Do" (The Door),* 1931–41; every scar seems the record of painful experience. *"Heavy the Oar to Him Who Is Tired, Heavy the Coat, Heavy the Sea" (The Fisherman). "Into the World Came a Soul Called Ida,"* 1929–30. *The Picture of Dorian Gray,* 1943–44; painted for the M-G-M film based on Oscar Wilde's famous story; Ivan's twin brother, Malvin, who took the name of Zzissly to avoid the confusion of two painters named Albright, painted the portrait of Dorian Gray before he had suffered the ravages of time and dissipation; Ivan's work shows a Gray far gone in criminal madness and nightmarish spiritual and physical dissolution.

YOUNGSTOWN: *Self-Portrait,* 1967–68.

MODERN: *Woman,* 1929.

Allston, Washington (1779–1843)

Allston was born in South Carolina but brought up and educated in New England. After graduating from Harvard, he studied art in London and on the Continent. He became a Romantic painter of international reputation, winning acclaim for his large historical, biblical, and literary paintings, for evocative portraits, and for creating what his biographer, Edgar P. Richardson, has aptly called "the landscape of mood." His work has been re-evaluated in recent years and may be found in most collections of American art. The outstanding group of his paintings is in Boston. Other good examples are in Andover, Charlestown, the Corcoran, Detroit, and the Fogg.

BOSTON: *Rising Thunderstorm at Sea,* 1804; nature's drama. *Self-Portrait,* 1805; a delightfully romantic young man. *Diana in the Chase;* idyllic classicism. *Dr. Channing;* appropriately spiritual for a famous and inspirational minister. *Coast Scene of the Mediterranean,* 1811. ★ *Elijah in the Desert,* 1818; complete with blasted tree and stormy sky, painted in skim milk, anticipating

modern casein; an outstanding Romantic picture. *Uriel in the Sun,* 1819; what Europe admired and America did not; cf. *The Dead Man Revived* below. ★ *Moonlit Landscape,* 1819; the epitome of Romantic landscape—enigmatic, mysterious, mnemonic. *Belshazzar's Feast,* 1817–43; a study for what was to be his masterpiece, left tragically incomplete at his death.

METROPOLITAN: *Spanish Girl in Reverie,* 1831.

PENNSYLVANIA ACADEMY: *The Dead Man Revived by Touching the Bones of the Prophet Elisha,* 1811–13; the kind of painting Morse, Vanderlyn, and so many other Americans wanted to do but found no acceptance for among their fellow Americans; Allston's considerable English reputation was founded on such immense creations.

COLUMBIA: *Coast Scene on the Mediterranean.*

Altdorfer, Albrecht (c. 1480–1538)

A German painter, draftsman, architect, and printmaker, Altdorfer was one of the earliest landscape painters to portray the rugged, forested Danube Valley in miniaturist detail, becoming the founder of the Danube School. His paintings are extremely rare in America; pictures in Chicago and Cleveland are attributed to him, and the National Gallery has a small triptych, *The Fall of Man,* c. 1525; but his etchings and woodcuts are in all major print collections.

Andrea del Sarto (1486–1530)

A Florentine painter of the High Renaissance and a contemporary of Raphael, and Michelangelo, Andrea's style served as a transition to Mannerism*. Almost all his important works are in Italy; among the few in America are the following:

NATIONAL GALLERY: *Charity,* before 1530; Florentine sculptural form.

METROPOLITAN: *Borgherini Madonna.*

CLEVELAND: *Sacrifice of Isaac,* 1527; unfinished and therefore most interesting in revealing the craftsmanship and discipline of Renaissance technique.

Angelico, Fra Giovanni (da Fiesole, or da Firenze), called Il Beato (c. 1400–55)

A dominican friar, he became known as the Blessed Angelico because of the joy and serene faith expressed in his paintings and in his active life. The Convent of San Marco in Florence is full of his frescoes; others are

in the Vatican. The perfect marriage of the grace of the International Style with the formal realization and humanism of the Renaissance are reflected in his inimitable art.

HARTFORD: *Head of an Angel.*

NATIONAL GALLERY: ★ The Adoration of the Magi, completed by Fra Filippo Lippi, *tondo* c. 1445; a masterpiece and a delight. *The Madonna of Humility* (1430–40); tender without sentimentality; compare Quercia's sculpture.

BOSTON: ★ *Virgin and Child with Angels and Saints, and Donor,* octagon; almost a miniature, an illumination.

GARDNER: *Death and Assumption of the Virgin.*

FOGG: *Crucifixion;* shows a moving and elevated seriousness.

DETROIT: *The Annunciation* (in two panels). *Madonna and Child with Angels;* lovely and tiny.

MINNEAPOLIS: *St. Benedict.*

METROPOLITAN: *Crucifixion;* monumentality on a small scale.

CLEVELAND: *Coronation of the Virgin;* done with the help of assistants, but a lovely painting nonetheless.

BUFFALO: *Two Scenes from the Legend of a Holy Hermit,* drawing.

PRINCETON: *The Penitant St. Jerome.*

HOUSTON: *Temptation of St. Anthony Abbott;* with none of the grotesque element this subject usually evoked.

PHILADELPHIA: *St. Francis.*

Antonello da Messina (c. 1430–79)

An important Italian Renaissance painter who was born and lived much of his life in Sicily. His contact with Petrus Christus in Milan in 1456 introduced him to the Flemish oil technique, which Antonello then took to Venice, Rome, and back to Messina. There are few paintings by him on this side of the Atlantic.

METROPOLITAN: *Ecce Homo;* originally dated 1470. *Berenson Madonna and Child;* attributed to him by Bernard Berenson and showing the influence of Piero della Francesca. The Met's *Portrait of a Man* was also attributed to him by Berenson.

PHILADELPHIA: *Portrait of a Man* (Johnson Collection).

Arp, Jean (Hans) (1887–1966)

A French painter, sculptor, and poet, Arp was a pioneer in abstract art, and a cofounder of both Dada (1916) and Surrealism (c. 1922). His style

is characterized by the use of suave curves and surfaces in organic forms. His work is in many American museums, among them Chicago, Philadelphia, Nebraska, Des Moines, Baltimore, Smith, Detroit, Buffalo, Oberlin, the National Gallery, and the Metropolitan. ☛ *Human Concretion* (1935) at the Modern and the large wooden relief (1950) he produced for the Harvard Graduate Center, Cambridge.

Audubon, John James (1785–1851)

An American painter and naturalist, Audubon was born in Haiti of French parents, lived in France until 1803, when he came to America. His lifework was the remarkable achievement of producing his great American ★ *Ornithology,* a double elephant folio showing all specimens life-sized; *Birds of America* in four volumes (1827–38), with the accompanying text; *Ornithological Biography* in five volumes (1831–39). This was followed by *The Viviparous Quadrupeds of North America,* in which he was assisted by his two sons, Victor and John. To produce his *Ornithology,* which he published himself, he had the plates engraved and colored in London after drawings he prepared while traveling through the greater part of America in search of birds. His work is far more than scientific, since it expresses the passionate love of nature and the sense of wonder that inspired him. Audubon's prints are in most American collections, his paintings hang in many museums, and his publications may be found in all major libraries. The largest collection of his original drawings and paintings is in the New-York Historical Society. He also painted portraits, mostly to earn his way while birding; for example, a pair of portraits are in the Speed Museum in Louisville, KY.

Bartolommeo della Porta, Fra (c. 1475–c. 1517)

With Andrea del Sarto, Fra Bartolommeo was a leading Florentine painter of the High Renaissance. His fame and influence rest on the large number of drawings he produced, fine examples of which are in Los Angeles, the Metropolitan, Clark, the Fogg, Louisville, Greenville, the National Gallery, and the Morgan. Among his few paintings in America are the following:

LOS ANGELES: *Holy Family;* classical High Renaissance style.

METROPOLITAN: *Madonna and Child with the Infant St. John,* early 1490s.

Barye, Antoine Louis (1796–1875)

Trained in Paris as a goldsmith, Barye became the greatest animal sculptor of all time. His groups and individual animals in violent movement recall his contemporary Delacroix's paintings. He worked at every

scale, from miniature to monumental. His watercolors are superb and too little known. There are large collections of Barye's works in this country.

CORCORAN: Said to have "every known sculpture," totaling more than 150.

WALTERS: More than five hundred sculptures, paintings, and drawings, incl. the elaborate table decoration, with five large hunting scenes, for the Duke of Orleans.

METROPOLITAN: A group of nearly forty bronzes.

Other examples are in the Norton, Boston, the National Gallery, Brooklyn, and Cleveland. There are fine watercolor drawings in the Walters, the Metropolitan, Baltimore, and Brooklyn.

Bearden, Romare (1914–)

Born in North Carolina and raised in Harlem in the twenties, when the Harlem renaissance was in full flower, Bearden graduated from New York University with a mathematics degree, studied at the Art Students League, and decided on a career in art. After serving in the Army, he had a taste of Paris, and finally set to work in the mid-sixties. He drew upon his past experiences to express, largely in painted collages, his continuing artistic pilgrimage, sometimes using the classical theme of the wandering Ulysses, representing him as a black prince from ancient Benin. His works are in major contemporary collections.

Bellini, Gentile (c.1429/30–1507)

One of three Venetian painters of this family, consisting of his father Jacopo and his brother Giovanni, the latter being the best known.

GARDNER: ★ *Portrait of a Turkish Artist;* Gentile visited the court of Mohammed II in Constantinople in 1478–80.

CHICAGO: *Two Orientals,* c. 1480.

FRICK: *Doge Giovanni Mocenigo,* 1478–85; another version is in Venice (Museo Correr).

BOSTON: *Portrait of a Doge;* of mysterious provenance; the background is ruinous, but the profile is firm and impressive.

Bellini, Giovanni (c. 1430–1516)

The leading Venetian Renaissance painter of his generation, whose pupils included Titian and Giorgione. He was influenced by Antonello da Messina in terms of oil technique and by Andrea Mantegna, his brother-in-law, in terms of formal structure and often minutely realized detail, esp. in his earlier years. Giovanni and Gentile were sons and pupils of

373

Jacopo Bellini, an exponent of the International Style who is credited with founding the Venetian school. One of the great painters of all time, Giovanni lived to become the patriarch of the Venetian school; in 1506 Dürer called him "the surpreme painter." His work has been much admired and collected, and there are many examples in North America.

ATLANTA: ★ *Madonna and Child,* c. 1512; showing the serenity and command of his old age.

CHICAGO: *Virgin and Child with Two Saints.*

DETROIT: ★ *Madonna and Child Blessing;* a work of his old age, with a wonderful landscape.

FOGG: *Madonna and Child;* with an inscription in Greek; Giovanni had scholarly and humanistic interests.

FRICK: *St. Francis in Ecstasy,* c. 1480; a lovely picture full of enlivening detail and Bellini's unique spirit.

KANSAS CITY: *Madonna and Child,* 1509; like the Detroit and Atlanta pictures, a mature work.

KIMBELL: *Christ Blessing,* c. 1490–95.

METROPOLITAN: ★ *Madonna Adoring the Sleeping Child;* sleep is a prefiguration of death, symbolizing Christ's trial to come; hence the grave atmosphere of the picture. *Sacra Conversazione,* 1502; literally, sacred conversation; a term applied to the subject of the Madonna and Child with Saints when the figures are aware of each other and not merely assembled in the same panel for iconographic reasons.

NATIONAL GALLERY: *Portrait of a Young Man in Red,* c. 1480. *St. Jerome Reading,* c. 1480–90; the poetic landscape setting is similar to that of the Frick *St. Francis* of the same period; note the sleepy lion. *The Feast of the Gods,* 1514; signed and dated, yet thought by several scholars to have been completed by Titian; fascinating, enigmatic, the subject of much scholarly detective work.

OTTAWA: *Head of Christ,* c. 1505.

PASADENA: *Portrait of Joerg Fugger,* 1474; of the famous Augsburg banking family.

PHILADELPHIA: *Madonna and Child;* an early work, Mantegnasque.

Bellotto, Bernardo (1721–80)

A nephew and pupil of Canaletto, Bellotto was also one of the greatest *veduta* painters of the eighteenth century. His paintings of Warsaw are so accurate down to the least detail that they served as guides for the

restoration of the city after its destruction in World War II. Though Bellotto studied in his native Venice, he traveled widely, spending his later years as court painter to Frederick Augustus II, Elector of Saxony, and to King Stanislaus Poniatowski of Poland. As a result, the majority of his paintings is in Dresden and Warsaw, but there are fine examples in American collections.

NATIONAL GALLERY: *Castle of Nymphenburg,* c. 1761. *View of Munich,* c. 1761.

HOUSTON: *Marketplace in Pirna, Saxony.*

Belter, John Henry (1804–63)

The leading furniture maker from the 1830s to the Civil War, Belter invented a laminated construction that allowed for the elaborate pierced ornamentation favored by his clients, without any loss of structural strength. Like Duncan Phyfe, he shipped furniture all over the United States and beyond. An inventive designer, he created a style imitated by many other furniture makers with great expertise. Examples of the Belter style are in innumerable historical and decorative arts collections. ☛ Fine groups in the New-York Historical, the Museum of the City of New York, and the Metropolitan Museum of Art—all located in New York City; Greenfield Village, Dearborn, MI; Cincinnati; Brooklyn; a fine parlor set, probably Belter's own work, is in Fountain Elms, the Tuscan villa-style historic house connected with the Munson-Williams-Proctor Institute in Utica, NY.

Bernini, Gian Lorenzo (1598–1680)

Born in Naples of a Tuscan family, Bernini became the leading Baroque architect and sculptor of seventeenth-century Rome, where most of his work is located. There are a few works in American museums.

NATIONAL GALLERY: *Monsignore Francisco Barberini,* bust.

CUMMER: *Cardinal Richelieu,* bust.

METROPOLITAN: *The Goat Amalthea,* c. 1615; a very early work done for Cardinal Borghese, for whom he did a number of his greatest sculptures.

FOGG: Several *bozzetti.*

NATIONAL GALLERY: *Self-Portrait,* a fine drawing.

Bierstadt, Albert (1830–1902)

An American painter of the Hudson River School, Bierstadt was born in Germany, brought to America as an infant, and later returned to Düsseldorf to study. He is best known for his panoramic and often, to

a modern eye, grandiose landscapes of the American West; yet at his best he is genuinely impressive. His swiftly painted oil sketches are uniformly excellent. He was very productive and popular during his lifetime, so virtually every older museum has an example of his work, which is also in American and Western collections.

CORCORAN: *Last of the Buffalo,* c. 1869; a late, large vision of a tremendously popular subject; another version, plus sketches, at Cody (see below).

METROPOLITAN: *Rocky Mountains,* 1863; another popular landmark.

BOSTON: *View from the Wind River Mountains, Wyoming,* 1860; a fine landscape. ★ *Indians Near Fort Laramie,* 1858; a fascinating snapshot-like record of the confrontation between modern and Stone Age man, vividly experienced and recorded.

CODY: *Last of the Buffalo,* with preliminary sketches. *Wind River.*

Others are in Amon Carter, Oakland, Atlanta, Gilcrease, Denver, Pittsfield, and many other collections.

Bingham, George Caleb (1811–79)

One of the outstanding American painters of genre scenes and political subjects, Bingham was self-taught, earning a living as a portrait painter in Missouri and elsewhere. From about 1845 his scenes of frontier life became popular and, through engravings, circulated widely. Study at Düsseldorf from 1856 to 1859 hardened his style. Though his activity in politics—he was passionately pro-Union and pro-Lincoln—lessened his artistic production, many of his best pictures date from this period. For several outstanding collections of Bingham's work, note the following:

BOATMAN'S NATIONAL BANK OF ST. LOUIS: *Stump Speaking,* c. 1845–47. *County Election,* 1951. *Verdict of the People*, 1844–45; paintings of this group are vivid, lively records of hard-cider politicking on the frontier.

KANSAS CITY: *Canvasing for a Vote* and an entire gallery of works, incl. a *Self-Portrait.*

WASHINGTON UNIVERSITY GALLERY OF ART (ST. LOUIS): *Daniel Boone Leading Settlers Through Cumberland Gap.*

BROOKLYN: *Shooting for Beef.*

METROPOLITAN: ★ *Fur Traders Descending the Missouri,* 1844–45; a glimpse, frozen in time, of an aspect of life beyond the frontier. *Jolly Flatboatmen,* 1844. *Raftsmen Playing Cards,* 1844–50; a picturesque and vigorous record of life on the river, anticipating Mark Twain.

376

ST. LOUIS: *Raftsmen Playing Cards,* another version; the museum also has a considerable group of his other works.

Engravings after Bingham's paintings, distributed by the American Art Union, are in a number of collections; among them are those listed above and New-York Historical, New York Public Library, and Chicago.

Blake, William (1757–1827)

A visionary English poet and painter, Blake earned what living he could eke out as an engraver, but in the meantime he produced highly idiosyncratic books, *Songs of Innocence, Songs of Experience,* and *Prophetic Books,* all engraved and colored by hand, and the cycles of watercolor illustrations for the Book of Job and Dante. He was as mad as a hatter but most wonderfully gifted. There are fine collections of his works in America, incl. Huntington, the National Gallery, the Library of Congress, Boston, the Metropolitan, the Morgan, the Fogg and Houghton Library at Harvard, Brooklyn, and the Yale Center.

Blakelock, Ralph Albert (1847–1919)

An American painter, like Quidor, Ryder, Inness, Allston, and Rimmer, Blakelock was an inward-looking spirit. He produced visionary scenes of a subjective and poetic character, often containing Indian teepees and a campfire, an image vividly retained from an early trip out West. Driven by the need to support a growing family and victimized by unscrupulous dealers, he became insane. Meanwhile, he was rediscovered as a significant artist and was elected to the National Academy. The prices for his pictures rose astronomically and, like Ryder, his paintings were often forged. His work is in most art museums, incl. the National Museum, the National Gallery, Andover, Brooklyn, Boston, Gilcrease, Philbrook, Toledo, and the Metropolitan. ☞ *Moon Magic* in the High Museum, Atlanta, and *Brook by Moonlight,* Toledo, show his subtle variations on a theme that visually reflect his love for music.

Blythe, David Gilmour (1815–65)

Born on the Ohio frontier, Blythe was apprenticed to a Pittsburgh woodcarver, worked as a shipcarver in Baltimore, and served in the Navy before setting up as a jack-of-all-trades in the Pittsburgh area. As a painter of genre and satire, he was the first painter of protest in American art. His work often displays a dark and cutting edge resulting from personal loss, but it also exhibits a moving compassion for human hardship. His political pictures show him to have been an ardent Lincolnian. In recent years his work has been much sought after and is in all major American collections.

377

CARNEGIE: Has a collection of two dozen or so of his works.

BOSTON: ★ *Libby Prison,* c. 1863–64; a moving painting employing almost comic-strip means to convey its compassionate message. *Lincoln Crushing the Dragon of Rebellion,* 1862; one of a group of paintings showing the painter's dedication to abolitionism and the Union cause.

FAYETTE COUNTY COURTHOUSE, UNIONTOWN, PA: ★ *Lafayette,* 1897; a 9-foot-high painted and carved wooden sculpture, which graced the courthouse dome for years and is now in the lobby there. Traditionally based on the artist's recollections of the appearance of the ancient hero on his return to America in 1825, it is perhaps the most monumental folk sculpture in American art.

Bologna, Giovanni da (Giambologna, Jean de Boulogne) (1529–1608)

Born in Flanders, Bologna became a leading Florentine Mannerist sculptor and the dominant artist in this field after the death of Michelangelo. He worked primarily in bronze and is represented in about every collection that has Renaissance and Baroque bronzes. ☛ The famous statue of *Mercury,* the centerpiece of the National Gallery's West Building, which exists in many versions; a marble *Venus* in Hartford.

Bonheur, Rosa (1822–99)

A French painter and sculptor who specialized in animals. She was honored as an outstanding artist by being awarded the first officership in the Legion of Honor ever held by a woman. ☛ Her immense *Horse Fair,* in the Metropolitan, is her most famous work. Her bronzes are in numerous collections. Her painting of *Buffalo Bill on Horseback,* 1889, is in Cody, Wyoming.

Bonington, Richard Parkes (1801/2–28)

A short-lived English landscape painter, Bonington studied in France with Géricault and Gros. His historical pictures reflect his Venetian experience, but his landscapes show his own lucid, airy style. His works are in many American museums, incl. the Corcoran, Ball State, Notre Dame, Louisville, Boston, the Fogg, Detroit, Kansas City, the Metropolitan, Cincinnati, Kimbell, Richmond, Ottawa, Toronto, and Quebec. ☛ *Cathedral of Notre Dame and the Marketplace of Caudebec-en-Caux* (Fogg) and Ottawa's *Landscape with a Wagon* show his lyric command of atmospheric perspective; his unfinished *View of a Norman Town* (Smith) is fascinating in its revelation of his painting technique.

Bonnard, Pierre (1867–1947)

Influenced by Japanese prints, by Gauguin, and by Impressionism after 1909, Bonnard's canvases became increasingly drenched in light and color. His serene celebration of the beauty of everyday life was expressed in brilliant garden scenes, still lifes, landscapes, and sunlit interiors, often with figures. He was exuberantly prolific, and his works may be found in most museums with modern art collections. Esp. attractive groups of works, both paintings and lithographs, are in the Modern, Phillips, Smith, the Guggenheim, the Hirshhorn, and Chicago. ☞ Phillips, ★ *The Open Window,* 1921; *Woman and Dog,* 1922.

Bosch, Hieronymus (c. 1450–1516)

A Netherlandish painter, Bosch was one of the greatest of fantasists. Despite the fact that his complex works are steeped in largely forgotten symbolism reflecting a final phase of the Gothic world, they are nonetheless impressive and disquieting.

SAN DIEGO: *Christ Taken Captive,* c. 1500; frightening grotesques.

YALE: *Intemperance;* an impressive homily.

NATIONAL GALLERY: *Death and the Miser,* c. 1490; another powerful lesson.

BOSTON: *Ecce Homo;* a nightmarish vision.

PRINCETON: *Christ Before Pilate;* also with ferocious grotesques.

METROPOLITAN: *Adoration of the Magi;* a curiously inappropriate subject for his style.

PHILADELPHIA: *Mocking of Christ;* showing the bestial in man.

NORFOLK: *Temptation of St. Anthony;* a perfect subject for his unique talents.

Botticelli, Sandro (Alessandro di Mariano di Vanni Filipepi) (c. 1445–1510)

A late fifteenth-century Florentine painter whose distinctive curvilinear style is best known through his famous *Primavera* (Spring) and the *Birth of Venus,* both much reproduced, in the Uffizi, Florence. According to Vasari he was a pupil of Fra Filippo Lippi. His is an art of poetic imagery culminating in an almost agonizing ecstatic faith influenced, in his later years, by the extreme religiosity of Savonarola, the religious reformer and fanatic who denounced the new paganism of the Renaissance and preached against the Medici.

CHICAGO: *Madonna and Child with Angels,* c. 1490; a lovely and subtle composition in *tondo.*

CINCINNATI: *Judith with the Head of Holofernes;* the graceful style belies the grisly subject.

GARDNER: *The Tragedy of Lucretia,* c. 1495; late and abstract in composition and style.

GLENS FALLS: *Annunciation,* 1472–80; intense and mystical; compare with that of c. 1505 in the Metropolitan.

METROPOLITAN: *Last Communion of St. Jerome,* early 1490s. *Three Miracles of St. Zenobius,* 1505; the rest of the panels are in Dresden and London.

NATIONAL GALLERY: *Madonna and Child,* c. 1470; with his typical grace and a touch of melancholy. ★ *Adoration of the Magi,* c. 1480–85; contains portraits of leading members of the Medici family. *Giuliano de' Medici,* c. 1478; perhaps painted shortly after Giuliano's murder (he was the younger brother of Lorenzo the Magnificent) in the Pazzi conspiracy of that year.

PHILADELPHIA: *Portrait of Lorenzo Lorenzano,* c. 1490. *Life of the Magdalene* (four predella panels), 1470s.

COLUMBIA: *Adoration of the Child.*

GREENVILLE: *Madonna and Child with Angels, tondo.*

Boucher, François (1703–70)

A leading French painter whose works epitomize the carefree, amorous Rococo spirit and style of aristocratic pre-revolutionary France. He was a gifted decorator who carried out many commissions for Mme. de Pompadour, his friend and patron, and for other members of the royal court. First trained as an engraver, he was much influenced by Watteau. Boucher was also a fine draftsman, and produced many tapestry cartoons. There are examples of his work in many American museums, incl. Getty, Timkin, San Francisco, Raleigh, the Frick, Pittsburgh, Kimbell, Norfolk, and Toronto. A series of tapestries designed by him are in the Metropolitan and the Huntington. ☛ *Four Myths on the Theme of Fire,* Kimbell, and a pair of handsome, big, decorative canvases in Boston.

Boudin, Eugène (1824–98)

A French painter whose luminous land- and seascapes link the vision of his friend Corot to that of the Impressionists, with whom he exhibited in the First Impressionist Exhibition of 1874. Examples of his work are in virtually all major art collections. Esp. interesting groups are in the Metropolitan, the National Gallery, and Boston. ☛ *The Beach at Deauville,* 1863 (Hartford); typical of Boudin's lucid vision and deliciously fresh color. An oil sketch of sailboats in a French port (Phoenix) is particularly freely brushed.

Bourdon, Sébastien (1616–71)

A French painter who studied in Italy, Bourdon was court portraitist to Queen Christina of Sweden; famous for religious and mythological scenes, his style was influenced by Poussin in its formal clarity, but with a personal palette of cool, clear color. His paintings are in a number of museums, incl. Hartford, the Ringling, the National Gallery, the Fogg, the Metropolitan, Providence, Greenville, and Montreal. ☛ The National Gallery's *Finding of Moses,* c. 1650, is a fine example of Bourdon's distinctive color and decorative qualities.

Bouts, Dirk (Dieric) (c. 1415–75)

A Netherlandish painter influenced by Roger van der Weyden, Bouts is noted for his sensitivity to light and atmosphere as exemplified in the landscape settings for his religious pictures. His figures, however, tend to be wooden despite the fact that they express an intense, sober piety. Few established works by him are in American collections. He is represented in the Metropolitan, Philadelphia, the National Gallery, and Cleveland. NATIONAL GALLERY: *Portrait of a Donor,* c. 1455. METROPOLITAN: *Virgin and Child. Portrait of a Man.*

Brancusi, Constantin (1876–1957)

A French modernist sculptor of Romanian birth, Brancusi lived and worked in Paris, where he played a leading part in the avant-garde with his hewn wood and stone figures and bronzes, all reduced to abstract essentials. Examples of his work are in the Modern, the Guggenheim, and Philadelphia (which has the largest collection of his works). ☛ *Muse,* the first Brancusi to come to North America; acquired in 1914 and now in Portland.

Braque, Georges (1882–1963)

A leading French modernist painter and printmaker, Braque began as an assistant to a decorator. Influenced by Cézanne, the Fauves, and the antique, he evolved a classical style of semi-abstraction best reflected in his mature works. In the meantime he and Picasso jointly developed a style known as Cubism. Braque also experimented with the mediums of sculpture, printmaking and collage. Because of his importance as one of the outstanding artistic figures of his era, his work is in almost every museum with a modern collection. Notable examples are in Buffalo, Cleveland, Detroit, the Modern, the Guggenheim, Philadelphia, San Francisco, Toledo, and Ottawa. ☛ Perhaps the finest group of his works is in the Phillips, displaying superb color and a classically serene mood.

Bronzino, Agnolo (1503-72)

A Florentine court painter to the Grand Duke Cosimo I of Tuscany, his elegant, cool, distinctive, and often enigmatic portraits, frescoes, and other compositions mark the high point of Mannerism. His paintings are in the Gardner, San Diego, Chicago, the Walters, Cincinnati, Cleveland, Detroit, the Metropolitan, the Frick, Toledo, Philadelphia, Worcester, the National Gallery, and Ottawa.

METROPOLITAN: ★ *Portrait of a Young Man,* c. 1535-37; immensely stylish.

FRICK: *Ludovico Copponi,* c. 1550-55; a leading Florentine statesman.

OTTAWA: *Cosimo I,* c. 1550; one of many portraits of his grand-ducal patron.

Brueghel, Pieter the Elder (c. 1525-69)

A fascinating Netherlandish painter and draftsman, a superb landscapist, a satirist and painter of genre, an illustrator of parables, and creator of unforgettable images. Despite his interest in peasant life, he was an educated and traveled humanist, enjoying aristocratic and imperial patronage. His sons and grandsons were also painters.

TIMKEN: ★ *Parable of the Sower,* 1557; a magical and poetic landscape.

BOSTON: *Fight Between Carnival and Lent.*

DETROIT: *The Wedding Dance,* 1566.

FRICK: *The Three Soldiers.*

METROPOLITAN: *The Harvesters,* one of a series of *Months*—also the subject of a series of prints after Brueghel's drawings—with the others in Vienna and Prague.

SEATTLE: *Dancing Peasants.*

NATIONAL GALLERY: *Temptation of St. Anthony.*

His drawings are in the Fogg, Bowdoin, Smith, and the National Gallery.

Burchfield, Charles Ephraim (1893-1967)

Born in Ashtabula, Ohio, Burchfield studied in Cleveland, and early on discovered watercolor as his own medium. Just before World War I he painted the first of his imaginative interpretations of nature, in which he developed a kind of visual symbolism to express his awareness of the sounds and patterns of growth, the rhythm of the seasons, and the vibration of light. After discharge from the Army in 1919, he moved to upstate

New York, near Buffalo, where he lived the rest of his life painting evocative celebrations of nature, interspersed with paintings expressive of the mood of a particular season and place. Highly respected, his unique work is in most American art museums.

UTICA: Wonderful watercolors and drawings, esp. ★ *Sphinx and the Milky Way,* 1946.

Buffalo and the Root Art Center, Hamilton College, Clinton, NY, also have important works, as do the Modern, Wichita, and Delaware.

Burgkmair, Hans the Elder (1473-1531)

An Augsburg painter, Burgkmair's style was, like Dürer's, much influenced by Venetian art. Though there are a few of his paintings in American collections, he is best remembered for the woodcuts he designed, which are to be found in virtually all print collections.

Calder, Alexander (1898-1976)

The third generation of a family of Philadelphia sculptors, Calder was trained as an engineer, became a pioneer in mobiles (Duchamp's term) and stabiles (Arp's designation), both of which are nonobjective biomorphic sculptural forms; he produced some of this century's most effective monumental abstract sculptures. He was also a playful draftsman and a printmaker. A genial bear of a man, he saw his last work, the immense mobile in the new East Building of the National Gallery, through to completion, but he died before it was properly installed—hence its lack of any title. "One does not name one's children before they are born," he remarked.

MODERN: *Black Widow,* stabile. *Lobster and Fish Tail,* 1939, mobile.

NATIONAL GALLERY: Untitled work, 1976.

RICHMOND: *Steel Fish,* 1934.

In his later years he constructed immense stabiles as outdoor landmarks; those in Grand Rapids and Hartford are particularly effective.

Callot, Jacques (1592/93-1635)

A master French etcher from Lorraine, Callot's *Miseries of War* series (1633) looks forward to Goya's terrifying *Disasters.* His tiny but lively prints are in virtually all print collections and are worth the detailed examination their small size demands.

Campin, Robert (Master of Flémalle?) (1378/79-1444)

A Flemish painter known to have been active in Tournai from 1406. No works can be positively identified as his, but many scholars believe he is the artist also known as the Master of Flémalle, a contemporary of Jan van Eyck and just as original. ☛ The one great work generally recognized as his is an altarpiece depicting the Annunciation, known as the *Mérode Triptych* (named after its former owners) in The Cloisters, a branch of the Metropolitan Museum of Art. It is one of the very great works of Western art, full of subtle symbolism and beautifully composed and executed.

Canaletto (called Giovanni Antonio Canale) (1697-1768)

A distinguished Venetian *veduta* painter, etcher, and draftsman who worked for some time in England. Much—and justly—admired and enthusiastically collected, he is represented in many museums in Europe and America, and in virtually all print collections. Everything he did is fascinating and full of life and light. His works are to be found in Birmingham, the Getty, Pasadena, San Diego, Hartford, the National Gallery, Chicago, Indianapolis, Baltimore, Boston, the Fogg, Springfield, Worcester, Detroit, Minneapolis, Kansas City, St. Louis, the Metropolitan, Raleigh, Cincinnati, Cleveland, Dayton, Toledo, Tulsa, Providence, Columbia, Memphis, the Kimbell, Houston, Seattle, Ottawa, Toronto, Montreal; his drawings in Buffalo, the Fogg, the Metropolitan, and Chicago.

Canova, Antonio (1757-1822)

The leading Neoclassic sculptor of his age, Canova gained an international reputation, and influenced the entire course of modern sculpture with his somewhat stagy, pure white marble figures, carved with an impeccably smooth technique that precludes any emotional expression. ☛ The one monumental example of his work in America is *Perseus Carrying the Head of Medusa,* 1804-8, in the Metropolitan. A marble portrait of *Pauline Bonaparte Borghese,* the emperor's beautiful and glamorous sister, is in the Athenaeum, Philadelphia.

Caravaggio, Michelangelo Merisi da (1567/71-1610)

An Italian painter who exerted a tremendous influence on subsequent painting for centuries, Caravaggio was an immensely gifted but deeply troubled personality, with a hair-trigger temper and given to violence. It is a wonder that—during a short life full of duels, feuds, murderous assaults, and flights from vengeance and from justice—he was able to produce a considerable body of paintings of unique power. All are

characterized by the use of street people as models, and by a use of chiaroscuro for dramatic effect. In them he transformed the murderous destructiveness that informed his life into a passionate and deeply disturbing artistic expression whose overtones of brutality and compassion are palpable today. His works, rare on this continent, are in Hartford, the National Gallery, Atlanta, Kansas City, Indianapolis, Boston, Detroit, Cleveland, and Ottawa.

HARTFORD: *Ecstasy of St. Francis,* c. 1593–95; youthful and shocking.

DETROIT: *Conversion of the Magdalene.*

METROPOLITAN: *Musicians,* an early work; the youth with the horn may be a self-portrait.

OTTAWA: Owns a Rubens sketch after Caravaggio's Vatican *Deposition.*

Carpaccio, Vittore (c. 1460/65–1523/26)

Probably a pupil of Gentile Bellini, Carpaccio was influenced by the latter's brother, Giovanni. He was an enchanting painter, who produced highly decorative frescoes and panels, full of lively detail and crowded with figures and excellent portraits. There are few of his works in America, but he is represented in several major museums.

NATIONAL GALLERY: *Flight into Egypt,* c. 1500. *Virgin Reading,* c. 1505. *Madonna and Child,* c. 1505.

METROPOLITAN: *Meditation on the Passion,* St. Jerome and Job are on either side of the dead Christ.

Carracci, Lodovico (1555–1619); Agostino (1557–1602); Annibale (1560–1609)

The Carracci were a family of Bolognese painters important for their formative influence on Baroque painting. Agostino and Annibale were brothers, and Lodovico was their cousin. Their great works were a series of frescoes and large canvases on which they assisted one another. All were trained as engravers and were fine draftsmen. To a modern eye their religious and mythological subjects seem rhetorical and grandiose—figures with upcast eyes and theatrical gestures—but they are much less dull than they may seem, having prepared the way for Rubens and many other painters of the High Baroque. Annibale introduced the lyric classical landscape that was later developed by Claude and Poussin. Agostino gained a certain fame for his pornographic *Lascivie,* depicting explicit sexual scenes from classical mythology, which enjoyed a wide circulation in engravings. There are Carracci prints in many museums, but their paintings are comparatively rare in America.

ATLANTA: Annibale's *Crucifixion*.

NATIONAL GALLERY: Annibale's *Landscape,* c. 1590; an example of his poetic treatment of landscape. Annibale's *Venus Adored by the Graces,* c. 1595. Lodovico's *Dream of St. Catherine of Alexandria,* c. 1590, and a drawing of a *Madonna and Child with Saints George and William;* two fine drawings by Agostino, *Head of a Faun* and ★ *Wooded Landscape with a Boat.*

METROPOLITAN: Annibale's *Coronation of the Virgin,* plus several drawings.

RINGLING: Agostino's *Susanna and the Elders.*

RALEIGH: Lodovico's *Assumption.*

Cassatt, Mary (1844–1926)

Born near Pittsburgh, Cassatt came of a rich family, determined upon a career in art, went to Europe to study, and settled in Paris in 1868, where she was accepted by Manet, Degas, Morisot, and others of the Impressionist group with whom she exhibited. A fine painter, pastelist, and printmaker, she could afford to maintain a private life-style of considerable luxury, devoting herself to her art with superb effect. As a result of her advice, contemporary painting was collected in considerable quantity by certain Americans, thereby greatly enriching museums in Chicago, Philadelphia, and New York. Because of her well-deserved reputation, Cassatt is represented in most American museums. Important groups of her work are in the National Gallery, Metropolitan, Philadelphia, and Chicago. Her lithographs are in virtually every print collection.

NATIONAL GALLERY: ★ *The Boating Party,* 1893–94; a Manet-like composition. *The Loge,* 1822; shows Degas' influence but reveals Cassatt's own sensibility and style. *Miss Mary Ellison,* c. 1880.

BALTIMORE: *In the Garden,* 1893.

WICHITA: *Mother and Child,* c. 1890.

BOSTON: *The Cup of Tea,* 1880; an informal portrait of the artist's mother and her sister Lydia; another version, 1879, is in the Metropolitan.

CHICAGO: *The Bath (La Toilette),* c. 1891–92; showing, like *The Boating Party,* the influence of Japanese prints as well as the work of Cassatt's artist friends Degas, Manet, and Morisot, but a classic in its own right.

METROPOLITAN: ★ *Lady at the Tea Table,* 1885; an informal portrait of the artist's friend Mrs. Biddle; Degas considered this picture "distinction itself."

Castagno, Andrea del (c. 1421–57)

A Florentine Renaissance painter who continued Masaccio's use of scientific perspective and naturalistic solidity of form, Castagno was influenced by the sculptures of his famous contemporary Donatello. Best known for frescoes, especially his *Last Supper* in San Apollinare in Florence (now the Castagno Museum), he also painted other works, a few of which are in American collections.

NATIONAL GALLERY: *Portrait of a Man,* c. 1450. *The Youthful David,* c. 1450; a parade shield for pageantry; leading artists produced many such items, but very few were preserved.

METROPOLITAN: *St. Sebastian.*

FRICK: *The Resurrection;* a small panel, apparently part of a predella for a lost altarpiece, attributed to Castagno or a close follower.

Catlin, George (1796–1872)

Catlin was a Philadelphian who gave up a law career to go West and devote his life to painting the likenesses and the folkways of American Indians, recognizing, as did his contemporary Seth Eastman, that their ways of life were doomed by white American expansionism. His works therefore have a scientific purpose, yet the human interest of the artist led him to produce more than scientific documents. His portraits capture striking personalities, while his other paintings record the color and barbaric pageantry of Indian ritual and the vigor of Indian life. "I was luckily born in time to see these people in their native dignity, and beauty, and independence," he wrote. His paintings were exhibited, with great popular success, both in America and in Europe. Catlin was so productive that examples of his work are in many American museums and in virtually all collections pertaining to Indians or the Old West. Outstanding concentrations of his work belong to the Smithsonian Institution and the National Gallery. ☛ The unfinished equestrian portrait of *Keokuk,* with the free calligraphy of its brush drawing, and the Mandan chief *Four Bears,* both in the Smithsonian Institution; *The White Cloud, Head Chief of the Iowas,* in the National Gallery.

Cellini, Benvenuto (1500–71)

A virtuoso Florentine goldsmith and sculptor, Cellini led a wildly picaresque life that he recorded in his swashbuckling and scandalous *Autobiography,* which makes for lively and entertaining reading and evokes a marvelous picture of fifteenth-century Italy. His best and most famous works are in Europe, but the Metropolitan and Cleveland have pieces attributed to him; an interesting wax figure in Boston has also been

ascribed to him. His coins and medals are in many numismatic collections. Among the few sculptures definitely by him seem to be the bust of *Benito Altoviti* in the Gardner, the marble bust of *Cosimo I de' Medici* in San Francisco, a small bronze of *Virtue Overcoming Vice* in the National Gallery, and another entitled *Neptune* in Raleigh.

Cézanne, Paul (1839–1906)

Born into a bourgeois family residing in Aix-en-Provence, Cézanne painted with the infinitely kind Pissarro in and around Paris and exhibited with the Impressionists. Then he returned to Aix to devote his life to "do Poussin again, from nature," by making Impressionism "something solid and durable, like the art of the Museums." Where Impressionism dealt with appearances, Cézanne sought to express the underlying form of things revealed through color and tone. In this lifelong, stubborn, and solitary pursuit he proved himself one of the great artists of all time, a classic French painter, and a founding father of modern art. Properly admired and sought after, his work is in all major museum collections. Important groups of his work are in the National Gallery, the Phillips, Chicago, the Metropolitan, the Guggenheim, the Modern, Barnes, Philadelphia, and Detroit.

NATIONAL GALLERY: *Still Life,* c. 1894; compare it with the late *Still Life with Apples and Peaches,* c. 1905. *Le Château Noir,* 1900–4; a house of mystery he painted often.

PHILLIPS: ★ *Mont-Sainte-Victoire,* a recurring theme in his works. *Self-Portrait,* 1878; revealing himself as stubborn, sullen, determined.

METROPOLITAN: *Bay of Marseilles Seen from l'Estaque.*

DETROIT: *Portrait of Mme. Cézanne. The Three Skulls.*

PHILADELPHIA: *Les Grandes Baigneuses,* 1898–1905.

MINNEAPOLIS: *Uncle Dominique,* one of the best of several portraits of his uncle.

Any work of Cézanne, from the sketchiest watercolor to the most architectonic, mature oil, merits serious study, even though his relentless austerity may seem forbidding at first.

Chagall, Marc (1887–)

An early modernist in Russia, influenced by Bakst and other designers associated with the ballet, Chagall settled in France, where he has lived since 1923, enjoying an international reputation as a gentle fantasist who works in paint, stained glass, mosaic, and lithography. His almost childlike imagery often recalls his childhood in Vitebsk (a charming and

classic example is *I and the Village,* 1911, in the Modern) and early years in St. Petersburg. His works are in virtually every major art museum. ☛ In addition to works in museums, he has executed wall decorations for the Metropolitan Opera House in New York City; his immense mosaic, a landmark in downtown Chicago, is immensely popular there.

Champaigne, Philippe de (1602–74)

Though born in Brussels, Champaigne became a leading painter at the court of Louis XIII and Richelieu, both of whom patronized him, as did Queen Marie de' Medici. A successful muralist and historical painter, he is best known as a portraitist; his sober and acutely observed likenesses, presented with naturalistic and formal clarity in cool and strong yet restrained color—similar to that of his contemporary Poussin—have an authoritative presence. His work is in the National Gallery, Boston, Detroit, the Metropolitan, and Toledo.

NATIONAL GALLERY: *Portrait of Omer Talon,* 1649; a magnificent grand-manner portrait of immense solidity.

METROPOLITAN: *Jean-Baptiste Colbert,* 1655.

HOUSTON: *Penitent Magdalen,* 1657; reflects the austerity of Jansenism, a Catholic reform movement centered in Port Royal, near Paris, with which the painter was closely associated.

Chardin, Jean-Baptiste (1699–1779)

A French painter of superb still life and genre pictures, in which the everyday is made memorable by an unsentimental clarity of vision and an unostentatious handling of paint in masterful compositions. Chardin is widely represented in American museums, incl. Pasadena, San Diego, San Francisco, Hartford, the National Gallery, the Phillips, Chicago, Indianapolis, Muncie, Louisville, Boston, the Fogg, Springfield, the Clark, Detroit, Minneapolis, St. Louis, Princeton, the Frick, the Metropolitan, Raleigh, Oberlin, Philadelphia, Norfolk, Ottawa, and Toronto. ☛ A pair of kitchen still lifes (Clark), *Vegetables for the Soup* (Indianapolis), ★ *A Bowl of Plums* (Phillips), *Attributes of the Architect* and *Attributes of the Painter* (Princeton), and *Un Bocal d'Abricots* (Toronto).

Christus, Petrus (c. 1420–72/73)

Christus was the chief Bruges painter after Jan van Eyck's death in 1441; he continued Jan's rather reserved style, but without his magical mastery of form and space and superb orchestration of detail.

DETROIT: *St. Jerome,* 1442.

FRICK: *Madonna,* 1443; both pictures may have been begun by Jan and finished by his pupil Petrus.

METROPOLITAN: *Lamentation;* related to a version in Brussels.

NATIONAL GALLERY: *Nativity,* c. 1445; disarmingly simple in spirit and beautifully carried out. *Donor and Wife;* a pair of panels, c. 1455; breathes an air of hushed devotion and idealistic faith.

Other examples are in Los Angeles, the Timken, and Kansas City.

Church, Frederic Edwin (1826–1900)

An American landscape painter and Thomas Cole's only direct pupil. He continued on a grand scale his teacher's approach to landscape painting, traveling in South America, Europe, Labrador, and the Holy Land, as well as in America. Church's technical mastery matched the breadth and the particularity of his vision, producing both epic panoramas and brilliant, swift sketches. He is represented in almost every American museum, with a remarkable collection of his works in the Cooper-Hewitt.

METROPOLITAN: ★ *Heart of the Andes*, 1859; a remarkably orchestrated, atmospheric, and evocative expression of the grandeur of the Andes as described by the scientist von Humboldt, in whose footsteps Church followed.

Church's picturesque house Olana was designed by the painter together with his friend Calvert Vaux, who was also the architect, with Frederick Law Olmsted, of Central Park in New York City; Olana is located in Hudson, NY, overlooking the Hudson River.

Cole, Thomas (1801–48)

Born in England, Cole came to America as a young man and founded the Hudson River School, the first national school of landscape painting. His pictures are characterized by an almost pantheistic view of nature, resembling that of Emerson and the transcendentalists. Cole also painted biblical and historical scenes, and his *Voyage of Life* series became the most famous group of paintings in America. He is represented in most collections of American art, with major groups in Boston, Hartford, Cleveland, Toledo, the New-York Historical, the Metropolitan, the National Gallery, Detroit, Albany, and the Corcoran.

NATIONAL GALLERY: ★ *Voyage of Life,* series of four paintings; the earlier versions are in Utica, 1839–40; engravings of them were circulated by the American Art Union in 1850.

CORCORAN: *Departure* and *Return;* major documents of the Gothic Revival, 1855; related to Amherst's *Past* and *Present,* 1838: "time's inexorable flow."

DETROIT: *Self-Portrait,* c. 1832; also sketchbooks, drawings, and other oils.

ALBANY: Large collection of oil sketches.

METROPOLITAN: ★ *The Oxbow,* 1846; an epic panorama of America's wild landscape, "fresh from the hand of the Creator." *Valley of the Vaucluse,* 1841; contrast Europe's scene with "everywhere the trace of men" in Bryant's famous phrase. *The Titan's Goblet,* 1833; showing Cole as one of the "inward-looking spirits," like Ryder and Inness.

HARTFORD: *Roman Campagna;* the aura of an immeasurable past. *Evening in Arcady;* idyllic landscapes, both continuing Allston's "landscape of mood."

NEW-YORK HISTORICAL: *The Course of Empire,* 1835–36; a series of five large canvases tracing the development of civilization, from *The Savage State* through *The Consummation of Empire* to the final *Desolation*—an operatic epic realized down to the minutest detail.

Constable, John (1776–1837)

Constable and Turner, his contemporary, were probably the greatest English landscape painters; they profoundly influenced the course of modern painting, stretching from Romanticism, the Barbizon School, and Naturalism to Impressionism. Constable's free but beautifully controlled impasto, airy skies, lush foliage dappled with light, and his masterful use of chiaroscuro are all uniquely his own. Widely represented in American museums, incl. Birmingham, San Francisco, Huntington, Hartford, Yale, Wilmington, the Corcoran, the National Gallery, the Phillips, Atlanta, Chicago, Indianapolis, Muncie, New Orleans, Baltimore, Boston, Smith, the Clark, Worcester, Detroit, Muskegon, Laurel, Kansas City, St. Louis, Omaha, Manchester, the Frick, the Metropolitan, Rochester, Raleigh, Cincinnati, Taft, Cleveland, Columbus, Philadelphia, Providence, Columbia, Richmond, Ottawa, and Toronto. Drawings are in Huntington, the Fogg, Providence, Vancouver, and Ottawa.

HUNTINGTON: *View on the Stour,* 1822. *Salisbury Cathedral,* 1873; one of seven versions for Bishop Fisher; compare Frick and Metropolitan pictures.

NATIONAL GALLERY: *Wivenoe Park, Essex,* 1816; the essence of English landscape.

BOSTON: *Weymouth Bay;* full of air and freshness.

ST. LOUIS: *The Leaping Horse (View on the Stour),* c. 1819; compare with the two versions of *The White Horse* (National Gallery and Frick).

FRICK: ★ *Salisbury Cathedral from the Bishop's Garden,* 1826; compare with Frick picture.

PHILADELPHIA: *Hampstead Heath, Storm Coming Up,* c. 1831.

Copley, John Singleton (1738–1815)

One of America's greatest painters and, along with Thomas Eakins, the leading American portrait painter. Without the benefit of resources, training, or good examples, and by an extraordinary act of determined application, Copley forged a style infinitely finer and stronger than anything he had ever seen in his provincial Boston. When he went to London on the eve of the Revolution, having unsuccessfully tried to reconcile the differences between Patriots and Tories, he became one of the leading painters of London and Europe, producing many memorable portraits, as well as historical scenes and works foreshadowing Romanticism. He left us a superb national gallery of Americans, incl. all the great political leaders of the pre-revolutionary period. His work is in the leading American collections, and every example is worth careful perusal. The largest collections of Copley's works are in Boston, the Metropolitan, and the National Gallery.

BOSTON: ★ *Paul Revere,* 1768–70; intelligent, alert, aware. *Samuel Adams,* 1770–72; blustering, triumphant. *John Hancock,* 1765; equivocal, self-conscious. ★ *Dr. Warren;* like his friend Revere, admirable and forthright. *Watson and the Shark,* 1778; a pioneering work of Romanticism; compare with versions in the National Gallery, the Metropolitan, and Detroit.

NATIONAL GALLERY: ★ *The Copley Family,* 1776–77; with the artist's infant son; the future chancellor of England, Lord Lyndhurst, and his little sisters, two of whom had died by the time the picture was finished; Copley's wife Sukey; her father; and the artist himself—a wonderful human document as well as a fine work of art.

METROPOLITAN: A very fine group of portraits, incl. the formal *Mrs. Jerathmael Bowers,* and *Mrs. John Winthrop,* showing her humor and quick intelligence.

Corot, Jean-Baptiste Camille (1796–1875)

After study in Paris and Italy, Corot returned to France to paint hundreds of pictures; these were so avidly collected that he remains one of the most frequently forged masters in history. (A biographer observed that of the one thousand paintings he produced, fifteen hundred are in America!) He never completely abandoned his early manner of clearly observed, broadly painted views flooded with light, but after 1850 he in-

392

creasingly produced the misty, silvery, poetic landscapes that enjoyed an exaggerated popularity. Of serene temper and great generosity, he largely supported the elderly Daumier when he was overtaken by blindness, and also aided Millet's impoverished widow. Corot's works are in virtually every museum in the Western world. Large collections are in Baltimore, Boston, Chicago, Cincinnati, the Clark, the Corcoran, the Metropolitan, the National Gallery, and Philadelphia.

CLARK: *Girl in a Pink Skirt,* 1854–60; an intense and haunting portrait.

NATIONAL GALLERY: *Ville d'Avray,* c. 1867–70; a lovely example of his silvery style.

OTTAWA: ★ *The Bridge at Narni,* 1826–27; flooded with the Italian light that Corot loved; compare the preparatory drawing.

PHILLIPS: *Città Castellana, Plains and Mountains,* 1826–27.

Courbet, Gustave (1819–77)

Largely self-taught, Courbet developed a strongly naturalistic style in his paintings of landscapes, nudes, and scenes of everyday life, the latter reflecting a spirit of social protest that earned him a reputation as a political radical. His realistic approach paralleled the writing of Balzac, Zola, and Flaubert. He was very productive, esp. in his later years, when he created paintings with a corps of assistants in an assembly-line manner. His work is in virtually every museum. There are upwards of two hundred of them in North America, with large collections in the National Gallery, the Metropolitan, and Philadelphia.

BALTIMORE: *The Grotto,* 1860–64.

CHICAGO: *Beach at Deauville,* 1865; compare Boudin's treatment of the same scene, a favorite subject that he repeated many times.

CLEVELAND: *Grand Panorama des Alpes,* c. 1865; interesting for the light it sheds on Courbet's technique, given its unfinished state.

KANSAS CITY: *Portrait of Jo.*

NORTON: *The Artist's Palette;* fascinating, showing his color range.

OBERLIN: *Castle of Chillon, Evening;* more romantic than usual.

PASADENA: *Cliffs at Étretat,* 1869 (another version in Ottawa); later a favorite subject of the Impressionists; it is even reflected in Henry Moore's sculpture.

Cranach the Elder, Lucas (1472–1553)

Court painter to the Electors of Saxony, Cranach was at his best in por-

traiture; he seems to have created the full-length portrait. He was famous in his day for erotic feminine nudes—girlishly slender, self-consciously being ogled by hirsute and elaborately costumed males in compositions masquerading as Judgments of Paris, nymphs, Venuses, Lucretias, etc. Because of a large shop, Cranach's pictures are numerous and uneven; he is represented in dozens of North American museums, incl. Pasadena, San Francisco, Hartford, Yale, the National Gallery, Atlanta, Chicago, Indianapolis, Louisville, Boston, Detroit, Muskegon, Minneapolis, Kansas City, St. Louis, Princeton, Brooklyn, the Metropolitan, Cincinnati, Cleveland, Toledo, Portland, Greenville, and Seattle.

HARTFORD: *Frederick the Wise* and *John the Faithful;* almost miniatures.

NATIONAL GALLERY: *Portraits of a Prince and Princess of Saxony,* 1517; pathetic and touching children.

METROPOLITAN: *Judgment of Paris,* 1529; see what I meant above? One of dozens! *John, Duke of Saxony;* a major patron.

CLEVELAND: *The Stag Hunt* (with Lucas Cranach the Younger); and that isn't all! A lively record of the passion for slaughter then prevalent.

Cranach's engravings are in many print collections.

Crawford, Thomas (c. 1814–57)

An American sculptor who studied in Rome with the famous Danish sculptor Thorvaldsen and joined the expatriate Neoclassicists there. He sculptured the bronze figure of *Armed Freedom* for the top of the dome of the U.S. Capitol, which one critic has called "a pregnant squaw three hundred feet in the air," and the successful equestrian statue of *Washington* in front of Jefferson's Capitol in Richmond, VA. A number of his works are in American collections, usually the white marble sentimentalizing subjects so beloved of the period; they are far less successful than his *Washington.* ☛ An immense *Sorrowing Indian Chief,* New-York Historical.

Credi, Lorenzo di (c. 1458–1537)

A Florentine painter, Credi served an apprenticeship in Verrocchio's shop along with Leonardo da Vinci. His works have tended to be overrated simply because of the distinguished ambience in which he traveled and worked. His paintings are in a number of American museums, incl. the Huntington, the Gardner, the Fogg, the Metropolitan, Princeton, Worcester, Yale, Cleveland, and Philadelphia.

394

KANSAS CITY: *Madonna and Child with the Young St. John;* showing a solid, sculptural Florentine manner.

NATIONAL GALLERY: *Self-Portrait,* 1488; at thirty-three; a fine Renaissance portrait.

Boston has a distinguished silverpoint drawing of a youth.

Crivelli, Carlo (c. 1430–95/1500)

Born in Venice, where he probably studied, Crivelli was influenced by Mantegna, giving his works a mannered emphasis on form and outline. His metallic surfaces and decorative, curvilinear style, often suggestive of goldsmithwork, were popular in the Marches, where he spent most of his life. He was prolific enough so that his works are in many American collections.

METROPOLITAN: *Madonna and Child;* mannered and decorative.

GARDNER: *St. George and the Dragon;* a fairytale illustration.

BOSTON: *Panciatichi Pietà,* 1485; attains a tragic grandeur unique in his work.

Cropsey, Jasper Francis (1823–1900)

A painter of the Hudson River School who particularly enjoyed painting autumnal scenes, Cropsey was also an able professional architect who designed his own house as well as other homes. He also created the romantic aerial fantasies that were the stations of the Sixth Avenue Elevated in New York City. His paintings, in many American collections, all show a sensitivity to light and atmosphere that links him to the Luminists.

TOLEDO: *Starrucca Viaduct,* 1863; an atmospheric panorama, incl. a view of one of the great engineering achievements of the period.

BLOOMINGTON: *American Harvesting,* 1864.

BOSTON: *Schatacook Mountain, Housatonic Valley,* 1845.

Currier, Nathaniel (1813–88); Ives, James Merritt (1824–95)

With their partnership, formed in 1857, Currier & Ives started the most successful popular printmaking firm in history. For a half century the firm produced, in vast quantity, hand-colored lithographs of popular subjects that together form a fascinating record of the life, attitudes, and interests of nineteenth-century America; the subjects range from slavery and temperance to portraits and the portrayal of contemporary events. Their prints are in collections everywhere.

Curry, John Steuart (1897–1946)

An American Regionalist painter who was born in Kansas, studied in Paris, and returned to live and paint in the Midwest. He painted historical murals for the state Capitol in Topeka, KS, and produced genre, historical subjects, and landscapes. As is the case with the other major Regionalists, Grant Wood and Thomas Hart Benton, Curry's pictures are in most American collections. ☞ Two of his most successful works are in the Metropolitan: *John Brown* and *Wisconsin Landscape.*

Cuyp, Aelbert (1620–91)

A versatile Dutch artist of Dordrecht who painted landscapes, animals, portraits, genre, still life, religious and mythological scenes, and church interiors with equal mastery. His handling of light is particularly notable. His work had a greater influence on the development of English landscape painting than on the art of his fellow Dutchmen. He is represented in a number of museums, incl. the National Gallery, Santa Barbara, the Frick, the Metropolitan, Toledo, Philadelphia, Raleigh, and Toronto. ☞ Four works are in the National Gallery and three in the Frick.

Dali, Salvador (1904–)

A Spanish Surrealist, Dali's greatest gift may be his imaginative self-promotion. He designed jewelry, ballet sets and costumes, and worked with the famous experimental film director Luis Bruñuel; he also produced prints and book illustrations. His best paintings are those created mainly in the 1930s, showing his famous soft watches and nightmare-like Freudian imagery. The importance of his religious works, usually arbitrarily sensational, has often been exaggerated because of his stylistic facility. He is represented in all major museums.

MODERN: *The Persistence of Memory,* 1931; this and the following two works are examples of classic Surrealism.

PHILADELPHIA: *Soft Construction with Boiled Beans, Premonition of Civil War,* 1936.

NATIONAL GALLERY: *The Last Supper,* 1955; a revealing tour de force.

Daubigny, Charles François (1817–78)

A French landscape painter and etcher, Daubigny's admirable work links

Corot and the Barbizon painters to Monet and the Impressionists through his interest in light and visual effects, which led him to paint atmospheric and often almost panoramic land- and seascapes, often from his floating studio, "Le Botin," his houseboat on the river Oise. He has been called "the originator of the riverbank scene," that ever-popular motif of later nineteenth-century French painting. His work is in many museums.

DETROIT: *Mills of Dordrecht,* 1872; shows his anticipation of Impressionist attitudes toward effects of light. An excellent and prolific etcher, his prints are in many print rooms; note esp. the collection of 1862, *Voyage en Bateau.*

OSHKOSH: ★ *Morning on the Oise,* 1886; a fresh and lovely painting.

Daumier, Honoré (1808–79)

A French painter, cartoonist, and sculptor, Daumier's satiric lithographs show his deep social concern, as do his oils, which are loosely and power-fully painted in a Rembrandtesque palette. A pioneer of Expressionism in both painting and sculpture and a great and deeply involved hu-manitarian, Daumier's output of lithographs was so colossal that he is represented in all print collections; his sculptures are rare; around one hundred of his paintings are in public collections, incl. Pasadena, San Diego, the Corcoran, the National Gallery, the Phillips, Chicago, Des Moines, Louisville, the Walters, Boston, the Fogg, the Clark, Detroit, Minneapolis, Kansas City, Buffalo, the Metropolitan, Cincinnati, Cleveland, Toledo, Philadelphia, Houston, Norfolk, Yale, Ottawa, and Montreal.

PHILLIPS: *The Uprising;* a symbol of the revolutionary spirit of the period.

BOSTON: ★ *Man Climbing the Rope,* c. 1860–62; an extraordinary symbolic vision. *The Horsemen;* equally remarkable.

OTTAWA: *The Third-class Carriage,* c. 1864; displaying intense human interest.

METROPOLITAN: *Don Quixote and the Dead Mule;* one of several works illustrating scenes from Cervantes' classic.

Drawings are in Stanford, Hartford, Chicago, the Walters, Brooklyn, Providence, and Montreal. Every work of Daumier is rewarding. The National Gallery has more than a dozen bronzes, all full of vitality in their wry commentary on human nature; note esp.

the powerful and affecting relief entitled *The Emigrants;* curiously, quite independently and some years later Thomas Eakins did a similar subject.

David, Gerard (1450/60?–1523)

Born near Gouda in Holland, David became a leading Flemish painter of Bruges dating from 1484; he was the last member of the native tradition started by the Van Eycks. His religious subjects have a quiet, almost tender seriousness, and his background landscapes are lucid, poetic, and serene.

CHICAGO: *Lamentation at the Foot of the Cross,* c. 1511; typically undramatic but deeply felt.

CLEVELAND: *The Nativity;* one of several versions.

DETROIT: *Annunciation,* c. 1490; a *tondo* version is in St. Louis.

FRICK: *Deposition,* c. 1510–15; totally devout.

GREENVILLE: *Crucifixion* and *The Risen Christ.*

METROPOLITAN: *Nativity with Donors and Saints Jerome and Vincent;* early work showing his Dutch origin.

NATIONAL GALLERY: ★ *Rest on the Flight into Egypt,* c. 1510; an enchanting little picture with a lovely landscape; another fine example is in the Metropolitan. *St. Anne Altarpiece,* c. 1500–10; shows his capacity for a more formal composition on a large scale.

PASADENA: *Virgin and Child with Saints and Donors;* sensitive, elegant, elevated.

SANTA BARBARA: *Deposition;* related to, but far from identical with, the version in the Frick.

David, Jacques Louis (1748–1825)

The leading Neoclassical painter of the late eighteenth and early nineteenth century, David was an enthusiastic revolutionary and virtual dictator of the arts for the revolutionary government. In 1798 he switched his allegiance to Napoleon, whose propagandist he became. After Napoleon's fall he retired to Brussels. Despite his political adventurism, he was a dominant artistic force, enlivening the dry, sculptural Neoclassic style with the color of the followers of Rubens and the chiaroscuro of Caravaggio, in a raft of great portraits and masterful subject pieces.

TIMKEN: *Portrait of Mr. Cooper Penrose.*

HARTFORD: *The Lictors Bringing Back to Brutus the Bodies of His Sons;* romanticized Neoclassicism.

NATIONAL GALLERY: *Napoleon in His Study;* the emperor

highly approved; note how David disguises his subject's short stature.

KRANNERT: *Achilles Displaying the Body of Hector at the Feet of Patroclus;* a fine painting, though its attribution to David is not certain; it is very close in style and spirit to David's brand of Neoclassicism.

CHICAGO: *Mme. Pastoret and Her Son,* c. 1792. *Portrait of Mme. Buron,* 1769.

FOGG: *Portrait of Emmanuel Sieyès,* 1817; a masterful portrait.

RALEIGH: ★ *Self-Portrait;* intense and vigorous.

METROPOLITAN: *Jeanne Eglé Desbassyns de Richemont and Her Daughter Camille. The Death of Socrates,* 1787; a dramatic tableau in austere Neoclassical style, like the *Oath*.

CLEVELAND: *Cupid and Psyche.*

TOLEDO: *The Oath of the Horatii,* 1786; this is a smaller version of his famous revolutionary painting in the Louvre; sometimes attributed to Girodet, a gifted follower.

DALLAS: *Nude Study,* 1780.

Davies, Arthur B. (1862–1928)

An American painter, muralist, and printmaker, Davies is known more for his part in organizing and participating in two revolutionary exhibitions that changed the course of American art: the show at Macbeth Galleries in New York in 1908, called Eight Americans or, more simply, The Eight (dubbed the Ash Can School by hostile critics), and the Armory Show of 1913, which showed unsuspecting Americans what had been going on in the art world in the way of experiment. Davies' works are in most American museums. Utica has two sets of his murals.

HIRSHHORN: *Hosanna of the Mountains,* c. 1905.

PHILLIPS: *Along the Erie Canal,* 1890; a fine landscape without his usual fantasy. *Springtime of Delight,* 1906.

WHITNEY: *Day of Good Fortune,* c. 1920.

BROOKLYN: *From the Quai d'Orleans,* 1925; immediately observed and painted.

ST. LOUIS: *The Wind's Way,* c. 1914–15.

UTICA: ★ *The Apennines,* 1926; a visionary Tuscan landscape.

Davis, Stuart (1894–1964)

An American painter who, under the influence of Cubism and jazz, developed a colorfully abstract style incorporating popular images and

anticipating Pop Art. His works are in almost all modern collections.

MODERN: *Lucky Strike,* 1921; looks forward to Pop.

WALKER: *Colonial Cubism,* 1956; his mature style.

WHITNEY: *Owh! In San Pao,* 1951; he had a good sense of humor!

Degas, Hilaire Germain Edgar (1834-1917)

Born in Paris of an aristocratic family, Degas studied with Ingres but developed a personal style influenced by Manet, Whistler, Japanese prints, and photography, reflected in arbitrarily cut-off compositions of great subtlety and unusual points of view. In this manner he painted, both in oil and pastel, ballet girls, women bathing, models dressing—all coolly observed as studies in composition, light, and form, like variations on a musical theme. He approached sculpture similarly; the pert and saucy little *Ballet Girl* is unique in its independent presence. There are pictures by Degas in every major art museum. Pasadena has the largest group (sixty-nine pieces) of his bronzes, as well as other works. The Metropolitan has a large collection of both bronzes and pictures, as well as drawings. The National Gallery has both paintings and bronzes. His prints are in all major print collections; note esp. his monotypes. Particularly interesting is his *Portrait of Estelle* (New Orleans), the blind wife of René de Gas, painted in 1872 while the artist was visiting his brother in New Orleans.

LOS ANGELES: *The Bellelli Sisters,* 1862-64; one of a group of paintings showing his development as a great portraitist.

DENVER: *Three Women at the Races;* pastel.

HILL-STEAD: ★ *The Tub;* a superb late pastel, its composition influenced both by photography and Japanese prints; note the rich, mixed, textured tones.

NATIONAL GALLERY: *Duke and Duchess of Morbilli,* c. 1865; relatives of the artist; aristocratic, formal, reserved; marvelously painted and subtly composed. *Madame Camus,* 1869-70; totally unorthodox in approach, brilliantly composed and painted. *Madame René de Gas,* 1872-73; a touching and beautiful portrait of Estelle, his brother's blind wife; compare the *Portrait of Estelle* in New Orleans, where Degas painted both pictures.

NEW ORLEANS: ★ *Portrait of Estelle,* 1872; Degas' sister-in-law, painted in New Orleans, where he visited the American branch of his family in 1872-73.

CHICAGO: *The Millinery Shop;* one of a group of such workaday subjects made memorable by Degas' extraordinary vision and technique.

FOGG: *The Cotton Market;* sketch for *The Cotton Exchange at New Orleans* (Pau, France), painted in New Orleans in 1872, a landmark in Degas' mature development; see *Portrait of Estelle* above.

CLARK: *The Ballet Dancer;* bronze; other versions in Boston, Omaha, the Modern, and the Metropolitan.

MINNEAPOLIS: *Mlle. Hortense Valpinçon;* an outstanding portrait.

SMITH: *Jephthah's Daughter;* early, showing the influence of Ingres. *Portrait of René de Gas,* c. 1855; the artist's brother.

METROPOLITAN: *Woman with Chrysanthemums,* 1865; a curious and fascinating informal portrait.

TORONTO: *Woman in the Bath,* c. 1892; like the Hill-Stead pastel (see above), a very fine late work.

Delacroix, Eugène (1798–1863)

The leader of the Romantic movement in French painting. Closely attuned to the contemporary Romanticism in literature represented by Byron (his favorite author), Scott, and Shakespeare, Delacroix was fascinated by the Near East, which he visited, and was, like Byron, a passionate partisan of the Greeks in their war for independence from the Turks. His immense energy is expressed in the vigor and number of his works. Delacroix is represented in fifty or so North American museums, incl. Los Angeles, Pasadena, San Francisco, Stanford, Hartford, Yale, the Corcoran, the National Gallery, the Phillips, Honolulu, the Krannert, Chicago, Baltimore, the Walters, Boston, the Gardner, the Fogg, Smith, Minneapolis, St. Louis, Omaha, Princeton, Buffalo, Brooklyn, the Metropolitan, Vassar, Cincinnati, Cleveland, Columbus, Oberlin, Toledo, Portland, Philadelphia, Providence, Richmond, Milwaukee, Ottawa, and Toronto.

HARTFORD: *Turkish Women Bathing;* Romantic exoticism.

PHILLIPS: ★ *Paganini;* compare the Ingres of the same subject.

WALTERS: *Christ on the Sea of Galilee,* 1854; another version in Philadelphia.

CHICAGO: *The Lion Hunt,* 1861; a wild mêlée recalling Rubens.

Delacroix's lithographs on Shakespearean and Faustian subjects are in most print collections. His drawings are in Stanford, Yale, the Fogg, Smith, Williams, Brooklyn, Vassar, Providence, Seattle, and Ottawa.

Demuth, Charles (1883–1935)

An American painter from Lancaster, PA, Demuth studied both in Philadelphia and in Paris. He developed a crystalline, planar style full of delicacy and firmness, which often leads to his being classed with his contemporary Charles Sheeler as a Precisionist. He used watercolor with great distinction. His works are in many museums, the most important painting being the oil *I Saw the Figure 5 in Gold* (1928) in the Metropolitan. It is based upon "The Great Figure" by his poet-friend William Carlos Williams. Fine groups of watercolors in the Metropolitan, incl. illustrations to Zola's *Nana;* the Modern, and the Whitney. ☛ *Trees and Barns,* Williams; examples in Utica, Columbus, and the Barnes.

Desiderio da Settignano (c. 1430–64)

A Florentine sculptor of the generation following Donatello, Desiderio has long been admired both for his sensitive handling of marble, in relief as well as in three dimensions, and for the graceful spirit that animates his forms. He achieved a great deal during his short life, and his influence was considerable, giving rise to many works by contemporaries and immediate followers that embody much of his spirit, and thus confuse art historians. ☛ Among the pieces on this side of the Atlantic generally agreed upon as his are a bust in Philadelphia, two marble reliefs in the National Gallery (★ *St. Jerome in the Desert* and a *Young Christ With St. John*), engaging children's busts, and the bust of *Marietta Strozzi*.

Donatello (Donato di Betto Bardi) (c. 1386–1466)

The greatest Florentine sculptor before Michelangelo, Donatello brought form to life in his figures and endowed them with the individuality, intellect, and passion that informed his own vigorous but ascetic personality. His unique skills and superb technique allowed him to express the full range of his questing spirit as he sought to reveal the potentiality of Renaissance man, cut loose from the restrictive but supportive framework of medieval belief, facing a world still familiar but somehow new, and extending to a limitless horizon. Like all really great artists, Donatello dominates yet also transcends his age to speak directly to us. Of the small number of works on this continent ascribed to him, the Martelli *David* (c. 1432–39) in the National Gallery and the marble relief of the *Madonna and Child with Angels* in Boston stand out. The latter is a superb example of *relievo schiacciato* (literally squashed relief) in which a perspective of infinity is reduced to millimetric distinctions of depth with masterful control. A terra-cotta bust of *St. John the Baptist* and a *Madonna and Child,* both polychromed, are in the National Gallery.

Doughty, Thomas (1793-1856)

Born in Philadelphia, Doughty gave up a leather business to turn to landscape painting. His Claudean vision of the American scene, still generalized and idealized, was transitional to the naturalism of the Hudson River School. He was very prolific, and his works are in most American collections. Engravings after his pictures illustrated gift books and annuals, and hand-colored lithographs were also published. In his day he was famous for the "silvery tone" of his paintings, his unique response to light, which anticipated the Luminists of the next generation.

Duccio di Buoninsegna (c. 1255-c. 1318)

The founder of the Sienese school, Duccio strove to add life to the Byzantine tradition, and developed an expressive style utilizing the Sienese grace of sinuous outline. His rare works are in the collections of the National Gallery, Boston, Wellesley, the Fogg, the Metropolitan, the Frick, Philadelphia, and the Kimbell.

NATIONAL GALLERY: A triptych of *The Nativity with the Prophets Isaiah and Ezekiel,* 1308-11. *The Calling of Peter and Andrew,* 1308-11; from the *Maestà,* the great altar for Siena Cathedral.

BOSTON: ★ *The Crucifixion;* a triptych; a small-scale masterpiece.

METROPOLITAN: *The Madonna and Child Enthroned With Angels* and *The Crucifixion;* a diptych.

FRICK: *Temptation of Christ on the Mount;* also from the *Maestà* (see above).

Duchamp, Marcel (1887-1968)

Marcel is the best known of three brothers, born into a bourgeois Norman family, who made their name in the avant-garde of modern art. Gaston, the eldest (1875-1963), was also known as Jacques Villon; he became a distinguished painter and designer in a colorful abstract manner influenced by Cubism. Raymond Duchamp-Villon, the youngest (1880-1916), left a landmark in modern sculpture in his series of bronze studies of *The Horse* (1914). Marcel was a painter and Constructivist, a founder of Dada, whose *Nude Descending a Staircase* ("an explosion in a shingle factory," as one critic called it) was the scandal of the Armory Show of 1913. His notoriety was enhanced when he submitted one of his "ready-mades," a urinal signed R. Mutt, to an exhibition. His major work is *The Large Glass,* or *The Bride Stripped Bare by Her Bachelors, Even* (1915-23), which was accidentally broken and thus "finished by

chance.'' The last forty years of Marcel's life were largely spent playir chess. The works of the three brothers are in many modern collection Jacques Villon's being the rarest in America. Raymond Duchamp Villon's bronze *Head of Baudelaire* (1911) and versions of *The Hor.* are in many modern collections, incl. the Modern, houston, and Utic Marcel Duchamp's *Nude Descending a Staircase* (both versions) is i Philadelphia, as are *The Large Glass* and several of his other works.

Durand, Asher B. (1796–1886)

Durand was early apprenticed to Peter Maverick, an engraver in Newar NJ, and when he had reached his thirties he was already a leader in th field. In the meantime he had tried portrait painting with some succes Encouraged by Luman Reed, one of America's greatest patrons, alwa generous and understanding towards young artists, Durand embarke upon landscape painting; following the lead of Thomas Cole, he becan pre-eminent in this field, and a cofounder of the Hudson River Schoc Durand's painting entitled *Kindred Spirits* (1849, in the New York Publ Library) records, at the request of Jonathan Sturgis, another great frier and patron of American artists, the comradeship and unity of poetic v sion of Cole and the poet William Cullen Bryant, showing the two stan(ing in a Catskill glen. It thus becomes an evocative monument to a hapf era in American arts and letters. Durand was greatly respected and avid collected, so his works are in almost all older collections; they form necessary part of any American collection. ☛ His portrait of *Luman Re(* is in the Metropolitan. Fine wood interiors are in Amherst, Andove Boston, and the Metropolitan; portraits and other works are in the Ne\ York Historical.

Dürer, Albrecht (1471–1528)

German painter, draftsman, etcher, engraver, and designer of woodcut author of treatises on measurement, fortification, proportion, and a tistic theory; diarist; and the great exponent of the Renaissance spirit Northern Europe. His superb prints are in every major collection. The are fine drawings in the National Gallery, Sacramento, the Clark, tl Fogg, Seattle, and Ottawa. His paintings are few in number.

NATIONAL GALLERY: *Portrait of a Clergyman,* 1516; Northern realism. *Madonna and Child,* 1496–99; and on the reverse, *Lot and His Daughters,* c. 1505; shows the Venetian influence on a Northern sensibility. ★ *Tuft of Cowslip,* 1526, gouache; lovingly observed and naturalistically painted.

GARDNER: *Man in a Fur Coat;* small-scale and miniaturistic in detail.

METROPOLITAN: *Virgin and Child with St. Anne,* 1519; intense and introspective.

PROVIDENCE: *Buttercups, Red Clover, and Plantain,* watercolor; though only attributed to him, a very fine work in Dürer's spirit.

Dürer's master prints exist in many collections:

★ *St. Jerome in His Study,* 1514; the life of the spirit. *Knight, Death, and the Devil,* 1513; the life of action. *Melancholia,* 1514; the life of the intellect.

These engravings are among the most important works of the Northern Renaissance—enigmatic, full of allusions and symbolism, and imbued with a contemplative humanistic spirit. The Clark has a sheet of captivating drawings in black ink and pen with blue, gray, and pink wash, incl. two tiny landscapes, two sleeping lionesses, a seated lion, a philosophical baboon, a sportive goat, and a sleepy lynx.

Dyck, Anthony van (1599–1641)

Born in Antwerp, Van Dyck began his studies there and then traveled to Italy; in Genoa he perfected the stylish and brilliant portrait formula that soon brought him fame. He spent his later years in England as painter in ordinary to Charles I. His portrait style established a tradition that was to last well into the nineteenth century. His paintings are in most North American museums, incl. San Diego, San Francisco, Hartford, Yale, the National Museum, the National Gallery, the Ringling, the Norton, Chicago, Indianapolis, Louisville, Baltimore, the Walters, the Gardner, Boston, Pittsfield, the Clark, Detroit, Minneapolis, Kansas City, St. Louis, Omaha, Glens Falls, the Frick, the Metropolitan, Rochester, Raleigh, Cincinnati, the Taft, Cleveland, Columbus, Oberlin, Toledo, Zanesville Art Center, OH, Greenville, Memphis, Dallas, the Kimbell, Norfolk, Richmond, Milwaukee, Ottawa, and Toronto. Significant groups are in the National Gallery, Boston, the Frick, and the Metropolitan.

METROPOLITAN: *Self-Portrait;* the Kimbell has a *Self-Portrait* painted at about age fifteen, showing his precocity.

NATIONAL GALLERY: The supreme elegance of the Balbi, Grimaldi, and Cattaneo portraits, all painted in the 1620s.

FRICK: *Frans Snyders;* the famous animal painter and favorite Rubens assistant.

BALTIMORE: *Rinaldo and Armida;* more interesting than the version in Boston, probably a studio work.

TORONTO: *Daedalus and Icarus;* a comparatively rare essay in classical mythology, as poetically done as the *Rinaldo and Armida.*

Eakins, Thomas Cowperthwait (1844–1916)

Born in Philadelphia, he was, with Copley, the greatest American portraitist. He was also an outstanding painter of genre, as well as a superb anatomist and teacher. He studied at the Pennsylvania Academy of the Fine Arts, where he later taught. He also studied in Paris and, as a result of an 1870 visit to Spain, was much influenced by Spanish painting. Nevertheless he developed his own powerful, introspective style. He is represented in almost all American collections.

METROPOLITAN: *Max Schmitt in a Single Scull,* 1871; Eakins was a natural and devoted athlete. *The Chess Players,* 1876; more portrait than genre.

CORCORAN: *The Pathetic Song,* 1881; Eakins loved music and had many musical friends.

PENNSYLVANIA ACADEMY: *Walt Whitman,* 1887; Walt approved of this portrait.

FORT WORTH: *The Swimming Hole,* 1883; American genre of a high order, recalling Mark Twain.

BROOKLYN: *Home Scene.*

PHILLIPS: *Miss Amelia C. Van Buren,* c. 1889; the subject was a pupil of the painter.

NATIONAL GALLERY: Four fine portraits plus *The Biglin Brothers Racing,* c. 1873.

ANDOVER: *Elizabeth at the Piano. Salutat,* 1898; athletes were of special interest to Eakins the anatomist.

JEFFERSON MEDICAL COLLEGE, PHILADELPHIA: ★ *The Gross Clinic,* 1875.

THE UNIVERSITY MUSEUM, PHILADELPHIA: ★ *The Agnew Clinic,* 1889. Both Clinics paintings are landmarks in art and medicine.

YALE: *Taking the Count,* 1898.

BOSTON: *Starting Out After Rail,* watercolor, 1874; another equally fine version is in Wichita. *Mrs. Mary Halloch Greenewalt,* 1903; a friend and a concert pianist.

PHILADELPHIA: *Wrestlers;* one of several versions. *William Rush Carving His Allegorical Figure of the Schuylkill River,* 1877.

NATIONAL ACADEMY: *Self-Portrait,* 1902; extraordinarily frank and revealing, a fascinating document of a remarkable, complex, creative personality.

Earl, Ralph (1751-1801)

Described as "a bigamist, a wife-deserter, a spendthrift, and a drunkard," Earl was nevertheless a leading painter of his generation. Until he left for England in 1778, he was a gifted primitive portraitist; on his return in 1785, after study with West, he displayed a mature and fluent style in which he produced many portraits, mostly in western Connecticut, before dying of "intemperance."

METROPOLITAN: *Col. Marius Willett;* a Revolutionary hero.

YALE: *Roger Sherman,* c. 1775-77; a great primitive portrait. Yale also owns *Mrs. William Mosely and Her Son Charles,* 1791.

NATIONAL GALLERY: Owns several of his works, esp. *David Boardman.*

CORCORAN: *Timothy Gay,* c. 1800.

WORCESTER: *William Carpenter;* another fine primitive.

HARTFORD: *Chief Justice Oliver Ellsworth and His Wife, Abigail Wolcott,* 1792; a handsome, formal composition showing two full-length seated figures in an interior, with a landscape viewed through another window of the same house seen from the outside—thus, a picture within a picture.

Eastman, Seth (1808-75)

Born in Brunswick, Maine, Eastman went to West Point in 1824, and later studied topographical drawing. While stationed at Fort Snelling, MN, in the 1840s, he began the pictorial record of "Indian character, and . . . their manners and customs, and the more important fragments of their history," as a contemporary observer recorded. Though a career officer who eventually became a general, Eastman devoted his life to this purpose. He illustrated many publications, incl. the landmark books of Henry Rowe Schoolcraft, and his works are in most art collections of the American West, the American Indian, and general American collec tions. Important concentrations of his work are in the Peabody Museum, Harvard University; the James Jerome Hill Library, St. Paul, MN; and the Newbury Library, Chicago.

Elsheimer, Adam (1578-1610)

A German landscape painter who lived and worked in Italy. He executed small, idealized, detailed views in oil on copper, which are fascinating in terms of their treatment of light. Though suffering from a growing state of depression that severely limited his capacity to work, like his contemporary Hercules Seghers, he produced works that had a great influence on Rembrandt, Claude, and Rubens—who was a friend and admirer—and affected the subsequent development of European painting. His rare paintings are in only a few major collections. ☞ There is a fine example of his work at Yale.

Eyck, Jan van (c. 1390-1441); Hubert van (fl. 1424-26)

The Ghent Altarpiece (completed 1432) of *The Adoration of the Lamb* in St. Bavon, one of the great landmarks in art history, bears the name of both brothers. Little else is known of Hubert, but Jan had a distinguished career as court painter to Philip the Good, Duke of Burgundy, and as an occasional diplomat. His paintings show the same superb mastery of the oil technique seen in the altarpiece, with subtle control of light, organization of detail, and luminous color—all of which profoundly influenced the entire course of Western art. Every one of his extraordinary works invites and rewards the most attentive scrutiny.

DETROIT: ★ *St. Jerome in His Study,* a tiny work (8 – 1/8″ × 5 – 1/4″); completed in 1442, after Jan's death, by his follower Petrus Christus; note the pensive lion and the marvelous still life.

FRICK: *Virgin and Child with Saints and Donor,* early 1440s; probably also completed by Petrus Christus.

METROPOLITAN: *Crucifixion* and *Last Judgment;* a diptych displaying incredible detail for its tiny size, yet monumental in its conception.

NATIONAL GALLERY: *Annunciation,* c. 1425-30; with a soaring Late Gothic spirit.

PHILADELPHIA: ★ *St. Francis Receiving the Stigmata,* another incredibly small work (5″ × 5 – 3/4″); like most of his other works, this was evidently painted with the aid of a magnifying glass; each of these miraculous pictures contains, in miniature, a whole late medieval world on the verge of entering the Renaissance.

Fantin-Latour, Henri (1836-1904)

A friend of Manet, Degas, and the other experimental artists of the

period, Fantin-Latour painted still lifes, figure groups, and portraits. He is at his best in the richly colored, velvety flower and fruit pieces found in many collections, and for a few remarkable portraits. Characteristic works are in Boston, Cleveland, Kansas City, the Metropolitan, the National Gallery, the Phillips, St. Louis, and Toledo.

NATIONAL GALLERY: *La Duchesse de Fitz-James,* 1867; a fine cabinet portrait. *Self-Portrait at Twenty-two,* 1858.

Feke, Robert (c. 1705–c. 1750)

Feke was a mysterious and extremely gifted American Colonial painter about whom very little is known. Born in Oyster Bay, Long Island, he worked in Boston, Philadelphia, and Newport, where he lived. Unbelievably accomplished for a provincial artist of his time, he is the only Colonial painter to rival Copley, who was more than thirty years his junior. He was described by a contemporary as having "exactly the phiz of a painter, having a long pale face, sharp nose, large eyes—with which he looked upon you steadfastly—long curled black hair, a delicate white hand, and long fingers." He painted "tolerably well by the force of genius, having never had any teaching." There are portraits by Feke in Providence, Cleveland, Rhode Island Historical, the Pennsylvania Academy, the Newport Historical Society, the National Gallery, the Historical Society of Pennsylvania, and the Redwood Library in Newport. ☛ A group of half a dozen works are in Bowdoin, particularly Feke's masterpiece ★ *General Samuel Waldo,* c. 1742, a full-length, life-sized portrait of superb quality, one of the greatest Early American paintings; and the Bowdoin family portraits, 1748–49. *Isaac Royall and Family,* 1741, at the Harvard Law School, is an outstanding group portrait.

Field, Erastus Salisbury (1805–1900)

A prolific folk painter from western Massachusetts, Field produced many beguiling portraits of friends, relatives, neighbors, and various inhabitants of the Connecticut River Valley. He also graphically rendered religious subjects, a favorite being *Adam and Eve in the Garden of Eden,* which he painted several times. He summed up his faith in the future of America in an immense and detailed architectural fantasy entitled ★ *Historical Monument of the American Republic,* c. 1876, Springfield. His work is in almost all folk art and American collections. ☛ Particularly interesting is the *Group Portrait* in the Karolik Collection in Boston.

Flémalle, Master of. *See* **Campin, Robert.**

Fouquet, Jean (Jehan) (c. 1420–c. 1481)
The leading French painter of the fifteenth century, Fouquet was patronized by Charles VIII. He painted portraits and miniatures and designed sculpture. He probably studied in Paris, is recorded as having visited Italy, and lived in Tours. His major works in America are illuminations from *The Book of Hours of Étienne Chevalier,* 1450–55, in the Lehman Collection in the Metropolitan, and a small prayer book in the Morgan. The National Gallery has a fine portrait in metalpoint. He was a masterful and versatile artist of great individuality.

Fragonard, Jean Honoré (1732–1806)
Fragonard epitomized the spirit of gallantry within aristocratic circles in pre-revolutionary France. He studied with Chardin and Boucher, traveled in Italy with Hubert Robert, where both produced superb drawings. His carefree, hedonistic painting could not survive the self-conscious high-mindedness of the Revolution, and he died in Paris forgotten. Fragonards are found in Tucson (fine collection of drawings), Los Angeles, Pasadena, the Timken, San Francisco, Hartford, the National Gallery, Indianapolis, Muncie, Louisville, Baltimore, Boston, the Fogg, the Clark, Detroit, St. Louis, the Frick, the Metropolitan, Raleigh, Cincinnati, Cleveland, Columbus, Toledo, Portland, the Frick-Pittsburgh, the Kimbell, Norfolk, and Milwaukee. Considerable collections are in Tucson, the National Gallery, the Frick, and the Metropolitan. Drawings are in Tucson (University of Arizona), and the Fogg.
NATIONAL GALLERY: *Portrait of Hubert Robert,* c. 1760;
 Robert was an outstanding painter of romantic ruins. A friend of
 Fragonard, both artists sketched and painted in Tivoli and Rome.
 Young Girl Reading, c. 1776; a delightful picture.
FRICK: *The Progress of Love,* 1771–72; a series of four paintings in
 the superb Fragonard Room, the epitome of courtly decoration at
 the highest level of quality, full of the spirit of gallantry and
 masterfully painted.
CLARK: *The Warrior;* an extraordinary character study suggesting
 the artist's distrust of the warlike; one of a series of imaginary
 portraits illustrating various temperaments.

Francesco di Giorgio Martini (1439–1501/2)
A Sienese painter, architect, sculptor, and military engineer, Francesco di Giorgio's works are rare in America. ☛ Among the few pieces at-

tributed to him are a painting of *God the Father Surrounded by Angels and Cherubim,* c. 1470, and a sensitively modeled bronze relief of *St. Jerome in the Wilderness,* c. 1477, both in the National Gallery. Other pieces are in the Fogg and the Metropolitan.

French, Daniel Chester (1850–1931)

After studying with William Rimmer and John Quincy Adams Ward, the twenty-five-year-old French, at the suggestion of Ralph Waldo Emerson, received the commission for *The Minute Man* (1875), in Concord, MA, which won him immediate fame. For the rest of the century he and his friend Augustus Saint-Gaudens dominated the sculptural scene in America. French's best known work is the colossal *Lincoln* (1922), in the Lincoln Memorial in Washington, D. C. He carried out innumerable official as well as private commissions during his active life. His most successful portrait bust is probably the *Ralph Waldo Emerson* he did from life in 1879; casts are in a number of collections. Virtually all major museums have examples of French's work.

Fulton, Robert (1765–1815)

Though best known for his invention of the steamboat, Fulton was an excellent painter, a pupil of Benjamin West in London, who produced exemplary portraits, examples of which are in a number of American museums. He once painted a panorama of *The Burning of Moscow by Napoleon's Army,* which he presented to the Parisian public, complete with sound effects, using the admission fees to finance his work on the steamboat.

Gabo, Naum (1890–1977)

A Russian modernist sculptor, Gabo (the name was changed) was the younger brother of the artist Antoine Pevsner. Both evolved from Cubist beginnings to become major exponents of Tatlin's Constructivism in Russia (1917–22). Gabo worked in Germany until he was driven out by the Nazis in 1932, when he went to England. He came to America in 1946. His work is in major modern art collections, with a concentration in the Modern.

Gaddi, Taddeo (c. 1300–66); Agnolo (c. 1345–96)

Florentine painters, father and son, transmitted the tradition established by Giotto, with whom Taddeo had studied, to Cennino Cennini, whose famous treatise on painting, *Il Libro dell' Arte* (c. 1390) carried it into the early Renaissance. (Cennino's book has been translated into English

411

and is available in paperback; it is an interesting document.) Few of the Gaddis' works are in America. In addition to those at Yale and Montreal are the following:

METROPOLITAN: *Madonna and Child Enthroned with Saints,* by Taddeo.

NATIONAL GALLERY: *Madonna Enthroned with Saints and Angels,* a polyptych by Agnolo, c. 1380–90. *Coronation of the Virgin,* c. 1370, also by Agnolo.

Gainsborough, Thomas (1727–88)

One of England's greatest portrait and landscape painters, Gainsborough started out painting small figures in landscape settings, but after moving to Bath in 1760, he painted formidable full-length portraits in a Van Dyck manner (like his famous *Blue Boy* in the Huntington). He moved to London in 1774 and became Sir Joshua Reynolds' only real rival. His later landscapes, so admired by Constable, show an ethereal quality resulting from a fluid handling of oil paint almost like watercolor. Gainsborough has been much collected and is represented in most museums; significant groups of his works are in the Huntington, the National Gallery, Boston, Detroit, the Frick, the Metropolitan, Cincinnati, and Philadelphia.

AMHERST: *Jeffrey, Lord Amherst,* c. 1785; "the soldier of the king," after whom both town and college were named; he is not nearly as warlike in appearance as the famous college song would lead us to believe.

BOSTON: *Landscape with Milkmaids and Cattle;* a good example of Van Dyck's landscape style, showing the influence of such Dutchmen as Hobbema and Ruisdael, but personal in both vision and handling.

FOGG: *Count Rumford,* 1783; the sitter, a New Englander named Benjamin Thompson, both genius and rogue, became a count of the Holy Roman Empire and a statesman unfettered by scruples.

GETTY: *The Earl of Essex Presenting a Cup to Thomas Clutterbuck,* 1784; which only goes to show what an artist of genius can make of the commemoration of an otherwise eminently forgettable event!

HARTFORD: *Woody Landscape;* like most of Gainsborough's landscapes, it shows elements of the picturesque rediscovery of nature in literature and landscape gardening.

HUNTINGTON: *Portrait of Jonathan Buttall,* 1770; better known as the *Blue Boy;* a deliberate recall of Van Dyck both in manner and costume; note also the charming *Cottage Door,* 1780.

INDIANAPOLIS: *The Old Stone Cottage;* the then newly discovered charms of rusticity, as in Boston's *Mushroom Girl.*

KIMBELL: *Suffolk Landscape*; Gainsborough's home country; he clearly transmits his feeling for it and his "strong inclination for in Landskip . . ."

RINGLING: *General Philip Honeywood,* 1759; an immense picture made memorable in spite of its subject—a Col. Blimp if there ever was one—by beautiful painting and a lovely landscape.

PHILADELPHIA: *View Near King's Bromley-on-Trent, Staffordshire;* freshly observed and painted; compare it with the *Classical Landscape,* equally fine but purposely unspecific as to place, though not dissimilar in mood.

TORONTO: *Harvest Wagon,* c. 1784; compare with Constable's *Scene in Helmington Park, Suffolk,* painted a generation later, to gauge the character of vision, feeling, handling, and personal style of two of the greatest landscape painters of all time.

There are fine drawings in the Fogg, Ottawa, Providence, Seattle, Smith, and several other collections.

Gauguin, Paul (1848–1903)

Born in Paris, Gauguin grew up in Peru, his mother's native country. In 1871 he returned from seafaring to become a stockbroker and an amateur painter who collected Impressionist art. Profoundly dissatisfied with his bourgeois life, he deserted his family in 1883 to become a full-time artist, first at Pont-Aven and Le Pouldu, Brittany, and then in Tahiti after 1890. There, failing health and increasing poverty diminished his production. In going to the South Seas he abandoned all connection with the artistic traditions of Western Europe, developing a powerful symbolic expression of his identification with the unspoiled, primitive societies. He was extremely influential in shaping the development of modern art. His works, which incl. paintings, sculpture, and prints, are in most art museums; all are of the greatest interest. Many are disturbingly enigmatic, with overtones of spiritual forces intensely alive among people living close to nature. His greatest statement is embodied in the monumental painting in Boston entitled *Where Do We Come From? What Are We? Where Are We Going?* Important groups of his art are in the National Gallery,

Los Angeles, the Phillips, Indianapolis, Hartford, Boston, Kansas City, Chicago, Buffalo, the Metropolitan, the Modern, Cleveland, etc. Distinctive prints are in all major print collections.

BOSTON: *Where Do We Come From? What Are We? Where Are We Going?* 1897; the climactic work of his Tahitian sojourn.

BUFFALO: *The Yellow Christ,* 1889; painted at Le Pouldu, Brittany; spirituality struggling for expression. *The Spirit of the Dead Watching,* 1892; Polynesian belief becomes a universal symbol.

HONOLULU: *Two Nudes on a Tahitian Beach;* paradisiacal aspects of primitivism.

INDIANAPOLIS: *Landscape Near Arles;* shows the influence of Van Gogh.

METROPOLITAN: *Ia Orana Maria (I Hail Thee, Mary);* a Tahitian Madonna.

MODERN: *The Moon and the Earth,* 1893; Gauguin attempted to make primitive mythology universal, not merely borrowing forms, as did Picasso.

NATIONAL GALLERY: *Self-Portrait,* 1889; painted at Pont-Aven, Brittany, but anticipating his Tahitian work. *Haystacks in Brittany,* 1890.

Gentile da Fabriano (c. 1370–1427)

An Italian painter who worked in Venice and Florence. His splendid altarpiece of *The Adoration of the Magi* (1423), in the Uffizi, is justly famous, showing his mastery of the elegant grace of the International Style, which flourished on the eve of the Renaissance. His *Quaratesi Altarpiece* (1425) is divided among the Uffizi, the Vatican, the British Royal Collection, and the National Gallery. He is represented in the Fogg, the Metropolitan, the Frick, and Yale.

NATIONAL GALLERY: *Miracle of St. Nicholas of Bari,* 1425, from the *Quaratesi Altarpiece. Madonna and Child,* c. 1422.

FRICK: *Madonna and Child With Saints Lawrence and Julian,* 1423–25.

Gentileschi, Artemisia (1597–1651/53)

This artist was the gifted daughter of Orazio Gentileschi, follower of Caravaggio and court painter to Charles I of England. She studied with Agostino Tassi, whom her father sued in 1612 for raping her, and Tassi was sentenced to several years in prison. Understandably, her dramatic

414

chiaroscuro style owes more to her father than to her teacher. Her last years were spent in Naples, where she was productive and greatly admired. Her favorite subjects were dramatic renditions of such episodes as Judith killing Holofernes. There are few works by her in America.

DETROIT: *Judith and Maidservant with the Head of Holofernes,* c. 1625; Caravaggesque drama.

COLUMBUS: *David and Bathsheba,* c. 1640–45.

EL PASO: *St. Catherine of Alexandria,* 1620s; from the artist's Florentine period, perhaps reflecting her study of the Mannerists.

Gentileschi, Orazio (1563–1639)

An Italian follower of Caravaggio, Gentileschi painted in Paris and settled in London in 1626 as court painter to Charles I. His daughter, Artemisia, was an equally gifted painter; she accompanied him on his travels on the Continent, probably often serving as his model. His paintings also are rare in America.

NATIONAL GALLERY: ★ *St. Cecilia and An Angel,* c. 1610. *The Lute Player,* c. 1610; if the artist's daughter posed for both of these pictures, as is likely, the motivations for the unwanted attentions of Agostino Tassi become understandable if unforgivable.

Géricault, Théodore (1791–1824)

A French Romantic painter and a contemporary of Delacroix, Géricault's sojourn in England (1820–22) contributed much to the development of Romantic painting there. His most famous work, *The Raft of the Medusa* (1819), in the Louvre, records the events following a shipwreck, which was also a national scandal. A landmark in Romantic painting, it was exhibited in England as well as in France. Géricault's sympathetic portrayal of inmates of a Paris insane asylum (1822–23) are moving testaments to the artist's sympathies and to the humanitarianism born of the Romantic movement. He was a superb lithographer and draftsman; his prints are in numerous collections, and an important group of his vigorous drawings are in American museums. Though he lived only thirty-two years, his achievement was remarkable. He is well represented in the National Gallery, Hartford, Chicago, the Fogg, Springfield, the Walters, Smith, Buffalo, Detroit, Providence, and Richmond.

CLARK: *Trumpeter of the Hussars;* as romantic as a trumpet call.

FOGG: *The Lion Hunt;* shows the influence of Rubens on Romanticism; compare with Delacroix's treatment of similar subjects.

415

NATIONAL GALLERY: *Trumpeters of Napoleon's Imperial Guard,* 1812–14; note the magnificent dappled Arabian horse; horses became a symbol for the Romantic artist, full of mettle, sharers of the human drama.

RICHMOND: *Scene from the Greek War for Independence;* like the poet Byron, who died in Greece, Europeans and Americans shared a profound sympathy for the Greeks' fight for freedom from the Turks.

SPRINGFIELD: *Portrait of an Inmate of Salpêtrière;* one of a notable series of paintings expressing the artist's sympathies for the afflicted and reflecting the contemporary reappraisal of the problem of mental illness.

STANFORD: *The Black Standard Bearer;* the black man as hero, another revolutionary attitude resulting from the Romantic artist's humanitarianism.

Ghiberti, Lorenzo (1378–1455)

Justly famous for the two bronze doors of the Baptistry in Florence—a second pair commissioned later Michelangelo described as fit to be the "Doors of Paradise"—Ghiberti's sculpture marks the transition from the Late Gothic to the Renaissance and thus represents a remarkable achievement. The doors were equivalent to art school training for many painters and sculptors who worked as his assistants, among them the great Donatello, and for those who came after him and used the doors as the basis for further study. An intellectual and a humanist, his *Commentaries* are among the most important writings on art in the Renaissance. The second book, which is autobiographical, is lively and fascinating, revealing an extraordinary mind and a creative spirit. There are a few works in American collections attributed to him, such as a fine terra-cotta *Madonna and Child* in the National Gallery, but nothing to suggest his unique position as an artist bridging the ancient, medieval, and modern worlds.

Ghirlandaio, Domenico (1449–94)

Ghirlandaio painted many handsome, well-composed frescoes filled with portraits of his contemporaries and details of everyday life, all of which display great liveliness and charm. He also painted individual portraits, several of which are in American collections; his works are in the Fogg, Detroit, the National Gallery, the Metropolitan, and Philadelphia.

NATIONAL GALLERY: *Portrait of Lucrezia Tornabuoni,* c. 1475. *Madonna and Child,* c. 1470.

METROPOLITAN: *Francesco Sassetti and His Son Teodoro;* a double portrait of great charm.

Giacometti, Alberto (1901–66)

A Swiss sculptor, painter, and poet, Giacometti was deeply influenced by Surrealism. He is best known for his attenuated, solitary figures, their surfaces roughened as if by some terrible ordeal, as by fire. He is represented in most museums with modern collections. The Hirshhorn has several characteristic examples of his sculptural style.

MODERN: *The Palace at 4 A.M.,* 1932–33.

NATIONAL GALLERY: *The Invisible Object (Hands Holding the Void),* 1934–35.

Giorgione (c. 1476/78–1510)

Born in Castelfranco, where there is an exceedingly fine altarpiece by him, Giorgione was an extremely gifted painter who died of the plague in his thirties. A pupil of Giovanni Bellini, he has always been considered one of the greatest innovators, yet his life and the identification of his work, much less the interpretation of the enigmatic pictures generally attributed to him, remain shrouded in mystery. Though scholars disagree as to which paintings are actually by him, there is general agreement concerning Giorgione's qualities: soft, *sfumato* modeling; atmospheric effects of light; and a kind of personal yet cool and remote lyricism (which is also reflected in Titian's art). Among works attributed to him in American collections are:

SAN DIEGO: *Portrait of a Man,* c. 1508–10; it bears a sixteenth-century inscription on the reverse.

NATIONAL GALLERY: ★ *Adoration of the Shepherds (Allendale Nativity),* c. 1505–10; has all the Giorgionesque qualities—a lovely painting. *Nativity,* probably early, but the Giorgionesque spirit is apparent.

PHILLIPS: *The Astrologer;* usually considered the school of Giorgione; fine and interesting.

GARDNER: *Ecce Homo;* also attributed to the school of Giovanni Bellini; impressive whoever painted it.

PRINCETON: *Paris Abandoned on Mt. Ida;* attributed to Giorgione by some experts.

417

Giotto di Bondone (1266/67 or 1276/77–1337)

One of the giants of the world of art, Giotto was a peasant's son who became one of the greatest painters and architects of all time. In his frescoes and altarpieces he conceived of his figures sculpturally, with bulk, mass, and roundness, occupying a physical space—a revolutionary change from the flat patterns of the Byzantine tradition. He renewed Western art and laid the foundations for modern art. Though he lived in the Middle Ages, he belongs to all ages.

SAN DIEGO: *The Eternal Father with Angels,* c. 1335.

NATIONAL GALLERY: ★ *Madonna and Child,* c. 1320; monumental but no longer utterly remote.

GARDNER: *The Presentation in the Temple;* supreme clarity of narrative and form.

METROPOLITAN: *The Epiphany;* combines the Annunciation to the Shepherds, the Adoration of the Magi, and the Nativity with touching simplicity.

RALEIGH: *Peruzzi Altarpiece,* c. 1318; painted by Giotto and members of his workshop; commissioned by a leading Florentine family whose chapel in Santa Croce Giotto frescoed.

Giovanni di Paolo (1403–82/83)

Giovanni di Paolo and Sassetta were the leading Sienese painters of the fifteenth century. Because of Siena's conservatism, both painted in an essentially late medieval manner, utilizing attributes of the International Style and showing the influence of Gentile da Fabriano. Giovanni was also an illuminator of manuscripts, as might be guessed from the childlike clarity of his visual narratives. His works are in many museums, among them an altarpiece in Pasadena, and paintings in the Walters, Boston, the Gardner, the Fogg, Chicago, Cleveland, Minneapolis, the Metropolitan, Philadelphia, Detroit, the National Gallery, and Yale.

NATIONAL GALLERY: *Adoration of the Magi,* c. 1450. *Annunciation,* c. 1445; both miniaturistic.

CHICAGO: *Six Scenes from the Life of St. John the Baptist;* graphic narrative through poetic means, combining real details with a nonrealistic style.

METROPOLITAN: ★ *Paradise,* c. 1445; this and the *Expulsion* are probably from the dismembered Guelfi altar done for San Domenico, Siena. *Adam and Eve Expelled from Paradise. Madonna and Child with Saints,* c. 1450.

DETROIT: *St. Catherine of Siena Dictating the Dialogues.*

CLEVELAND: *Adoration of the Magi,* c. 1430; strongly influenced by Gentile da Fabriano's magnificent altarpiece in the Uffizi.

Glackens, William (1870–1938)

An American painter and printmaker who studied at the Pennsylvania Academy of the Fine Arts and in Paris, was a combat artist during the Spanish-American War, and was one of The Eight, the famous exhibition held in 1908, which critics labeled the Ash Can School. He gave excellent advice to his boyhood friend, the terrible-tempered Dr. Barnes, on the formation of the latter's outstanding collection (now the Barnes Foundation, located in Merion, PA). Glackens' pictures are well painted, lively in observation, always attractive without being pretty, and have nothing of the ash can about them whatsoever. His works are in virtually all museums with American collections.

CHICAGO: ★ *Chez Mouquin,* 1905; Manet-like in composition, but very much Glackens in style; the man is James B. Moore, an art patron and friend of the artist, and the young lady is one of his several "daughters"; Mrs. Glackens, also an artist, is reflected in the mirror and is seen from the rear; the setting is a fashionable restaurant in New York. Glackens' portrait of his wife (1905), in Hartford, reflects her humor and her delightful personality.

CLEVELAND: *The Drive, Central Park;* characteristically lively.

SANTA BARBARA: *The East River from Brooklyn;* vividly observed and vigorously painted.

Goes, Hugo van der (c. 1440–82)

In the generation following the Van Eycks, Van der Goes was outstanding among Netherlandish painters. His famous *Portinari Altarpiece* (c. 1475), painted for a Medici banker in Bruges and sent back to Florence (Uffizi), influenced the course of Florentine art through its luminous demonstration of the richness achieved by means of the oil technique developed in the North. His decided mystical tendencies appear in the visionary quality of his art, which represents a sublimation of the religious melancholia that shadowed his late years, though he continued to paint as a lay brother in a monastery near Brussels and was much honored by his contemporaries. There are few works on this side of the Atlantic attributable to him. Among these are a *Portrait* in the Walters and the following:

METROPOLITAN: *Portrait of a Man* (a fragment cut out of a larger picture); shows his interest in human psychology, as does the *Portrait of a Monk.*

PHILADELPHIA: *Madonna and Child,* probably before 1475; like all his earlier works, this one is rich in color.

Gogh, Vincent van (1853–90)

A Dutch artist who inherited a sense of mission from his minister father and took up painting as a means of communication when his attempts at religious missionary work failed. Always of precarious mental health, he was afflicted with bouts of insanity, which became more frequent until, seeing the inevitable, he died by his own hand at only thirty-seven. Almost entirely self-taught as a painter, he learned his craft from Gauguin and the Impressionists, whom he knew well. His mature work, both in oil and in pen and ink (which he used with great distinction), vibrates in accord with a mystic rhythm expressed in the pattern of his sure strokes. Paint is applied in a superbly controlled but yet spontaneous manner that poignantly expresses his pantheistic view of nature. His goal was "to express hope with a star, the ardor of being with the radiance of the setting sun." His brother Theo appreciated his gifts; Vincent's letters to Theo are a marvelously revealing and interesting record. Theo died only six months after Vincent, and the brothers are buried side by side in the walled graveyard of Auvers-sur-Oise, the town where Dr. Gachet, who cared for him during his later, troubled years, maintained the clinic that was his refuge. Only nine years of Van Gogh's life were devoted to painting, yet he produced more than six hundred paintings and more than eight hundred watercolors and drawings. He is represented in every major museum collection, from the East Coast to Hawaii. Everything he touched expressed "the ardor of his being."

BOSTON: *The Postman Roulin,* 1888; painted at Arles; a wonderfully French character! For the portrait of Roulin's baby, visit the National Gallery.

CARNEGIE INSTITUTE, PITTSBURGH: *The Plain at Auvers,* 1890; wheatfields after rain, painted just before the artist's death.

CHICAGO: *Bedroom at Arles,* late 1880s.

FOGG: *Self-Portrait,* 1888.

HONOLULU: *Wheatfields,* 1880s; one can feel the intensity of the southern sun.

METROPOLITAN: *L'Arlésienne (Madame Ginoux),* 1888; painted when Van Gogh and Gauguin were working together.

MODERN: ★ *Starry Night,* 1889; one of his most evocative pictures, painted in the South of France.

NATIONAL GALLERY: *Farmhouse in Provence,* 1888. *Self-Portrait,* 1889; also a superb drawing of the ★ *Plain of La Crau* for the magnificent landscape in the Stedelijk Museum, Amsterdam.

PHILLIPS: *Entrance to the Public Gardens at Arles.*

YALE: *Night Cafe,* 1888; the ordinary viewed as a miracle.

Goncharova, Natalia (1881–1962)

A gifted Russian experimental painter and theatrical designer, Goncharova developed the movement called Rayonism, an offshoot of Cubism, with Mikhail Larionov, in 1911. She left Russia for Paris because her views of art ran counter to Communist ideology. There she continued until past mid-century a distinguished artist career. Among the comparatively few works in America are those in the Guggenheim, esp. *Cats* (c. 1911), and her set designs for Rimsky-Korsakoff's ballet *Le Coq d'Or* for the 1914 Ballets Russes production, in the Modern.

Gorky, Arshile (1904–48)

Gorky was born in Turkish Armenia and came to America as a child in 1920 with his parents, refugees from Turkish oppression. Influenced by Cubism and by other aspects of the art of Picasso, Gorky evolved a Surrealist style of biomorphic character, which brought him into contact with the New York School. Following a cancer operation in 1946 and a car crash in which he broke his neck, he felt his physical control failing and committed suicide in 1948. His work is in virtually all museums with modern collections, with significant groups in the Modern, the Guggenheim, the Hirshhorn, and Buffalo. ☛ The dual portrait of *The Artist and His Mother* (1926) at the Whitney is an affecting record.

Goya, Francisco José de Goya y Lucientes (1746–1828)

Goya and Velázquez are the two greatest giants of Spanish art. Velázquez represents a cool, austere, almost remote Spanish sensibility embodied in pictures of incredible scope and command. Goya, on the contrary, was the artist of passion, his imagination fired to incandescence by what he observed of humanity. No protest against man's cruelty is more poignant than his remarkable series of etchings entitled *The Disasters of War* (1810–14), or against human folly than *Los Caprichos* (1793–98). His portraits are incredibly revealing, esp. those of the cretinous royal families

of Charles IV and Ferdinand VII. Yet his tapestry cartoons, despite occasional touches of the satanic, are earthy and poetic evocations of the picturesqueness of Spanish life. Late in life, isolated by a resounding deafness, he explored the realm of the imagination yet further, producing monstrous visions. Goya's prints are in every print collection. His paintings are in dozens of North American museums, incl. Pasadena, San Diego, Hartford, the National Gallery, the Phillips, Chicago, Indianapolis, Des Moines, Louisville, Baltimore, Boston, the Clark, Worcester, Detroit, Muskegon, Minneapolis, Kansas City, St. Louis, Omaha, Brooklyn, the Frick, Hispanic Society, the Metropolitan, Raleigh, Cincinnati, Cleveland, Toledo, Philadelphia, Providence, the Kimbell, Richmond, Quebec. Drawings are in the Phillips, Chicago, the Fogg, Princeton, Seattle, Ottawa, and the Metropolitan. Significant collections of paintings are in the National Gallery and the Metropolitan.

CHICAGO: *The Capture of the Bandit Maragato by Fray Pedro* (six panels) 1806; a lively narrative.

CLARK: *Asensio Julia,* 1814; Spanish intensity and reserve.

FRICK: *The Forge;* suggests the influence of Delacroix and anticipates Manet.

HISPANIC SOCIETY: *The Duchess of Alba,* 1797; formal yet very personal; signed "Goya Alone," it was for years his souvenir of his stay with the duchess at one of her estates in southern Spain; Princeton has a fine drawing of her from the Madrid sketchbook.

METROPOLITAN: *Majas on a Balcony,* 1810–15; Majas were young women of the people whose gamine chic was copied by upper-class ladies. ★ *Don Manuel Osorio de Zuñiga,* 1784; a delightful child's portrait with some of the best cats in the history of art.

NATIONAL GALLERY: *Marquesa de Pontejos,* c. 1786; done at height of Spanish Rococo style. *Queen Maria Luisa,* c. 1799; a vicious harridan! (another portrait is in Cincinnati). *Carlos IV as Huntsman,* c. 1799; a nincompoop whose dog is by far the nobler and more intelligent of the two. *Señora Sabasa García,* c. 1806; a haunting portrait, deliciously painted. *Condesa de Chinchón,* 1783; a charming child's portrait, playfully serious.

ST. LOUIS: *Self-Portrait,* c. 1771–75; a direct, youthful, totally confident appraisal.

TOLEDO: *Children with a Cart,* 1778; a tapestry cartoon, of which Goya did many.

Goyen, Jan van (1596–1656)

One of the outstanding Dutch painters of land- and seascapes, Van Goyen's mature works are atmospheric and spacious views of the flat, watery countryside and humid skies of the Netherlands, painted in an almost monochromatic palette so subtly handled as to suggest far more color than is actually present. A superb draftsman, he produced many drawings as finished works of art. His works are in Los Angeles, the Getty, Pasadena, San Francisco, Yale, the Corcoran, Chicago, Baltimore, Boston, the Fogg, Springfield, Worcester, Detroit, St. Louis, the Metropolitan, Cleveland, Oberlin, Toledo, Memphis, Kimbell, Richmond, and Toronto.

PASADENA: ★ *Winter Scene with Skaters,* 1640.

SAN FRANCISCO: *Thunderstorm;* a dramatic skyscape.

CHICAGO: *Fishing Boats off an Estuary,* 1653.

CLEVELAND: *View of Emmerich Across the Rhine,* 1645.

TORONTO: *View of Rhenen,* 1641 (other versions are in the Corcoran, Baltimore, and the Metropolitan).

Graves, Morris (1910–)

An American Northwest Coast painter who primarily worked in gouache and watercolor, Graves has been greatly influenced by the art of Japan, where he lived and studied, to produce a style of symbolic imagery expressed through bird and animal and other natural forms, abstracted in an almost calligraphic manner. Graves' is an art of "the inner eye," to use his own phrase. His work is in most modern collections, with the greatest concentrations on the West Coast, esp. in Seattle and Portland.

METROPOLITAN: *Bird in the Spirit,* 1943; shows the influence of the painter Mark Tobey's white writing. *Spirit Bird Transporting Minnows from Stream to Stream,* 1953; elegance and "Zen wit."

WHITNEY: ★ *Flight of Plover;* the rhythm and pattern of flight.

MODERN: *Blind Bird,* 1940.

NATIONAL MUSEUM: *Folded Wings—Memory—& the Moon Weeping,* c. 1942.

Greco, El (Domenikos Theotokopoulos) (1541–1614)

Born in Crete (hence his name El Greco, which translates as The Greek), he went to Rome and Venice, where he was influenced by Tintoretto's Mannerism. By 1577 he was established in the ancient and austere city

of Toledo, in Spain, where he evolved his own passionate and personal style—spectral, flamelike forms, acrid color, and smoky chiaroscuro—which became the perfect visual expression of the intensely mystical spirit of the Counter-Reformation in Spain. Immensely popular and productive, he was utterly forgotten by later ages until he was rediscovered by Cézanne's generation. Since then he has been much collected and is represented in all major American museums. Significant collections of his work are in the National Gallery, the Hispanic Society, the Metropolitan, and Chicago.

CHICAGO: ★ *Assumption of the Virgin,* 1577; so triumphant in spirit that one can almost hear the trumpets!

DUMBARTON OAKS: *The Visitation,* c. 1607; the dematerialized figures have lost all substance.

FRICK: *St. Jerome,* c. 1600; one of several of El Greco's idealized portraits of the saint; compare this to the version in the Metropolitan.

METROPOLITAN: ★ *View of Toledo,* 1608; El Greco's only pure landscape; a brooding, dreamlike vision. *Adoration of the Shepherds,* c. 1610; full of a breathless sense of the miraculous. *Apocalyptic Scene,* c. 1610; the extreme expressionism of his last years. *Portrait of Cardinal Niño de Guevara,* c. 1598–1600.

MINNEAPOLIS: *Christ Driving the Money Changers from the Temple,* c. 1575; one of several versions, this one uniquely with tiny portraits of Giulio Clovio (a miniaturist and El Greco's teacher in Venice), Michelangelo, and Titian, his spiritual masters.

NATIONAL GALLERY: *St. Martin and the Beggar,* 1597–99; compare with the later, still more abstract version in the same collection. *The Laocoön,* c. 1610; a nightmarish interpretation of the classical legend, with Toledo in the background.

TOLEDO: *The Agony in the Garden,* 1585–86; a hallucinatory, agonized vision.

WORCESTER: *Christ in the House of Martha,* c. 1570; reflects El Greco's absorption of Tintoretto's dramatic manner while in Venice.

Greenough, Horatio (1805–52)

Of a solid Boston family, Greenough early on showed proclivities toward sculpture, leaving Harvard in his senior year to move to Italy. There he became, with Hiram Powers and Francis Crawford, one of the three leading American sculptors of the period, considered by contemporaries the equal of Canova and Thorwaldsen. For years he was the instructor

in sculpture at the Grand Ducal Academy in Florence. His works, except for his excellent portraits, share the chilly Neoclassicism then dominant, but his astute essays on art and architecture are among the liveliest and most perceptive of their kind. His works are in all older New England museums as well as in other collections, esp. on the East Coast. His most famous work is the heroic marble statue of *George Washington* (1832–41), in the Smithsonian Institution, commissioned by the U. S. Government, which was the source of much controversy in its day.

METROPOLITAN: *Portrait Bust of Samuel Finley Bronze Morse,* c. 1832; the original plaster of a young vigorous, clean-shaven Morse, not the whiskery Morse of later years as is usually seen.

NEW-YORK HISTORICAL: *Bust of James Fenimore Cooper,* the famous American author and a good friend of Greenough's.

BOSTON: *Arno;* Greenough's pet greyhound and his constant companion; for years it was kept in Edward Everett's study.

Greuze, Jean Baptiste (1725–1805)

A French painter who enjoyed great popularity by combining maudlin sentimentality and a false moral tone with titillating glimpses of nudity of nymphettes and youthfully nubile females. His works were much engraved, affording him a considerable income, which was appropriated by his sluttish wife. His works are in many museums, but they are scarcely worth seeking out.

NATIONAL GALLERY: *Ange-Laurent de Lalive de Jully,* c. 1759; a curious but interesting portrait of a musician, perhaps Greuze's best work on this side of the Atlantic in a public collection.

Guardi, Francesco (1712–93)

A Venetian *veduta* painter, like Canaletto, whose pupil he seems to have been, Guardi's immense popularity dates only from the period of the Impressionists, when his visionary, atmospheric, scintillating artistic style was recognized as a perfect poetic expression of the image of Venice, and came to be preferred by many viewers to Canaletto's more accurate realizations. Guardi took far more liberties with fact, and many of his *vedute* approach being *capricci.* His work is in all major American museums. Significant collections are in Chicago, the National Gallery, the Metropolitan, and Ottawa. Drawings may be found in Stanford, the Fogg, the Metropolitan, the Phillips, and Hartford.

KIMBELL: *Venice Viewed from the Bacino,* c. 1780.

MONTREAL: *Storm at Sea;* a wild and dreamlike vision.

NATIONAL GALLERY: *Seaport and Classic Ruins in Italy,* 1730s; a decorative *capriccio.*

BOSTON: ★ *The Marriage of Venice and the Adriatic;* the famous annual Venetian festival, painted as if it were an imaginary pageant.

FOGG: *An Island in the Lagoon;* a shimmering mirage.

CLEVELAND: Two paintings recording the papal visit to Venice in 1782, both executed with great stylistic éclat.

Guercino ("Squint Eye," his real name being Giovanni Francesco Barbieri) (1591-1666)

A Bolognese follower of the Carracci, Guercino was influenced by Caravaggio and became a fine illusionistic Baroque decorator. He had a considerable studio, with many assistants to carry out large series of frescoes, so his production was considerable. His works may be found in a number of museum collections. Though generally accomplished, his paintings are often rather routine, though highly professional. He was a master of the Baroque portrait, carried out with panache, though he was somewhat overshadowed both in his own day and in ours by his fellow Bolognese-trained contemporary Domenichino. Characteristic examples of Guercino's work are in Hartford, Detroit, Minneapolis, the Ringling, Cleveland, Greenville, Providence, and Ottawa.

Hals, Frans (1580-1666)

A contemporary of Rembrandt, Hals spent his life in Haarlem, producing some of the most accomplished portraits of the Netherlandish school. His vivid interpretation of personality was rendered with a slashing, bravura technique of tremendous virtuosity. His group portraits of various military companies, confraternities, boards, and other assemblies so beloved by the Dutch increased in depth of expression until they approached those of Rembrandt. Though his work has long been admired, he is less well represented in North American collections than might be expected. Hals' paintings are in the following museums: Los Angeles, Pasadena, San Diego, Hartford, Yale, the National Gallery, the Ringling, the Krannert, Baltimore, Boston, Detroit, Kansas City, St. Louis, Glens Falls, Brooklyn, the Frick, the Metropolitan, Rochester, Cincinnati, the Taft, Cleveland, the Kimbell, Houston, Richmond, Ottawa, and Toronto. Significant collections are in the National Gallery, Detroit, the Frick, and the Metropolitan. ☞ Perhaps the most dashing

and stylish Hals on this side of the Atlantic is the ★ *Portrait of a Man* (Pieter Tjarck), in painted oval, in Los Angeles.

Harnett, William Michael (1848–92)

Born in Ireland, Harnett was taken to Philadelphia when he was one year old. He learned the trade of engraver, studied briefly in New York at Cooper Union and the National Academy, and in Philadelphia at the Pennsylvania Academy, and then started to paint still lifes in a manner derived from James and Raphaelle Peale a half century earlier. From 1882–1886 he studied and worked in Germany, then returned to paint the extraordinary trompe l'oeil still lifes for which he is famous, with glowing color, palpable textures, shades and shadows, and reflections and highlights magically realized. His works are in many major American collections.

CALIFORNIA PALACE: *After the Hunt,* 1885; his most famous painting; other versions are in Columbus and Youngstown.

BOSTON: ★ *Old Models,* 1892; a particularly poetic and nostalgic example.

CARNEGIE: *Trophy of the Hunt,* 1885.

METROPOLITAN: *Music and Good Luck,* 1888.

HARTFORD: *The Faithful Colt,* 1890; entirely appropriate for the city where Col. Colt lived and manufactured his famous firearms.

Hartley, Marsden (1877–1943)

Born in Lewiston, Maine, Hartley studied at the Art Students League in New York before going to Berlin (1912–15), where he experimented with Expressionism and exhibited with the group calling itself Der Blaue Reiter (The Blue Rider). Driven back to America by the war, there were years of wandering and searching before he returned to Maine to paint the solidly constructed land- and seascapes inspired by Ryder, whom he knew and admired, and the group portraits of his fishermen friends. His work is in most American collections, with important groups at the University Gallery, Minneapolis and the Treat, where many drawings, documents, and sketches are located, and at La Jolla.

CHICAGO: *Portrait of a Sea Dove,* 1935; recalls Ryder's *Dead Bird* (Phillips) in feeling, but abstracted to the point of becoming a symbol of the sea and the natural world.

NEUBERGER MUSEUM, PURCHASE, NY: *Fisherman's Last Supper,* 1940–41; the auras around two of the figures symbolize

427

that they will also be lost at sea, joining the former occupants of the empty chairs.

Heade, Martin Johnson (1819–1904)

An American landscape painter, Heade was a restless traveler who found subjects to paint in both North and South America. He studied in Italy, France, and England in the late 1830s. After 1859 he had his headquarters in New York City until 1883, when he moved to St. Augustine, Florida. A passionate naturalist, he painted dozens of pictures of orchids and hummingbirds, and planned a book on the latter, but gave it up because the only means of color reproduction then available were not good enough. He painted dozens of studies of the Newport marshes which display a sensitivity to light and atmosphere that place him among the Luminists. Though rediscovered only in the last quarter century, the recognition of Heade's importance as a later Hudson River School painter of remarkable quality has led to his representation in most important American collections. Perhaps the finest group of his works is in Boston, in the Karolick Collection.

BOSTON: ★ *Approaching Storm, Beach Near Newport,* c. 1860; a painting of great and eerie power. *Lake George,* 1862; the benignity of nature, in total contrast to the sinister forces expressed in *Approaching Storm.*

BOWDOIN: *Newburyport Marshes,* c. 1865–70; Heade painted the marshes again and again in varying light, like variations on a musical theme, much as Monet did later in the century.

NATIONAL GALLERY: *Rio de Janeiro Bay,* 1864; Heade visited South America to paint hummingbirds and orchids, which he did with a naturalist's accuracy and an artist's eye.

Henri, Robert (1865–1929)

A gifted and important teacher who influenced a generation of American artists. He studied in Paris for three years and was aware of what was being done there in the last decade or so of the nineteenth century. Henri was the leader of the group that was derisively dubbed the Ash Can School after the exhibition of The Eight in 1908. He was a lively portrait painter and keen observer of the urban scene in New York, where he moved from Philadelphia around the turn of the century. His *Art Thoughts,* consisting of random observations made while teaching, are excellent and to the point even today. His work is in virtually all major American collections.

WICHITA: *Eva Green,* 1907; painted on Christmas Day, this portrait of a very happy little black girl shows Henri's feeling for children.

UTICA: *Dutch Soldier,* 1907; the brushwork is as vigorous as the subject.

ATLANTA: *Lady in Black Velvet,* 1911; a handsome full-length portrait of Eulabee Dix Becker, a famous beauty and a fellow artist.

METROPOLITAN: *Dutch Girl in White,* 1907.

Hicks, Edward (1780–1849)

A Quaker visionary from Pennsylvania, Hicks was trained as a sign and wagon painter. He was also an eloquent preacher, the essential lesson of whose sermons was the constant message of such devotional paintings as *The Peaceable Kingdom,* whether based on the remembered harmony of the farm where he grew up or a literal realization of the prophecy in the eleventh chapter of Isaiah concerning animals, both domestic and wild, forming a contented group, with the little child who was to lead them. Hicks is represented in almost all collections of American painting, as well as in folk art collections. His works, often with painted and inscribed frames, have an earnest naïveté and genuine devotional quality.

COOPERSTOWN: *The Peaceable Kingdom,* 1830–35; note the scene of William Penn's treaty with the Indians in the left distance, and "the little child" with the lion and other animals at near right; the painted frame contains Hicks' faltering but touching verses, painted in his best sign painter's style.

ROCKEFELLER FOLK ART: *The Peaceable Kingdom,* 1830–40; Penn's treaty scene is still there, but this time with a whole menagerie of animals.

NATIONAL GALLERY: *The Cornell Farm,* 1848; sometimes Hicks' peaceable kingdom was of this earth; here it's the handsome stock of a prosperous Bucks County farmer, painted shortly before the artist's death.

Hiroshige, Andō (1797–1858)

With Hokusai, a leading illustrator of the *ukiyo-e,* the Floating World of gaiety of Tokyo. Hiroshige has been avidly collected and was very influential in the West. His masterful color woodcuts are in virtually every American collection of Japanese prints.

Hobbema, Meindert (1638–1709)

A Dutch landscape painter whose work, eagerly collected in England in the eighteenth and nineteenth centuries, influenced the development of

English landscape painting. His eye was sensitively attuned to every nuance and variation of light. His landscapes are thus quiet celebrations of the more picturesque aspects of the countryside near Amsterdam. His works are in San Francisco, Chicago, Indianapolis, the Clark, Detroit, the National Gallery, Minneapolis, Kansas City, Elmira, Brooklyn, the Frick, the Metropolitan, Cincinnati, the Taft, Cleveland, Oberlin, Toledo, Memphis, Richmond, Philadelphia, and Ottawa. The most significant group is in the National Gallery (six); Detroit has three, including one of his earliest, dated 1658.

CHICAGO: *The Watermill with the Great Red Roof,* c. 1670; within the limited scope of Hobbema's subject matter, he achieved great variety; note the decorative qualities of the bold and rugged silhouettes of the trees.

INDIANAPOLIS: *The Water Mill,* 1667; a major example of his skill.

KANSAS CITY: *A Road in the Woods.*

TAFT: *Landscape with Cattle;* a picturesque idyll.

RICHMOND: *River Landscape with a Boat;* full of the feeling of the Dutch landscape, with ever-present water and moist, atmospheric skies.

Hoffman, Malvina (1883–1952)

Born in New York, Hoffman studied sculpture there before going to Paris as a pupil of Rodin. She was an excellent portraitist, as shown by her several heads of Paderewski, the great Polish pianist and statesman, and of Pavlova, the famous ballet dancer. Her most impressive works, however, are the series of life-sized bronze figures representing the ethnological types of the world, made for the Hall of Man in the Field Museum in Chicago. They are the result of years of travel and research and represent the humanistic naturalism that is so important an aspect of the American tradition. Her works are in many of the larger, older museums.

FIELD MUSEUM OF NATURAL HISTORY, CHICAGO: Hall of Man sculptures; the series goes beyond scientific accuracy to become a statement about human dignity.

Hofmann, Hans (1880–1966)

Born in Bavaria, Hofmann studied in Munich and Paris, was influenced by Matisse and other members of the Fauves. He taught in Munich from World War I until 1932, the year he came to America. He increas-

ingly experimented with abstraction in a splashy and Expressionist manner that influenced Pollock. More important than his work was his formative influence as a teacher on a variety of pupils, incl. a number of the leaders of the forties, fifties, and sixties. Hofmann's work is in many collections, esp. modern ones. His archive and the contents of his studio, including forty-five paintings, are in Berkeley.

BUFFALO: *Exuberance,* 1955; abstract but not yet nonobjective.

CLEVELAND: *Smaragd Red and Germinating Yellow,* 1959.

NATIONAL MUSEUM: *Fermented Soil,* 1965.

Hogarth, William (1697–1764)

A Londoner who started out as an engraver, Hogarth was basically a moralist, more closely related to contemporary literature than painting. He began, he wrote, "painting and engraving modern moral subjects . . . similar to representations on the stage. . ." *The Harlot's Progress,* engraved in 1732 (compare Defoe's novel *Moll Flanders*) was so popular that it was often pirated, leading to the Copyright Act of 1735. *The Rake's Progress* (1735) and *Marriage à la Mode* (1743–45) followed, also with recognizable contemporary characters, and was a tremendous popular success. But Hogarth was also a superb painter whose small group portraits and larger half-lengths are not only vivid evocations of personality, but are also deliciously executed. His *Analysis of Beauty* (1753) remains a key document in aesthetics of the period. Hogarth's prints are in virtually all print collections. His paintings are in the Getty, the Huntington, Louisville, Boston, Smith, Worcester, Detroit, Muskegon, Minneapolis, Kansas City, St. Louis, Buffalo, the Frick, the Metropolitan, Columbus, Oberlin, Toledo, Philadelphia, Memphis, Richmond, Vancouver, Ottawa, and Montreal.

HUNTINGTON: Separate portraits of *Bishop and Mrs. Benjamin Hoadley,* c. 1740; admirable British types.

LOUISVILLE: *Mr. Dudley Woodbridge Celebrates His Call to the Bar in His Chambers at No. 1 Brick Court, Middle Temple,* 1730.

MINNEAPOLIS: *The Sleeping Congregation,* 1728; in those days sermons were interminable!

METROPOLITAN: *The Wedding of Stephen Beckingham and Mary Cox,* 1729; charming genre scene.

COLUMBUS: Delightful portraits of *Mary and Ann Hogarth,* c. 1740.

PHILADELPHIA: *The Assembly at Wanstead House,* 1729–31; note the interplay among various characters, the marvelously detailed interior, costumes, and furnishings.

Hokusai, Katsushika (1760–1849)

Hokusai was one of the leading woodcut artists of Japan in the nineteenth century whose superb color prints of *ukiyo-e*, life in the Floating World of Tokyo, were so influential on nineteenth-century European painting. He is represented in virtually every Japanese print collection.

Holbein, Hans, the Younger (1497/98–1543)

Born in Augsburg, Germany, Holbein was the son and pupil of Hans the Elder, went to Basel, Switzerland, where he became a lifelong friend of the great Dutch humanist, Erasmus. In 1526 he went to England with letters of introduction from Erasmus to Sir Thomas More with whom he stayed in Chelsea before settling in London as court painter to Henry VIII. He died of the plague in London in 1543. His austere and reserved portraits are fascinating historical and human documents as well as being impressive works of art. His rare drawings are particularly beautiful, esp. those of members of the More family. His prints, esp. *The Dance of Death,* are world-famous.

LOS ANGELES: *Portrait of a Young Woman with White Coif,* miniature *tondo,* 1541.

YALE: *Merchant of the Hanseatic League,* 1538.

NATIONAL GALLERY: *Edward VI as a Child,* 1538; an affecting portrait of a tragic figure. *Sir Brian Tuke;* a solid, marvelously realized picture.

MUNCIE: *Erasmus of Rotterdam;* a powerful miniature portrait of one of the greatest humanist philosophers.

GARDNER: *Sir William Butts;* vigorous, aware. *Lady Butts;* a superb pair of likenesses.

DETROIT: *Sir Henry Guilford, tondo* miniature; Houston has another version.

ST. LOUIS: *Portrait of Lady Guilford,* 1527; a fine, full-sized portrait.

FRICK: ★ *Sir Thomas More,* 1526; a great portrait of a remarkable and admirable personality. *Sir Thomas Cromwell;* Holbein shows him as the brutal opportunist he was. The Frick portraits present a dramatic confrontation: Two years after the More portrait, Cromwell sentenced More (canonized in 1935) to death for high treason because the latter would not approve Henry VIII's divorce from Catherine of Aragon, his marriage to Anne Boleyn, and his assumption of the leadership of the Church. Cromwell, the scramblingly ambitious son of a Putney blacksmith, followed More to the block in 1540, also for treason.

METROPOLITAN: Among ten portraits, see esp. *Lady Lee;* the personality is striking. *Portrait of a Member of the Wedigh Family,* 1532. *Edward VI, tondo;* compare with the National Gallery portrait.

TOLEDO: *Lady of the Cromwell Family,* c. 1535–40; courtly and melancholy.

Homer, Winslow (1836–1910)

Homer, Eakins, and Ryder were the three outstanding American painters of the late nineteenth and early twentieth century. Homer started out as an illustrator and was a combat artist in the Civil War. He was an expert lithographer and, after the war, turned to oil painting with great success, adding watercolor in 1873. His earlier works in all media were genre scenes: he, Eakins, and Eastman Johnson were all outstanding artists in this field. But gradually Homer evolved the subject to which he devoted his life with such outstanding success, the traditional American theme of man and nature in the New World, at first in terms of Maine fishermen or Adirondack guides, and finally, in his later years, in terms of heroic sea pieces. This was a theme introduced into American art by Copley with *Watson and the Shark;* it recurs, in literature, in Cooper's *Leatherstocking Tales,* Melville's *Moby Dick,* and in the painting of Fitz Hugh Lane, Thomas Cole, Martin J. Heade, and others. No one ever gave it a more epic expression than Homer. His work has been much admired and much collected, so it is in most museums and in all American collections. All major museums have representative works, incl. his drawings and prints.

CHICAGO: *Croquet Scene,* 1866.

ST. LOUIS: *The Country School,* 1871; both delightful genre paintings in oil.

COLBY: *The Berry Pickers,* 1873; genre scene in breezy watercolor.

BOSTON: *The Adirondack Guide;* the man-and-nature theme. *The Fog Warning,* 1885; there is an anonymous heroism in these paintings of Grand Banks fishermen (compare with Kipling's *Captains Courageous*). *"All's Well,"* 1896.

ANDOVER: *Eight Bells,* 1886.

PHILADELPHIA: *Huntsman and Dogs,* 1891; man, solitary. *Winter Coast,* 1890; man has almost disappeared.

NATIONAL MUSEUM: ★ *High Cliff, Coast of Maine,* 1894.

CLARK: *West Point, Prout's Neck,* 1900.

CLEVELAND: *Early Morning After a Storm at Sea,* 1902; in these last sea pieces, man is the solitary, invisible artist, and the observer—you and I.

Hooch, Pieter de (1629–83)

Although he never equaled Vermeer, de Hooch was among the best of the Netherlandish genre painters who specialized in scenes of everyday life in prosperous Protestant Holland. Most of his best paintings show pairs or small groups of figures in comfortable and picturesque Delft, Amsterdam, or Rotterdam interiors. De Hooch's paintings are in Los Angeles, the University of California Galleries in Los Angeles, the Corcoran, the National Gallery, Honolulu, Indianapolis, Boston, Pittsfield, Detroit, St. Louis, the Metropolitan, Raleigh, Cincinnati, the Taft, Cleveland, and Toledo.

CINCINNATI: *The Game of Skittles,* c. 1665; a delightful Dutch garden scene.

NATIONAL GALLERY: *The Bedroom,* c. 1660; typical and sensitive treatment of light in an interior.

CLEVELAND: *The Music Party,* c. 1665; reflects the constant presence of music in the everyday life of the period.

Hopper, Edward (1882–1967)

Hopper was a tall, quiet, reserved person, an American painter who spent his lifetime working in the naturalist tradition. He was a pupil of Henri, from whom he inherited the urge to paint the life he saw about him as seen in the light which was the real subject of his painting. The preoccupation with light, the attention to everyday matters, the detached approach, and the mood of loneliness run throughout his art, and show him to have been in the main line of the American tradition. He painted superb watercolors as well as oils, and was quietly productive throughout a long life, so examples of his work are in virtually all American museums. The greatest bulk of his work is in the Whitney, since he bequeathed his own collections, his drawings, sketchbooks, papers, and the contents of his studio, to this museum, which is devoted to American art.

CHICAGO: *Nighthawks,* 1942.

DES MOINES: *The Automat;* both reflect the loneliness of the city at night.

WHITNEY: *Early Sunday Morning,* 1930; a cityscape of mood.

LINCOLN: *Room in New York,* 1932; a feeling of bleak anonymity pervades.

Houdon, Jean-Antoine (1741–1828)

Houdon was the pre-eminent French sculptor of the eighteenth century, combining a superb technique, a naturalistic approach, a classical sense of decorum and order, and modern psychological insight to produce the

finest sculptured portraits of the age. Because he portrayed many of the Americans of the period of the American Revolution and the early republic, many of his works are in American collections. A number of them exist in considerable numbers, esp. those of Washington, Jefferson, Franklin, and Lafayette. His full-length marble Washington is in Richmond, while there are numerous busts and heads based on it in various collections. The original plaster of his Franklin bust is in St. Louis; there are also a bronze in the Metropolitan and numerous other versions elsewhere. Almost everyone of importance in the period sat for him, yet he maintained an exemplary level of quality even in the production of numerous replicas.

BOSTON: ⋆ *Jefferson,* the original plaster; a superlative portrait of a complex, brilliant, and fascinating American.

NATIONAL GALLERY: Compare the marbles of the wigless and the formal *Voltaire.*

ST. LOUIS: *Franklin;* the original plaster; contrast with William Rush's Franklin head in wood (Yale); these are probably the two finest sculptured portraits of the canny philosopher and diplomat.

Hunt, William Morris (1824–79)

The older brother of the architect, Richard Morris Hunt, he studied painting in Paris with Thomas Couture, later Manet's teacher, and discovered Millet and the Barbizon School, a discovery which gave him the direction he needed. About 1854 Millet painted a striking portrait of Hunt which is now in the Smith College Museum. Hunt returned to America to spread the gospel of this new approach to art and to develop his own broad, atmospheric style. Through his influence, Paris began to replace Germany as the locus of European study for young Americans. His murals for the Assembly Chamber of the New York State Capitol in Albany, long since destroyed, were the only respectable such commission carried out by any artist of his generation.

METROPOLITAN: *Flight of Night,* a sketch for the Albany murals.

BOSTON: *Flight of Night,* plaster of the horses. *Flight of Night,* another sketch for the Albany murals.

COUNTY COURT HOUSE, SALEM, MA: *Chief Justice Lemuel Shaw;* life-sized, full-length, one of the best portraits of the period.

Ingres, Jean-Auguste-Dominique (1780–1867)

A confirmed adherent of Classicism, Ingres was the leading opponent of the Romanticism of his contemporary, Delacrois. Because of his pomposity and rigidity of mind, Ingres became the figurehead of the increas-

435

ingly conservative academicism against which most of the ablest artist of his own and the following generation reacted violently. Ingres religious and historical subjects tend to be pretentious and theatrical, hi oriental scenes excuses for the display of pneumatic nudes. He was a accomplished draftsman whose portrait drawings are as completely real ized as his painted portraits—and justly admired. He is well represented in American museums, among them: Sacramento, San Diego, Baltimore the Walters, the Fogg, Chicago, Hartford, Detroit, Kansas City, Smith Buffalo, the Metropolitan, the Frick, Cincinnati, the Taft, Philadelphia Cleveland, the National Gallery, and the Phillips.

NATIONAL GALLERY: *Mme. Moitessier,* 1851; an outstanding Empire portrait. *Pius VII in the Sistine Chapel,* 1810.

PHILLIPS: *Paganini,* c. 1832; compare the Delacroix painting in the same collection, a fascinating contrast of styles, attitudes, and temperaments.

FOGG: *Odalisque with Slave,* 1839; Romantic exoticism in Classical style; contrast with Delacroix. *Self-Portrait at the Age of Seventy-nine,* 1859; humorless, indomitable.

FRICK: *Louise, Princesse de Broglie, Comtesse d'Haussonville,* 1845; a disarmingly attractive personality comes through the immaculate style.

METROPOLITAN: *Monsieur Leblanc* and *Mme. Leblanc,* both 1823; coolly elegant. *Portrait Drawing of Monsieur Bertin;* for the Louvre. *Portrait of the Princesse de Broglie;* in its way as aristocratic as a Van Dyck.

Inness, George (1825–94)

An American landscape painter who transformed the romantic realism of the Hudson River School into a subjective and dreamlike expression. Influenced by Swedenborgian mysticism, Inness carried Allston's "landscape of mood" into a yet more personal expression of natural forms shimmering in glowing color and pools of aqueous shadow. His Italian landscapes, done over a series of trips, are particularly successful. His work was much admired and collected during his lifetime, so it may be found in many museums. There are particularly important groups of his pictures in Chicago, Montclair, and the Metropolitan. In his sense of the underlying unity of nature, Inness was a true heir of the Hudson River School and the Luminists.

ANDOVER: ★ *The Monk,* 1873; painted on the grounds of the Villa Barberini in Albano, Italy, a wonderfully evocative and haunting vision.

NEW BRITAIN: *View of St. Peter's,* 1857; painted during the artist's first Italian trip; the light and air are Italian, but the detailed naturalism and stillness recall Lane, Kensett, and other Luminists.

MOUNT HOLYOKE COLLEGE ART MUSEUM, HADLEY, MASSACHUSETTS: *Conway Meadows,* 1876; painted in the White Mountains of New Hampshire; a free yet controlled landscape realized at large scale (an oil sketch for it is in Fort Worth).

BROOKLYN: *On the Delaware River,* 1873; a grand atmospheric panorama.

LOS ANGELES: *Autumn Landscape, October,* 1886; this, like many in the collections in Chicago and Montclair, carries Allston's landscape of mood into a yet more subjective expression.

Johnson, Eastman (1824–1906)

Born in Maine, Johnson studied in Europe, lived in New York, and became, along with Homer and Eakins, the leading genre painter of the late nineteenth century. He was also a fine portraitist who produced group portraits of extraordinary interest. He painted primarily in New York and New England and is best known for his scenes of maple sugar camps, blueberrying in Maine, and cranberrying on Nantucket. These paintings are not, like those of Mount, lively records of events, but are more broadly and atmospherically handled also to become evocative of mood and place. His work is in most American collections.

METROPOLITAN: *The Brown Family,* 1869. *The Hatch Family,* 1871; both marvelously realized records of life of the period, with lively portraits and rich interiors. *The Funding Bill,* 1881; an almost Eakins-like double portrait of Johnson's brother-in-law, Robert W. Rutherford, a prominent New York businessman, and the painter, Samuel W. Rose, a friend of the artist.

CORCORAN: *The Shelter,* c. 1870; painted in connection with a series on "sugaring off" (converting maple syrup into sugar) created in Fryeburg, Maine, and now scattered among various American collections.

Kalf, Willem (1619–93)

One of the most accomplished still-life painters of all time, Kalf was an inheritor of the rich Dutch still-life tradition and sums up its accomplishments, and more, in his own superlative work. He lived and worked in Paris as well as in Amsterdam and Rotterdam. His brilliant

handling of paint in what is almost a Pointillist manner on a minute scale may reflect the influence of Vermeer. His works are in a number of North American museums, including the Getty, Springfield, Detroit, St. Louis, the Metropolitan, Cincinnati, Cleveland, and Portland. Kalf's partly peeled lemons are mouthwatering. ☛ The examples in Chicago and the National Gallery.

Kandinsky, Wassily (1866–1944)

One of Russia's pioneer modernists, Kandinsky started experimenting with abstract and nonobjective painting about 1910 in Germany. He was a member, with Franz Marc and later, Klee, of the group called The Blue Rider (beginning in 1911). As did Klee, he taught at the Bauhaus in the 1920s and in 1933 moved to Paris. The Guggenheim has the major group of his works on this side of the Atlantic. He is also represented in virtually all modern collections, especially the Modern. ☛ The early paintings in the Guggenheim, many of them small, show him developing through stages of ever-greater abstraction from Romantic Russian colorism, increasingly expressionistic, to a nonobjective style, which, in turn, becomes increasingly geometric; it is a fascinating record of artistic evolution at the very outset of modernism.

Kauffmann, Angelica (1741–1807)

Born in Switzerland, Kauffmann studied in Italy and lived in London, Paris, and later in Rome. She is best known for her portraits, solidly painted and attractive, and influenced by the work of Sir Joshua Reynolds with whom, despite his tendencies toward pomposity, she seems to have been on intimate terms. She painted historical and literary subjects in a manner influenced by Neoclassicism, and made decorative designs, engraved in vast numbers, used on china and for plaques applied to furniture, so she has been unjustly credited with the authorship of innumerable mediocre decorative works of the late eighteenth century. Her portraits are in many museums. ☛ Richmond's example of her rarer mythological-historical work: *Cornelia, Mother of the Gracchi,* 1785.

Kensett, John Frederick (c. 1816–72)

A member of the Hudson River School, Kensett was a leader among the Luminists. He studied and painted in Europe and traveled widely in the United States, but was more at home with the mountains and lakes of New York and New England, the coast of Long Island, and the vicinity of Newport. His paintings have a mastery of atmospheric depth and a silent visual poetry which were universally admired. With his friend, the poet William Cullen Bryant, he was a founder of the Metropolitan

Museum, to which he left the contents of his studio. His work is in almost all American collections, with significant groups in the Metropolitan and Brooklyn.

BROOKLYN: *Thunderstorm, Lake George,* 1870.

NATIONAL MUSEUM: *Along the Hudson,* 1852.

NEW-YORK HISTORICAL: *View from West Point,* a panoramic view with typical clarity, depth, and silence.

AMHERST: *Niagara Falls,* c. 1850; a particularly attractive view of what was perhaps the most popular painting subject in America; Kensett treated it several times (another, entirely different, is in Boston).

CORCORAN: *High Bank, Genesee River,* 1857.

METROPOLITAN: *Lake George,* 1869.

CHICAGO: ★ *Third Beach, Newport,* 1869; almost an ultimate Luminist picture, a solid landscape-seascape, utterly clear, shimmering with light, immediate, yet timelessly serene.

Kirchner, Ernst Ludwig (1880–1938)

A German Expressionist of tortured sensibility, Kirchner painted black-outlined figures in wild and unnaturalistic colors, and made prints, especially woodcuts, with a deliberate crudeness of technique. He is represented in almost all print rooms, and his paintings are in many modern collections. ☛ His *Self-portrait with Model* (1907) in La Jolla, and *Self-portrait with a Cat* in the Fogg.

Klee, Paul (1879–1940)

A Swiss painter and etcher who studied in Munich and Italy, Klee was one of the foremost and sublest fantasists among modern artists, with a deliciously simple poetic style derived from children's and primitive art and the study of symbols and hieroglyphs. He taught at the Bauhaus and gained recognition as an important innovator after World War I. He is well represented in most museums with modern collections. ☛ The famous ★ *Twittering Machine* (1922, the Modern).

Kollwitz, Käthe (1867–1945)

A German draftsman, printmaker, and sculptor, Kollwitz was an artist of pacifist convictions and left-wing tendencies whose life and art were conditioned by tragedy, both personal and national, as a result of war and political and social disruption. Her work is highly accomplished technically and has a poignant emotional impact because of its humanistic basis. She is represented in practically every print collection both here

439

and in Europe. ☞ Storrs, the Walter Landauer Collections of prints and drawings.

Lane, Fitz Hugh (1804–61)

Born in Gloucester, MA, Lane had polio as a child, leaving him a paraplegic. Yet he sailed up and down the Atlantic coast, got around town in a handsome gig, and became the outstanding American marine painter before Winslow Homer. His seafaring neighbors admired the accuracy of his rigging. His sensitive treatment of light places him among the Luminists. He was a fine draftsman and expert lithographer. An outstanding collection of Lane's drawings and paintings is in the Cape Ann Historical Association in Gloucester, MA. (Also note the sea serpent figurehead, said to have been modeled from life when a sea serpent spent several days in Gloucester harbor in the early nineteenth century.) Lane's paintings are in almost all major American collections. An important group is in Boston.

BOSTON: ★ *Owl's Head, Penobscot Bay,* 1862; cool morning light and northern stillness. *Brig Antelope in Boston Harbor,* 1863; a superb ship's portrait of a clipper ship which held the speed record from America to China.

CORCORAN: *The U. S. Frigate* President *Engaging the British Squadron, 1815,* painted 1850.

La Tour, Georges de (1593–1652)

Totally forgotten from his own times until a couple of decades ago, almost nothing is known of Georges de La Tour's life except that he seems to have lived it almost entirely in his native Lorraine. His few known works, almost entirely religious, are presented as if they were episodes of peasant life, elevated through chiaroscuro, simplification of forms, and rigorous understatement. Their atmosphere of hushed expectancy and intense inwardness express a height of spiritual power which makes them silently resounding affirmations of timeless faith and hope. His few nonreligious scenes have an enigmatic quality and a curious psychological tension but without a sense of spiritual elevation. Among the few works attributed to him:

NATIONAL GALLERY: *Repentant Magdalen,* c. 1640; a recurring theme which was very popular, hence much repeated with a number of replicas or studio pieces.

HARTFORD: *St. Francis in Ecstasy;* an impressive fragment.

DETROIT: *St. Sebastian;* the original is recorded as having been given to Louis XIII; there are seven other versions.

FRICK: *Education of the Virgin;* perhaps one of several studio
versions of a lost original.

CLEVELAND: *Repentant St. Peter,* 1645.

Two paintings in San Francisco, *The Peasant Family* in the de Young
and *Young Girl With a Lamp* in the California Palace of the Legion
of Honor, have been sometimes considered as early works. Others
are in Kansas City, the Getty, and elsewhere.

Lawrence, Jacob (1917–)

A leading painter and educator who has been associated for years with
the University of Seattle and also with the Skowhegan School in Maine.
His works are in all major collections; among the most impressive are
his *Migration of the Negro,* a series of paintings of powerful and per-
sonal symbolism, black in subject but universal in human significance.

Lawrence, Sir Thomas (1769–1830)

So precocious that portrait drawings he made at the age of six sold for
a guinea apiece, Lawrence was self-taught and became a tremendously
successful portrait painter who made a fortune with his dashingly
brushed, lively, and very fashionable likenesses. He formed one of the
finest collections of Old Master drawings ever asssembled. There are
Lawrence portraits in at least fifty North American museums, the most
interesting groups being in the Huntington, the National Gallery,
Chicago, the Fogg, the Metropolitan, Raleigh, Cincinnati, Toledo, and
Montreal.

HUNTINGTON: *Sarah Barrett Moulton* ("Pinkie"), 1794; painted
for the girl's grandmother who wanted to see "my dear little
Pinkey" and who asked her niece to have "her picture drawn at
full length, by one of the best masters in an easy careless at-
titude." Pinkie came to London for the portrait from her home in
Jamaica and died of consumption before it was shown. A wonder-
fully fresh painting.

HARTFORD: *Benjamin West,* 1820–21; a fine portrait of the
American Quaker and artist who became the second president of
the Royal Academy after Sir Joshua Reynolds.

BOSTON: *Sir Uvdale Price;* with Richard Payne-Knight, Price
evolved the theory of the Picturesque, so important for
nineteenth-century British literature, painting, and landscape
architecture.

FOGG: *Mrs. Siddons,* 1792; a revealing informal portrait of the
distinguished actress.

METROPOLITAN: *Miss Eliza Farren;* later the Countess of Derby;

portrait of another famous actress painted when the artist was twenty-one. *The Calmady Children;* delightful!

Léger, Fernand (1881–1955)

A friend of Picasso and Braque, Léger painted geometric figures influenced by Cubism and by his interest in technology and machines. He collaborated with the American composer George Antheil on the first abstract film, *Ballet Mécanique* (1924). There are tremendous murals by him in the United Nations headquarters in New York City. His paintings are in a number of modern collections, especially the Modern.

ITHACA: *Still Life,* 1936; his developed brand of Cubism.

WELLESLEY: *Mother and Child,* 1921; a lively Cubist experiment.

MODERN: *Grand Déjeuner,* 1921.

Lehmbruck, Wilhelm (1881–1919)

A German sculptor influenced by Rodin but using the attenuated forms of the Gothic, Lehmbruck became a leading modern sculptor before his suicide in 1919. There are examples of his work in most modern collections; his fine drawings and etchings are in some print rooms. The outstanding examples of his sculptures are in the Modern.

MODERN: *Standing Woman,* 1910. *Kneeling Woman,* 1911. *Young Man Standing,* 1913.

Lely, Sir Peter (1618–70)

Lely was a painter of Dutch family who became the leading portraitist of England under Charles II, whose mistresses he portrayed with languid sensuality. His male portraits are vigorous to the point of being macho. He had a large shop which produced hundreds of pictures of varying quality, so he is widely represented in museum collections, the comparatively few works by his own hand being excellent. Typical examples are in the Metropolitan and Ottawa.

Le Nain, Antoine (c. 1588–1648); Louis (c. 1593–1648); Mathieu (c. 1607–77)

The three Le Nain brothers, all born in Laon, were all working in Paris by 1630. Their individual artistic personalities are insufficiently distinguishable as they usually signed their paintings, when they did sign them, with the family name alone. They specialized in somewhat enigmatic genre subjects of peasant life at a small to medium scale, in a palette running to cool, grayish tones. Their works are in the California Palace, Los Angeles, Hartford, the National Gallery, the Clark,

442

Boston, Springfield, Worcester, Vassar, Hagerstown, Detroit, Cleveland, Toledo, Philadelphia, the Frick, and Pittsburgh.

Louis Le Nain

BOSTON: *Peasants in Front of a House.*

HARTFORD: *Peasants in a Landscape.*

Mathieu Le Nain

TOLEDO: *Family Dinner.*

Louis Le Nain, assisted by his brothers

PHILADELPHIA: *Procession of the Ram;* probably by Louis and Mathieu; has an austere but beautiful landscape painted in a silvery blond palette.

Leonardo da Vinci (1452–1519)

One of the greatest artists and thinkers of all time, Leonardo, with the younger Raphael and the older Michelangelo, dominated the Italian Renaissance and influenced the entire course of Western art and thought. Born in Vinci, in Tuscany, he studied with Verrocchio in Florence and worked also in Milan, Rome, and finally in Amboise in France as painter to, and admired friend of Francis I. He died and was buried in Amboise. There is only one painting by him in this hemisphere, ★ *Ginevra de' Benci,* a miraculous portrait in the National Gallery. The most outstanding collection of his drawings is in Windsor Castle, but there are individual sheets in the United States, and recently a notebook of his has been purchased in England for the Los Angeles County Museum. The National Gallery also has a fine drawing of a horseman, and the ★ Metropolitan has a superb sheet of studies for a Nativity.

Lewis, Edmonia (1843–?)

Part black and part Indian, Lewis early showed sufficient gifts as a sculptor to gain patronage to study abroad. She went to Italy, and lived and worked there for the rest of her life. A tiny person of indomitable purpose, she produced marble mythological figures in the then-popular Neoclassical mode. When fashion changed, she disappeared from history, and her death date is unknown. ☛ *Hagar* (1875) in the Museum of African Art, Washington, DC.

Leyster, Judith (1609–60)

Judith Leyster and her husband, Jan Molenaer, were both Dutch painters of the school of Haarlem where they were probably pupils of Frans Hals. Both were known for genre scenes painted in a manner obviously influenced by Hals. ☛ Her attractive *Self-portrait* in the National Gallery;

The Gay Cavaliers (The Last Drop), c. 1628–29, is characteristic of her genre style (Philadelphia).

Lipchitz, Jacques (1891–1973)
Born in Lithuania, Lipchitz went to Paris in 1909 where his sculpture was influenced by both Cubism and Expressionism. In 1941 he came to America permanently. His sculpture is in most modern collections, significant groups being in the Barnes and the Modern. His monumental bronze of *Duluth* is in front of the Tweed Museum in Duluth, MN. There is a collection of Lipchitz maquettes in the University of Arizona Museum of Art, Tucson.

MODERN: *Man with Guitar,* stone, c. 1916. *Figure,* bronze, 1930; a totemlike image of sinister power, probably his best work.

PHILADELPHIA: *Prometheus II,* 1944–53; a revised version of his immense allegory, *Prometheus Strangling the Vulture,* produced for the Paris Exposition of 1937; another such work is in the Walker.

NEW HARMONY, IN: A *Madonna and Child* in the very interesting shrine designed by Philip Johnson.

YALE: *Man with Mandolin,* stone, 1917; an early Cubist work.

Lippi, Filippino (c. 1457–1504)
The son of Fra Filippo Lippi, Filippino studied with his father and completed a number of works left incomplete at his father's death. By the age of twelve he had embarked on his own painting career. His major works were frescoes in Florence and Rome. There are a number of panels in American collections by this accomplished Florentine Renaissance artist.

NATIONAL GALLERY: *Adoration of the Child,* c. 1480; influenced by Neoplatonic poetry. *Portrait of a Youth,* c. 1485; forceful and elegant. *Tobias and the Angel,* c. 1480; displays Botticellian grace. ★ *Adoration of the Magi, tondo,* c. 1445; painted with Fra Angelico, a lovely and enchanting picture, full of lively imagination and freshly painted detail; one can join the procession and wander about in it, as in a Chinese scroll.

CLEVELAND: *Holy Family with the Infant St. John and St. Margaret, tondo,* c. 1495. (Cleveland also has a fine working drawing of *St. Jerome in His Study* for the painting in El Paso).

Lippi, Fra Filippo (c. 1406–69)

An important early Renaissance Florentine artist patronized by the Medici family, Lippi was a far better painter than he was a monk, because he persuaded a beautiful nun, Lucrezia Buti, to elope with him. Their son, Filippino, became an outstanding painter of his generation. Best known in Italy for his frescoes, Fra Filippo is represented by several paintings in a number of American collections.

METROPOLITAN: *Madonna and Child Enthroned,* 1437–40. *Alessandri Altarpiece,* 1442–47. *Man and Woman at a Casement;* probably a marriage portrait.

NATIONAL GALLERY: ★ *Madonna and Child,* 1440–45; models were probably Lucrezia Buti, the painter's mistress (and later his wife) and their son, the future painter Filippino. *Annunciation,* c. 1440; Filippo's linear grace was further developed by Filippino.

CLEVELAND: Two panels from an altar of 1457: *St. Anthony Abbot* and *St. Michael.*

FRICK: *Annunciation* in two panels, c. 1440.

Lorenzetti, Pietro (c. 1280–1348); Ambrogio (c. 1290–1348)

The Lorenzetti brothers were important in Sienese painting in continuing the graceful tradition of Duccio to the mid-fourteenth century. Both were major mural painters, and both died in the disastrous outbreak of the Black Death in 1348. Both are represented by panel paintings in a number of American collections, including the National Gallery, Yale, Baltimore, the Fogg, the Metropolitan, Cleveland, and Philadelphia.

Pietro

NATIONAL GALLERY: *Madonna and Child with Saints Mary Magdalene and Catherine,* triptych, c. 1330–40; probably a chapel altarpiece.

PHILADELPHIA: *Virgin and Child Enthroned,* 1320s.

Ambrogio

YALE: *Saint Martin and the Beggar;* slightly less austere than Pietro; El Paso has a delightful *Madonna and Child* long attributed to Ambrogio but now recognized as the work of a gifted follower.

Lorenzo Monaco, Piero di Giovanni (i.e., Lorenzo the Monk) (c. 1370–1422/25)

A Sienese painter and illuminator, Lorenzo lived and worked in the monastery of Santa Maria degli Angeli in Florence, an important center

of miniature painting. He introduced the International Style, the last flowering of the Gothic, into Florence. Although he painted with Florentine firmness, he retained a Sienese conservatism and grace. He is represented in American museums, among them the National Gallery, Yale, Worcester, the Metropolitan, Toledo, Philadelphia.

NATIONAL GALLERY: *Madonna and Child,* 1413; delicate and decorative.

METROPOLITAN: A set of four panels of *Abraham, Moses, Noah,* and *David;* handsome and conservative.

Lorrain, Claude (Claude Gallée, called Claude) (1600–82)

A French artist from Lorraine—hence his name—Claude studied in Rome, where he spent most of his life as a pre-eminent landscape painter. He combined compositional devices like those employed in theatrical scenic design to attain depth with atmospheric perspective, and the golden light "of a perpetual summer afternoon," in Henry James' phrase. He was very productive and his works are in all major museums, incl. Pasadena, the Timken, San Francisco, Hartford, Yale, the National Gallery, Chicago, Boston, the Clark, Detroit, Kansas City, St. Louis, Omaha, Elmira, Glens Falls, the Frick, the Metropolitan, Raleigh, Cincinnati, Cleveland, Oberlin, Toledo, the Kimbell, Houston, Richmond, Ottawa, Toronto; his drawings are in the Fogg, Ottawa, Wellesley, and Vassar; Pasadena has sixty.

PASADENA: *Landscape with a Piping Shepherd,* 1635.

TIMKEN: *Pastoral Landscape,* 1646–47.

HARTFORD: *St. George and the Dragon,* 1646.

CINCINNATI: *Artist Studying from Nature;* many sketches show that Claude studied from nature, but he painted in his studio.

CLEVELAND: ★ *Roman Campagna near Tivoli;* though Tivoli was a thriving town, Claude shows only a hint of its Roman ruins on the heights; a medieval church spire punctuates the mid-distance, and two tiny soaring eagles emphasize the vast sweep of sky above the deeply shadowed landscape of early evening.

Lucas (Hugensz.) van Leyden (1494–1533)

A Dutch painter and printmaker, Lucas used diluted pigments so that his paintings almost resemble gouache or watercolor, with an individual palette of dull orange, yellow, acid green, and light blue. A distinguished draftsman, he was influenced by Dürer. His prints are in most collections. His paintings are rare in North America, although he is represented in Boston and Philadelphia. Several tapestries of the series of *The Months,*

for which he made cartoons, are in American collections—for example, *December* in Denver. The series was produced for the Barberini Palace in Rome.

FOGG: *An Angel;* a delightful fragment painted with a linear grace reminiscent of his prints.

NATIONAL GALLERY: *The Card Players,* c. 1520; a rare essay in genre; note the acquisitive noses!

Luks, George (1867–1933)

A member of The Eight, Luks was trained as a newspaper artist. A pupil of Robert Henri, Luks painted lively scenes of everyday life, street characters, and urchins with a breezy good humor typical of the artist. Like Henri, he was a natural teacher who dressed "to the nines" in the manner of the elegant William Merritt Chase, but unlike Chase, he often entered his classes doing a vigorous buck-and-wing tap dance to the accompaniment of an often bawdy version of the latest popular song. His paintings are in most American collections. ☛ His masterpiece is the winning, full-length portrait of ★ *Mrs. Gamley* (1933, the Whitney) shown holding her pet rooster; Utica has several of his lively drawings.

Lysippos (c. 370–300 B.C.)

One of the three great masters of pre-Hellenistic Greek sculpture, the others being Scopas and Praxiteles; no works of any of these can be definitely identified, but Roman copies reveal certain stylistic traits, such as slender proportion, smaller head, and greater naturalism, which have led to the identification of the life-sized bronze male nude, recovered from the water of the Mediterranean and now in the Getty, as being a possible original by Lysippos. Whoever did it, it is an outstanding work. Lysippos has also been identified by some scholars as the sculptor of the superb *Horses of St. Mark* in Venice, gloriously beautiful Apollonian steeds of supernatural grandeur and power.

Maillol, Aristide (1861–1944)

A leading French sculptor, Maillol achieved great monumentality in his handsome, statuesque figures which have a calm serenity in the spirit of fifth-century Greece but are very much in the classic nude tradition of nineteenth-century France, as seen in the painted nudes of Renoir. He was a close friend of Matisse and knew the other leaders of Impressionism and Post-Impressionism. He sculptured the Cézanne monument now in the Tuileries in Paris (a maquette is in Boston). His work is in many American museums, with significant groups in the Modern, the National Gallery, Buffalo, and the Metropolitan. He also did illustrations in the

same spirit as his sculpture, notably for *Daphnis and Chloe,* which are in most print collections.

UNIVERSITY OF ARIZONA MUSEUM: *Flore Nue.*

BALTIMORE: *Summer.*

MODERN: *Nude;* in the sculpture garden, along with others, esp. *Méditerranée;* an earthy, serene seated figure.

UTICA: ★ *Île de France;* a torso of a young woman in bronze with a golden patina, a lyric piece.

RICHMOND: *The River;* a monumental bronze.

Malevich, Kasimir (1878–1935)

A Russian experimental modernist, Malevich was influenced by Cubism and became recognized as a pioneer of the avant-garde. His works were suppressed by the USSR because they were regarded as not being sufficiently propagandistic of the ideals of the Communist party, so he could no longer be a painter and decorated china in a factory until his death in obscurity. His work is in a few American museums, especially the Modern, where his *White Square on a White Background* (c. 1919) is perhaps his most radical work.

Manet, Édouard (1832–83)

Manet came of a wealthy family who hoped for better things for him, but he persisted in becoming an artist. He traveled widely and formed his painterly style influenced by Goya, Velázquez, and Hals, only later adopting the lighter Impressionist palette, under the influence of Berthe Morisot, his sister-in-law. An independent innovator, he was refused participation by the Salon, so he was instrumental in founding the Salon des Refusés of 1863 where the most interesting painting then being done was exhibited. His work has been much respected and much collected, and may be found in virtually all major museums, incl. the National Gallery, the Phillips, Boston, the Fogg, Chicago, the Barnes, St. Louis, the Frick, the Metropolitan, Toledo, Philadelphia, and Providence.

NATIONAL GALLERY: *The Dead Toreador,* 1865; the top half— Manet cut it in two horizontally—is *Bullfight* (1866) in the Frick; it uses a dramatic black emphasis in the manner of Velázquez. *Gare Saint-Lazare,* 1873; painted in one sitting in a friend's garden; a glorious piece of painting.

PHILLIPS: *Ballet Espagnol,* 1862; things Spanish became fashionable in Paris in the 1860s.

CHICAGO: *The Races at Longchamps,* 1864; full of movement.

BOSTON: *The Street Singer,* 1862; actually a portrait of Victorine Muerand, painted in curious, chalky tones.

FOGG: *Skating,* 1877.

PHILADELPHIA: *The Battle of the Kearsarge and the Alabama,* 1864; depicts an event that took place off Cherbourg.

METROPOLITAN: *The Guitarist,* 1861; probably the popular Spanish entertainer Lola de Valence. *Mlle. Victorine in the Costume of an Espada,* 1862.

HILL-STEAD: *The Guitar Player;* another portrait of Victorine Meurand; she was also the model for the famous *Olympia* (1863) and the *Déjeuner sur l'Herbe* (1863), both in the Louvre.

PROVIDENCE: ★ *Le Repos,* c. 1872; an informal portrait of the painter Berthe Morisot, Manet's sister-in-law.

Mantegna, Andrea (c. 1431–1506)

An Italian Renaissance painter who worked in Padua where he was much influenced by Donatello's sculpture. Mantegna developed a sculptural painting style in which every detail is realized with an emphatic three-dimensionality. He was related by marriage to the Bellinis of Venice and influenced Giovanni especially. He was court painter to the Gonzaga family, rulers of Mantua. Among his few works in America are examples in the National Gallery, the Metropolitan, and Cleveland. His distinguished prints are in major print collections. ☛ The Metropolitan's ★ *Adoration of the Shepherds* of c. 1450; Cincinnati's *Esther and Mordecai;* see also the Clark.

Marin, John (1870–1953)

Trained as an architect, Marin became famous for his abstract and expressive watercolors, esp. his seascapes, although he also painted in oil. His work is in many American museums' collections, with important groups in Colby, Andover, the Whitney, the Modern, the Metropolitan, the Phillips, and La Jolla.

ATLANTA: *Gray Ledges, Blue Breaking Sea—Region Cape Split,* 1937; watercolors; painted "in a gale of wind from the Northwest."

COLBY: *Opera House, Stonington,* 1923; early watercolor; note the painted frame; Marin often made his own frames and included them as a part of the pictures.

WICHITA: ★ *Sunset, Casco Bay,* 1919 watercolor; given by fellow artist and old friend, Georgia O'Keeffe. *The Fog Lifts,* 1949; a

fine late oil. *Tunk Mountains,* 1952, oil; the taut, linear geometry shows him still experimenting at age eighty-two to express "the expansive, joyful poetry of earth, and sun, and sea," in art historian E. P. Richardson's happy phrase.

Manzù, Giacomo (1908–)

One of Italy's leading sculptors of today, Manzù was born in Bergamo, studied with a woodcarver, and after time in the army, worked in Paris for a short time before settling in Milan where he has lived ever since. His seated and standing cardinals—brooding, inward-looking religious figures—and his great bronze doors for St. Peter's in Rome have won him great respect. He is a painter and illustrator also, being a fine draftsman. Like his contemporary countryman Emilio Greco, Manzù is one of the rare artists of our times who can carry out religious commissions with conviction and power. There are not many of his works in American public collections. Examples may be found in the Modern and Cleveland. Other works are in the Hirshhorn, Los Angeles, Buffalo. ☛ The Modern's *Portrait of a Woman* (1946); the Hirshhorn's *Cardinal,* one of a series; and *Cardinal Enthroned* in Providence, the maquette for the monumental sculpture in Bologna.

Martini, Simone (c. 1284–1344)

A Sienese painter and a pupil of Duccio, Martini was a leading Gothic painter, anticipating the International Style of the late fourteenth century in the flamelike forms and curvilinear design of his paintings, executed with grace and surety. He spent his later years at the papal court in Avignon during the Babylonian Captivity. There he knew the great humanist poet Petrarch, for whom he illustrated a Virgil manuscript (Ambrosian Library, Milan). Among the few works of his in America, examples are in Yale, the Fogg, and the Gardner.

FOGG: *Christ on the Cross,* c. 1320; the grave seriousness and linear grace are typical of Martini's style.

GARDNER: *The Madonna and Child with Four Saints;* a polyptych; a lovely example of Late Gothic with a distinctively Sienese flavor to its sophisticated flat pattern and formal elegance.

Masolino da Panicale, Tommaso di Cristoforo Fini (c. 1383–1447)

Masolino ("Little Tommy") belonged in time to the first generation of the Renaissance, but like his contemporary Lorenzo Monaco, Masolino practiced the graceful Late Gothic International Style except when influenced by the younger and far greater painter Masaccio ("Hulking Tom"), with whom he worked on the Brancacci Chapel frescoes in Santa

450

Maria del Carmine in Florence, a great landmark in the development of the Renaissance. Examples of his work are in several American museums, among them the National Gallery, Detroit, the Metropolitan, and Philadelphia. ☛ Two paintings of the *Annunciation* in the National Gallery.

Masaccio, Tommaso di Giovanni (called "Hulking Tom") (1401–c. 1428)

Although he lived only about twenty-seven years, Masaccio was the first of a succession of outstanding Florentine artists, a pioneer of the Renaissance, whose Brancacci Chapel frescoes in Santa Maria del Carmine, Florence, combine the sculptural bulk of Giotto with the naturalistic vision of the early Renaissance in a style of simple grandeur. Humanistically based, Masaccio's achievement was equal to that of his older and much longer-lived contemporary, the great sculptor Donatello. Very few works in American collections are ascribed to Masaccio. ☛ A *Portrait of a Young Man* (c. 1428) in the National Gallery and another in the Gardner.

Matisse, Henri (1869–1954)

Matisse brought a sound academic training, a sensitive awareness of the directions of experiment of Cézanne, Van Gogh, and Gauguin, and an innate sense of the joy of living to create an art of exuberance and celebration to which he devoted a long and immensely productive life of painting, drawing, sculpture, printmaking, and decoupage. In its essential sanity, his work is profoundly unlike that of most of the Fauves and other Expressionists, among whom he was a leader, and closer in spirit to Monet, Pissaro, Renoir, and Maillol in its affirmative vitality. His work is in virtually every modern collection, outstanding groups being in the Modern, the Barnes, and Philadelphia. The National Gallery has recently acquired wonderful examples of his decoupage, done late in life when physical limitations prevented his painting and he was confined to bed and to a wheelchair; they are a triumphant expression of unquenchable spirit.

BARNES: *Joy of Life,* 1905–6; a classical bacchanal in the spirit of Titian and Poussin, and a landmark in modern art; compare with *Dance II,* 1932–33, equally classical in spirit, but austere and monumental, a splendid mature work.

BALTIMORE: *The Pink Nude,* 1935; one of his great works.

CARNEGIE: *The Thousand and One Nights,* 1950; gouache on cut-out pasted paper; a twelve-foot frieze in collage.

MODERN: *The Red Studio,* 1911; a symbolic self-portrait in terms

of the objects seen in the artist's studio. ★ *The Piano Lesson,* 1916; superbly orchestrated in a bold flat design in luscious color.

NATIONAL GALLERY: ★ *Apples on a Pink Tablecloth,* 1925; Cézanne's *Still Life with Apples and Peaches* (c. 1905) and Braque's *Peonies* (1926), both in the same collection, make a fascinating comparison—all three are absolutely tops!

ST. LOUIS: *Bathers with a Turtle,* 1908.

Memling, Hans (1435–94)

Born in Germany, Memling (also spelled Memlinc) went to Bruges about 1467, where he apparently studied with Rogier van der Weyden and had a highly successful painting career both as a portraitist and a religious artist. Two dozen or so Memlings are in the following museums: Pasadena, San Diego, the National Gallery, Chicago, Notre Dame, the Clark, Kansas City, the Frick, the Metropolitan, Philadelphia, Raleigh, Cincinnati, Greenville, Houston, Ottawa, and Montreal. The major groups are in the Metropolitan and the National Gallery.

NATIONAL GALLERY: *St. Veronica* (on the reverse, *The Chalice of St. John,* a fascinating symbolic still life), c. 1480.

METROPOLITAN: Portraits of *Tommaso Portinari* (head of the Medici bank in Bruges) and his wife; Portinari ordered the famous Portinari altarpiece by Hugo van der Goes (c. 1476, Ufizzi), which greatly influenced Italian Renaissance painting.

CINCINNATI: *St. Christopher. St. Stephen;* both are small and fine, with delightful landscape backgrounds.

MORGAN: *Young Man with a Pink.*

Meryon, Charles (1821–68)

An outstanding etcher of architectural subjects, Meryon's *Views of Paris,* started about 1850, were much admired by Victor Hugo. They combine objectively recorded scenes with strange fantasies, symptomatic of the insanity which shadowed his later years, during which he came to know Dr. Gachet, the doctor friend of Van Gogh who cared for him when he was similarly afflicted. Meryon's works are in all major print collections.

Michelangelo, Buonarroti (1475–1564)

One of the greatest artists of all time, Michelangelo was also the finest Italian poet of his generation. He studied briefly with Ghirlandaio and then with Bertoldo di Giovanni, the curator of the medici sculpture garden in Florence. From the early *David* (1501–4) to the late *Pietàs,* his

Sistine and Pauline frescoes, his architectural designs for St. Peter's dome and the Campidoglio in Rome, no one has ever surpassed the power and grasp of his tremendous conceptions. As in the case of his younger contemporary, Leonardo da Vinci, everything that Michelangelo touched has the force and the magic of his own unique and towering genius. There are few works in America that can be attributed to him. ☛ The finest is perhaps the ★ *Studies for the Libyan Sibyl* for the Sistine ceiling (the Metropolitan), a sheet of drawings of consummate authority, with both delicacy and strength and a commanding presence.

Miller, Alfred Jacob (1810-74)

A Baltimorean, Miller studied briefly with Sully in Philadelphia before leaving in 1833 for the École des Beaux-Arts in Paris. Before returning home, he traveled widely in Europe. Back in Baltimore he met a visiting Scot, Captain William Drummond Stewart, who asked him to go on a Western expedition with him as staff artist to paint a series of Western scenes for Stewart's Scottish castle. Miller also did a series of watercolors for William T. Walters of Baltimore, now in the Walters Art Gallery. Miller's sketches and paintings provide a graphic picture of the West at the height of the fur trade and the westward expansion. His works are in many collections, the most important groups being in the Walters, Cody, and Boston.

Millet, Jean-François (1814-75)

A peasant's son who developed into an important artist under Daumier's influence, Millet evolved a smoky, atmospheric style with which he painted scenes of peasant life and landscapes of Barbizon, near Fontainebleau, where he was, with Corot, a central figure in the so-called Barbizon Group. His works are in many American collections, the most important group of them being in Boston, consisting of a large number of paintings and lithographs. ☛ *The Sower,* c. 1850, perhaps his most monumental; the Carnegie has another version.

Miró, Joan (1893-)

A leading Spanish painter and sculptor, Miró is a Surrealist who designs tapestries and stage sets. His lively, fantastic, and very personal style in both painting and sculpture often reveals a delightful and unexpected humor. Large groups of his work are in the Modern and the Guggenheim. One of his tapestries, on an immense scale, is in the new East Building of the National Gallery. A mural is in Cincinnati. He produces many lithographs.

BUFFALO: *Carnival of Harlequin,* 1924–25; delightful humor and a brilliant palette.

HARTFORD: *Composition,* 1933; as in automatic writing, the forms emerge spontaneously from the artist's subconscious mind and then are consciously further organized.

MODERN: *Painting,* 1933; "poetry pictorially expressed speaks its own language," the artist wrote.

PHILADELPHIA: *Dog Barking at the Moon,* 1926; shows Miró's typically puckish quality.

Modigliani, Amedeo (1884–1920)

Modigliani was born in Italy but lived his adult life in France. His paintings and sculptures, influenced by Cézanne, African art, and Picasso, are characterized by a sinuous grace of form and contour. Examples are in most modern collections, with an important group in the Modern. His sculptured *Head of a Woman* (c. 1910) in the National Gallery is one of his most successful works.

Mondrian, Piet (1872–1944)

A leading Dutch modernist, Mondrian early abandoned naturalistic painting for an increasingly purist geometry of rectilinear spaces divided by black lines, in white, black, and gray, and in red, yellow, and blue. In 1940 he came to New York where his work influenced the sudden and explosive emergence of the New York School. ☞ The most important collections of his work are in the Guggenheim and the Modern. His *Broadway Boogie-Woogie* (1942–43, the Modern) is a record of his New York visit.

Monet, Claude (1840–1926)

A leader of the Impressionist group, throughout his life Monet remained true to Impressionist principles of faithfulness to the transitory surface appearance of things. His series of canvases of a single subject, painted in the changing light of different times of day, are like variations on a theme in music. Monet had an Olympian personality; he painted constantly and is represented in most museum collections. His late, tremendous, enveloping canvases of water lilies, painted in the garden of his house at Giverny, laid out himself (recently restored through American generosity), are not only the culmination of his devotion to the visual impression, but also anticipate Abstract Expressionism and environmental art. Important collections of his work are in the National Gallery, the Metropolitan, and Boston. All he did is fascinating.

NATIONAL GALLERY: *Banks of the Seine, Vétheuil;* the sun and

sparkle are typical of Monet. *Artist's Garden at Vétheuil. Argenteuil,* c. 1872. *Houses of Parliament, Sunset,* 1903.

FOGG: *La Gare Saint-Lazare, Paris,* 1877.

METROPOLITAN: *The Terrace at Sainte-Adresse,* 1866; showing his emerging grasp of an Impressionist style. ★ *La Grenouillère,* 1869; the dappled light and vibration of his mature style.

CARNEGIE: ★ *Water Lilies,* 1920–21; Monet began his water lily series as early as 1899; in such tremendous late paintings he anticipated aspects of contemporary art; other examples are in the Modern.

Morisot, Berthe (1841–95)

Morisot and Cassatt were among the leading painters of their generation; both were members of the Impressionist group. Morisot married Édouard Manet's younger brother, Eugène, and had considerable influence in her brother-in-law's stylistic development toward an Impressionist vision and palette. Like Cassatt, Morisot had a fully professional, independent, and highly successful career. Her prints and drawings as well as oils and pastels are in several collections.

NATIONAL GALLERY: *The Artist's Mother and Sister,* 1869–70; the composition is Degas-like, but the style is pure Morisot, as is the pensive mood. ★ *The Harbor at L'Orient,* 1869; a disarming simplicity of means for a thoroughly sophisticated result.

CHICAGO: *Self-portrait;* a quiet self-awareness and authority.

CLEVELAND: *Madame Pontillon Seated on the Grass,* 1873; a portrait of the artist's sister; her own vision expressed with her own sensibility.

Morse, Samuel Finley Breese (1791–1872)

A student of Benjamin West in London and of Washington Allston, Morse aspired to be a history painter, an art form little appreciated by his countrymen despite its popularity in Europe. He spent some years as an artistically successful but financially impoverished portrait painter, producing such distinguished work as the great *Marquis de Lafayette* (1824–26; City Hall, New York) and *The Muse* (1837, the Metropolitan), a portrait of the artist's daughter, Susan Walker Morse. So he turned again to science and prospered. With the invention of the telegraph in 1832, he had established his reputation. He was the first president of the National Academy of Design (1826–45) and a founder of the Metropolitan Museum.

CORCORAN: *Old House of Representatives,* 1822; a tour de force, eighty-six portraits from life!

COOPERSTOWN: *View from Apple Hill,* c. 1828.

SYRACUSE UNIVERSITY ART COLLECTION: ★ *The Gallery of the Louvre,* c. 1833; the artist's friend James Fenimore Cooper, the author, is in the far doorway.

YALE: *The Dying Hercules;* sculpture in plaster done for a projected mythological painting; a very capable piece.

Moses, Anna Mary Robertson (Grandma) (1860–1961)

Grandma Moses first started to paint at sixty-seven and continued to do so until she as a hundred. A genuine primitive, she painted pictures out of her imagination and memory of life on the farm. Their unpretentiousness and wit give them a winning charm. Her work has been much collected and is in many museums, among them the Modern, Whitney, and the Metropolitan. The Bennington, Vermont, Museum has a large collection, incl. the schoolhouse from Eagle Brook, New York, where she lived, and various memorabilia.

Mount, William Sidney (1807–68)

Mount was a leading American genre painter who lived and worked in Stony Brook, Long Island, after a period in New York City. His subjects were the rural life and amusements of his family and neighbors. He was a capital fiddler who loved to perform at parties, and the theme of music runs through his painting. Although he earned his living chiefly by portrait painting, his reputation is based on his cannily observed and expertly painted genre subjects which have been much collected. His works are in almost all American collections, but the most important concentration of them is in the Suffolk Museum at Stony Brook. He is well represented in the Metropolitan, the New-York Historical, Detroit, Brooklyn, and Chicago. Both humor and nostalgia run through his art which, at its best, is an unsentimental celebration of the folkways of village and farm.

COOPERSTOWN: ★ *Eel Spearing at Setauket,* 1845; a superbly constructed composition, the artistry of which is hidden by the ease and apparent simplicity of presentation.

DETROIT: *The Banjo Player,* 1858.

BOSTON: *The Bones Player.*

METROPOLITAN: *Cider Making,* 1841; delightful, full of sun and air. *Long Island Farmhouses,* 1854–59.

Munch, Edvard (1863-1944)

Munch was born and lived most of his life in Norway where most of his work is located. He was an important Expressionist whose neurotic obsession with love and death produced some of the most powerful and disturbing paintings, prints, and drawings of the period, and had a great influence on German Expressionism. He designed sets for Ibsen's *Peer Gynt,* and in his later work, after recovery from a breakdown in 1908, he strikes a note of distinctive, lyric color and a less hysterical mood. His paintings are rare outside of Norway, but his prints are in every major collection.

Murillo, Bartolomé Esteban (1618-82)

A Spanish painter of Seville, Murillo enjoyed great popularity from his own times through the nineteenth century for his pictures of sentimental beggar boys and enraptured madonnas with upcast gaze. Except for a few fine portraits, some emotional religious pieces, and a group of ethereal but genuinely poetic landscapes, Murillo's work has unfortunately little attraction for us today. Murillo's paintings are to be found in Pasadena, San Diego, the Timken, Hartford, the National Gallery, the Norton, the Krannert, Chicago, Indianapolis, Louisville, the Walters, Boston, the Fogg, Pittsfield, the Clark, Detroit, Kansas City, St. Louis, Elmira, the Metropolitan, Raleigh, Cincinnati, Cleveland, Toledo, Portland, Providence, Columbia, Greenville, the Kimbell, Houston, Richmond, Ottawa, and undoubtedly others.

NATIONAL GALLERY: *A Girl and Her Duenna,* c. 1670; a more freshly observed creation than is typical of Murillo.

METROPOLITAN: Portraits of *Don Andrés de Andrade y la Cal* and *Pedro Núñez de Villavicencio;* good examples of his portrait style.

RALEIGH: *Blessed Giles Before Pope Gregory IX;* from a series of his best religious works.

Nevelson, Louise (1900-)

Born in Russia but brought up in Rockland, Maine, Nevelson is one of today's outstanding sculptors, with an international reputation. Although she has worked in Cor-Ten steel, stone, and bronze, her most successful medium is the assemblage of found wooden forms, arranged in shallow relief, often free-standing. Her pieces are painted black, white, or gold, and almost seem to constitute an environment because of their size and format. She is represented in major modern collections both here

and abroad, with particularly significant pieces in groups in Pasadena, the Modern, the Whitney, Hirshhorn. The Walker has fourteen pieces, including *Sky Cathedral Presence*. She created a chapel for the skyscraper church in the Citicorp Building, on Lexington Avenue in New York City, which is a most successful environment.

MIT: *Transparent Horizon,* 1975; painted steel, planned and executed at a very large scale for its outdoor situation.

WHITNEY: *Dawn's Wedding Chapel II,* 1959; wood construction, painted white.

WALKER: *Sky Cathedral Presence,* one of an important group of black pieces created over more than a decade.

Noguchi, Isamu (1904–)

A Japanese-American sculptor and designer who studied with Constantin Brancusi, Noguchi is a consummate craftsman in the use of natural materials in geometric, but, more often, biomorphic forms, often of great simplicity. He has designed parks and playgrounds, and produced successful monumental sculpture. His work is in the Modern, the National Gallery, the Metropolitan, Seattle, and other museums with modern collections. Its Far Eastern flavor is unmistakable and deliberate because the artist maintains consistent contact with Japan as well as the United States and produces much work in his Japanese studio.

DETROIT: Civic Center Plaza landscape and sculptures.

NATIONAL GALLERY: *Great Rock of Inner Seeking,* 1975; with overtones of traditional Japanese garden art and of Zen Buddhist contemplation.

LINCOLN: *Song of the Bird.*

WHITNEY: *Humpty-Dumpty,* 1946; in ribbon slate, immaculately carved.

O'Keeffe, Georgia (1887–)

From early in her life, O'Keeffe knew she wanted to be an artist. She studied at the Art Institute of Chicago and the Art Students League in New York, but it was the influence of oriental art that gave her a direction, and Alfred Stieglitz, the director of the first New York gallery devoted to showing the new in art, who encouraged her. For years she has lived in the New Mexico desert, painting tremendous flowers, cloudscapes, and the objects and materials of the desert. Her works are in all major American museums, with important collections in the Modern, the Whitney, Chicago, and the Metropolitan.

CHICAGO: ★ *Black Cross, New Mexico,* 1929; symbolic of the Hispanic heritage in the American Southwest. *Cow's Skull and Calico Roses,* 1931.

ROSWELL: *Ram's Skull with Brown Leaves,* 1936; the last two works both suggest the empty spaces of the desert that the artist loves.

Pannini, Giovanni (1691–c. 1765)

An Italian architectural painter whose major subject was the picturesque ruins of Rome, Pannini also painted contemporary Roman views and capriccios including Roman landmarks. He shared archaeological interests with his contemporary Piranesi. Always popular, his works are in many collections.

NATIONAL GALLERY: *Interior of the Pantheon,* c. 1780; one of many versions. *Interior of St. Peter's,* 1746–54.

METROPOLITAN: *Ancient Rome. Renaissance Rome,* both dated 1757; carry out a popular conceit in painting an assemblage of views as if they were pictures hung in an imaginary gallery; Boston also has a work exemplifying this idea.

Peale, Charles Willson (1741–1827)

The son of an English remittance man, Peale learned a saddler's trade, took up woodcarving, and started in on his own as an untrained portrait painter, doing well enough to gain patronage for a trip to London where he studied with West for two years. He returned to Philadelphia in 1769 to be the undisputed leader of the portrait field in America until Stuart's return from Europe in 1793, Copley having settled permanently in London. Charles's brother James (1749–1831) was a miniaturist in Philadelphia. Between them the brothers had twenty-three children, all of whom painted, and a number of their descendants are painting yet. Charles's son Raphaelle (1774–1825) produced outstanding still lifes; his brother Rembrandt (1778–1860)—all of Charles's children were named after artists—painted excellent portraits among other subjects. The work of various members of the family may be found in many American museums, esp. in Philadelphia, Baltimore, and the New-York Historical. The last-named museum has Charles's *Peale Family Portrait,* a work which even includes the family dog Argus, who assisted as a custodian of the Peale Museum that Charles founded in Baltimore in 1786.

PITTSFIELD: *General David Forman;* a convincingly forthright portrait of a doughty Revolutionary hero.

459

PENNSYLVANIA ACADEMY: ★ *The Artist in His Museum,* 1822; a sturdy, vigorous self-portrait, in which he invites us to enter his beloved museum in which he pioneered in the display of habitat groups; painted when he was a lively eighty-one.

PHILADELPHIA: *The Staircase Group,* 1795; an illusionistic portrait of two of the artist's sons, Raphaelle and Titian Ramsey Peale, originally framed in a real doorframe.

BALTIMORE, THE PEALE MUSEUM: *Exhuming the First American Mastodon,* 1806-8; the artist's own record of his own memorable excursion in paleontology which provided the first mastodon skeleton to be reassembled and displayed, a feature of the Peale Museum.

Pevsner, Antoine (1886–1962)

Gabo's older brother, Pevsner was born in Russia, studied in Kiev, went to Paris in 1911 where he was much influenced by Cubism. In 1917 both brothers returned to Russia, planning, with the approval of the Revolutionary government, to develop a new art of "Constructivism," as it was dubbed. But the Communist party's ultimatum against all but Socialist Realism (i.e., political propaganda painting) led to his flight to Paris in 1923. His works are less common than his brother's in the United States, but are in the Modern and a few other collections of modern works.

Phyfe, Duncan (1768–1854)

Brought from Scotland as a boy by his widowed mother, by 1792 Phyfe had his own cabinetmaking shop in Partition (later called Fulton) Street, in New York City. His fine work was noticed by John Jacob Astor, another immigrant who had made a fortune in beaver skins, and Phyfe's shop became the busiest in New York until he retired in 1847 in his eightieth year. He worked in all aspects of the styles of the period from Hepplewhite and Sheraton to Empire and Victorian, filling orders from all parts of the country, until his style became almost exclusively that of an era. His tremendous popularity produced many imitators. His shop also produced many fine craftsmen who opened up their own shops, often in other cities. One of these was Prudent Mallard (1809–79), Paris-trained, who set up in business in New Orleans in 1838 and produced excellent pieces, handsome and large in scale, appropriate for high-ceilinged Southern houses. Phyfe's work is in many museums, and in virtually all American domestic arts collections. Groups of works are in Boston, Yale, Winterthur, Chicago, the New-York Historical, and the Metropolitan.

Picasso, Pablo Ruiz y (1881-1973)

Picasso remains the protean and predominant artistic figure of the century, the brutality and power of whose disquieting images, after 1907 and the revolutionary *Demoiselles d'Avignon* (the Modern), seem consistently to destroy the various traditions and directions art had taken up to that time. The compulsive inventiveness which characterized the rest of Picasso's life led him to challenge almost every artistic convention, attitude, or preconception, from notions of beauty, harmony, and the classic ideal to the idea of craftsmanship itself, and to assumptions of what art is and ought to be. The antic egotism and iconoclasm which run through his long and fecund career further emphasize the incredible creative drive which produced such a variety of expression in so many forms and media, all pursued with a relentless vitality. His life and art form an inescapable landmark in cultural history. Picasso was so productive that his works, in some medium or other, are in virtually every art museum. The majority of the most significant are in the Modern, however.

BUFFALO: *La Toilette,* 1906; an early nude.

CHICAGO: *The Old Guitarist,* 1903; like *The Blind Man's Meal* of 1902 in the Metropolitan, it still retains the pathos of his early work; see also the portrait of *Daniel-Henri Kahnweiler,* his famous dealer, and a fine early drawing, *Peasants from Andorra,* 1906.

NATIONAL GALLERY: *The Lovers,* 1923; a particularly attractive example of his classical phase; compare also the early (1905) ★ *Family of Saltimbanques* (acrobats), with its quiet melancholy, with the almost harshly angular Cubist *Still Life* of 1918 and the uncompromising *Nude Woman* of 1910.

PHILLIPS: ★ *The Jester,* bronze, 1905; in the mood of the National Gallery's *Saltimbanques.*

FOGG: *The Bathers,* 1918; a beautiful drawing in classic style reminiscent of Ingres, sharing the Apollonian spirit of his illustrations (1931) for Ovid's *Metamorphoses.*

METROPOLITAN: *Gertrude Stein,* 1906; reflects the masklike abstraction of the *Demoiselles d'Avignon,* curiously appropriate for the famous author-collector.

MODERN: *Three Musicians,* 1921; another version in Philadelphia; a brash, vigorous exercise in Cubist abstraction; the museum has an outstanding collection of all aspects of Picasso's work, incl. the well-known *Demoiselles* and sculptures, among which note esp. the *Baboon with Her Baby,* 1951.

461

PHILADELPHIA: Among many other Picasso works, note esp. *Man with a Sheep* (bronze, 1944), still retaining vestiges of Rodin in its surfaces despite its deliberate primitivism.

OBERLIN: *Fernande,* 1906, a fine early sculpture.

Piero della Francesca (de' Franceschi) (1410/20–92)

Forgotten for centuries, Piero is now considered one of the greatest Renaissance painters, whose sculptural style presents figures arranged with Euclidian clarity, frozen into immobility, in compositions of architectonic finality. His light, clear palette, natural to fresco, appears in his panel paintings as well. The resulting works have a silent grandeur and Dorian monumentality at the opposite end of the spectrum from Donatello's sinewy forms, instinct with energy, and from Michelangelo's figures, which are taut with tensions and the constant promise of movement. His works are rare in the New World.

CLARK: ★ *Madonna and Child with Angels,* c. 1465; austere, silent, grand.

GARDNER: *Hercules,* c. 1460–66; detached fresco; like a Roman athlete.

METROPOLITAN: *Crucifixion;* an iconic, symbolic interpretation.

FRICK: *St. John the Evangelist, St. Monica,* and *An Augustinian Saint*—all three of these are as immobile as icons.

NATIONAL GALLERY: A *St. Apollonia* is attributed to a follower; stiffness and stolidity have replaced Piero's sculptural reserve; compare with the Frick saints.

Piranesi, Giovanni Battista (1720–78)

Although a Venetian architect, Piranesi found his spiritual home in Rome. In a period of decline, when there was little building being done, he recorded, in magnificent etchings, the antiquities there with archaeological accuracy yet with a markedly romantic spirit. His prints continued to be issued long after his death and created the vision of Rome which dominated the imagination of generations. His dramatic and emotional creations called the ★ *Carceri d'Invenzioni* (1745), or *The Prisons,* are properly appreciated as magnificent romantic visions of tremendous power. Works by him are in virtually every collection of prints.

Pisanello, Antonio (c. 1395–c. 1455)

Pisanello, a painter, muralist, and draftsman, was probably a pupil of Gentile da Fabriano whose Late Gothic International Style elegance he

inherited. He was a brilliant medalist whose works were much sought after, and his drawings show close observation and great command, esp. his studies of animals which are done with a loving, naturalist's eye. Examples of his medals are to be found in a few major museums, including the National Gallery and the Metropolitan. ☞ The series representing Lionello d'Este (c. 1440s).

Pisano, Nicola (c. 1220/25–84?); Giovanni (c. 1245/50–post-1314)

The two Pisani, father and son, respectively, carried the Proto-Renaissance of the court of the Emperor Frederick II north at the emperor's death in 1250, thus enlarging that humanistic anticipation of the real Renaissance of the fifteenth century to include central Italy. Their work in sculpture parallels that of Giotto in painting. Their major works were done in Pisa, Pistoia, Siena, and Perugia. Among their followers were Arnolfo di Cambio (a sculptor who was architect of the cathedral of Florence), Tino da Camaino, and others, whose works are rare, but are represented in a few American museums such as the Metropolitan, Cleveland, Boston, Los Angeles, and others.

Pollock, Jackson (1912–56)

A pupil of Thomas Hart Benton at the Art Students League in New York, Pollock soon took a direction in his art as far from that of his teacher as one could imagine, creating the famous drip-and-spatter style which characterizes all his mature work, and gave him a place of leadership in the New York School among the Abstract Expressionists. His work is in most modern collections and is esp. well represented in the Modern and Buffalo.

METROPOLITAN: *Autumn Rhythm,* 1950; shows his mature style.

MODERN: Compare *She-Wolf* (1943), painted in a totemic manner before he developed, later in the decade, the free-flowing rhythms of his mature style, as seen in *Number 1* (1948) and *Full Fathom Five,* in addition to *Autumn Rhythm*.

IOWA CITY, UNIVERSITY OF IOWA MUSEUM: *Mural,* 1943; painted for the famous collector of contemporary art, Peggy Guggenheim, it shows the emergence of the gesture, here calligraphic and still suggesting images, which became the basis of his developed style.

Poussin, Nicolas (1594–1665)

Poussin studied and worked in Paris, but found his true direction in Rome, where he lived from 1624 on, except for some months in Paris

in the early 1640s at the behest of Louis XIII and Cardinal Richelieu. He found Paris competitive and unsympathetic, and returned to Italy to live in an imaginary classical world of his own creation. He evolved a distinctive style derived from Raphael, Domenichino, and the Carracci, Venice, and the antique. He conceived a series of modes, as in music, each suited to a certain category of subject, each with a distinctive palette whose colors expressed the appropriate emotion. Despite these self-assumed conventions and compositions planned in three dimensions with great subtlety, his paintings have a lyricism and feeling which are distinctively his own. Poussin's paintings are in the Getty, Pasadena, Hartford, the National Gallery, the Ringling, Chicago, Baltimore, Boston, the Fogg, Worcester, Detroit, Minneapolis, Kansas City, the Metropolitan, Cleveland, Toledo, Philadelphia, Providence, Greenville, Richmond, Ottawa, Toronto, and Montreal.

NATIONAL GALLERY: ★ *Holy Family on the Steps,* 1648; a fascinating composition with a curious use of perspective to give an especial significance to the group; another version is in Cleveland.

DETROIT: ★ *Selene and Endymion,* 1635; pure poetry, deliciously painted.

METROPOLITAN: *The Blind Orion Searching for the Rising Sun;* mythic subject, mythic landscape. *The Companions of Rinaldo,* from Ariosto's poem *Orlando Furioso.*

MONTREAL: *Man Pursued by a Snake,* 1643–44; cryptic, curious, enigmatic.

MINNEAPOLIS: *The Death of Germanicus,* 1628.

Powers, Hiram (1805–73)

Powers grew up in Vermont as a jack-of-all-trades, and when his family moved to Cincinnati, he got a job at the Western Museum (where Audubon had been a taxidermist), and he won instant fame there by inventing life-sized mechanical figures which writhed and moaned with disquieting realism in a Dantesque hell. In 1837, with the patronage of Nicholas Longworth, Powers took his family to Italy and settled in Florence, where he lived the rest of his life, most successfully carving in Carrara marble dozens of portrait busts as well as many idealized figures, of which *The Greek Slave* (1843) is the most famous. Although the statue was nude, six Cincinnati clergymen testified that she was not really naked but "clothed in her own virtue!" *The Greek Slave* was the hit of the Crystal Palace Exposition in London in 1851. After that, it was shown in American cities (in Boston on alternate days for men and women, just

to be sure), and Powers' reputation was internationally secure. Many museums have examples of his work, innumerable vapid Proserpines and personifications. Some of his busts are convincing portraits, however.

CORCORAN: *The Greek Slave,* 1843; apparently the first of several versions.

NATIONAL MUSEUM: The Powers Studio Collection, incl. the plaster of his *Andrew Jackson* bust c. 1835 (the marble of it is in the Metropolitan); *Eve Tempted,* marble, 1839–42; *America,* plaster, 1848–50.

BOSTON: *Portrait Bust of Horatio Greenough,* marble; a young, handsome Greenough, Powers' only rival as a sculptor.

CINCINNATI: Several pieces, incl. a *Proserpine* and a *Ginevra.*

Prendergast, Maurice Brazil (1859–1924)

Born in Newfoundland, Prendergast grew up in Boston, where he studied art before going to Paris. There he came into close contact with Impressionism and Post-Impressionism. In 1888–89 he sojourned in Venice. As a result, he developed the independent and unique style, influenced by Pointillism, which appears in his superb watercolors and his oils. His brother, Charles, was an accomplished and imaginative cabinetmaker who often framed Maurice's paintings. Maurice exhibited with The Eight and in the Armory Show, but was basically a free individual, belonging to no special group and producing over a lifetime a remarkable body of work—pictures of poetic elegance in which all the familiar scenes of city, park, and shore are transformed by his firm and delicate brush into a vivacious and personal vision, at once serene and gay. His works are in almost all art museums and American collections. Full of lovely invention, they are always rewarding.

NATIONAL MUSEUM: *Summer, New England,* 1912; a good example of his use of oil instead of his more usual medium, watercolor; compare with *Central Park in 1903* (in the Metropolitan).

ANDOVER: *In Central Park,* 1901; painted the year he moved from Boston to New York.

METROPOLITAN: *Street Scene,* 1901; one of a fine group of his watercolors in the Metropolitan's collection, incl. the ★ *Piazza di San Marco* (1898), perhaps his finest watercolor, a view from the top of the Torre dell'Orlogio (Clock Tower) where the artist painted in the shadow of the gigantic bell with its attendant pair of colossal Moors who have struck out the hours with their immense hammers for five hundred years; compare with the lovely ★ *Procession, Venice* (1899, Atlanta).

WHITNEY: *Central Park,* 1901; another of the group he painted in this very productive year when he was obviously stimulated by his move to New York.

Prior, William Matthew (1806–73)

Born in Bath, Maine, Prior lived in East Boston where he maintained, along with his brother-in-law, Sturtevant Hamblen, and a crew of helpers from their combined families, a "painting loft" where a very large number of excellent portraits were produced, as well as "moonshines"— nocturnal views of such popular scenes as Washington's Tomb. Prior traveled continually to make drawings and collect orders for portraits, from heads "without shadows," framed and glazed for $2.95 to "fancy portraits" complete with elaborate settings and such props as dolls, dogs and cats, nosegays, and go-to-meeting clothes, for $25. Except for works that are signed, it is very difficult to distinguish between Prior himself and the other members of the family, since they all shared his popular style. Attractive examples of the group are to be found in many American collections. Among those by Prior himself:

BOSTON: ★ *Three Sisters of the Coplan Family;* signed and dated 1854, and painted in Chelsea, MA, this delightful group, with the following pair, are outstanding examples of his portraits of Negroes; a dedicated abolitionist, he was one of the few artists of the period who depicted black subjects with the same dignity and respect he accorded all his sitters.

SHELBURNE: *The Reverend William and Mrs. Nancy Lawson,* 1843.

Puvis de Chavannes, Pierre (1824–98)

An outstanding French muralist who sought to recapture, in large oils of chalky paleness, the formal dignity and classic simplicity of the great fresco cycles of the Renaissance. His work is in Chicago, St. Louis, and the Metropolitan. ☛ Puvis' most important work in America is the series of murals in the Boston Public Library (1893–95).

Quercia, Jacopo della (1374/5–1438)

The great early Renaissance sculptor of Siena, Jacopo was a direct contemporary of Donatello and Ghiberti. In vigor of composition, breadth of form, and idealism of content, he anticipates Michelangelo, who admired Quercia's work. He worked in Florence, Lucca, Bologna, and his native Siena.

METROPOLITAN: *Study for the Fonte Gaia* (the monumental polygonal fountain in the main square of Siena, for which Quercia received the commission in 1402, carried out in 1414-19; the original sculptures, now in the local museum, are replaced by copies) a fascinating drawing, still partly medieval.

NATIONAL GALLERY: *Madonna of Humility,* c. 1400; marble with traces of gilding; a favorite late medieval-early Renaissance subject, with the Virgin seated on a cushion on the ground instead of being enthroned as queen of heaven; in amplitude of form and sculptural vigor it looks forward to the Renaissance, while its spiritual inwardness reflects Gothic mysticism.

Quidor, John (1801-81)

A curious and eccentric American painter and illustrator, Quidor drew his inspiration largely from the literary works of his neighbor, Washington Irving, lending a macabre and mocking, satanic flavor to subjects from *A History of New York . . . by Diedrich Knickerbocker, The Tales of a Traveller,* and *The Sketch Book.* He is said to have earned his living decorating fire engines, banners and signs, and winning local fame for his buxom Indian beauties.

NATIONAL GALLERY: *Return of Rip Van Winkle,* 1829.

BROOKLYN: *The Money Diggers,* 1832; grotesque humor.

BOSTON: *Battle Scenes from Knickerbocker's History of New York,* 1838; burlesque. *Rip Van Winkle at Nicholas Vedder's Tavern,* 1839.

WICHITA: *Voyage to Hell Gate from Communipaw,* c. 1861; based on the *Knickerbocker History.*

Raeburn, Sir Henry (1756-1823)

An orphan from Edinburgh, Raeburn was apprenticed to a goldsmith, who recognized his gifts as a draftsman and introduced him to the studio of Allan Ramsey, the leading portrait painter of the Scottish capital. Raeburn was immediately successful and became the pre-eminent portrait painter of the northern kingdom. His style is forthright and direct. He used no preliminary sketches or drawings on the canvas. As a result there is an immediacy and vitality in his portraits which reflect his own ardent and hardy personality. Raeburn's popularity has never diminished, so he is represented in almost every art museum in North America. Significant groups of his work are in the Huntington, the National Gallery, Chicago, Indianapolis, Baltimore, Detroit, the Metropolitan, Raleigh, and Montreal.

RALEIGH: *Major General Andrew Hay; Mrs. Andrew Hay* is in Omaha.

NATIONAL GALLERY: *Miss Eleanor Urquhart,* c. 1793. *Col. Francis James Scott,* c. 1800.

CINCINNATI: *The Elphinstone Children;* a superb children's portrait.

Raphael (Raffaello Sanzio) (1483–1520)

Born in Urbino, Raphael studied with Perugino in Perugia, went to Florence in 1504, where he rapidly mastered the developed Renaissance style. In 1508 the pope summoned him to Rome where he lived the rest of his short life, decorating with frescoes the Stanze (apartments) incl. the incomparable *School of Athens,* painting portraits, altarpieces, and, in 1514 succeeding Bramante as architect of St. Peter's. Along with the older Michelangelo and Leonardo, Raphael took a leading part in the High Renaissance, which was virtually over by the time of his death at only thirty-seven of a Roman fever. He was a man of serene spirit, and the untroubled clarity of his vision shines through all his work and tends to make it seem remote, especially to us today. Yet if we remember the troubled world in which he lived and created his supreme celebrations of the best and most beautiful in thought and feeling, we can perhaps begin to appreciate his amazing gifts. There are scarcely more than a dozen works by Raphael alone, not incl. shop works, in North American museums.

GETTY: *Madonna del Velo,* 1509.

PASADENA: *Madonna and Child with Book,* 1504.

NATIONAL GALLERY: *St. George and the Dragon,* 1504–5; an early work, done in Florence, full of Renaissance freshness. *The Niccolini-Cowper Madonna,* 1508; like the following, classic Raphael. *The Alba Madonna,* c. 1510, *tondo.* ★ *Small Cowper Madonna,* c. 1505; painted when Raphael was twenty-two; pensive, touched with melancholy. In the background is the church of San Bernardino in Urbino for which it was painted.

BALTIMORE: *Emilia Pia de Montefeltio,* 1509.

WALTERS: *Madonna of the Candelabra* (with assistants).

GARDNER: *Count Tommaso Inghirami;* a very fine portrait. *Pietà,* c. 1504; painted when the artist was only about twenty as a part of the predella of the Metropolitan Museum of Art's great altar.

DETROIT: *Incident in the Life of St. Nicholas of Tolentino* (in two predella panels).

GLENS FALLS: *Portrait of a Man,* c. 1510.

METROPOLITAN: *The Agony in the Garden* (predella panel for the following; see also Gardner above). ⋆ *Madonna and Child Enthroned with Sts. Catherine, Peter, Cecelia, Paul, and the Infant St. John the Baptist, God the Father, and Angels,* c. 1504 (in the lunette); a wonderful example of the Renaissance monumental altarpiece, in this case painted for the Convent of St. Antonio in Perugia, c. 1500–10.

RALEIGH: *St. Jerome Punishing the Heretic Sabinian;* don't worry about the recondite subject chosen by some now-forgotten churchman!

There are Raphael drawings in the Metropolitan: a marvelous *Madonna and Child with the Infant St. John,* with an anatomical study on the reverse; note also the Fogg's *Head of a Girl* and Ottawa's *Praying Saint.*

Redon, Odilon (1840–1916)

Famous for still lifes of flowers and poetic landscapes, painted in a colorful palette influenced by the Impressionists, Redon also produced Surrealist monsters and dreamlike fantastic images in oil, pastel, and lithography. His works are in many collections.

ARKANSAS ARTS CENTER, LITTLE ROCK: *Andromeda* (1912); both design and color reflect medieval stained glass.

CARNEGIE: *Flowers in Green Vase* (1905); otherworldly in spirit, glowing in color.

Rembrandt van Rijn (1606–69)

A Leyden miller's son, Rembrandt studied with various mediocre painters, settled in Amsterdam to work in a style influenced by Caravaggio's chiaroscuro and by Elsheimer. His marriage to Saskia van Uylenburgh in 1634 brought him happiness and money. With a successful artistic career, the young couple assumed a life-style which resulted in bankruptcy. Saskia's early death and his financial ruin initiated Rembrandt's mature, inward-looking style which characterize his greatest works. The extraordinary series of self-portraits documents the changes which made him one of the greatest and most influential artists of all time. He was immensely productive, and his prints are in every print collection of any importance; his drawings are numerous and superb. There are dozens of his finest works in North American collections.

NATIONAL GALLERY: *Self-portrait* of 1650 and the touching *Lucretia.*

LOS ANGELES: The dramatic *Raising of Lazarus,* a subject he also etched.

PASADENA: The *Self-portrait* of 1636, plus many etchings.

BOSTON: Fascinating little *Artist in His Studio,* of which there is more than one version.

FRICK: ★ *The Polish Rider,* a wonderful and mysterious picture, and a *Self-portrait* of 1658.

GARDNER: ★ *Landscape with an Obelisk,* a marvelous little landscape, and a *Self-portrait*.

FOGG: *Self-portrait* of 1629 and a superb group of prints and drawings.

METROPOLITAN: *Aristotle Contemplating the Bust of Homer, Self-portrait* of 1660 and a moving portrait of *Hendrickje Stoffels* (1660), who lived with him and took care of him and his son Titus after Saskia's death; also numerous fine prints and drawings.

RICHMOND: *Portrait of Saskia.*

CHICAGO: ★ *Young Girl at Open Half Door,* 1645; a wonderfully subtle painting; but every Rembrandt painting, drawing, or print is infinitely worth seeing and studying and enjoying, and feeling oneself become more alive as a result.

Remington, Frederic (1861-1909)

One of the leading artists to portray life in the Old West. After a year at the Yale Art School, he became an illustrator, painter, and sculptor. His work has always enjoyed great popularity, and his bronzes have been virtually mass-produced, so there are examples in many museums. Major collections are in Ogdensburg and Cody, which has an entire collection from his studio and many other pieces.

AMON CARTER: A large collection of paintings and bronzes.

METROPOLITAN: A dozen or so typical bronzes.

HOUSTON: One of the largest groups of sculptures and paintings.

Renoir, Pierre Auguste (1841-1919)

One of the leading Impressionists, who evolved a personal style from studying the Old Masters; he painted landscapes, portraits, and figure pieces, all full of the light and air and sun of southern France where he lived. Even though his later years found him crippled with arthritis, he fastened brushes to his misshapen hands and painted as exuberantly and optimistically as ever. He was, like his friends Maillol and Matisse, an Olympian figure; his work, like theirs, is a celebration of life. His deservedly popular works have been much collected, and examples are

in every major museum, with esp. important concentrations in Boston, the Fogg, Chicago, Toronto, the National Gallery, the Phillips, the Clark, the Barnes, the Modern, and others.

NATIONAL GALLERY: *Diana,* 1867; with Maillol's classic monumentality. *Girl With a Watering Can,* 1876. *Mme. Monet and Her Son,* 1874; the boy, in his best clothes, is bored to tears.

PHILLIPS: ★ *The Boating Party;* an enchanting picture.

BOSTON: ★ *Le Bal à Bougival;* note the marvelous painting of the little bouquet of violets.

METROPOLITAN: *Mme. Charpentier and Her Children,* 1878.

FOGG: *Victor Choquet,* 1875. *Flower Piece.*

BARNES: *The Artist's Family,* 1896.

Revere, Paul (1735-1818)

A leading goldsmith of Boston, Revere was also an engraver whose prints served as propaganda for the patriot cause in the Revolutionary years. The son of a Huguenot immigrant, Apollos Rivoire, Paul continued his father's craft, and produced many fine pieces of silver during a long and useful life. He established a bronze foundry in Canton, MA, where many of America's church bells were cast, the beginning of Revere Cooper and Brass of today. Revere's silver has been much sought after, and important collections of it are found in Boston and the Metropolitan, with smaller groups in Chicago, Bayou Bend, Winterthur, Yale, Worcester, and elsewhere. A single outstanding piece is the famous ★ *Liberty Bowl* in Boston (1768) from which punch was served to Sam Adams' Liberty Boys in the Bunch of Grapes tavern when they plotted independence. Boston also has the portrait of *Revere* by his friend Copley; it shows him to have looked like the resourceful, cool, and intelligent individual his life proved him to be.

Reynolds, Sir Joshua (1723-92)

Sir Joshua was the majesterial personality in British painting of his period. In a grand style based on a study of Raphael, Michelangelo, and the antique, and on the rich palette of the Venetians and Rubens, he painted portraits of virtually every prominent personality of the second half of the eighteenth century. Uniquely among British painters, he was well educated, and he numbered such literary figures as Dr. Johnson, Oliver Goldsmith, Edmund Burke, Henry Fielding, and others of the intellectual establishment, among his friends. He was the inevitable choice as first president of the Royal Academy when it was founded in 1768,

a position in which he was followed by the American Quaker, Benjamin West. His *Discourses,* delivered at the Academy, are excellent and are organized with a clarity of thought he shared with Dr. Johnson. He had many pupils, ran a large shop, and is represented in practically every art museum in the United Kingdom and in North America.

YALE: ★ *Omai;* beautifully brushed portrait of a Hawaiian brought back to England by Captain Cook.

HUNTINGTON: *Diana, Viscountess Crosbie. Sarah Siddons as the Tragic Muse,* 1784.

NATIONAL GALLERY: *Lady Caroline Howard,* c. 1778; a delightful young girl.

ST. LOUIS: Has three fine, vigorous male portraits.

METROPOLITAN: Has more than a dozen; note esp. *Col. George K. H. Coussmaker, Grenadier Guards,* with his horse, 1782.

COLUMBUS: *Collina* (Lady Gertrude Fitzpatrick); a charming child's portrait.

TORONTO: *Horace Walpole;* prominent English literary figure.

FOGG: Paintings and drawings.

Ribera, Jusepe de (c. 1591–1652)

Born in Spain, Ribera became a leading Baroque painter of Naples, in a style combining Spanish realism with Caravaggesque chiaroscuro which gives his often brutal depictions of martyrdom and biblical episodes a shocking bite. He painted many half-lengths, busts, and full-length figures of rugged saints. His work is in many American collections, incl. Hartford, Boston, Worcester, Pasadena, Los Angeles, the Fogg, Cleveland, Toledo, the Hispanic Society, the Metropolitan, Philadelphia, and Montreal. ☛ A fine repentant *St. Jerome* is in Omaha.

Rimmer, William (1816–79)

Born in England, Rimmer came early to America, where, despite extreme poverty, he taught himself painting, sculpture, etching, lithography, music, medicine, anatomy, and drawing. In 1855 he was licensed to practice medicine. He was a superb art teacher whose pupils included John La Farge, William Morris Hunt, and Daniel Chester French. Like Eakins later, he was an expert anatomist. A curious, tragic person, whose life was haunted by illness, poverty, and personal loss, he transformed his personal tragedy into some of the greatest sculpture produced by an American, as well as into haunting paintings.

METROPOLITAN: *Falling Gladiator,* 1861; Rimmer's monument to the national tragedy of the Civil War.

BOSTON: ★ *Dying Centaur,* 1871; the original plaster; a bronze is in the Metropolitan, another in the National Gallery; *St. Stephen;* a life-sized granite head. *Flight and Pursuit,* 1872; a strange, nightmarish vision of a painting. *Evening, or the Fall of Day;* a large wash drawing of a falling, Icarus-like winged figure, a tragic symbol of great power.

Robert, Hubert (1733–1808)

Robert was a French *veduta* painter of distinction who lived in Italy from 1754–65 where he became a friend of Pannini and Piranesi and shared their appreciation of the Romantic picturesqueness of ruins of the Classic past. He and Fragonard sketched and painted together in Italy from 1756–61, and their sensitive drawings are a vivid record of the experience. After the French Revolution, Robert became one of the first curators of the Louvre. His works are in a majority of museums, including Chicago, Detroit, the Metropolitan, and Worcester.

NATIONAL GALLERY: ★ *The Old Bridge,* c. 1775; with the drama of Piranesi's prints.

BOSTON: *Interior of the Pantheon;* very similar to Pannini's version in the National Gallery. *The Picture Gallery;* again, compare with several similar pictures by Pannini, among them the pair in the Metropolitan; the similarities are those of interest, tradition, and period; the two artists' styles are related but distinctive.

Rockwell, Norman (1894–1978)

Rockwell was an accomplished illustrator famous for his engaging *Saturday Evening Post* and other magazine covers of subjects from everyday American life, interpreted with nostalgia and sentiment and recalling our yesterdays as idylls of small-town life portrayed with unfailing good humor and an innocence which never was. A collection of his sketches and paintings may be seen in the Old Corner House, Stockbridge Historical Society, Main Street, Stockbridge, MA, 01262 (413 289-3822; daily 10–5; closed Tues., holidays; fee).

Rodin, Auguste (1840–1917)

The outstanding sculptor of the late nineteenth century, Rodin was a worldwide celebrity. He occupied a transitional position in sculpture comparable to that of Cézanne in painting, pioneering in expressionistic handling of surfaces, formal abstraction, and the use of the fragment to suggest the whole. Almost every notable personality of the period sat for a portrait, although all his official commissions were subject to frustrating

473

problems, as his imaginative, innovative conceptions were too much for bureaucratic acceptance. His ★ *Balzac* and *Victor Hugo* monuments (both 1897), for example, were never accepted, although they are landmarks in the history of art. Tremendously productive, he often allowed a proliferation of bronze casts, so his work is represented in virtually every art museum collection. Large collections are in:

NATIONAL GALLERY: Many plasters as well as many bronzes.

PHILADELPHIA: Rodin Museum; note Balzac studies.

GOLDENDALE, CA, MARYHILL MUSEUM: Both sculptures and drawings.

STANFORD: The B. Gerald Cantor Collection of major bronzes.

CALIFORNIA PALACE: Note the *Burghers of Calais,* 1884–86; among the most tragic and heroic of monuments, full of Rodin's inner force.

Rogers, John (1829–1904)

A sculptor who traveled and studied abroad, Rogers eschewed fashionable Neoclassicism and settled for traditional American naturalism in the many "Rogers groups" which he developed and marketed with adroit efficiency. He faced head on the problem of multiples in art, something that has boggled the art world for centuries, and came up with his own pragmatic solution, namely, to disregard the concept of the original and to produce in quantity. His ingenious invention of flexible molds and his personal devotion to the quality of his product gave him great success, and his famous "groups," sneered at by many, are a valid aspect of the preoccupation with genre in nineteenth-century American art and are often admirably composed and sympathetically observed. Although technically far better, they are parallel to Currier and Ives prints and represent a typically American fusion of idealism and practicality in a truly popular expression which was well understood by Rogers' amusing and equally ingenious contemporary, P. T. Barnum. Examples are in innumerable historical collections nationwide; outstanding collections are in the Robert Hull Fleming Museum, Burlington, VT, and Greenfield Village, Dearborn, MI.

Rosa, Salvator (1615–73)

Rosa was a swashbuckling Neapolitan who settled in Rome and specialized in wild landscapes with bandits, battle pieces, and stormy marines, often with shipwrecks. He was also an accomplished draftsman and etcher and is reported to have been a musician and actor as well. His works have been greatly admired from the Romantic Period on. His prints are in almost all print collections, his paintings in most older museums. His drawings are fine, free performances.

Rouault, Georges (1871-1958)

Rouault began as an apprentice to a stained glass maker and always preserved in his paintings the strong black outlines reminiscent of that demanding craft. He developed a tragic and powerful expressionistic style which carried over into his etchings and lithographs. He also designed tapestry cartoons and stained-glass windows. His work is in most modern collections, his graphics in virtually all print collections. ☛ A particularly outstanding oil is *The Old King,* 1916-36 (Carnegie).

Rousseau, Henri (1844-1910)

A French primitive painter, Rousseau is often called "Le Douanier," the customs officer, because he worked in the Paris city customs bureau. A self-taught amateur, he began painting regularly about 1880, and his dreamlike canvases with their often exotic, tropical settings, were soon discovered by Picasso and other modernists, just as they also discovered the primitive arts of Africa, Oceania, and elsewhere. He exhibited in Paris with the Independents from 1886, and combining credulity, vanity, and craft in equal measure, he became a picturesque fixture of the Paris art scene. Because of their decorative, colorful appeal, his paintings are in many collections.

MODERN: *The Dream,* 1910 (also known as *Yadivigha's Dream*); a reclining nude in a wildly tropical setting, which he accompanied with an explanatory poem in childlike verse. *The Sleeping Gypsy,* 1897; an unforgettable image of haunting power, expressive of sensations we all have known—the feeling of vulnerability in sleep, and of apprehension approaching panic often felt in dreams.

Rubens, Peter Paul (1577-1640)

Aristocrat, diplomat, and scholar, Rubens, with Rembrandt, was the greatest artist of the Baroque in northern Europe. After study in the Netherlands and Italy, he settled in Antwerp as court painter to the Spanish governors of the Netherlands. His palatial house was a showplace, complete with a fine collection of works of art and a superb garden. He had many pupils and several leading assistants, distinguished artists in their own right—among them, Van Dyke, Jacob Jordaens, and Frans Snyders, an expert in still lifes and animals. Rubens painted vast mural series, altarpieces, panel paintings, portraits, and historical and mythological subjects with superb orchestration and great vitality. His own sketches are marvels of swiftness and control, and his rare landscapes look forward to Constable and beyond. He designed architectural projects, including his own house, and many tapestry cartoons. No leading artist ever maintained a higher standard of production, no matter the degree of his own participation in a given work. Because of his immense

475

output, his works are in almost every art museum, although his fluid, vivid oil sketches are especially treasured as autograph works of genius. Of the hundred and fifty or so Rubens in North American collections, the largest groups are in the National Gallery, the Ringling, Chicago, Detroit, the Metropolitan, Raleigh, and Philadelphia.

GETTY: *Four Studies of a Negro's Head.*

PASADENA: *Sketch of a Calydonian Boar Hunt.*

HARTFORD: *Tiger Hunt;* Rubens' lively treatment of such subjects points directly to Delacroix.

NATIONAL GALLERY: *Marchesa Brigida Spinola Doria;* shows Rubens' initial creation of the aristocratic portrait carried on by Van Dyke.

CHICAGO: Several fine sketches.

BOSTON: ★ *Portrait of Mulay Ahmad;* a magnificent romantic portrait. ★ *Head of Cyrus Brought to Queen Tomyris;* Snyders painted the beautiful dog; Rubens' children posed for the children in the painting which is a religious picture; the incident depicted is considered a prefiguration of the sorrows of the Virgin.

DETROIT: *Meeting of David and Abigail,* c. 1618.

METROPOLITAN: *Triumph of Henry IV. Venus and Adonis,* c. 1635.

KIMBELL: *Triumph of David. Duke of Buckingham.*

MONTREAL: ★ *The Leopards.*

And there are fine drawings also. Everything Rubens touched is full of health, exuberance, and vigor.

Ruisdael, Jacob van (1628/9–82)

Nephew and pupil of Salomon van Ruysdael (note the slight difference in spelling), Jacob lived and painted in Amsterdam where, late in life, he seems also to have practiced medicine. Through landscape painting he found a personal expression of the grandeur, lyricism, and occasional melancholy that he found in nature. Through his own painting and that of his pupils, esp. Meindert Hobbema, he was tremendously influential. All Ruisdael's works are worthy of study. Particularly interesting groups are in Indianapolis, Detroit, the Metropolitan, Cleveland, and the Pennsylvania Academy. There are a few fine drawings. Works are in Birmingham, the University Galleries of the University of Southern California at Los Angeles, Pasadena, San Diego, the Timken, Santa Barbara, the Corcoran, the National Gallery, the Krannert, Chicago, Indianapolis, Notre Dame, Louisville, Baltimore, Boston, the Fogg, the Smith,

Springfield, the Clark, Worcester, Detroit, Kansas City, St. Louis, Omaha, Manchester, Glens Falls, the Frick, the Metropolitan, Raleigh, Cincinnati, the Taft, Cleveland, Columbus, Dayton, Toledo, Philadelphia, Reading, Providence, Columbia, the Kimbell, Ottawa, and Montreal.

DETROIT: ★ *The Cemetery;* the poet Goethe's favorite painting, a prefiguration of Romanticism in its solemn grandeur.

HARTFORD: *Bleaching Grounds Near Haarlem,* a marvelous skyscape.

CHICAGO: ★ *Ruins at Egmond.*

METROPOLITAN: *Wheatfields,* c. 1670.

KIMBELL: *Landscape with Ruins of Egmond Abbey.*

Rush, William (1756–1833)

The son of a shipwright, Rush grew up in the Philadelphia shipyards and became the outstanding shipcarver of his period, filling orders for figureheads from Europe as well as America, and even for the Dey of Algiers. He carved lively figures of *Tragedy* and *Comedy* (both 1808) for the facade of the Chestnut Street Theater, *Water Nymph and Bittern* for Pump House Square (these and many more in the Philadelphia Museum), a life-sized *Washington* for Independence Hall, and many other commissions. His style shows a vigorous expressionism resulting from his direct and knowing attack on the wooden blocks. His masterfully carved organs of the human body are still used in the study of anatomy. His busts of ★ *Lafayette* and *Franklin* (Pennsylvania Academy of the Fine Arts and Yale) are lively and characterful, the latter perhaps the most knowing portrait of Benjamin Franklin extant. The Philadelphia Museum has almost all the rest of his work except for the figureheads lost at sea. A *Pocahontas* in the Kendall Whaling Museum of Sharon, MA, is generally ascribed to him.

Russell, Charles M. (1864–1926)

Russell is famous as a cowboy artist, painter, draftsman, and sculptor of the Old West. He was very prolific, and his work is in many museums. ☛ Cody has a large collection of paintings and sculpture, as does the Amon Carter; Wichita has the Naftsger Collection of drawings and sculptures.

Ryder, Albert Pinkham (1847–1917)

Born of a seafaring family in New Bedford, MA, Ryder lived in New York City, studied at the National Academy of Design, but evolved a personal

style with simplified images and heavy impasto with which to paint his haunting personal visions, so many of them related to the sea. In describing his method of working he wrote, "Have you ever seen an inchworm crawl up a leaf . . . and then, clinging to the very end, revolve in the air, feeling for something to reach something? That's like me. I am trying to find something out there beyond the place on which I have a footing." Like Rimmer, Inness, Blakelock, and others, he was one of the "inward-looking spirits" of American art. He worked and reworked his paintings and has been frequently forged, but there are examples of his painting in many museums.

NATIONAL GALLERY: *Siegfried and the Rhine Maidens,* 1875–91; from Wagner.

PHILLIPS: *Macbeth and the Witches;* from Shakespeare. *Homeward Bound;* a magical marine. ★ *The Dead Bird;* this could be Walt Whitman's "featherd guest from Alabama" in "Out of the Cradle Endlessly Rocking," full of pathos without sentimentality.

METROPOLITAN: *Toilers of the Sea,* 1884; like almost all his marines, an unforgettable image. *The Forest of Arden,* 1897; also from Shakespeare. *Moonlight Marine;* luminous and serene.

BUFFALO: *The Temple of the Mind;* from Edgar Allan Poe.

WICHITA: ★ *Moonlight on the Sea;* a solitary boat against the sky, with implications of life as a voyage as in Thomas Cole.

CLEVELAND: *The Race Track,* or *Death on a Pale Horse,* 1895; with an obsessive, nightmarish quality reminiscent of Rimmer's *Flight and Pursuit,* 1872 (Boston).

Saint-Gaudens, Augustus (1848–1907)

Born in Dublin, Saint-Gaudens was brought to America as an infant. He studied at the Cooper Union and the National Academy in New York, then in Paris and Rome in 1870. On his return in 1875 he received the commission for the Admiral Farragut monument in Madison Square, New York (completed in 1880) which made his reputation. From then until his death, he and Daniel Chester French dominated the American sculptural scene, sharing innumerable governmental and private commissions. He made a specialty of sensitively modeled relief plaques. There are examples of his work in many museums. ☛ The ★ *Memorial to Mrs. Henry Adams* (1891) in Rock Creek Cemetery in Washington and the *General Sherman* monument near the Plaza Hotel on Fifth Avenue in New York City (1903).

478

Sargent, John Singer (1856–1925)

Born in Florence of an American family, Sargent early showed the mastery of the brush which soon won him international fame. He studied in Paris, but his style was formed out of the traditions of Italy and Spain. A true cosmopolitan, he traveled all his life, maintaining headquarters in London, and secondarily, in Boston. His portraits, for which he is best known, are almost everywhere, but his oils of other subjects, such as his Venetian scenes and palace interiors, Paris sketches, and the magical *El Jaleo* (1882), with Spanish dancers, in the Gardner, are superb, as are the dashing watercolors which he produced with such amazing ease. He also painted murals for the Boston Public Library and for the Museum of Fine Arts in Boston.

NATIONAL GALLERY: ★ *Repose,* 1911; in a Venetian interior.

BOSTON: ★ *The Daughters of Edward D. Boit,* 1882; an amazing composition, masterfully handled.

METROPOLITAN: *Madame X,* 1884; this portrait of Madame Gautreau caused a scandal because of the plunging neckline of the dress and the odd skin color. *Mr. and Mrs. I. N. Philip Stokes,* 1897.

MINNEAPOLIS: *Luxemburg Garden at Twilight;* almost as broadly painted as his watercolors.

CLARK: *Venetian Interior;* one of several, with shadowy, mysterious palace rooms.

Sassetta, Stefano de Giovanni (c. 1392–1451)

Sassetta and Giovanni de Paolo were the leading fifteenth-century painters of Siena, both continuing the fourteenth-century Sienese tradition, although Sassetta was more influenced by the International Style and by the experiments with a more naturalistic treatment of space being pioneered in Florence by Masaccio, but with a mystic poetry which reflects a Franciscan innocence of beguiling charm.

NATIONAL GALLERY: *Madonna and Child,* c. 1435; as delicate as a miniature. Four panels in the *Life of St. Anthony,* c. 1440; with an assistant.

DETROIT: *The Passion,* three panels; treated like a graceful illumination.

METROPOLITAN: *Temptation of St. Anthony;* not a very rigorous temptation. ★ *Journey of the Magi,* a lovely fragment.

Other works are in Yale, Boston, the Frick, and Cleveland.

Schimmel, Wilhelm (1817–90)

A morose old wanderer of German descent who whittled and painted lively and vigorous birds and animals which he traded for lodging, food, and drink. After a life as an itinerant handyman, he died penniless in an almshouse in Carlisle, Pennsylvania, but he left behind a Noah's ark full of ornery eagles, fierce lions, combative roosters, and lively squirrels in taverns, inns, restaurants, and houses throughout the Cumberland Valley area of Pennsylvania. His work is in practically all major folk art and American collections.

Schongauer, Martin (c. 1450–91)

A German artist best known for his engravings, which reveal a delightful, imaginative personality. A superb draftsman, Schongauer exerted a considerable influence over Dürer. His prints are in most print collections. The Gardner has one of the rare paintings attributed to him.

Seghers, Hercules (c. 1590–1640)

A Dutch landscape painter and master etcher, influenced by Elsheimer, whose magical little landscapes are full of a sense of mystery. Rare and not as well known as they should be, his works were influential on Rembrandt and the development of landscape painting generally. His prints are in most major collections; important paintings are in Detroit and Philadelphia.

Seurat, Georges (1859–91)

Profoundly influenced by scientific studies of vision and color, Seurat branched out from the Impressionists to evolve a theory of his own which he called Divisionism, but which has been more popularly known as Pointillism, a system of painting with tiny touches of pure color to be mixed in the eye of the beholder. Despite the forbiddingly scientific nature of his approach—he also had a highly intellectualized system of composition—his paintings are a visual delight.

CHICAGO: ★ *Sunday Afternoon on the Island of La Grande Jatte,* 1886; his masterpiece (three studies are at the Smith).

INDIANAPOLIS: *Port of Gravelines.*

NATIONAL GALLERY: *Study for La Grande Jatte,* 1889–95; *Seascape of Port-en-Bessin, Normandy,* 1880.

BARNES: *Les Poseuses,* 1886–88.

Other works are in the Metropolitan, the Modern, and Boston; his drawings are in major collections.

Shahn, Ben (1898–1969)

Shahn was born in Lithuania, came to America at the age of eight, and became an important photographer, showing the serious social concern which also appeared in his paintings and prints. He did murals (the Bronx Post Office in New York City, and the Social Security Building in Washington, DC) but is best known for his paintings and prints, all tending toward mannerism through the presence of an edgy line, but all displaying an engaged and sympathetic attitude. His book *The Shape of Content* (1957) is excellent. His works are in most museum collections.

WICHITA: *The Blind Botanist;* a touching image.

UTICA: *The Parable;* enigmatic, powerful.

FORT WORTH: *Allegory;* a fiery chimerical beast becomes a frightening, ambiguous symbol.

WHITNEY: *Pacific Landscape;* a small, fallen figure stands for the finality of death and the horror of war.

TRENTON: A collection of paintings, drawings, and prints, and his monumental mosaics, *Tree of Life* and *Atomic Table.*

Sheeler, Charles (1883–1965)

An expert photographer and painter, Sheeler established the industrial forms of America as the domain of art; with Walker Evans, the photographer, in 1921 he produced *Manhatta,* a landmark documentary of New York with quotations from Whitman as commentary. Works are in all major collections.

MODERN: *American Landscape,* 1920; one of a series of the Ford plant.

METROPOLITAN: *Golden Gate,* 1955; the bridge tower soars like a cathedral spire.

WHITNEY: *River Rouge Plant;* another of the Ford series.

FORT WORTH: *Continuity;* as in *Golden Gate,* reveals the poetry of technological and industrial forms.

Shinn, Everett (1876–1953)

Shinn was one of The Eight. He studied at the Pennsylvania Academy and, like Henri, Glackens, and others, moved to New York where he painted scenes of theatrical life, his major interest, and wrote marvelously absurd plays in which he and his artist-friends acted with great verve and grotesque humor. He painted in oil and pastel, and produced many animated drawings and prints. His illustrations often appeared in *Harper's Magazine.*

NEW YORK PUBLIC LIBRARY: *A Winter's Night on Broadway,* 1899; a pastel of the fashionable opera crowd on a snowy evening.

WICHITA: *The Monologist,* 1910; a pastel of vaudeville.

YOUNGSTOWN: *Dancer in White;* pastel; all the tinselly glamour of popular theater.

Signorelli, Luca (c. 1441/50–1523)

Signorelli was an Italian Renaissance painter from Umbria whose best-known works are the frescoes in Orvieto Cathedral of the *End of the World* and *Last Judgment,* which display his highly developed anatomical knowledge, athletic style, bricklike coloration, and sense of drama. His works are in a number of American museums, incl. Boston, Baltimore, Detroit, the Walters, Philadelphia, Toledo, and Yale.

NATIONAL GALLERY: *Calvary,* c. 1505; muscular and dramatic. *Marriage of the Virgin,* c. 1491; seen as a courtly Renaissance ceremony. *Madonna and Child with Saints,* c. 1515; fully realized sculptural forms in an abstract composition.

Sisley, Alfred (1839–99)

A French artist of an English family, Sisley was an important Impressionist painter who produced landscapes with great charm of color and style, and of consistent quality. He is represented in most major collections, incl. the Modern, Ottawa, the Metropolitan, and the National Gallery.

BUFFALO: *Street in Marlotte,* 1866; beautifully textured walls.

NATIONAL GALLERY: *Meadow,* 1875; wonderfully and freshly observed and painted.

Sloan, John (1871–1951)

A pupil of Robert Henri, Sloan studied at the Pennsylvania Academy in Philadelphia and became a reporting artist for newspapers before developing the free and colorful style of American genre scenes and the cityscapes for which he is best known. He was one of The Eight in the landmark exhibition in New York City in 1908 and a supporter of the Armory Show in 1913. He was a lively draftsman and printmaker. His works are in virtually all American collections, with a particularly good group in the Whitney.

ANDOVER: *Sunday, Women Drying Their Hair,* 1912; full of light, air, and good humor.

PHILLIPS: ★ *The Wake of the Ferry,* 1907; view from the stern of the Staten Island ferry on a stormy day.

SANTA FE: *Music in the Plaza;* like his friend Henri, from 1920 onward Sloan spent summers in Santa Fe, where he recorded the lively goings-on of the mixed Hispanic, Indian, and Anglo population.

WICHITA: *Eve of St. Francis,* 1925; the evening procession, lit by bonfires.

Smibert, John (1688–1751)

Born in Scotland, Smibert started out as a house and carriage painter; he went to Florence in 1717 to study the pictures in the collection of the Grand Duke of Tuscany. He gained a modest success in portraiture in London before coming to America with Bishop George Berkeley in early 1729 as a professor of drawing, painting, and architecture in a proposed college to be established in Bermuda for the purpose of educating Indians. The college never came about, but Smibert's ★ *The Bermuda Group* (1729, Yale) commemorates the proposal in an ambitious multiple portrait. Smibert became the leading painter of Boston, producing solid likenesses of its leading citizens with forthright vigor, designing Faneuil Hall, the city's new market building in 1742 (later sympathetically enlarged by Bulfinch), and with his collection of copies of Old Masters and his own sober dignity, winning a place for the arts in workaday, serious-minded New England. Smibert's paintings are in many museums. ☛ What has been identified as a *Self-portrait* in Montclair.

ESSEX INSTITUTE, SALEM, MA: *Sir William Pepperell,* 1745; bandy-legged and determined!

METROPOLITAN: *Nathanial Byfield at Seventy-eight,* 1730; looking like an old bulldog!

Smith, David (1906–65)

An American sculptor whose early industrial employment gave distinction to his work, Smith produced big, powerful abstractions in steel with an uncompromising and brutal presence related to painting of the New York School. He is considered a leading sculptor of his generation, and examples of his work are in almost all American art museums, with notable representations in such modern collections as the Modern, Buffalo, the Hirshhorn, and Chicago. Smith's *Tank Totem* series of the 1950s was particularly noted by critics.

BUFFALO: *Cubi XVI,* 1963, stainless steel; one of an important series.

METROPOLITAN: *Becca,* stainless steel; a late work, named for the artist's daughter, Rebecca.

WHITNEY: *Hudson River Landscape,* steel, 1951; a witty reflection on Hudson River School compositions.

Snyders, Frans (1574-1657)

Snyders was a Flemish painter famous for sumptuous still lifes and for his portrayal of animals, specialties for which he was employed by Rubens as one of the latter's major assistants. Snyders' expert hand is involved in almost all animals appearing in Rubens' large canvases. Note for example the superb, intelligent greyhound in Rubens' *Queen Thomyris with the Head of Cyrus* (Boston), which was a family pet as well as the model. Snyders' independent works are rarer, but all are admirably painted. There are examples in major museum collections.

ALLENTOWN: *The Larder with Figures;* a gigantic canvas, effectively composed and painted with gusto.

Spencer, Lilly Martin (1822-1902)

Born Angélique Marie Martin of a French family in Exeter, England, Spencer came as a small child to an Ohio farm with her family. She was determined to be an artist, so her parents, recognizing her talent, moved to Cincinnati so she could have instruction, and she embarked on a successful artistic career. Her husband, Benjamin Spencer, acted as her business partner and assisted in raising their thirteen children. From 1848 until her death she worked in New York City, enjoying a considerable success with charmingly realized domestic scenes, usually with children, expertly painted and interpreted with spirit and with the sentiment popular in the period. Her works are in a number of museums.

COLUMBUS, OHIO HISTORICAL CENTER: *Shake Hands,* 1854.

NATIONAL MUSEUM: *We Both Must Fade,* 1869.

NEWARK: *Celebrating the Victory at Vicksburg,* 1866.

Steen, Jan (1625/6-79)

Steen was a Dutch genre painter of genial temperament—he also kept a tavern—whose pictures are full of humorous and rather trivial incidents and have proven popular enough so that examples are in most collections. ☛ His bawdy satire of the *Rape of the Sabine Women* (Ringling) with its barroom humor.

Still, Clyfford (1904-79?)

Pugnaciously independent, Still was a leading action painter associated

with the mid-century flowering of the New York School. He was one of the first to paint gigantic canvases related by size alone to environmental art. His pictures are in many modern collections, with important groups in San Francisco, the Modern, and Buffalo.

WHITNEY: *Untitled, 1957.*

FORT WORTH: *Yellow—56;* both are among the works which attracted such attention when they were first shown.

BUFFALO: Has an entire gallery devoted to Still and the most important collection of the artist's work.

Stix, Marguerite (1907–75)

An American painter, sculptor, and jewelry designer, Stix was born and studied in the Vienna of Josef Hoffmann, Adolf Loos, and the Wiener Werkstatte. An expert ceramist, she won international fame at a youthful age for sculptured portraits and worked on projects with Hoffmann and others. The Nazi takeover in 1938 made her a refugee. After a time in Paris, imprisonment in a French concentration camp, and other adventures, she came to America where she made a great success as a painter, sculptor, and jewelry designer. Her work is in many American museums, with substantial groups in the Hirshhorn, St. Paul, Storrs, Portland, the Cooper-Hewitt, Orono, Columbia, and the Nashville Fine Arts Center.

HEADLEY-WHITNEY MUSEUM, LEXINGTON, KENTUCKY: *Lion's Paw Shell Box,* 1970, rare shell, gold, opal; a sensitive combination of the natural and the crafted, with superb design.

HIRSHHORN: *Kneeling Bather,* 1958, bronze.

ARKANSAS ART CENTER, LITTLE ROCK: *Descent from the Cross,* 1951; painted terra-cotta.

NOTRE DAME: *Nativity,* 1951; painted terra-cotta; like the *Descent* (Little Rock), reduced to an almost toylike simplicity and curiously moving.

ST. PAUL: *The Stairs,* 1950; enigmatic; one of an interesting group of terra-cottas.

TULSA: *Portrait of Dorothea,* 1952, lead; a sensitive and appealing portrait; note the expressive hands.

Stuart, Gilbert (1755–1828)

Born in Rhode Island, Stuart studied in London with West, made a precocious success there, but had to leave for Ireland secretly to avoid imprisonment for debt; a friend said he dressed as fashionably as the Prince of Wales. Perhaps the most charming of all American painters, Stuart could beguile even such formidable sitters as John Quincy Adams.

His portraits of Washington made his fortune. Ebullient, feckless, witty, and warmly sympathetic, he produced a lifetime of memorable portraits, all painted with his inimitable, brilliant, flickering brushwork, realized with his keen insight into character and feeling for personality. During the long illness of his later years, when pain drove him to the bottle, his devoted and gifted daughter Jane completed many of his pictures and developed a career of her own. There are Stuart portraits in almost all museums.

BOSTON: *The Athenaeum Washington,* 1796; it has the status of a holy relic and is the basis of all other likenesses. *Martha Washington.*

WORCESTER: ★ *Mrs. Perez Morton,* c. 1802; unfinished, it shows particularly well the lovely free but sure brushwork which is Stuart's trademark; Mrs. Morton was a poet, and during sittings she and Stuart spoke in verse to each other.

COOPERSTOWN: ★ *Chief Joseph Brant,* 1786; the famous Mohawk leader most sympathetically portrayed.

NATIONAL GALLERY: *The Skater,* 1782; together with a couple of dozen fine portraits.

SMITH: ★ *Henrietta Elizabeth Frederica Vane,* 1783; subtly and delightfully Stuart reveals the real little girl—a holy terror— beneath grand-manner trappings so appropriate to her polysyllabic name.

Stuart, Jane (1812–88)

A fine painter in her own right, Jane Stuart studied with her famous father, Gilbert Stuart, and served as his assistant.

BROWN UNIVERSITY, RI: *Portrait of Gilbert Stuart;* sympathetic and incisive; the *Washington* in Oshkosh has often been attributed to Jane rather than to her father.

Sully, Thomas (1783–1872)

Sully was a distinguished portrait painter of Philadelphia. He studied with West in London and Stuart in Boston, and developed an easy, romantic style of great charm. He was very prolific, and most American collections have examples of his work.

NATIONAL GALLERY: *Lady with a Harp: Eliza Ridgely,* 1818; a charming, full-length, fashionable portrait.

PENNSYLVANIA ACADEMY: ★ *Fanny Kemble as Bianca,* 1833; a portrait as vivacious as the famous actress' personality.

PHILADELPHIA: *Portrait of Queen Victoria,* 1839; one of the most attractive portraits of the young queen.

METROPOLITAN: *Study for the Victoria Portrait,* c. 1837.

BOSTON: *Washington at the Passage of the Delaware,* 1819; a huge picture, beautifully composed and painted.

SPENCER MUSEUM OF ART, LAWRENCE, KS: *Miss C. Parsons as the Lady of the Lake,* 1812; in the Romantic period young ladies liked to fancy themselves as literary heroines, although they were rarely painted so charmingly as here, in the guise of the mysterious figure in Scott's famous poem.

Tiepolo, Giovanni Battista (Giambattista) (1696–1770)

A superbly accomplished Venetian painter, Tiepolo's magnificent fresco cycles in Italy, Germany, and Spain brought the Italian Baroque to a resounding and triumphant climax. With a gifted corps of assistants working under his immediate supervision, he was also able to produce many altarpieces and mythological and historical subjects. He was a prolific draftsman and a master etcher. There are well over a hundred of his paintings in American museums, with several times that number of drawings and prints. The Metropolitan has a superlative collection of drawings and prints, frescoes, and oils.

METROPOLITAN: The ceiling painting of *The Glorification of Francesco Barbaro,* c. 1750.

HARTFORD: *The Building of the Trojan Horse.*

YALE: *Allegory of Drama. Allegory of Poetry.*

CHICAGO: ★ *Ubaldo and Guelpho Surprising Rinaldo and Armida in the Garden,* c. 1750–55; in four panels from Tasso's *Jerusalem Delivered.*

LOUISVILLE: *Sacrifice of Iphigenia;* superb sketch.

FRICK: *Perseus and Andromeda;* for a ceiling painting in Milan.

NATIONAL GALLERY: *Madonna of the Goldfinch,* c. 1760. *Timocleia and the Thracian Commander,* c. 1750–52.

MONTREAL: *Apelles Painting a Portrait of Campaspe,* c. 1727.

There are fine groups of drawings also in Yale, the Fogg, Providence, Ottawa, and elsewhere.

Tiffany, Louis Comfort (1848–1933)

Tiffany was a leading American designer of his period, a strong proponent of Art Nouveau, who designed stained glass, ceramics, mosaics, and works in many other media at his Tiffany Studios in New York City. Very

aware of the craft revivals in Europe resulting from the work of William Morris in England and Henry van de Velde on the Continent, Tiffany gathered trained artisans in a deliberate and amazingly successful attempt to combat the total tastelessness of rampant machine production. With a strong sense of style and of history, his Favrile glass and other such achievements won him international recognition. Only in recent years have his importance and quality been rediscovered, so now his designs are being shown in an increasing number of museum collections. Especially important displays are in Chicago and in the new American Wing of the Metropolitan Museum. Corning has outstanding examples of his glass, as does Brooklyn.

METROPOLITAN: Loggia from Laurelton Hall, Tiffany's house at Oyster Bay, with ceramic capitals, lanterns, stained-glass windows, etc.

MORSE GALLERY, WINTER PARK, FL.: An important collection of objects and paintings by Tiffany.

Tintoretto, Jacopo Robusti, called (1518–94)

Called Tintoretto because he was the son of a Venetian dyer; although he studied briefly with Titian, Tintoretto seems to have been largely self-taught and developed a fascinating Mannerist style full of dramatic light and movement, with drastic foreshortenings and strange bodily positions, curious contrasts of scale, and deliberate distortions of traditional perspective for emotional effect. He painted colossal murals with impetuous speed, and his other pictures, whether portraits or religious, mythological, or historical in subject, share the same lively characteristics. With a large shop, he was very productive. Significant collections incl. murals or ceiling paintings are in the National Gallery, Detroit, and the Metropolitan.

NATIONAL GALLERY: *Susanna,* c. 1575; a delightful object of voyeurism! *Christ at the Sea of Galilee,* c. 1562; compare with El Greco, on whose development Tintoretto had great influence.

HARTFORD: *Combat Between Apollo and Marsyas,* 1545.

FRICK: ★ *Susanna;* note details of animals—shades of Circe!

KIMBELL: *Raising of Lazarus;* painted with the drama appropriate to such a miracle.

METROPOLITAN: *Miracle of the Loaves and Fishes,* c. 1558; considered by some scholars a replica of the version in Florence.

MORGAN: *Portrait of a Man;* a fine example of a genre in which he excelled.

Titian, Tiziano Vecellio, known as (c. 1485–1576)

The great master of Venetian painting, whose Olympian personality, marvelous color, apparently effortless ease of handling, and visual opulence sum up the splendor of Renaissance Venice, with its influences from both East and West. In a style owing much to Giovanni Bellini, and the latter's short-lived, brilliant pupil, Giorgione, Titian painted monumental altarpieces, sumptuous portraits, and delicious mythologies. His work is in all major art collections, the largest groups being in the National Gallery and the Metropolitan.

NATIONAL GALLERY: *Venus with a Mirror,* c. 1555. *Madonna and Child with the Infant St. John in a Landscape,* c. 1550; a lovely landscape. *Doge Andrea Gritti,* c. 1535–40. *Cardinal Pietro Bembo,* c. 1542; the famous Humanist cardinal and poet.

GETTY: *Penitent Magdalene,* 1567.

INDIANAPOLIS: *Ludovico Ariosto;* a portrait of the great Baroque poet, whose *Orlando Furioso* supplied subjects to so many artists.

FRICK: *Pietro Aretino;* the witty polemicist, pornographer, blackmailer, raconteur, poet, and writer of scurrilous letters.

OMAHA: ★ *Man with a Falcon,* c. 1530; identified as a portrait of Giorgio Carnaro, a Venetian statesman.

GARDNER: ★ *Rape of Europa;* a late work, anticipating Impressionism in its magical, personal handling of paint, virtuosity, and absolute command; considered by many scholars the finest piece of painting on this side of the Atlantic; look closely at the miraculous brushwork, so expressive of Titian's vigor and spirit.

Tobey, Mark (1890–1976)

Tobey studied to be a commercial artist, worked in England, and went to the Far East where he studied calligraphy and brush painting with a Zen monk. From the early 1930s he practiced his mature personal style which he called "white writing." He settled in the Northwest, and museums there have rich collections of his paintings and drawings, esp. Seattle, both the Seattle Art Museum and the Henry Gallery of the University of Washington. Representative groups are in the Metropolitan, the Modern, and elsewhere.

WICHITA: *Golden Gardens,* 1956.

OGUNQUIT: *Meditation Series No. 7.*

METROPOLITAN: *Broadway,* 1936; compare with *World Dust* (1957) to see the evolution of his "white writing" style.

MODERN: ★ *Edge of August;* perhaps his most beautiful picture.

WHITNEY: *New Life (Resurrection),* 1957.

Toulouse-Lautrec, Henri de (1864–1901)

A French aristocrat and a dwarf because of a childhood accident that stunted his growth, he became one of the great modern artists, whose distinctive style, influenced by Degas, Japanese prints, and Van Gogh, recorded the Paris of the music halls, cafés, the world of popular entertainment, and the brothels where he felt a degree of acceptance despite his deformity. He used all sorts of media with great virtuosity, and his works are in virtually every art collection. A superb draftsman and printmaker, Toulouse was one of the greatest poster designers as well. His prints are in every substantial print collection. ☛ Lithographs (1894 and 1898) of Yvette Guilbert, another famous entertainer, and those to illustrate Jules Renard's *Les Histoires Naturelles* (1899)—superlative animal studies, equaling in liveliness Picasso's illustrations for Buffon's *Natural History*.

NATIONAL GALLERY: *A Corner of the Moulin de la Galette,* 1892. *Alfred la Guigne,* 1894; both include the raffish types which frequented Toulouse's half-world. ★ *The Artist's Dog Flèche,* c. 1881; an early work in which the painter gives far more nobility to his faithful hound than he found in the people of the Paris cabarets and bordellos.

HARTFORD: *Jane Avril Leaving the Moulin Rouge;* the National Gallery has another of his many portraits of the famous entertainer.

CHICAGO: *At the Moulin Rouge,* 1892; the artist's self-portrait appears in the background, the dwarflike little figure with his tall cousin, Dr. Gabriel Tapié de Céleyran, his frequent companion in his night life.

CLARK: *The Studio;* early, still recalling Degas; compare *The Tracheotomy* in his own fully developed style, recalling both Daumier and Van Gogh, but all Toulouse-Lautrec.

CLEVELAND: *May Belfort,* 1895; a famous cabaret singer.

Trumbull, John (1756–1843)

Born into an established Connecticut family, John Trumbull was by nature irascible and intolerant, prideful, and formal in manner. He is best known for his paintings of episodes of the Revolution, the sketches for which are at Yale, to which he left his entire collection and for which he designed the first college art gallery.

YALE: *Battles of the Revolution;* a series of lively sketches. *Declaration of Independence;* a trial run for his mural in the national Capitol—and better.

METROPOLITAN: Portrait sketch of *Thomas Jefferson*, 1787; excellent!

BOSTON: *Self-Portrait*, 1777; as an ingenuous young man before he turned into an embittered martinet.

Turner, Joseph Mallard William (1775-1851)

A short man with a large nose and immense talent, Turner was self-taught; he started as an engraver and etcher; engravings after his topographical drawings are models of composition and draftsmanship. He was very hard working and produced hundreds of oils and water-colors, full of shimmering light and atmosphere anticipating Impressionism and yet-later developments. At the *vernissage* of the Royal Academy exhibitions he liked to complete his paintings, instead of merely varnishing them, to the consternation of would-be rivals and the delight of his admirers. Turner is widely represented in North America. Significant collections are in Indianapolis (esp. the Pantzer Collection), the National Gallery, the Frick, Providence, and the Fogg. Outstanding examples are numerous.

HUNTINGTON: *The Grand Canal, Venice: Shylock*, 1837.

NATIONAL GALLERY: ★ *Keelmen Heaving in Coals by Moonlight*, c. 1835; a workaday subject turned into a luminous vision. *Venice: Dogana and San Giogio Maggiore*, c. 1834; for Turner Venice was a kind of lovely mirage.

CHICAGO: ★ *Valley of Aosta—Snowstorm, Avalanche, and Thunderstorm* (two versions); the drama of nature.

BOSTON: *The Slave Ship*, 1840; Romantic humanitarianism. *Falls of the Rhine at Schaffhausen*, 1806; a perfect example of the picturesque, even incl. the quality of the *impasto*.

CLARK: *Rockets and Blue Lights (Close at Hand) to Warn Steamboats of Shoal Water*, 1840; looks forward to Whistler.

FRICK: *Cologne: The Arrival of a Packet Boat: Evening*, 1826.

CLEVELAND: *The Burning of the Houses of Parliament*, 1835; another version is in Philadelphia; both are equally dramatic.

Fine watercolors are in Stanford, Indianapolis, the Smith, Providence, Toronto, and elsewhere.

Utrillo, Maurice (1883-1955)

The son of Suzanne Valadon, a good painter who was also a model for Degas, Renoir, and others, Utrillo grew up in a world of art; but as a youth he became an alcoholic and drug addict, which led to constant trou-

491

ble with the police, to confinement and attempted cures which did not work. His mother persuaded him to take up painting as a therapy, but he seems to have used it to support his habits as well. His pictures, often routine and repetitious, are fair Post-Impressionist efforts, mostly city scenes in chalky tones, which are in many museum collections.

Vanderlyn, John (1775-1852)

Born in Kingston, New York, Vanderlyn was a protégé of the notorious Aaron Burr, vice president under Jefferson and the murderer of Alexander Hamilton in the infamous duel on the heights of Weehawken, New Jersey. Vanderlyn studied in Paris, won a gold medal from Napoleon for his *Marius Amid the Ruins of Carthage* (de Young). His ★ *Ariadne Asleep on the Island of Naxos* (1812) is the best American nude for many a decade (Pennsylvania Academy). He hoped his panoramas of the *Palace and Gardens of Versailles* (the Metropolitan) would gain public approval in America where his historical and mythological subjects did not, but the venture failed and Vanderlyn retreated in defeat to his native Kingston to disappear into bitter obscurity. His fine *Niagara* (1827) is in the Senate House Museum there.

Velázquez, Diego Rodríguez de Silva y (1599-1660)

Velázquez dominated Spanish art in the seventeenth century as Goya did in the nineteenth. He developed a masterful style compounded of Spanish realism, the Caravaggesque tradition, Venetian color, the influence of Rubens, and Iberian sobriety. As court painter to the moody and unhappy Philip II, he produced superb portraits and character studies of the royal family, attendant courtiers and dwarfs, and historical and religious subjects. His paintings or those of his shop are in many North American museums—San Diego, the National Gallery, Chicago, the Gardner, Boston, Detroit, Kansas City, the Frick, the Metropolitan, the Hispanic Society, Cincinnati, Cleveland, Toledo, and Norfolk.

NATIONAL GALLERY: *Pope Innocent X,* c. 1650; shrewd and suspicious.

CHICAGO: *The Servant;* shows his cool, clear observation. *St. John in the Wilderness,* 1620-22.

GARDNER: *King Philip IV of Spain;* other portraits of him are in Boston, Cincinnati, and the Metropolitan.

BOSTON: ★ *Don Baltasar Carlos and His Dwarf;* superb double portrait. *Luis de Gongora,* 1622; a Baroque poet and religious mystic.

DETROIT: *Portrait of a Man,* c. 1624.

KANSAS CITY: *Maria Anna, Queen of Spain,* c. 1650.

FRICK: *Philip IV;* a full-length version, austere and handsome.

HISPANIC SOCIETY: *Camillo Astalbi, Cardinal Pamphili. Gaspar de Guzman, Count-Duke of Olivares,* 1625; a totally corrupt minister and a real ruffian.

METROPOLITAN: *Supper at Emmaus;* fine, early. *Infanta Maria Theresa;* pathetic and proud. *Don Gaspar de Guzman, Count-Duke of Olivares;* he loved to see himself in paint. ★ *Juan de Pareja,* 1650; one of his finest portraits, depicting his black painter-assistant, friend, and traveling companion, painted in Rome at the same time as the *Innocent X* portrait.

CLEVELAND: *The Jester Calabazas;* like his dwarfs, showing both dignity and understanding.

TOLEDO: *Man with a Wine Glass;* possibly not by Velázquez, but a very fine picture.

Vermeer, Jan (1632–75)

Vermeer was born and worked in Delft. Almost nothing is known of him except that when he died at only forty-three he left many debts and "eight children, under age." Apparently little appreciated in his own day, he left a studio full of paintings. Only about forty are known today, a dozen of which are in the United States. Today his works are treasured as fascinating, enigmatic, superbly composed, and painted with a technique of breaking highlights into crystalline particles of paint and of luminous, colored shadows in a way not practiced again until the nineteenth century. Every one of his paintings is made memorable, no matter how commonplace the subject, by his incomparable, unique vision.

NATIONAL GALLERY: *Woman Weighing Gold,* c. 1657. ★ *Girl with a Red Hat,* c. 1665; a near-Pointillist technique. *Young Girl with a Flute,* c. 1658–60. *A Lady Writing,* c. 1665; she is writing to you!

GARDNER: *The Concert;* music is often a part of Vermeer's art.

FRICK: *Officer and Laughing Girl,* c. 1657; look at the painting of the highlights, the 1621 Willem Blau map of Holland and West Fiesland (dating from 1621) on the wall. *Girl Interrupted at Her Music,* 1660–70. *Mistress and Maid;* a late and unfinished painting.

METROPOLITAN: *Allegory of the Faith,* c. 1669–70; as fascinating for the elaborate iconography as for the magical painting; note the handling of the draped tapestry and the highlights on the hanging globe. *Young Woman with a Water Jug,* c. 1658–60. *Woman with a Lute;* another work influenced by music.

Veronese, Paolo Caliari, called (c. 1528–88)

Born in Verona, as his name tells us, Veronese lived and worked in Venice from 1553 until his death. The oriental splendor of Venetian life and the picturesqueness and variety of the Venetian scene were the real subjects of his paintings, whatever title might be given them. An accomplished composer, he orchestrated vast murals or large canvases in a pageantlike celebration of Venetian opulence, rendered with the rich color of Giorgione and Titian. He painted easily and fast, had many assistants, and is represented in almost all major museums.

LOS ANGELES: *Two Allegories of Navigation.*

GETTY: *Self-Portrait;* a most interesting document.

DENVER: *Portrait of Vignola,* 1568–84; the great early Baroque architect of the Gesù in Rome.

NATIONAL GALLERY: *The Finding of Moses,* early 1570s; glorious color.

RINGLING: ★ *Rest on the Flight into Egypt;* note the activities of the attendant angels.

BOSTON: Four typical mythologies, richly composed and painted.

DETROIT: *The Muse of Painting;* a tiny sketch.

FRICK: Two handsome *Allegories.*

METROPOLITAN: *Mars and Venus United by Love,* 1576–84; cryptic and sumptuous.

PHILADELPHIA: *Diana and Actaeon;* Venetian pageantry.

Verrocchio, Andrea del (c. 1435–88)

The leading Florentine painter, sculptor, and goldsmith of the generation after Donatello, Verrocchio is famous for being the master of Leonardo da Vinci as well as for his own considerable achievements in several media. Among the very few works attributed to him in American collections are fine sculptures in the National Gallery. ☛ The impressive portrait bust in terra-cotta of ★ *Lorenzo de' Medici,* humanist, poet, composer, and ruler of Florence during the golden years of the Renaissance, one of the greatest patrons of the arts of all time, and a colorful and complex personality. Toledo has *Two Angels* that are attributed to Verrocchio also.

Vigée-Lebrun, Élisabeth (1755–1842)

A highly successful portrait painter in both oils and pastels, Vigée-Lebrun was a friend of Queen Marie Antoinette, had a famous salon in Paris, and produced many portraits of leaders in French society before the

Revolution. Thereafter she enjoyed similar success in Italy and the capitals of eastern Europe and Russia before returning to Paris briefly in 1802, then London, Switzerland, and Paris again. Among American collections with examples of her work are Boston, the National Gallery, St. Louis, Raleigh, Columbus, and the Metropolitan. ☞ A portrait from her Russian visit of *Varvara Ivanova Narishkine* (1800, Columbus).

Vuillard, Édouard (1868–1940)

Primarily a painter of intimate interiors with figures, Vuillard's compositions were influenced by photography. In his application of paint, he paid great attention to the principle, common with Pointillism also, of the visual mixing of color in a technique shared to a degree by the Impressionists. He is represented in most major collections with his always painterly and visually interesting canvases, characteristically on a small scale.

CARNEGIE: *Interior with Women,* 1900; a fine example of his patterned, intimate style.

NATIONAL GALLERY: *Théodore Duret,* 1912; a fascinating portrait of a distinguished French critic portrayed forty years earlier by Whistler in one of his best works (in the Metropolitan). *Repast in a Garden,* 1898; near-Pointillist in style; note also a marvelous group of small gouache and mixed-medium sketches in the Ailsa Mellon Bruce Collection.

SMITH: *The Suitor,* 1893; the variety of names given to this panel in the past suggests the relative unimportance of the subject matter as compared to the sheer visual effect.

Ward, John Quincy Adams (1830–1910)

Born on an Ohio farm, Ward was determined to become a sculptor and studied with Henry Kirke Brown in Brooklyn. His *Indian Hunter* (1864) was the first sculpture financed by public subscription to be placed in New York's Central Park. His work is characterized by an intense, objective naturalism which gives it a striking presence.

METROPOLITAN: *Indian Hunter;* bronze cast of Ward's original model for the sculpture in Central Park (New York City). *Henry Ward Beecher;* another bronze cast for the sculpture in front of Borough Hall, Brooklyn.

FEDERAL HALL NATIONAL MEMORIAL: (Subtreasury Building), 28 Wall St., New York City: *Washington* (1883); a fine, dignified, monumental figure.

THE CAPITOL, WASHINGTON, D.C.: *African Freedman;* an important expression of Ward's passionate abolitionism.

Watteau, Jean-Antoine (1684–1721)

Of Flemish ancestry, Watteau was in Paris by the time he was eighteen and developed his sure and delicate style after studying the Rubens paintings in the Luxembourg Palace and other Old Masters. Before his untimely death from tuberculosis—like Raphael, he lived only thirty-seven years—he had become a painter of gallantry, portraying courtiers and actors of Italian comedy in delightful scenes of sophisticated pastoralism often pervaded with a feeling of quiet melancholy, of the transiency of love and life. He was an accomplished and vivid draftsman, and many of his drawings are in American collections.

PASADENA: *Reclining Nude,* 1713.

HARTFORD: *La Danse Paysanne.*

NATIONAL GALLERY: *Italian Comedians,* 1720. *Sylvia (Jeanne-Rose-Guyonne Benozzi),* c. 1720. *Ceres (Summer),* c. 1712–15.

CHICAGO: *The Dreamer;* and drawings, one of various figures of the Italian comedy.

INDIANAPOLIS: *La Danse Champêtre.*

MUNCIE: *Portrait of Frère Blaise.*

BOSTON: *La Perspective,* 1712–15.

METROPOLITAN: *The French Comedians,* c. 1720. *Mezzetin;* a guitar-playing figure of the Italian comedy.

TOLEDO: *La Conversation,* 1712–15.

RICHMOND: *Le Lorgneur.*

Ottawa has drawings; works can also be found in the Fogg, Chicago, Bloomington, the National Gallery, Phillips, and the Metropolitan.

West, Benjamin (1738–1820)

Born of a poor Quaker family on the Pennsylvania frontier, West early won recognition by his precocious artistic abilities, was assisted to study abroad, and visited Italy where he was vastly impressed by the antique and by Venetian color. A brief visit to England on his return was stretched to a lifetime by his instant popular success with ambitious historical and mythological subjects. He became historical painter to the king and succeeded Sir Joshua Reynolds as the second president of the Royal Academy. As a Quaker he would not fight, but during the American Revolution he remained a loyal American even though he was a personal friend of King George III. He was an important figure in the Romantic movement, but his major significance for American art was his unfailing generosity to aspiring young American art students who were

always welcome in his studio. He taught them, supported them, and found them patrons. His work is in many American museums.

OTTAWA: *Death of Wolfe,* 1771; a landmark, as it records a historical event for the first time in an important painting utilizing the costumes of the period.

YALE: *Agrippina Landing at Brindisium with the Ashes of Germanicus,* 1768.

NATIONAL GALLERY: *Self-Portrait,* c. 1770. ★ *Col. Guy Johnson,* 1776; a fine Romantic portrait of the superintendent of Indian affairs in the colonies, with his friend and secretary, the famous Mohawk chief, Joseph Brant, the very symbol of Rousseau's "noble savage." *The Wise Men's Offering,* 1794; a design for a window of the chapel George III planned for Windsor Castle, a project never carried out; some of West's designs for this project, all wildly Romantic in nature, are in Greenville.

CINCINNATI: *Laertes and Ophelia;* a vast picture which once belonged to Robert Fulton; Nicholas Longworth bought it and had it hauled over the Alleghenies in the 1830s.

Weyden, Rogier van der (Rogier de la Pasture) (1599/1600-64)

The leading Flemish painter of the generation after Jan van Eyck, Rogier's warmer, more expressive and humanistic art was also immensely influential. His work is in many museums, among them: the Getty, Huntington, Chicago, Detroit, Boston, Memphis, Philadelphia, and Houston.

BOSTON: ★ *St. Luke Painting the Virgin,* c. 1436; through an ancient confusion of the Evangelist St. Luke with an early, saintly Eastern monk who was a painter of icons, the Evangelist became the patron saint of artists; note the charming glimpses of the city and its life.

HUNTINGTON: *Madonna.*

METROPOLITAN: *Francesco d'Este of Ferrara;* compare with Italian Renaissance portraits and feel the Northern flavor.

NATIONAL GALLERY: *Portrait of a Lady,* c. 1455; delicate, sensitive, aware; compare with *St. George and the Dragon,* c. 1432; a Gothic fairy tale.

Whistler, James Abbott McNeill (1834-1903)

An American painter and etcher of international reputation, Whistler was born in Lowell, Massachusetts, a fact he managed consistently to forget. After a disastrous episode at West Point, he gratefully escaped

to Paris and finally settled in London, where he enjoyed a colorful career as a painter, wit, and dandy. His collection of essays *The Gentle Art of Making Enemies* (1890) is a minor classic. Aware of revolutionary contemporary developments in France, Whistler remained independent, developing his own distinctive, poetic style based solidly on objective reality, but full of light and atmosphere, showing him to be an heir of the Luminists. He was a superb draftsman and etcher whose works are in most American art collections. There are important groups of his work in the National Gallery, the Metropolitan, Chicago, and esp. the Freer, which has his entire Peacock Room (c. 1865) and a large number of paintings.

CHICAGO: *The Artist in His Studio,* c. 1867–68; typically fluid handling of oil; note the snapshotlike composition.

CORCORAN: ★ *Battersea Reach,* c. 1863–65; the River Thames provided a constantly recurring theme in Whistler's art, Allston's "landscapes of mood" carried to a still further degree.

DETROIT: *Arrangement in Gray: Self-Portrait,* 1871–73; one of several. ★ *Nocturne in Black and Gold: The Falling Rocket,* c. 1874; the painting that caused the most notorious court case involving art in the century, in which Whistler sued the critic Ruskin for accusing him of "wilfull imposture"; it pushes abstraction to the point where it anticipates artistic movements of more than a half-century later.

FOGG: *Alley in Venice,* 1850; pastel on tinted paper; one of a series made in connection with his famous Venetian etchings.

METROPOLITAN: *Arrangement in Flesh Color and Black: Portrait of Theodore Duret,* 1882–84; one of his most distinguished portraits; the subject was a prominent French art critic and an admirer of Whistler's painting. (Compare Vuillard's informal portrait of Duret of forty years later, in the National Gallery.)

NATIONAL GALLERY: *Chelsea Wharf: Gray and Silver,* c. 1875. *Symphony in White No. 1: The White Girl,* 1862.

TAFT: *At the Piano,* 1858; as immaculate an abstract geometric composition as those of Mondrian; beautifully rich tonal qualities and paint surfaces.

Whittredge, Worthington (1820–1910)

Whittredge was born on an Ohio farm. Determined to become a painter, he walked to Cincinnati where he made signs. Nicholas Longworth helped him go to Düsseldorf to study, but when he came home he abandoned

the tight, meticulous Düsseldorf style and developed the broad atmospheric manner which represented his personal response to the American scene, so different from that of Europe.

METROPOLITAN: *Deer in the Forest,* c. 1850; and others.

BOSTON: *Outskirts of the Forest,* c. 1880. *Old Homestead by the Sea,* 1883.

CORCORAN: *Crossing the Rocky Mountains,* 1859. *Trout Brook in the Catskills,* 1825.

WICHITA: *Beach at Newport,* c. 1860.

Wood, Grant (1892–1942)

An American painter and printmaker, Wood studied abroad where he discovered the work of early Flemish painters. He developed a sophisticated, primitivistic style of sharply delineated and modeled forms with which he painted such subjects of American folklore as *Parson Weems' Fable* (Whitney), *Paul Revere's Ride* (1931, the Metropolitan), *American Gothic* (1930, Chicago), and *Daughters of Revolution* which is a biting satire of smug narrowmindedness (Cincinnati). He is usually classed with the Regionalists of the 1930s, but his work has more humor, bite, and sophistication.

Wyeth, Andrew (1917–)

An American painter in oil, tempera, and watercolor, famous for portraits, genre scenes, landscapes, and seascapes, Wyeth was the pupil of his father, N. C. Wyeth, the famous illustrator. He lives and works at Chadds Ford, Pennsylvania, with summers in Maine, always in a style based on traditional American naturalism, but with a spare, understated, and often oblique connotation in the interpretation of his subjects. His pictures have a mood of melancholy and nostalgia which, with their naturalism, has made them extremely popular and much collected so that there are examples in the great majority of American collections. The most important single group is in the Brandywine Museum in Chadds Ford, an old mill made over into an ecology center and an art museum devoted to Howard Pyle, Wyeth, and the tradition of American illustration. Wyeth's most famous single painting is *Christina's World* (1949, the Modern). His son, James, and his sisters, Henriette and Carolyn, are also successful painters, as is Henriette's husband, Peter Hurd. The Greenville County Museum has an important collection of Andrew's work.

Zurbarán, Francisco de (1598–1664)

One of the great Baroque painters of Spain, Zurbarán combined earthy Spanish naturalism with Counter-Reformation mysticism to create devotional images of powerful intensity. Through his wife's family, who had settled in Peru, he and his shop produced quantities of religious paintings for churches throughout Latin America. His work may be found in major collections throughout North America and much of South America.

SAN DIEGO: *Agnus Dei;* a trussed lamb as a symbol of Christ's sacrifice; a gentle and touching picture.

SANTA BARBARA: *A Franciscan Monk;* an intense study of meditation on mortality.

HARTFORD: ★ *St. Serapion,* 1628; a martyred monk, portrayed with great power and totally without sentiment, beautifully painted and poignantly moving; it may have been cut from a full-length picture, yet it seems satisfactorily complete as is.

METROPOLITAN: *The Battle with the Moors at Jerez;* a depiction of the intercession of the Virgin to ensure Christian victory. *The Young Virgin;* an example of the Spanish tradition of portraying sacred figures in a genrelike setting.

KANSAS CITY: *Entombment of St. Catherine;* an outstanding altarpiece on a large scale.

MEADOWS MUSEUM, DALLAS: *Mystic Marriage of St. Catherine;* another handsome altarpiece.

Glossary of Art Terms

Abstract Expressionism

A nonobjective style of art that dominated American painting in the 1950s and '60s, as exemplified in the work of Jackson Pollock, Willem de Kooning, Franz Kline, and others; also known as the New York School and Action Painting.

American Impressionists

A label often loosely applied to a small group of painters, incl. Theodore Robinson (1852–96), who worked with Monet at Giverny; John H. Twachtman (1853–1902); and Childe Hassam (1859–1935). Though their palette was influenced by Impressionism, these painters never sought merely to record the transitory visual effect, as did the true Impressionists. Following the tradition established by the Luminists of an earlier generation, they strove to enliven the naturalistic substance of their work by the brilliant, broken brushwork and handling of paint developed by Monet. Paintings by these artists are in almost all American collections.

Art Nouveau

An international decorative style of the 1890s, based on the use of organic, plantlike forms in sinuous compositions, as in the drawings of Aubrey Beardsley, the architecture of Victor Horta and Henri van de Velde, and the posters of Alphonse Mucha.

Barbizon School

A group of mid-nineteenth-century French painters, among them Millet, Théodore Rousseau, and Diaz de la Peña, associated with the village of Barbizon in the forest of Fontainebleau. Their directly observed paintings of the French countryside and peasant life—influenced by Corot, the Dutch landscapists Hobbema and Ruisdael, and the English painters Constable and Bonington—eventually led to the Impressionist movement. One of the largest collections of Millet's works, both paintings and prints, is in Boston, where the other members of the group are also represented.

Baroque

A style characterizing all the arts of the seventeenth and eighteenth centuries in Europe, involving a sense of movement and drama and a highly organized, complex use of space and perspective.

Blaue Reiter, Der (The Blue Rider)

A group of experimental modern artists briefly associated in Munich in 1911, whose major adherents incl. Wassily Kandinsky, Franz Marc, and

Paul Klee. This group later combined with Die Brücke (The Bridge), an influential group of modernist artists—incl. Ernst Ludwig Kirchner, K. Schmidt-Rottluff, Erich Heckel, and F. Bleyl—based in Dresden and active from 1905 to 1913.

Bozzetto
(pl. bozzetti)

The Italian word for sketch. Used in connection with models for sculpture; equivalent to the French term *maquette* (small model), also a frequently used art-historical term.

Bulto. *See* Santo

Capriccio

The Italian word for caprice or fantasy. Refers to scene paintings, often using actual elements of architecture and place but freely manipulated to create picturesque effects. A leading exponent was Francesco Guardi.

Chiaroscuro

From the Italian words for light (*chiaro*) and dark (*scuro*), referring to dramatically contrasting lights and darks in art. Caravaggio was the most influential user of this technique.

Classical Revival

A nineteenth-century phenomenon, largely in architecture, involving the revival of the forms and the styles of Greece and Rome.

Diptych

A painting consisting of two panels, usually hinged together.

The Eight

A group of American painters exhibited at the Macbeth Gallery in New York City in 1908 in the revolutionary exhibition called Eight Americans. The group incl. Robert Henri, John Sloan, George Luks, Maurice Prendergast, Everett Shinn, Ernest Lawson, Arthur B. Davies, and William J. Glackens.

The Fauves

The French word for wild beasts. It was applied to the art of Matisse, Rouault, Derain, Vlaminck, Marquet, and others who exhibited together at the Paris Salon d'Automne in 1905, because of their expressionistic distortion of form and unnaturalistic use of color.

Fraktur

The Pennsylvania German (so-called Pennsylvania Dutch) art of manuscript and document illumination, involving decoration with pen and ink and watercolor and utilizing traditional images of birds, flowers, etc.; practiced mostly in the eighteenth and nineteenth centuries.

Fresco

True fresco painting is done by applying paint to the freshly plastered wall or ceiling surface while it is still wet, so that the paint becomes integral with the plaster. Painting on dry plaster, called *fresco a secco*, is not true fresco, but it is less demanding because the artist can paint whenever he pleases, not just when the plaster is still wet, but it generally does not last as well. The great age of fresco extended from the thirteenth through the seventeenth centuries.

Genre

The French word for kind or category. Used to describe an art devoted to the portrayal of aspects of everyday life as opposed to the ideal or heroic.

Gothic

The final phase (1140–c. 1500) of the art of the Middle Ages in northern

Europe. A style characterized by the use of the pointed arch in architecture.

Gouache. *See* Watercolor

Hudson River Portraits

A group of early eighteenth-century portraits, primitive and formal, originating with the Dutch landowners of the Hudson River Valley; the work of largely anonymous craftsmen, sometimes called Patroon Painters. There are also a few religious pictures, based upon prints, as were the costumes and settings of the portraits. The group represents the first regional school of painting in America. Examples are in the larger American collections.

Hudson River School

The first American landscape school, led by Thomas Cole, and incl. Asher B. Durand, Frederic E. Church, Worthington Whittredge, Jasper F. Cropsy, John W. Casilear, Albert Bierstadt, Sanford R. Gifford, Martin J. Heade, and John F. Kensett. They shared an almost pantheistic view of nature, as seen in the unspoiled vistas of the New World, and an attitude close to that of Emerson, Thoreau, and the Concord transcendentalists.

Iconography, Iconology

From the Greek word for portrait or image (*ekon*); the study of the form and meaning, respectively, of images.

Impasto

A paint surface of considerable thickness and deliberate irregularity for artistic effect.

Impressionism

In 1872 Monet painted a picture of the sun reflecting on the water entitled *Impression, Sunrise*, which was shown two years later in the First Impressionist Exhibition in Paris. As a result, his work and that of the other artists who participated in that exhibition (among them Degas, Renoir, Pissarro, Cézanne, Sisley, Morisot, and Boudin) was derisively called Impressionist. To achieve a greater visual accuracy in painting nature, the Impressionists sought to capture the surface of things, with the momentary play of light and shade, usually in a light, bright palette, painted out of doors in a swift and direct manner, broadly enough so that the brush strokes enliven the surface.

Inro

Small Japanese lacquer carrying cases for medicines, etc., formed of several small containers joined by a cord and hung from the belt.

International Style (International Gothic)

The final phase of the Gothic in painting, with a flowering in the late fourteenth century of all the attenuated, curvilinear aspects of late medieval art, and an emphasis on its naturalistic detail. Paintings in this style are characterized by sophistication of design and notable decorative quality. Major examples are Gentile da Fabriano, Pisanello, and Lorenzo Monaco in Italy, and the Limbourg Brothers and Melchior Broederlam in Burgundy.

Luminism

A movement in nineteenth-century American painting, incl. such artists as Kensett, Lane, Heade, Gifford, and Whittridge, all of whom used light not only as a unifying element in their naturalistic art but also as an expres-

sion of an almost transcendental identification with the American scene.

Mannerism

A style in which artists assume the manner of one or more artists of reputation; most often used to categorize the elongated, elegant, and unreal style of the transitional artists from the High Renaissance to the Baroque.

Neoclassicism

A return to the forms and the spirit of classical Greece and Rome that occurred in the eighteenth and early nineteenth century under the impetus of contemporary Romanticism.

Netsuke

A small Japanese toggle, often carved in grotesque or amusing animal, human, or other natural form, to fasten a purse or other article to a kimono sash.

New York School. *See* Abstract Expressionism

Nonobjective Art

An art whose forms have been sufficiently abstracted to leave no trace of a recognizable image; art conceived without image.

Palette

The flat, thin plate, traditionally of wood, with a hole for the thumb, used for mixing a painter's colors; the range and quality of colors used by an artist; color scheme.

Pointillism

A system of painting in which the artist applies many small touches of pure color in juxtaposition on the theory that they recombine into various tones in the eye of the observer. Tachism is a similar system, but with less regularly circular dots and larger brush-strokes. Seurat was the leading Pointillist.

Polyptych

A painting in three or more panels, usually hinged together to form an altarpiece.

Precisionist

A name applied to Charles Sheeler, Stuart Davis, Georgia O'Keeffe, Charles Demuth, and other American painters whose style shows a sharp and distinctive clarity enhanced by varying degrees of abstraction.

Pre-Raphaelite

The Pre-Raphaelite Brotherhood was formed in England c. 1848 by Dante Gabriel Rossetti, William Holman Hunt, Sir John Everett Millais, and others; it was a very literary art movement stressing serious, often religious, subject matter, and a detailed, symbolic interpretation. Their works are in several American collections, the only significant groups being in the Delaware Art Museum, Wilmington, and the Fogg, Cambridge.

Regionalism

A movement marking the return to the American scene that took place in the 1930s. Leading exponents were Thomas Hart Benton, John Steuart Curry, and Grant Wood.

Renaissance

A period in history customarily marking the beginning of the modern world; a movement in the arts, starting about 1400 in Florence, that spread throughout Italy and Europe throughout the next two centuries, characterized by a revival of individualism, humanism, and a rediscovery of the classical heritage of ancient Greece and Rome.

Retable

A large structure forming the rear of an altar, with painted or sculpted panels, common in Iberian and Latin American art; also called reredos.

Romanesque

That period of the Middle Ages, c. 1000–c. 1150, with architecture characterized by the round arch (as in Roman architecture, hence Romanesque).

Santo

Santos and bultos are the religious paintings and sculptures, respectively, made by Indians of the American Southwest and Mexico under Christian inspiration; santo is often used collectively for both santos and bultos.

Sfumato

From the Italian word for smoked or smoky, referring in painting to soft modeling of form without sudden or marked transition from light to shade.

Surrealism

A twentieth-century post-Freudian movement in the arts that sought to express, through dreamlike images and symbols the inner world of the subconscious mind. It also stressed automatism, an aspect that led to the action painting of the Abstract Expressionists. Salvador Dali, Yves Tanguy, and Juan Miró are among the best known Surrealists.

Tachism. *See* Pointillism

Tempera

The traditional Western painting medium up until the later fifteenth century, when oil largely replaced the egg used in tempera as a binder. Many artists used tempera for underpainting, finishing the work with transparent oil glazes, a system called the mixed method. Modern tempera paints, which may be purchased in any artist supply store, are poster colors using a plastic binder; they have no relation whatsoever to the traditional medium of the same name.

Tondo

From the Italian word for round, meaning a circular painting or relief.

Triptych

A painting in three panels, usually hinged together to form an altarpiece.

Veduta
(pl. vedute)

From the Italian word for view, referring to topographical scene painting; many artists, among whom Canaletto was the most famous, specialized in vedute, esp. for visiting travelers.

Vernissage

Literally, varnishing; now a pre-public exhibition opening, usually for participating artists, critics, and patrons.

Watercolor

A painting technique using transparent washes of water-soluble color on white paper. True watercolor is always transparent, yet most of the greatest practitioners also used touches of opaque color, or gouache, for accent. Homer and Sargent were among the greatest American watercolorists, as was Turner in England. It is considered a major medium in America, but only a minor one in England.

ABOUT THE AUTHOR

RICHARD MCLANATHAN, former director of the American Association of Museums, is internationally known as an art historian and interpreter of the arts. He is the author of a number of books, including *Images of the Universe: Leonardo da Vinci, the Artist as Scientist; The Pageant of Medieval Art and Life, The American Tradition in the Arts, Art in America,* and, for the National Gallery of Art, *The East Building: A Profile.* He was educated at Choate and Harvard, where he received his A.B. in 1938, a Ph.D. in 1952, and was elected to the Society of Fellows. In 1948 he was awarded a Prix de Rome. He has been active in the museum field at the Fogg Museum in Cambridge and at the Museum of Fine Arts in Boston, where he was Assistant Curator of Paintings, Curator of Sculpture and Decorative Arts, Editor of Publications, and Secretary of the Museum. While in Boston he started the first television program regularly to originate in a museum. As director of the Munson-Williams-Proctor Institute in Utica, he was responsible for the new museum building designed by Philip Johnson and the restoration of Fountain Elms, a Tuscan villa house of 1850. He has been a contributor to numerous art periodicals and other publications, including *Art News, Antiques, The Atlantic Monthly,* the New York *Times, Museum News,* and the *Encyclopedia of World Art.* In 1959 he served as curator of the American National Exhibition at the Moscow Fair, and was an American specialist for the State Department in West Germany, Poland, Denmark, and Yugoslavia. He was an original member of the New York State Council on the Arts, Rockefeller Senior Fellow at the Metropolitan Museum of Art, and has been associated throughout his professional career with the arts as educator, lecturer, consultant, writer, and administrator. Since 1979 he has been living in Maine, devoting himself primarily to writing.

Notes

Notes

Notes

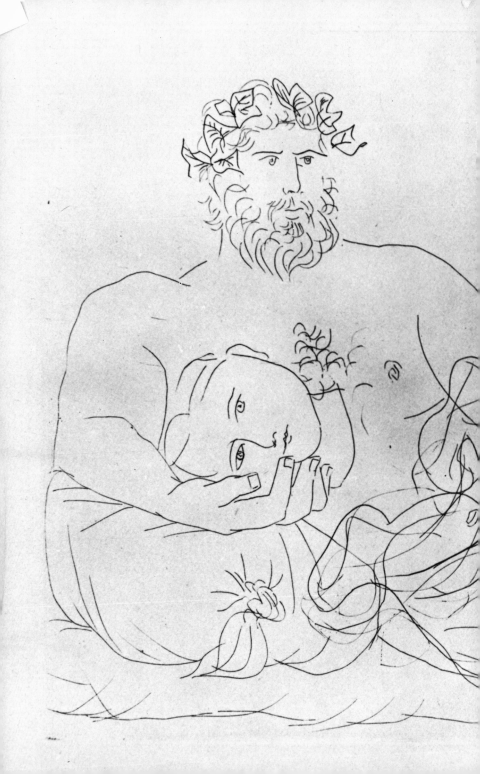